The Art of
East Asia

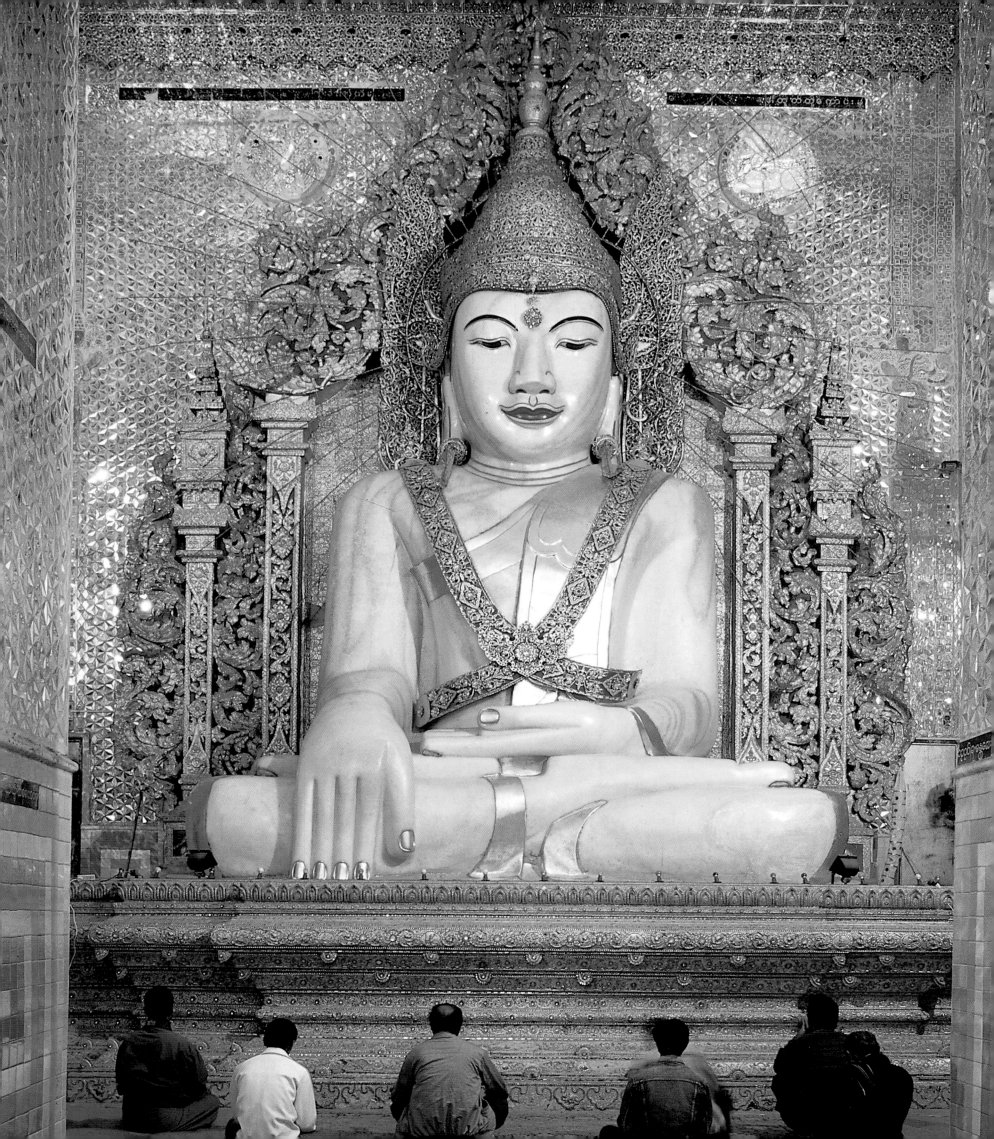

Gabriele Fahr-Becker

(Editor)

The Art of
East Asia

Volume 2

Contributing authors are
Gabriele Fahr-Becker
Michaela Appel
Michael Dunn

KÖNEMANN

Notes: where dimensions of objects are given in captions, the order is:
height x width, or height x width x depth.

If the location of the objects shown is not given, they are in private
ownership or unidentified collections.

Transcription of Southeast Asian names and terms follows largely the
customary English-language transcription, without diacritical signs except for
the unavoidable length marks. In the chapter on Thailand, the transcription
follows largely that current in Thai.

Endpapers: design based on a traditional Japanese pattern.

Frontispiece, Vol. 1: *Ksatriya* figure, *wayang golek*, pre-1925, Staatliches
Museum für Völkerkunde, Munich

Frontispiece, Vol. 2: Statue of Buddha, Kyauktawgyi pagoda, completed 1878,
Mandalay, Burma

Ills. pp. 4(5, Vol. 2: Obaku Kōsen (1633–1695), *Hotei's bag and stick*,
Collection of J. E. V. M. Kingadō

© 1998 Könemann Verlagsgesellschaft mbH
Bonner Str. 126, D–50968 Cologne

Art direction and design: Peter Feierabend
Project coordinator of the German edition: Birgit Dunker
Layout: Sabine Vonderstein and Bernd Elfeld (chapter on *China*)
Picture research: Barbara Linz
Production Manager: Detlev Schaper
Production: Mark Voges
Reproduction: CDN Pressing, Verona

© 1999 for the English edition:
The author Michael Dunn wrote his text in English
Translation from German for the rest of the text: Paul Aston,
Peter Barton, Anthea Bell, Sandra Harper, Christine Shuttleworth
Editor of the English edition: Chris Murray
Project coordinators: Jackie Dobbyne and Bettina Kaufmann
Typesetting: Goodfellow and Egan, Cambridge
Printing and binding: Neue Stalling, Oldenburg

Printed in Germany
ISBN: 3-8290-1745-6

10 9 8 7 6 5 4 3 2 1

三千大千界
在一壺中

Volume 1

** Co-author: Detlef Kuhnt*
*** Co-author of the section on modern choreography: Maria Darmaningsih*

Volume 2

** Co-author of the captions: Maria-Theresia von Finck*

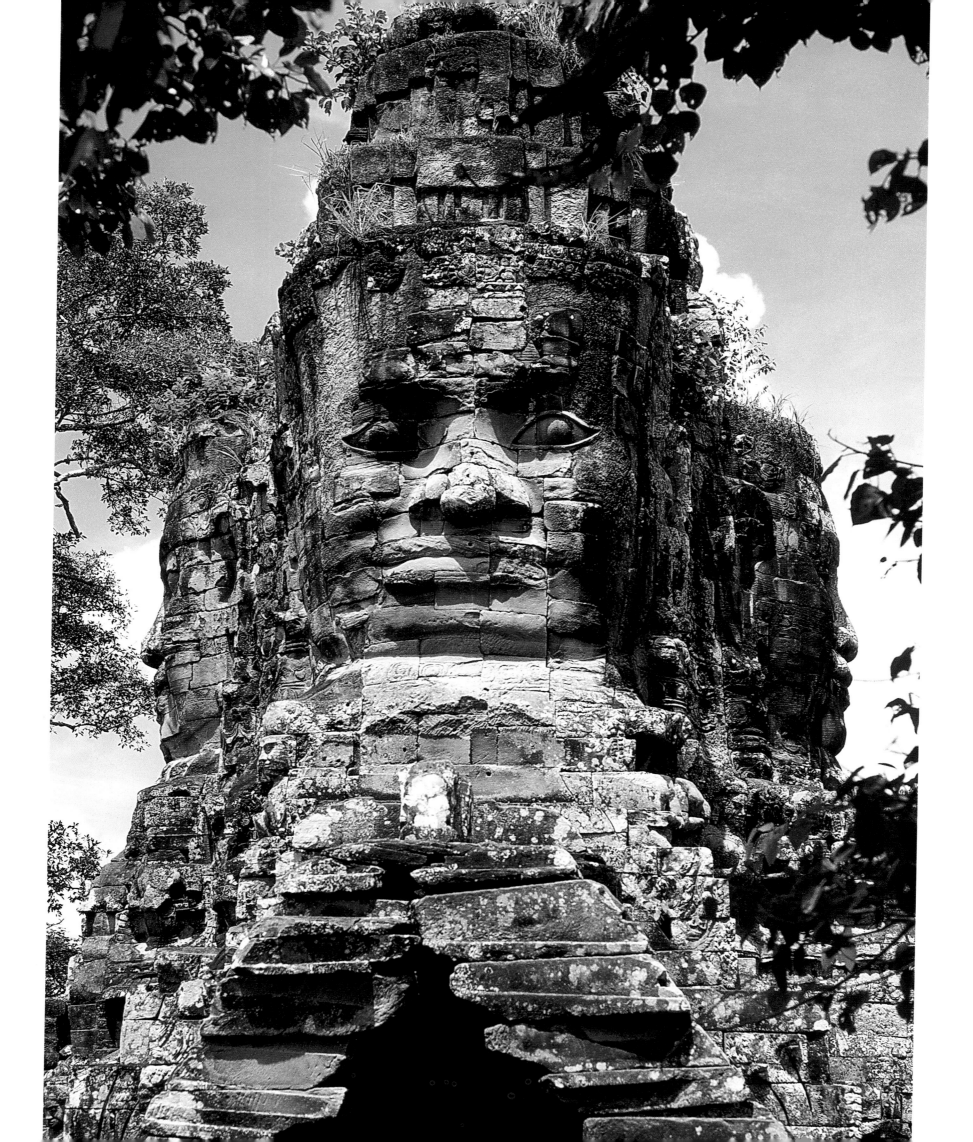

The Kingdom of the Khmer

Though the recent history of Cambodia has been one of profound tragedy, its past was the epic of a civilization of astonishing splendor and power — the kingdom of the Khmer. Rising out of the jungles of Cambodia, the ruins of the great city of Angkor bear eloquent witnesses to a lost culture that for centuries dominated a substantial part of Southeast Asia. Since their rediscovery around 1860, these astonishing monuments, created by god-like kings as pledges of immortality, have exercised a powerful fascination over those who have come to know them. They have also, sadly, fascinated smugglers of antiquities, souvenir-hunters, and even self-styled "conservators." And in recent years another, grisly threat was added: the long civil war and its bitter legacy — thousands of land mines.

Despite all this damage, and the slow, steady encroachment of the jungle, Angkor remains a wonder of architecture and sculpture. No description, no image, can reproduce the overwhelming impression created by the breathtaking beauty of the temples, sanctuaries, and statues submerged in the jungles of Southeast Asia.

Gate tower with four faces of the Bodhisattva Lokeshvara

Last quarter 12th century to 1st quarter 13th century, south gate of the Bayon, Angkor Thom, Angkor, Cambodia

"And it was in such a moment of elation that I caught sight of the four-headed, crowned towers above the city wall of Angkor. Four friendly faces gazed at me, each seven meters high; within the walls lay the beautiful Angkor Thom. In the pink and golden sunset, every stone appeared to be breathing."

(Han Suyin in: Donatella Mazzeo, Chiara Silvi Antonini: Angkor, Monumente großer Kulturen, Wiesbaden 1974)

Prasat Kravanh

921, brick temple, Angkor, Cambodia

Below left
Baksei Chamkrong

900/921, Angkor, Cambodia

A step pyramid built of laterite with a prasat (sanctuary) built of brick, Baksei Chamkrong is a classic of the "temple mountain" form.

Below right
Brick relief of Lakshmi

About 925, Prasat Kravanh, inner room of the north tower, south wall, Angkor, Cambodia

An outstanding portrayal of the goddess of happiness and beauty, Lakshmi, wife of Vishnu.

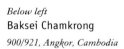

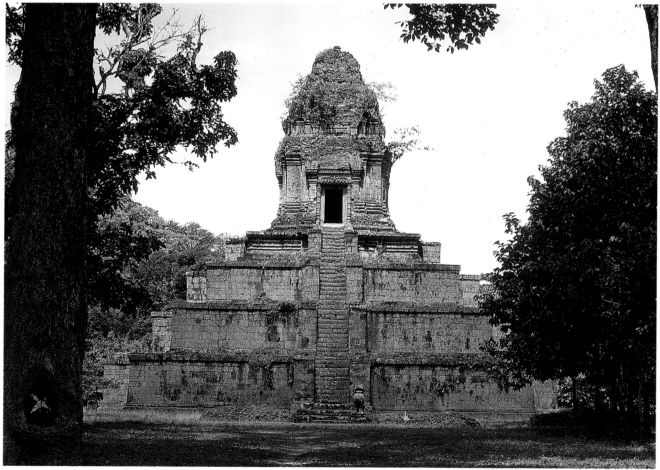

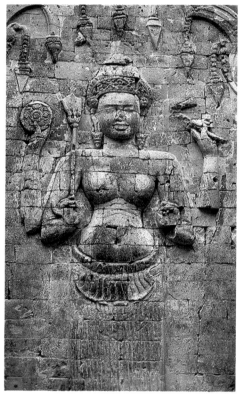

The Political and Cultural Background

Angkor casts a spell on everyone fortunate enough to be led to this strange and mysterious place. Moved by the astonishing ensemble of vast temples, romantic ruins, and lush vegetation, one may be less curious about the cultural and ethnic descent of the people who created these monuments than about the motivation of this architectural extravagance. Sadly, when we think of the Khmer we are likely to think of the Khmer Rouge and the tragic events of the recent past – and not the Khmer who built Angkor, the Khmer whose empire once ruled large areas of Southeast Asia.

According to legend, the mighty kingdom of the Khmer originates in the marriage between Kambu, a religious ascetic, and the goddess-nymph Mera. The Kambuja, sons of Kambu, gave their name to Cambodia. The actual history of the Khmer and Cambodia was far from mythical.

For thousands of years Indochina was isolated from the rest of the world and only marginally affected by its powerful neighbors, India and China, who discovered the country no earlier than the first millennium; in succeeding ages, however, both civilizations had a profound impact on Cambodia's religion and art. The most recent research suggests that the kingdom of Fu-nan was the first kingdom to occupy the region now known as Cambodia: by the mid-3rd century A.D. mountain tribes in the region had established the first Hindu state of Southeast Asia. Their rulers were chosen for their fighting ability and the power to offer security, which is why the suffix -varman (protector) was added to their names.

The immediate predecessor of the kingdom of Angkor was the Khmer kingdom of Chen-la, the "Sun Dynasty," the kingdom that came into being through the marriage of Mera and Kambu. In fact the beginnings of Angkor can be seen as the emergence of Chen-la from Fu-nan. An early Chinese chronicler wrote: "The kingdom of Chen-la is located to the south-west of Lin-yi. It was originally a vassal state of Fu-nan [...] the king's family name was Citrasena; his forebears had gradually increased the power of the state; Citrasena occupied and subjugated Fu-nan. When he died he was succeeded by his son Isanasena; the latter lived in the city of Isana."[1]

The first capital of the various but now united kingdoms of Cambodia was at Sambor in the east. Isanavarman I (616–635) founded a new capital in the center of the country, at Sambor Prei Kuk. His successor Jayavarman I (657–681) transferred it to the region of Angkor Borei; his death marks the end of an era that can be referred to as "pre-Angkor." From then until the beginning of the Khmer dynasties at Angkor there was no longer a unanimously recognized ruler. This unsettled period, during which the Khmer lived under the suzerainty of Java, ended when a Khmer prince also called Jayavarman returned to his ancestral homeland from his birthplace in Central Java in

Plan of Angkor
1. The environs of Angkor Thom
 a. Prasat
 b. Preah Pithu
 c. Royal Palace
 d. Phimeanakas
 e. Royal Terrace
 f. Baphuon
 g. Bayon
 h. Monumental gates
2. Preah Khan
3. Neak Pean
4. Ta Som
5. Phnom Bok
6. Eastern Mebon
7. Ta Kĕo
8. Banteay Samre
9. Western Mebon
10. Ta Prohm
11. Pre Rup
12. Banteay Kdei
13. Srah Strang
14. Prasat Ak Yum
15. Baksei Chamkrong
16. Phnom Bakheng
17. Bat Chum
18. Prasat Khavanh
19. Angkor Wat
20. Lolei
21. Preah Kŏ
22. Bakong
23. Prei Monti
24. Kak O Chrung
25. Phnom Krong

790 and became king: in doing so he changed the course of Cambodian history, for his reign, as king-of-kings Jayavarman II (802–850), is seen as the foundation of the Khmer empire in Angkor.

The architectural forms and styles found in the areas of Sambor and Sambor Prei Kuk provided several of the prototypes of later Angkor art and architecture, some persisting for many centuries in Angkor. The pre-Angkor *prasat* (tower shrine) rises above a rectangular *cella* (inner sanctuary) distinguished by exterior columns or pilasters. The *cella* was where the temple statue, the divine image, was kept. The tower itself was formed by a series of stepped terraces; a more complex variation of this step-by-step diminution appears in the ornamentation of each façade, which is repeated on a smaller scale on each terrace, and also on the *cella* itself. Stylized decorative motifs are found on these early buildings, including garlands and the earliest surviving Cambodian relief carvings of human figures.

Jayavarman II founded the Khmer dynasty in Angkor in 790, establishing it as a divine kingdom. The symbol of this union of king and god was the lingam, the erect phallus of Shiva; being divine, Shiva contains within his own nature the innermost nature of the king, the *suksmantaratman* (see page 17). The king built the first of the step pyramids at Angkor, drawing upon the concept of a "temple mountain" (an image of the mythical Mount Meru) containing the royal lingam.

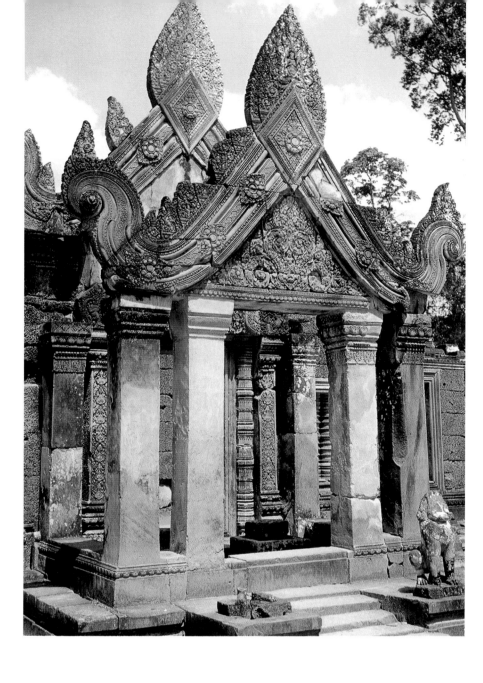

Below
Phimeanakas

Pyramid temple, Angkor, Cambodia, 2nd half of 10th century to 1st half of 11th century

Formerly covered with gold, Phimeanakas sheltered the spirits of the dead kings of Angkor. Its ground plan is not a square but a rectangle, a completely new approach to temple design. Above this, on the uppermost terrace, stands a gallery with bracket arches that served as a passageway. Within the walls is the Sras Srei, the women's bathing pool, which was described by Zhou Daguan, a Chinese visitor. He was gracious about the young women's charms, but rather surprised by their happy lack of prudery as they entered the pool completely naked.

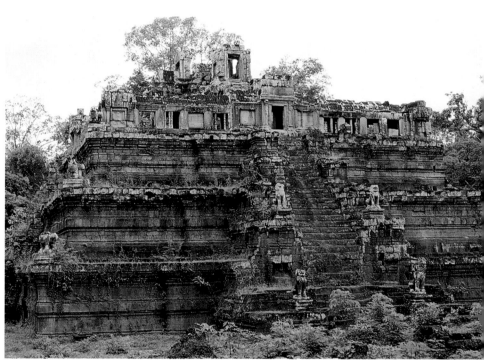

The Wonder in the Heart of the Jungle: Angkor

The first millennium

Above
Banteay Srei

About 967, gateway of the temple area, north of Angkor, Cambodia

East gopura (temple gate construction) with a superb tympanum decorated with foliage ornamentation that springs from the head of *kāla* (the "night-colored one," a mythical monster that eats time).

(Donatella Mazzeo, Chiara Silvi Antonini: Angkor, Monumente großer Kulturen, Wiesbaden 1974)

King Indravarman I (877–889) was important in Khmer history both for his territorial conquests and also his construction of a great reservoir at Angkor. The religious "hour of birth" of the city of Angkor is fixed by his construction in 881 of the Hindu shrine of Bakong (inspired by the temple complex of Borobodur in Java). Under Indravarman's successors, the temple mountain of Phnom Bakheng (888–893) and the reservoir the Eastern Baray (889–900) were created.

The well-preserved Prasat Kravanh (921) (see page 10, top) and the Baksei Chamkrong (900–921) (see page 10, bottom left) come from the reign of Harsavarman I (900–921). The Chamkrong is a classic stepped pyramid of laterite with a *prasat* of brick; it is a fine example of the architectural metaphor of a "temple mountain." Brick was also used for the Prasat Kravanh (the "cardamom shrine"), whose five towers are, unusually, arranged in a straight line. Inside there are brick reliefs, including a fine likeness of Lakshmi, the spouse of Vishnu (see page 10, bottom right). For 20 years the capital was in Koh Ker, north of Angkor, but Rajendravarman II (944–968) re-established it in Angkor. The ancestors' temple of East Mebon was built at this time, as was Pre Rup, the last brick shrine, and the Phimeanakas, the "heavenly, or flying palace" (see above, left). Once entirely covered with gold, it was the seat of the kings of Angkor.

The ground plan of Phimeanakas (2nd half of 10th century to 1st half of 11th century) is square rather than rectangular, a change that was a revolution in Khmer architecture (in which features served a symbolic rather than practical purpose). On the uppermost terrace stands a gallery with bracket arches that served as a passageway.

Within the walls is the Sras Srei, the women's bathing pool, described by Zhou Daguan, a Chinese diplomat who visited in the 13th century. He remarked that the bathers shamelessly entered the pool completely naked, covering themselves "only fleetingly with their left hands."[2]

Angkor Wat: The Khmer Idea of the Divine

The Bayon – "Architecture as Sculpture" – Mount Meru and the Temple Mountain

The Khmers' architectural hymn to the gods was continued by all the kings of Angkor, but it was Jayavarman VII (1181–1218?) who brought it to an astonishing climax. Formerly a humble monk, he twice spurned the throne, yet in time became the mightiest of all the Khmer rulers. To convey something of the grandeur and drama of this architecture, we turn to an account by the Chinese writer Han Suyin, written in 1972:

"All the green and all the yellow of the world was hanging from the leafy heaven of the forest in the afternoon quiet, and a little breeze played soundlessly among the branches of the trees. And it was in such a moment of quiet elation that I caught sight of the four-headed, crowned towers above the city wall of Angkor. Four friendly faces gazed at me, each seven meters high; within the walls lay the beautiful Angkor Thom. In the pink and golden sunset, every stone appeared to be breathing. It was a wonderful moment, when I came to Angkor for the first time 16 years ago.

Silent and timeless, the huge faces were characteristic of the Khmer people, with knowing eyes and that distinctive, widely curved mouth with upturned corners (see page 18): a beautiful ethnic type, strong yet supple, full of good humor and earthy, gentle yet capable of powerful passions, skillful, shrewd, and very brave. I came for four days and stayed for five weeks. And I returned; I returned twelve times. 'If you have learned to love Angkor,' said Bernard-Philippe Groslier, the French curator of Angkor, totally absorbed in his task, during my visits, 'then you will always be drawn back here, and you will end your days in Cambodia.'

No film, no photograph can prepare one for the overwhelming impression of Angkor. And it is difficult to speak of it in other than effusive terms, for it is monumental, tremendous, wonderful, astonishing, awe-inspiring… one can only love or hate it. Anyone who cannot endure gigantic proportions, terrifyingly superhuman dimensions, will reject Angkor out of hand, or simply 'see

Angkor Wat

1st half of 12th century, Angkor, Cambodia

An aerial view showing the temple with its characteristic tiara-shaped towers rising above the rich vegetation of the Cambodian landscape.

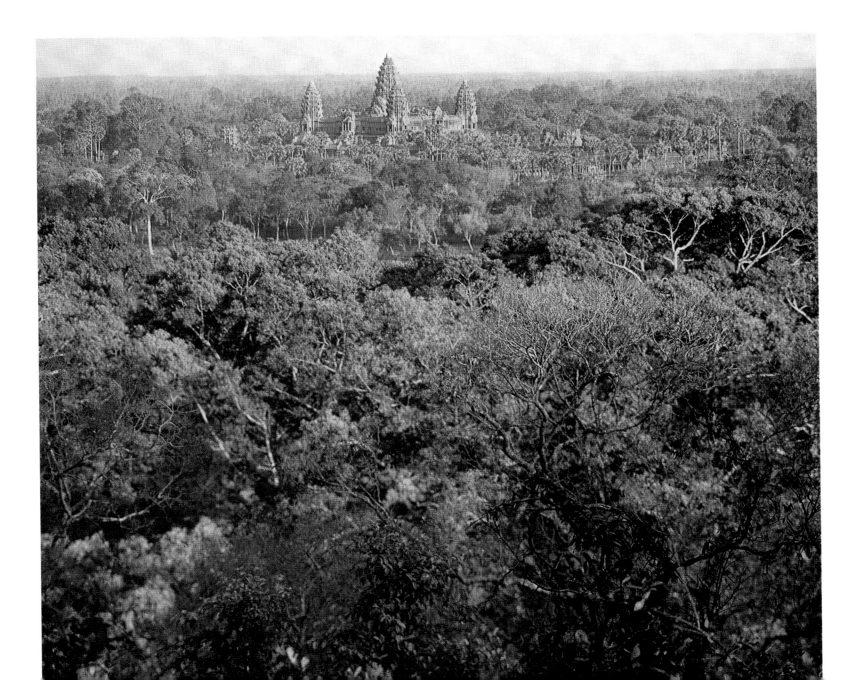

Plan of Angkor Wat

0 30 m

To main entrance and
Nãga balustrade

Cruciform
platform

Library

Gallery of
1000
Buddhas

Library

Bas-reliefs

2nd terrace

Main shrine

Bas-reliefs

Bas-reliefs

Right
Angkor Wat

1st half of 12th century, Angkor, Cambodia

"Angkor Wat, the largest and, by Western standards, the most harmonious temple of this complex in its proportions, is the mighty monument of a king who has been transformed into a god. The structure covers an area of 1.2 by 1.3 kilometers (1,300 by 1,400 yards) and is surrounded by a man-made ditch. Viewing the forecourts, staircases, and towers is exhausting even for the hardened tourist. But what a rich abundance of sights worth seeing!"

(Han Suyin in: Donatella Mazzeo, Chiara Silvi Antonini: Angkor, Monumente großer Kulturen, Wiesbaden 1974)

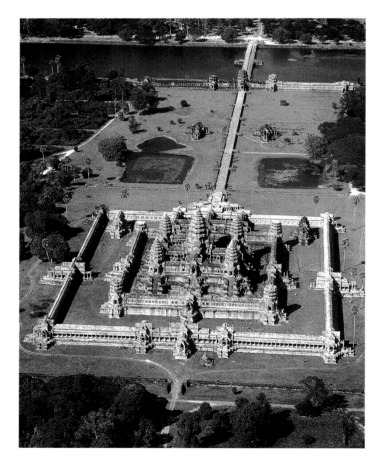

Left
Aerial view of Angkor Wat

1st half of 12th century, temple layout, Angkor, Cambodia

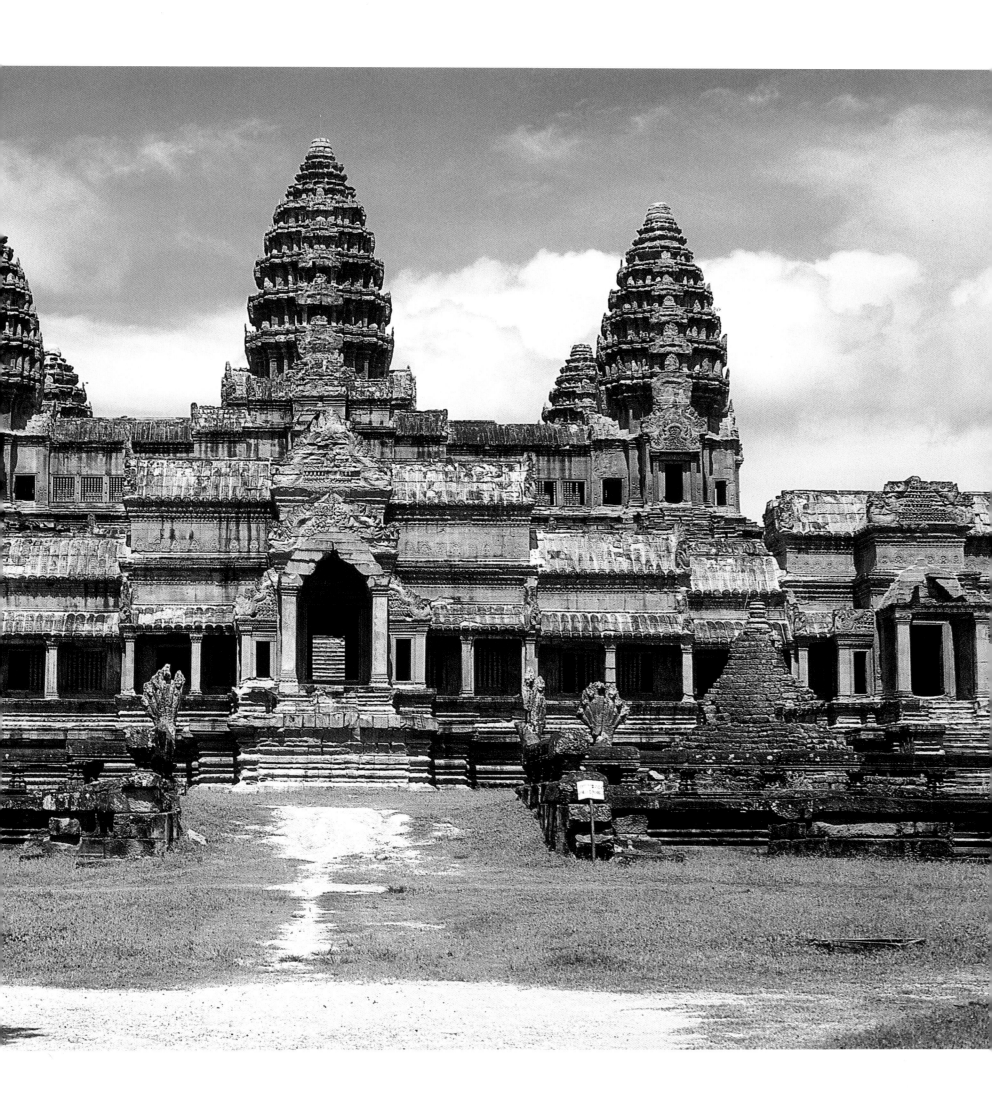

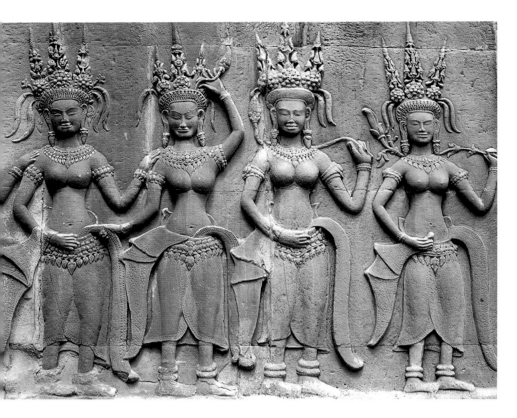

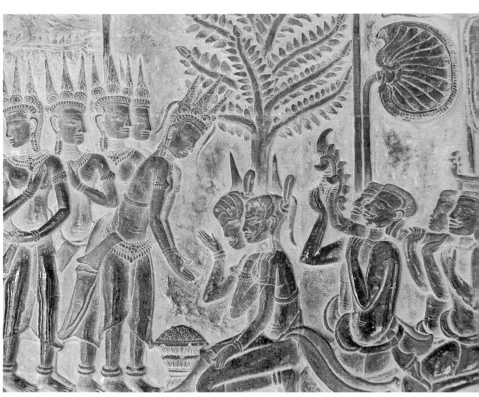

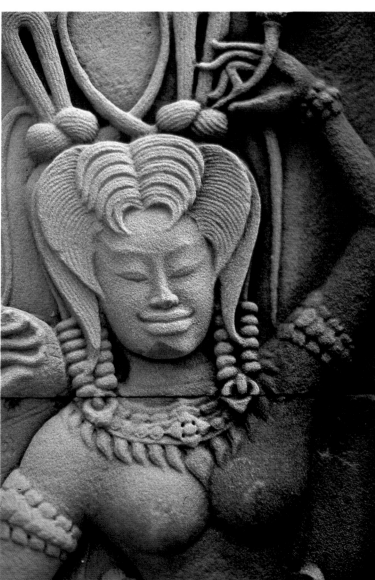

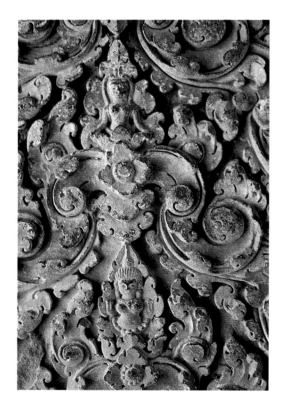

Above left
Devatas (female deities)

(Detail), 1st half of 12th century, relief on the outer wall of the northwest corner tower of Angkor Wat, Angkor, Cambodia

The figures wear a special hair decoration consisting of at least three metal disks or plates, from which both decorative objects and plaits of hair extend upwards.

Above right
The heavens and the underworld

(Detail), 1st half of 12th century, outer gallery of the south side of Angkor Wat, third enclosure, bas-relief, Angkor, Cambodia

Right
Devata (female deity)

(Detail), 1st half of 12th century, south library of Angkor Wat, south side, second enclosure, relief, Angkor, Cambodia

Above
Carved decoration at Angkor Wat

(Detail), 1st half of 12th century, gallery of the third enclosure, north gopura, bas-relief, Angkor, Cambodia

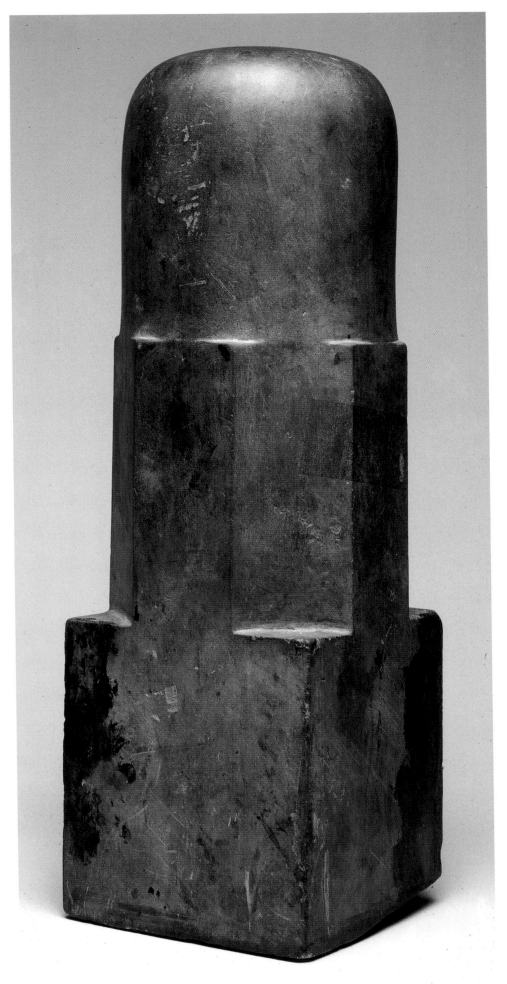

A representation of the "faceless one" – a lingam of Shiva in the Angkor style

10th to 13th century, sandstone, H 46.7 cm, W 14.6 cm, D 14.6 cm, The James and Marilynn Alsdorf Collection, Winnetka, Illinois

The symbol of the union of king and god was the lingam, the erect phallus of Shiva, which was placed at the center of the inner sanctuary. It provided a link between the king and Shiva, who contained within his own divine nature the innermost nature of the king, the *suksmantaratman*.

nothing in it.' 'What is the point of it?' such people ask. The answer is: None of these temples or monuments was intended to serve human beings as dwelling-places, or to be used by human beings; Angkor is not the Parthenon or Colosseum; it was built as an expression of the idea of the divine: it is the realization in stone of the divine power of the kings of Angkor… But the kings, the dignitaries, and the people did not live in these stone temples. They lived in huts of wood and straw, in the grounds of the temples or near to them, but never in the temples themselves. For this reason the city of Angkor with its temples and various other structures is the greatest sacred complex in the world. The king who had built the monument lived nearby: the site itself was the image of his power, his lingam, his monarchy, his cult, his divine substance; his body was merely his human frame.

Fu-nan was the name given to the Khmer kingdom by the Chinese travelers who visited it. The indefatigable passion of the Chinese for the writing of historical records has bequeathed to posterity invaluable documents covering the Angkor period. But neither the Chinese nor the Indians were the architects; out of the flux and reflux of many cultures, but with their own highly individual stamp, the people of the Mon-Khmer here created a massive monument to centuries of power and wealth.

'The men are slender and dark… but many of the women are white… they wash every morning and brush their teeth.' The Chinese observed this and much more, but above all they were astonished by the religion of the country and the extravagant sacred buildings, not intended for use, with their elaborate stone sculptures. In the eleventh century, under the great Jayavarman VII, the kingdom was at the height of its power. It is to this king of kings that we owe Preah Khan, Banteay Kdei, Ta Prohm, and many other edifices. His greatest creation was the city of Angkor Thom, designed as a square of three kilometers [almost ten miles] along each side. In its exact center (which was considered the very center – the *umbilicus* or *omphalos* – of the world) lies the Bayon, perhaps the strangest, the most fabulous monument in the world (see page 19).

The Bayon is a sculpture, not a work of architecture; there is something profoundly enigmatic about it, and only after long contemplation does one suddenly discover that this is a lotus-blossom

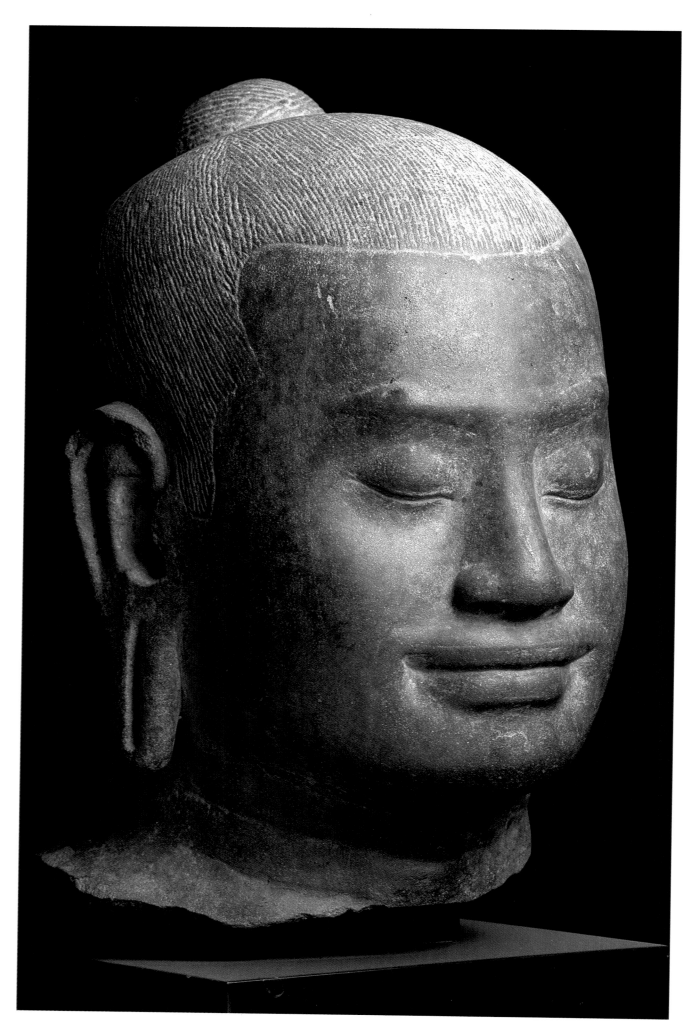

Head of Jayavarman VII

Late 12th to early 13th century, portrait sculpture, sandstone, H 42 cm, W 25 cm, D 31 cm, Preah Khan, National Museum of Cambodia, Phnom Penh

"Silent and timeless, the faces were characteristic of the Khmer people, with knowing eyes and that distinctive, widely curved mouth with upturned corners…"

(Han Suyin in: Donatella Mazzeo, Chiara Silvi Antonini: Angkor, Monumente großer Kulturen, Wiesbaden 1974)

Opposite, below

Preah Khan, "happy city of victory"

1191, entrance to the Hall of the Dancers, Angkor, Cambodia, frieze of a lintel with apsaras (female celestial dancers)

Preah Khan was the first capital of Jayavarman VII (1181–1218?), before Angkor Thom was completed.

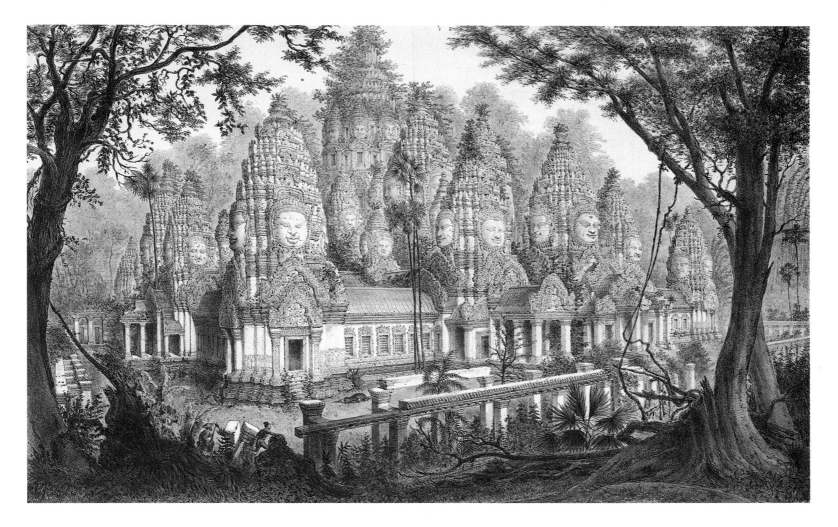

of stone. For it is a gigantic flower, out of the middle of which the central tower emerges, standing 43 meters (141 feet) above the inner courtyards. Apart from the central tower there are sixteen large and forty small towers, and each tower bears a face on each of its four sides. On all the towers four faces, eight eyes, gaze towards the distant horizon, encompassing the whole world, visible and invisible (see page 20). As the eye of the Sun allows the earth to ripen, so the eyes of the Bayon keep the world in balance, and ensure that Sun and Moon keep to their paths. For vision means control and power; vision is immortality, achieved through imagination. It is said that the heads and faces on the towers bear the features of the great Jayavarman VII (see page 18), whose sympathy was so great that he experienced the sufferings of his subjects with them, and thus, after death, cared for their well-being with his all-seeing gaze. The Bayon also has an astrological significance, for today, as they did a thousand years ago, the Khmer believe in fortune-telling and prophecies, in omens and the evil eye, in the innumerable possibilities of seeing the future and of avoiding ill-fortune. In its interior the Bayon conceals a gigantic image of Jayavarman in the shape of Buddha, intended to recall not his likeness but his divinity as a king (see page 24). No Khmer would seek out or go near the Bayon at night, for it is said that this would amount to a challenge to fate, and would result in a speedy death. The Bayon made

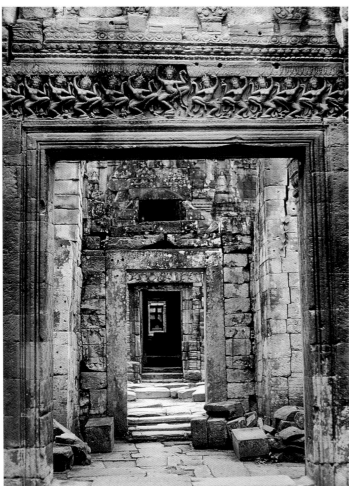

Above

Bayon

Last quarter of the 12th century to 1st quarter of 13th century, prasat with the faces of the Bodhisattva Lokeshvara, Angkor Thom, Angkor, Cambodia

"Apart from the central tower there are sixteen large and forty small towers, and each tower bears a face on each of its four sides. On all the towers four faces, eight eyes, gaze towards the distant horizon, encompassing the world, visible and invisible. As the eye of the Sun allows the earth to ripen, so the eyes of the Bayon keep the world in harmony, and ensure that Sun and Moon keep to their paths. For vision means control and power; vision is immortality, achieved through imagination. It is said that the heads and faces on the towers bear the features of the great Jayavarman VII, whose sympathy was so great that he experienced the sufferings of his subjects with them, and thus, after death, cared for their well-being with his all-seeing gaze.

(Han Suyin in: Donatella Mazzeo, Chiara Silvi Antonini: Angkor, Monumente großer Kulturen, Wiesbaden 1974)

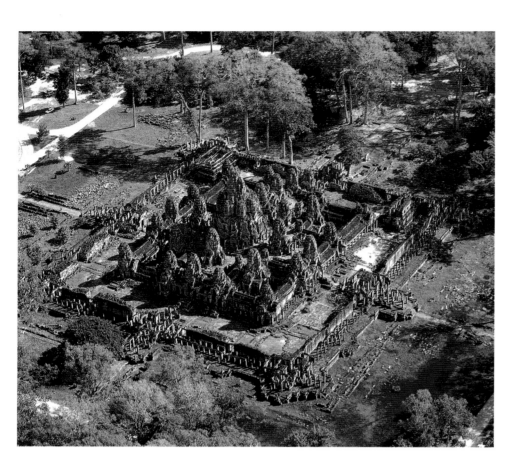

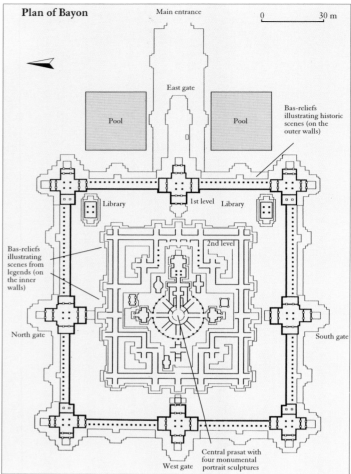

Plan of Bayon

Above
Bayon

Last quarter of 12th century to 1st quarter of 13th century, Angkor Thom, Angkor, Cambodia

Aerial view of the temple mountain.

Right
Bayon

Last quarter of 12th century to 1st quarter of 13th century, prasat with faces of the Bodhisattva Lokeshvara, Angkor Thom, Angkor, Cambodia

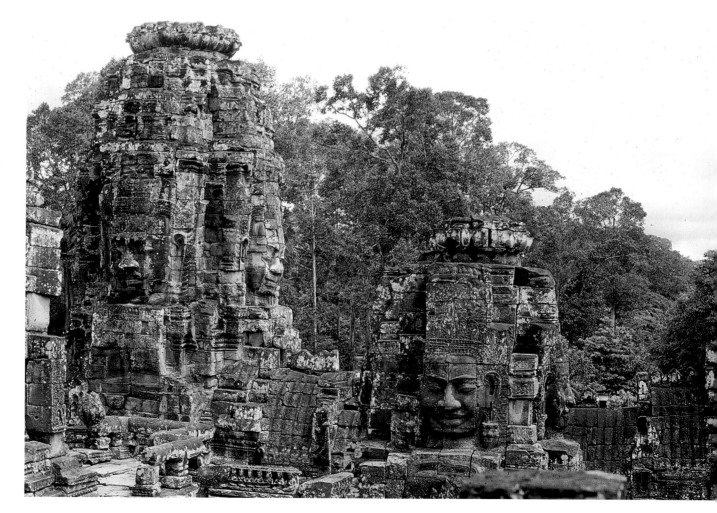

an indescribable impression on me. I clambered up the steps to the upper gallery: a confusing maze, a structure which has been turned completely upside-down by successive programs of building and rebuilding, a labyrinth of galleries and little tunnels, an overwhelming muddle. And yet this overloaded, luxuriant abundance conceals a mystical longing, a prayer become stone. Surrounded by all these faces under the heavens of Cambodia one is transported back into history, to the time of Angkor's greatness; those times are here, are present; chiseled in stone, they still breathe in these galleries. The portrayals in the galleries describe the great wars (see top right), which were triggered by the wealth of the Angkor civilization. These images are powerful and beautiful; the fine sandstone of which Angkor was built is particularly suitable for working in this way.

On these friezes the history of those centuries is recorded, the wars with the Cham, the great battles; but also scenes from times of peace, for the people who created these extraordinary, apparently chaotic works did not forget to represent themselves.

Just as the builders of Europe's cathedrals, the stonemasons and carpenters, gave their own features to the heads which peered out beneath the feet of saints, so the Khmer of Angkor chiseled their lives, their joys, their deaths on friezes below their images of great battles, triumphal processions, fighting elephants, warriors on chariots, foot-soldiers, and dignitaries carried in litters (see right).

So along with the majestic procession we see how the lives of the Khmer were lived: how they built houses, ate and drank, watched cock-fights, conducted business. We see women giving birth, men fishing and plowing, driving ox-carts, frying fish on bamboo skewers, sitting under sunshades to watch a circus performance; there are tightrope-walkers and wrestlers, musicians playing. Exactly the same musical instruments, the same ox-carts, fishing nets, scythes, the same faces, figures, movements, can be observed today in the villages and fields of Cambodia. The Khmer of today are the true descendants of those who built Angkor, and today they still use the same tools as in those days, though the transistor radios, the motorcycle, the permanent wave, and the jeep are even here slowly altering their way of life.

Angkor Wat (see pages 14 and 15), the largest and, by Western standards, the most harmonious temple of this complex in its proportions, is the mighty monument of a king who has been transformed into a god. The structure covers an area of 1.2 by 1.3 kilometers (1,300 by 1,400 yards) and is surrounded by a man-made ditch. Viewing the forecourts, staircases, and towers is exhausting even for the hardened tourist. But what a rich abundance of sights worth seeing! The pictures in the galleries, which are hundreds of meters long, relate the epics of the *Ramayana* and *Mahabharata* (see page 16), the story of the wondrous Vishnu, who turned the Sea of Milk to butter in order to obtain the elixir of life (see pages 22 and 23). I needed almost five days to see the whole temple, and

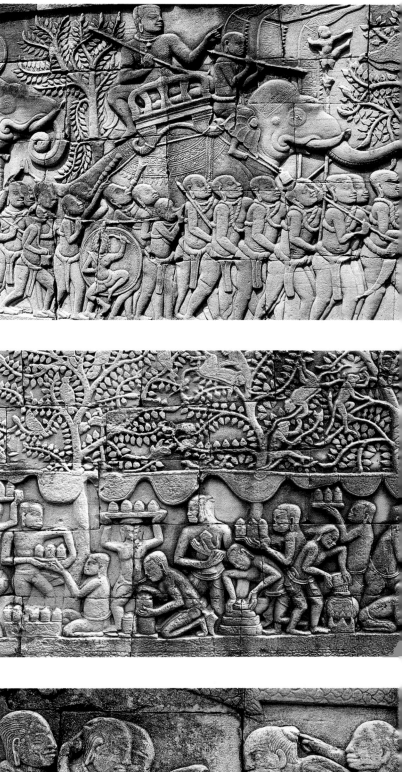

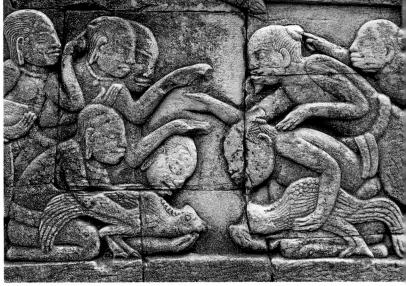

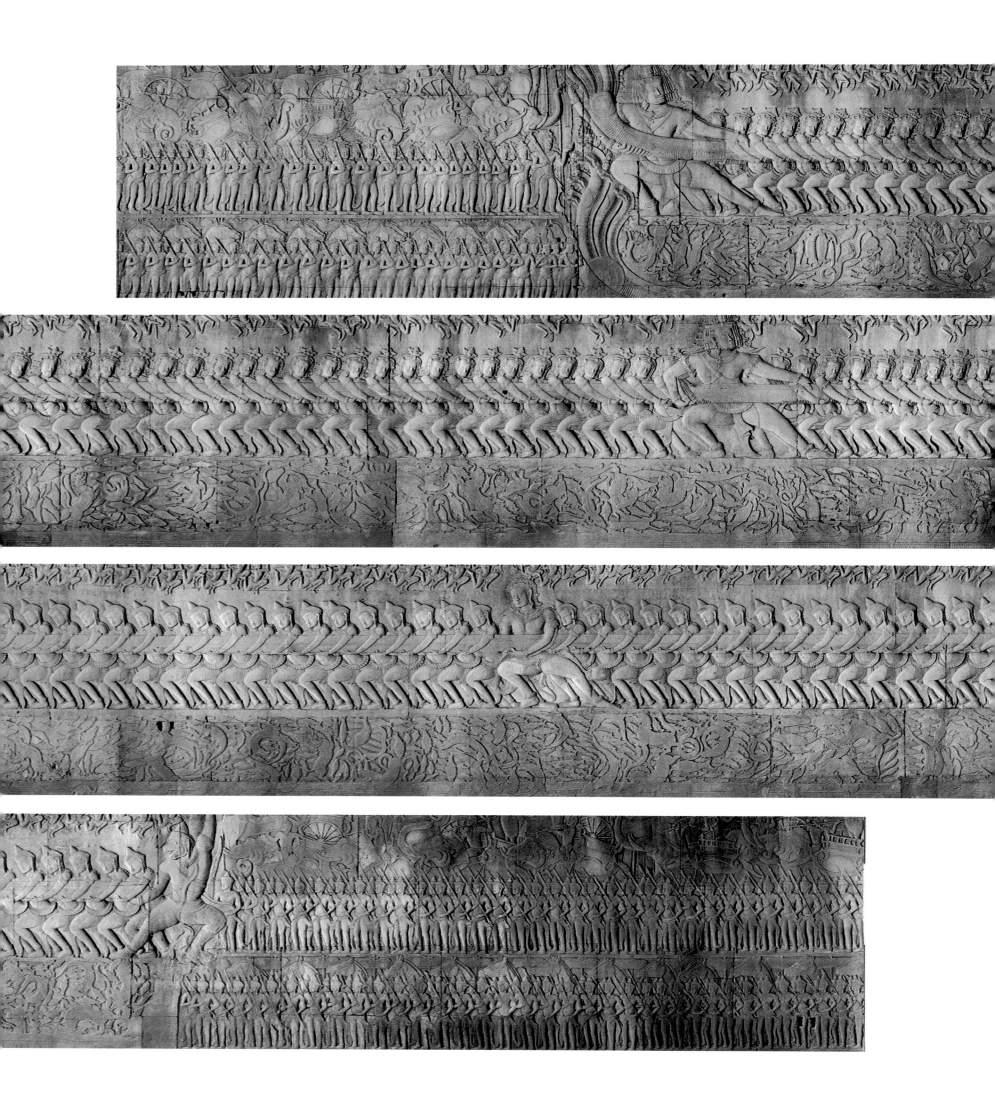

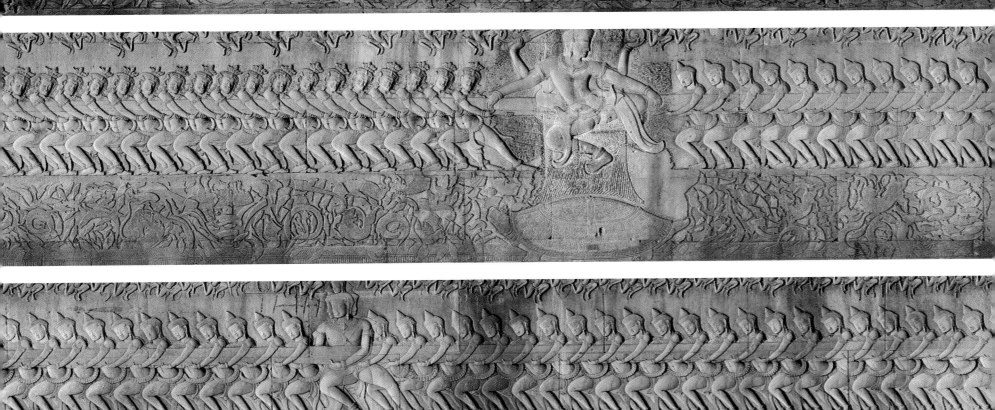

Churning of the Sea of Milk

1st half of the 12th century, bas-relief, outer gallery of the east side of Angkor Wat, third enclosure, Angkor, Cambodia

"The Churning (turning to butter) of the Sea of Milk. The complete relief shows Vasuki (the serpent which helped the deities to turn the Sea of Milk to create the elixir of life), pulled back and forth by the *asuras* (demons) and *devas* (deities). The lower part of the panels is populated by countless real and imaginary water-

creatures and represents the ocean; on the upper edge are the dancing *apsaras* (nymphs born from the Sea of Milk), who symbolize the heavenly spheres."

(Donatella Mazzeo, Chiara Silvi Antonini: Angkor, Monumente großer Kulturen, Wiesbaden 1974)

Last quarter of 12th century to 1st quarter of 13th century, Angkor Thom, Angkor, Cambodia

View through a gate to the prasat, on which the face of the Bodhisattva Jayavarman VII has been carved: the dead king has become a spiritual entity.

though my feet were aching, I was still unable to take in all the details (see page 16). Though there are many legends about Angkor Wat, the temple is not an object of fear, as is the Bayon. The royal ballet of Cambodia appeared here during the reign of Prince Sihanouk, who did so much to preserve peace and prosperity for his people. Since the coup against him, the country has been torn apart by war, and even Angkor Wat is threatened. Today, statues and stone reliefs are even turning up in the markets of the capital, Phnom Penh, since no one cares any more about this precious heritage.

The most popular temple with Europeans is perhaps the Banteay Srei (see page 12). Personally, I was not that impressed with it; it is too beautiful, too perfect. It is a small building, exquisite and charming, made all of pink stone. Banteay Srei, the 'citadel of the women,' was built in A.D. 967. Its sculptures, carved in very hard stone, and closely related in style to Indian works, are perfect works of art. I saw the temple for the first time sixteen years ago, when it could be reached only by jeep; now there is a good road leading to it. More than Banteay Srei, I love Banteay Samre, the

building which, like the Bakong, appears in its passionate architecture to break open the masses of stone; a passion which is stronger than cannon shot. Seeing it makes my imagination bubble like the 'Sea of Milk.' It is related that Banteay Samre was built by a gardener who became known as the 'Cucumber King.' This man, a poor peasant who knew how to grow wonderfully sweet cucumbers, was a *samre*, in other words a peasant, despised by the noble Khmer. He became king because a royal white elephant stopped in front of him (perhaps because of the sweet cucumbers), 'knelt down, raised its trunk and lifted the gardener onto its back.' Having been chosen in this way, the gardener attempted to rule, but the nobles refused to bestow on him the honor due to his position, and continued to pay respects to the memory of the last king, bowing down before his empty throne and even before his garments. This angered the Cucumber King, and for this reason he built Banteay Samre, the 'citadel of the *samre*,' which indeed resembles a fortress. Of course this was not his residence, but the temple or seat of his 'deified' essence. Then he demanded that the nobles

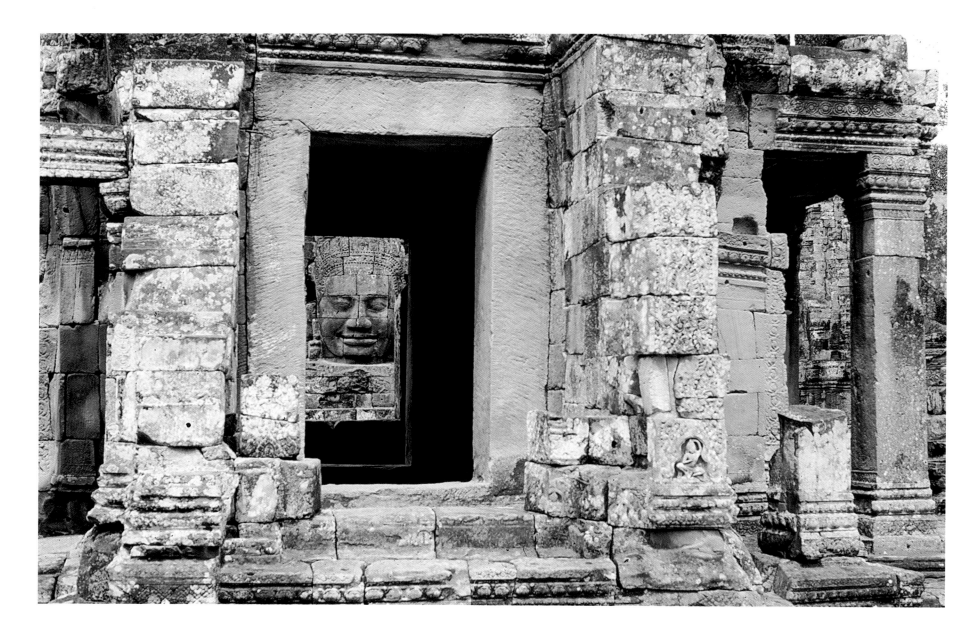

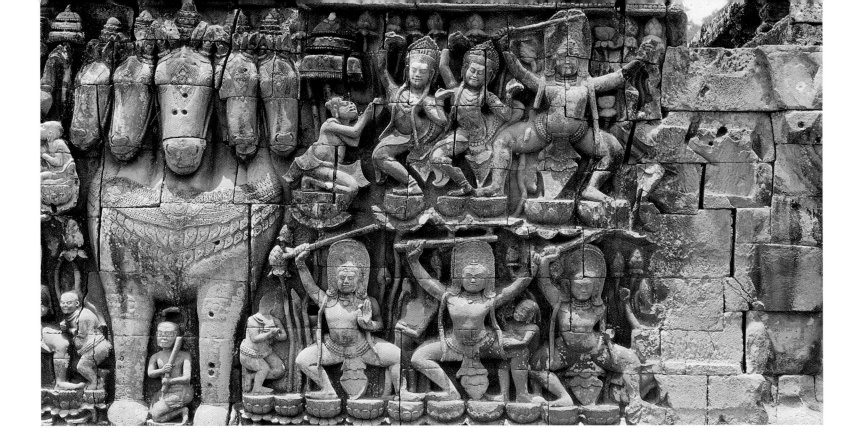

should come to pay obeisance to him there. As he knew that they would refuse, he ordered the late king's chamber-pot to be brought. When they paid their respects to it, he had them all beheaded.

Ta Kēo, the 'crystal tower,' Pre Rup, the 'pyramid,' also called the 'rotating body,' and the mighty Bakong – all these buildings are representations of Mount Meru, the cosmic, five-stepped pinnacle of the world. The same symbolism is found again in the pagodas of Nepal, with their fivefold-stepped roofs, in the gate structures of India, the pagodas of China, and the vast temple of Borobadur of Indonesia. The sacred Mount Meru also has its symbolic equivalents in the ziggurat of Babylon, the Temple of Jerusalem, and the mountain temples of the Maya. All these holy sites serve only the idea of the divine, its nature, power and glory, but not its physicality. The legendary vastness of Angkor is the expression in stone of the human will to live on after death, to overcome time and space by transcending the span allotted to human life. Hinduism, Buddhism, vivid powers of imagination, and the skills of the Khmer united to create a way of life, a culture, which lasted many centuries, only to be destroyed, finally, by its own passion for extravagance – by the prodigal, heedless way in which human resources were employed in building for the gods until there were literally no men left to go to war or to bring in the harvest.

And so it came about. The Bayon was built at the time of the greatest splendor, in the reign of Jayavarman VII. But parts of the building remained incomplete, as though a great war or a plague had put a stop to the work of the sculptor's chisel. In fact, the Bayon is the last of the great monuments. The amounts of gold and silver used, and the number of people needed to hew the stones out of the quarries of the mountain of Kulēn and transport them to the building site, to build the temples, and carve the sculptures and ornamentation, beggars imagination. Cement was not used. The carefully hewn blocks of stone, accurately joined together, were held in place only by their own weight and the precision of the cut. In structures such as Angkor Wat, almost every stone surface, from the foundations up to the gables, is covered with chiseled ornamentation and sculpture (see page 16). In viewing these monuments we have to constantly remind ourselves of how much work was involved; of how hundreds of thousands of workers year after year – for 60 to 70 years – labored on a single monument; of what quantities of gold and silver, pearls and precious stones were used in the sacred service of the king's divinity.

And so this was the way Angkor was destroyed; it died under the weight of its own magnificence and splendor, its architectural megalomania. In 1432 it was finally abandoned as the capital of the kingdom. The irrigation systems which could have preserved it fell into disrepair, and a new intruder appeared on the scene: the jungle. The trees came, and the stones and heads became overgrown, and Angkor was suffocated. But the Khmer peasants had not forgotten Angkor, even if it seemed that it had been forgotten by those who were busy building another capital, Phnom Penh.

French travelers heard stories about a splendid city dedicated to the gods and now hidden deep in the jungle. In the 17th century a Spanish missionary accidentally stumbled on it, but thought the city had been built by Alexander the Great! Then one day an adventurous Frenchman followed the jungle paths, and above the treetops he glimpsed the conical towers of Angkor Wat. It had been

Stone relief depicting warriors

(Detail), last quarter of 12th century to 1st quarter of 13th century, Bayon, the Royal Terrace, Angkor Thom, Angkor, Cambodia

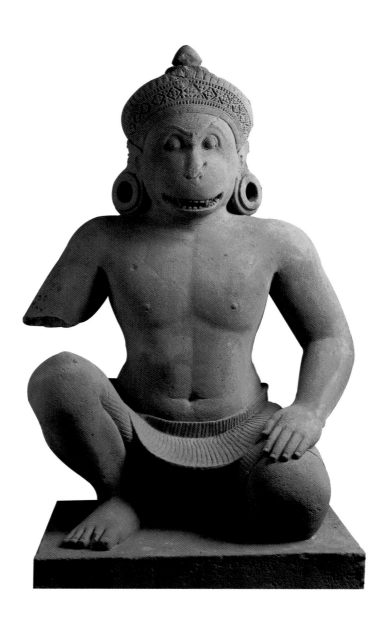

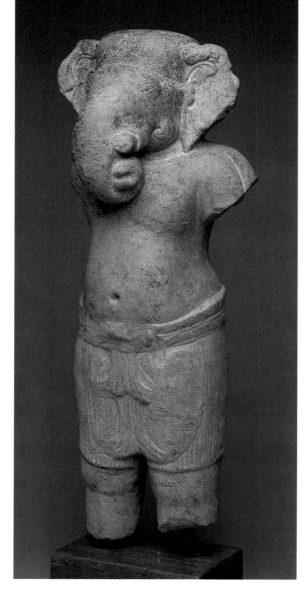

foretold, so the peasants maintain, that Angkor would rise again after five hundred years. And in fact, in the 20th century, exactly five hundred years after the abandonment of Angkor, the French archaeological institute, under the guidance of eminent scholars, rebuilt a great part of Angkor. It became the pride and the jewel of Cambodia, the seventh wonder of the world, an almost unbelievable, deeply enriching experience for all those who are receptive to beauty and art."[3] (By kind permission of Dr Han Suyin.)

The Sculpture of the Khmer

The aesthetic ideals of Cambodian sculpture have little in common with the Western concept of beauty. For even if the sculptures were given human or animal form, their sole purpose was to express a concept of divinity: with its perfection of form, the idealized face of Cambodian figures was far from being an expression of earthly perfection. Yet even though these works are alien to Western concepts of art, their spirituality and formal elegance are often deeply moving.

In the temples of Southeast Asia, the posting of guardian figures in the form of animals and mythological creatures was an ancient practice.

The most familiar guardians were the *singha* (lion), *Ganesha* (the elephant-headed god, son of Shiva and Parvati), and the *makara* (hybrids of elephant, eagle, and water-monster, usually impressive freestanding figures in the grounds of the temple complex). *Nāgas* (serpents, represented as many-headed cobras), *kālas* (the "night-colored ones," mythical monsters that eat time), *garudas* (mythical birds that are the traditional enemies of the *nāgas*), are all integrated into the architecture of Angkor in a uniquely rich profusion. Perhaps the finest of these guardian figures are those found in the environs of the superb temple of Banteay Srei (967). The sculptures, noble in posture and bearing, are richly adorned with jewels and have the carefully worked *mukuta* (crown), characteristic of their time (see above, left).

In large part a Khmer invention are the figures and sculptural reliefs of the *apsaras* ("those who glide over the water"), celestial nymphs who appeared at the Churning of the Sea of Milk (see pages 22 and 23). Together with the five towers of Angkor Wat, they have become one of the best-known symbols of Khmer culture. The female figures in general are of great charm (see opposite, left); their appearance, shapely and elegant, can almost be called erotic. Since they have been asso-

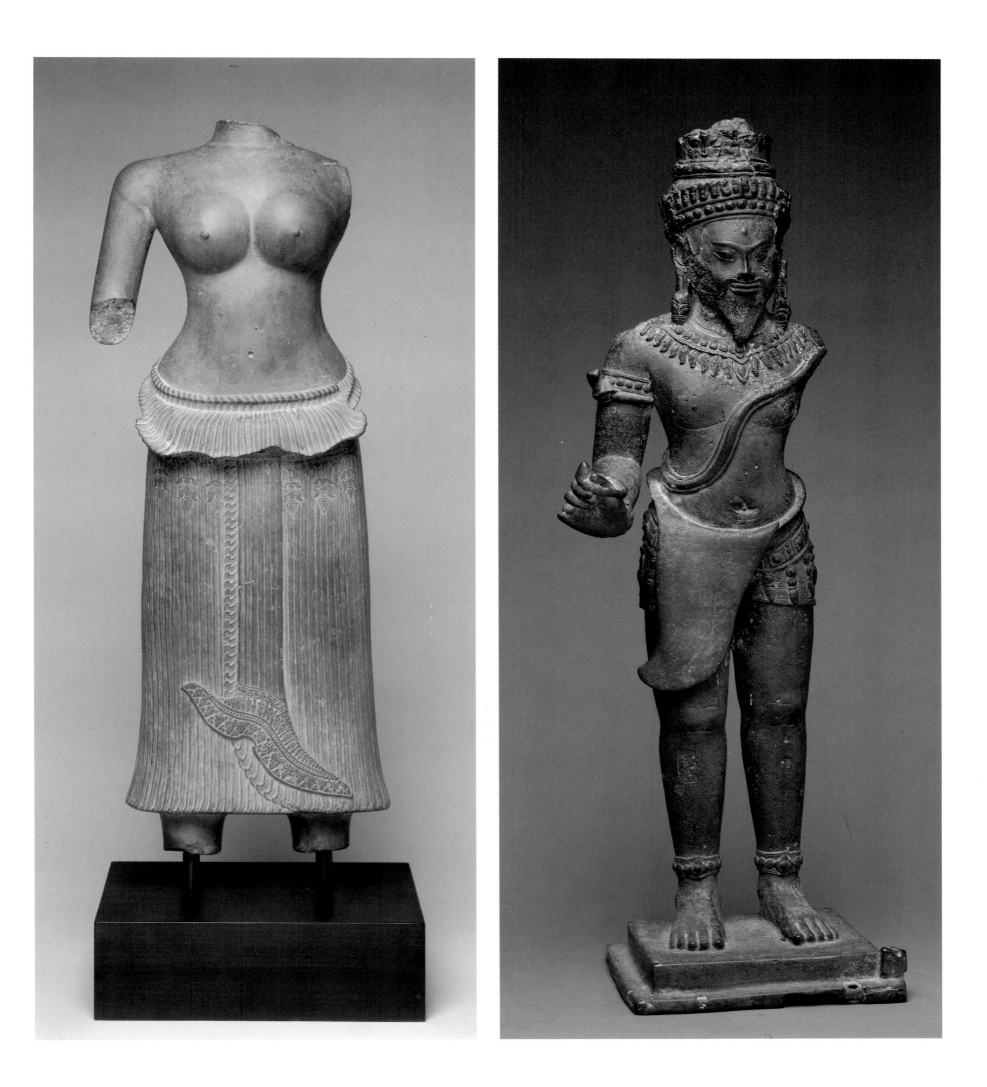

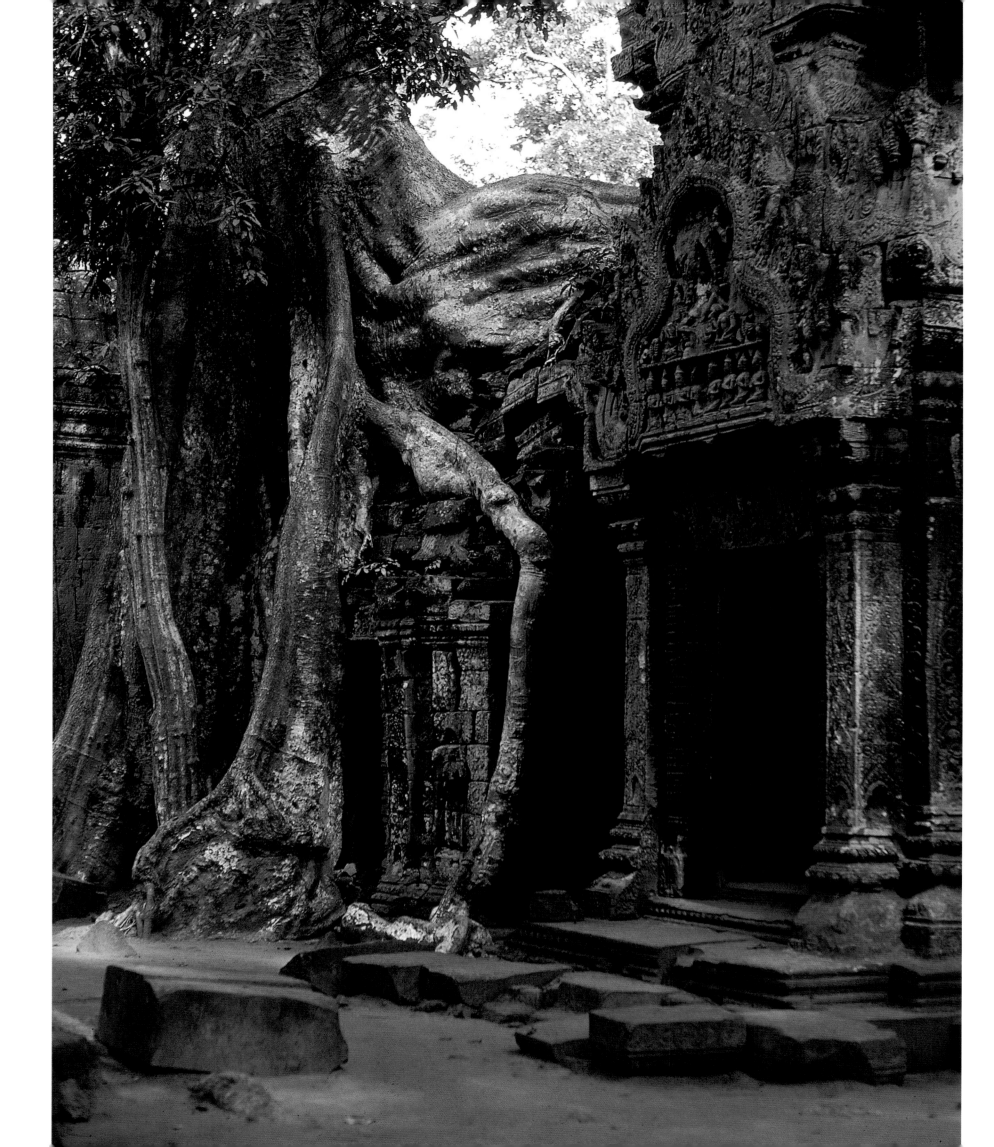

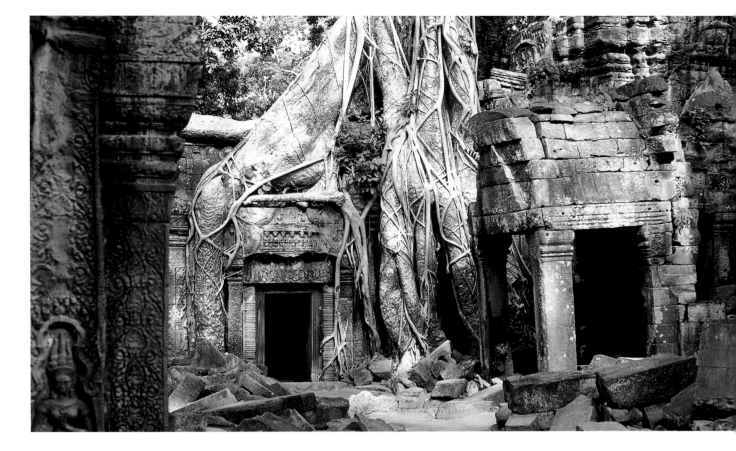

ciated through the centuries with the early Sambor style, these examples of sculptural art of the Angkor period (12th century) are generally known by the label of "Khmer classicism." During the Bayon period (in the 13th century), the sculptures began to acquire more individual traits, and at the same time coarser proportions and more pronounced bodily decoration. Temple donations by noblemen came into fashion, and with them bronze figures (see page 27, right).

The Splendor of Ta Prohm

Five years after coming to power, Jayavarman VII founded the temple complex of Ta Prohm. An inscription supplies detailed information about the extensive complex, which included 39 *prasats*, 566 houses of stone, and 288 houses of brick. Ta Prohm functioned as a monastery; after the late 12th century, temple complexes were no longer exclusively reserved for religious observances.

That Ta Prohm is considered the most enchanting spot in Angkor is without question due to the fact that it is a perfect example of the "temple lost in the jungle." To quote Norman Lewis: "Ta Prohm is an arrested cataclysm. In its invasion, the forest has not broken through it, but poured over the top, and the many courtyards have become cavities and holes in the forest's false bottom. In places the cloisters are quite dark, where the windows have been covered with subsidences of earth, humus and trees. Otherwise they are illuminated with an aquarium light, filtered through screens of roots and green lianas.

Entering the courtyards, one comes into a new kind of vegetable world; not the one of branches and leaves with which one is familiar, but that of roots. Ta Prohm is an exhibition of the mysterious subterranean life of plants, of which it offers an infinite variety of cross-sections. Huge trees have seeded themselves on the roofs of the squat towers and their soaring trunks are obscured from sight; but here one can study in comfort the drama of those secret and conspiratorial activities that labour to support their titanic growth.

Down, then, come the roots, pale, swelling, muscular. There is a grossness in the sight; a recollection of sagging ropes of lava, a parody of the bulging limbs of circus-freaks, shamelessly revealed. The approach is exploratory. The roots follow the outlines of the masonry; duplicating pilasters and pillars; never seeking to bridge a gap and always preserving a smooth living contact with the stone surfaces; burlesqueing in their ropy bulk the architectural motives which they cover… Whole blocks of masonry are torn out, and brandished in mid-air. A section of wall is cracked, disjointed and held in suspension like a gibbeted corpse; prevented by the roots' embrace from disintegration.

There are roots which appear suddenly, bursting through the flagstones to wander twenty yards like huge boa-constrictors, before plunging through the up-ended stones to earth again. An isolated tower bears on its summit a complete sample of virgin jungle, with ferns and underbrush and a giant fig tree which screens the faces of the statuary with its liana-curtains, and discards

Relief on a lintel at Prasat Muang Tham

10th to 11th century, Muang Tham, Thailand

The reliefs at Muang Tham display great artistic freedom.

Muang Tham

10th to 11th century, "Temple of the lower-lying city," Thailand

Modest in its dimensions, but perfectly executed, this temple of the 10th–11th centuries was completed by Jayavarman V (986–1001), though the lack of a inscription makes a precise date impossible.

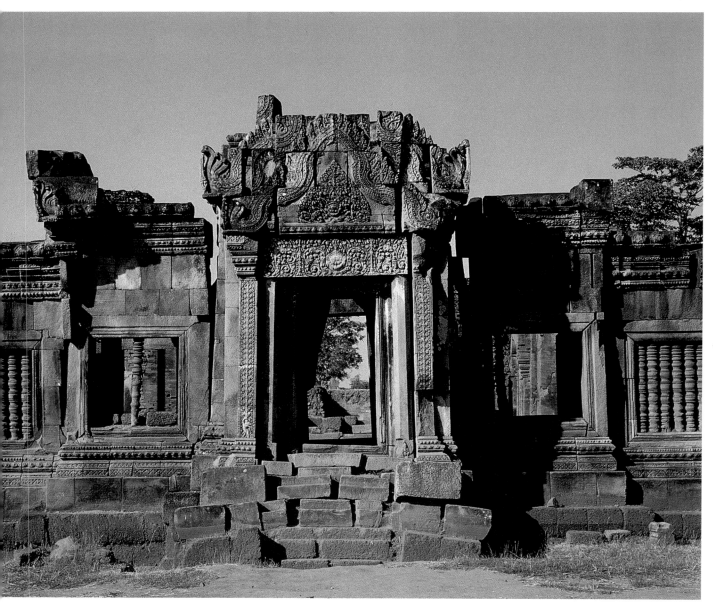

Opposite, above
Relief of a lintel

About 1050/1150, temple of Phanom Rung, sandstone, Thailand

Opposite, below
Prasat Phanom Rung

About 1050/1150, Thailand

The temple complex of Phanom Rung ("great mountain") sits on a hill whose name means "rainbow mountain," an extinct volcano that overlooks the Thai–Cambodian border.

a halo of parakeets at the approach of footsteps…
The Khmer gods have accompanied their
worshippers in their decline."[4]

The Khmer in Thailand

After the creation of a number of temple
complexes under Khmer rule in the area now
known as Cambodia, the "architectural area of
influence" of the kings also began to extend into
the regions of today's Thailand, Vietnam, and
Laos. On the way from Angkor to Phimai in
Thailand lie the temples of Phanom Rung, the
archetypes of Angkor Wat, which was yet to be
built. The tract of land on the border between
Cambodia and Thailand fell within the domain of
a cousin of Suryavarman II (1112–1152), King
Narendraditya, who used his family connection to
enlarge his authority in Thailand. Built on a hill,
Phanom Rung is an imposing complex, approached
by an avenue of pink sandstone 160 meters
(525 feet) long. The monumental staircase, climb-
ing over five levels, is reached by the *nāga* bridge
(separation between the worlds of mortals and

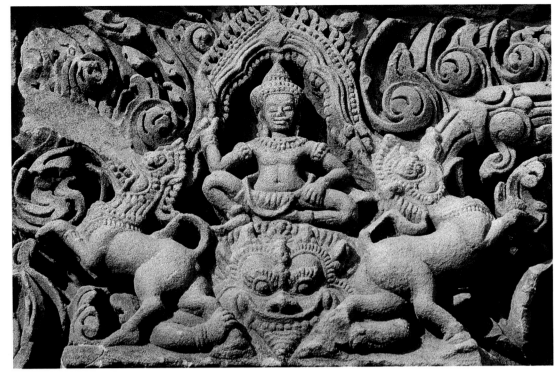

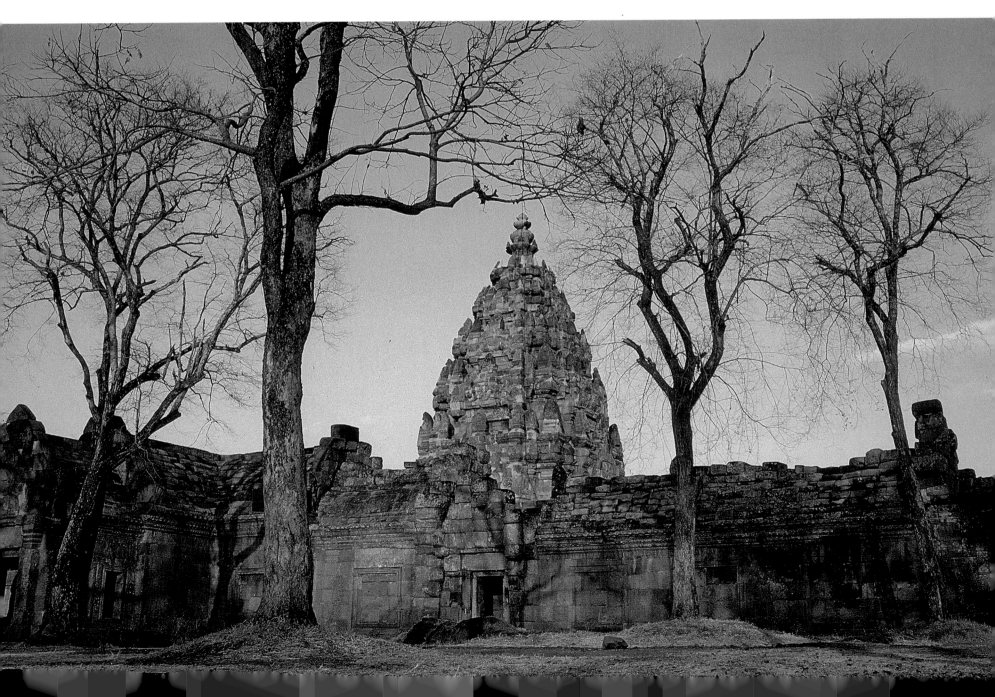

Phimai

End of 12th century, temple complex, Thailand

A supreme achievement of Khmer architecture is represented by the temple complex of Phimai. Jayavarman VII (1181–1218?) had this shrine built in the west of his kingdom, on an old Hindu site.

Below
Phimai

End of 12th century, temple complex, Thailand

A special feature of this temple complex, in contrast to other Khmer shrines, which face eastwards, is the orientation toward the southeast. The reason for this was probably the wish to face Angkor, which was still seen as by far the most important religious and political site in the region.

Opposite
Phimai

End of 12th century, temple complex, Thailand

A distinctive Khmer *prang*, a stupa or pagoda in the form of a corn-cob, in Thailand. The complex of Phimai, like all Khmer temples, is recognizable when seen from the air as a replica of "cosmic order."

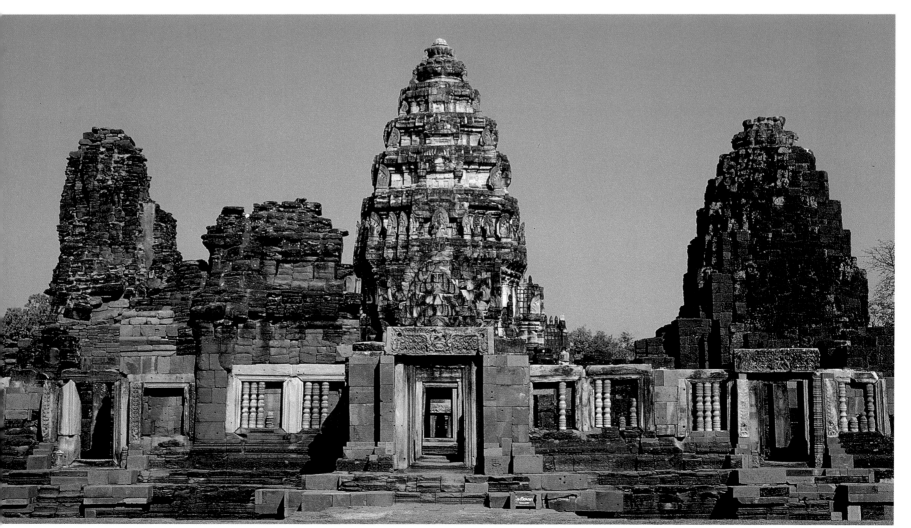

gods); the five-headed cobras, finely executed in stone, are in particularly good condition. The *prasat* is the epitome of a Khmer shrine, most probably built between 1050 and 1150 (see page 31, bottom). The quality of the relief portraits from the epic the *Ramayana* is equal to those in Angkor, and anyone who shrinks from the laborious and often dangerous journey to Angkor may see exquisite Khmer art in Phanom Rung (see page 31, top). In the complex there are also two early brick *prasats*, which are dated to the years 900/960; one impressive shrine, abandoned in the 13th century, was registered as a cultural site as late as 1935. Only a short distance from Phanom Rung stands the Muang Tham, the temple of the lower city (see page 30). More modest in its dimensions, but perfectly executed, this temple of the 10th–11th centuries was largely completed by Jayavarman V (986–1001), though the lack of any inscription makes it impossible to date precisely. The *nāgas* that adorn the L-shaped ponds around the *prasat* are very different from those of Phanom Rung. In their delicate, softly outlined execution these mythical serpent-monsters could almost be called charming, and are widely considered unsurpassed in their beauty. Clearly the sculptors here enjoyed complete artistic freedom; lotus-blossoms entwine on the breast of the serpents, jewels stream from their throats, and garlands crown their heads. Massive walls of laterite bound the brick towers. Countless pieces of these walls are scattered on the ground, conveying a vivid impression of the collapse of a glorious era.

A further supreme achievement of Khmer architecture is the temple complex of Phimai, also in Thailand. Jayavarman VII had this shrine built in the west of his kingdom, on an old Hindu site. A well-constructed road connected the 240 kilometers (150 miles) from Angkor to Phimai, via Phanom Rung and Muang Tham. In contrast to other Khmer shrines, which always face east, Phimai faces southeast – where Angkor lies. The whole rectangular complex is recognizable from the air as a replica of "cosmic order;" the modern achievement of flying through the air was at that time the sole prerogative of the gods. The *prang*, which represents Mount Meru, center of the universe and home of the gods, occupied the center of the complex (see right); on the terraces around it are depictions of the inhabitants of the various divine regions. Surrounding stone galleries and smaller towers represent subordinate peaks and encompassing mountain ranges; the ponds and pools symbolize the cosmic ocean, the bordering rectangular wall the boundary wall of the universe. This elegantly curved central tower, covered in reliefs of great power, is a highlight of Khmer architecture and a possible precursor to the five famous towers of Angkor Wat. In the 12th and 13th centuries Khmer culture attained its fullest flowering and its boldest, most concise expression. Such elaborate structures, overflowing with flamboyant decoration, were also integrated into the new temple complexes in Sukhotay.

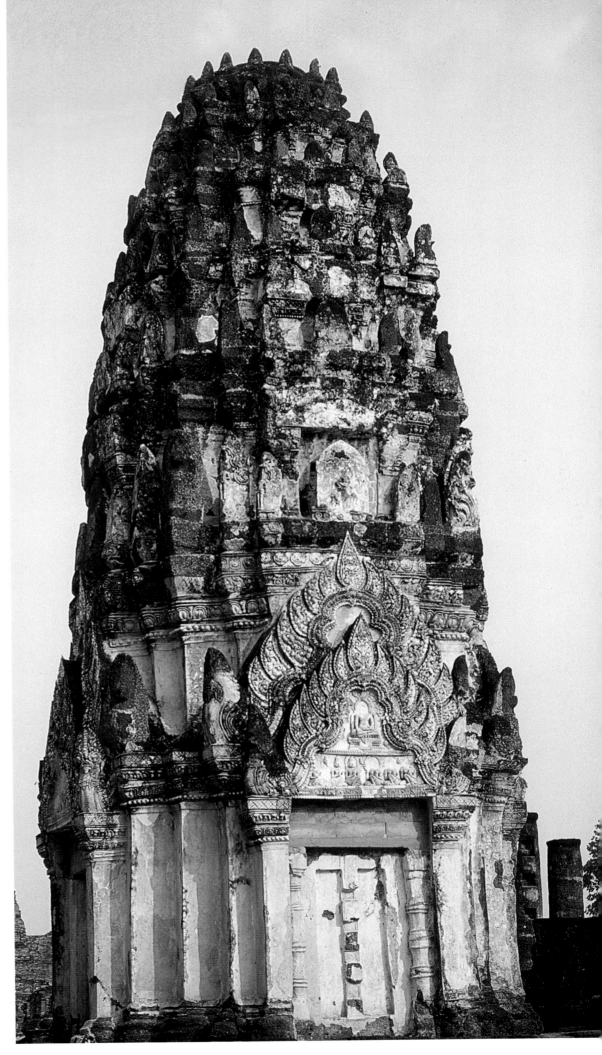

The Wat Phra Phrai Luang was also built under Jayavarman VII. Originally, it consisted of three *prasats*, of which only the northern tower remains. The Thais added the *vihara*, *chedi* (relic chambers, normally in the form of a hood or bell), and *mondop* (a cube-shaped building for housing relics) buildings, which were indispensable for them. In all, Wat Phra Phrai Luang possesses more than 30 stupas of varying styles, so that it illustrates the connecting threads running through the various manifestations of Buddhism, Hinduism, and Brahmanism.

Left
Linga Parvata

"Lingam of Parvati Mountain," Laos

For the Khmer, the shape of the Linga Parvata resembles a phallus, and as early as about A.D. 600 a Hindu temple in the form of a lingam was placed on its peak.

The Lingam as a Monument: Wat Phou in Laos

Wat Phou, in modern Laos, connected with Angkor by a road 100 kilometers (62 miles) long, is today almost forgotten. Situated in the region of the former Laotian kingdom of Champassak, near the city of the same name, it is a focal point for the lingam cult, which was of great importance to the Khmer. Even the mountain behind the temple bears the name Linga Parvata ("the lingam belonging to the spouse of Shiva"), since, according to the Khmer viewpoint, its shape resembles the contour of a phallus, and as early as about A.D. 600 a Hindu temple in the form of a lingam was placed on its peak (see above). Parts of the remaining temple ruins at the foot of the mountain were built by Jayavarman IV (921–944) in the pre-Angkor style, and are thus around 200 years older than Angkor Wat.

Champassak was once the center of power in the lower Mekong, but today only vestiges of its glorious past are found in the plain, now covered with rice fields. A long processional way, laid out by Jayavarman VI (1080–1107), leads from the low-lying area to buildings on the hillside (see page 36, top). Originally this processional way was edged with statues of mythical beasts. The two sandstone pavilions that flank the processional way probably served as accommodation for pilgrims, men and women being kept separate. These

Right
Wat Phou

6th to 12th century, main shrine, Champassak, south Laos, temple with seated Buddha in foreground

The area behind the statue is still a part of a very early (6th-century) brick building. In order to wash the lingam, which was ritualistically smeared with offerings, holy spring water was directed into the temple through an opening in the masonry.

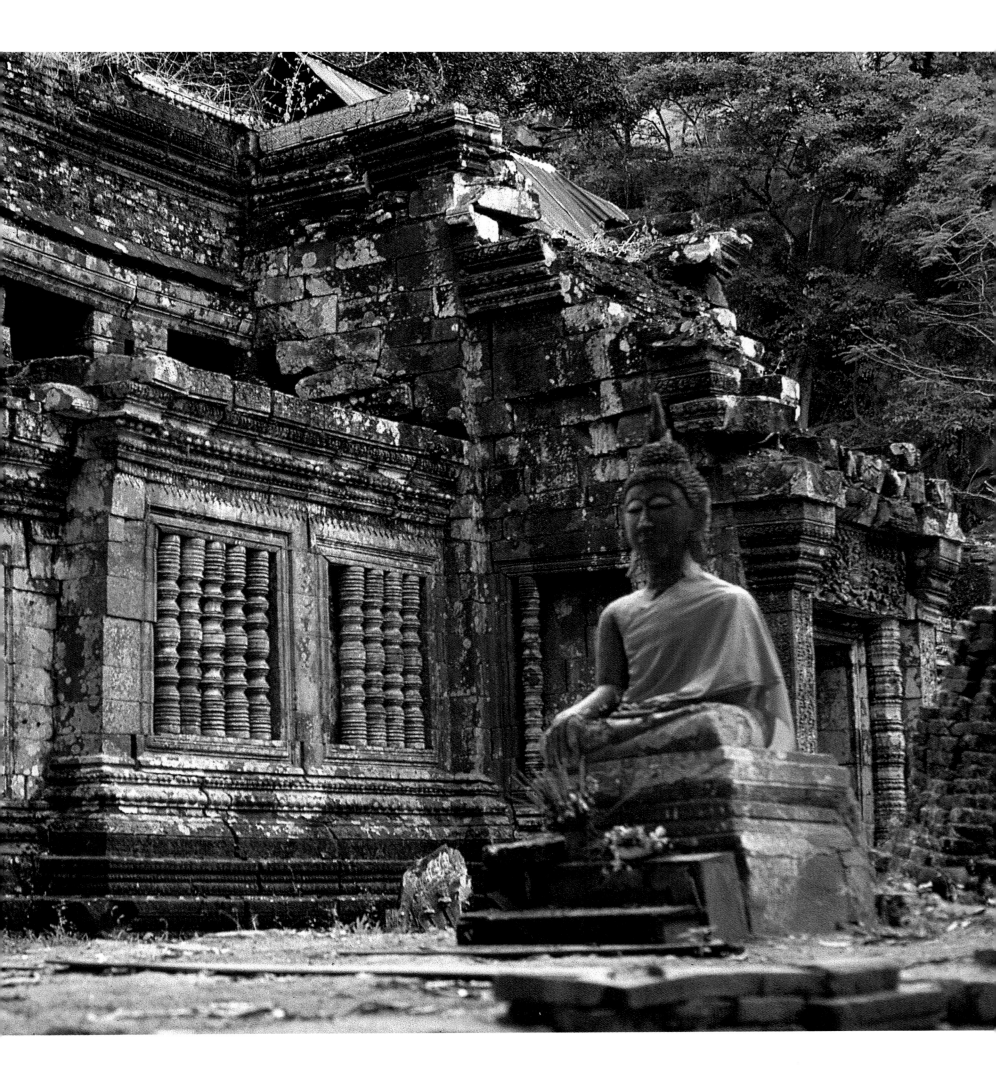

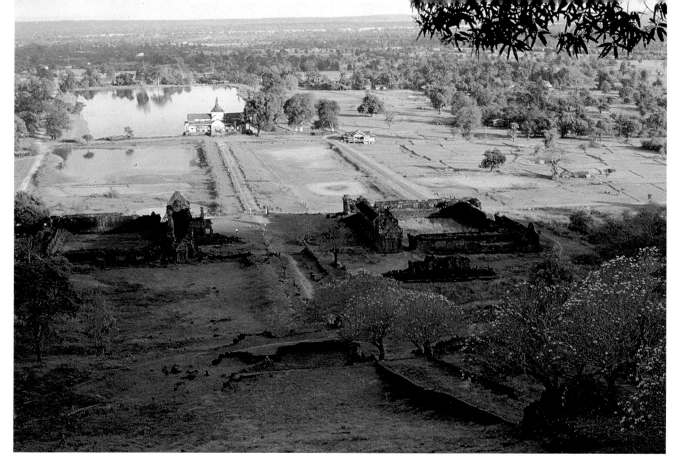

Wat Phou

6th to 12th century, Champassak, south Laos, view of the plain; processional way with the Women's Palace on the right, and the Men's Palace on the left

A long processional way, laid out by Jayavarman VI, leads from the low-lying area to the sacred buildings on the hill; originally the pathway was edged with statues of mythical beasts, of which individual traces are still to be found. The two flanking sandstone pavilions (foreground) probably served as accommodation for pilgrims, with men and women being kept separate. These well-preserved structures are now known as the Men's and Women's Palaces, since remains of a brick building, which was formerly the queen's residence, have been found at the back of the women's pavilion.

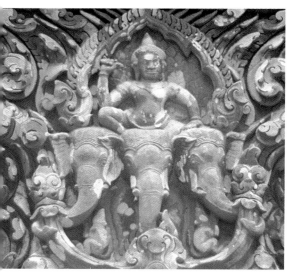

Above
Façade relief

(Detail), 6th to 12th century, main shrine, Wat Phou, Champassak, south Laos

Added in the 8th to 9th centuries, this façade exhibits magnificent relief work featuring *apsaras*, Vishnu dancing, and Indra riding a three-headed elephant.

Right
Female deity

6th to 12th century, main shrine, relief, Wat Phou, Champassak, south Laos

Statue of a female deity in a wall niche.

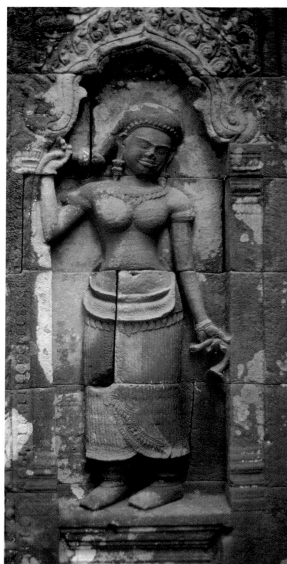

well-preserved structures are known as the Men's and Women's Palaces, since remains of a brick building, which was formerly the queen's residence, have been found at the back of the women's pavilion. Above lies the Nandi pavilion (Nandi was the white bull who served as Shiva's mount), with three consecrated chambers (recently used to house stolen works of art).

At the start of the path that leads up to the main shrine stands the statue of the king. More than 100 dilapidated steps, protected by a low wall and edged by frangipani trees (in Laotian, "temple trees"), lead to the *prasat*. In the *prasat*, the area behind the statue of the Buddha is still a part of the 6th-century brick building (see page 35). Holy spring water was directed into the temple through an opening in the masonry, for the purpose of the washing of the holy lingam (see page 37, top). The façade, added in the 8th to 9th centuries, displays reliefs that include *apsaras*, Vishnu dancing, and Indra riding a three-headed elephant (see page 36, left). Further remains are the library and the *trimurti*, a statue that incorporates the three principal Hindu gods, Vishnu, Shiva, and Brahma. The temple complex of Wat Phou continued to be of importance to the kings of Angkor until the end of the Khmer kingdom, and they supported it with generous donations of money.

Though today Wat Phou is a Buddhist monastery where only a few monks still live, the annual temple festival attracts the faithful from all over Southeast Asia. The high point is the sacrifice of a buffalo to the local earth spirit, an ancient tradition of the Indonesian group called the Lao-Theung. In 1959, in order to follow the performances adequately, the Laotian king had a palace built for himself at the foot of the mountain.

Wat Phou

*6th to 12th century, Champassak,
south Laos*

Decorated lingam in the main temple.

Below
Wat Phou

*6th to 12th century, Champassak,
south Laos*

The main shrine at Wat Phou.

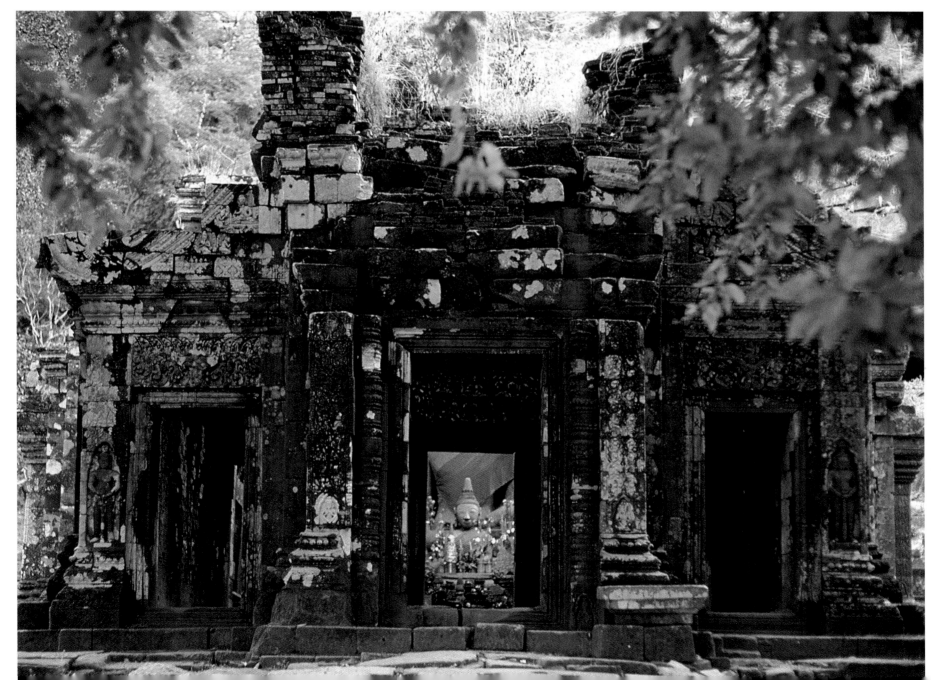

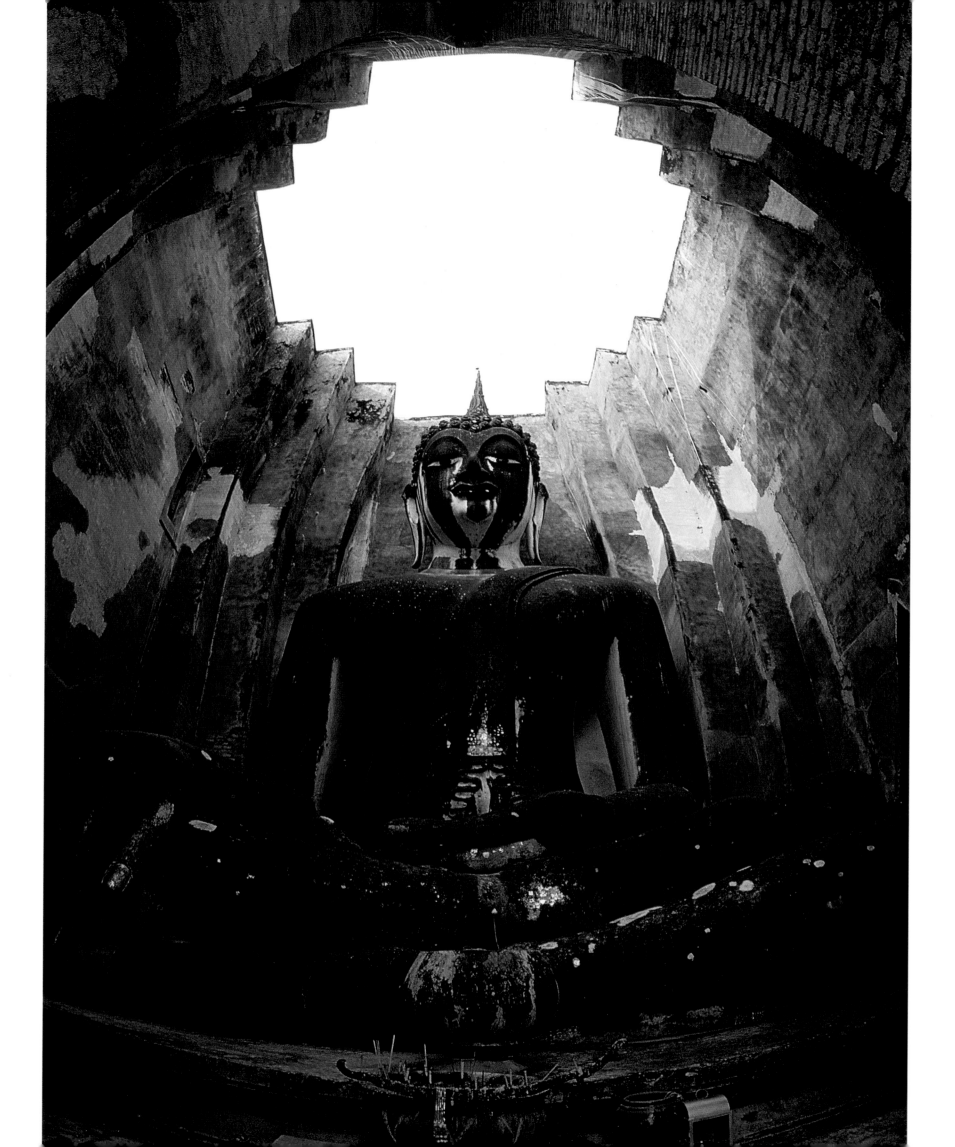

Thailand

The social harmony achieved in the Thai (Siamese) kingdom when Sukhotay was its capital is clearly reflected in both its architecture and its sculpture. This was a golden age of Thai culture, its arts characterized by the skillful combination of various influences — primarily Khmer architecture and the arts of the Mon — but also by a newly developed range of indigenous forms. The subsequent, equally glorious era of the Thai kingdom of Ayuthaya preserved these skills of adaptation and integration, which in fact continued well into the 19th century, responding to both Chinese and then European influences. The extraordinary diversity, richness, and delicacy of Thai art and architecture are the result of an aesthetic that has always been able to draw together diverse elements into a new and harmonious synthesis.

Wat Sri Saway

1240, temple complex, Sukhotay,
Thailand, seated Buddha

Wat Sri Saway was built when Sukhotay was under Khmer control. It was probably during the so-called Sukhotay period that the Thai began the tradition of building Buddhist *chedi* (a relic chamber, normally in the form of a hood or bell) in the style of Khmer architecture.

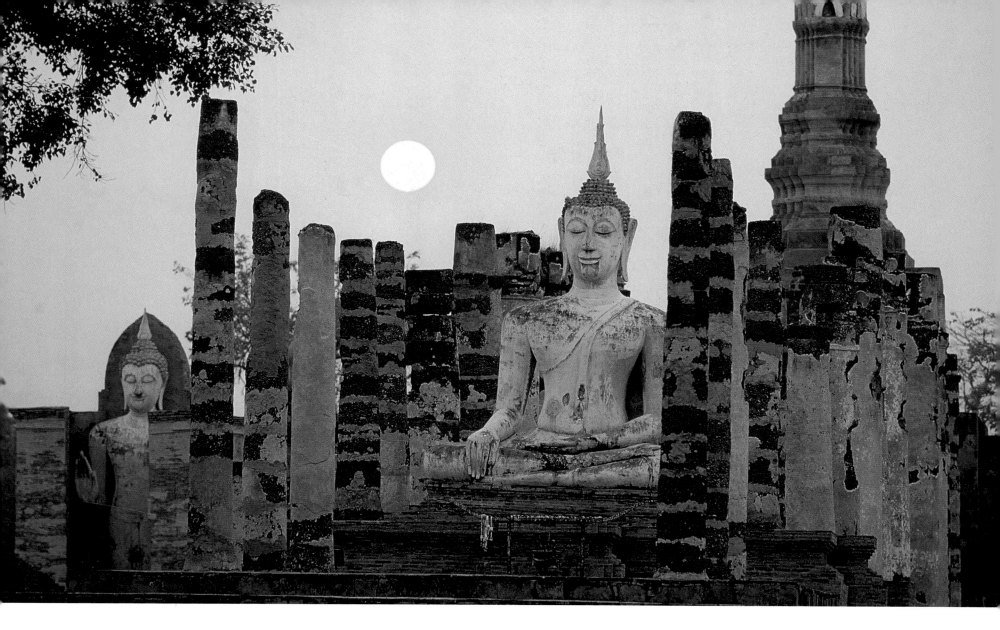

Sukhotay and Sri Saccanalay: The Thai's Golden Age

Wat Mahathat

Completed 1345, Buddha statue in the ruins of the temple complex, Sukhotay, Thailand

This statue is one of the few works of art preserved from the period when the temple was built. The Wat Mahathat (Mahathat means "a relic for Buddha") is the most important shrine for relics, and is situated at the very center of the rectangular city of Sukhotay. As a stone plaque dating from the period when the temple was constructed makes clear, the nine towers on the raised platform are symbols of Mount Meru (here called Kailasa) and its environs, home of the Hindu god Shiva.

The first work of Thai literature to be handed down to us, written during the reign of the great king Ramkhamhaeng (1275–1317), includes famous lines describing the blissful life of the kingdom of Sukhotay (Sanskrit: *sukhodaya*, "source of happiness"):

"In the time of King Ramkhamhaeng, this land of Sukhothai is thriving. In the water there is fish, in the fields there is rice. The lord of the realm does not levy toll on his subjects for travelling the roads; they lead their cattle to trade or ride their horses to sell; whoever wants to trade in elephants does so; whoever wants to trade in horses, does so; whoever wants to trade in silver and gold, does so. [...] When [the King] sees someone's rice he does not covet it, when he sees another's wealth he does not get angry... he has hung a bell in the opening of the gate over there: if any commoner in the land has a grievance which sickens his belly and gripes his heart, and which he wants to make known to his ruler and lord, it is easy; he goes and strikes the bell which the King has hung there; King Ramkhamhaeng, the ruler of the kingdon, hears the call; he goes and questions the man, examines the case, and decides it justly for him. So the people of this *muang* (city/state) of Sukhotai praise him."[1]

The golden age of the Thai kingdom of Siam, which was also the heyday of Thai art, lasted from the 13th to the 15th century. Earlier than this, and during a brief overlapping period, from the 7th to 14th centuries, east, northeast, and central Thailand were influenced by the art of the mighty Khmer, whose irresistible artistic dominance began with the reign of Suryavarman I (1002–1050).

The so-called Lopburi style – named after a city in central Thailand conquered by the Khmer – was succeeded by the Chiang Mai style, which marks the beginning of an independent Thai art. An important element in the development of this independence was the fact that the Thai and Khmer had completely different notion of kingship: for the Khmer, the king was a god, and he was honored accordingly. The Sukhotay rulers, on the other hand, were close to the people, and all the subjects took part in the religious feasts and rituals that in the Khmer kingdoms were reserved

for a small elite. This greater degree of social unity in Thai society is clearly reflected in their arts: it is precisely a skillful and harmonious blending different artistic elements and influences (primarily Khmer architecture and the art of the Mon) and the subsequent creation of a new canon of architectural and sculptural forms that characterize the art of the golden age in Thai culture.

The religious heart of the kingdom was undoubtedly the Wat Mahathat in Sukhotay, a temple complex surrounded by an artificial watercourse and a wall – an allegory of the cosmic ocean and the boundary wall of the universe. The temple for the relics of the Buddha (a hair and a bone from the neck), which according to tradition came from Ceylon (Sri Lanka), was completed in 1345 by King Lo Thai. Adorned with nine towers and crowned by the unique Lotus *Chedi*, this sacred complex expresses the political superiority of Sukhotay by means of an elegance and refinement that draws on several artistic traditions. The central tower is surrounded by four smaller *chedis* in the Srivijaya (Sumatra) style, alternating with the four Khmer *prangs*.

Remains of the original stucco decoration, as well as a few reliefs depicting monks, are still preserved on the *prangs*. The inner peak of the wat is an allegory of the mythical Mount Meru, which stands at the center of the universe. Some original statues of seated Buddhas are still to be found between the ruins, as well as two monumental seated statues of the "forgiving Buddha." Their apparently accidental presence, together with the sublime and at the same time almost weary delicacy of their bearing, lend a mythical charm to the complex.

The twin city of Sukhotay, Sri Saccanalay, became the seat of the king's son during the fourth regency period of the kingdom. Probably built in the grounds of the former Khmer city Chaliang, Sri Saccanalay is also thickly dotted with monuments. The capitals Ceylonese-inspired *chedi*

Chang Lom is the first example of a new style and the model for many later buildings. On the lowest step of the building are the remains of 39 elephant caryatids, separated by columns that served as lantern supports.

In time the "golden kingdom" of Sukhotay was eclipsed by the kingdom of Ayuthaya, which appeared in the central plain of Thailand about 50 kilometers (30 miles) from present-day Bangkok. In the course of the succeeding centuries, the cities of Sukhotay and Sri Saccanalay gradually succumbed to the all-embracing jungle.

Only in recent times have these historic sites begun to be secured and restored. Today they are part of the world cultural heritage program, and so are protected by UNESCO.

Wat Chang Lom

14th century, temple complex, Sri Saccanalay, Thailand

In Sanskrit *sri sajjanalaya* means "residence of the true man." Seen here is a *chedi* built in the Ceylonese style, adorned with elephant caryatids and niches containing Buddhas.

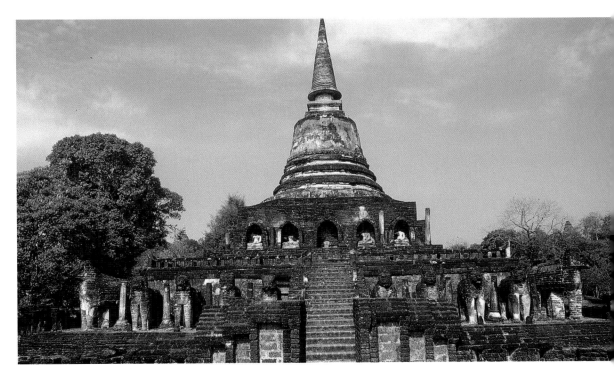

Left
Wat Mahathat

Completed 1345, Sukhotay, Thailand

Seen here is part of the complex of the main shrine with a typical *mondop*, a cube-shaped building that is usually crowned by a conical structure. (The related word *mandapa* comes from Sanskrit and means "open hall, pavilion, tent temple.") These buildings were used to house sacred objects, such as relics of the Buddha.

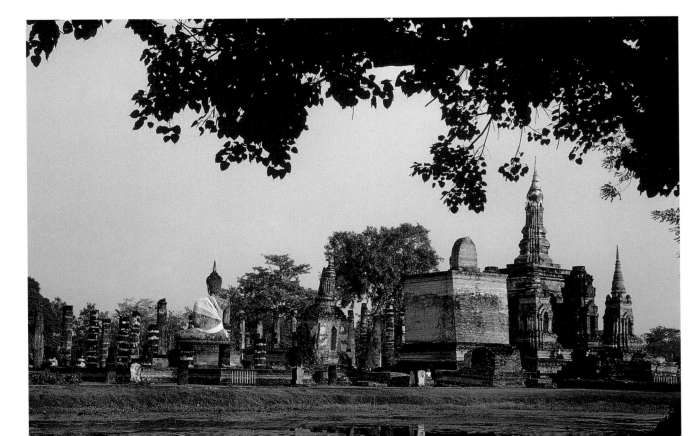

Founded in the Year of the Tiger: The Kingdom of Ayuthaya

The royal chronicle of Ayuthaya records: "712, the Year of the Tiger, second decade, on a Friday, the sixth day of the waxing moon of the fifth month, at three *nalika* and nine *bat*, after the break of dawn, the capital city of Ayuthaya was first established [ie Friday March 4 1351, about 0900]."[2] The name Ayuthaya comes from Sanskrit: *ayodhya* means "unassailable fortress," the name given to the residence of Prince Rama, the hero of the Indian epic the *Ramayana*.

This foundation date proved auspicious for the city, which developed into a glittering metropolis that astonished the world for more than 400 years from 1351 to the fall of the city in 1767. European merchants, travelers, and ambassadors described in the most glowing terms the multicultural seat of the Siamese kings, often called the "Venice of the Orient," which in the 16th century had a population larger than that of London.

In the 17th century the French visitor Jean de Lacombe noted that the palace of Ayuthaya, in "the richness of its materials, transcends every other building of the World, [and] renders it a Dwelling worthy of an Emperor of the whole World."[3]

Today the ruins still evoke a suggestion of the lost splendor – temples, towers, roofs, Buddhas in the midst of lush vegetation. "It is nine in the morning, the sun is burning, the green is a more poisonous color than in countries where winter is coming, I walk over endless expanses of grass, birds sing, and something languid hangs in the air which makes me walk more slowly, something to which one adheres – the past which has gone forever… Ruins have something about them which makes them more beautiful than most restorations."[4]

Innumerable architectural forms that had their origin in the Sukhotay period were taken up and developed by the artists of Ayuthaya. The *chedi*, the distinctive, bell-shaped Thai stupa, was repeated in countless variations, and the Khmer *prangs* were also very much *en vogue*. One of the most impressive examples of successful "Khmer adaptation" is the Wat Chay Vattanaram. In this temple, which was restored only recently, the special ability of Thai architects to create an individual form of expression from the amalgamation of various styles and iconologies becomes very evident; the cosmology of the temple, a blending of

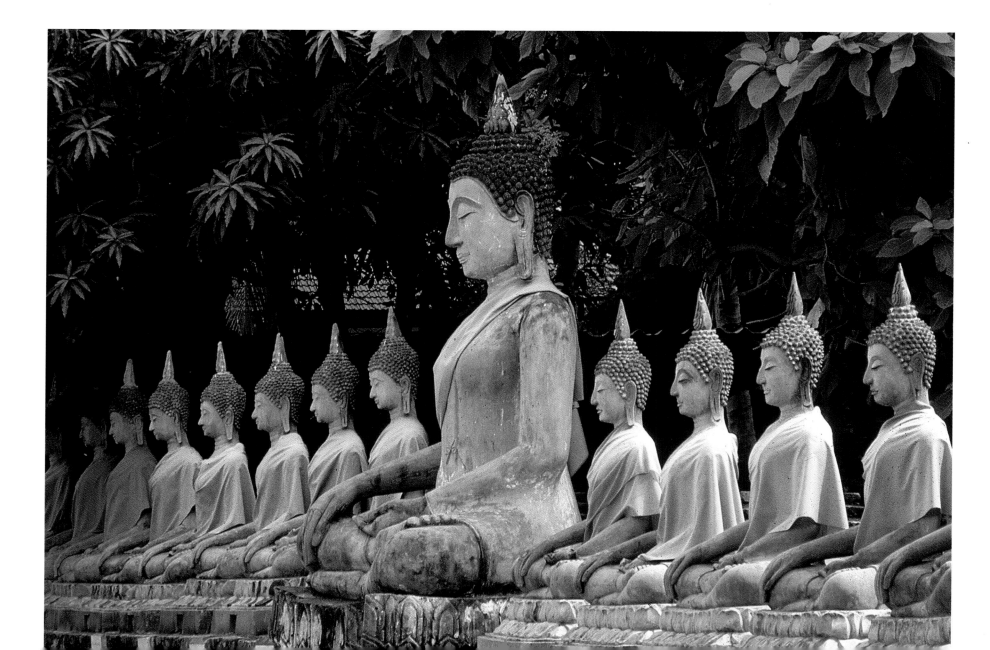

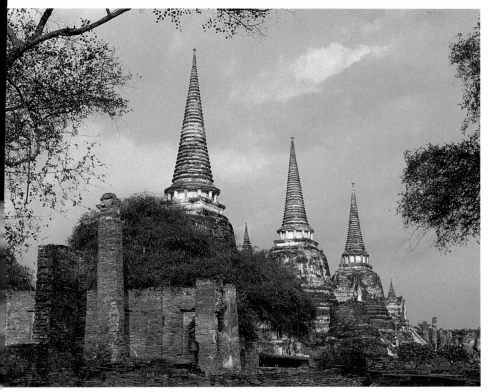

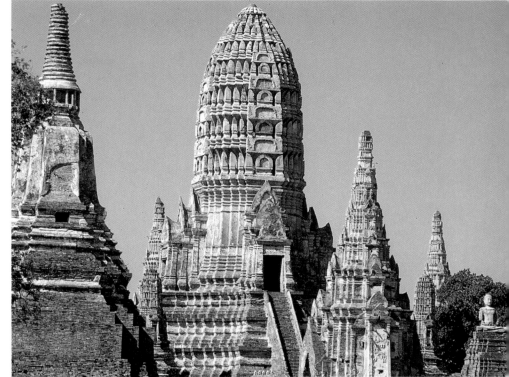

Hinduism and Buddhism, is particularly striking. The temple complex, built in 1630 at the command of King Prasat Thong (1630–1656), is conceived as a magic diagram set within a square. At one time a seated Buddha, today headless, looked out across the river over which the wat was sited in a commanding position. The apparently weightless central *prang* or Mount Meru is surrounded by two rows of smaller *chedis* and a gallery of Buddhas sculpted in stucco and now reduced to shattered torsos.

Apart from this architecturally unusual wat, the Wat Pra Sri Sampet is the most astonishing of the many "living ruins," largely because of its vast dimensions. Begun in 1491, it was continued under the rule of a number of kings. Lying near the Wang Luang, the royal palace, the Wat Pra Sri Sampet is dominated by three *chedis* in the Ceylonese style, bounded by smaller *chedis* and *vihans* (assembly halls). Countless remaining fragments of columns and walls give a powerful impression of the former greatness of the wat.

As a rare secular building to have survived, the palace of Candra Kasem deserves mention. It was built by Maha Thammarat (king 1569–1590) for his son Naret (1555–1605), who repulsed the Burmese in the famous elephant battle of Nong Sarai in 1593. Today the palace is used as a museum.

The Thai kings were keen collectors of their traditional art and their collections offer a broad history of the development of Thai art, revealing both its variety and exquisite quality. A delicate bronze from the Mon Dvaravati period (see page 46) bears witness to the early flowering of Buddha sculptures in Thailand. The Mon kingdom of Dvaravati is an enigma for the historian, but has left behind outstanding works of art in central Thailand.

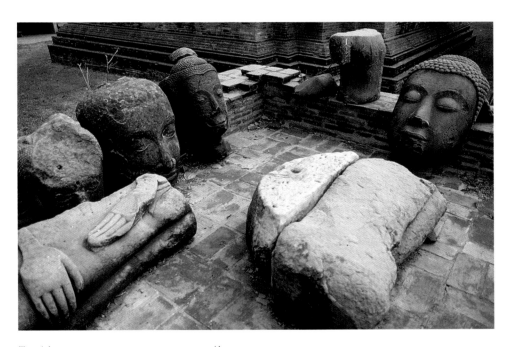

Top right
Wat Chay Vattanaram

1630, temple complex, Ayuthaya, Thailand

In Sanskrit, *ayodhya* means "the uncapturable fortress." The Wat Chay Vattanaram was built by King Prasat Thong (1630–1656), who wanted to create a monument comparable to those of Angkor. Here the central *prang* (Sanskrit: *pra-anga*, a stupa in the form of a corn-cob) is a Thai relic chamber clearly built in the style of a Khmer temple mountain.

Above
Candra Kasem palace

About 1580, Buddha heads and torsos, Ayuthaya, Thailand

The palace of Candra Kasem was built by the 17th king of Ayuthaya, Maha Thammarat (known as the "law king," 1569–1590) for his son Prince Naret (Sanskrit: *nareshvara*, "lord of humanity," 1555–1605).

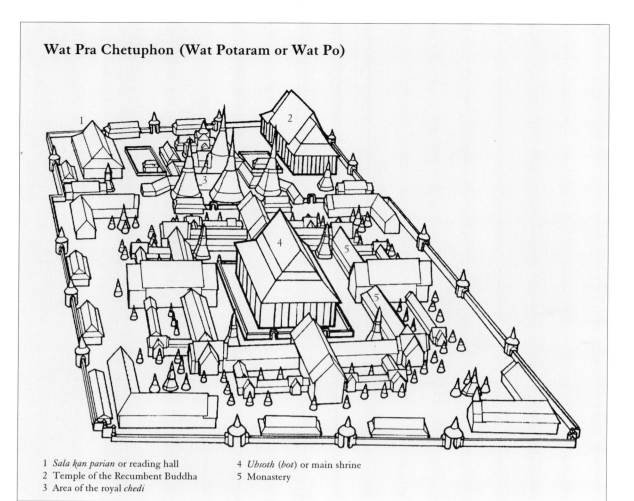

Wat Pra Chetuphon (Wat Potaram or Wat Po)

1 *Sala kan parian* or reading hall
2 Temple of the Recumbent Buddha
3 Area of the royal *chedi*
4 *Ubsoth* (*bot*) or main shrine
5 Monastery

Below
Wat Pra Chetuphon

1824/51, so-called Temple of the Recumbent Buddha, view of the colored roofs, Bangkok, Thailand

The Wat Pra Chetuphon, situated in a historic part of the city of Bangkok, is also called Wat Potaram (or Wat Po), from the Sanskrit word *bodhi*, "grove in which Buddha preached."

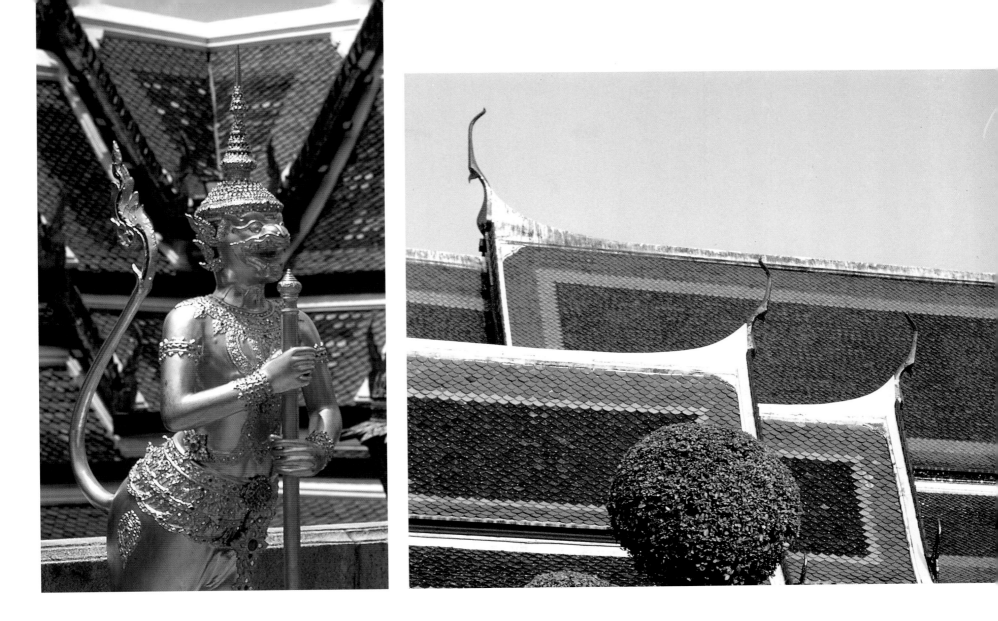

Bangkok: The Rebirth of the Thai Kingdom

The history of the kingdom of Ayuthaya was marked by the long-drawn-out struggle against the kingdom of Burma. In 1767, after 400 years of sieges, incursions, and set battles, the final outcome was the defeat and consequently the fall of Ayuthaya, which was pillaged and destroyed to such an extent by the Burmese that there could be no hope of recovery. "The Burmese wrought an awful desolation. They raped, pillaged and plundered and led thousands of captives away to Burma. They put the torch to everything flammable and even hacked at images of the Buddha for the gold with which they were coated. King Suriyamarin is said to have fled the city in a small boat and starved to death 10 days later."[5]

The Thai kingdom moved south, first to Thonburi and from there to Bangkok, a name which, freely translated, means "marshy village of the wild olive." The spirit of the Thai people had not been extinguished with Ayuthaya.

The Chakri dynasty, which still reigns today, was founded in 1782 by General Chakri, who ruled as Rama I (1782–1809), and who immedi-

ately decided upon a large-scale building program. As a matter of priority Rama I created temple complexes, and furnished them with statues of the Buddha he had tracked down in his devastated kingdom and brought to Bangkok. As it was felt to be essential to preserve the glorious tradition of Ayuthaya, the restoration of old buildings and the recreation of the Ayuthaya style were made priorities. The *prang* and the *chedi* remained the favorite forms of architecture, as well as the *vihans* and the *ubsoth*. In the third kingdom of the Chakri dynasty, in the 19th century, the Chinese influence became more significant and there developed the distinctive style we now associate with Thailand.

The first magnificent buildings of the Bangkok (or Rattanakosin) period were the Great Palace and the Wat Pra Keo (see above left, and page 51), the latter built exclusively to create a worthy home for the Emerald Buddha, the most highly revered of Thailand's works of art. According to legend, this Buddha was first recorded in Chiang Rai in 1434, after which its home was in Vientiane (Laos) for 214 years (see page 64); in 1778 it was plundered by the Thai army.

Above left
Golden guardian figure
Wat Pra Keo, Bangkok, Thailand

Above right
King's palace
Begun 1782, renovated 1982, view of roofs, Bangkok, Thailand

The Thai ruler Rama I (1782–1809) built the palace as a royal residence and seat of government. Each Chakri ruler after him made structural alterations to the palace in accordance with his own desires. After a journey to Europe, Rama V, King Chulalongkon (Pali: *chulalangkarana*, "the one adorned with a hair-knot"), employed an English architect to built the Chakri Maha Prasat in the European Neo-classic style (1876–1880). The traditionalists at the court were by no means pleased with this "travel souvenir" and eventually it was decided to add Thai-style roofs to the building.

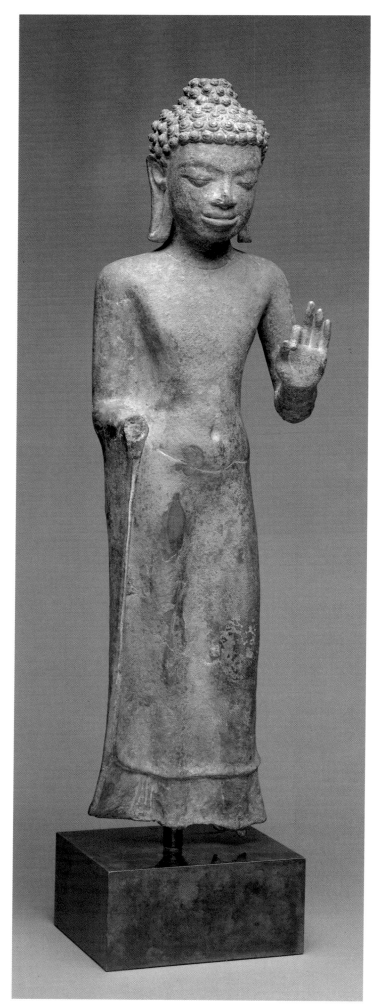

Buddha Shakyamuni

8th/9th century, Mon Dvaravati period, bronze, H 54.6 x W 15.3 x D 8.6 cm, Thailand, The James and Marilynn Alsdorf Collection, Winnetka, Illinois

Wat Pra Keo:
"Jewel-box of the Emerald Buddha"

Begun in 1782, the temple buildings, known as the "pearls" of Bangkok, lie on the shores of the Chao Phraya river and cover an area of one and a half square kilometers (half a square mile). As the first edifice of the gigantic complex of Wat Pra Keo, Rama built a replica of the royal prayer-house in Ayuthaya. His successors steadily increased the area of the "city in the city," surrounded by walls, which was organized to be completely self-sufficient. The *ubsoth* – a rectangular Buddhist

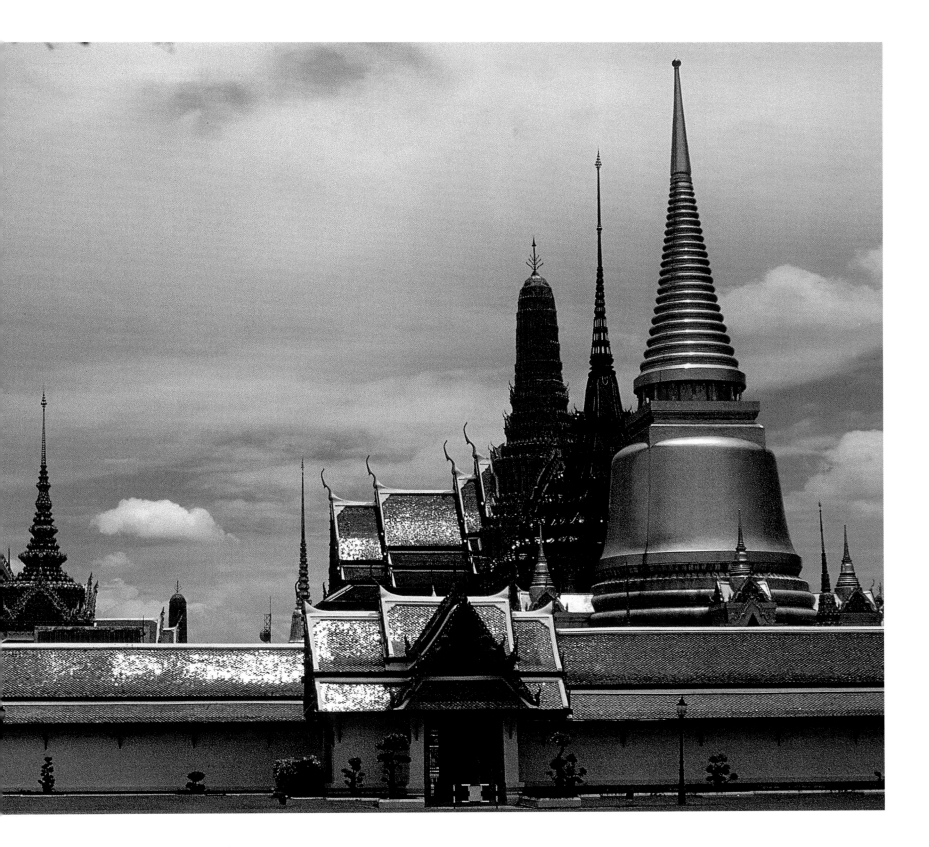

hall of consecration – of the Wat Pra Keo is constructed on a marble platform and is adorned with a frieze of gilded figures. The doors are inlaid with mother-of-pearl; the façade is covered with mosaics of colored glass. The lavish decoration of the whole complex is the very image of Thai art.

While the stupas, *chedis*, and *mondops* of the wat give the impression of being copies of Ayuthaya or Angkor, the palace itself represents an interesting contrast, since here the dominant influences are Chinese and European. In the third kingdom of

the Chakri dynasty (1824–1851) interest in China grew as a result of increased trade, and many elements of Chinese decoration began to be adopted in royal architecture. Thus the assembly halls show the influence of Chinese building types, especially in the structure of the roofs. Starting out with the stone "telescope roofs" of the Khmer (each roof being smaller than the one below), the Thai transformed the "ship" (with broad, sweeping curves) and gable roofs of Chinese origin into highly distinctive roofs of

King's palace

Begun 1782, renovated 1982, view of palace complex from outside the perimeter wall, Bangkok, Thailand

Originally the palace was a self-governing city, the cradle of all power, surrounded by a high wall – self-supporting and self-contained.

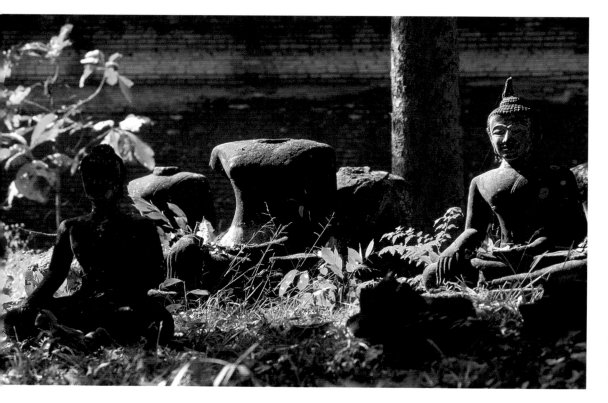

brick, always crowned by a row of spiky "battlements." Even though the resulting architecture remains close to Chinese models, the roof constructions that result are unmistakably Thai. Thus in the Bangkok period Thai art again showed that it was based on the creative absorption of external cultural influence.

A further hallmark of Thai wats are the elaborately formed guardian figures (see page 50), whose iconography is described in the influential work of Thai literature, the *Traiphum Phra Ruang*. In the deep underground areas of the Mount Meru reside the *yaksha*, the colossal demon guardians of the kind positioned at the temple of the Emerald Buddha. In the depths of this mountain, the *nāga* also live, the legendary serpents, guardians of the waters and the underworld. The function of these guardians, demons, and serpents, is to protect the universe. In the forests of the Mount Meru dwell the enemy of the *nāga*, the fantastic creature called *Garuda*, half-human, half-bird.

The Hindu god Indra has his seat in a palace on the peak of Mount Meru; it is the place where all wishes come true. The Thai version of Indra, often

Above
Buddha figures
About 1390, Wat Umong, Chiang Mai, North Thailand

Right
Detail of a façade
Bangkok, Thailand

Paricolored and highly ornate, such Thai carvings show an uninhibited blend of Hindu and Buddhist elements.

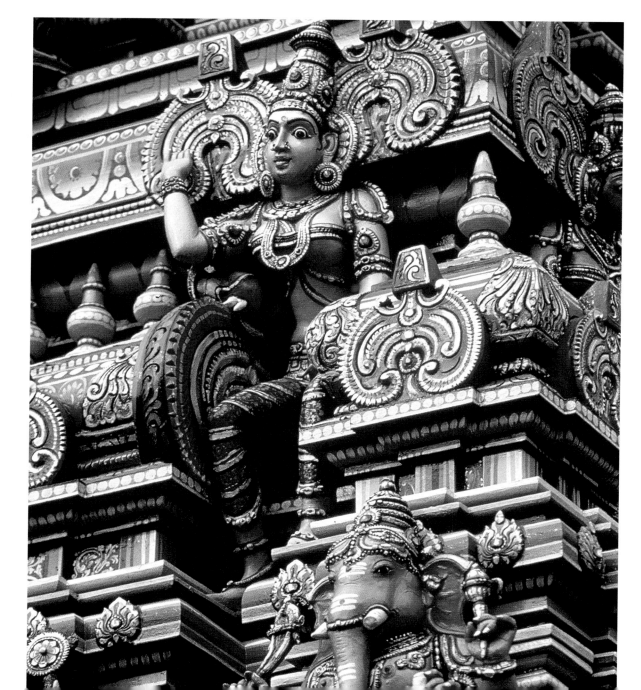

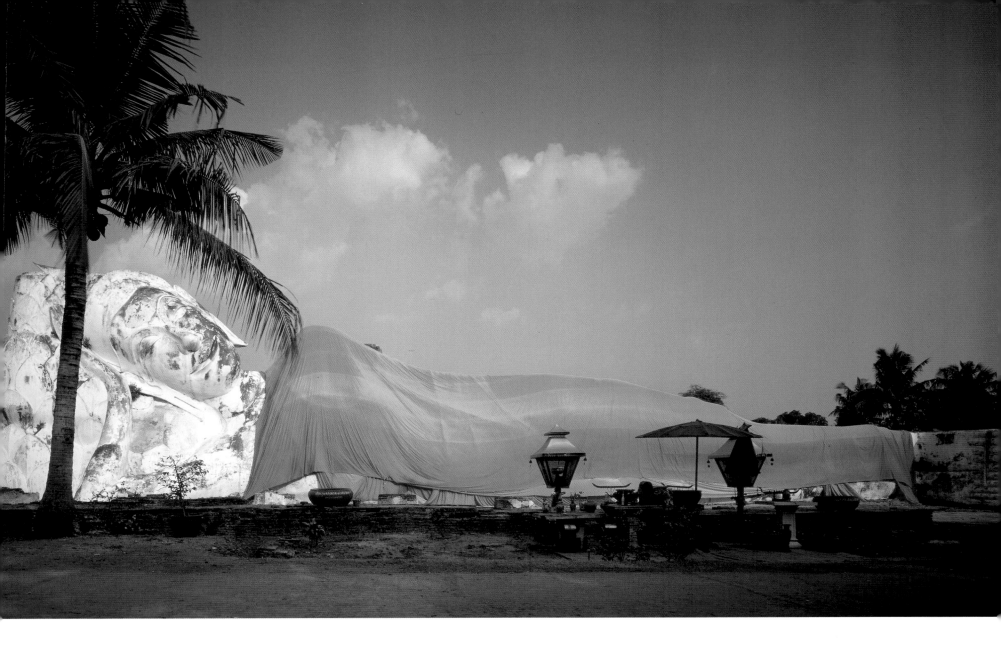

Recumbent Buddha
Ayuthaya, Thailand

found in temple complexes, sits on a three-headed elephant. Under the regency of Rama II (1809–1824) the threat from Burma was replaced by a new and very real threat: from Europe. The 19th century was a critical period for Thailand (then known as Siam), for at this time Southeast Asia was systematically divided between England, France, and the Netherlands. The fate of its neighbors would also have been met by Siam if two outstanding rulers – Mongkut (Rama IV, 1851–1868) and Culalongkon (Rama V, 1868–1910) – had not preserved their country's independence by means of their adroit diplomatic skills and their sensitive approach to modernization. Unfortunately, Mongkut is largely known to us not because of his abilities as a statesman, but because of Anna Leonowens' defamatory accounts of his court, caricatured in the musical based on her book, *The King and I*.

In art, the final decades of the 19th century were determined more and more by the incorporation of European influences. The mixture of colonial and traditional styles was avoided, however, in the reception hall of the palace in Bangkok; contrary to original plans to crown it with a Western cupola, it was completed with Thai-style roofs (see pages 45 and 47); the skyline of the old city remained intact. Wat Pra Chetuphon (see page 44), the Temple of the Recumbent Buddha, begun 200 years ago, is the biggest wat in Bangkok and is famous for its statue of Buddha 46 meters (150 feet) long and 15 meters (50 feet) high. The entire work is gilded, and has beautiful mother-of-pearl inlay, on the soles of the feet, representing the 108 Thai good-luck signs. Although the Buddhas created during the Bangkok period did not attain the subtle quality of the statues of earlier eras, they did gain an impressive majesty.

However, in the Wat Pra Chetuphon complex there are also 1,000 bronze Buddhas from the ruins of Ayuthaya and Sukhotay, which offer a first-rate summary of the artistic riches of the sculpture of Thailand. Equally remarkable are the 95 *chedis* of varying size scattered throughout the complex. During the regency of Rama III (1824–1851) the library of the wat was ornamented in the Chinese tradition, patterns being created from small pieces of colored ceramic. In 1832 he had the *vihan* built, the housing for the colossal recumbent Buddha.

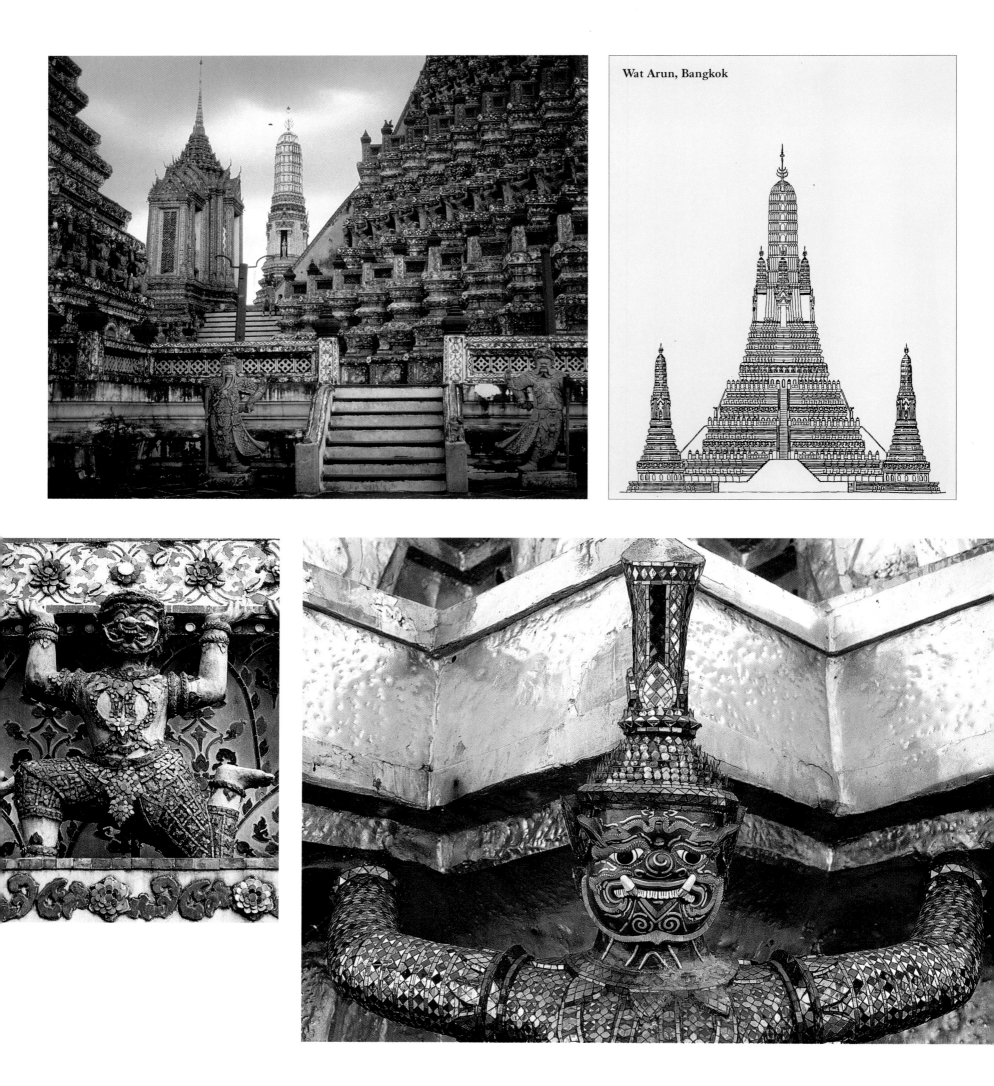

Wat Arun, Bangkok

Right
Wat Pra Keo, Thailand

1782, renovated 1982, royal palace,
Bangkok, Thailand

The palace has many points in common
with the imperial palace in the former Thai
capital, Ayuthaya.

Opposite, top
Wat Arun

Early 19th century, temple complex,
Bangkok, Thailand

In Sanskrit *aruna* means "temple of the
rosy dawn." On the peak of the *prang* is a
three-dimensional representation of the
weapon of the god Indra, the *vajra*, or
thunderbolt. Its form has been interpreted
as an image of the Earth on the mountain
of Meru, a way of underlining the concept
of cosmic harmony.

Opposite, below
Guardian caryatids

Before 1900, Bangkok, Thailand

The costly and elaborately shaped demon
guardians, which dwell in the lower
underground regions of the sacred
Mount Meru, are a distinctive feature
of Thai wats.

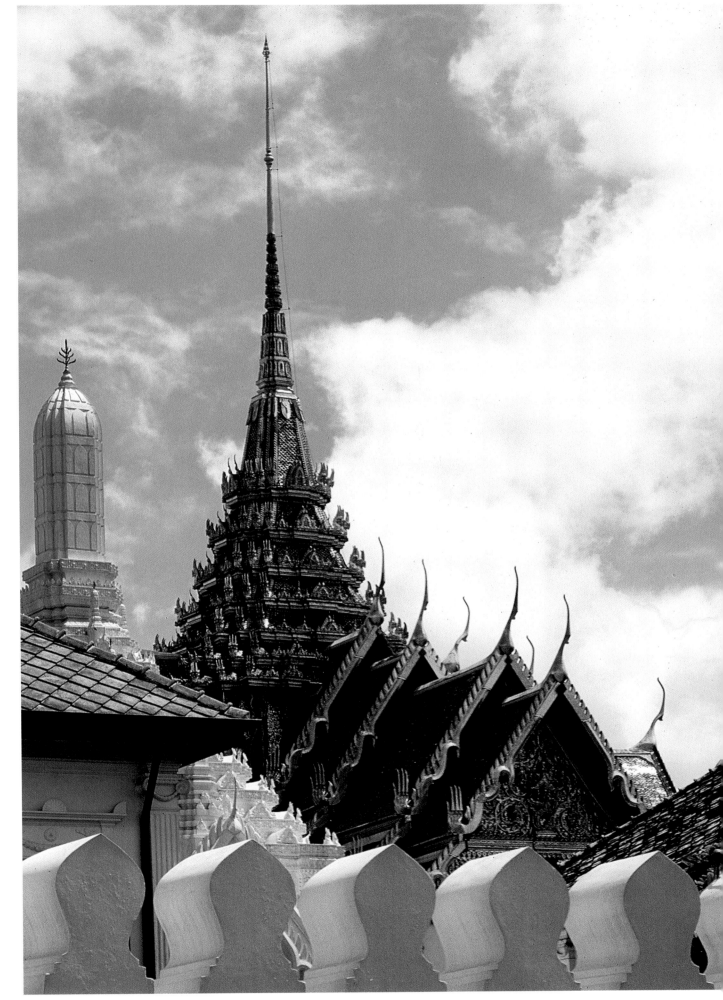

Royal palace

After 1782, mural, the gallery of the Wat Pra Keo, in the grounds of the royal palace, Bangkok, Thailand

A scene from a mural depicting the exploits of Prince Rama, from the *Ramakien*, the Thai version of the Indian epic the *Ramayana*.

Mount Meru

Covered over and over in colored pieces of ceramic is the Wat Arun, the "temple of rosy dawn" (see page 50). Although it lies outside the area of the old city, on the banks of the river Chrao Phraya, it became one of the most famous buildings of the metropolis. The beauty of the complex, with its 81-meter (266-feet) high *prang*, is best admired from the opposite bank, from the Wat Pra Chetuphon, since its function as a religious metaphor is most clearly evident when the whole site is taken in at once.

The colorful "texture" created by the decoration evokes the luxuriant vegetation of Mount Meru, whose cosmological "world" (the terraces of the wat) is supported by both heavenly and demonic caryatids. Its earthly counterpart is the mountain of Meru in the Himalayas. On the peak of the *prang*, which represents this magic mountain, Indra is enthroned on his three-headed elephant. In its fusion of the Hindu and Buddhist faiths, Wat Arun is the symbol of the Thai concept of the universe; in its variety of forms, it is also a mirror of the various cultural influences absorbed, and gloriously transformed, by the Thai people.

Thai painting and the *Ramakien*

Thai paintings are almost exclusively works meant to be conducive to contemplation, and their themes were drawn from well-known religious writings. Unfortunately, only a few are older than 150 years, since the *al secco* technique used (in which the color is applied to dry plaster) is susceptible to heat and damp. Because of their prominent position, the murals in the gallery of the Wat Pra Keo (see below), in the grounds of the royal palace, are the best-known examples of Thai painting (first version from 1782).

Depicted is the *Ramakien*, the Thai version of the Indian epic the *Ramayana*; in 178 episodes the murals tell of Prince Rama, an epic comparable to the *Odyssey*, and written about 2,000 years ago by the Indian poet Valmiki. Rich in painted details, and full of humor, the prince's adventures unfold in vividly conceived scenes that, in their scope, subtlety, and drama, offer a panorama of the soul of the Thai people. Particularly rare treasures include preserved Thai book illustrations that depict the everyday life of Siam in miniatures as original as they are entertaining (see opposite).

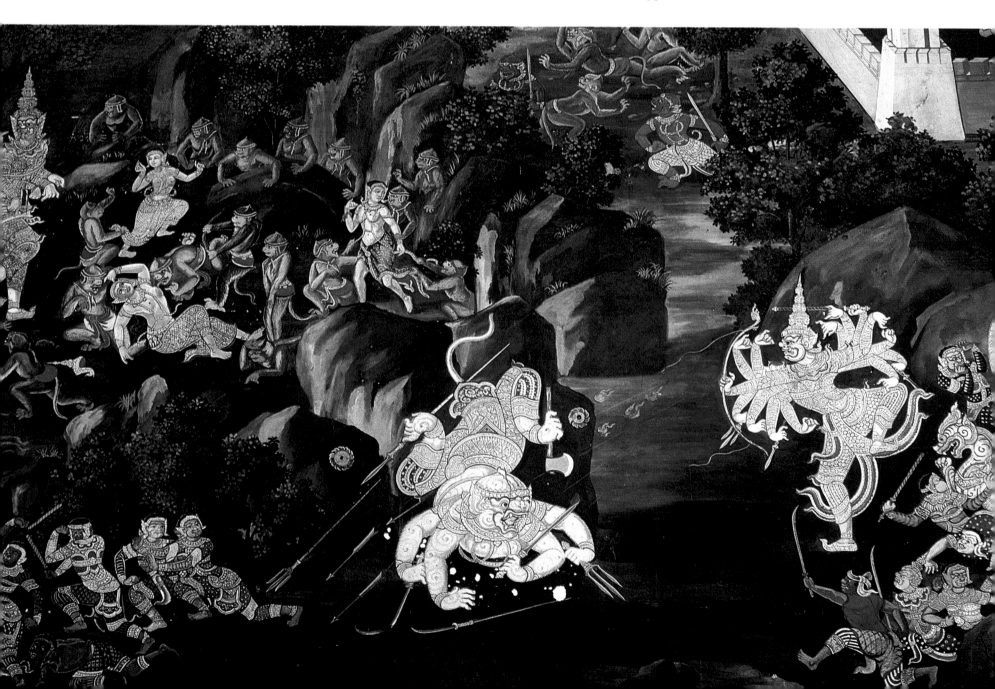

Illustrated folding book

Before 1908, w 14 cm, Thailand, State Ethnographic Museum, Munich

Above right is a page of "numerological symbolism" depicting a clock. The symbols (identified by captions) depict: a *prasat*, a *pra*, a *chedi*, time, chance, opportunity, a turtle, gold, mortified flesh, a pagoda, a stupa, *caitya*. At the beginning of the book are several pages with Thai text, then a symbolic representation of the named 12 *nidānas* (stages of human existence); following these are the images of the 12 signs of the zodiac, with the gods appropriate to them. At the end are two guardians of the world (see left).

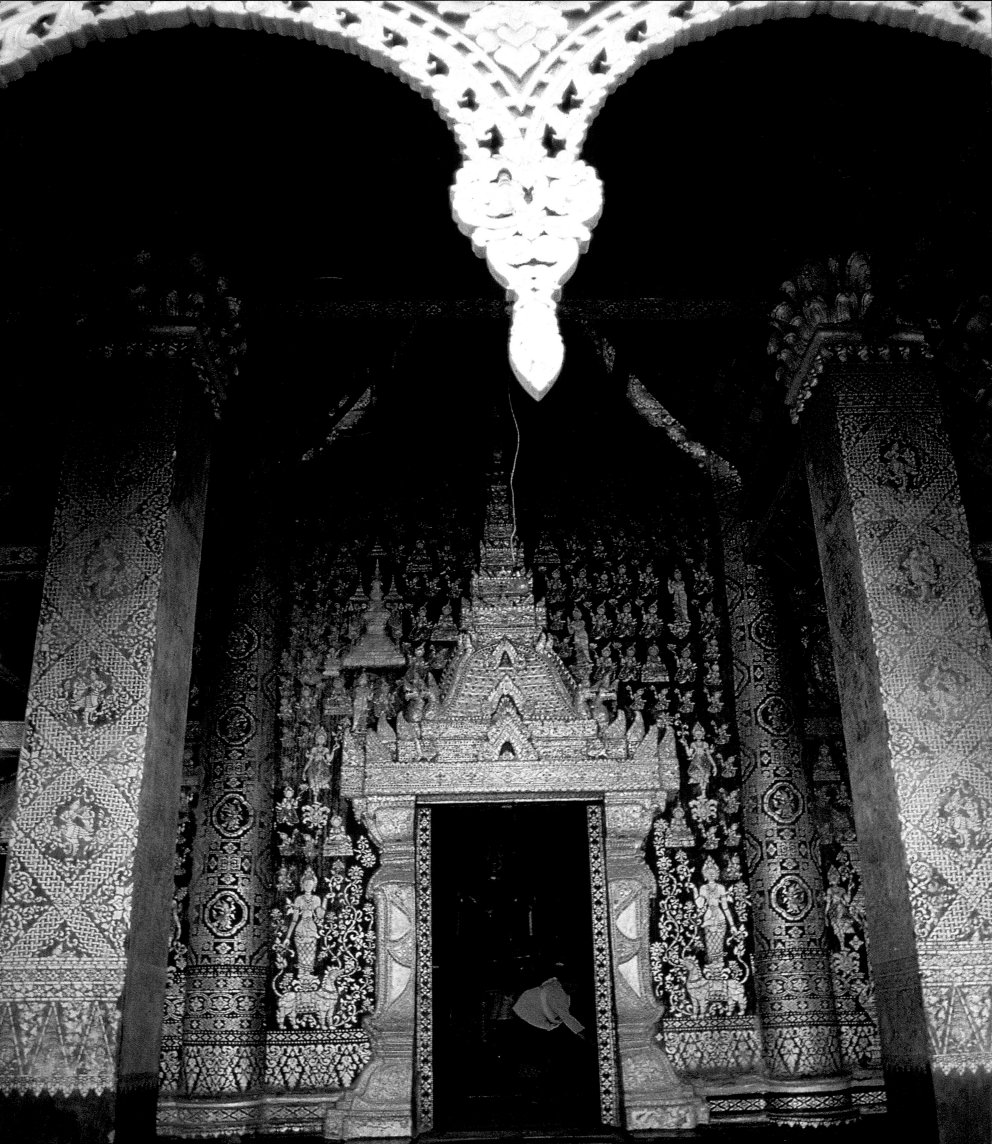

Laos

The art and architecture of Laos were largely the products of foreign influences, for the fact that the landlocked kingdom was surrounded by powerful nations meant that it was frequently the subject of violent attempts to unify the whole region. Yet despite these various cultural "invasions," in particular by Thai art, the art of Laos did succeed in developing its own clear identity. Among its most distinctive aspects are an extravagant wealth of ornamentation, often displayed in a range of brilliant colors, and also the "floating" effect of the roofs in the Luang Prabang style, with roofs piled one on top of another in as many as seven layers — creating what seems a weightless, almost immaterial architecture.

Wat Xieng Thong

1559, Luang Prabang, Laos

Entrance to the *sim*, the main shrine in a Laotian temple complex.

The Kingdom of Laos

In the course of its history, Laos suffered many invasions: China, Thailand, Burma, Vietnam, and the Khmer kingdom have all dominated the country and have left their mark on Laotian culture. It was the fall of the adjoining Thai kingdom of Sukhotay to Burma in 1345 that sent shock waves through the entire region, that made the peoples of the Laos region form the first totally independent Laotian kingdom (though smaller Lao *muang*, independent city states, had existed previously). This kingdom of Lan Xang – described as the "land of a million elephants and white sunshades" – corresponded to the area of present-day Laos, extending from northern Cambodia as far as the southern border of Yunnan, and to the west from Siam to the kingdom of Dai-Viet (Vietnam) in the east. The first ruler of Lan Xang, the Laotian prince Fa Ngoum, who was brought up at the Khmer court in Angkor, ruled from 1353 to 1373, and created the first Laotian state system. It is important to remember, however, that he was the ruler of an association of small *muangs*, some difficult to control; at first the kingdom of Lan Xang was, in effect, a kind of focal point of regional power.

Danger from outside remained a constant threat even under his successors, and posed a

Left
Inlay work
(Detail), 1559, Wat Xieng Thong, side wall of the sim, Luang Prabang, Laos

Below
Wat Xieng Thong
1559, back view of the sim, Luang Prabang, Laos

This impressive building, painted in gold and red, is richly decorated with complex carvings, paintings, and mosaics. The roofs are built in the Luang Prabang style, with deep-set gables and "wings" that overlap. The large mosaic on the gable represents the Bo tree, the thong, which gives the temple complex its name (see page 59).

Opposite right, above
Five of the 40 *mudras*, the symbolic attitudes of the Buddha

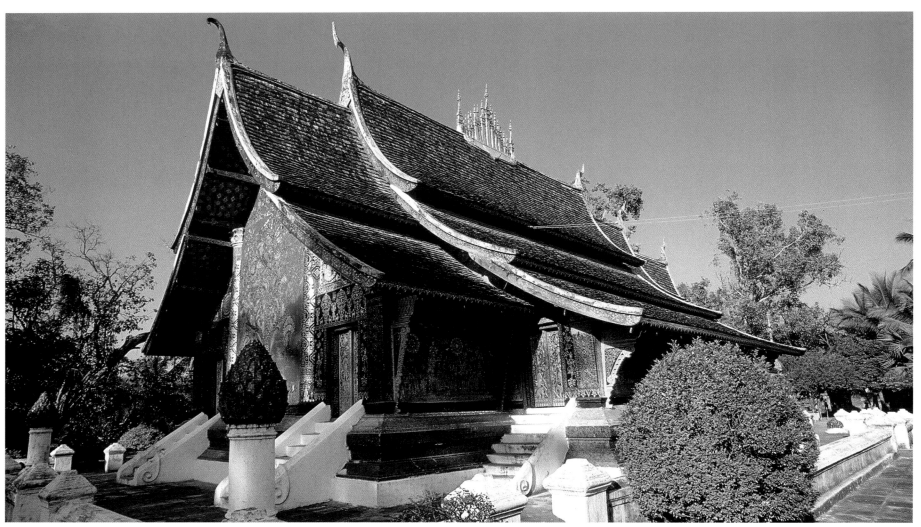

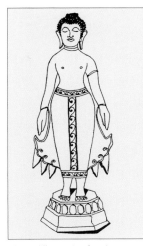

The Buddha praying for rain

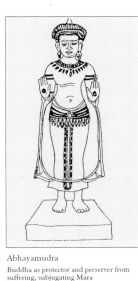

Abhayamudra

Buddha as protector and preserver from suffering, subjugating Mara

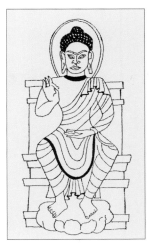

Bhūmisparshamudra

The Buddha calling the earth goddess as witness to his enlightenment and his victory over Mara

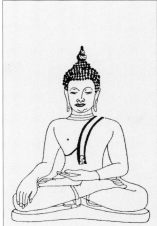

Vitarkamudra

The Buddha setting in motion the "wheel of the Law"

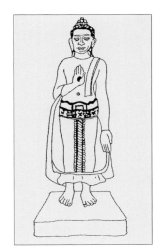

Abhayamudra

The Buddha as protector and preserver from suffering

lasting problem for Laos. Fa Ngoum elevated the city of Luang Prabang to the status of capital in 1353 and declared Theravada Buddhism the state religion. It was from this point onward that an individual Laotian art and culture began to develop. The earliest preserved evidence of architecture, sculpture, and painting, however, dates from the 16th century, since the incursions of the Burmese and the Thai repeatedly resulted in heavy destruction in Laos; the fact that most of the buildings were made of wood, and so subject to rapid decay, increased the losses. Nevertheless, testimony from earlier times has been preserved thanks to reconstructions. As in all other East Asian countries, the art of Laos was largely religious in character. Because of the dominance of powerful neighbors, the kingdom of Laos never developed a culture as independent and sophisticated as that of the Khmer or the Cham (in southern Vietnam), and as a result its art has been neglected by art historians, or else treated as an appendage to Thai art, to which it is closely related: both countries draw from the same artistic sources. Despite this dependency, there was the clear development of an indigenous style, notable for a wealth of ornamentation, for fragile-seeming constructions, and for "high-flying," wing-roofed buildings, a style that flourished above all in Luang Prabang and Vientiane. Moreover, the Laotian Buddha sculptures have in the truest sense of the term very individual "faces:" striking aquiline noses, noticeably large earlobes, and crisp, tightly curled hair. The "Buddha praying for rain," standing with hands pointing to the ground, is a form unmistakably Laotian, and the "Buddha contemplating the tree of enlightenment" is found only in Laos. Similarly, Laotian textiles work shows superb mastery of weaving.

Wat Xieng Thong

1559, Hor Latsalot, burial chapel, Luang Prabang, Laos

The end wall of this chapel is decorated with gilded carvings depicting scenes from the epic the *Ramakien*.

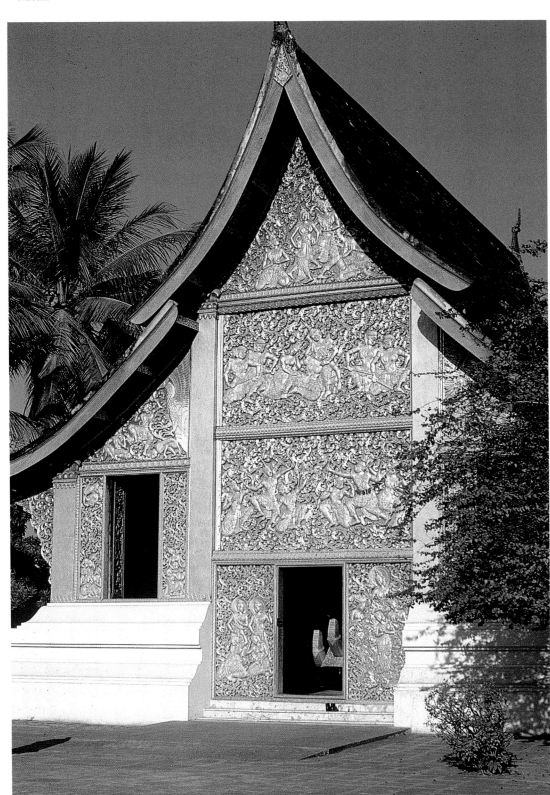

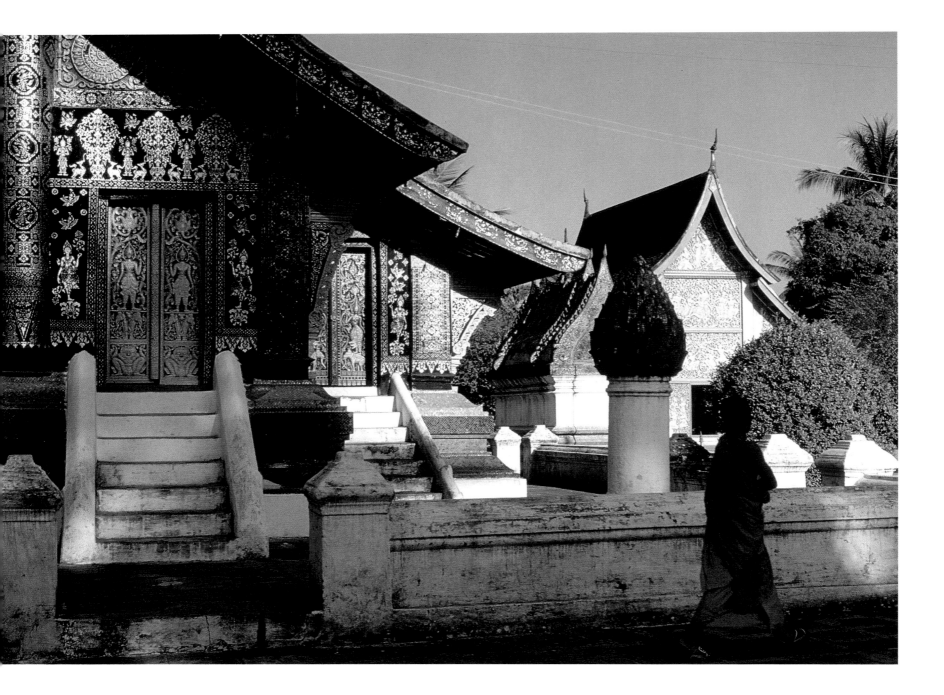

Luang Prabang: Manhattan on the Mekong River

The royal city of Luang Prabang lies in what is known as the Golden Triangle, bounded by mountains, on the upper reaches of the Mekong. Though powerful, its kings were unable to integrate into the state the nearby mountain tribes who had their own tradition and language, a problem which still exists today. According to legend, the place was first inhabited by two hermits and was known by the name of Xieng Thong: the "mulberry tree city." It is also notable that the old name for Luang Prabang was Chawa (Java). Luang Prabang, because of its superb monuments, has been declared a world cultural heritage site by UNESCO.

A graphic description of the city is given by the writer Norman Lewis: "Luang Prabang lies at the end of a long, curling descent from the mountains and through smoking bamboo groves, on the banks of the Mekong. It is built into a tongue of land formed by the confluence with the river of a tributary; a small, somnolent and sanctified Manhattan Island... a tiny Manhattan, but a Manhattan with holy men in yellow robes in its avenues, with pariah dogs, and garlanded pedicarts carrying somnolent Frenchmen nowhere, and doves in its sky. Down at the lower tip, where Wall Street should have been, was a great congestion of monasteries... A main street has turnings down to the river on each side and a pagoda at every few yards, with a glittering roof and doors and pillars carved with a close pattern of gilded and painted designs (see page 61). There is an infallible sense of color, a blending of old gold and turquoise and of many grays; but the bonzes are continually at work, painting and carving and refurbishing, so that everything is just a little too new... The roof finials glisten with new applied glass and china mosaic... For all the briskness

Wat Xieng Thong
1559, entrance arrangement of the sim,
Luang Prabang, Laos

Opposite
Wat Xieng Thong
1559, gable of the sim with the Bo tree,
Luang Prabang, Laos

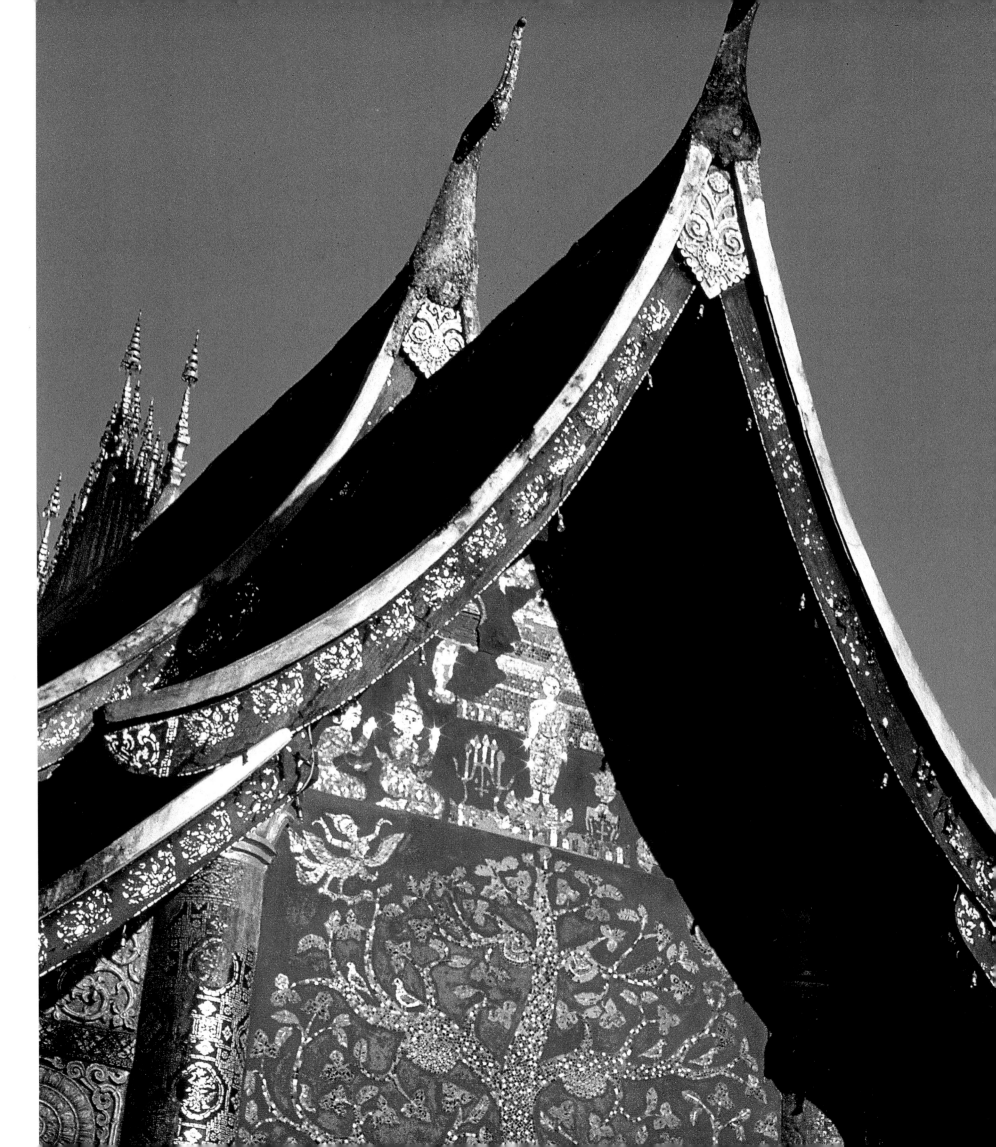

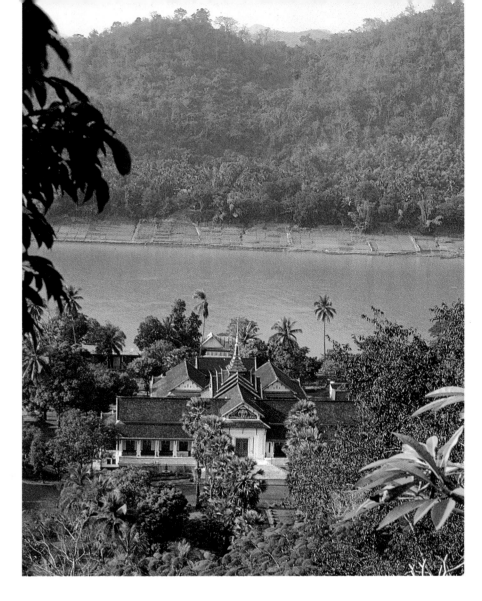

Above left
Royal palace
Begun in 1904, Luang Prabang, Laos

View from Phousi mountain of the royal palace, which is now the National Museum of Laos.

Above right
A "woven house"
At Luang Prabang

The house, made from interwoven palm leaves, stands in a village on the way to the Pak Ou caves.

with which its holy places are maintained, the silence in Luang Prabang is only disturbed by the distant, classroom sounds of bonzes chanting in Pali, and the slow, mild booming of the gongs. It is the home-town of the siesta and the Ultima Thule of all French escapists in the Far East... Several painters have retired here to escape the world, and to produce an occasional tranquil canvas, but Luang Prabang has not yet found a Gauguin."[1]

More than 30 of the former 60 wats of the royal city are intact today, impressive with their sweeping piled-up roofs in the Luang Prabang style, stacked in up to seven layers, which elegantly extend down to the ground (see pages 58 and 59). The upward-sweeping rooftops (called *chao fa*, "princes of the sky"), are meant to act as a trap for evil spirits. Laotian wats are usually separated from the profane outside world by two walls, between which lie the monks' quarters and a bell-tower. The inner wall, which usually takes the form of a gallery, houses in its niches a great number of Buddha sculptures of varying size. The main buildings are the *sim*, the shrine reserved for the monks, and the *vihan*, the assembly hall. In smaller, windowless rooms the holy books of the Pali canon are preserved.

Places of spiritual calm and golden shimmer: the wat and *that*

The most important wat in Luang Prabang, Wat Xieng Thong, was begun in 1559 by King Setthathirat (crowned 1548). Lying high above the Mekong, this wat is a prototype of the local style (see pages 56–57, 58–59). The back of the *sim* is decorated with a glass mosaic that depicts the Bo (mulberry) tree that, known as a *thong*, gave its name to the temple complex (see page 59). Eight richly decorated columns support the beams of the single-chamber building, which is decorated with murals and texts expounding the *dharma* (eternal teaching of the Buddha). On the set-back outer wall of the library is a red-ground mosaic that was put in place in 1957 in honor of the 2,500th anniversary of the birth of the Buddha. The images tell the stories of events in the daily life of the people. Set diagonally to the *sim* is a chapel in which the 12-meter (40-feet) high gilded funeral hearse of King Sisavang Vong of 1959, and a range of other funeral accessories, are now displayed. Gigantic, gilded wood panels with scenes from the *Ramakien*, the epic of Rama, adorn the outer walls of the chapel (see page 57, bottom).

Wat Mai, the "new monastery," formerly Wat Souvanna Phommaram, was until 1947 the seat of the Buddhist spiritual leader in Laos, Phra

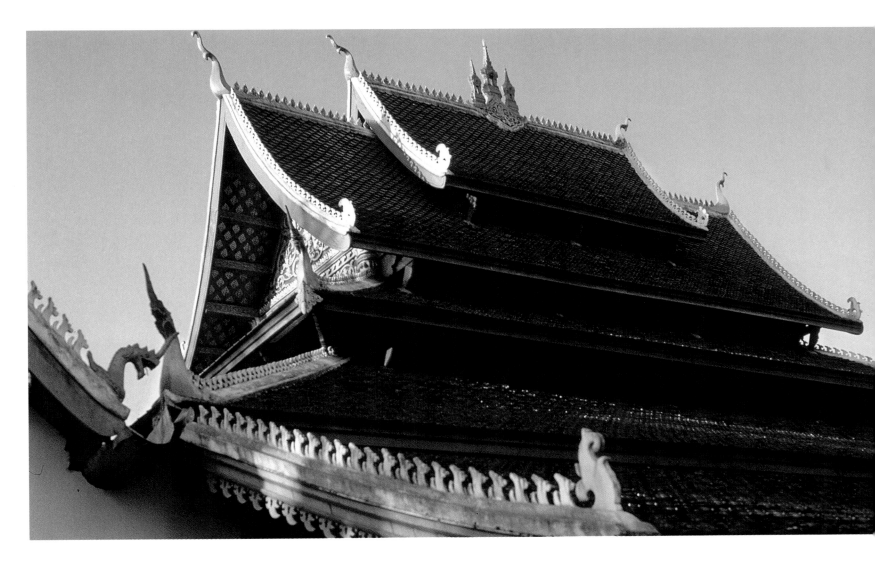

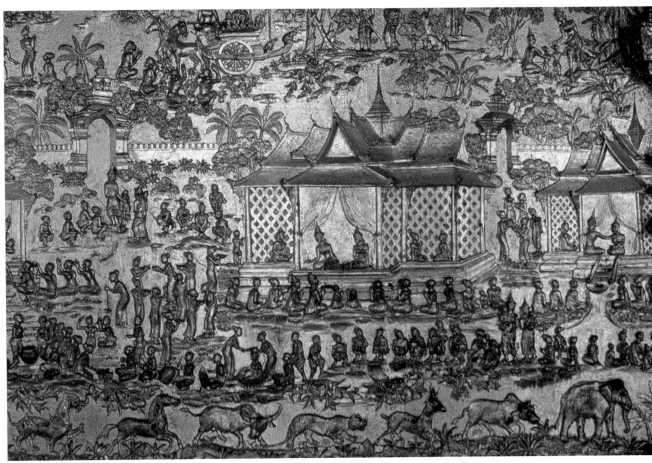

Above
Roofs at Wat Mai
about 1790, Luang Prabang, Laos

The roof construction demonstrates a particularly impressive variation of the Luang Prabang style, with a fivefold series of roof layers.

Left
Gilded bas-relief illustrating the story of Phravet
about 1790, Wat Mai, Luang Prabang, Laos

Officially the temple was called Wat Souvanna Phommaram and was the residence of the Buddhist religious leader in Laos, Phra Sangkharath. On the façade is a monumental bas-relief, which tells the story of Phravet (one of the last reincarnations of Gautama Buddha). The relief is particularly interesting because it shows scenes of everyday village life.

That Makmo

1504, the "melon temple," Luang Prabang, Laos

The That Makmo was built by Queen Visounalat, the consort of King Visunarat (1500–1520), and shows strong Ceylonese influence.

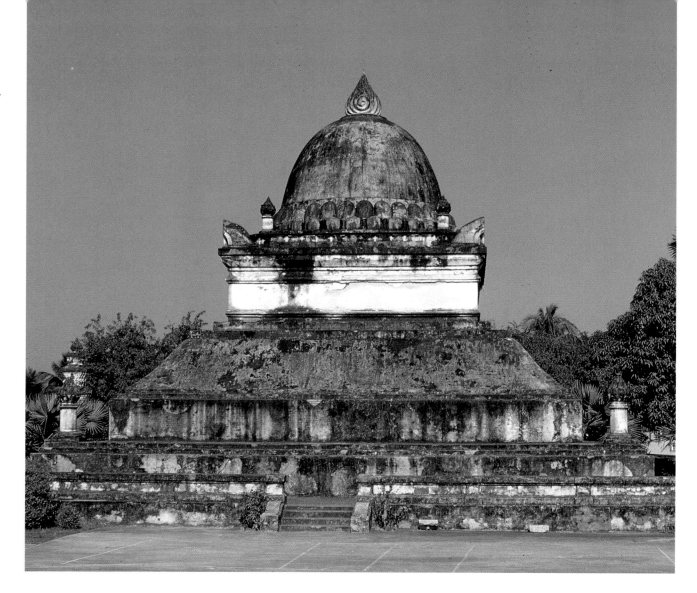

Opposite, left
Wat Visunnarat

Built 1513, rebuilt 1898, Luang Prabang, Laos

Wat Visunnarat was destroyed by marauding Chinese tribes, probably during the 18th century.

Far left and opposite, top right
Cave with Buddha statues

Discovered 16th century, Pak Ou caves at Luang Prabang, Laos

At Pak Ou, presumed to have been discovered by King Setthathirat (crowned 1548), there are two sacred caves filled with thousands of gilded Buddhas.

Left
The Buddha as protector

Wood, Pak Ou caves at Luang Prabang, discovered 16th century, Laos

The attitude of the hands shows Buddha as protector and preserver from suffering.

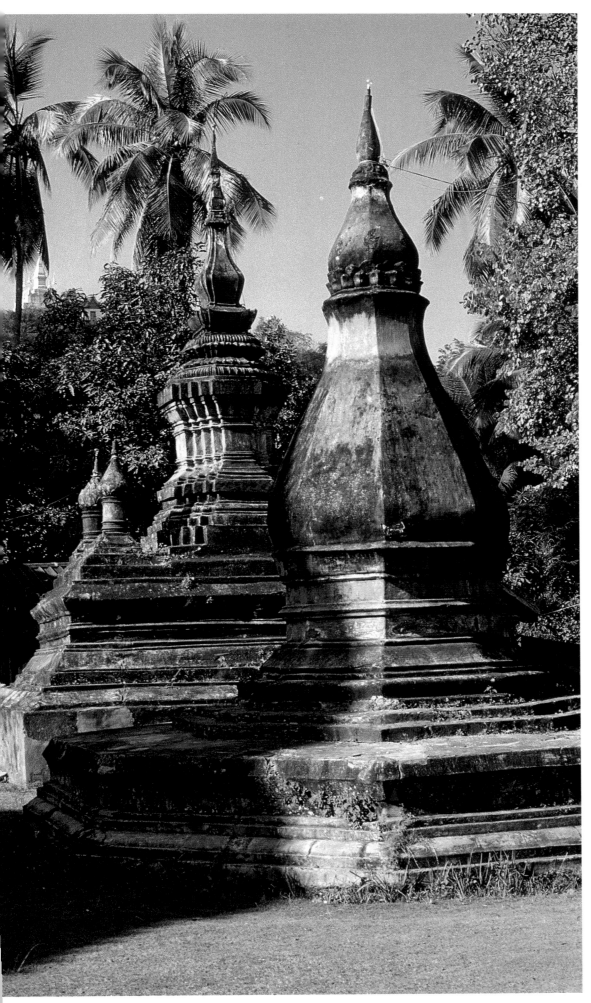

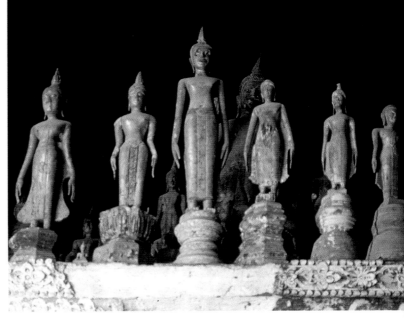

Sangkharath (see page 61). Planned as early as 1790, and begun in 1796, the wat became, in accordance with the wishes of King Anourouth, the most splendid temple of the kingdom. The fivefold roof is a jewel among the fine roofs of Luang Prabang. On the façade is an enormous golden bas-relief that relates the story of Phravet (one of the last reincarnations of Gautama Buddha) in a series of village scenes (see page 61, bottom).

At the foot of the mountain of Phousi lies the royal palace (see page 60, left); though of recent date (1904) the palace is built in the Khmer style, on a four-story platform and cross-shaped ground plan. Today this rather modest structure houses the national museum.

Place of pilgrimage in the mountains: the holy caves of Pak Ou

The greatest concentration of Buddha figures is to be admired in the caves of Pak Ou (see opposite, bottom, far left and above, right). These caves, situated far up the Mekong river, are hidden away in bizarre mountain formations; according to legend, they were the seat of the holy guardians and were discovered in the 16th century by King Setthathirat; in earlier times they were inhabited by monks. Tham Thing, the lower, and Tham Phum, the upper cave, are the caves that should be visited. Thousands of Buddha figures, wooden or gilded, rub shoulders along the walls of the rock. Some are over 300 years old and are gifts from pilgrims and the faithful. Both sophisticated works and naive carvings provide the visitor with a "nature trail" of the *mudras*, the 40 different "attitudes" of Buddha. One of the most frequent poses is the *abhayamudra*, which shows the Enlightened One as protector and preserver from suffering. The standing or seated figure has his right hand (or both hands) raised, with elbows bent, and the

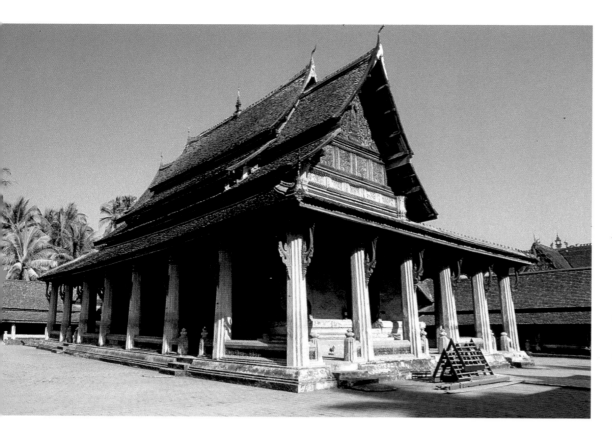

Wat Sri Saket

*1818, view of the main shrine,
Vientiane, Laos*

Wat Sri Saket was built during the reign of
King Anou and is the oldest preserved
building in Vientiane. The roof structure
shows great similarities to those of the
Thai temples that had impressed King
Anou on a visit to Bangkok. Possibly this
wat escaped destruction by the Thai
because of this similarity to Thai temples.

palms turned outward (see page 62, bottom right).
In the caves one also frequently encounters the
"Buddha praying for rain," typical of the Lao.

An architectural form peculiar to Laos is the
that, which represent a variation of the stupa, in
particular those of Sukhotay. Bell-shaped or dome-
shaped, the *that* is crowned by a tall, arrow-shaped
structure and has a stepped base. The form with an
onion-shaped cap is also pure Laotian in style.

The most original *that* in Luang Prabang is
That Makmo (see page 62, top), built in 1504 by
Queen Visounalat, the consort of King Visunarat
(1500–1520). It was given the name of Makmo
(the "melon stupa") because of the distinctive
shape of its dome. The architecture shows
Ceylonese influence, with a smaller stupa at each
of the four corners of the base of the structure
to symbolize the four elements. That Makmo is
part of the complex of the Wat Visunnarat (see
page 63), which was destroyed by marauding
Chinese tribes. The original complex of 1513 was
rebuilt in 1898 and is today a museum.

Vientiane: the "city of the moon"

King Setthathirat made Vientiane the capital city
of his kingdom as early as 1563. Here, at the
middle of the course of the Mekong, the Khmer
lived up to the 14th century. Vieng Chan, which
means "fortified city of the moon," a small,
protected city, which thanks to the fertile areas
surrounding it and the trade along the Mekong
was extremely prosperous, survived unscathed
until 1827, when it was it was plundered by the
Thais. The city remained abandoned for decades

and in 1860 the French found only ruins over-
grown by the jungle and a little fishing village in
the place of the shining "city of the moon."

In the year of its rediscovery, the French naval
officer Francis Garnier described finding just "a
head of ruins" and after surveying the site observed
that "the absolute silence reigning within the
precincts of a city formerly so rich and populous,
was... much more impressive than any of its
monuments."[2] At the end of the 19th century
the colonial masters reconstructed the temple
complexes, interspersing them with sumptuous
fin-de-siècle villas and wide boulevards, turning
the ruined city into their capital, Vientiane.

The date of foundation of most of the temples,
monasteries, and stupas in Vientiane goes back to
the beginnings of the capital of Lan Xang, but only
a few originals have been preserved. Wat Sri Saket,
built as late as 1818 under King Anou, is the oldest
monastery in Vientiane, and at the same time one
of the most important.

The complex follows the structure of a Laotian
wat, with a surrounding wall that has a gallery
running around its inner side. Here there are 120
large Buddha figures in the *bhūmisparshamudra*
pose: the right hand rests on the right knee, with
the fingertips pointing downwards, while the left
hand rests in the lap, palm upwards. Buddha is
calling the earth goddess as witness to his enlight-
enment and his victory over Mara, the king of the
demons (see opposite, top). Altogether, Wat Sri
Saket possesses 6,840 Buddha statues, many of
them housed in the wall niches of the gallery. Most
date from the 16th to 19th centuries and were
gathered together from temple complexes in the
city and from Luang Prabang. There are figures of
stone, bronze, and wood, ranging from work of
very high quality to naive pieces made in the
surrounding villages. The *sim* holds 2,052 Buddha
statues, mainly in terracotta. The veranda that
goes around it is supported by skillfully worked
columns with lotus capitals (see opposite, bottom).
Little is preserved of the wall paintings in the Thai
style, which depict stones of the life of the Buddha.
The ceiling, decorated with a flower pattern,
shows Ayuthaya influence. Presumably Wat Sri
Saket was spared during the Siamese attack
because of its similarity to Thai temples. At the
back of the *sim* is a gigantic tub in the form of a
nāga (mythical serpent), which is used for the
ritual washing of the Buddha statues and is a
reminder of the mythical origins of the city.

The *hor trai* (library) of the wat has a *pyathat*
(Burmese tower with five or seven roofs), and once
housed the Pali Buddhist canon, until this too was
carried off to Bangkok (see page 66, right).

Directly opposite Sri Saket lies the Wat Pra
Keo, which has been converted to a museum. It
was never used as a monastery; it was used as a
royal prayer-hall. King Setthathirat had it built in
1565 as a temple for the Emerald Buddha, which
he brought to Laos from Chiang Mai, where he
had ruled as king. In 1778 the Thai stole the

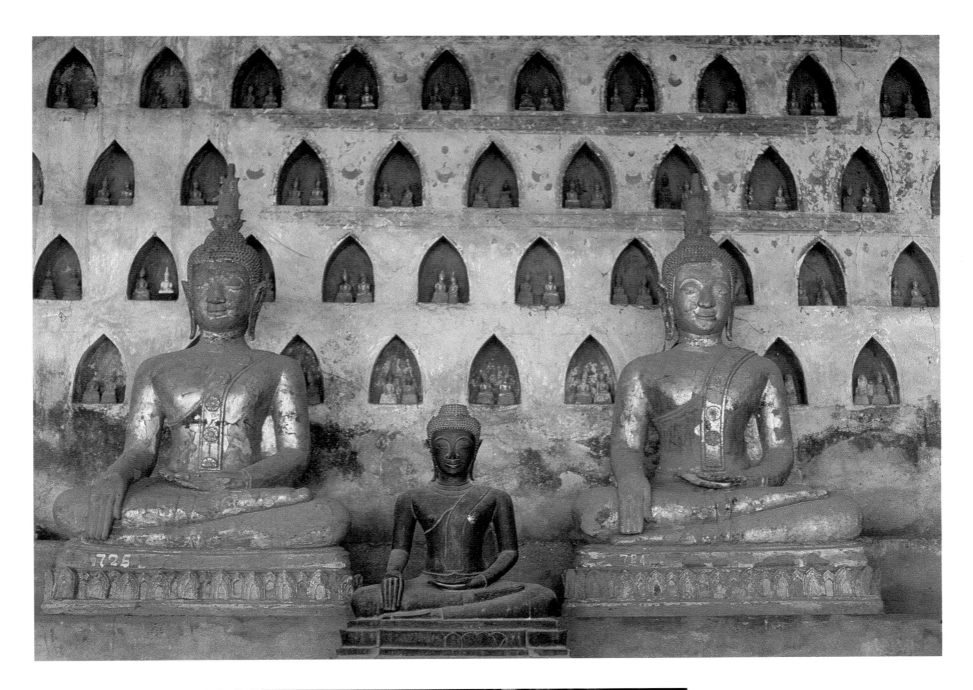

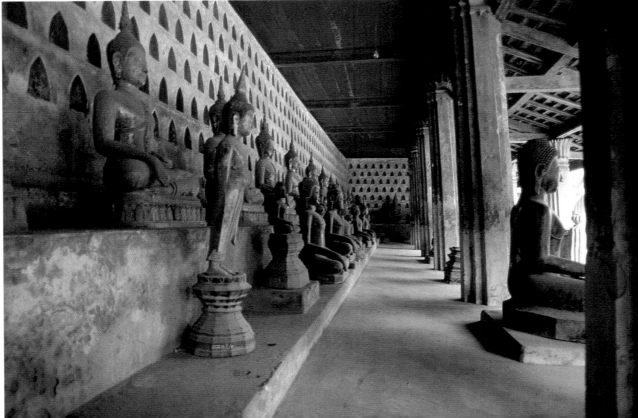

Wat Sri Saket

1818, niches with Buddha statues,
Vientiane, Laos

In the *sim* (main shrine and ordination
hall in a Lao temple complex) of this wat
there are thousands of Buddha statues in
little niches, mainly of terracotta, bronze,
and wood. The position of the hands and
long figures show the Buddha calling the
earth goddess as a witness to his
enlightenment.

Left
Wat Sri Saket

1818, veranda with Buddha statues in
niches, Vientiane, Laos

It is typical that the niches in which the
Buddha figures stand set into the upper
half of the wall.

Buddhist treasure and for their part built an impressive complex in Bangkok, Wat Pra Keo (see page 45). Staircases flanked by *nāgas* and dragons lead through three galleries to the main shrine.

Of the original parts, the doors of the *sim* are still preserved, and they form an outstanding example of the superb wood carving in Laos; Buddhas are shown surrounded by birds and flowers. A number of Khmer Buddha statues are found within the building, the only part of the once large-scale complex, which was reconstructed in 1940–1950. Equally outstanding craftsmanship is found in the wood-carvings of the Wat Ong Tu,

which was built about 1570, destroyed in 1828, and reconstructed in the 19th century (see opposite, bottom). Doors and windows are adorned with stories from the epic the *Ramakien*. The wat is famous for its *dok sofa* (bouquet of flowers), a fan-like carved decoration on the gable; the ten different flowers show that the Wat Ong Tu was built by a king. Ong Tu means "heavy Buddha," and refers to a one-tonne statue within the temple, one of the largest and oldest in Vientiane.

Wat In Peng, which possesses frescoes in the popular style with pictures from the *Ramakien*, was reconstructed in 1940 (see opposite, top).

Below, top left
Wat Pra Keo
Built 1565, reconstructed 1940–1950, entrance hall to the former royal prayer hall, today a museum, Vientiane, Laos

Wat Pra Keo was built by King Setthathirat (crowned 1548), to house the Emerald Buddha or Pra Keo, which is now in Bangkok. The king brought the Buddha from Chiang Mai (Thailand), where he had earlier been ruler. The Emerald Buddha was stolen by the Thais in 1778 and Wat Pra Keo was destroyed during the plundering of Vientiane in 1827.

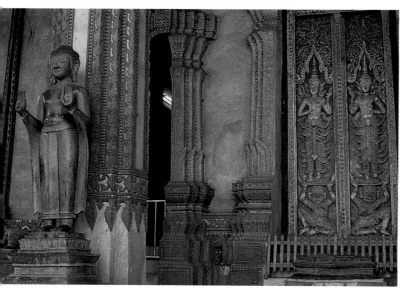

Wat Pra Keo
(Detail), 1565, dragon at the staircase leading up to the entrance hall, Vientiane, Laos

Right
Wat Sri Saket
1818, hor trai, a Burmese style library, Vientiane, Laos

The extensive, paneled space of this building was formerly used to house important Buddhist manuscripts.

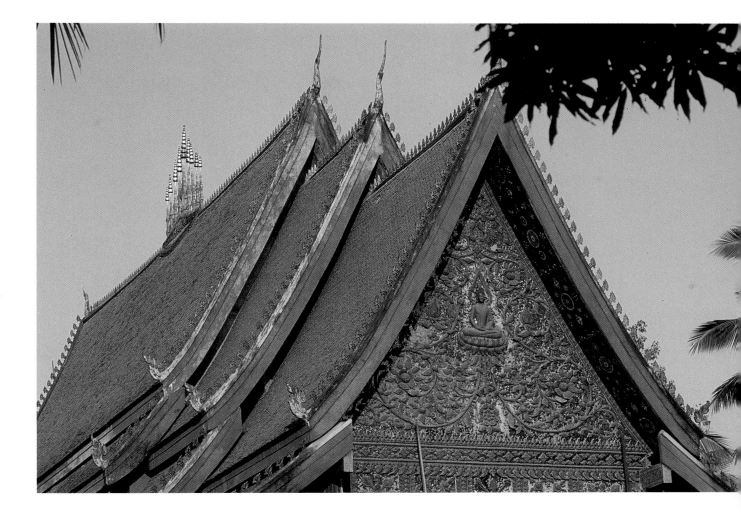

Left
Wat Ong Tu

*Built about 1570, destroyed 1828,
reconstructed in the 19th century, general
view of the monastery, Vientiane, Laos*

This monastery is the seat of the second
patriarchate of the country and houses
some 300 monks. The Buddha statue in
the temple is one of the three oldest in
the country.

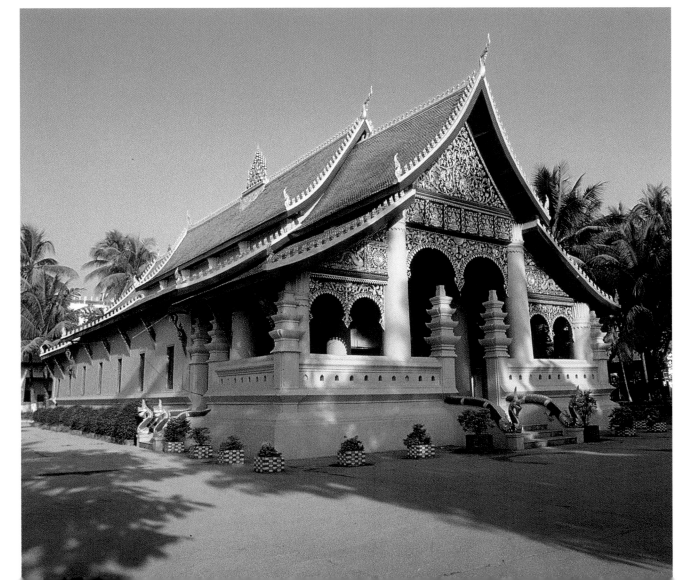

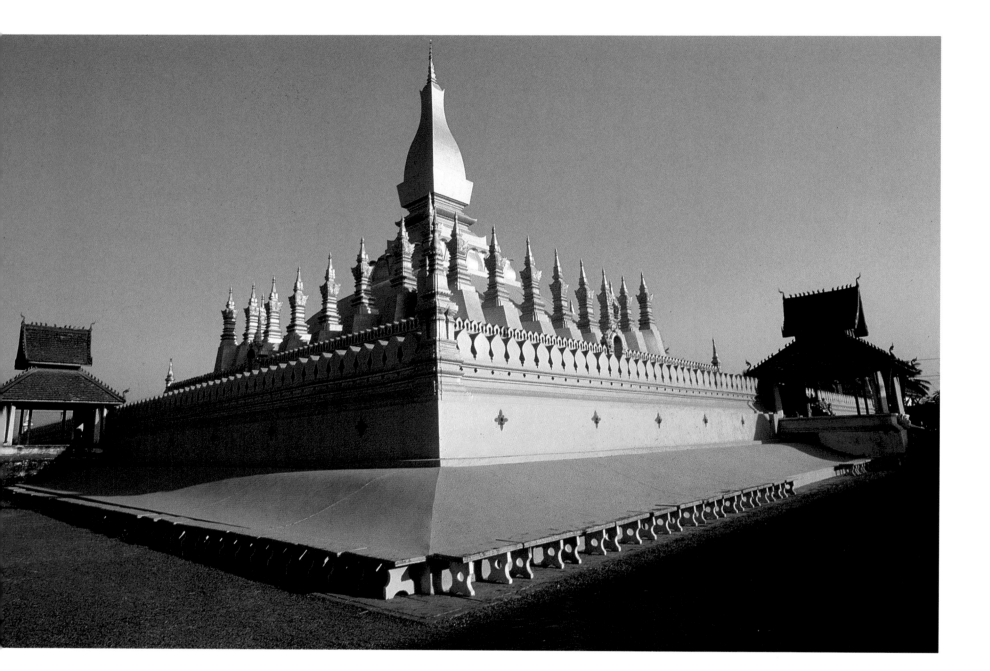

That Luang: the "golden lotus bud"

The symbol of Vientiane, and of the country's independence, is the That Luang. This magnificent golden stupa is situated on a hill to the northwest, its gleaming summit, looking rather like a modern sculpture, standing proudly over the city – and, as a national symbol, over the whole of Laos. According to tradition, the That Luang was built over an existing chamber of relics of the 3rd century, but after excavations were carried out, only the remains of a much later Khmer temple were found. The architecture of the original That Luang goes back to the shrine built by King Setthathirat in 1566, which fell victim to the mania for destruction visited upon the city by both the Thai and the Chinese. King Anou set in motion the work of renovation as early as the beginning of the 19th century and added the monasteries that belonged to it, as well as pavilions in the Burmese style. Careful restoration work was carried out

around 1900 by the École Française d'Extrême Orient, which also restored parts of Angkor.

The foundations of the *that* are a combination of Khmer, Lao, and Ceylonese influences; a surrounding gallery was added early in the 19th century. The first terrace of the stupa, measuring 69 by 69 meters (226 feet), is furnished at each wing with a *hor way*, a roofed temple of sacrifice (see opposite, top). The second terrace measures 48 by 48 meters (158 feet) and is enclosed by lotus leaves; on its base stand 33 smaller stupas; before being plundered, each of these stupas guarded a further shrine made of pure gold. This series of terraces serves as a processional way that symbolizes the path to spiritual enlightenment. The third and last terrace is reached through semicircular prayer gates, and on it there rises the crown of the shrine, similar to a lotus bud which, framed by its leaves, stands clearly outlined on the sky.

Above
That Luang

1566, destroyed 1828, reconstructed about 1900, general view, Vientiane, Laos

This astonishing temple, originally built by King Setthathirat (crowned 1548), overlooks the city of Vientiane.

Opposite, above
That Luang

1566, destroyed 1828, reconstructed about 1900, main entrance, Vientiane, Laos

The 30-meter (98.5-feet) tall tower peak resembles an extended lotus bud crowned by a banana flower.

Opposite, bottom
Lotus leaves

1566, destroyed 1828, reconstructed about 1900, That Luang, Vientiane, Laos

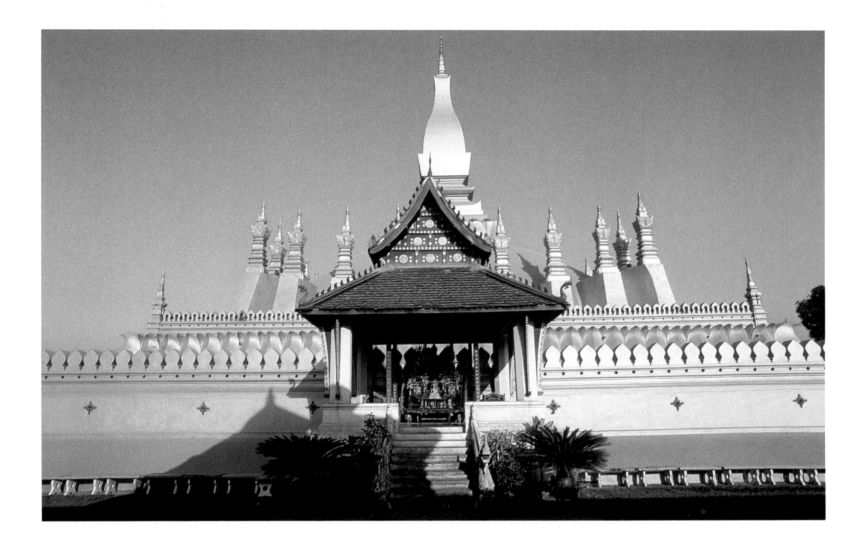

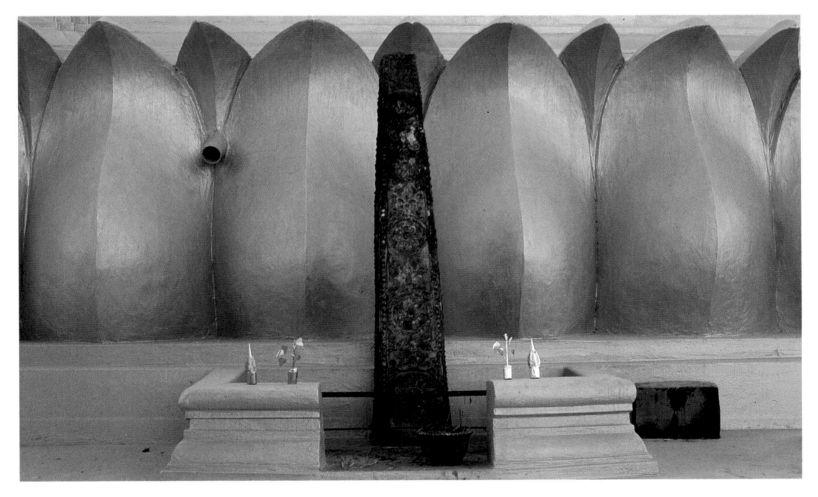

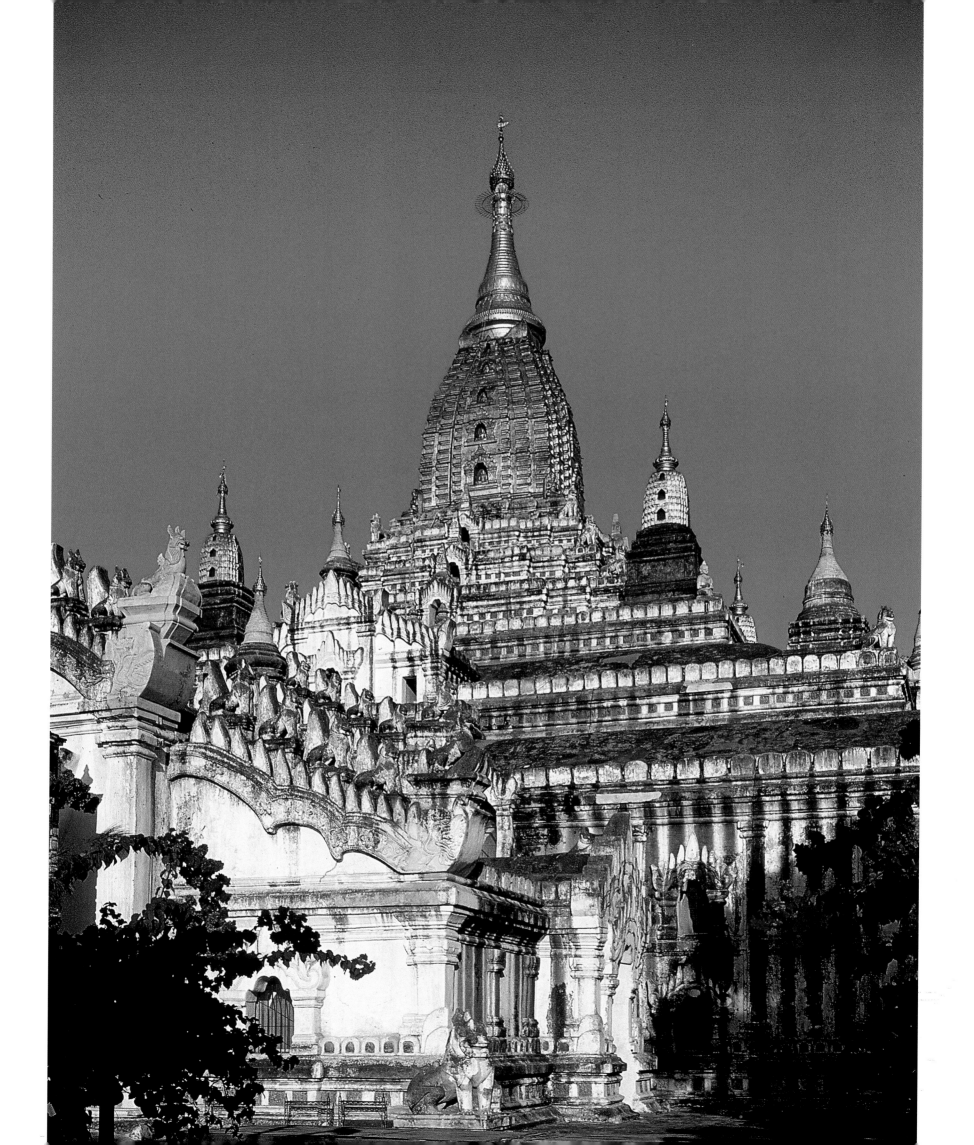

Burma

The magic of Burma captivates all visitors; few don't feel the poignancy of leaving behind the brilliance and enchantment of a country of countless temples and shrines, a country where the past is still very much alive. A journey along the 2,000 kilometers of the Irrawaddy river, Burma's vital line of trade and communication, reveals an incomparable range of astonishing architecture, with one temple or palace complex after another lining its banks, along which the ancient cities of Sri Ksetra, Pagan, Mandalay, and Rangoon stand — it is a journey into the history and the soul of Burma. And the enchantment is not merely that of the astonishing architecture, but also that created by the ever-changing moods and subtle colors: the peaks of the pagodas seem to float above the early mists; the temples shimmer gold and white in the evening light; and the robes of the monks display endless variations of bright yellows, the rice fields endless variations of subtle greens… colors superbly captured in the longyi, the Burmese sarong, which captures all the delicate shades of the landscape.

Ananda temple

1091, inner courtyard, Pagan, Burma

Ananda was the cousin and favorite disciple of the Buddha. This astonishing temple dedicated to him, begun by King Anawrahta (1044–1077) and completed by King Kyanzittha (1084–1113), inspired the temple architecture of many subsequent Burmese kings.

Pagan: Splendour of the Pagodas on the Irrawaddy

Before the Burmese dynasty unfolded in the culture of Pagan, the Pyu people were rulers in the fortified capital of Sri Ksetra (near present-day Prome), between the 5th and the late 9th centuries A.D. Finds from this era, mostly terracotta plaques, are rare, and tradition is fragmentary. It is believed that Sri Ksetra was conquered by the Chinese province of Yunnan, and the Pyu enslaved. Other groups, such as the Mon of Suvannabhumi in southern Burma, as well as the Dvaravati-Mon, later developed their own forms of artistic expression, above all in life-size sculptures of the Buddha, before becoming totally absorbed into the Burmese civilization. The decisive contribution of the Mon to the cultural history of Burma was in their promulgation of Theravada Buddhism.

Pagan was founded in 849 on the banks of a sheltered bend in the river Irrawaddy. The reasons for choosing that place were not only strategic (it was an ideal site on which to develop a trading center), but also religious – it was near the mountain of Popa, the center of a Burmese devotion to the *nats* (spirits). Pagan was the capital city of Burma for over 230 years (11th–13th centuries). Its story begins with King Anawrahta (1044–1077), who united the country and made Theravada Buddhism the state religion – previously a combination of Mahayana Buddhism and Brahmanism had been practiced. The splendour of Pagan ended abruptly with its annexation by Kublai Khan in 1287, and the city was abandoned as a result. During Pagan's brief life this plain bordered by the Irrawaddy saw the creation of some 30,000 temples, pagodas, and stupas; 2,217 of these buildings have survived invasion, earthquake, heat, and disrepair; 2,000 have survived as extensive ruins (see pages 74–75). "At any rate they [the kings of Pagan] began between the 11th and 13th centuries to build the temples and stupas which now lie on the plain like stranded Titanics. Their metropolis of Pagan no longer exists. […] Anyone who wishes to visit the dead city must go by horse and cart, and this is how we get there, seated on straw bales, our legs bent into strategic question marks, the blaze of the sun in our faces. Only twice have I experienced anything comparable, in Persepolis and in Ayuthaya, a plain full of ruins, the very bones of a vanished existence."[1]

For the devout Buddhist, one of the paths to Nirvana is to build a temple or a stupa; clearly the kings, noblemen, and monks of Pagan became obsessed by this idea and created thousands of monuments to immortality in brick and stucco. Of their secular buildings, made of wood, only traces are to be found. Thanks to this building craze, we can now follow the development of Burmese architectural styles very clearly in a single place – from the early Mon buildings and Indian-inspired forms, to the classical Burmese stupas. These are the historical and art-historical facts; but the magic of Pagan can be described only by someone with a

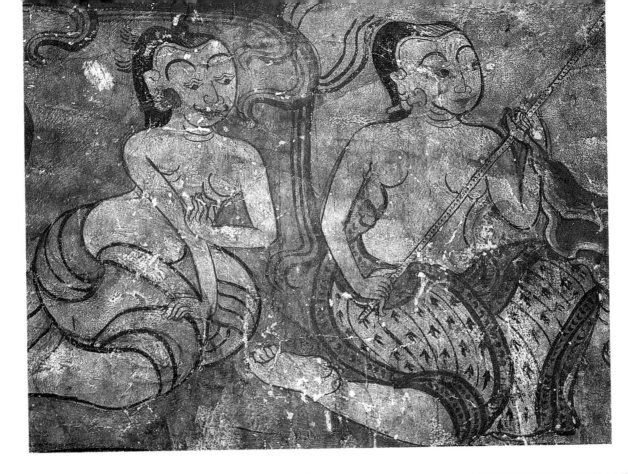

Opposite, left
Dhammayangyi temple

About 1164, view through arch,
Pagan, Burma

The Dhammayangyi temple is related in
its design to the famous Ananda temple.
It was begun by King Alaungsithu (1113–
1169) and continued by his son, Narathu
(1169–1174), who hoped to improve his
karma by building this huge complex.

Right
Ananda Okkyaung

Wall painting, scenes from the jataka,
1774–1778, monastery of the Ananda
temple, Pagan, Burma

Below
Upali Thein-Sima

1st half of 13th century, wall painting,
scenes from the lives of the Bodhisattvas,
about 1794/95, inner eastern wall,
ordination hall, Pagan, Burma

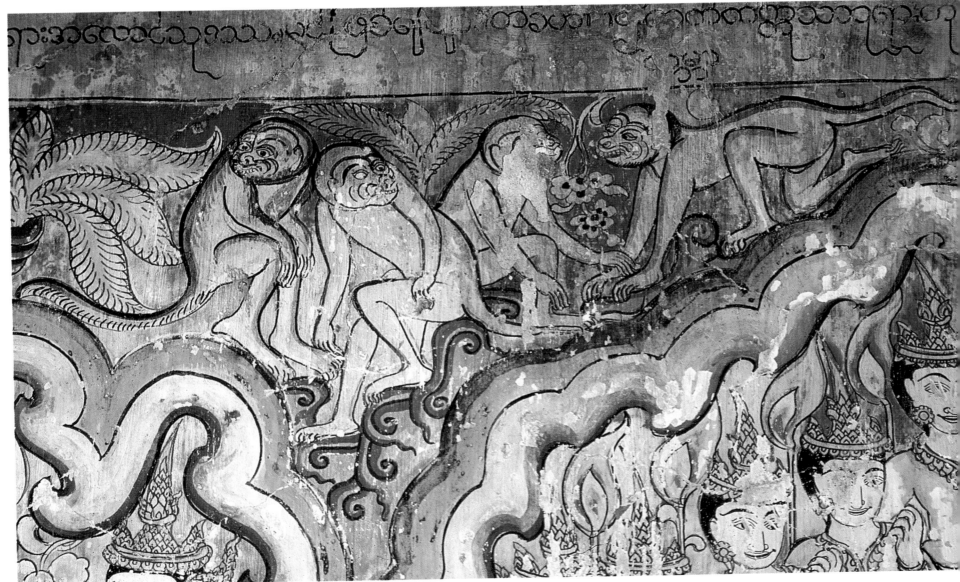

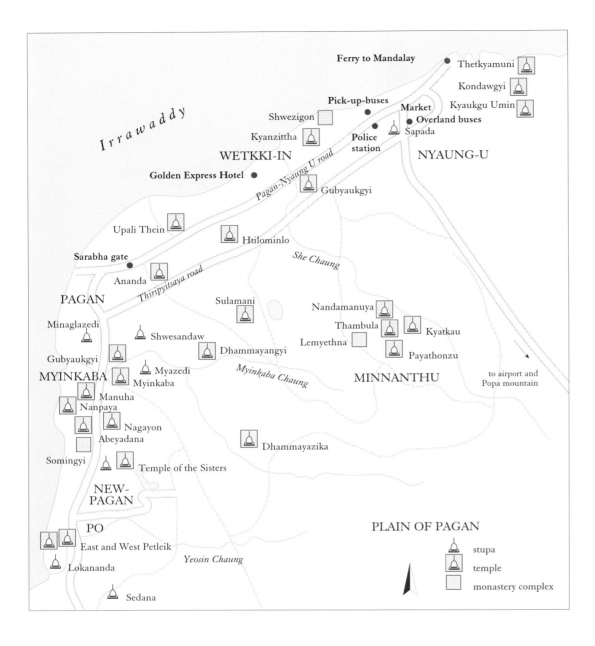

Irrawaddy

Ferry to Mandalay

Thetkyamuni

Pick-up-buses

Kondawgyi

Shwezigon

Market

Kyaukgu Umin

Kyanzittha

Overland buses

WETKKI-IN

Police station

Sapada

NYAUNG-U

Pagan-Nyaung U road

Golden Express Hotel

Gubyaukgyi

Upali Thein

She Chaung

Htilominlo

Sarabha gate

Thiripyitsaya road

Ananda

PAGAN

Sulamani

Nandamanuya

Minaglazedi

Thambula

Kyatkau

Shwesandaw

Lemyethna

Gubyaukgyi

Dhammayangyi

Payathonzu

Myazedi

MYINKABA

Myinkaba Chaung

MINNANTHU

Myinkaba

to airport and
Popa mountain

Manuha

Nanpaya

Nagayon

Abeyadana

Dhammayazika

Somingyi

Temple of the Sisters

NEW-
PAGAN

PLAIN OF PAGAN

PO

East and West Petleik

Yeosin Chaung

stupa

Lokananda

temple

monastery complex

Sedana

touch of the poet: "Pagan [is] in many respects the most extraordinary religious city of the world. Jerusalem, Rome, Kiev, Benares, none has such a great number of temples, with such an extravagant multiplicity of forms and ornamentation, as this wonderful, abandoned capital city on the Irrawaddy. […] The whole surface is densely packed with pagodas of every shape and size, and even the ground is covered with remains of vanished temples, so that, according to the vernacular, one can move neither hand nor foot without touching a consecrated object."[2]

The origin and stylistic history of the pagodas of Pagan (in Burma pagoda is the term applied to the whole temple complex) can be divided into three periods: the Early period, about 850 to 1120, the monarchs important architecturally being King Anawrahta (1044–1077) and King Kyanzittha (1084–1113); the Middle period, about 1120 to 1170, under King Alaungsithu (1113–1169) and King Narathu (1169–1174); and the Late period, about 1174 to 1300, including the royal patrons of architects Narapatisithu II (1174–1211), Htilominlo

Gawdawpalin pagoda

About 1200, Pagan, Burma

A photograph of Pagan at dawn. The Gawdawpalin pagoda is on the left in the foreground, the Ananda temple in the background on the right.

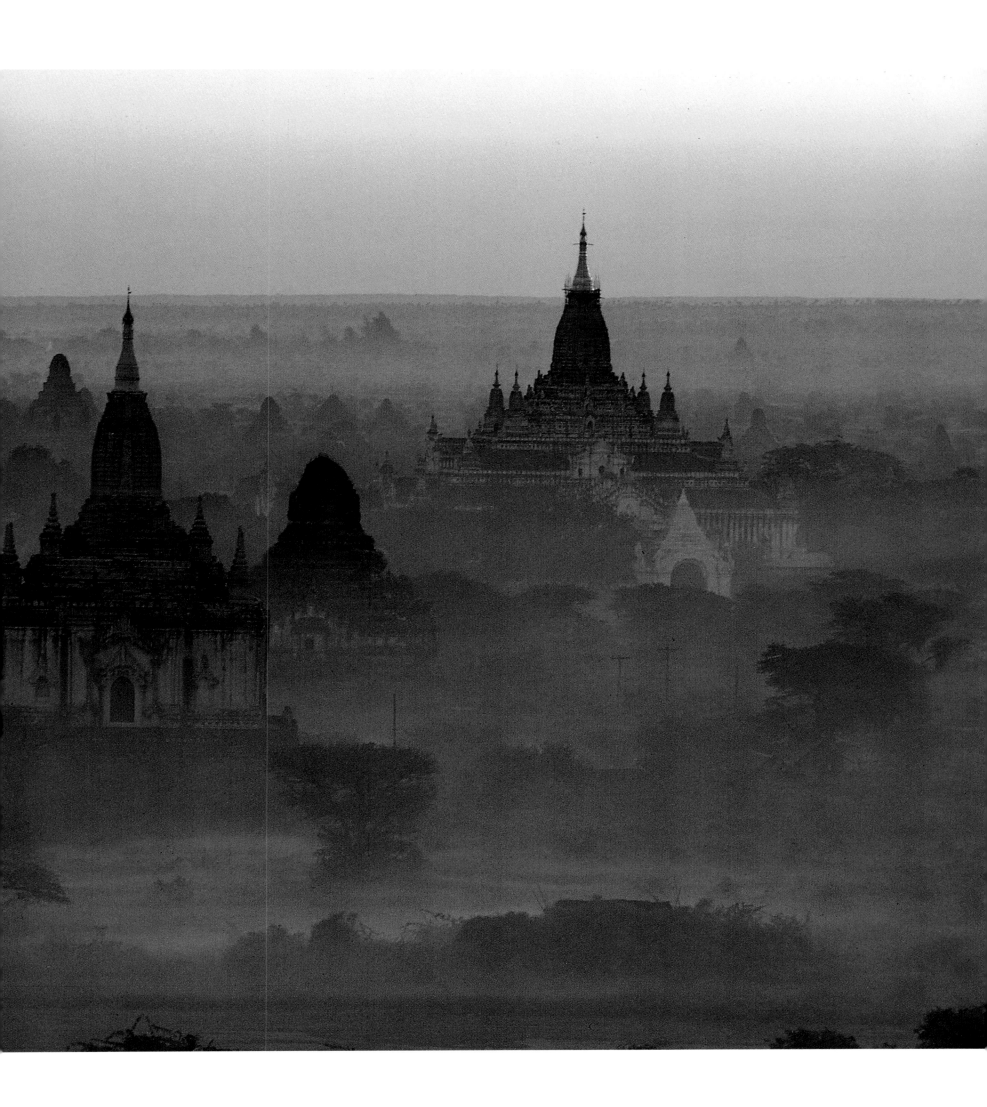

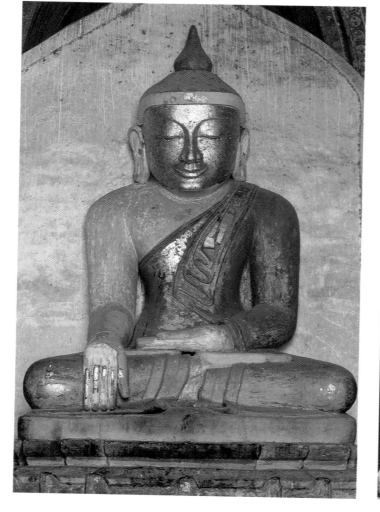

Below
Buddha figure

*Stucco, painted, Dhammayangyi temple,
Pagan, Burma*

Bodhi trees

*Metalwork, Shwezigon pagoda,
Pagan, Burma*

These ornate metal trees represent the
bodhi tree under which the Buddha was
sitting when he achieved enlightenment.

(1211–1234), and Narathihapati (1248–1287). The domes of the stupas in Pagan gradually taper from the massive semicircular form of the Early period into slender, elongated structures, mostly on rectangular, later pentagonal, bases (see page 78, left). The columns and plinths of the terraces became steadily more detailed and extravagant. The sacred structure that houses the image of Buddha is derived from the form of the stupa and possesses only one entrance, usually a vaulted chapel. From the early, simple shape of a central chamber the temples develop into elaborate, multi-chambered complexes with corridors and, not infrequently, their own monasteries. The stucco decoration of the façade, the cornices, the arches, and the pillars becomes heightened into a positively flamboyant decorative scheme; and the inner rooms become covered with wall paintings and lit by openwork windows.

The Ananda temple (see page 70), begun by King Anawrahta and completed by King Kyanzittha, with its white *sikhara* (pointed tower), is a masterpiece of Mon architecture: "In the... Ananda-paya the entrance door leads directly to

Shwezigon pagoda

About 1060, Pagan, Burma

The Shwezigon pagoda is the largest temple from the period of King Anawrahta's reign (1044–1077). According to legend, a holy relic of the Buddha was loaded on to the back of a white elephant at the command of the king. The pagoda marks the spot where the elephant knelt down on the river bank (Shwezigon means "golden stupa on the sandbank"). This is one of the most important pagodas in Burma, since it is reputed to house the Buddha's collar-bone, part of his skull, and one tooth.

the recess in which stands the colossal image of Ananda. The high vaulted passages in which the reciting of the evening services re-echo with wonderful solemnity, cross each other, and everywhere niches cut into the walls contain a great multiplicity of different figures. [...] The Ananda temple was built by an architect who descended from heaven, though skeptics have seen it differently. The king once engaged an architect who disappeared as soon as he had been paid his advance, and he was therefore referred to as Pyan-Panja-tama, the 'fleeing architect.'"[3]

The four great porticos give the temple the outline of a Greek cross. Above six terraces and the roof, which is decorated with 389 green-glazed terracotta tiles, the tower rises up, accompanied by four smaller stupas at its sides. The inner and outer walls of the corridors are interspersed with niches that accommodate 1,424 statues of the Buddha. In the complex of the Ananda pagoda is a monastery with superbly preserved 18th-century wall paintings depicting both *jataka*, scenes from the life of the Buddha, and the history of Pagan (see page 73). The Ngakywenadaung pagoda with

its massive, cylindrical stupa is dated to a pre-Anawrahta period, the 10th century, its appearance reminiscent of early Aztec temples. Normally the stupa is designed in a bell shape, with set-back terraces, and is crowned with a conical peak. The Bupaya stupa (built from 162 to 243, according to legend) and the Ngakywenadaung stupa, on the other hand, both have bulbous, elongated towers, in contrast to the tall, "spinning-top" structures more usual in Pagan (see page 79). The Mon king Manuha of Thaton, who was taken prisoner by King Anawrahta, built the Manuha temple in 1059. He hoped in this way to improve his fate, and sold his last jewels to finance the building work. At the back of the shrine within the stupa there is a recumbent Buddha and also several seated Buddha figures, crammed into narrow spaces, a symbol of the king's imprisonment (see page 80, bottom). The upper stories of the temple fell victim to the earthquake that struck Pagan in 1975.

The Shwezigon pagoda, built about 1060 by King Anawrahta as the main center of Theravada Buddhism, is today still the chief reliquary shrine of Burma. King Kyanzittha completed the work in

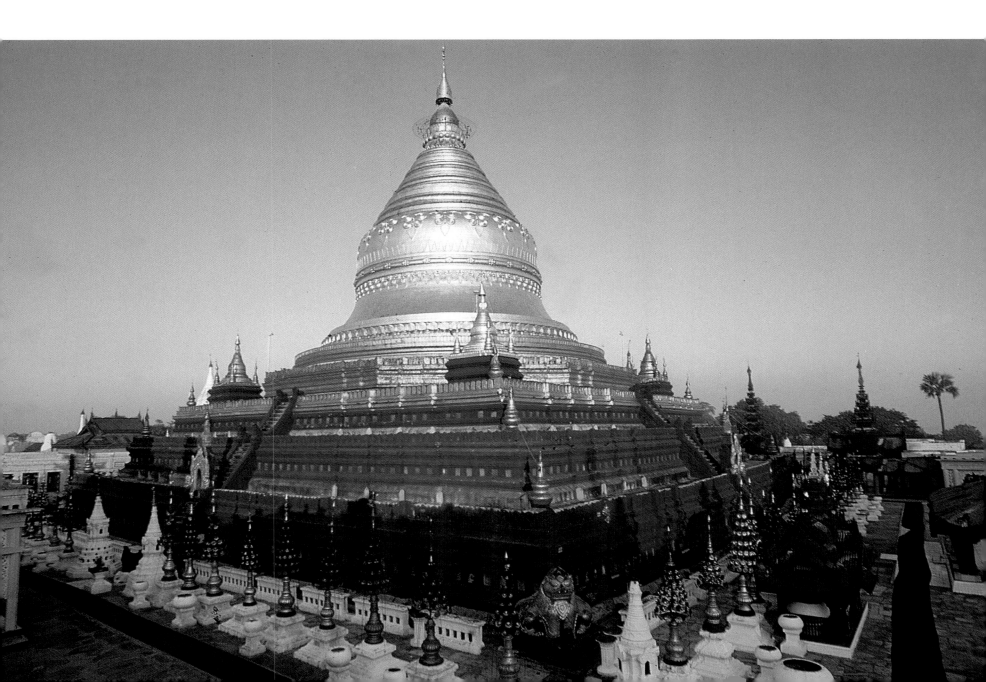

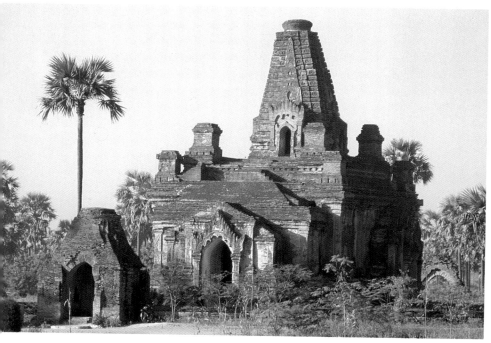

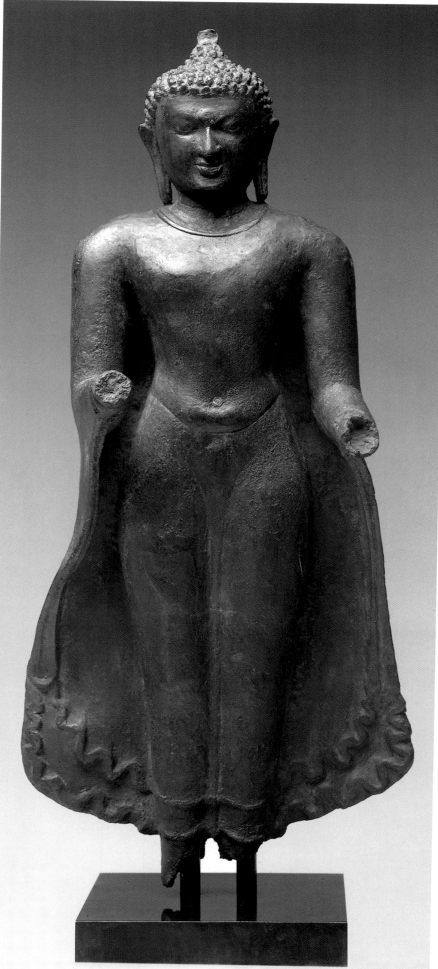

Top left
Shwezigon pagoda

About 1060, Pagan, Burma, black and white photograph of 1910/11, Scherman collection in the State Ethnological Museum, Munich

Above
Kubyaukgyi

1113, temple complex, Pagan, Burma

This temple was built by Prince Rajakamur, the only son of Kyanzittha (1084–1113), in honor of his father. The photograph shows the view of the temple complex from the east.

Right
Sculpture of the Buddha Shakyamuni

11th century, bronze with silver inlay, H 47.6 cm, W 21.6 cm, D 10.8 cm, James and Marilynn Alsdorf Collection, Winnetka, Illinois

This figure of Buddha Shakyamuni (the historical Buddha) dates from the Pagan era (about 1050–1287). The facial features and the shape of the garment are typical of works of Theravada Buddhism during this era.

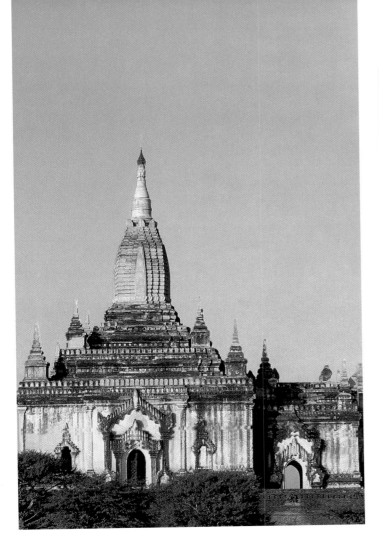

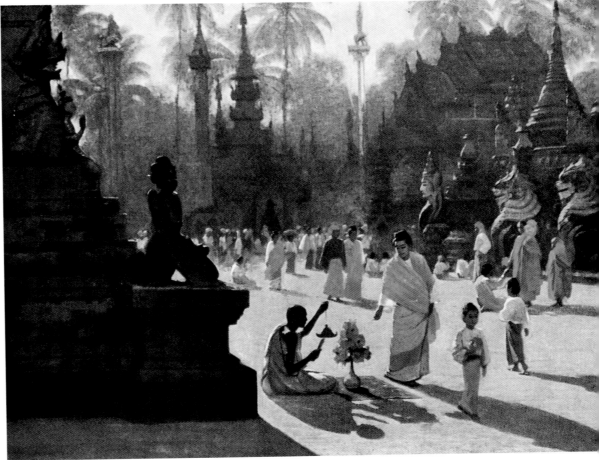

Shwegugyi pagoda

1131, Pagan, Burma, built by Alaungsithu (1113–1169)

According to the inscribed stone panels inside, this elegant temple was built in the remarkably short time of only seven months.

Above right
"The Praying Hermit"

Before 1904, oil on canvas

A painting by the Scottish artist James Raeburn Middleton (1855–about 1910).

1077 after the violent death of his predecessor. As the first building in a predominantly Burmese style, it became a prototype for the stupas subsequently built in Burma (see page 77). Noble and golden, the stupa rises over five terraces – three of them on square bases, two on circular bases – framed by four rectangular temples, in which stand the largest bronze Buddha statues of Pagan. In an unassuming side building are housed the 37 *nats* of the older religious tradition of Burma; King Anawrahta permitted their worship during what he saw as a transition period to the full adoption of the new beliefs, Theravada Buddhism.

Of the greatest importance to the study of inscriptions is the Kubyaukgyi temple (see opposite, bottom left), built in 1113 by Kyanzittha's only son, Rajakamur. In this temple, built in the Mon style, a stone was found in 1887 with Mon, Pali, Burmese, and Pyu inscriptions that document the history of the kings of Pagan.

Built by King Alaungsithu (1113–1169) in 1131, the Shwegugyi pagoda is an example of the building methods of the Middle period (see above, left). The prayer hall and the inner corridor are wide and flooded with light, and the pillars, plinths, and arches are covered with delicate stucco decoration that has none of the lushness of the Late style. Related to the Ananda pagoda in its construction is the Dhammayangi temple (see page 72), also begun by King Alaungsithu and continued by his son, the cruel king and patricide

Narathu (1169–1174), who hoped to improve his own *karma* by building a grand-scale and extraordinary complex. "We come to a great square, whose floor consists of firmly stamped earth. The building stupefies one. I see broad steps going upward and disappearing behind a wide door, and do not understand where they lead. Like orphan children we leave our dusty shoes behind and set about clambering up this decorated Alpine peak barefoot. [...] We climb higher and higher, by way of narrow outer steps, and we reach the topmost story, but it's as though the building were flying away ahead of us, getting ever higher with its niches, towers, stupas, decoration. [...] Between sun and earth there is now only a centimeter, which will very soon be closed up. Then they touch each other, and it's such an extraordinary moment that it's difficult to believe there won't be an appropriate sound of some kind, a drum beat. But there's nothing, nothing at all; the ship with the sails dipped in red glides quietly along, the ox-cart moves in the silent dust."[4]

Buildings of the Late period include the Gawdawpalin (about 1200) and Lawkahteikpan temples (after 1113). The former is one of the tallest two-story pagodas of Pagan (see page 75), with a curved spire that stands more than 60 meters (almost 200 feet) high. King Narapatisithu (1174–1211) began work on the pagoda, which was completed by his son, King Htilominlo (1211–1234), as a place of prayer in honor of the deceased

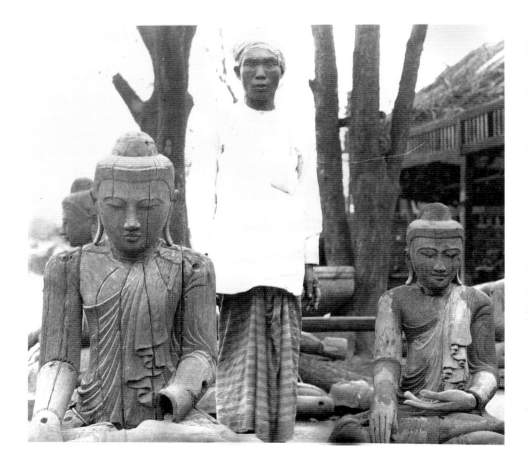

rulers of Pagan. The second temple, the Lawkahteikpan (built after the reign of Kyanzittha, 1084–1113), is known for its paintings of historical events and *jataka*, such as the eight wonders of Buddha, and images from the noble houses of the Blessed Ones of Vimanavatthu, followers of the Buddha (see page 81). Often the paintings are bordered by friezes on the ceiling and floor.

Most of the Buddha sculptures from the Pagan era are made of brick and stucco and designed to fill the niches of the temple walls (see page 76, left); individual pieces in bronze are comparatively rare.

Characteristics of Buddha figures in the pure Burmese style are the relatively short neck, the powerful trunk, and long fingers of the same length. The hair is made up of tight, snail-like curls, and the earlobes touch the shoulders. The garment is stylized and falls from the left shoulder with a pronounced curve. Precious metals or stones are often inserted into points of the body that have spiritual significance – the head, chest, naval, and upper arms. As a consequence, vandalism and plundering have led to the mutilation of statues, many of which have been moved to museums. Toward the end of the 18th century, a more naturalistic style began to develop, particularly in the body's proportions and depiction of garments.

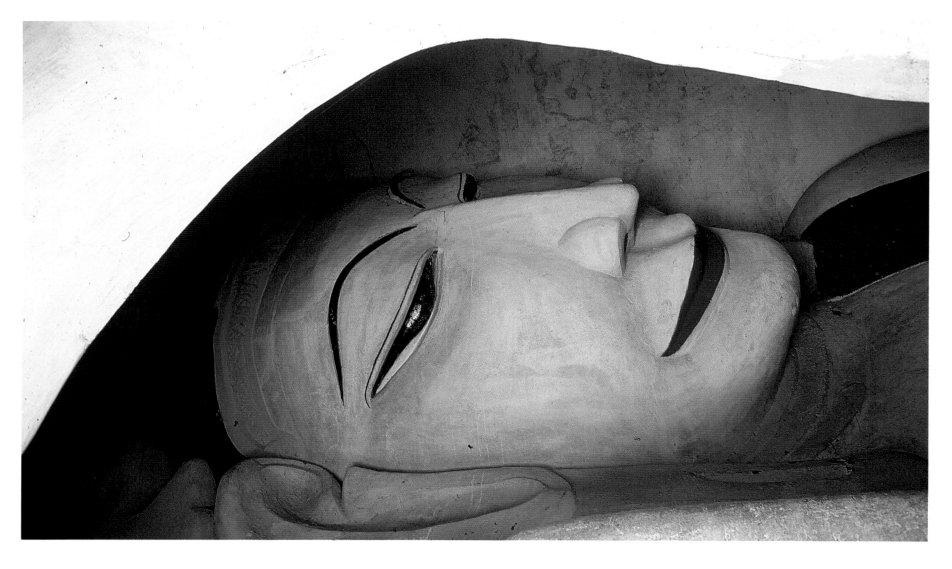

Right
A disciple of the Buddha

After 1113, wall painting, Lawkateikpan, Pagan, Burma

Paintings from the post-Kyanzittha period (after 1113) are found in many temples in Pagan and in nearly all the temples of the area around Minnanthu. The walls are decorated with *jataka* scenes from both religion and history.

Opposite, top
Seated Buddha figures in wood

Before 1910, black and white photograph of 1910/11, Scherman collection in the State Ethnological Museum, Munich

Opposite, bottom
The "Cramped Buddha"

Manuha temple, 1059, Pagan, Burma

The Manuha temple was built by a captive Mon king, who feared that he would end his life as a slave. For this reason he sold all his jewelry and financed a temple with the proceeds, hoping that this would improve his fate. In the restricted space of the pagoda, the three seated and one recumbent Buddha may well have been meant to tell the story of the king's soul.

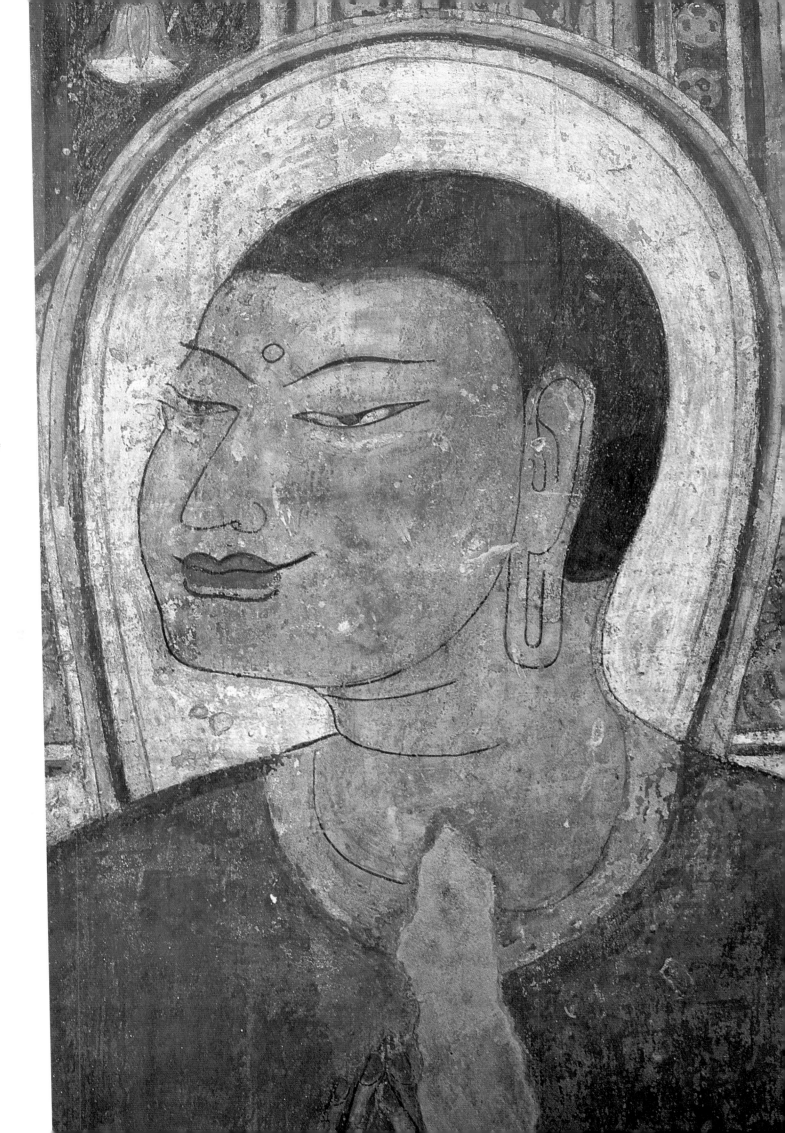

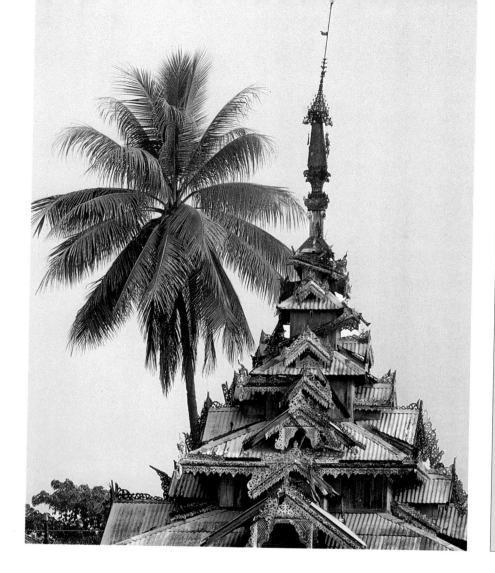

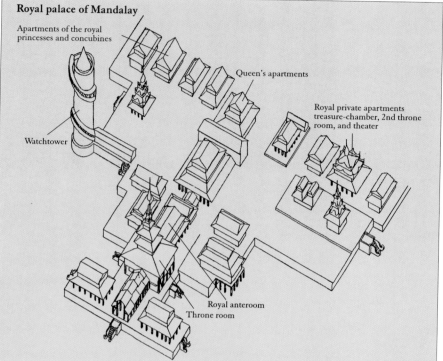

Royal palace of Mandalay

Apartments of the royal
princesses and concubines

Queen's apartments

Royal private apartments
treasure-chamber, 2nd throne
room, and theater

Watchtower

Royal anteroom

Throne room

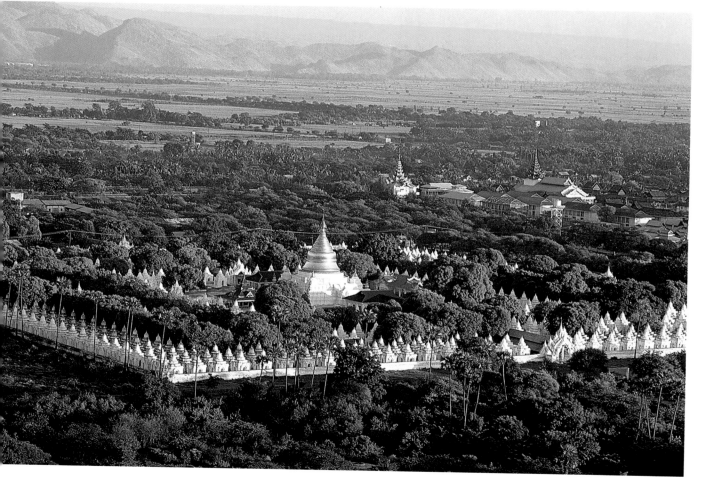

Above left
Wat Jong Klang

*Mid-19th century, part of a monastery
complex for pilgrims, Mae Hong Son,
Thailand*

A roof constructed in the Burmese style.
The city of Mae Hong Son in Thailand was
the constant plaything in struggles for
supremacy between Burma and Thailand.
The city's ever-changing fate is clearly
illustrated in the differing architectural
styles of its many monasteries.

Left
Kuthodaw pagoda

*(Also Maka-Lawkamarazein pagoda),
1857, temple complex, Mandalay, Burma*

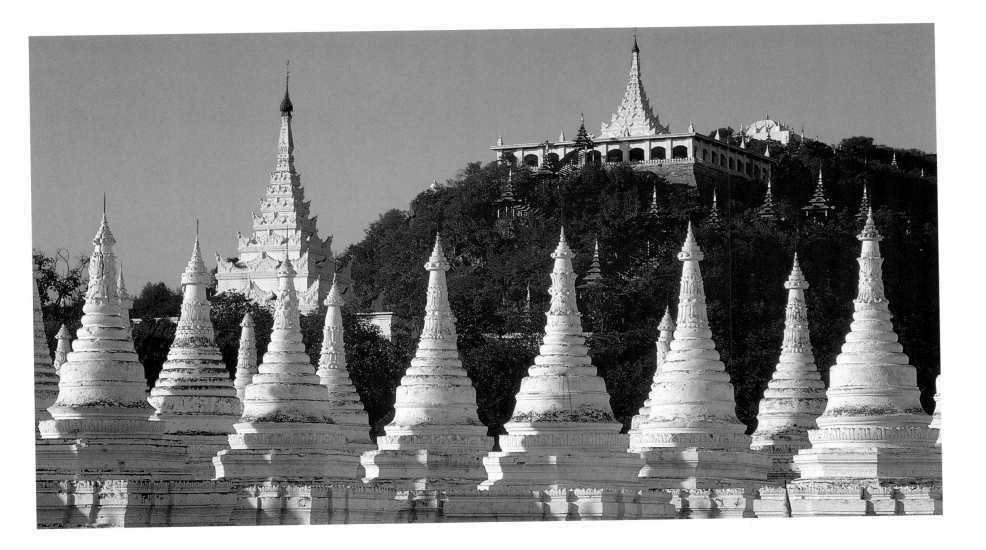

Mandalay: City of Contrasts

In contrast to Pagan, the "golden city" of Mandalay is a young royal city, still very much alive, though equally disfigured by the effects of war. In 1857 King Mindon (1853–1878) established this city, formerly known as Yadanatin, as his royal seat. He was following a prophecy according to which the Buddha had predicted that on the 2,400th anniversary of his death a city would be created as a center of Buddhist teaching at the foot of the Mandalay mountain, which he had himself sought out (see above).

Mindon ordered the dismantling of all the teak buildings of his Golden Palace in Amarapura and had them transported to Mandalay. Although, according to an old custom, Mindon had 52 subjects buried alive under the foundation walls of his new city – they were to be transformed into guardian spirits – a mere 25 years later Mandalay was annexed by the British. "Mandalay presents a series of violent contrasts: jewel-studded temples and gilded monasteries standing side by side with wattled hovels penetrated by every wind that blew; the haughty prince preceded by the respited murderer, his victor; the busy Chinaman next door to the gambling scum of the low country; the astrologer, learned in his mantras, overpersuaded by the glib talk of the Western adventurer…"[5]

The battle between the allies and the Japanese for the hill of Mandalay in 1945 achieved a tragic fame and allowed the former splendor and diversity of the city, noted by Bertolt Brecht, to be reduced to rubble and ashes. Only the reports of foreign ambassadors recall the glory of the last royal court of Burma: "… a collection of twenty or more separate buildings, all built of specially selected teak, brightly painted and gilded, and having the same upturned eaves and carved ornamentation common to all royal religious buildings in Burma. It has many audience chambers, in each of which is a carved and gilded throne. Above the principal one towers the lofty and elegant *pyathat* [a tower with five or seven roofs] called by the Burmese 'The center of the universe'…"[6]

The Shwe Nandaw Kyaung, the "golden palace monastery" (built about 1880), is the only part of the fabulous palace of King Mindon to have survived. Its costly decoration, in lacquer, teak, gold, and glass mosaic, gives an impression of the extravagant splendor of the land known as the "Golden Earth." Each column consists of a single teak trunk, remains of the original lacquer and gold pattern are still to be seen, and the roof is edged with *nats* praying to Buddha. The ten powerful carved *jataka* scenes on the outer wall of

Kuthodaw pagoda

(Also Maka-Lawkamarazein pagoda), 1857, with view of the Mandalay mountain, Mandalay, Burma

Built by King Mindon, the Kuthodaw pagoda, a replica of the Shwezigon in Pagan, has a very special feature: a collection of 729 stone panels on which are engraved all the Buddhist holy writings. The 5th Buddhist Synod, convoked by King Mindon to fix the Buddhist canon, complied the Tripitaka, a collection of authorized texts. These texts were written on the stone panels, each of which has its own walled shrine in the pagoda.

Below

Kyauktawgyi pagoda

Completed 1878, Mandalay, Burma

This pagoda, built by King Mindon, houses a statue of Buddha that was carved from a single block of marble (completed in 1865). In honor of this statue, the king himself made an appearance at the dedication festival.

Bottom

Ordination hall lined with Buddha figures

U-Mon-Kyaukse pagoda, Sagaing, Burma

Right

Nats seated on an elephant

About 1910, teak, 62 x 30 x 33 cm, Pagan, Burma, State Ethnological Museum, Munich

This wooden sculpture comes from the series called "37 *nats* from Pagan," which was ordered from the Subdivisional Officer in Pagan, or more precisely, Nyaungu. Thirty-one *nats* are listed, including Sakka (Indra), their function being to protect the outer walls of the Shwezigon pagoda in Pagan; these 31 deities are venerated throughout Burma. There are also five further *nats* for the protection of the inner circle of the pagoda.

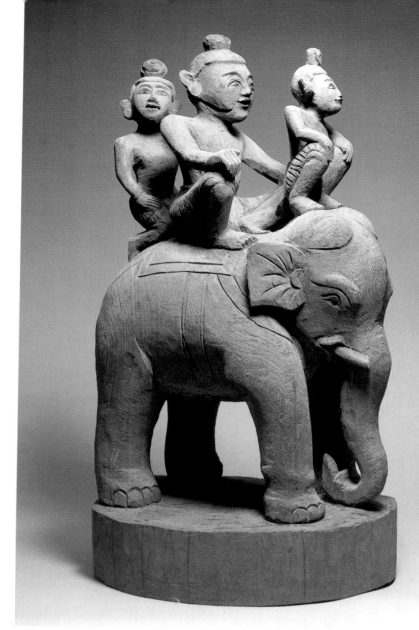

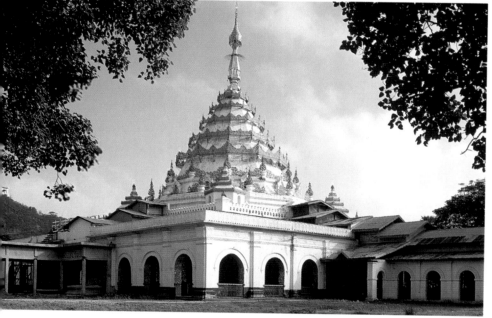

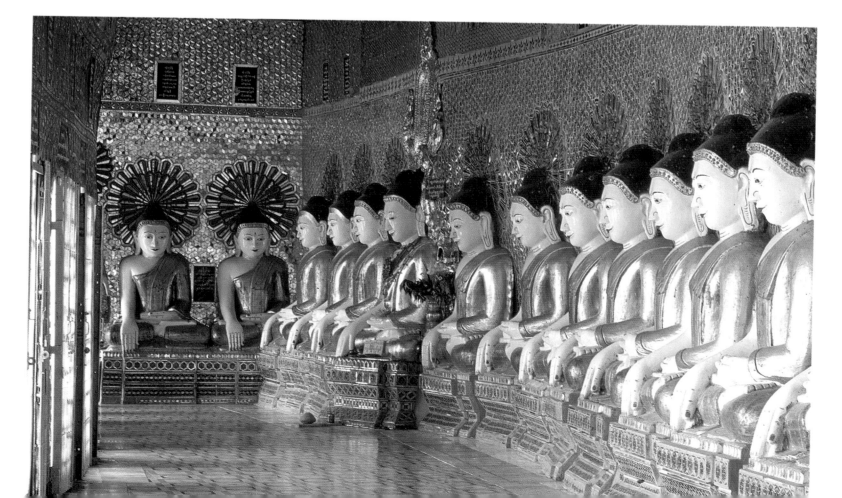

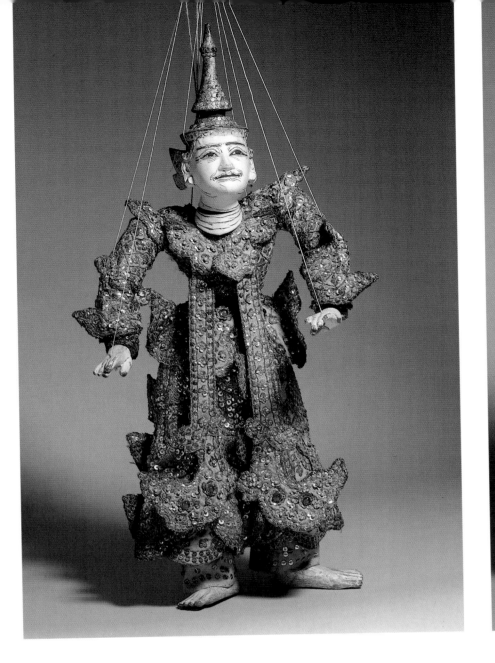

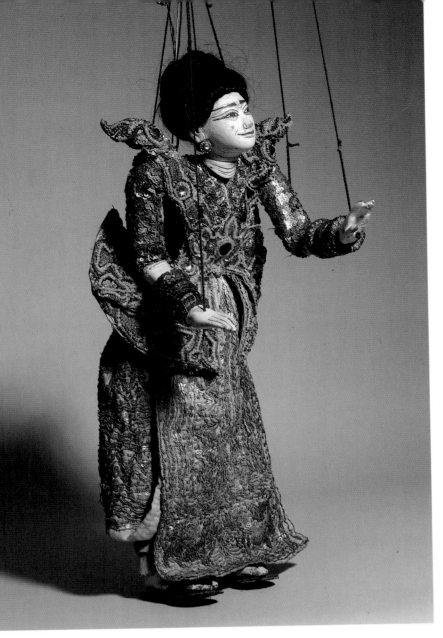

the building are in excellent condition, and in places are still covered with the original gilding.

At the foot of the hill of Mandalay lies the complex of the Kuthodaw pagoda (1857) with the Maka Lawkamarazein, a replica of the Shwezigon pagoda in Pagan (see page 82). The main feature of the temple complex is the collection of 729 marble panels covered with Buddhist holy writings; each text is housed in its own miniature, gleaming white pagoda. King Mindon commissioned 5,000 stone-masons, who over a period of eight years copied from palm-leaf manuscripts to the panels the Tripitaka, the canon of Buddhist texts, authorized by the 5th Buddhist Synod of 1872. It takes a monk two years to recite the entire scriptures; only five of the 20,000 monks living in Mandalay today have mastered this feat of memory.

On the other side of the hill stands the Kyauktawgyi pagoda (completed 1878), originally begun by King Mindon on the model of the Ananda temple in Pagan (see opposite, top left). Its comple-tion was thwarted by a palace revolution and the murder of Prince Kanaung in 1866. The pagoda, typically Burmese, is known for its colossal Buddha statue, cut from a single block of pale green marble. The figure is covered with precious stones and surrounded by figures of the disciples of the Buddha, 20 along each of its four sides.

Jewels, Gold, and Puppet Shows

Perhaps the most striking contrast in this "land of pagodas" is that between the austere, self-denying lives of the monks on the one hand, and, on the other, the extravagant splendor of golden temple roofs and of countless Buddhas gilded and jeweled… not to mention the jewels and valuables of the noblemen. Burma is practically a synonym for gold and precious stones; Burmese sapphires, emeralds, and rubies are sought by dealers world wide. Burmese jewelry and work in precious metals are also greatly admired; the Burmese crown jewels, made during of the Mandalay period, are the outstanding examples of these arts. The crown jewels have had a turbulent history; after the Anglo-Burmese war of 1886 they were looted by the British occupying forces and taken to London. In 1964, however, the Victoria and Albert

Left
A puppet king

Devā or nat type, 1752–1885. Painted wood, metal, precious metal, textiles, H 28 cm, Rangoon, Burma, National Ethnological Museum, Munich

"In the Kone Baung dynasty, only the kings wore such sumptuous ceremonial robes as the puppet shown here, a masterpiece of Burmese craftwork.

Right
A puppet prince

1752–1885, painted wood, metal, precious metal, textiles, H 59 cm, Rangoon, Burma, National Ethnological Museum, Munich

"The carving is superb, the painting wonderful; the face is charming and graceful, the clothing delightful. [...] One can only wonder what sort of people could have carried out this delicate and difficult work, requiring so much skill, craftsmanship, precision, and time."

(Dr Tin Maung Kyi, Mandalay, 1995, lecture at National Ethnological Museum, Munich)

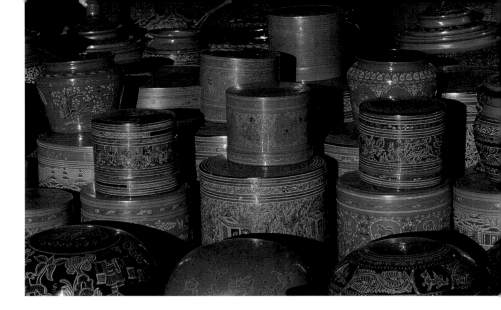

Below
Royal slippers

Before 1886, metalwork with gold and precious stones, Mandalay, Rangoon National Museum, Burma

As part of the crown jewels of Mandalay, these golden royal slippers were looted by the British in 1886 after the third Anglo-Burmese war. In 1964 they were restored to Burma by the Victoria and Albert Museum in London.

Right
Lacquer boxes

20th century, Pagan, Burma

In Burma, lacquer boxes are still made today using traditional techniques and used in everyday life, or sold as souvenirs in the busy tourist trade.

Museum returned the precious objects as a gesture of goodwill; this token of friendship in turn prompted President Ne Win (1962–1974) to send selected items of the treasure to England. Thus parts of the Burmese crown jewels can be admired in the Victoria and Albert Museum in London, while the majority are in the National Museum in Rangoon. Apart from jewelry, Burma has always been rich in folk art. Early wooden figures are highly prized by collectors (see page 84, top right). They were roughly chiseled from a block on which the outlines had already been drawn, their finer details being carved with sharp knives. The artistic design of simple objects such as clothing and containers vividly displays the traditional feeling for aesthetic form that is still alive today.

Among these objects are lacquer containers, above all begging bowls for monks; lacquer is the Burmese equivalent of porcelain and ceramics. Lacquer work has a very long history in Burma, the earliest preserved pieces, which were found in Pagan, dating from 1274. It is probable that the technique came to Burma from China in about 1050. Originally, the lacquer containers had a woven bamboo frame, knotted with horsehair, a structure that guaranteed a high degree of flexibility; today

Right
Hintha Kwam-Oak

"Holy golden goose," before 1886, gold inlaid with precious stones, Mandalay, Rangoon National Museum, Burma

In 1964, as part of a goodwill gesture, the Victoria and Albert Museum in London returned to Burma the valuables previously looted from the Burmese royal treasury. This token of friendship in turn prompted President Ne Win (1962–1974) to send selected items of the treasure as a present to Britain.

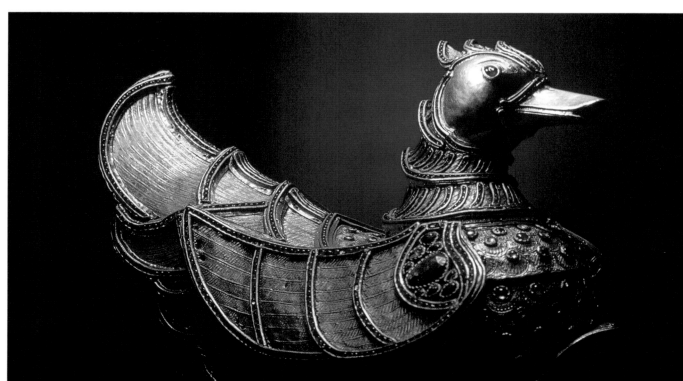

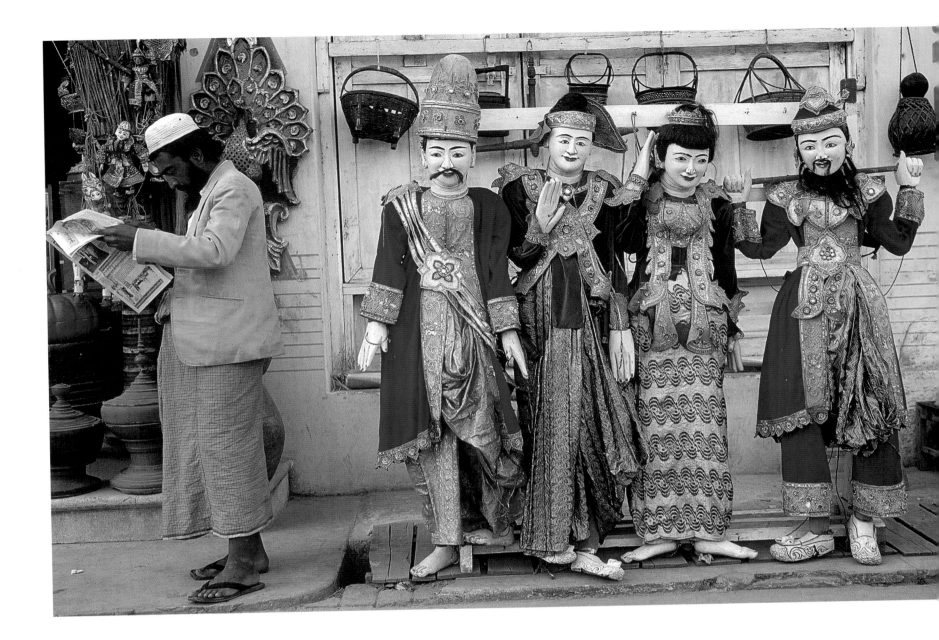

bamboo and wood are used. The raw material for lacquer is drawn off from the *thitsi* tree, like rubber, and applied to the framework; soon after coming into contact with the air, this natural substance hardens and turns black. A second layer of lacquer mixed with ash acts as a filler, giving the light framework a smoother surface. Each application has to dry thoroughly before another is applied. New applications of lacquer continue until all the unevennesses have disappeared and a smooth surface has been created. Finally, the lacquer is rubbed with sesame oil and polished on a stone slab. The production of a high-quality lacquer container usually takes several months, and the application of color in several stages requires a high degree of artistic skill. Many of the traditional designs are inspired by the wall paintings in the temples of Pagan.

A high point among the performing arts of Burma is the *yokthe-pwa*, the popular puppet theater. In order to get around the rigid regulations on public decency, the Burmese simply allowed puppets to do what was forbidden to humans. The figures can be more than one meter tall and represent personages from the *jataka* and the epic the *Ramakien*. The main characters and central focus of each play are the prince and the princess (see page 85, right). "The traditional puppet play consists of 27 figures, including the king, prince, princess, *nats* (spirits), ministers, magicians, clowns, various animals, etc. As in the Javanese shadow theater, there are right-hand and left-hand puppets; that is, those which appear from the right or the left. The right-hand (good) figures include, for example, the king, ministers, *nats*, and elephants; left-hand (evil) types are sorcerers, beings possessing magical powers, monkeys, and tigers. Supernatural beings and monkeys often leave the stage upwards, to demonstrate their magical powers. In recent times, further characters have been added to the 27, and the style of performance has also been considerably altered."[7]

A traditional performance, a puppet play in Kemendyne (today a district of Rangoon) in September 1861, is described by Adolf Bastian, the ethnologist and first director of the Berlin

Life-size puppet figures

Photographed in Pin U Lyin, Burma

Burmese puppet theater came into being during the second half of the 18th century, on the whole independently of developments in other countries in the region. The traditional puppet play consists of 27 figures, including the king, prince, princess, *nats* (spirits), minister, magician, clown, and various animals.

and discussed the affairs of the country and the intentions of the king. The last one on the right had a red face (while those of the others were white), and served as the clown, his wry observations causing continual laughter among the spectators."[8]

The World of the Gods

Fairy tales, traditional stories, and deeply held religious beliefs are interwoven in the mystical fabric that makes up the magic of Burma. Another element is provided by the many caves containing Buddha statues that are dispersed over the country. In Pindaya, for example, is the Shweumin pagoda, the pagoda of the "golden cave." Here, in a limestone grotto, are some 6,226 Buddha statues, mainly donated by devotees and pilgrims. Countless chambers and niches house the statues of marble, bronze, and plaster, gilded or painted, Buddhas great and small, venerable old specimens and new ones roughly fashioned by folk artists. The stupa of the temple complex dates from the 12th century, though the first use of the cave is unknown.

The veneration of the Buddha is proclaimed in the sheer abundance of sculptures and in the exaggerated dimensions of the images: "Between the cacti and the bushes lie ruined pagodas, announcing the proximity of the city founded in 573 [Pegu]. Opposite the station one observes the colossal figure of a recumbent Buddha, which as a result of the building of the railway was released from the vegetation which had overgrown it. Its height is 17 meters, its length 60 meters, and it is made of brick covered with stucco. Further away, resembling a tower, on a wide base are four seated colossal Buddhas, leaning back to back, the four Buddhas in human form of the present age of the world"[9] [see opposite, bottom].

Probably the most unusual pagoda is the Kyaiktiyo pagoda in the jungles of southern Burma. Only a walk of many hours will enable a visit to the legendary rock, covered with gold, which threatens at any moment to plunge headlong into the abyss below (see page 90). The stupa, a reliquary shrine housing a hair of the Buddha, stands on the shoulder of the rock; it is this hair that is reputed to maintain the precarious balance of the structure. The hair had been given to King Tissa in the 11th century by a hermit, who had preserved it for many years in his own knot of hair. His last wish was that Tissa should preserve the hair as a sacred object, together with his own head, in a pagoda on a mountain, which was to resemble his skull. The king of all *nats*, Thagyamin, found the required lump of rock at the bottom of the sea, and brought it to the peak of the mountain.

From the jungles in the south of Burma to the mountains of the north, from Lake Inlay to the Irrawaddy, from the ancient centers of kings and pilgrimage Sagaing (see page 84, bottom) and Amarapura (see opposite, top)... the many ethnic groups of the land – the Burmese, Shan, Mon, Karen, Kachina, and Arakanese – are unified by

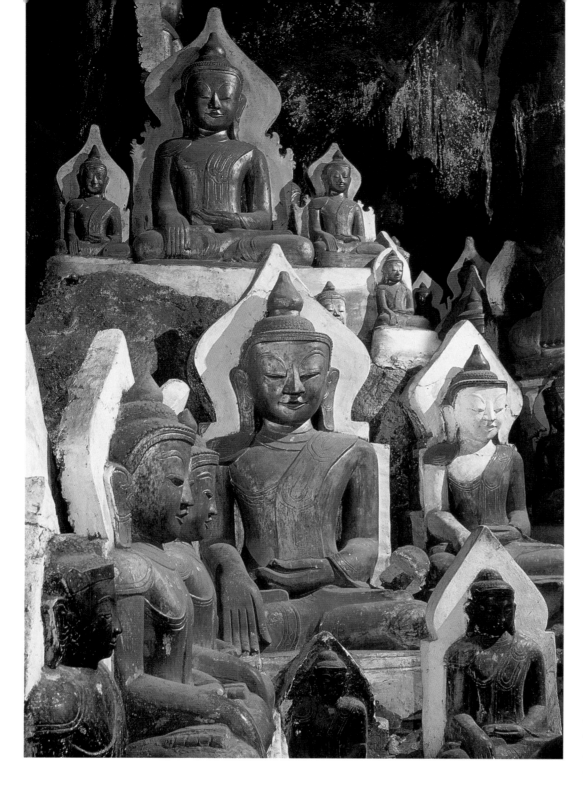

Buddha statues in the cave of Pindaya

From 12th century onwards, Shweumin pagoda ("golden cave pagoda"), marble, bronze, stucco, Pindaya, Burma

In this limestone cave are chambers containing a total of 6,226 Buddha statues, made of marble, bronze, and stucco; many are gilded.

Ethnological Museum: "The stage consisted of a longish bamboo framework, somewhat raised and covered with a roof. The background was formed by a curtain, and above this, on the rafters of the roof, sat the persons whose hands controlled the puppets. After a kind of prologue had been delivered by a figure clothed in velvet, a white monkey-monster turned cartwheels over the stage, followed at the gallop by a white horse, and then the king of the Belus (Belu means monster) leapt out with two companions, who carried out a monster dance with widely splayed legs, to the continual accompaniment of music and monotonous singing. After them, in slow procession, there appeared four ministers clothed in pointed hats and long robes, who sat down next to each other

Landscape with pagodas

About 1849/50, fresco, Kyauktawgyi pagoda, eastern corridor, Amarapura, Burma

The Kyauktawgyi pagoda was built by King Mindon's predecessor, King Pagan Min (1846–1853) on the model of the Ananda temple, Pagan. The four large antechambers are adorned with frescoes. Still preserved are the paintings of the barrel vault, which show a compendium of Burmese temples, accompanied by lovingly painted scenes from everyday life.

Below

Colossal Buddha statues of Kyaikpun

1476, Pegu, Burma

These statues, 30 meters (98 feet) high, are four seated Buddhas. They sit back to back gazing towards the four points of the compass. The west-facing Buddha was damaged in 1930 by an earthquake, but the others are preserved in their original state.

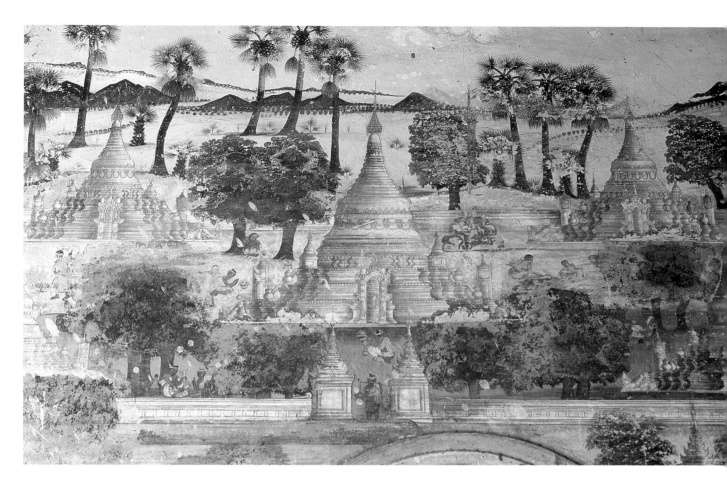

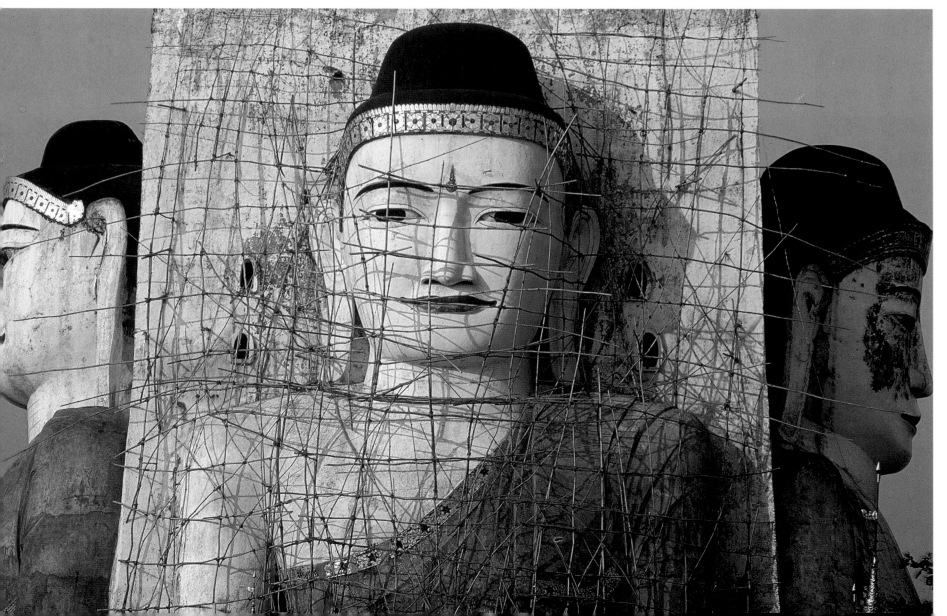

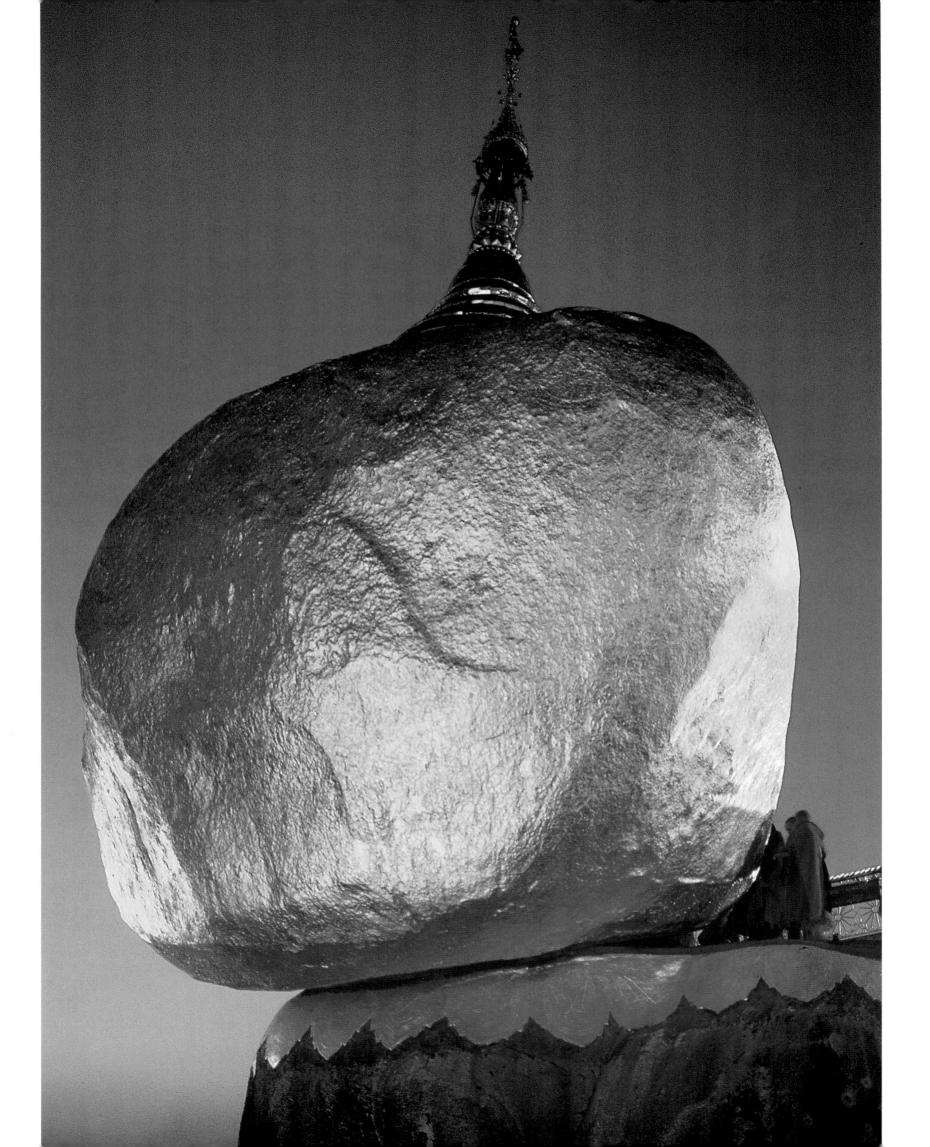

Right
Burmese "viewing" boat

Burma, black and white photograph,
1910/11, Scherman collection in National
Ethnological Museum, Munich

Below
Taugthaman Lake, Mandalay

Mandalay, Amarapura, Burma

Opposite
Kyaiktiyo pagoda

"Pagoda of the golden rock," about
11th century, east of Pegu, Burma

Here the small stupa stands on a gold-
covered rock. According to the legend, the
pagoda contains a hair of Buddha, which
was given to a hermit who preserved it in
his knot of hair. His last wish was that the
hair should be preserved as a sacred
object, together with his own head, in
a pagoda on a mountain that was to
resemble his skull.

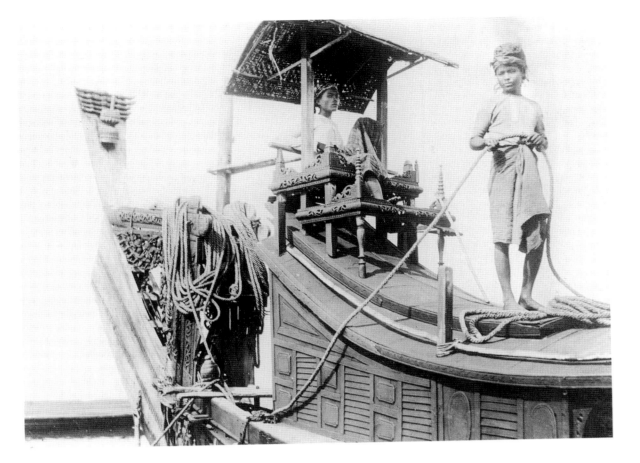

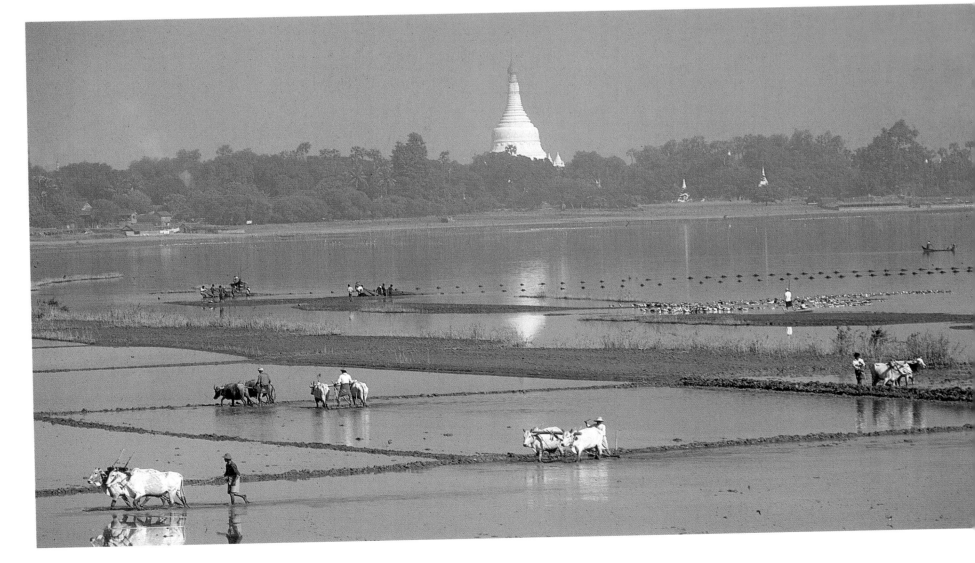

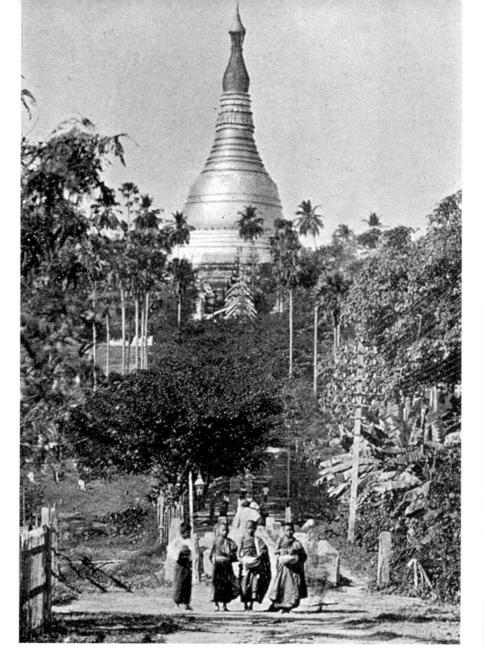

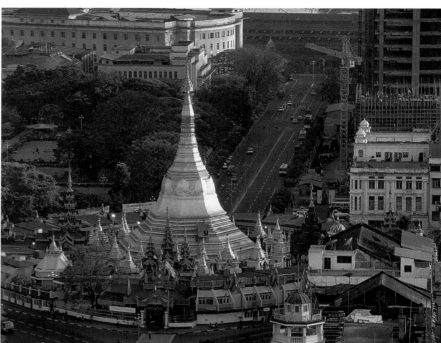

Below

Sule pagoda

Built from 3rd century B.C., reconstructed 1880, Rangoon, Burma

The special characteristic of this pagoda in the city center is its octagonal stupa, which keeps its form right up to the top of its spire. This peculiarity goes back to the division of the week into eight days, with each day being represented by a planet and a bird or animal.

Opposite

Shwedagon pagoda

Presumably begun 524 B.C., Rangoon, Burma

This golden stupa (shwe means "gold") dominates Rangoon and attracts thousands of pilgrims every year. The novelist Somerset Maugham wrote that for him it was "like a sudden hope in the dark night of the soul."

Above

Monks on the way back from the Shwedagon pagoda

Rangoon, Burma, black and white photograph, before 1904

the stupas rising up through the mists. "Burma has been called the land of pagodas, and rightly so, for they are a typical landmark. As I have already mentioned, the small pagodas were built by pious private people, freely copied from the large pagodas that are generally associated with monasteries, gigantic reliquary shrines that contain mementoes of Gautama Shakyamuni or one of his mythical predecessors. If the former vary in height from four to twelve meters, the latter compete in height with our church towers."[10]

In many places everyday life in Burma continues to follow the deep-worn ways of the past. The following description of a journey of more than 130 years ago could be an up-to-date travel report: "One cart, bought in Mandalay, drawn by two oxen, contained under a roof of mats and bamboo the trunks, the traveling bags, and the bed on which I was able to lie. The other cart, which was hired in addition, carried the rest of the luggage and the cooking utensils, and still had room for one of the servants."[11]

The mystery of the Shwedagon

The capital city, Rangoon, makes an attempt at modernity, but here too the pagodas hold sway. The golden dome of the Sule pagoda, 48 meters (157 feet) high, rises from within the square of colonial buildings in the city center . The pagoda was renovated by the British in the city laid out in 1880, while legend dates the temple to the 3rd century B.C. The ultimate spiritual magnet and universal treasure of Burma is the Shwedagon pagoda. For 2,500 years its spell has drawn Buddhist pilgrims and other travelers from all over the world. Covered with gold and set with many thousands of diamonds, rubies, sapphires, emeralds, and topazes, and crowned by a 76-carat brilliant, it is, as Rudyard Kipling wrote, a "winking miracle."[12] And it is not merely the eye that is enchanted, but the soul also: the English novelist Somerset Maugham wrote that it was "like a sudden hope in the dark night of the soul."[13] A more recent traveler has described it thus: "'Shwe-Dagon' we said, and we land at the foot of this heavenly body, where the crowd of

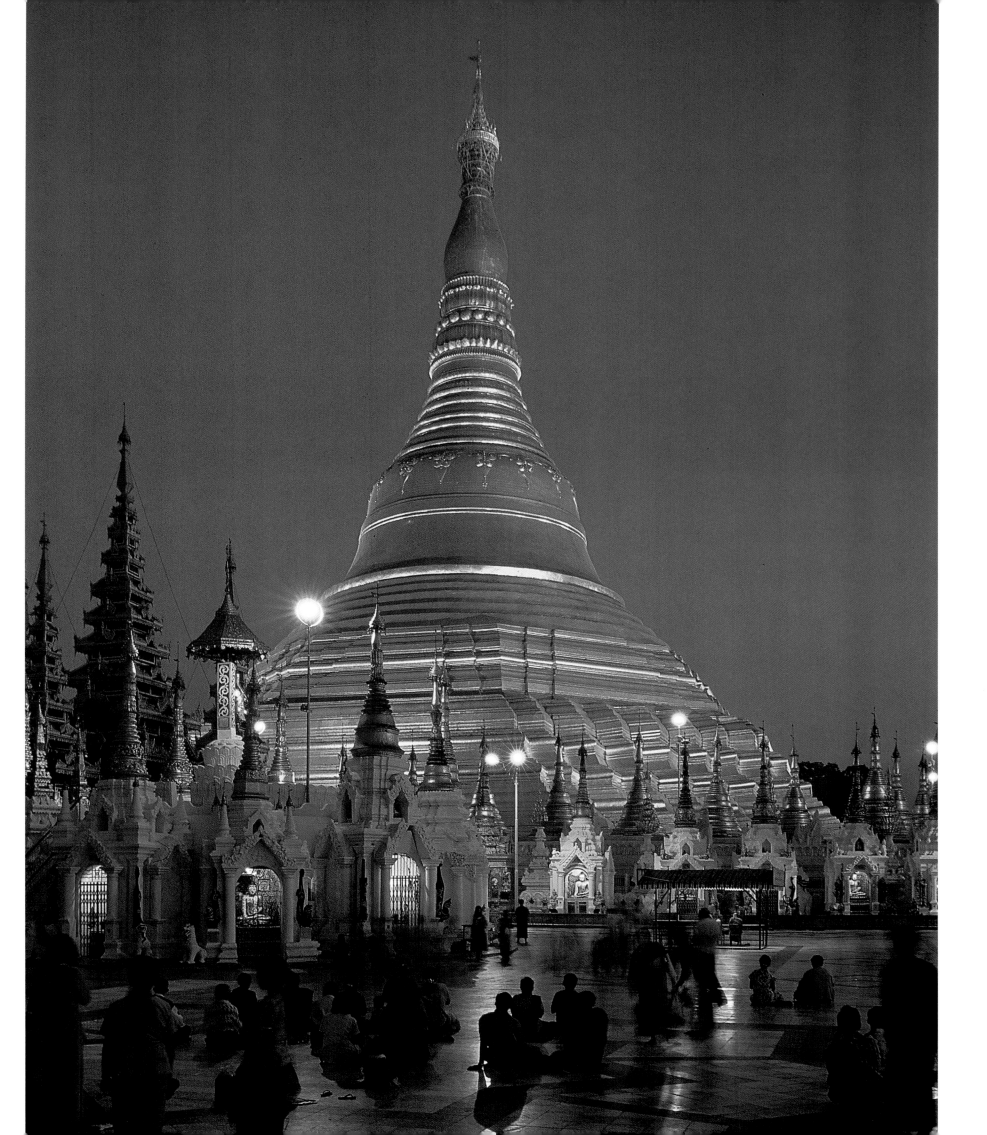

people is at its densest... I know that I am now in an astrological system, a symbol of the cosmos; I know about the unprovable connection between day, wind direction, planet, animal, quality... but what does my 'unprovable' mean when the man who enters the *Konagama Hall* (hall of worship) by my side experiences this Friday, which we experience together, as the day of the north wind, of Venus, of the mole, and of talkativeness? [...] Pagoda: *zaydi* they call it in Burma. In Pali it is called *cetiya*, in Nepal *chaitya*, in Thailand *chedi*, and this is supposed to be a transposition of the Ceylonese *dagoba*, which for its part comes from the Sanskrit, in which it means 'reliquary shrine.' A heap of rice, that is what Gautama Buddha wanted on his grave, a tumulus in the form of a mountain of rice, and therefore... therefore? I stand here in front of this towering, soaring golden form, a planet."[14]

The Shwedagon is not merely a pagoda: it is the expression of a spiritual world-order. The story of its origin fills volumes, and the 100 structures surrounding it form a city in themselves. Over thousands of years, and out of respect for tradition, one stupa was built upon another; the first was nine meters (30 feet) high, the present one is 107 meters (350 feet) high. According to legend, two Burmese merchants once traveled to India, where they met the Buddha under the holy *bodhi* tree. They shared bread with him, and as thanks he gave them eight consecrated hairs. On their journey home the merchants gave four hairs to kings who controlled the roads, and handed the remaining four to their ruler in Dagon, King Okkalapa, who preserved them in a golden shrine on the holy mountain of Singuttara. When the shrine was examined later, all eight hairs were still there. Through earthquake and fire, the Shwedagon has always risen again in even greater magnificence. In every direction one can ascend to the main platform, where one is overwhelmed by the number and splendor of the buildings, in whose center stands the stupa. An apparent confusion of smaller stupas, pavilions, and figures opens up but everything is arranged in a clearly defined order: the cosmos represented by the complex is arranged in terms of planets, spirits, animals, and spiritual petitions. Beside richly decorated *bodhi* trees stand brightly painted *nats*, elephants, lions, guardian figures, and countless statues of the Buddha. Elegant *htis*, alternate with the carved wooden gables of the pavilions. The pavilions, *tazaung*, and the rest houses, *zayat*, have up to nine tapering roofs painted in a brilliant green that contrasts with the gold of the bell-shaped, 22-meter (62-feet) high main stupa. Above this rises the curved "turban" 12.5 meters (41 feet) in height, then the slender 16-meter (52-feet) high tower, crowned by a jewel-encrusted *hti* 10 meters (33 feet) in height, and a sphere set with a 76-carat emerald. But without the thousands of pilgrims and faithful attendants, of monks in their robes of all shades of yellow, the picture would be incomplete; together, temples and devotees form an image of an enchanting and still vibrant world.

Top
Shwedagon pagoda

Presumably begun 524 B.C., roofs over the southern entrance to the pagoda, Rangoon, Burma

The familiar multiple roofs of Burmese architecture, their ridges richly ornamented.

Above
Shwedagon pagoda

Presumably begun 524 B.C., Rangoon, Burma

Some of the many gold-covered pinnacles at the Shwedagon pagoda, each one crowning a stupa. On the right are several ornate *bodhi* trees.

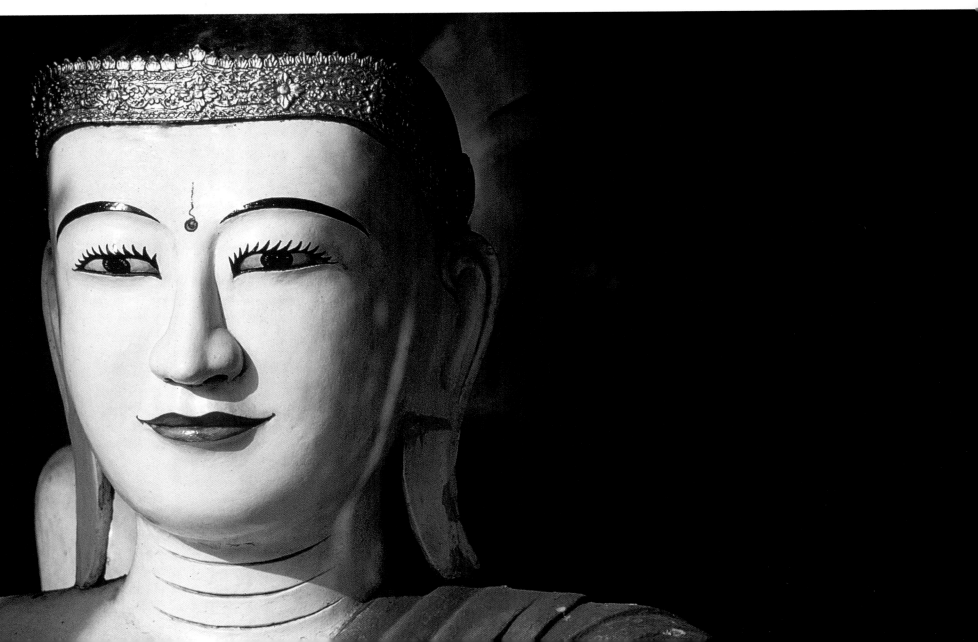

Vietnam

The political sway China has exercised over Vietnam for many centuries has meant that the culture of the Vietnamese is very different from that of its neighbors in Southeast Asia. Yet it is wrong to see Vietnam as merely a satellite of its mighty neighbor to the north. The imperial city of Hué, for example, lying on the northern shore of the "Perfumed River," unquestionably provides evidence of a genuinely Vietnamese cultural achievement. Among the most unusual and most moving architectural creations are the imperial tombs in the enchanting hills around Hué — here, in their own lifetime, the Vietnamese emperors tried to create a remote Paradise where the buildings of mortals were brought into perfect harmony with nature and the divine.

Painted stone sculpture of a
spiritual guardian
Thien Mu pagoda, 1601, Hué, Vietnam

Nam Viet: Viet Nam

The very name "Vietnam" now conjures up vivid
images of colonialism, the long and bitter struggle
for independence, and of course internecine war –
not historic sites and artistic monuments. It is not
pagodas, monks, and palaces we recall, but scenes
of destruction from the film *Apocalypse Now* or
perhaps, in a nostalgic mood, impressions of the
French colonial era: "Saigon, Paris of the East."

The history of Vietnam's struggle for its own
identity, and even its very survival, against the
superior strength of China and other neighboring
countries, and finally against Europe and America,
is indeed a dark and troubled one. When the
country was founded in 1802 the new emperor had
to submit the country's name to the Chinese
emperor for approval: he sent his ambassador to
the Forbidden City of Peking to confirm the unifi-
cation of the old kingdom of An Nam with that of
Viet Thuong by means of a new name, Nam Viet.

This request was long debated by the Chinese
court and denied in this form, since the name
Nam Viet was too reminiscent of the old kingdom
of Nam Viet Dong, which now included Chinese
provinces. Seeking a compromise, they agreed to
reverse the names and so the new nation became
Viet Nam. "Viet" referred to the largest group in
the south of the country, and "Nam" was presum-
ably a name that helped to differentiate between
the Viet of the north living in China and those
who had migrated south. The Chinese emperor's
edict was a reminder of the fall of the first
Vietnamese kingdom Nam Viet, with its brilliant
Dong Son culture, which was destroyed by the
invading Chinese in the 2nd century B.C.: it was
this early defeat that sealed Vietnam's fate in rela-
tion to its powerful neighbor to the north.

The short-lived autonomy of the reunited
kingdom – the French captured the imperial seat

Hué as early as 1883 – permitted no golden age and no monuments created for eternity. After the Dong Son culture, the golden age of Vietnam was that of the kingdoms of the Cham (A.D. 200–1720), but our knowledge of this great culture has almost disappeared from historical awareness. Interestingly, the most notable achievement of Vietnamese culture, in contrast to that of other Southeast Asian countries, lies not in the visual and applied arts, but in literature. Even the everyday conical huts are often decorated with stereotyped lines of verse and known as *non bai tho* (poetry huts).

In 1961 Bernard-Philippe Groslier remarked: "… nevertheless the execution and the technical aspects [of the artistic creations of Vietnam] are worthy of commendation, so that a number of works take up an honorable place among the artworks of Chinese provinces."[1] Though there is a point in Groslier's remark, it is in fact simplistic and quite misleading to dismiss Vietnam as a Chinese "province." Moreover, he overlooks the

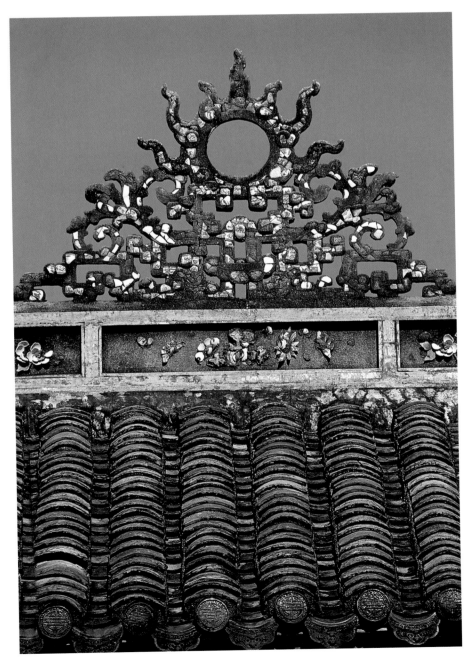

Above
Imperial palace

1833, imperial tiled roof of the Ngo Mon gate, Hué, Vietnam

After arduous restoration work the nine, tiled roofs, glazed in imperial yellow, once again gleam above the stone base and the two-story balustrades of wood lacquered in red and yellow.

Left
Sun motif on a roof

1864–1867, on a roof in the tomb complex of Emperor Tu Duc, Hué, Vietnam

Top
Imperial palace

1833, partial view of Ngo Mon gate, imperial tiled roof, Hué, Vietnam

Roofs such as these, here decorated with a dragon motif, were dedicated to the ruler and reserved for his use. These imaginative figures are decorated with colorful ceramic mosaics and enameled bronze.

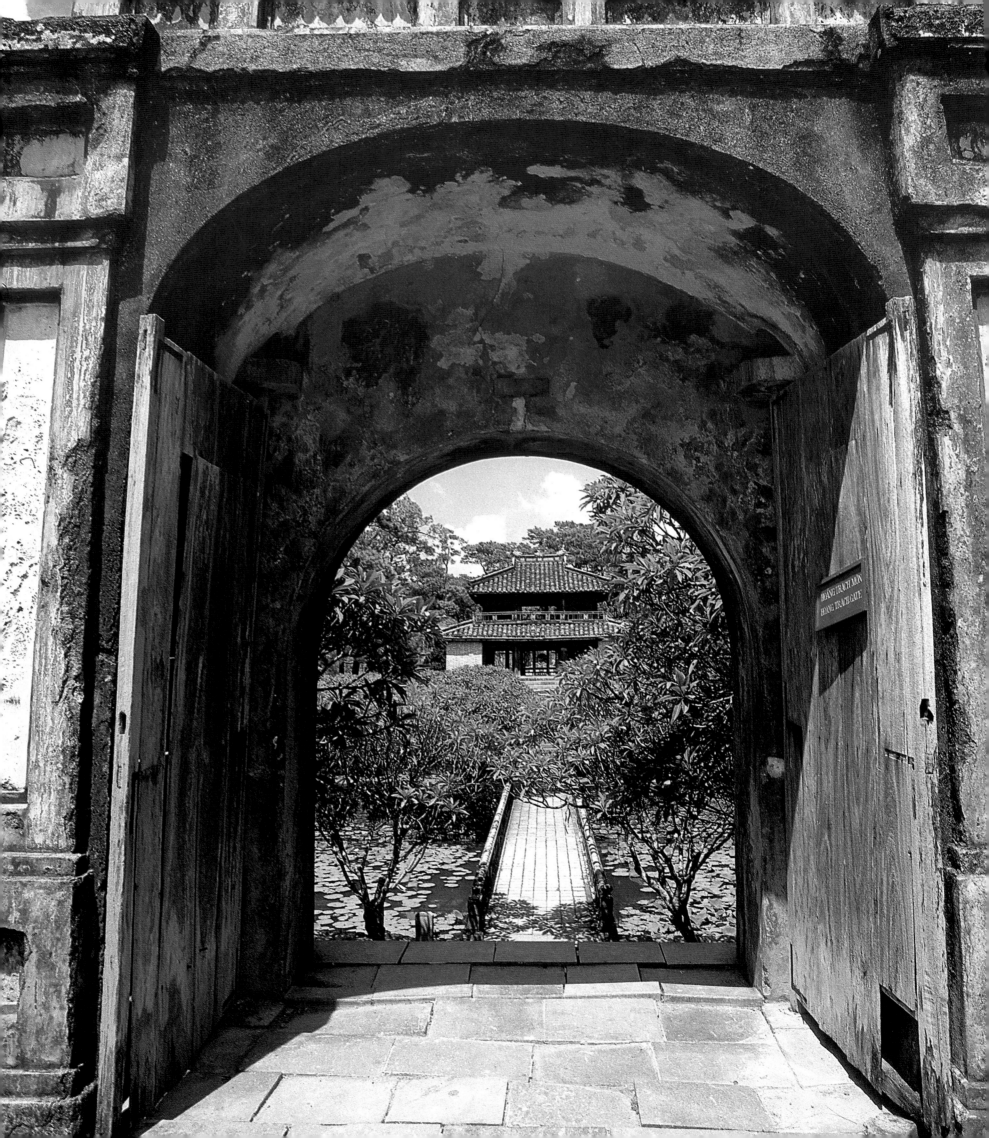

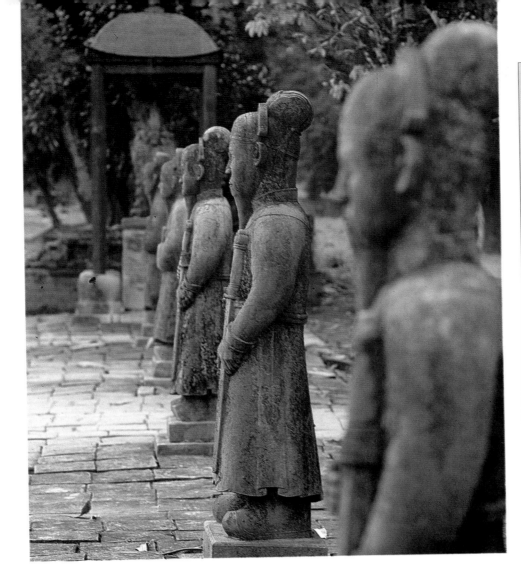

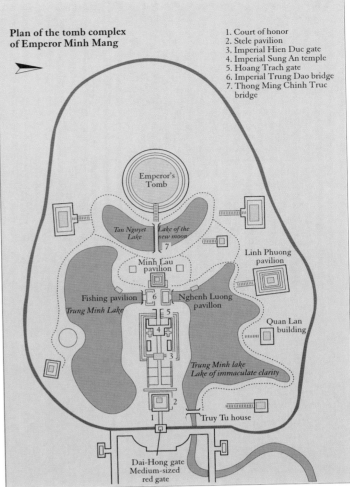

Plan of the tomb complex
of Emperor Minh Mang

1. Court of honor
2. Stele pavilion
3. Imperial Hien Duc gate
4. Imperial Sung An temple
5. Hoang Trach gate
6. Imperial Trung Dao bridge
7. Thong Ming Chinh Truc
 bridge

Emperor's
Tomb

Tan Nguyet Lake *Lake of the new moon*

Minh Lau
pavilion

Linh Phuong
pavilion

Fishing pavilion
Trung Minh Lake Nghenh Luong
pavilion

Quan Lan
building

Trung Minh lake
Lake of immaculate clarity

Truy Tu house

Dai-Hong gate
Medium-sized
red gate

Above
Guardian figures: mandarins

*1841–1843, tomb complex of Emperor
Minh Mang, Hué, Vietnam*

Opposite
Tomb complex of Emperor
Minh Mang

*1841–1843, view of Minh Lau pavilion,
Hué, Vietnam*

All the tomb complexes in the Hué area
follow the same stylistic pattern. Although
arranged in different ways and reflecting
the personal taste of each builder, the
complexes all consist of five elements: an
extensive tiled courtyard with figures; a
pavilion with a stele on which is engraved
the life of the dead person; a temple
dedicated to the deceased; a pavilion for
the concubines; and the tomb.

artistic achievement of the imperial city of Hué,
which unquestionably represents the cultural
heart of the country.

Hué: imperial city on the banks of the "Perfumed River"

The founder of Vietnam, Gia Long (1802–1819)
of the Nguyen dynasty (1802–1945), chose as the
base for his seat of power the northern bank of the
Huong Giang, the "Perfumed River," where his
family had lived for generations. For the first time
in Vietnamese history, one court alone ruled from
Yunnan to the Gulf of Thailand. Requiring great
sacrifices of the population, Gia Long built his
own "Forbidden City," a mirror image of the
emperor's palace in Peking.

Reports by foreign visitors always express great
admiration for the beauty and splendor of the
capital city of Hué. The court itself resembled its
"elder brother" in Peking in its hierarchy and its
court intrigues, with throngs of mandarins,
eunuchs, princesses, and scholars. Sadly, while the
Forbidden City of China can still be admired
intact today, by far the greater part of the palace in
Hué fell victim to the Vietnam war.

The complex is enclosed by seven walls each ten
meters (33 feet) in thickness, and by canals and a
number of towers. The wall, which encloses an

area of six square kilometers (2.3 square miles), is
interrupted by ten gates. The Ngo Mon gate (see
page 98), built under Emperor Minh Mang as the
main entrance to the south of the palace, has been
restored with the help of UNESCO and appears in
its original form with the crowning pavilion known
as the Five Phoenixes, from which the emperors
watched the festivals and ceremonies. After arduous
restoration work, which was performed in constant
competition with fungal parasites and weeds, the
nine tiled roofs, glazed in imperial yellow, gleam
above the stone base and the two-story balustrades
of wood lacquered in red and yellow (see page 99).

Of the former 147 structures of the imperial
city – halls, pavilions, temples, residences, and
bridges – those partially restored include The
Mieu, the memorial temple for all 13 emperors of
the Nguyen dynasty; the Palace of the Throne; the
Hall of the Highest Harmony, with its adjacent
reception room, Huu Ta Dai Lam Vien, in front of
which are the Huu Vu and Ta pavilions, as well as
the Hien Lam Cac, the pavilion dedicated to the
urns of the emperors; and, as a *pièce de résistance*,
the imperial reading room, and the Palace of the
Mandarins. The Tu Cam Thanh, the forbidden
purple city within the grounds of the palace, was
almost completely razed during the Tet Offensive
in 1968, and today local farmers grow their melons,
salad vegetables, and groundnuts on this site.

The structure of the buildings shows Chinese influence, but also distinctively Vietnamese features. Both palace and sacred buildings consist of open halls without room divisions, rhythmically broken up by rows of columns, on which rest interconnected, carved beams that form the support for the lavishly tiled roof-truss. In order to support the increasingly heavy roofs, Vietnamese builders over the centuries added further structures to the long sides of the halls. The parallel roofs were linked to each other, a form of construction known as *trung thiem diep oc*, "multiple roofing."

The columns in the halls are made of indigenous fashioned, extremely hard ironwood, which, to the regret of the restorers, has become rare because of the extensive destruction of the jungle. The crossbeams of the open spaces are adorned by elaborate carving, including images of the four seasons, sacred animals, flowers, swords, and fans. Decoration is also applied to the columns, which are lacquered in brilliant red and yellow. The roof bases are painted in delicate pastel colors; above them rise roof and gable decorations in glass and ceramic mosaic.

The Thien Mu pagoda

Another of the oldest buildings in Hué, the Thien Mu pagoda, which was begun in 1601 (see pages 96 and 104). It attained a tragic fame on June 11 1963, when Thich Quang Duc, a monk living in the monastery there, committed suicide in a street in Saigon. He set himself on fire in protest against the coercive measures that the hated President Ngo Dinh Diem (1955–1963) had imposed upon Buddhists, and helped to bring about the collapse of the anti-communist Diem regime.

The 21-meter (69-feet) high Phuoc Duyen, the pagoda's "Tower of Good Fortune and Beauty," was built in 1844 by Emperor Thieu Tri (1841–1847). In each of the seven stories of the tower is an altar dedicated to the Buddha.

The imperial tombs: the Paradise of the Sons of Heaven

The relics of the Nguyen dynasty that are the most unusual and at the same time the most moving architectural creations are the imperial tombs in the enchanting hills around Hué. In their own lifetime, the Vietnamese Sons of Heaven created their remote paradise and devoted great care to its realization. Although arranged in different ways and reflecting the personal taste of each builder, all the tomb complexes consist of five elements: an extensive tiled courtyard with stone figures, saddled horses, elephants, municipal and military mandarins; a pavilion with a stele on which is engraved the life story of the dead person; a temple dedicated to the deceased; the pleasure pavilion for his

Above, left
Tomb complex of Emperor Minh Mang
1841–1843, Hué, Vietnam

View of the doors of the Minh Lau pavilion.

Above, right
Gate to the tomb complex of Emperor Tu Duc
1864–1867, Hué, Vietnam

Even during his own lifetime Tu Duc, a melancholy man, preferred to live in his tomb complex, which was built between 1864 and 1867, rather than in his palace. Unable to conceive a son and heir by any of his 104 wives, he wrote his own epitaph.

Opposite, left
Tomb complex of Emperor Dong Khanh
1889, Hué, Vietnam

Columns decorated with reliefs, with dragon sculptures behind.

Dragon motif

1889, stone, Hué, Vietnam

This stone-carved dragon motif is on the base of the memorial stele of Emperor Dong Khanh.

Above
Tomb complex of Emperor Gia Long

1820, remains of the Elephant Parade, Hué, Vietnam

Gia Long's tomb complex was completed a year after the emperor's death, and because of its secluded position on a hill above the city it is now seldom visited. The tomb is designed in imitation of the architecture of Chinese Ming tombs; in the immediate vicinity of the emperor's resting-place is a lotus pond with five mandarin figures, today headless, as well as figures of horses and elephants, guardians of the dead.

Above left and right

Dragon motif on a roof gable, and wall ornament

Tomb complex of Emperor Tu Duc, 1864–1867, Hué, Vietnam

Right

Thien Mu pagoda

(Also called Linh Mu pagoda, and Thien Mau Tu pagoda), begun 1601, Phuoc Duyen, pagoda tower, Hué, Vietnam

This seven-story, 21-meter (69-feet) high Tower of Good Fortune and Beauty was built in 1844 under Emperor Thieu Tri, at the command of Prince Nguyen Hoang, the governor of Hué. Thien Mu means "pagoda of the heavenly lady, the goddess Mu." On June 11 1963, a young Buddhist monk living there, Thich Quang Duc, committed public suicide in a street in Saigon by burning himself to death.

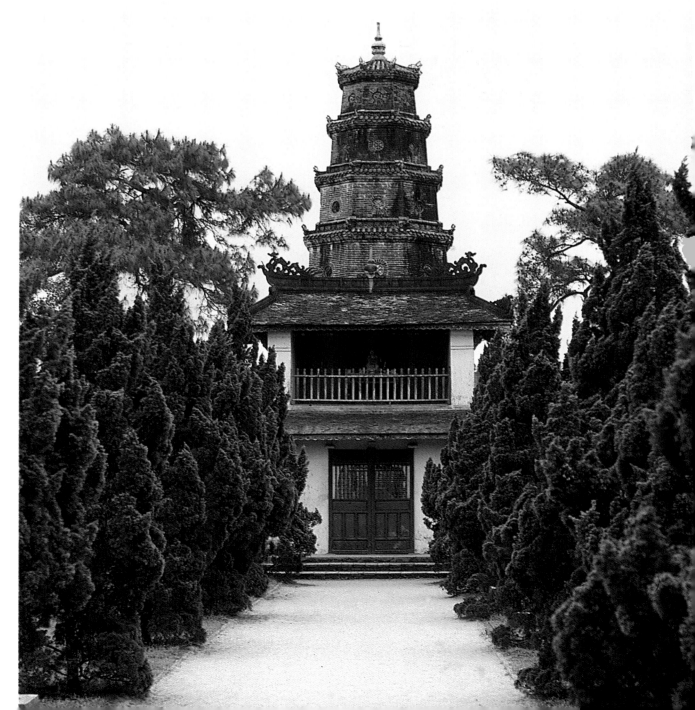

concubines; and the tomb itself. The monument of the long-reigning but unfortunate Emperor Tu Duc (1847–1883) is an exception, however, since it has a lake with a pavilion, which was available as a bathing-house and from which the emperor went fishing (see page 102, right). Even during his own lifetime Tu Duc preferred to live in his tomb complex, built between 1864 and 1867, than in his palace. This suited his melancholy temperament, a natural disposition confirmed by the fact that though he had 104 wives, he had not been able to beget an heir by any of them. Thus he was forced to compose his own obituary for his memorial stele, a duty usually performed by a son. An impression of his frame of mind may be obtained from the last lines of a confession that he wrote in 1867 following the French occupation: "Alas! The centuries are fraught with pain, and man is burdened by fear and woe. Thus we express our [my] feelings that they may be known to the world."[2] Shortly after his death, France was in total control of Vietnam and allowed his successors an existence merely as puppet emperors.

It was the aim of the builders of all tomb complexes to bring the divine nature into harmonious unity with the building works of mortals. One of the best-known literary figures of the country, the former minister of culture Quynh, wrote of this architectural style: "In this tomb [of Minh Mang] all the colors of the heavens and all the tones of the waters are united: it is the blending together of high mountains, dense forests and the wind in the leaves. This tomb is a drama of nature, a jewel created by human hand. It is the work, marked by patience and inspiration, of an artist whose ambition it was to give to the landscape a certain air which allows the waiting soul to awake, which rises above the stillness of this place of mourning, or whispers in the top of a lonely pine-tree. The singular, delicate and carefree feeling which overcomes the visitor to this landscape loosens the tongue of every poet."[3]

The tomb of Emperor Minh Mang (1820–1840) is architecturally the most striking (see pages 100–101 and 102). Arranged in totally symmetrical fashion on a sacred axis, known as a *shendao*, it has an air of great nobility. The tomb, built in 1841–1843, is to be reached by boat across the "Perfumed River," and is one of the best-preserved of the seven tomb complexes in the Hué area. Although the Nguyen dynasty produced 13 rulers, only those already mentioned, Gia Long, Minh Mang, Thieu Tri, and Tu Duc, as well as Kien Phuc (1883–1884), Dong Khanh (1885–1889), and Khai Dinh (1916–1925), were accorded tomb complexes, since only these reigned up to the time of their death. Gia Long's complex was completed in 1820, a year after his

Tomb complex of Emperor Tu Duc
1864–1867, Hué, Vietnam

View from the lake of the entrance to the mausoleum.

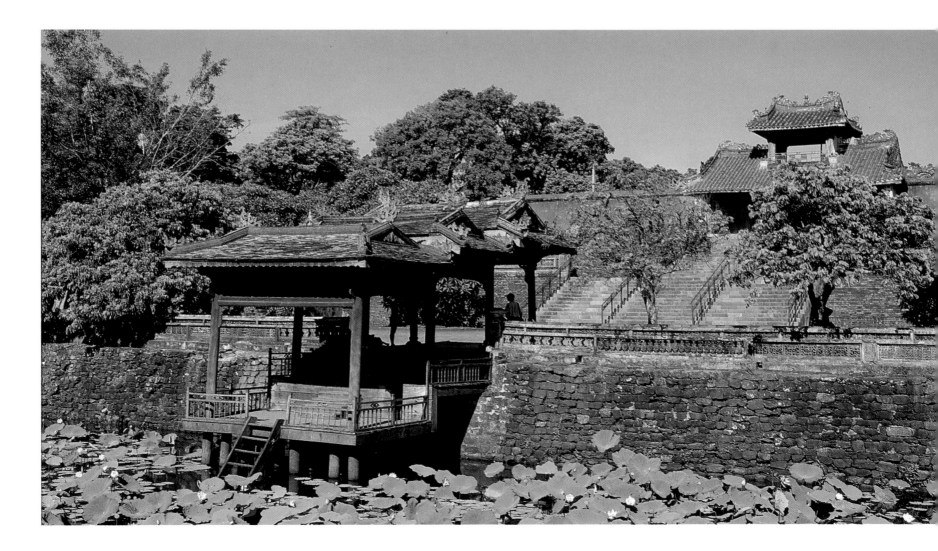

death, and because of its secluded position it is seldom visited (see page 103, bottom right). This first ruler of Vietnam planned that his last resting place should be on a hill, from which he could observe his entire kingdom. The smallest of the imperial mausoleums is that of Dong Khanh, but it is nevertheless one of the most individual, with a fascinating collection of the emperor's personal possessions, which are now on display in the pavilion (see page 103, top right). The tomb of Khai Dinh, the penultimate emperor of the Nguyen dynasty, is the last Nguyen memorial; it is also a curiosity in its own right, for here Eastern and Western architectural styles are mingled in a mighty castle and temple complex constructed in concrete. Nevertheless it is the most lavishly decorated of all the tombs and took a period of 12 years to build, from 1920 to 1932.

Hoi An:
Former Gateway to the West

Originally a seaport of the earlier Champa kingdom, Hoi An, known to Europeans as Faifo, developed from the early 16th century into one of the most important trans-shipment centers in Southeast Asia. Around 1800, however, the city was practically abandoned, since the long-standing power struggles between the rival kings of Vietnam had drastically restricted trade, and as a result the natural harbor eventually silted up; Da Nang now became the leading port. Again thanks to UNESCO, at the beginning of the 1980s a large-scale rescue operation was inaugurated for Hoi An.

The city is divided into five districts on the model of Chinese clans, each district having its own pagoda. It was the Chinese and Japanese who settled here as early as the 16th century and helped Hoi An to attain international significance. The old city today offers a vivid cityscape of temples, pagodas, assembly halls, shrines, clan houses, business premises, and private residences, mainly in the Cantonese style (see below). The best-known building is the roofed Japanese Bridge, which the local residents had built in the 16th century to connect the districts of Cam Pho and Minh Huong (see page 107, top, and bottom right). Begun in the Year of the Monkey (1593) and completed in the Year of the Dog (1595), the bridge has two fine sculptures of dogs at the western end and two monkeys at the eastern end. On the northern side of the bridge is a pagoda dedicated to the protection of sailors.

Phuoc Kien pagoda

About 1690, enlarged about 1900, temple entrance with courtyard. (Phuc Kien Hoi Quan), Hoi An, Vietnam

This pagoda was built in honor of Thien Hau Mau, the "heavenly lady" who was goddess of the ocean and protector of sailors.

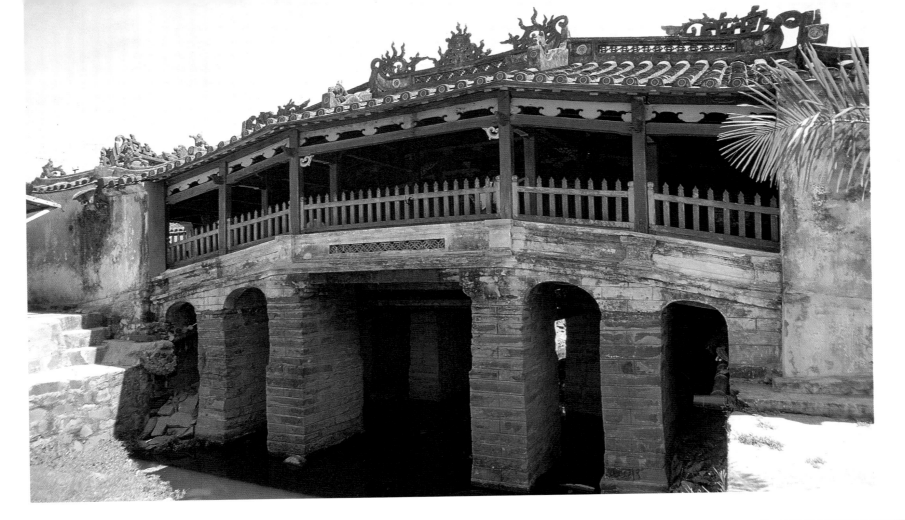

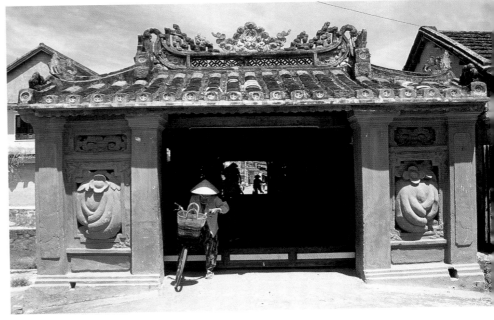

Left
Clan house

About 1700, Hoi An, Vietnam

Top, and above
The roofed Japanese Bridge
in Hoi An

Begun in 1593, Hoi An, Vietnam

The exits to the bridge were decorated
with animals representing the year the
bridge was began and the year it was
completed.

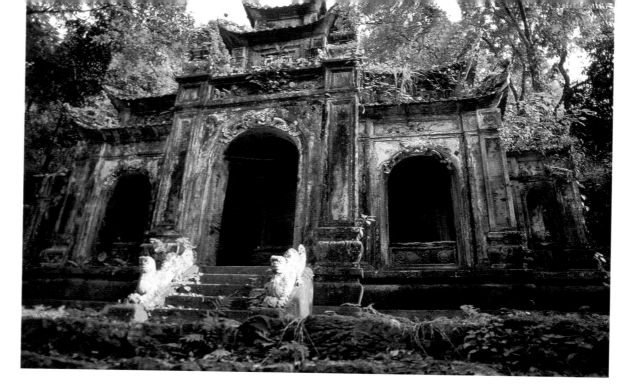

Chua Huong pagoda

About 1575, "fragrant pagoda," near Hanoi, Vietnam

One of the so-called "fragrant pagodas," this was built in honor of Quan Am, the female spirit who protects mothers and children. According to legend, a woman called Quan Am was unjustly turned out by her husband, publicly humiliated, and accused of abandoning her children; she ended her life in a convent. When the Chinese emperor learned of Quan Am's tragic fate, he elevated her into a protective spirit.

Below
River at Danang

(Cue Han, mouth of the river Han), landscape around the river Han, Danang, Vietnam

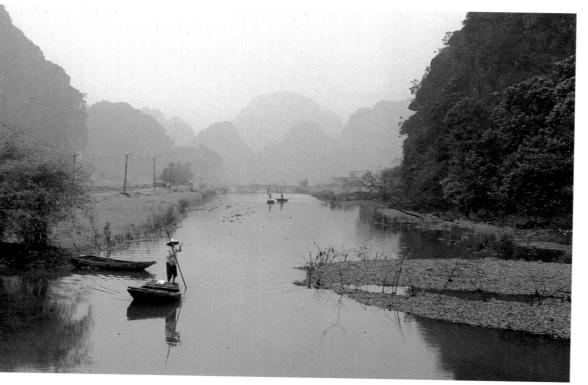

Right
Water puppets

Wooden puppets, Hanoi, Vietnam

Probably the most original theatrical art form is the water puppet theater. This remarkable form of theater is unique to Vietnam and is of great antiquity. The puppets are operated from behind a bamboo curtain.

Of the greatest cultural interest are the private houses, now restored in their original style, along the Nguyen Thai Hoc street. Each of these wooden houses has its own distinctive internal division of space, sculptural decoration, and garden design. The extravagant roof constructions give evidence of a harmonious mingling of Japanese and Chinese styles, which were transformed by Vietnamese architects into a new canon of forms. With their crab-like carapaces, and their *yin* and *yang* tiles (representing the male and female principles, united to bring harmony to the household), the roofs require sturdy roof beams, which are constructed in the Japanese dovetailed manner. The entrance doors are Japanese, the doors to the inner rooms are Chinese, while the Chinese gardens at the backs of the houses are provided with a row of Japanese bonsai trees.

Vietnam and the Land of the Dragon

Vietnam's relationship with China, in the religious and philosophical spheres (the teaching of the Chinese philosopher Confucius (c. 551–479 B.C.) also became decisive for Vietnam), or in the visual arts, often caused its genuine cultural achievement to be overlooked, as for example in literary and dramatic art. Probably the most original theatrical art form is the "water puppet theater." For a long time it was thought that this form of theater also had its origin in China, but more recently it has been proved that it developed in north Vietnam, and goes back to the early part of the first millennium. The surface of the water serves as the stage for the puppets, which are operated from behind a bamboo screen that represents the traditional communal house of a village. The plays, mostly allegorical, are accompanied by traditional music and by popular singers.

A combined natural and architectural feature is found in the Huong Tich grotto near Hanoi, first used over 2,000 years ago. Here there is an

extended temple complex, which comprises several pagodas and Buddhist shrines that are embedded in the limestone rock. Building began in 1575 and the "fragrant pagodas" remain today one of the main religious centers of Vietnam. Another purely Vietnamese phenomenon is the religious sect of the Cao-Dai. The spiritual leader of this sect was an obscure employee of the French colonial government, who in 1919 claimed to have received a message from the divine being, Cao-Dai. From this time on his objective became to unite all the religions of Vietnam under this spiritual being. This synthesis of all world religions and beliefs allows the followers of the Cao-Dai sect to venerate as saints Joan of Arc, Winston Churchill, Moses, Brahma, and Sun Yat-sen. The Cao-Dai cathedral, also known as the Great Temple, is in Tay Ninh, about 100 kilometers (62 miles) northwest of Saigon, and was aptly described by Norman Lewis as "a cathedral… that looked like a fantasy from the brain of Walt Disney, and all the faiths of the Orient have been ransacked to create the pompous ritual, which had been grafted on an organization copied from the Roman Catholic Church."[4]

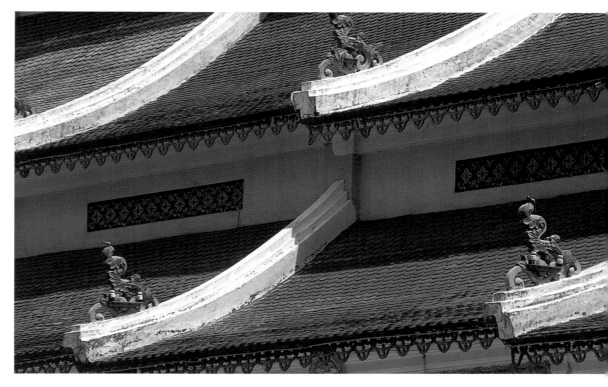

Above and left
Cao-Dai temple
1933–1955, temple, Tay Ninh, Vietnam

"a cathedral… that looked like a fantasy from the brain of Walt Disney, and all the faiths of the Orient have been ransacked to create the pompous ritual."

(Norman Lewis: A Dragon Apparent, Travels in Cambodia, Laos and Vietnam, London 1951)

Loincloth (*cidako*)
belonging to a successful
head-hunter

*Early 20th century, bast decorated with
painted oyale motif, Alun, Ceram,
Moluccas, L 217 cm, B 8–24 cm,
Staatliches Museum für Völkerkunde,
Munich, inv. no. 25-41-22*

Loincloths painted with the oyale motif
could be worn only by headhunters who
had notched up eight successes. They thus
indicated social status.

Textiles in Southeast Asia

The textiles of Southeast Asia are among the most fascinating and diverse cultural phenomena the region has produced. In Indonesia and mainland Southeast Asia both the making and the use of textiles were – and still are – closely linked to the spiritual and ritual aspects of life. Textiles are never just material or articles of clothing, but powerful symbols that both testify to the status or social achievements of the wearer, and also serve as important barter gifts in marriage or death. They play a major role at many rituals, and as a consequence spiritual significance and supernatural powers are often attributed to the textiles themselves.

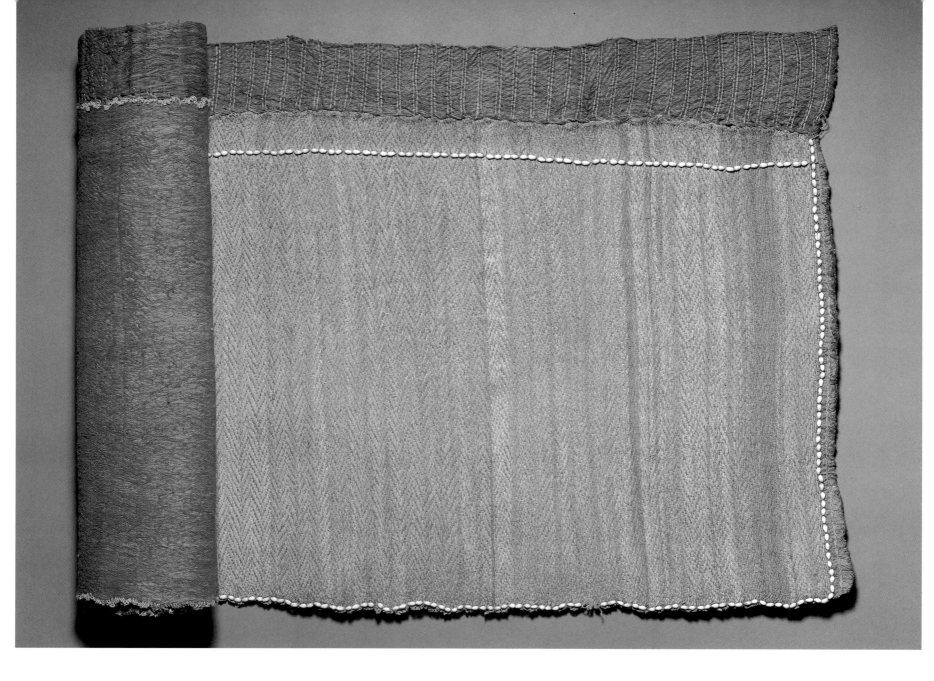

Early Textile Materials, Techniques, and Motifs

Woman's skirt

*Pre-1876, bark cloth, pineapple thread,
Job's-tears, L 124.5 cm, B 44.5 cm,
Mentawai, Staatliches Museum für
Völkerkunde, Munich, inv. no. Gr. 403*

This female skirt already formed part of a
collection before 1876. It is an extremely
unusual example of bark clothing
decoration from Mentawai Island.
Obviously such pieces rarely reached
museums. A further example is in the
Imperial Ethnographic Museum in Leiden,
where it is described but not illustrated in
the catalog.

To understand the development and importance
of textile production in Southeast Asia, a glance
into prehistoric times is necessary. The ancestors
of the textile producers of today lived thou-
sands of years ago on the mainland and islands
of Southeast Asia. Various waves of migration
brought ethnic groups from Taiwan and southern
China into the area, where they mingled with the
established population. These waves of migration
into Indonesia via the Philippines took place
between 3000 and 2500 B.C. The languages of
these early settlers – Proto-Austronesian, Austro-
Asiatic, and Thai-Kadai – formed the roots of
today's Southeast Asian languages, and it was in
this period that the cultural foundations were laid
for a wide range of Southeast Asiatic customs and
techniques, many of which are still clearly recog-
nizable today.

Important aspects of the culture of these early
eras include, for example, the belief in ancestors
and spirits, omens and magic, shamanist practices,

lengthy burial rites, headhunting, tattooing, the
domestication of various animals, early forms of
agriculture, and boat building. A centralized class
system apparently did not exist; rank and authority
were based principally on clans, who occupied
locally defined areas.

Many aspects of early Southeast Asian lifestyles
still exist, and some feature in the textiles of the
region, for example in their motifs and manner of
use. Although textiles themselves have scarcely
survived the millennia in a tropical climate,
prehistoric grave finds of bast beaters and clay
spools suggest that the production of bark cloth
and woven fabrics was common to the ethnic
groups who migrated southwards. Significantly,
many patterns and motifs known from ceramics
and metal objects from pre-historic, neolithic,
Bronze Age, and Iron Age finds still crop up on
modern textiles. Though archaeologists consider
this prehistoric period to have come to an end
around the time the Christian era began, because

of the growing influence of India and China, the materials, techniques, and motifs themselves used in textiles indicate that they have been handed on from prehistoric times to today.

Untreated leaves and plant fibers were no doubt the earliest form of clothing, and simple loincloths made of leaves and plant fibers were worn in remote areas of Southeast Asia into the 20th century (for example in Mengano and Mentawai off the west coast of Sumatra, on Luzon, Palawan, and Mindanao in the Philippines, and among the Sakai in Malaysia). It may be assumed that this kind of clothing was worn in neolithic times by the early inhabitants of the area, who were absorbed by the technically more advanced immigrants.

Bark bast

The making of bark cloth with the help of bast beaters and the weaving of plant fibers were techniques known to these advanced peoples. The plants used included certain types of fig tree (the *Ficus* species); the bread-fruit tree (*Artocarpus*); and, above all, the paper mulberry tree (*Broussonetia papyrifera*), which is among the earliest cultivated plants of an area extending from Southeast Asia to Polynesia. Moistening and beating the bast produces a kind of matting, several layers and strips of which can be sewn together. This material was used for loincloths, headbands and scarves, jackets, blouses, and skirts. A very rare example of decorated bark cloth is the female skirt from the small island of Mentawai, west of Sumatra, and now in Munich (see opposite). The bark cloth was delicately embroidered on one side with thread made of pineapple fibers to produce a herringbone effect, and was then painted. Hemming was done with a grass known as Job's-tears (*Coix lacryma jobi*). The embroidery threads are scarcely visible on the other side. The only other record of such a piece is found in the catalog of the Imperial Ethnographic Museum in Leiden. The garment was delivered there

Blouse

Acquired in Borneo in 1904. Bark cloth reinforced with embroidered lines, L 47 cm, B 48.5 cm (not including sleeves), Staatliches Museum für Völkerkunde, Munich, inv. no. 17-27-13

At the armhole of both sleeves of the blouse, pieces of natural colored cotton material have been inserted, for cotton wears through less easily than bast at the shoulders and armpits.

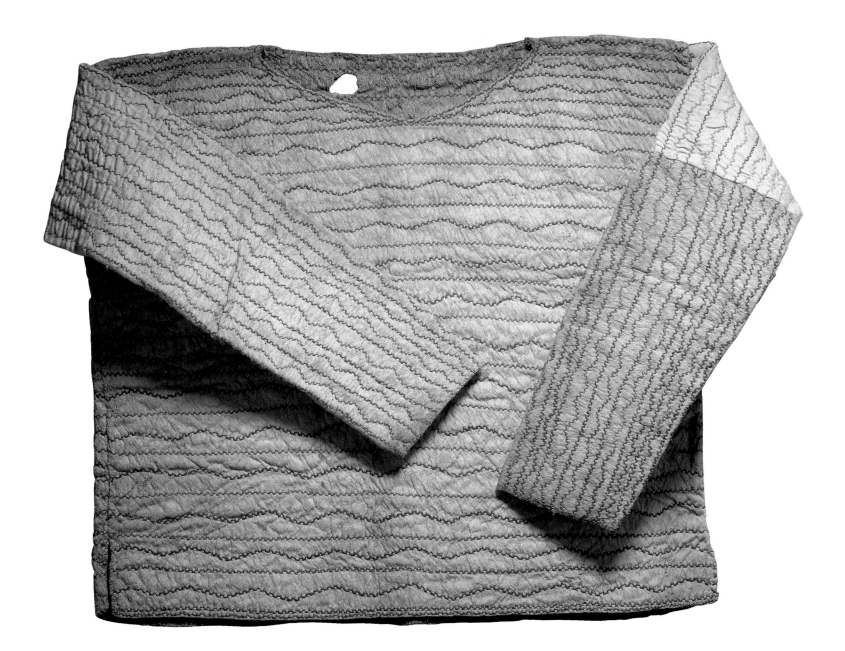

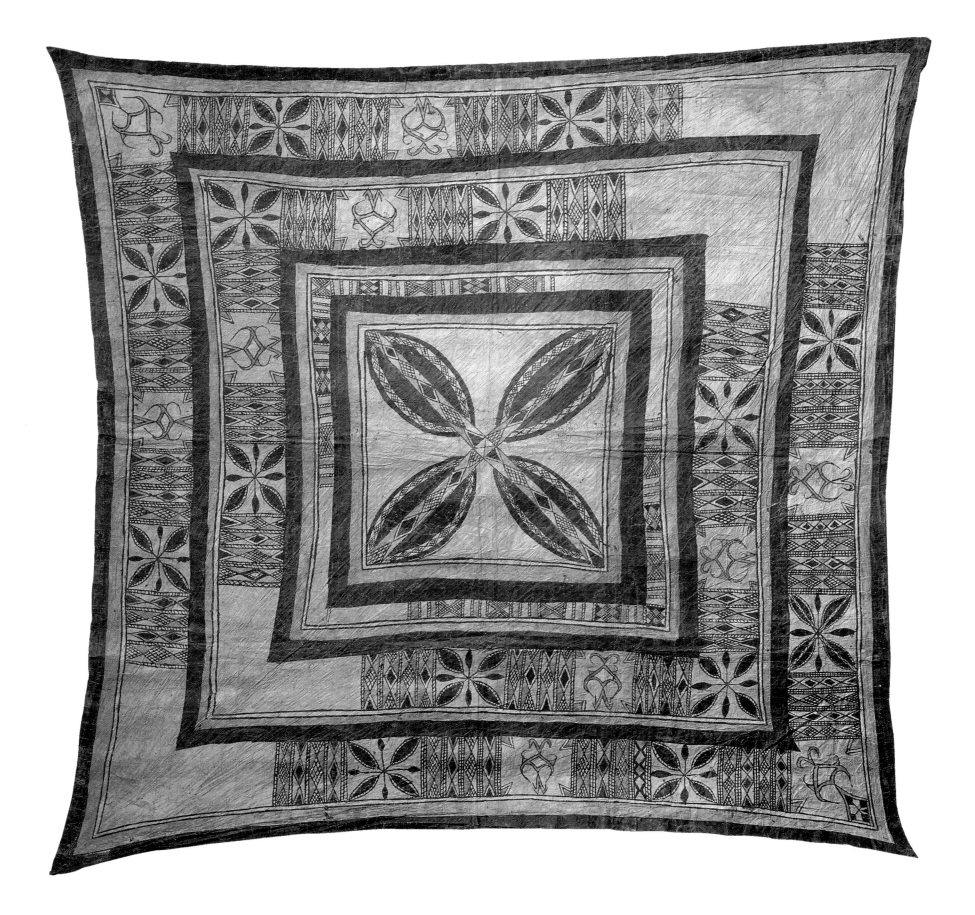

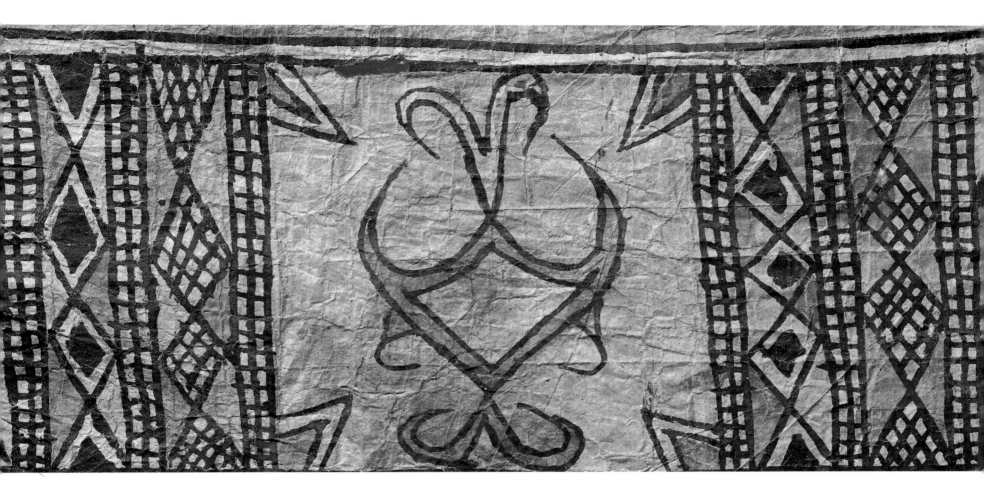

described simply as *lemba* (a wild marsh grass), and as coming from the island of Nias, just off Sumatra. However, a description of female clothing on Mentawai suggests it originated from there.

A further example is a bark cloth shirt from Borneo, which is reinforced with straight and undulating embroidered lines (see page 113). Pieces of natural-colored cotton have been inserted at the tops of the sleeves, possibly to make them harder wearing. Writing in the 1930s, Gerald Tichelman observed that the Toraja on Sulawesi could wear a skirt made from a properly processed piece of bast for about seven to eight months; blouses did not last as long as they wore through easily under the arms and on the shoulders.[1]

In central Sulawesi (an island east of Borneo), men among the East and West Toraja wore at ceremonies square headscarves made of paper-thin bast (*fuya*) that was painted (see opposite and above). Up to the end of the 19th century, the painted decoration related to the number of headhunts in which a man had taken part. Thus a design known as the "buffalo head" motif (*petonu*) could appear on the scarf only after its wearer had taken part in five successful headhunts. The central motif represented on such scarves is the betel leaf, which was used, in a long-established tradition in Southeast Asia, as an accompaniment to chewing betel nuts. The scarves also feature the ears of the water buffalo. On the scarf illustrated here, the buffalo motif appears ten times in all (see above). Other motifs represent the sun or valuable glass beads.

Tichelman and Kooijman are of the view that the buffalo head motif of central Sulawesi is related to the *oyale* motif of the Alun on West Ceram in the Moluccas (Spice Islands). The *oyale* turns up on loincloths (*cidako*) worn only by very successful headhunters on festive or ceremonial occasions (see page 110). The cloth was wound between the legs and around the waist, leaving one end dangling in front. Sewn into the part at the back was a slightly curved, oval piece of bark, to give the *cidako* support. The motifs painted on the back piece and ends related – as with the To Bada on Sulawesi – to participation and success in headhunting. After such a headhunt, the men returned to the village with their trophies, whereupon a feast was given. The headman of the village then painted the *cidakos* of the men with the appropriate symbols. For instance, two yellow diagonal stripes meant its wearer had touched a cut-off head during the hunt. A circle (*toune*) indicated that a head had been carried off. A man who had notched up at least eight heads was finally able to display the *oyale* motif.

Several authors are of the view that the interpretation of this motif as a buffalo head is a later gloss, for buffalo were introduced to Sulawesi relatively late. Tichelman at least has no doubt that these motifs constitute ancient cultural elements, possibly dating back to neolithic times, and that they were originally connected with deeply rooted social institutions, particularly those relating to headhunting.

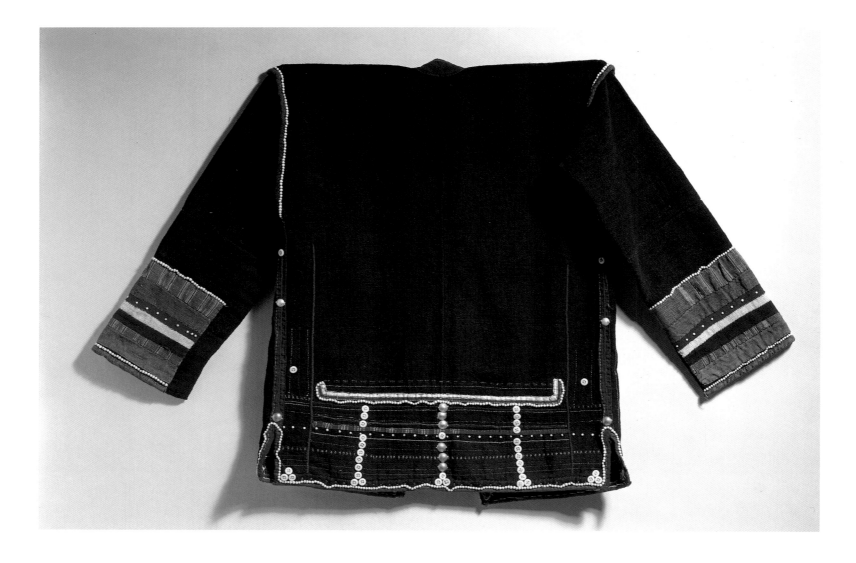

Plant fibers

Along with processing bast, weaving plant fibers must have been one of the early techniques for making clothing. Simple weaving devices, the horizontal back-slung looms with continuous lengths of warp, are found all over Southeast Asia and Micronesia as far as Melanesia. Many of the motifs and raw materials also occur outside Southeast Asia in the Pacific region, so that a Pacific origin may be presumed.

Whereas cotton reached the archipelagos of Southeast Asia relatively late, there were many species of fibrous wild plants suitable for weaving. They are treated even today without the use of a spindle, in other words by knotting and rolling on the thigh. Hemp, which is found beneath the bark of a species of cannabis (*Cannabis sativa*), is the preferred material among the Hmong of northern Thailand for their batik pleated skirts, though cotton is also used. The Atayal of Taiwan also make ceremonial wear out of hemp fiber (see pages 118 and 119). Another favorite bast fiber is *abaka*, though the best known is Manila hemp or manila, which was exported from Luzon in the Philippines in the colonial era. This is cut from the leaf sheath of a wild banana species (*Musa textilis*), dried, divided into fibers, then twisted into the lengths required for weaving. On Mindanao, the

fibers are used not only for thread but also as bindings for *ikat*, a decorative technique in which the patterning of the threads is produced by dyeing them before weaving. On Borneo, a wild marsh grass called *lemba* (*Curculigo latifolia*) is used for weaving. The Benuaq call it *daun doyo*, and use it to make *ikat* fabrics for women's skirts, and in earlier times used it for ceremonial garlands as well. On Tanimbar in the southern Moluccas, it is the threads of the Palmyra palm (*Borassus flabelliformis*) which is served (has other pieces of thread tied round it to form a pattern) and then dyed for use in *ikat* fabrics. In East Indonesia, fibers from banana plants, pandanus palms, and sago palms, plus other lesser known plants, are used. Throughout Southeast Asia, processing fiber and weaving traditional textiles is traditionally the province of women.

Dyes

One of the most important stages in making textiles is the dyeing of the fabric or (as in the case of many of the early forms of patterned textiles) the dyeing of the yarn before weaving. In Southeast Asia, there are numerous strong natural dyes and mordants available. In combination with natural-

Above
Woman's jacket
Rear view, about 1960, appliqué work, embroidery and sewn-on Job's-tears, silver buckles and European shirt buttons, L 65 cm, Phami-Akha, northern Thailand, Staatliches Museum für Völkerkunde, Munich, inv. no. 85-306 297

Opposite
Song shawl
(Detail), about 1960, glass beads, cowry shells, beetle wings; L 136 cm, B 14 cm, Pwo-Karen, northern Thailand, Staatliches Museum für Völkerkunde, Munich, inv. no. 85-306 373

Textiles like these show the imaginative use of natural products such as beetle wings and the seeds of Job's-tears grass in adorning clothing, but also commercial goods such as cowry shells, glass beads, and European shirt buttons.

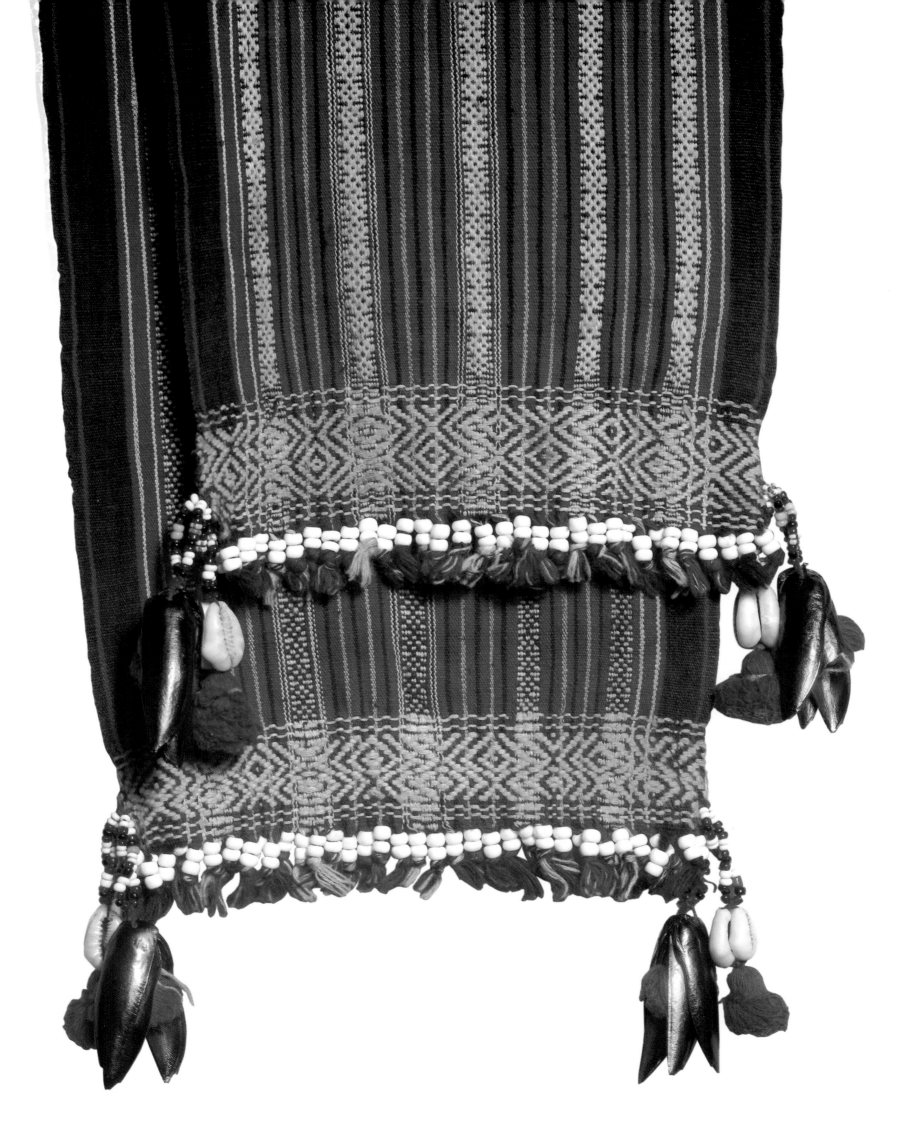

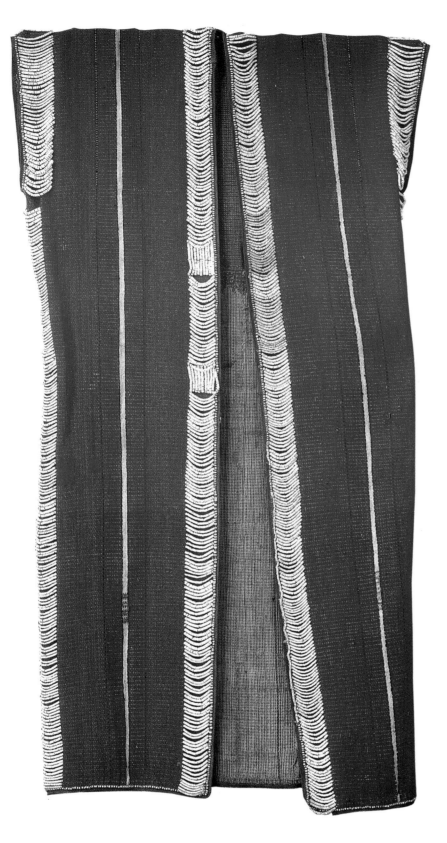
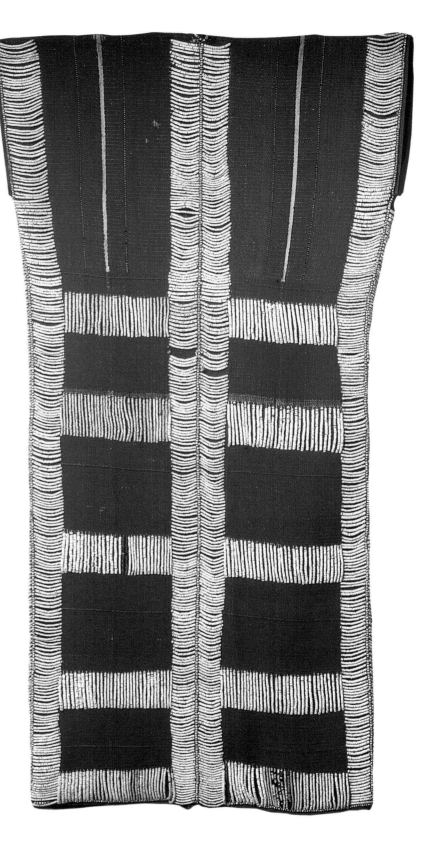

Ceremonial sleeveless jacket
for men

*Front (left) and back, 19th century?,
acquired 1984, decorated with mussel
beading, L 96 cm, B 52 cm, Atayal, central
Taiwan, Staatliches Museum für
Völkerkunde, Munich, inv. no. 84-303 412*

Sleeveless jackets decorated with mussel
beading were used among the Atayal as
ceremonial garments. They were also
regarded as highly prized status symbols.

colored, undyed thread, blue-black, and red-brown shades are preferred.

Blue-black shades were obtained with mud and types of indigo, for example *Indigofera tinctoria*; and red-brown shades from bark and roots of particular species of tree such as *Morinda citrifolia*, *Caesalpina sappan* and *Pelthophorum ferrugineum*. *Lakshadia chinensis*, a scale dye secreted by the female scale insect in certain trees, is the most popular red dye in mainland Southeast Asia, though it is also found in Indonesia.

Bühler believes that indigo has a longer tradition in Southeast Asia than red dyes, even though in many regions red was later preferred for ceremonial fabrics. However, the combination of natural color with blue-black or red-brown shades seems to be the earliest, and is certainly the most widespread.

Fruit seeds, mussels, shells, and glass beads

Along with the decorative techniques already mentioned, such as embroidery, painting, and reserve patterning with *ikat*, it was common even in the earliest periods to decorate clothing with fruit seeds such as those of the grass Job's-tears, with polished mussels and other shells, and with stone and clay beads. Beads of glass, gold, and semiprecious stones imported from India were later additions to the range. The garments, accessories, and jewelry thereby acquired an economic, spiritual, and ritual value. Native materials like Job's-tears and nassa shells are still used today, though combined with more recent materials such as small white European shirt buttons (see in particular pages 117 to 120).

Young women of the Pwo-Karen in northern Thailand wore (and still wear) "song shawls" at burials, which are decorated not only with glass beads and cowry shells but also with shiny green beetle wings (see page 117).

Often, garments decorated with mussels, shells, and glass beads could be worn only on ceremonial occasions, their main function being to protect the wearer against malign influences. They were also used as objects for ritual exchange, and thereby indirectly as currency. The Atayal of Taiwan, for example, made long, sleeveless jackets for men (often interpreted as warrior jackets) woven of hemp and wool and decorated with fine mussel beads. As highly prized status symbols, they served as ritual barter objects in exchange for pigs (for example in marriage negotiations), or as fines for a breach of traditional laws. In the currency system of the Atayal, 50 bunches of mussel beading each containing ten strings were needed to decorate a beaded skirt and twice as many for a jacket such as shown here (see opposite, and right).

In metaphorical terms, mussels, shells, and glass beads are "hard" objects, and so classified as "masculine," as were ivory, metal ornamentation, and weapons. Textiles, on the other hand, were classed as "soft" and therefore "feminine." Thus, the making of fabrics decorated with mussels or glass beads required the cooperation of both sexes, and thereby symbolically unites the realms of masculine and feminine. The role of men in producing or trading mussels, shells, and glass beads complements the exclusively female tasks of processing fiber or cotton and weaving.

A good example of the multiple use of a ceremonial object made of glass beads is the *kandaure* of the Sa'dan-Toraja in central Sulawesi (see page 120, right; and page 121). Very exceptionally, *kandaure* are made there by men, in which case a funnel-shaped bamboo frame is used. Above the *pa'sekong* spiral motif is a row of anthropomorphic figures, possibly representing ancestors.

Kandaure seem to symbolize prosperity and abundance, and are worn by female dancers at numerous ceremonies as back decorations, the cords of glass beads being knotted at the breast. They are also hung up on long poles at burials; or, during the *merok* or *maro* ceremonies intended to ensure the prosperity of a family, on the clan houses. On such occasions they are draped over a funnel-shaped bamboo frame so that the anthropomorphic figures stand upright on the upper edge. This was possibly their original use.

On Borneo, glass beads were valuable barter goods; they were treasured as family heirlooms and only disposed of in emergencies. They were thought to ward off evil spirits and illnesses, and were worn as amulets. Clothing decorated with glass beads was purely for ceremonial wear, and likewise provided protection against evil. Many glass beads rated very highly indeed: a single glass bead of this sort could be traded for a slave, or a buffalo, or a bronze gong. The natives knew the value and appearance of individual types of glass bead so intimately that they themselves recognized deceptively similar imitations at the first glance and refused to accept them.

Not only clothing and jewelry were decorated with glass beads, but also objects of everyday use such as betel bags and baskets (see pages 122 and 123). The custom of chewing betel goes back a long way in Southeast Asia, probably to prehistoric times, and so do the utensils associated with the practice. Artistically wrought bags, little baskets and their covers were designed to carry, store, and offer betel nuts, betel leaves, and chalk, which when chewed together have a slightly intoxicating effect. The custom of chewing betel has assumed ceremonial significance, and the ingredients are components of many offerings to deities, ancestors, and spirits.

On the small island of Sawu west of Timor, during the processes of dyeing and weaving, betel sacrifices were placed on the roof of the house, where benign spirits were to be found, and also on the corners of the loom, to ward off evil spirits that might mix up the threads. Among the Iban of Borneo, betel palm blossom is used for fortune telling, and betel nuts form part of sacrificial offerings that are covered by ceremonial textiles (*pua*) with magic powers. On Sumba and Timor, betel bags are part of the burial goods for powerful

Ceremonial jacket for men

(Detail), back, 19th century?, acquired 1984, decorated with mussel beading, L 96 cm, B 52 cm, Atayal, central Taiwan, Staatliches Museum für Völkerkunde, Munich, inv. no. 84-303 412

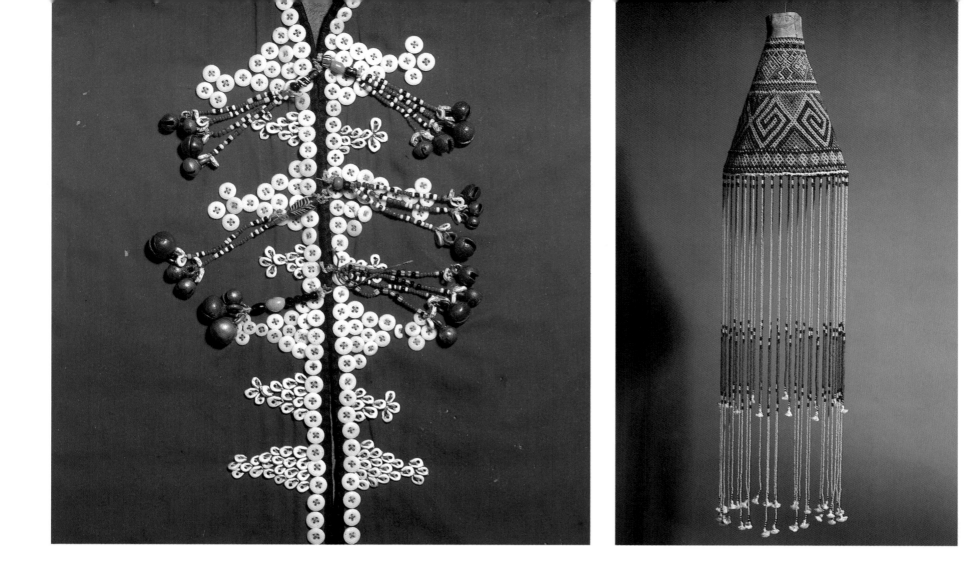

rulers, and are also hung up on the central pile of the house as symbols of departed ancestors.

In many Malay and Indonesian languages, the expression *meminang* ("offering betel") is equivalent in meaning to "ask for a woman's hand in marriage." In such situations, if the family of the man offers betel and the woman's family accepts, then the first necessary step has been taken and further negotiations can now take place. Betel baskets and chalk cylinders covered with beaded material are used at home for offering betel, while betel bags with drawstrings and carrier straps are used for those on the move or traveling.

Cotton Work

There are indications that the production of cotton and the use of indigo and red mordants – even if known earlier – were revived under Indian influence. The word for cotton in many local languages of Southeast Asia seems to be derived from the Sanskrit word *karpasa*, "cotton shrub, cotton" (*Gossypium herbaceum*). Among the Ifugao in north Luzon, the word is *ka'po*; on Flores *kapek* or *kapa*; on Roti *abas*; and on Bali *kapas*. The spinning wheel was almost certainly introduced from the Indian subcontinent, since it is designated by words that derive from the Indian words *jantra* and *chakra* (both meaning "wheel"): *jantre* in Bali; *jata* in Ende on Flores; and *cerka* among the Gayo on

Sumatra. The spinning wheel gained a foothold moreover only in areas affected by trade routes, such as Ende and Sikka on Flores, whereas more remote areas on the same island stuck to manual spindles. The same applies to mainland Southeast Asia, where for example the Karens used the spinning wheel but the more remote Akhas continued with spindles. The word for indigo can be words derived from Sanskrit *nila* or Pacific words such as *taum*, *tayum*, *tarum*, or *tarung*.

As already mentioned, the work of manufacturing cotton fabrics, ranging from planting the cotton to weaving the finished fabric, was entirely a matter for women, and was linked with ceremonial rites at every stage.

Processing cotton, and warp ikat making in the Sikkan area of Flores

As an example of the way cotton was processed, we can look at the traditions of the women in the Sikkan area of central Flores. They have been chosen because one of the first descriptions of the processes was written by Käthe Tietze, the wife of a German doctor active on Flores in the 1920s and 1930s, who donated part of her collection of textiles to the Staatliches Museum für Völkerkunde in Munich.

Although she was not a trained ethnographer, as a woman Tietze had access to information that had remained largely concealed from male field

Above left
Woman's jacket

(Detail), front, about 1910, decorated with nassa shells, European shirt buttons, glass beads and brass bells, L 54 cm, B 46 cm (excluding sleeves), Dayak, Borneo, Staatliches Museum für Völkerkunde, Munich, inv. no. 10.820

Many glass beads were very highly prized in Borneo. One such bead might be traded for a slave, or a buffalo, or a bronze gong. The natives knew the value and appearance of the genuine article so precisely that they were not to be taken in by imitations.

Above right, and opposite
Ceremonial piece (*kandaure*)

1st half of 20th century?, acquired 1989, L 104 cm, B 34 cm, Sa'dan-Toraja, Central Sulawesi, Staatliches Museum für Völkerkunde, Munich, inv. no. 89-312 251

Kandaure were worn by women as decoration during dancing, hanging down at the back with the cords tied at the front. They were also used as drapes during burials and other ceremonies. Made by men, they symbolized the prosperity of a family, and were intended to bring future wealth and fertility.

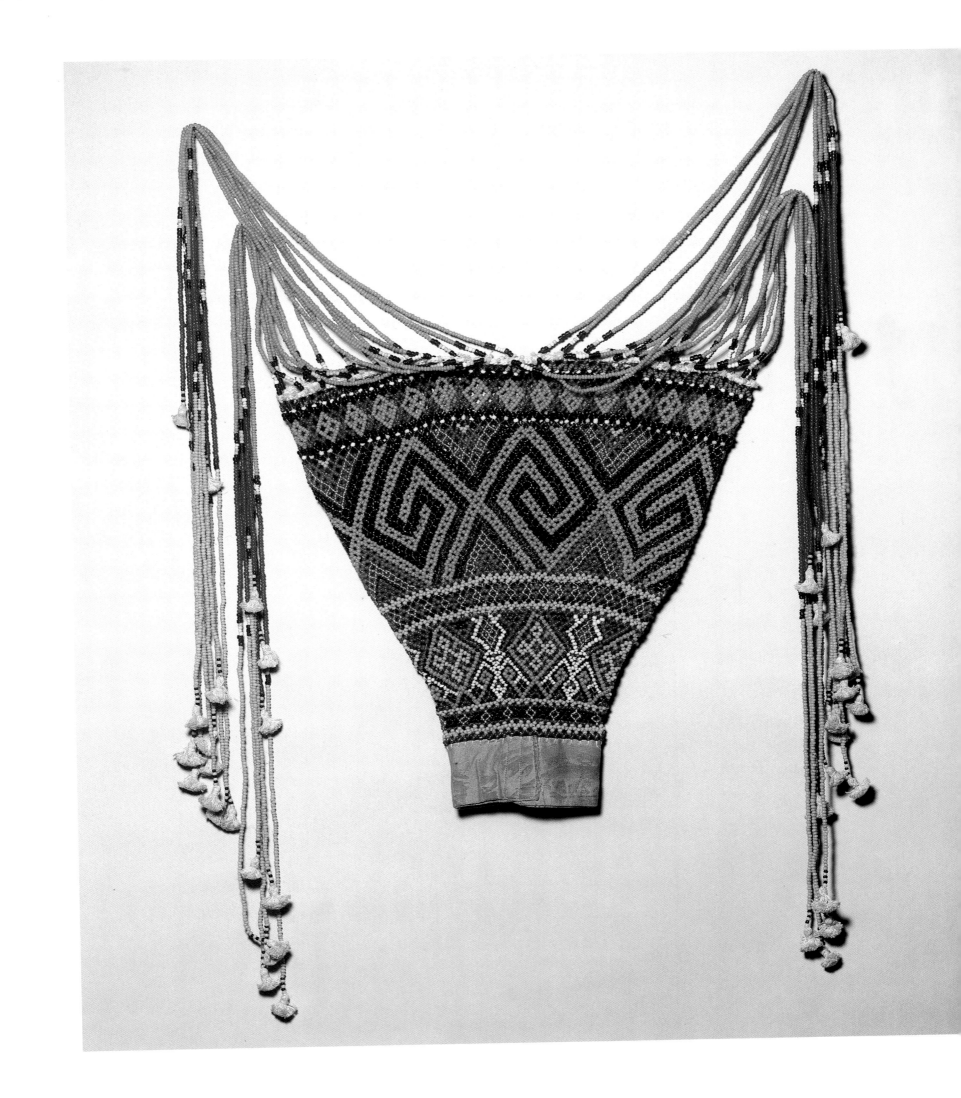

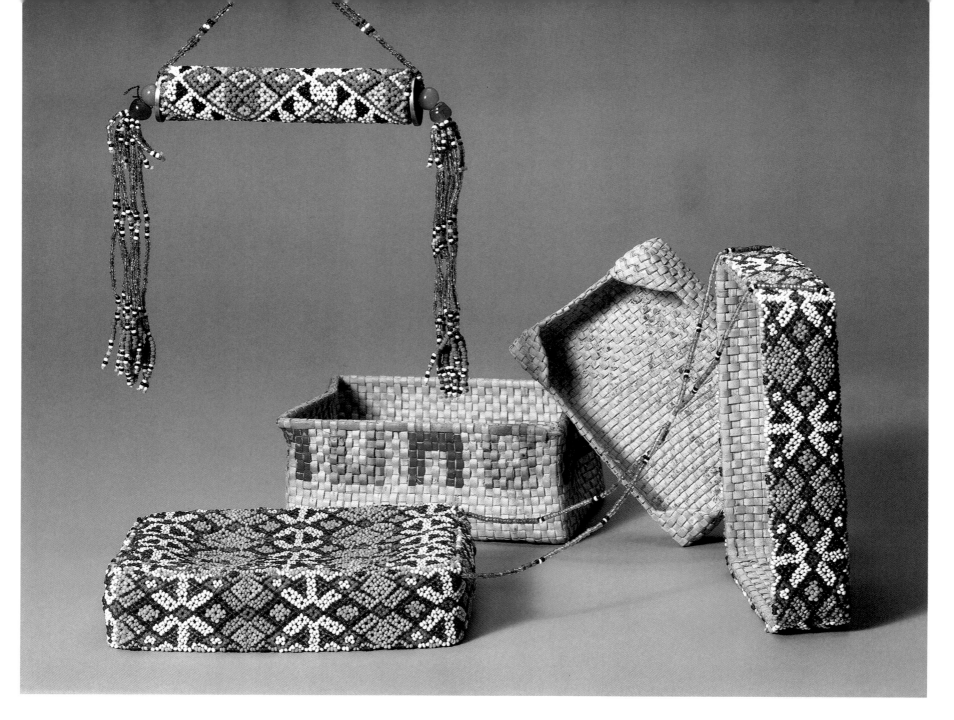

Betel baskets and a chalk cylinder

Early 20th century, Palmyra palm weaves and bamboo, covered with glass-beaded fabric, L. 13.5 cm and 10.5 cm, Atoni, Timor, Staatliches Museum für Völkerkunde, Munich, inv. no. 28-30-40 and 28-30-46

Betel has a long tradition as a luxury article in Southeast Asia. The betel nut, betel leaves, and chalk have a slightly intoxicating effect when chewed together. Offering betel assumed ceremonial significance, and great artistry was used in the plaiting and weaving of them, and in their decoration with glass beads.

workers. No doubt a further factor was also that in her ten-year stay on Flores she gained the trust of the local women. Although cotton is still home-produced and processed on Flores – especially for textiles to be used as bridal gifts – these days it is mostly imported thread that is bought in the market or in shops. That is why the past tense is used about cotton processing and the relevant ceremonial rites associated with it.

Tietze describes how every phase of the cultivation of cotton, from sowing through weeding to harvesting, was decided by watching for good and bad omens, and was accompanied by sacrificial acts and magic formulae to ward off evil spirits, conjure up the good ones, and keep off the rain so that the cotton should not get wet before the harvest. On the first day of the cotton harvest, a sacrifice was offered to the ancestors in the fields in gratitude for the harvest, and the women would often dance the whole night away before bringing the harvest home.

After that, the cotton was left to lie for a while so that it could recover – it was believed – from the effort of germinating, growing, and developing.

After an auspicious day had been selected for beginning the work, wicker mats were spread out in front of the hut, and work began on peeling the balls of cotton (*nemit kapa*). The down of the cotton was grasped firmly and pulled from the husk in a single go. The down was them spread out on the mat and placed in the sun. "You have to put the cotton in the sun so its warmth makes the cotton strong,"[2] it was said, and three days of sunshine were allowed.

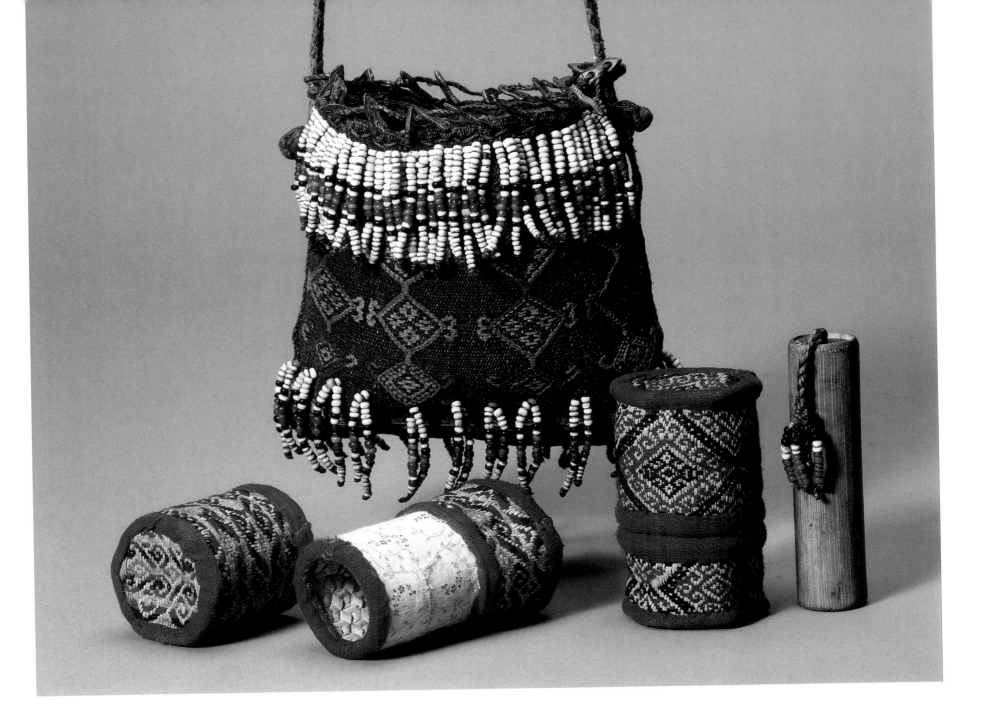

Getting rid of the cotton seeds

Following this, the cotton was put through a small gin (*ngeung kapa*). The woman of the house fetched the gin and placed it on the veranda of the house. If she was training a daughter, then mother and daughter would first chew betel together (*sirih-pinang*). Only a marriageable daughter would be trained to process cotton, and only after that was she allowed to chew betel from time to time. After this first joint betel chewing, the mother would explain to her daughter how to use the gin. Despite its simple, practical design, operating the gin was not easy. Only after extensive practice could a novice work it as quickly and effortlessly as the older women. The gin consisted of a wooden frame that held two helical rollers set one above the other (see page 128). When turned, these rollers turned in opposite directions; a winder cranked the lower roller, whereupon the upper roller also started to move. The cotton down was

now passed through the rollers a piece at a time; the pressed-out seeds fell on the ground in front of the gin. The compressed cotton dropped into a basket and was then examined for impurities. It was assumed that the amount of cotton required for a sarong took five days to process through the gin. Once the mother thought her daughter had watched long enough, she made way for the daughter so that she could try operating it herself. This was a kind of baptism of fire for the young girl. If she got her fingers between the rollers, she might be subjected to a humiliating torrent of abuse from her mother and the neighbors.

Flailing the cotton

Once enough cotton for a sarong had been processed, work began the next day on flailing (*tutu kapa*) the cotton, using *rotang* canes (see page

Betel pouch with portable betel case and chalk cylinder for carrying around

Early 20th century, cotton, glass beads, Palmyra palm weave, bamboo, pouch, L 13 cm, B 15 cm, Timor, Staatliches Museum für Völkerkunde, Munich, inv. no. 32-28-2 a-d

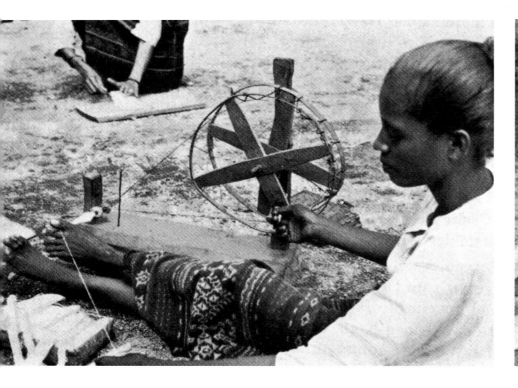 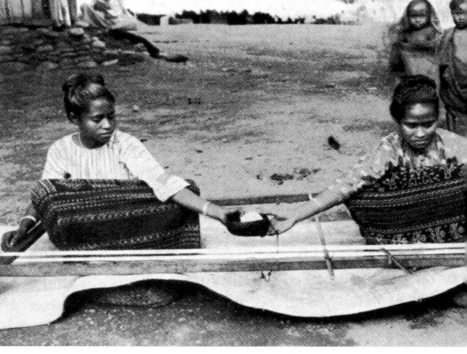

Spinning the cotton

129, top left). These *rotang* canes were handed on by mothers to their daughters, and were considered as valuable as the family jewelry. The fact that her mother had used the canes for her work year in, year out led the daughter to believe that her mother's soul was closely associated with them even after her death. An offering was therefore made of rice, fish, fruit, and a piece of cloth, asking the departed soul to ensure the success of the work. She and her own daughter would then chew betel together because success in flailing the cotton, more than in any other task, depended on mutual harmony. Also, red betel-stained spittle drove away the evil spirits, the *ueng*.

The women then got down to work seriously and collectively, anxious not to lose the beat. But after making the same movement for hours, the wild rhythm and the heat tended to encourage them to change the beat and follow one rhythm of stroke with another. When the cotton for a sarong had been beaten flat to form a thick layer, it was the custom on the third evening to dance the night away with the *togo* dance.

Rolling up the beaten cotton

These *tutu kapa* (flailing) festivities were followed by a day of highly monotonous work. The beaten out layers of cotton were loosened with a cotton bow, after which the layers were divided into hand-sized pieces and wrapped firmly round a wooden spool[3] (see page 129, top right). Once the rolled-up cotton was thick and firm like a fat cigar, the spool was withdrawn and the roll was added to the others in a wicker basket. The tedious work was enlivened by a constant flow of anecdotes and gossip.

As soon as the cotton had been wound into rolls, spinning began. Spinning enough cotton for a sarong was reckoned to take four weeks. Both the spinning wheel and the manual spindle were used, though the method of making thread was the same (see above, left).

It required not just care and endurance to spin properly, but also skill and strength. Constant practice, however, soon meant the daughter would get steadily better, spurred on and taught patience by her ambition to be regarded as a fluent, talented spinner. To be accepted as a good spinner enhanced not only the daughter's marriageability, but also the reputation of her mother and her family.

However, if a mother found herself forced to acknowledge that, despite all her efforts and patience, her daughter was not becoming a capable spinner under her guidance, she would become troubled and look for a supernatural explanation. Perhaps a *ueng*, an evil spirit, had attached itself to the yarn and pulled at it till it broke; possibly the *nitu*, the souls of the dead, were taking their revenge on her child because she once forgot to make the offering they had every right to expect. As a punishment for the omission, they had diverted the young girl's thoughts from her spinning and directed them towards other things, so that the strands were spun unevenly and negligently. The mother would then bid her daughter to put out a much bigger and better offering than usual on the sacrificial stone for the ancestors every morning for seven days, and to say as she did so: "I beseech you, souls of my ancestors, accept this sacrifice as atonement for my thoughtlessness. I beseech you, leave flesh and blood on me! For the sake of the ivory tusk that we placed with you in

Left
Spinning with a spinning wheel

Above
Stretching the cotton threads over the warp frame
Eastern Sikka region, pre-1941

The various stages in the processing of cotton (from cultivation of the cotton right through to the finished fabric) took a long time, so that nowadays machine-made cotton yarn or "shop yarn" (*benang toko*) bought in the market is preferred. Only textiles used for trousseaus are still made using home-produced cotton.

the grave as a pillow when you died, for the sake of the journey-money we placed in your mouth when you passed away, for the sake of the seven pants and eight skirts in which we dressed you so you should be received in the realm of your ancestors like princes, I beg you, cool my forehead with the soft wind from Tole Mountain so my thoughts stay bright and clear and undimmed by cloud!"[4]

Once a spindle was spun full, it was taken off and the cotton was rolled up into a ball. This had to be done evenly and roundly so that, when wound on a reel or spool and drawn over the warp frame, it would not jump out of the cotton holder or bowl, thus preventing rapid unraveling. To arrange single-color warps and weft yarns, reels and spools were used. The hanks thus produced were placed in vats (consisting of tree trunks hollowed out lengthways), doused in black pigment and, after being steeped for a while in the dye, were hung up to dry.

Tentering the yarn on the *ikat* frame

The woman of the house would do the job of tentering the yarns for the *ikat* patterning on an *ikat* frame. This was something for which she required the help of a neighbor or her daughter. Usually, filling a frame with warp yarns was reckoned to take three quarters of a day, from the first pig feeding (around nine in the morning) to the last pig feeding (around five in the afternoon). The job was only begun if the auspices had been favorable; offerings of rice, *huler*, and Palmyra leaves and millet were made and prayers said for the success of the undertaking. A suitable place to work was chosen by divination (in this case by casting stones) so that the work could not be interrupted by evil spirits. Mother and daughter also rubbed the leaves from the offerings on their foreheads and mouths so that no evil spirits could wrench thoughts from their heads and words from their mouths, as it was absolutely vital to keep their thoughts on the job while tentering the yarns, and not be distracted by talk and stories, not even a single word.

The *ikat* frame was set up horizontally on stones, the mother seated on one side, her daughter on the other (see opposite right). They began by attaching two separators or ravels in the middle between them. The ball of yarn was placed in a coconut shell that had a hole through which the thread unraveled, the end being then tied to a cross bar on the tentering frame. Before mother and daughter began the work, they swapped betel, as a symbol of peace and harmony, and then began to stretch the threads. The mother drew the thread around the cross bar on her side, pulled it over the first separator and under the second separator, and then passed the coconut to her daughter. The latter accepted the shell of yarn, drew the thread round the cross bar on her side and handed the shell back to the mother below the two separators. The mother once again drew the thread round the cross bar of the frame on her side, but this time

tucked it under the first separator and over the second before handing the shell back to her daughter. Not a word was uttered during these actions. Thus the threads flew alternately over and under the separators of the upper layer of yarn. As soon as the frame was full, the mother drew one thread each through separators, so that the group of even and odd warps were separated and the distribution of the warp yarns was not hampered by the separators.

She now carried the fully laden *ikat* frame on to the veranda of the house and carefully selected a protected spot, because she knew she would be spending a lot of time there in the coming weeks serving the warps.

Only at this point could mother and daughter talk to each other or anyone else again. The mother would talk over with her relatives the question of which day she should start the actual work of serving the warps, in other words doing the *ikat*. As she was usually relieved of all household duties during this period, released from all work in the fields and left alone untroubled by daily worries, it was necessary to ask relatives or neighbors for help, which was then returned in kind when the time came.

Serving the pattern

A mother would only teach her daughter *ikat* motifs from the latter's paternal clan affiliation, as only paternal descent mattered. After the daughter was married – though of course only after she had had a child and thereby become a full member of her husband's clan group – her mother-in-law would teach her the *ikat* patterns of her husband's clan. A married woman could retain the motifs of her paternal lineage as well, but such motifs could have a subordinate role in the total pattern; they

Serving the warp on an upright *ikat* frame

Eastern Sikka region, pre-1941

Tying in the pattern (serving) is even today a long, difficult, and painstaking task, but it is what gives the cloth its unique character and value. A woman with ability, a skillful hand, a steady eye, and a great deal of experience can serve a pattern in three to four weeks, depending on its complexity.

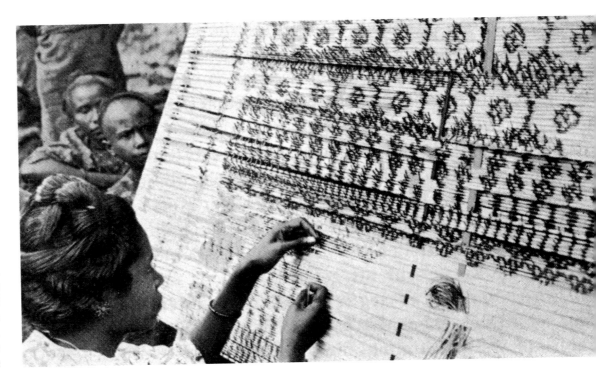

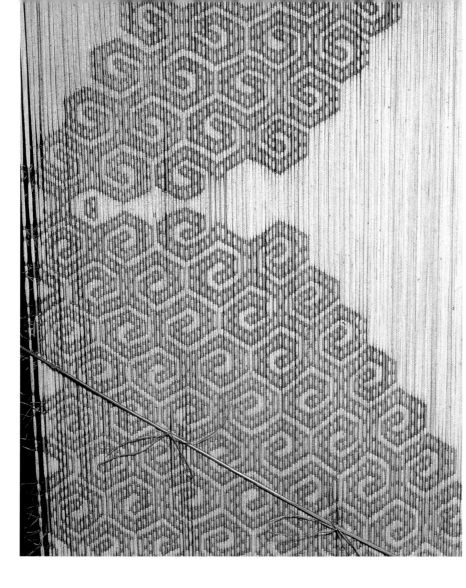

would henceforth indicate what family she originally came from. Apart from this, how she used and arranged the motifs was entirely up to her, and she could allow her talents and imagination free rein.

The *ikat* technique consists of tying a pattern into the stretched cotton yarn by winding bast (*ikat* in Indonesian, *mata perong* in Sikkanese) round it, that is, serving it. Used for this are leaves of the gebang palm cut into strips about two millimeters (0.078 of an inch) wide, or strips of bamboo bast cut to the same width (see above).

Developed *ikat* skills involve pulling the bast tight, evenly and firmly; getting the strips to run across without a gap; tying the knots securely; and using the small but sharp bamboo knife to trim the strips an even two millimeters behind the knots. A woman would read from the *ikat* frame of her future daughter-in-law what feeling she had for tidiness and cleanliness, which is why mothers would put so much effort into teaching their daughters well.

The afternoon before work began on the *ikat* frame, mother and daughter would go down to the river or the sea, have a thorough bathe, wash their hair and dry it in the sun, and rub a liberal helping of coconut oil into it. This thorough ablution was indispensable because they were not supposed to bathe, wash, comb their hair, or remove lice during

the *ikat* period, or at least not until the pattern and its embellishment were laid out. The belief was that washing oneself made the thoughts cold, and that combing shocked the "soul" of the *ikat*[5] and put it to flight.

After completing their wash, mother and daughter put on their work clothes, and would keep them on throughout the coming weeks until the last knot was tied in the *ikat* pattern. If they changed, they could be certain their minds would go blank as they sat down in front of the *ikat* frame, since the soul of the *ikat* would remain in the warmth and security of the old clothes. After changing their clothes, mother and daughter would go home but would not speak to each other or with neighbors or the inhabitants of the house any more, because the soul of the *ikat* would be fluttering around them, wanting to settle down with them; talk and noise would drive it away. For the whole of the following period, mother and daughter would talk only about things that concerned their work. It was strictly forbidden for others to address them or make a noise near them. During the *ikat* period, the woman of the house would sleep with her daughter in the room right at the back of the house, not with her husband. There they would be as far away as possible from the others, and were thus least disturbed and least drawn into domestic matters.

The pattern on an *ikat* frame

(Details), front and rear views, acquired 1988, L 150 cm, B 60 cm, central Timor, Staatliches Museum für Völkerkunde, Munich, inv. no. 88-311 446

The *ikat* technique consists of winding bast round the threads stretched over the frame so as to form a pattern. The bast used is palm leaves cut into strips about 2 mm (0.078 inch) wide. Skill at *ikat* work involved pulling the bast tight evenly and firmly, not leaving gaps, tying the knots securely, and cutting off the rest of the strips at the back evenly about 2 mm from the knot (right).

Before going to sleep, mother and daughter would prepare offerings, and the dreams they dreamt that night counted as good or bad omens for starting work. The next morning at the first cockcrow (about 3.30), mother and daughter would get up and take themselves off to a "sacred grove" (*tuang pireng*),[6] a group of ancient, dark-leafed trees whose roots above and below ground were intergrown into strange, mysterious shapes, and therefore were considered the home of spirits and ancestor spirits. There they would set up a pole on which they placed offerings (chicken liver, millet, fruit, and an egg), while in the hollows of the trees they deposited betel, chalk, and tobacco so that the spirits would look favorably on their request. Then they would pray:

"Ina Yang Gati, thou mother up there at the beginning of the cloud, and thou, Ama Kopa Rae, Father King up there on high, we beseech you, let your radiant countenances be turned towards us! […] Because today the great day has dawned at last which we have awaited with such longing. We have stretched the frame full and should like to begin winding in the threads and tying in the pattern: the sacred pattern on which our progenetrix sits day and night down there in the underworld and warms it and guards it so that it does not run away or get coaxed away by evil spirits with thieving intent. We beg you, Ina Yang Gati and Ama Kopa Rae […] that our bodies be fresh as dew during the *ikat* work, that our thoughts be as unclouded and clear as water from the mountain spring of Ili Gai and that our hands may work nimbly and deftly to captivate our thoughts before they hasten away from us. If we succeed in completing this sacred and difficult task undisturbed, then a splendid reward will be summoned up for you, O ye who live high above us. At the end of the task, we wish to dance the *togo* all night without ceasing, in your honor, and give you as much to eat and drink so that ye can eat no more for years."[7]

After returning home, they would put out further offerings for the progenetrix on the sacrificial stone near the house. Then they would go to the veranda where the *ikat* frame was set up. The woman of the house would hang up amulets and protective charms against evil spirits around the work place and on the *ikat* frame itself. After these precautionary measures, she and her daughter would sit down at the *ikat* frame and solemnly exchange betel. While chewing betel, the two of them would start cutting the strips of bast to shape for serving the pattern. Then the mother would initiate her daughter into the basic features of the *ikat* motifs of her husband's clan group, explaining them with the help of old sarongs, and scratching the drawing with the bamboo knife in a banana leaf to act as a model for the girl. Then the mother would begin to lay out the threads in strips of greater or lesser width with a flat bamboo stick, and then into smaller or greater groups of threads. After dividing up the yarns into lengths, the actual *ikat* work would then begin, that is, tying in the pattern and enwrapping the groups of thread that would be kept out of the first and second steeping in the basic color. First the main motif of the man's family (*mata kuat*) would be tied in, initially just in outline, then worked out in decorative detail without losing the main motif. If the motif of the wife's paternal clan was to be added, this always

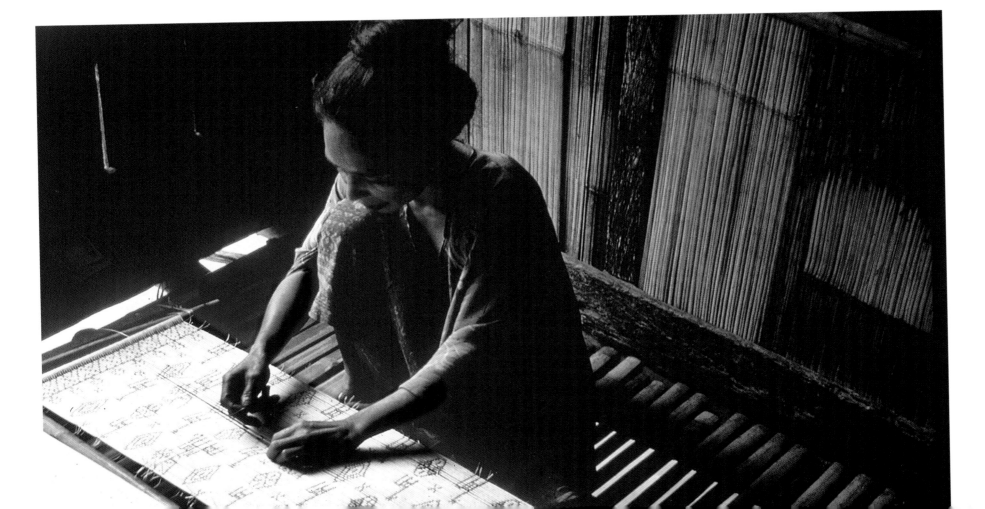

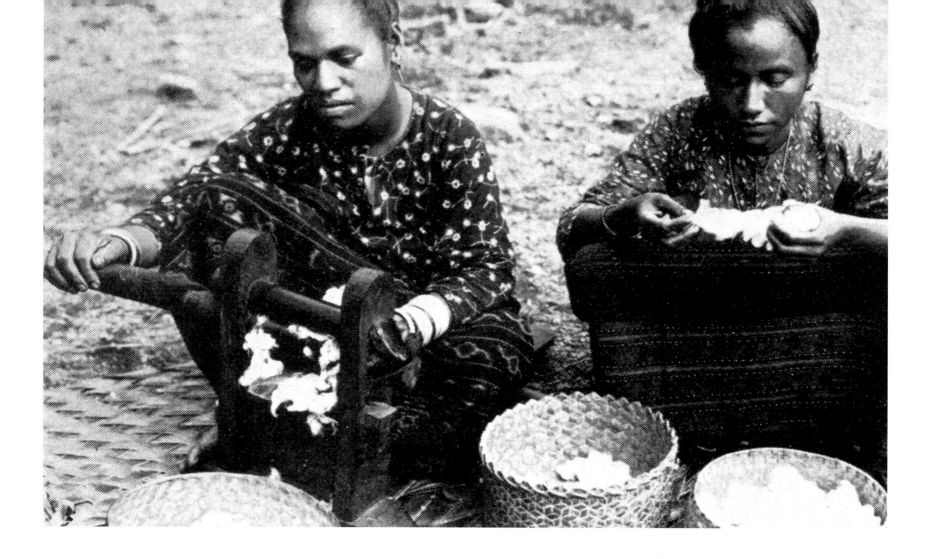

came in second place, and the woman made sure that it occupied a subordinate position to the main motif. It would only be then that she went over to the lengths of yarns, which she could arrange to satisfy her own imagination. It was long, difficult, and painstaking work, but it was the nature of the work that gave the cloth its character, value, and uniqueness, and therefore formed the decisive factor in judging the work. A woman with talent, a deft hand, a steady eye, and experience could *ikat* a standard length of warp in three to four weeks (see page 125). Once the woman had *ikat*ed the full length, she would clap her hands and call to her neighbor: "The great journey is done," in other words: "I've done it!" Then she would go down to the shore, wash herself thoroughly from head to foot and dress in her best clothes, because in the evening the *togo laro*, the "dance for joy," would take place. It lasted till morning, and served as an expression of thanks for the success of the *ikat* work. The following day, the woman of the house would sit down with her female relatives and friends and asked them to give the warp a thorough look over and offer their criticism. On their judgment would depend whether the material should be used for a festive, going-out, indoor, or work garment. The woman would then clamp individual lengths of the warp between small, thin slats so that they did not get mixed up and could be stretched out on the frame again in the same order after dyeing. She then tied or sewed

the slats together, removed the length of warp from the frame, folded it up, and stored it away carefully. Dyeing, which could take years, was done between household duties and work in the fields: she did not have to devote herself to it exclusively.

Dyeing

In the following weeks, leaves and roots would be collected as opportunity offered, and the dye prepared so that it would be to hand and ready for use when there were quiet times in the work in the fields or at home.

The small pinnate leaves of the indigo shrub (*Indigofera tinctoria*, in Sikkanese *tarung*), which grows everywhere in the wild, provided the blue dye. The leaves were steeped for three or four days in an earthenware pot. As soon as the liquid began to ferment, the woman of the house would add chalk and stirred it in with a stick until the mushy mass turned a deep blue color. The liquid was then sieved and the cloudy dye poured through a cloth filter, under which stood an earthenware vessel or large bamboo stem into which the blue dye (*tarung lotang*) could run clear and purified.

The red-brown dye was made from the dried roots of the *kebuka* tree (*Morinda citrifolia*). The roots were beaten with stones until they became soft, then placed in the mashing tub and pounded to mush. Now the woman added water and leaves from the *roma* shrub, stirred everything together

Above
Ginning the cotton

Opposite, top left
Flailing the cotton with *rotang* canes

Top right
Rolling the cotton into layers

Bottom left
Making dye

Bottom right
Weaving a sarong with *ikat* patterns

Eastern Sikka area, pre-1941

Before being spun, tentered on a frame, and served (*ikat*), the cotton had to have its seeds removed (above); then flailed flat with rotang canes (opposite, top left); and rolled up (opposite, top right). Only after being served (see page 125) did preparation of dyes begin (opposite, bottom left), followed by the lengthy process of dyeing, which could take years. The final stage was the weaving itself (opposite, bottom right).

thoroughly and waited until fermentation set in. Having poured the thick, fermented mass into a cloth which she tied up at the top, she then squeezed and twisted the cloth until the viscous red-brown dye seeped through the material, which acted as a filter, as a clear and purified dye that could be collected in an earthenware vessel.

For dyeing, she laid the warp threads in a wooden tub, scooped the dye from the pot beside her with a pumpkin shell, and poured it slowly over the warp threads. As the threads absorbed the dye, it was necessary to feed more dye in a little at a time, otherwise the process might be ruined. The warp would have its revenge for rough treatment: the dye would take only on the outside while sealing the inside, leaving an ugly greyish sheen when the warp dried. Once the warp had been covered with dye in this way, it would remain in the dye bath for some hours. A neighbor would then come and help her remove the dyed warp and, using two bamboo canes, wring it out

thoroughly until no more dye trickled out. One of the bamboo canes would be suspended between two stakes, while the other would be left at the bottom of the length of warp as weighting, until the material was thoroughly dry. It was then taken off and placed in the dye bath again, wrung out, and dried. This process was repeated for three successive days, after which the warp was left to dry for three months, as the dye needed time and rest to bind with the thread and penetrate to its core. The threads, for their part, also needed time to absorb the dye and become united with it. After three month's rest, the dyeing process began again. A sarong became more and more valuable each time the dyeing was repeated. In the case of garments for festive and visiting purposes, the material was dyed 25 times, so that an overall period of six years was required. For everyday clothing, the housewife would be content with dyeing it six or eight times, so that weaving could only take place after two years. Once the warp was

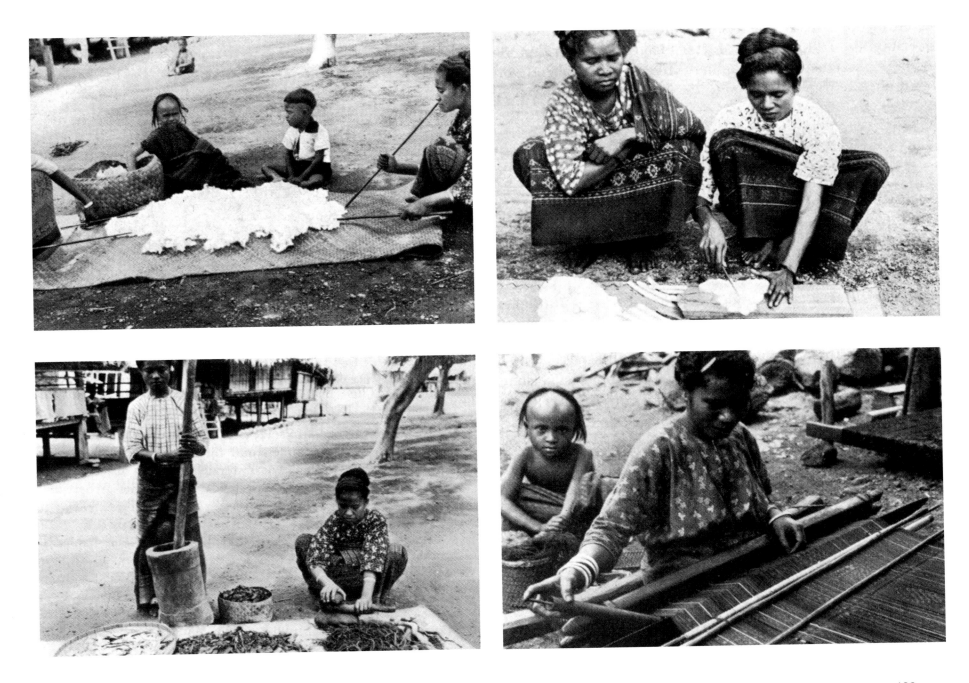

dyed, the colors were fixed by being washed in rice water in which tamarind had been dissolved. Before the warp was woven, it was again left to lie for three months so that the dye could dry out completely.

Weaving

To make the warp ready for weaving, it was tentered on the frame once more. The housewife arranged, tugged, stretched, and loosened the threads until the motif was clearly visible on the frame. Unpatterned strips of warp were now carefully added.

The first time the thread had been tentered on the frame, the upper layer of threads had already been threaded once over and once under the separator. This time the woman would hang up the threads lying beneath the separator, using slings to attach them to a "sling rail" so that they could be pulled through the upper layer of threads when she pulled the sling rail. The separation thus effected between the even and odd threads formed a gap or "shed" between the lower and the raised warp threads, through which the weft yarn could be passed during weaving.

After these preparations, the woman would carry the frame under the four posts of the hut and would look for a place that best protected her from sun, rain, and wind. By means of divination (in this case possibly throwing rice) she would attempt to find out whether evil spirits were resident there. Once she had found a suitable place, two stakes were driven deep into the ground about a meter apart, with about 50 centimeters (18 inches) being left above ground. She could now undo the lengthways side of the warp frame, replace the topmost cross bar with the warp beam of the loom (half a thin tree trunk cut lengthways) and tie it firmly to the two stakes about 40 centimeters (15 inches) above the ground. The other cross bar she would replace with the breast beam, which had a groove along its entire length into which she wedged the upper layer of warp threads, using a strip of wood that fitted exactly so that the threads could not move (see pages 158–159). After the warp had thus been transferred from the frame to the loom, she would get ready to weave. She put on amulets to ward off evil spirits, went to the sacrificial stone beside the house, placed some gifts on it and muttered a prayer: "When in the beginning the Earth was still desolate, the first men wandered around and cried: 'Earth, where is our mother?' Then Deot Amapu sent them all possible things, including the pieces of the loom. Since thou hast sent us this consolation, Mother at the beginning of the clouds, the looms have not ceased to clatter, nor the wawaks [sound sticks] to ring. I too am about to weave, thou Mother of mine, I too am about to run the loom and ring the sound stick. I beg thee, therefore, give me some of the power of thy hands so that mine do not quickly tire at my work, strengthen my spine so that it can bear the weight of the yoke, and let me be alert in my mind. Here thou hast rice and fish, Deot Amapu, with which thou canst eat to thy heart's content. Thy reward will be a thousand times better if thou helpest me to complete the work well and undisturbed!"[8]

The housewife would now fetch the wawak, a piece of bamboo with holes in it that was tied to the warp beam and rang at every stroke with a bright, melodious note. Then she placed a coconut shell with rice and dried fish to the right of her seat, as a welcome dish for the deceased female ancestors, who would be summoned with irresistible force by the sound of the wawak to the place of their earlier activity, and would hover round it during weaving and whisper good advice to the weaver. To the left-hand side of her seat, she laid a horse's tail for driving off evil spirits, in case any should approach.

After she had fetched a generous stock of betel, she would sit down on the ground with an old sarong beneath her as a cushion, place the breast beam in her lap and move a heavy block of wood to her feet as a support, which was held firmly in position by the pegs driven into the ground. As a support for her back she used a heavy, curved yoke with a back rest, which she tied to the breast beam with cords, so that she sat firmly wedged in between breast beam and back rest. Then she would begin to weave (see page 129, bottom right).

As soon as a section of the cloth was ready woven, she opened the wooden slat holding the upper layer of warp in the breast beam and wound the warp round the breast and warp beams so that the threads of the lower layers slowly moved upwards. A skillful weaver could finish a cloth in the course of eight to ten days, as long as she could dedicate herself to weaving from early to late, and was relieved of all household duties. If she could get down to it only from time to time, she generally needed four weeks for the task, chiefly because it was not normal to take turns: each woman had her own touch, so that an alien hand would have been visible in the cloth.

As soon as the weaving was so far advanced that making a new weaving "section" was no longer possible, the housewife took the cloth off the loom and washed it in rice water, to give it a finish. It would then be stretched between two bamboo poles, a process that helped to keep it smooth later. Where the warp threads had not yet been woven, the cloth was cut through and sewn together. However, the threads of fabrics that were intended for ritual exchange of gifts at births, marriages, and deaths were (and are) not allowed to be cut, as they symbolize the continuity of life (see page 131).

Tietze's descriptions of cloth making on Flores show clearly that it was not the actual weaving that formed the main part of the task, but the many stages from cultivating the cotton to preparing it and, above all, dyeing it, which could take years. In addition, these processes were linked with ceremonial duties to appease malign spirits or conjure up benign ancestors and so bring the current enterprise to a happy conclusion.

Woven length for a woman's sarong

Pre-1934, L 150 cm (double), B 89 cm, Sikka region of Flores, Staatliches Museum für Völkerkunde, Munich, Käthe Tietze Collection, inv. no. 34-45-4

Woven lengths made of home-grown and spun cotton with uncut warp threads served as bridal gifts. The uncut warp threads symbolize the continuity of life.

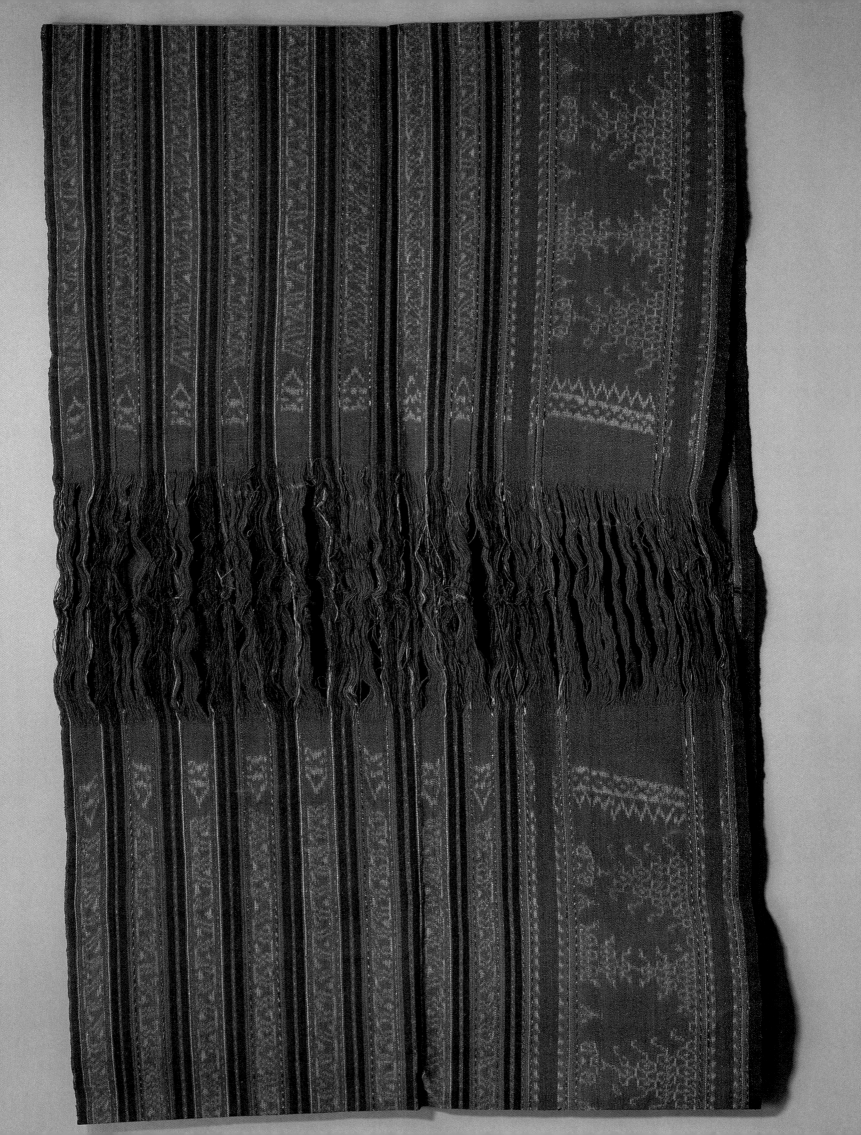

On Borneo, the only ethnic group producing *ikat* are the Iban, among whom the process of dyeing with red dye made from the roots of the *engkudu* tree (*Morinda citrifolia*) was considered as dangerous for women as a headhunting campaign was for the men. Consequently this dyeing process is still known as the *kayau indu*, the "women's campaign." So that the dye takes to the thread, the latter has to be treated first with a mordant solution. The technical aspects of this process are called *nakar* (the proper measuring and mixing of ingredients for the mordant solution). For the mixing to succeed, it has to take place in a ritual context called *gawai ngar*. The word *ngar* describes the whole process, including the required ritual tasks, which could be carried out only by women. The preparation and application of the mordant solution is highly complex, and few women master the skill, which is revealed to them by spirits in a dream. A woman who can perform this ritual is called *indu tau nakar tau ngar*, the "one who knows the right ingredients and quantities, the one who knows the rituals." She enjoys the highest standing that an Iban woman can achieve in her whole life. Even to carry out the ritual, she must be instructed by a spirit in a dream. Other women would then join her.

In the prestige system of the Iban, this skill in a woman was considered the equivalent of a man's success in carrying off a head. Iban women say: "Men brave the dangers of headhunting. We women brave the dangers of *ngar*."[9] The fact that weaving and headhunting were considered equal in the prestige system of the Iban is indicated also by the fact that in earlier times a man could not marry until he had carried off a head, and a woman could not marry until she had learned to

weave. How deeply this outlook was rooted is clear from a marital quarrel that the anthropologist Derek Freeman witnessed during his field work among the Iban. After she had publicly abused her husband, the wife finally screamed: "Call yourself a man? Prove it! Bring back a head!" The man, blushing with shame, replied: "And you make a *pua* [ceremonial cloth]!"[10] Likewise, a man gained the right to have his hands tattooed only after he had taken a head, and a woman only after she had woven several fabrics. The tattooing then showed permanently the high status of the man or woman in society (see below).

There is also a story attached to the motifs used on the *ikat* ceremonial fabrics (*pua kombu*) of the Iban. According to tradition, Iban women learnt to *ikat*, dye, and weave from spirits and deities who wanted to enjoy the patterns. Even today, these spirits and deities show themselves to many women in dreams and give them instructions about dyeing and weaving, as well as inspiration for new motifs. Simple, already familiar motifs can be imitated or easily adapted even by young women. But if a spirit is to be represented, this "dangerous" part of the pattern is carried out by an older woman. Most women limit themselves to imitating existing models, which carry no danger because the spirits attack only the creators of new patterns. New, dream-inspired motifs with representations of zoomorphic or anthropomorphic spirits are reserved for experienced weavers, since, if the pattern is not executed exactly, the spirit represented might fall into a rage and punish the weaver with blindness, mental illness, miscarriages, or even death. This is why only older women past the age of childbearing dare to undertake new, dream-inspired motifs. The creation of new motifs is thus not without dangers. A woman needs not only inspiration to do it, but also strength of mind and an ability to get in touch with the world of the spirits. The weaver Kerja from Sungai Sut had had such an encounter with Kumang in a dream (Kumang is for the Iban one of the most important spiritual advisers in weaving). She might be described as a cultural heroine responsible for love, beauty, and all female activities, but especially weaving. "Kumang was travelling upriver with her husband Kling. She left a *pua* with Kerja, saying she would call for it later. 'Kerja at once set to work to… copy the *pua*. She worked with great speed and when Kumang and Kling returned she had completed the *ngebat* [Ibanese for *ikat*].' On their way back down river Kumang and Kling reclaimed the *pua* they had left with her. Kerja commented on her dream, saying that 'in her dream she could see the patterns of Kumang's *pua* with great clarity. She said she saw it in colors. In her dream, she did the *ngebat* with extraordinary speed and ease. When she woke she could remember the pattern and later copied it.'"[11]

Not every woman is inspired like this; but a woman who is told in a dream to create a new

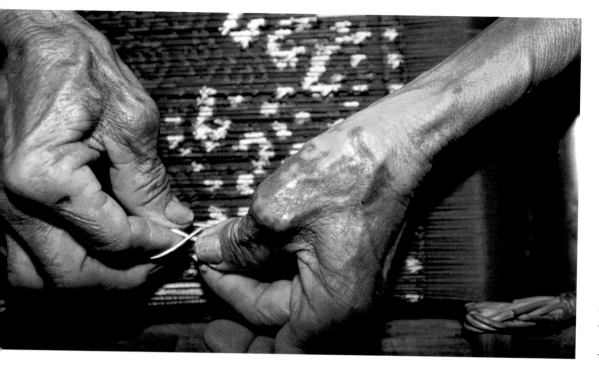

Tying the *ikat* pattern into the warp threads

Mujong River region, Sarawak, Malaysia, 1988

Among the Iban, only particularly experienced weavers could sport tattoos on their thumbs, just as only successful headhunters could have the backs of their hands tattooed.

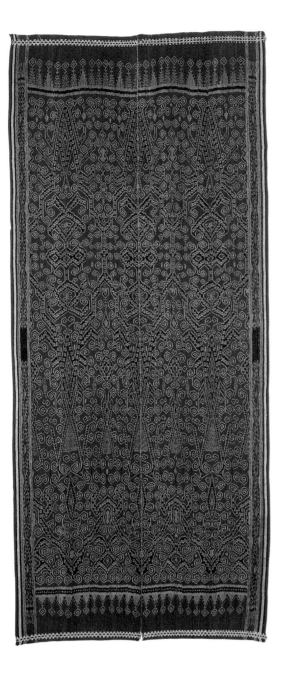

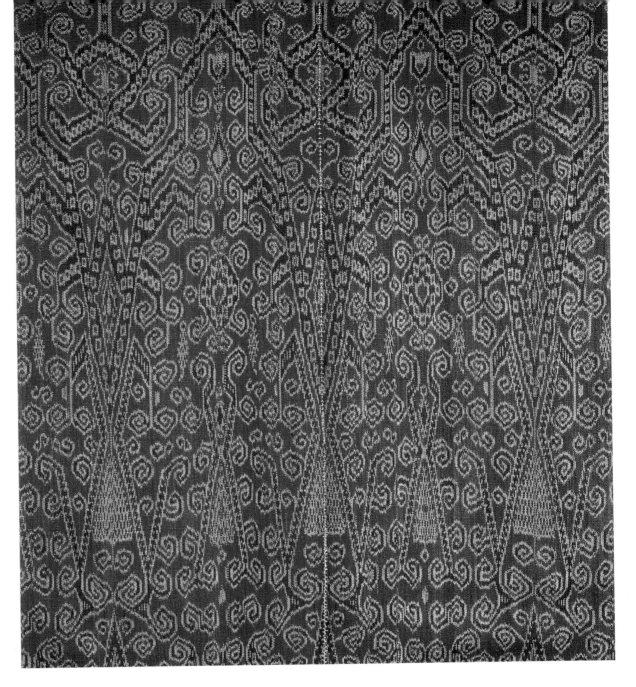

Ceremonial cloth (*pua kombu*)

*(Overall view, above; and detail, right),
pre-1876, L 210 cm, B 85 cm, Iban,
Borneo (Sarawak, Malaysia), Staatliches
Museum für Völkerkunde, Munich, inv.
no. Gr. 424*

Ceremonial cloths made by Iban women
were indispensable for the proper conduct
of rituals. At ceremonies connected with
headhunting, fabrics with the most
effective patterns such as the "skull trophy
motif" were used. Only women who had
made such powerful motifs were granted
the honor of accepting the heads of the
enemy in their ceremonial cloths. The
motif recognizable in the detail (right) is
strongly reminiscent of the "skull trophy
motif" (see page 115).

pattern cannot disobey the command without
annoying the spirits. All patterns originally derive
from their realm, and the purpose of the patterns is
to bring them pleasure.

The relationship between weaving and head-
hunting is also evident in the use of ceremonial
cloths, that is, all patterned cloths to which protec-
tive and disaster-averting functions are attributed.
They are also a medium through which contact
can be established with spirits and deities. They
are therefore still used in a wide range of ceremo-
nies, and also serve to induce promising dreams.
Women and the *ikat* cloths they wove played an
important part in ceremonies connected with
headhunting. After a successful campaign, the
captured skull trophies would be brought to the
village by the men and ceremoniously taken over
by the women. On occasions like this, ceremonial
cloths with the most powerful and effective
patterns, such as the "skull trophy pattern" (*buah
rang jugah*), had to be used. The fabric retained the
spiritual "heat" of the skull trophies and protected

those that went around with them against the
curse of the headhunted victims. Only women
who had mastered such powerful motifs were
granted the honor of ritually accepting the heads
of the enemy in their ceremonial cloths. Today,
these powerful motifs are reserved for other import-
ant ritual occasions.

The Iban of today say explicitly that the pattern
is not a "picture" or "symbol" of a skull trophy.
Nonetheless, the open lozenge motif at the lower
end or "origin" (*pun*) of the fabric is the character-
istic feature of the skull trophy pattern. When the
weaver serves this part of the pattern, she stands in
the greatest danger. She has therefore to make
particular offerings, and complete this part of the
work at a single go. This lozenge motif thus not
only determines the identity of the pattern, but is
also very closely linked to its ritual effectiveness
and power.

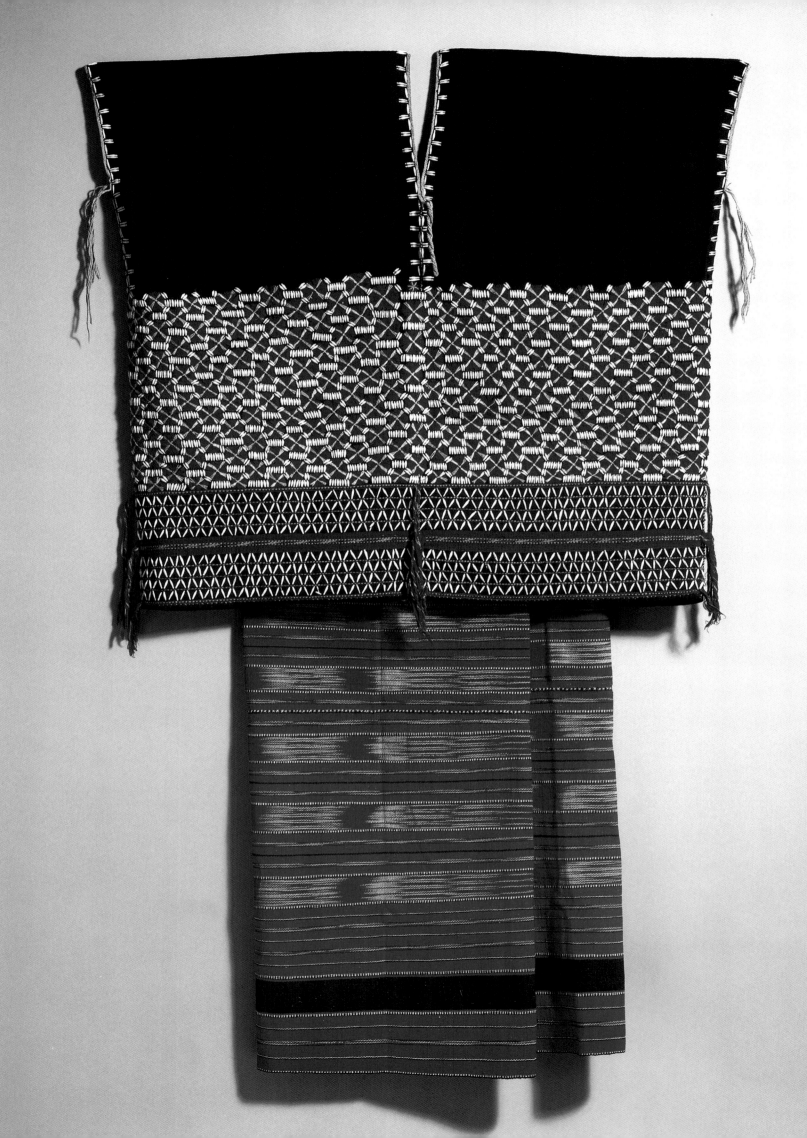

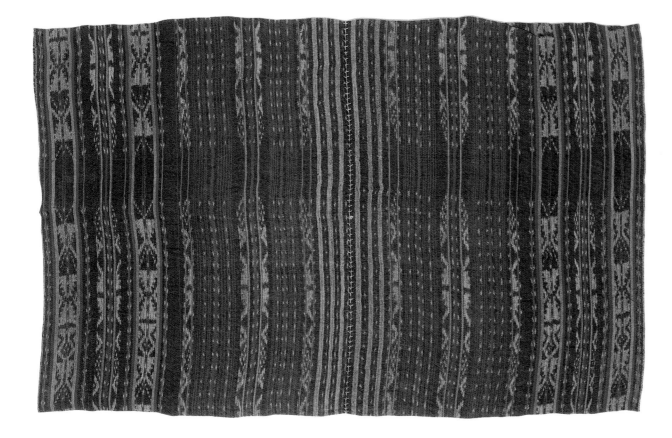

Opposite
Woman's skirt (*ni*) and blouse (*hse*)

L 85 cm and 68 cm, Sgaw Karen, northern Thailand, Staatliches Museum für Völkerkunde, Munich, inv. no. 85-306 353 and 85-306 356

The skirt is decorated with a python-skin *ikat* pattern, the blouse with embroidery and Job's-tears.

Left
Woman's sarong (*alisin*)

Pre-1913, woven from Palmyra strips, L 81 cm, B 55 cm (double), Selaru, Tanimbar Archipelago in the southern Moluccas, Staatliches Museum für Völkerkunde, inv. no. 13-83-60

Below
An *ikat* skirt (*kain kebat*)

Acquired 1989, with narrow ikat strips, L 54 cm, B 50 cm (double), Iban, Borneo (Sarawak, Malaysia), Staatliches Museum für Völkerkunde, inv. no. 89-312 149

Narrow *ikat* strips with triangular motifs are among the oldest decorative forms of Southeast Asia.

The Development of *ikat* Motifs

With regard to the history or development of *ikat* motifs, it is generally agreed that originally only narrow *ikat* strips were customary, and these alternated with single-color strips of warp. The simple back-strap loom permitted only a certain width of weaving length, and to make a larger piece of cloth it was necessary to sew several lengths together. The earliest patterns in Southeast Asia were narrow *ikat* strips with simple or double S-shaped triangular lozenges or hooked motifs plus the V-shaped "arrowhead" motif. An *ikat* patterning reminiscent of the arrowhead motif is called "python-skin pattern" among the Karen of northern Thailand, following a legend in which a woman was caught by a mythical white python; she began to weave the pattern after being released by the python. The blouses of the Sgaw Karen women are, in contrast, adorned with embroidery and Job's-tears.

As further examples of narrow *ikat* strip patterning, mention may be made of a woolen *ikat* skirt from the Iban in Sarawak and a sarong woven of Palmyra palm leave strips from the island of Selaru in the Tanimbar group, in the southern Moluccas. Both pieces display triangular forms, which are a very ancient motif in Southeast Asian art. They appear as double rows of small triangles on the narrow *ikat* strips of one of the earliest surviving textile fragments. Dating from the 14th century and made from banana fiber, the fragments were found in a burial urn on the island of Banton near Mindoro in the Philippines. Motifs

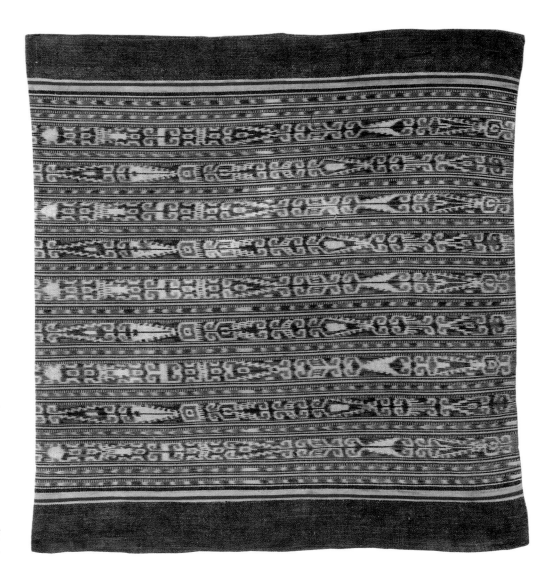

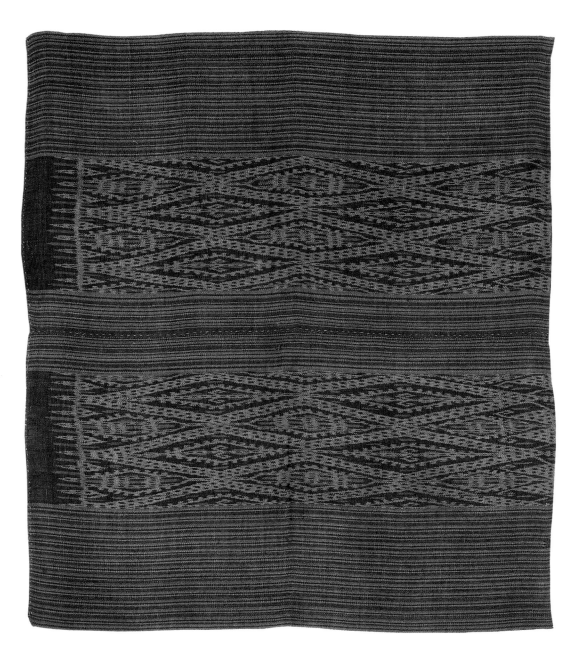

Whereas continuity with the past has been preserved, new combinations of these early motifs are recognizable, and new motifs are often developed that include them. Thus, with time, the *ikat*-patterned strips became wider, as is shown by the ceremonial sarong made of *lemba* or *doyo* bast (*Curculigo latifolia*) by the Benuaq of east Kalimantan on Borneo. Here lozenges and strongly stylized reptile motifs are embedded in narrow single-color strips.

The Mandaya in the Davao Gulf on Mindanao in the Philippines make *ikat* fabrics from banana bast (*Musa textilis*, known as *abaka* in the Philippines) using both narrow and wider *ikat* strips. The broad strips show anthropomorphic and reptile motifs, which are placed inversely beneath or inside each other, and which greatly resemble similar figures on textiles of the Atoni in the Niki-Niki district of southwest Timor and, though less closely, those of other peoples on Borneo, Sulawesi, and Sumba.

The fact that these motifs turn up in different localities indicates that they are not purely decorative elements but are charged with a deep meaning. They occur on the burial urns of Mindanao dating from 1000–500 B.C. On the strength of these, one could assume that there is some connection with the hereafter and the spirit world. The Mandaya, for example, believe that we are dead when the soul has left the body. Their view is that the soul wanders through the hereafter, which looks just like this world, with the exception that everything is the wrong way round or upside down. The soul is changed into a spirit, and is therefore able to influence the lives of people on earth positively or negatively. To appease these spirits, the living bring them sacrificial gifts in the form of material goods and sustenance, and invite them to ceremonies and feasts held in their honor. The living are constantly aware of being surrounded by the spirits of the dead, and fear their malignant attacks. These spirits can be represented in zoomorphic shape.

In addition, the Mandaya have a particular fear of crocodiles, regarding them as the embodiment of one of their deities. They believe that the very depiction of a crocodile, for example carved in wood, can ward off evil spirits because they think that this reptile is feared everywhere and by everyone, but especially by malignant spirits. Thus the crocodile motif on textiles is meant to repel and protect. As Laura Benedict observed: "Another charm for scaring off evil beings… is the representation of a crocodile, a figure which the women weave into their textiles […] In place of the real animal, a mere figure of this greatly dreaded reptile of the rivers… is expected to fill the demons with fear."[12]

The myths of the Mandaya suggest that the crocodile is also seen as an intermediary between this world and the next, a function that fits in well with what has been said above. As the living Mandaya want to know what their ancestors desire so that they can satisfy them and thereby receive

Ceremonial women's sarong (*ulap doyo*)

Acquired 1989, doyo-bast (Curculigo latifolia) with lozenge and crocodile motifs, L 60 cm, B 52 cm (double), Benuaq, eastern Kalimantan, Staatliches Museum für Völkerkunde, Munich, inv. no. 89-312 148

Opposite
Ikat fabric

(Overall view, right; and detail, left), 19th century?, acquired 1962, banana fiber (abaka in Philippinese, Musa textilis), L 176 cm, B 69.5 cm, Mandaya, Davao Gulf, Mindanao, Philippines, Staatliches Museum für Völkerkunde, Munich, inv. no. 62-4-6

In time, the narrow *ikat* strips grew wider. Reptile motifs referring to the ancestral world are still used today.

like these are interpreted in many ways these days: for the Ifugao on central Luzon, triangles represent sheaves of rice or, arranged in pairs, a dragonfly; whereas the Tanimbarese interpret them as flags. Triangles are also associated with sharp and dangerous objects such as daggers and teeth, which protect either the wearer of the textile or the central pattern. This interpretation is applied by Iban weavers to the triangular border markings of the central motif of a ceremonial cloth (compare the border woven on Flores, seen in the illustration on page 133, left).

The above-named motifs can be traced back far into the history of Southeast Asian art. Lozenges, hooks, spirals, circles, crosses, meanders, T-shapes, and triangles are found for example on prehistoric pottery and metalwork. These decorative elements became part of the artistic lore of the whole region, and although over 2,000 years have passed, they are still important components of today's textile patterns.

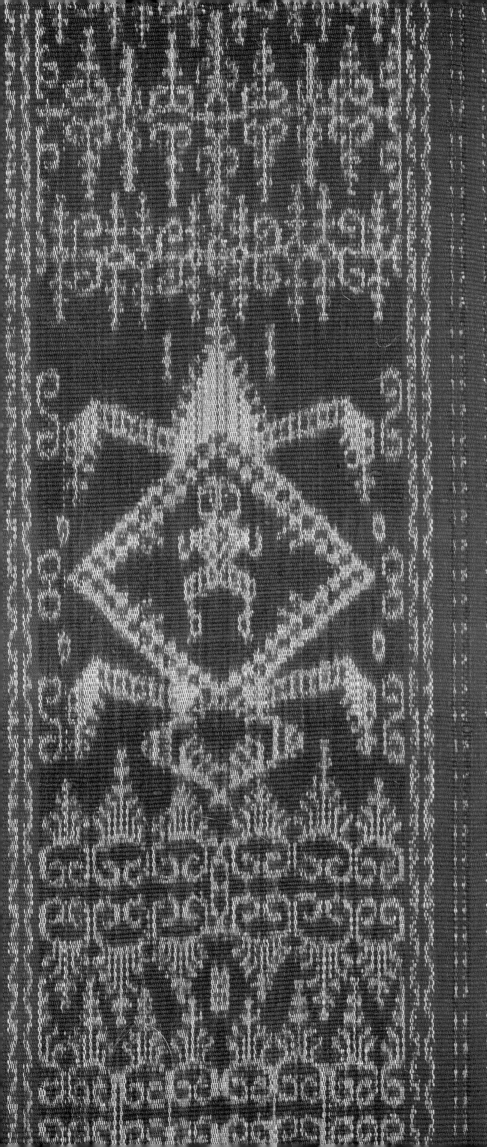
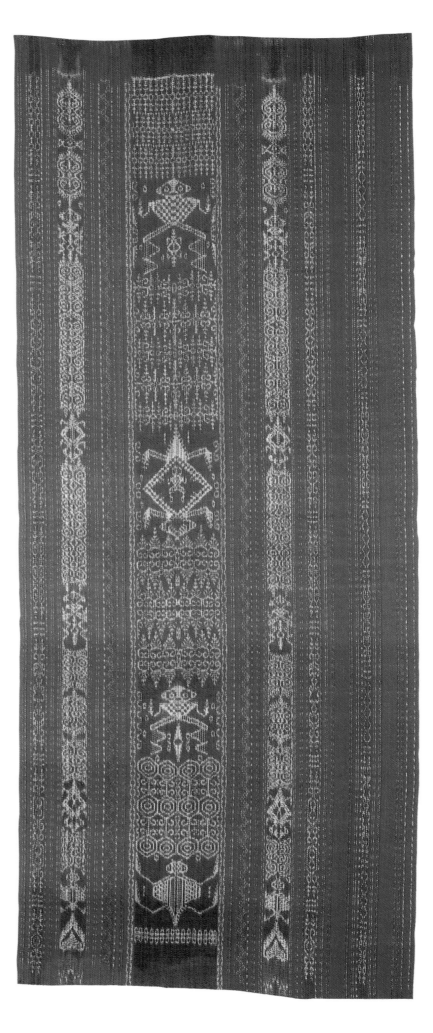

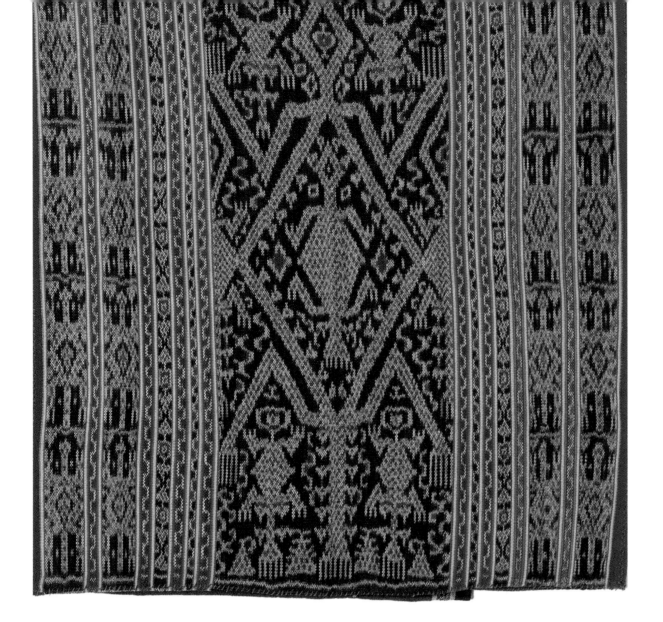

their blessing, they make their intention to carry out the wish or instructions clear in the image of the intermediary. As the crocodile is a link between this world and the hereafter, it has another function as well, namely to carry the soul of the deceased into the world of his or her ancestors. This role is depicted vividly in the fabric mentioned. A human figure is placed inside the body of the crocodile; the animal is shown with its head held downwards, in accordance with the view of the Mandaya that a dead person perceives the hereafter (initially at least) as an upside down world. These functions of the crocodile are not restricted to the Mandaya and neighboring ethnic groups on Mindanao; they are widespread throughout Southeast Asia and the Pacific, and can be seen, for example, in the ceremonial sarong shown here from the island of Timor, eastern Indonesia, displaying reptile and human figures (see above).

There are also similarities in the way textiles were used in the Philippines and Indonesia, for example in burial or marriage ceremonies, and so we may presume the traditions were related. Thus on Sulawesi, Sumba, and Timor, prominent people who died were wrapped in as many *ikat*

cloths as possible, as an indication of status and wealth. The Mandaya wrap rich people in an *ikat* shroud of banana fiber, poor people in a mat. *Ikat* textiles also serve as festive and ceremonial clothing at marriages and burials, and as ritual gifts exchanged by the families involved.

Influences of Indian textiles

The motifs used in Southeast Asian textiles underwent a change as a result of the influence of textiles exported from India, which were highly sought after. Contacts between the Indian subcontinent and Southeast Asia go back over 2,000 years, but their intensity and cultural influence varied greatly at different times and in different places. The great period of the dissemination of Indian philosophical, religious, and political ideas began during the first millennium A.D., along the trade routes stretching from the Mediterranean to China. According to the historian James D. Legge (whose description of the situation in Indonesia can be applied to much of Southeast Asia in that period): "By the seventh century A.D. the main outlines of the characteristic political situation of the islands may be discerned – a situation in which a varying

Formal sarong

Central length, acquired 1987, wool, warp ikat with reptile and human motifs, L 141 cm, B 58 cm (double), Tetum, Timor, Staatliches Museum für Völkerkunde, Munich, inv. no. 87-309 125

Like the previous example from the Philippines (page 137), this ceremonial sarong for women from the Tetum area in central Timor also shows reptile and possibly anthropomorphic figures (with round heads) placed inside and beneath each other. In many parts of Southeast Asia, reptiles are considered intermediaries between this world and the ancestor world. The figures with round heads could therefore represent stylized ancestor figures.

number of kingdoms rival one another, conquer and absorb one another, and contribute to new groupings as dynasties rise or fall or merge."[13] The result was a sustained fusion and overlaying of cultural characteristics that had developed since prehistoric times. The prehistoric migrations that had formed the island cultures of Southeast Asia had came to a stop before the period of pronounced Indian and Chinese influence began; but the geographical relocation of ethnic groups continued, and in fact still takes place in modern times, particularly on mainland Southeast Asia.

One of the most important questions posed by the spread of Indian culture in Southeast Asia relates to the nature and manner of its transmission. Although the travel and trade routes between the Indian subcontinent and Southeast Asia had brought certain groups into contact with visiting Indian traders and seafarers, and had taken many Southeast Asian seafarers and travelers to the ports of India, it is questionable whether these well-established trade connections brought about the spread of Hindu-Buddhist thought in Southeast Asia. Ideas based on this philosophy first took root at the princely courts of the region before gradually spreading into the surrounding areas. Despite the growth of trade bases, there seems to have been little contact between the foreign traders in the ports and the native population in the hinterland.

It is probable that the transmission of Indian religion, ritual, and statecraft was effected by Indian rulers and Brahmin scholars invited to Southeast Asia by native dynasties in order to legitimize their claims to authority. Over the centuries, aspects of Hindu and Buddhist thinking were continually being absorbed into Southeast Asian culture. Some philosophical and religious concepts emanating from India, particularly those relating to the nature of the universe, seem to have embedded themselves so deeply in already existing traditions that it is sometimes difficult to distinguish the Indian elements from the indigenous, especially when we try to interpret products of artistic output.

In the case of Southeast Asian textiles, for example, we can identify both the adaptation of Indian stylistic forms and the transformation of Indian patterns, motifs, and subjects in accordance with local aesthetic principles. Indian trade goods were obviously much sought after in the parts of Southeast Asia where Indian ideas and concepts were influential, and the combination of ideas and objects played a great part in the development of a new aesthetic in Southeast Asian art, especially in court circles. The region was a source of many goods that encouraged Indian traders to travel as far as the Moluccas, Timor, and even New Guinea. As a consequence, the influence of Indian objects acquired through trade were by no means concentrated on the capitals and centers of trade, but were spread to many of the most remote and apparently inaccessible areas via local trading networks.

And among the most important products of inter-Asiatic trade were Indian textiles, for which all kinds of goods could be traded. These export textiles had a decisive effect on the textile art of the region long after the direct Indian influences had ceased to exist. It is impossible to say when Indian export textiles first turned up in Southeast Asia. A Javanese inscription of the 10th century A.D. mentions south Indian textiles (*wedihan kling*), and a text of the 15th century refers to *patawala*, the textiles nowadays known as *patola*. We do not know if the Indian export textiles of that time were the same as those still surviving, as the patterns often had to be adapted to the taste of the destination countries in order to be accepted. The best-documented *patola* today may nonetheless be seen as examples of the influence of Indian export textiles.

Patola (singular *patolu*) are sari-shaped silk fabrics about four meters long and one meter wide (twelve feet long by three feet wide); they are made using a highly complicated double *ikat* technique during which both warp and weft threads are served and dyed before weaving, so that the pattern arises during weaving. Such fabrics were made principally in Gujarat on the northwest coast of India, both for personal consumption and for export. Nowadays, they are made by only two families of the Salvi weaver caste in the town of Patan in Gujarat. In India, these fabrics are

Silk fabric (*patolu*)

(Detail), acquired 1964, with jelamprang motif, L 490 cm, B 108 cm, made in Gujarat in India for export to Indonesia. Staatliches Museum für Völkerkunde, Munich, inv. no. 64-20-1

Indian export textiles to Southeast Asia – for example silk fabrics like this one from Gujarat, which displays an eight-point flower motif – had a lasting effect on the textile making of the region, and were translated into different techniques on the various islands. The yellowing stripes are possibly a sign of long storage.

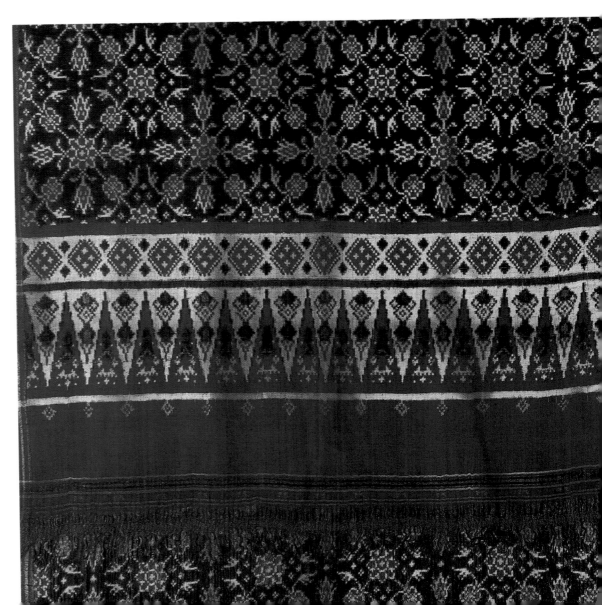

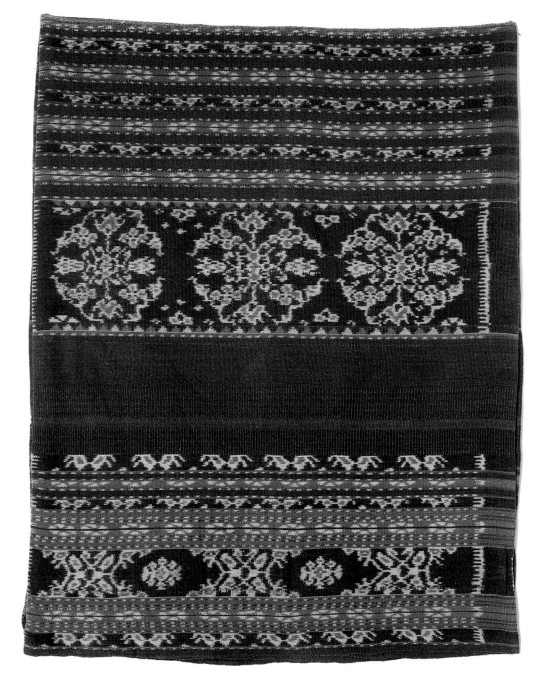

Woman's sarong

(Detail), acquired 1987, cotton, warp ikat, *with the jelamprang motif borrowed from patola fabrics, L 150 cm, B 58 cm (double), Sawu, east Indonesia, Staatliches Museum für Völkerkunde, Munich, inv. no. 87-309 132*

On the small island of Sawu in east Indonesia, the eight-point flower motif of the Indian silk fabric (see page 139) was translated into warp *ikat* technique in a cotton fabric and combined with other motifs. Even today, the motif is reserved for noblewomen.

considered pure and lucky, and are therefore preserved as family heirlooms and used on ritual occasions. In Indonesia, they were considered prized trade goods and were initially exchanged by Indian traders for spices and sandalwood. At the beginning of the 16th century and during the 17th century, this trade must have become more intensive under European influence. The Portuguese and Dutch were very aware of the importance of these fabrics for starting trade relationships, and at times even took control of the trade and established a monopoly. Only at the beginning of World War II was the export of *patola* from India to Indonesia finally discontinued.

Like all rare and unusual objects of unknown origin, *patola* were (and are) highly prized and preserved as valuable family heirlooms. They lend the possessor rank and standing, and often supernatural powers are attributed to them. The *patolu* shown here displays an eight-point flower motif known in Indonesia as *jelamprang* (see page 139). The black background suggests that this *patolu*

was specially made for export, because in India the color black is considered unlucky as it is associated with death. The fabric contains yellowing stripes (probably in places where it was once folded), indicating lengthy storage. In Indonesia, *patola* with the *jelamprang* motif were widespread and were made differently in the various regions.

The population of the small east Indonesian island of Sawu, lying between the larger islands of Sumba and Timor, had regular contact with Europeans from the 17th century on, initially the Portuguese who were trying to set up missionary stations there. Towards the middle of that century, sundry local princes got together with the Dutch and declared their readiness to trade exclusively with the Dutch United East India Company. The Dutch recognized four or five of these local rulers on Sawu, and the trade took place only at the highest level. Each of the princes paid a tribute in the form of slaves, beeswax, and foodstuffs, in return for which he received muskets, gin, and princely insignia, mainly in the form of silk *patola* fabrics. The Dutch awarded these fabrics only to the highest-ranking princes with whom they traded, and the right to wear such cloth thereby became the exclusive privilege of the aristocracy on every island. When the Company went bankrupt and *patola* fabrics became rare, the nobility adopted the *patola* motifs on their home-produced cotton warp *ikat* fabrics. The most important of these motifs is the *jelamprang* motif, which to this day is worn only by noblewomen on Sawu.

The men on Sawu are proud of their traditions and stick loyally to their ceremonies, in which textiles play a central part. Their social organization is very complex, the island being divided up into defined domains or ceremonial territories, each with its own priesthood. These domains are subdivided into villages, which are the homes of particular clans.

Basically, every individual belongs initially to his father's clan. What unites the island is nevertheless a kind of "dual affinity" system, for an individual belongs to one of two possible clan groups on his mother's side at the same time. These highly important groups of distaff affinity are termed "blooms" in Sawunese, and distinguished from each other as the "Greater Bloom" (*Hubi Ae*) and the "Lesser Bloom" (*Hubi Iki*). Each "bloom" is divided into about six subgroups designated by name and called "seeds" (*wini*).

The system is complicated; what is interesting nonetheless is that a precise knowledge of the otherwise rather masculine oriented society of Sawu (even as far as carrying out ceremonies is concerned) remains a secret. Men may know perhaps what "bloom" they belong to, but no more. Women know about the "seeds," and this knowledge is indispensable for arranging marital connections and the many other ceremonies in the cycle of life, especially burials. Yet knowledge about these clan affinities are not publicly discussed. It is not even passed on in words but handed down in visual representation from mother to daughter in the

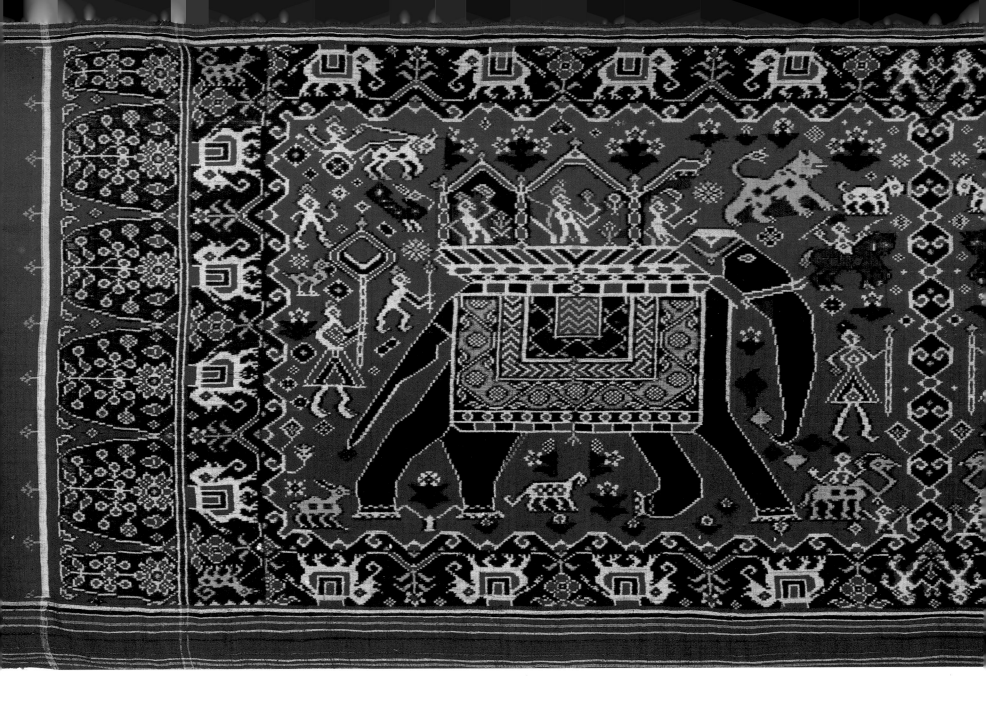

motifs on the women's sarongs. Each principal motif on a woman's sarong therefore indicates a particular "seed" within the two "blooms," which are seen as female. These motifs are of such importance that if a woman dares to wear the wrong sarong at a burial, other women would tear it off her and drive her away.

Along with the *patola* with geometric motifs, there were others with large elephant motifs, which must have been particularly sought after in Indonesia and therefore specially manufactured for exporting there. All *patola* motifs known up to the end of the 1970s were compiled in an exemplary collection by Alfred Bühler and Eberhard Fischer. Quite recently this study was augmented by new *patola* motifs discovered by Robert Holmgren and Anita Spertus. Among these newly discovered motifs is the large elephant motif depicted here, which is framed by smaller white elephants (see above).

In 1993, the Völkerkunde (Ethnology) Museum in Munich managed to acquire a nobleman's shawl (*hinggi kombu*) from east Sumba, which represents an astonishing copy or reworking of this elephant *patolu*, which incidentally also came from the Lesser Sunda Islands to which Sumba belongs (see pages 142 and 143). This can be assumed from certain details, such as the variegated elephant *howdah*, the dog-like creature between the elephant's legs, and the elephant's fettered back feet. The smaller white elephants, which serve as a frame in this type of *patolu*, are arranged here in the middle of the cloth (see above). The tusks and tails of these small elephants were treated with yellow dye, after the main dyeing and weaving procedure was completed, in order to obtain a golden color symbolizing magical powers. The cloth is sewn together of two lengths, while the narrow sides are finished with *ikat* fringes and a woven trimming (*kabakil*). The pattern is arranged not in horizontal strips, as would be normal for Sumba cloth, but vertically, as on the *patolu* that served as a model.

On east Sumba, as on other Indonesian islands, *patola* fabrics and imitations of them are reserved

Silk fabric (*patolu*)

(Detail), 19th century?, with large elephant motif framed by smaller white elephants, L 399 cm, B 107 cm, Lesser Sunda Islands, in a collection by Robert J Holmgren and Anita E Spertus, New York

Silks from India with large elephant motifs were evidently highly prized in Indonesia and were probably specially produced in India for exporting there. This new variant of the large elephant motif surrounded by smaller white elephants was discovered by Robert Holmgren and Anita Spertus only a few years ago.

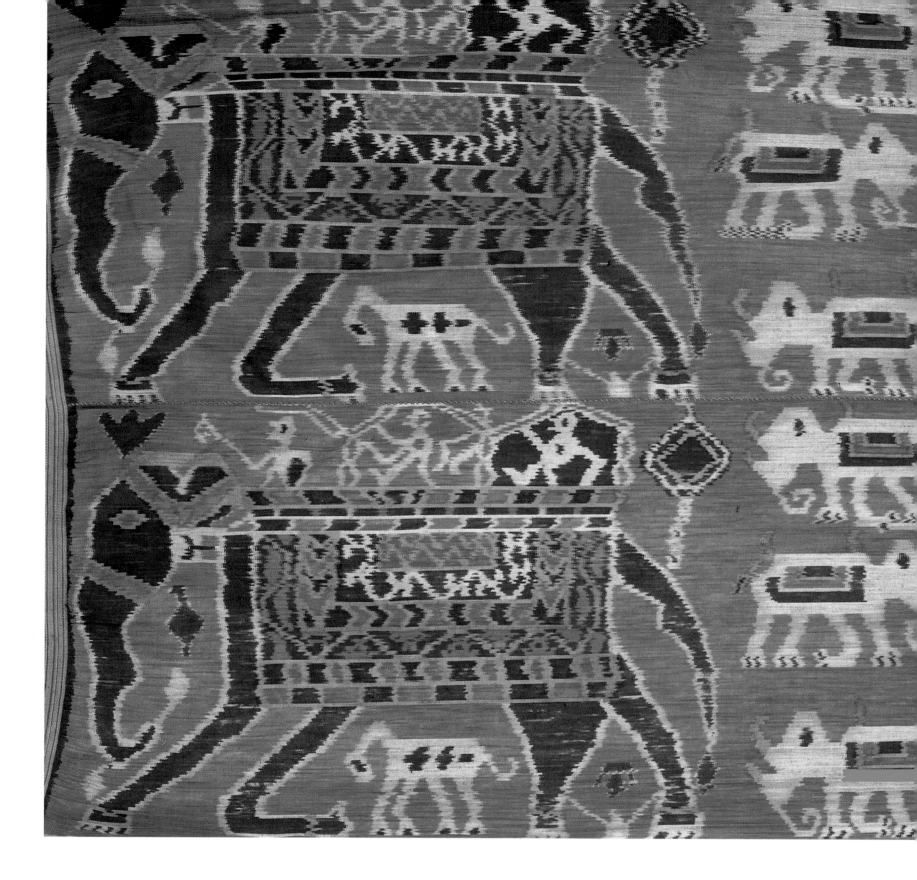

Shawl (*hinggi kombu*)

Early 20th century?, acquired 1993, cotton, warp ikat, kabakil borders, with elephant patola *motifs, L 300 cm, B 136 cm, east Sumba, Staatliches Museum für Völkerkunde, Munich, inv. no. 93-317 483*

This shawl is an astonishing imitation of the Indian silk fabric with the elephant motif shown on the previous page, a motif probably not known earlier in Indonesia.

for the nobility. Native *ikat* fabrics are worn by the nobility as ceremonial wear, used for ritual exchanges at weddings and burials, and as grave goods. As in other parts of eastern Indonesia, exchange goods are here classified as male and female: textiles, ivory bangles, glass beads, pottery, and pigs are considered female and are given by the wife's family. The gifts from the husband's side include gold jewelry, weapons and horses, and in earlier times slaves as well. The most important occasion for ritual exchanges of gifts on Sumba

was during the burial of members of noble families. All related families of the deceased had to contribute to the celebration, in the course of which great wealth was displayed and partially destroyed. The burial of an aristocrat thus took on the nature of a celebration of achievement that would enable the deceased to enjoy high status in the hereafter and thereby guarantee his descendants the goodwill of the deceased.

Sometimes the deceased is covered not just with native *ikat* cloths but also with a *patolu*, which, as a

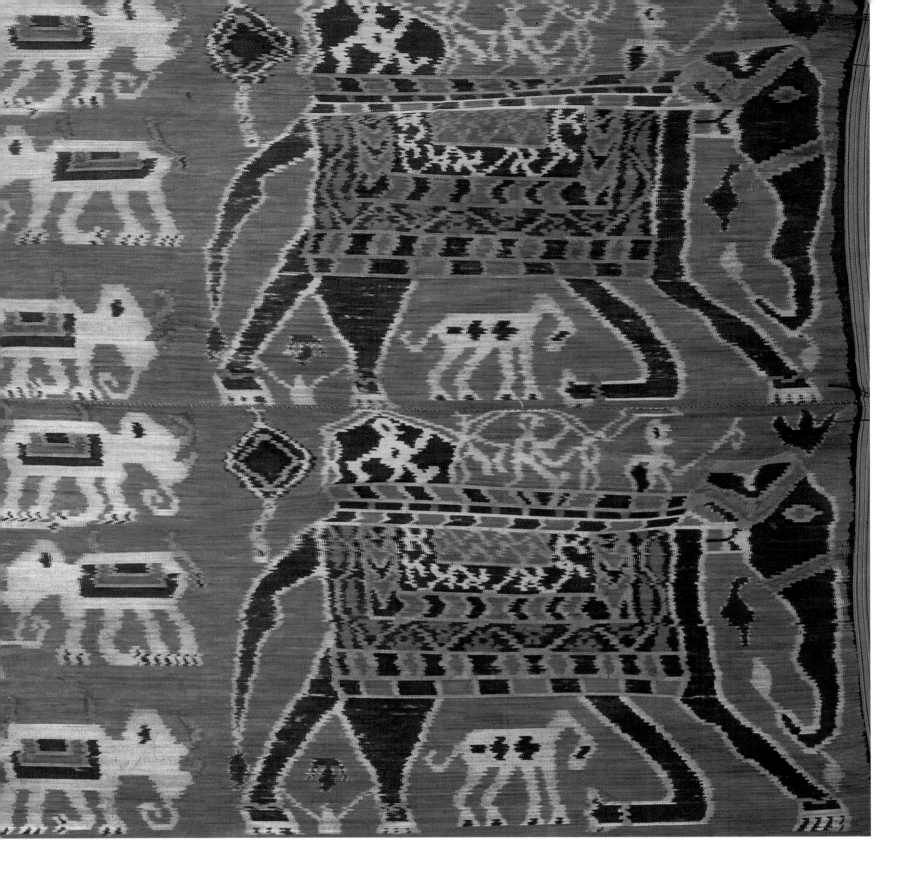

valuable family heirloom, indicates his high rank, and also acts as protection from spirits.

The ritual exchange of goods – especially of textiles and jewelry – is indispensable on Sumba for introducing and maintaining social relationships and thereby the fabric of ordinary life and the status quo. As we have seen, in many areas of Indonesia the unwoven warp threads of a textile remain uncut as long as the textile is intended for ritual exchange; cutting the warp threads turns a fabric previously considered to be sacred and ceremonial into a secular, everyday object. On Flores and Lembata, only fabrics with unsevered warps, which are interpreted as ongoing lifelines, can act as bridal gifts. On Bali and Lombok, such fabrics are considered particularly curative.

Among the Toba Batak on Sumatra, a tubular black fabric with unsevered warps (*ulos lobu-lobu*) symbolizes the continuity of the generations and is therefore prescribed as a fabric with the character of an omen, and is used, for example, as a suitable remedy for a mother with a sick or dying child.

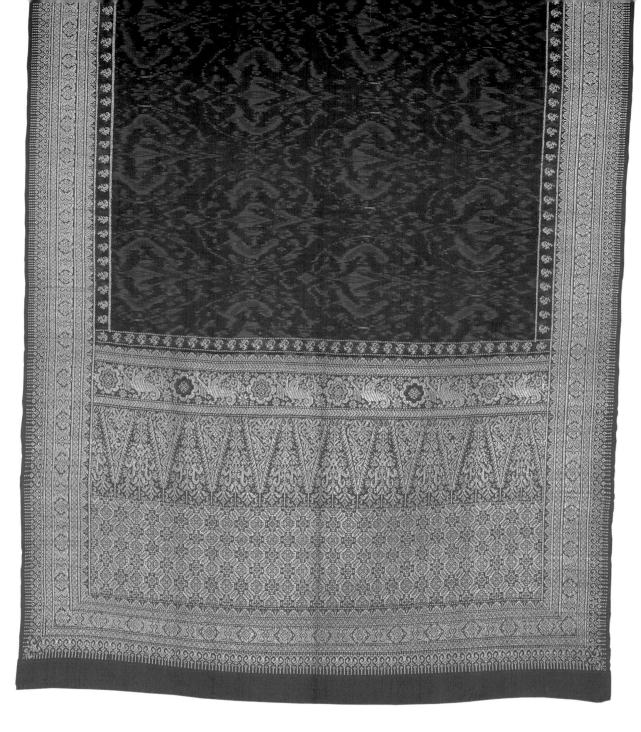

New Materials and Techniques

Silk and gold thread, weft *ikat*, and pattern weft

Trade connections with India influenced not only the motifs used on textiles, but also introduced new materials and techniques, such as silk and gold thread, weft *ikat*, and pattern weft. The Sanskrit words *sutra* ("thread," adapted to mean "silk") and *suvarna* ("gold") are used throughout Southeast Asia and thus underline the role of India in the spread of threadwork in silk and gold. Their delicacy makes silk threads more difficult to handle than cotton or other plant fibers, so a way had to be found to prevent the fine threads getting tangled up during weaving. This was done (and not only in Southeast Asia) by introducing a comb or reed, through which the warp threads are threaded during the installation of the loom. However, this makes certain techniques of warp patterning (such as warp *ikat*) very difficult. In

warp *ikat*, the warp threads must be carefully measured up and stretched on an *ikat* frame: the length of the weave running round it is set and cannot be changed. After serving the pattern and dyeing, the threads are installed on the loom by inserting the breast beam and warp beam without the threads having to be stretched across again. Where a comb is used, this is no longer possible: the *ikat*-patterned threads would have to be completely reinstalled and fed through the comb, a procedure which is highly difficult to achieve with a precise alignment of complex patterns.

Southeast Asian silk weavers seem to have found a solution to this problem by using single-color warp threads and going over to weft patterning, such as weft *ikat* and pattern weft; in other words, weaving in additional weft threads.

Sarong or shoulder wrap (*kain limar*)

Late 19th century?, acquired 1936, silk, metal thread with core, weft ikat, pattern weft, L 216 cm, B 86 cm, Palembang, Sumatra, Staatliches Museum für Völkerkunde, Munich, inv. no. 36-27-11

Models provided by Indian export textiles influenced not only the motifs of Southeast Asian fabrics, but also the materials and fabrics used. Especially in coastal areas, cotton and warp *ikat* were replaced by silk, weft *ikat*, and pattern weft interwoven with gold thread. The arrangement of the motifs was in many respects adapted from Indian models.

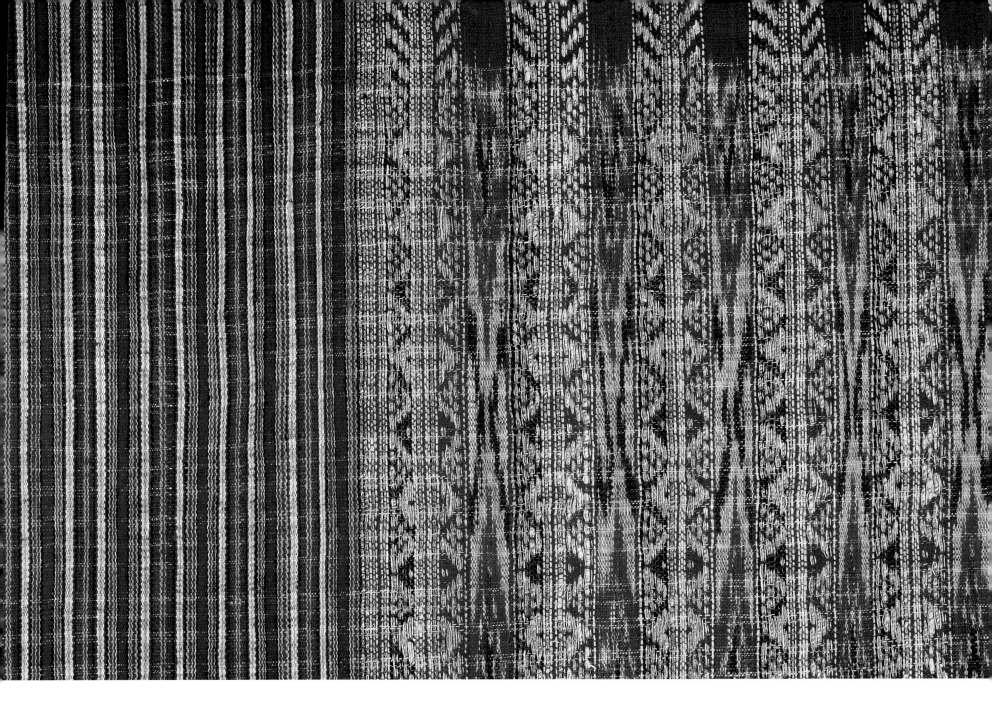

Unlike in the warp *ikat* technique, in which the *ikat*-patterned warp threads are firmly installed on the loom and are therefore easier to control during weaving, the weft *ikat* technique requires the *ikat*-patterned weft threads to be rolled up on bobbins. Working this way makes inserting the weft threads very complicated, as the weaver has to line up every new weft thread very carefully so that a clear pattern emerges. In this technique, the warp threads do not constitute a continuous loop of warp threads any more; they gradually unroll off the warp beam while the already woven part is rolled up on the breast beam. The finished fabric is thus taken off the loom as a flat, rectangular cloth and is not tubular like a warp *ikat* fabric produced on a simple back-strap, combless loom.

For this reason, silks produced with the weft *ikat* technique, which are often decorated with additional gold or silver threads woven in, are indeed admired as expensive objects of great beauty and worn as artistic ceremonial and court wear, but nonetheless have no sacred or ritual meaning, which is, inherent only in cotton fabrics with unsevered warp threads (a symbol of the continuity of life). Dyeing and weaving silks is not associated with ceremonial acts, and they are not used as ritual exchange gifts in marriage. As gifts to loyal servants of the state and foreign dignitaries, these lavish, expensive fabrics are considered more as symbols of elegant court life and visible symbols of heavenly blessings than as magical works endowed with supernatural powers.

The division of the pattern of silk-weft *ikat* fabrics decorated with gold thread is mostly orientated to Indian export fabrics: a large rectangular central field with weft *ikat* patterning is bordered with selvage strips adorned with gold thread and side strips with *tumpal*, triangular motifs (compare the illustrations on pages 133 and 139).

Hip cloth

(Detail), acquired 1908, cotton and yarn made from white ramie (bagu in Balinese; Boehmeria nivea Gand), metal thread with core, ikat-patterned weft, knitted selvages, L 111 cm, B 220 cm, Bali, Staatliches Museum für Völkerkunde, Munich, inv. no. 08.216

Although new techniques such as pattern weft, and new materials such as silk and metal threads, were taken over from Indian textiles, ancient motifs such as the snake skin, triangles, diamonds, and S-shapes were preserved (compare the illustrations on pages 134 and 135). The motifs also emphasize the early links between the mainland and the islands of Southeast Asia.

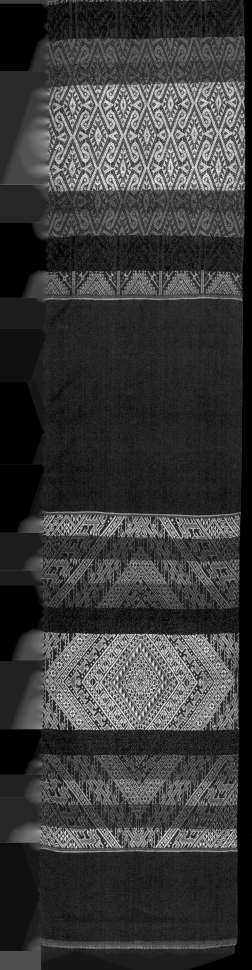

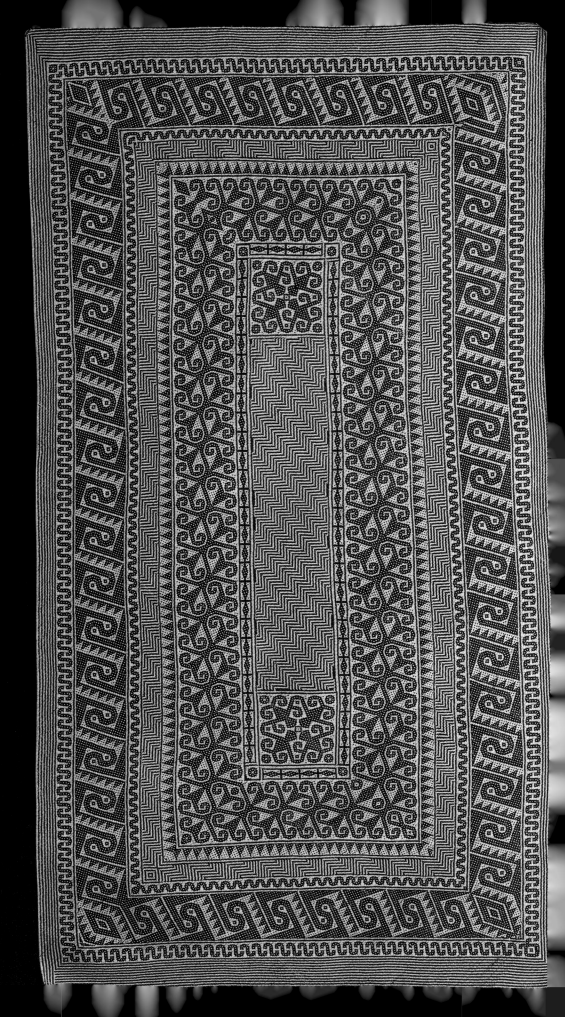

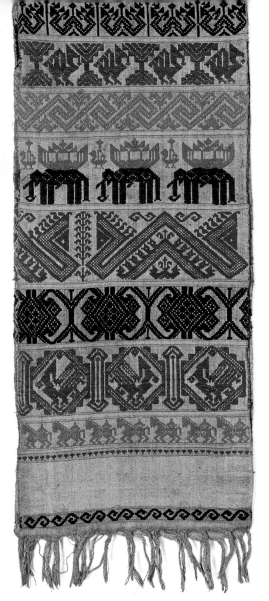

The receptivity of Southeast Asia to new ideas and influences from outside did not however mean that earlier motifs and patterns vanished without trace. On the contrary, earlier motifs appear again and again, particularly in areas strongly exposed to external influences. The continued use of earlier materials, techniques, and motifs is remarkable in the face of apparently overwhelming new possibilities, as the example for a relatively unknown type of textile from Bali makes clear (see page 145). The fabric was produced by the weft *ikat* technique and decorated with additional silver threads woven in and knitted selvages. However, the material is not silk but plant fiber (white ramie, called *bagu* in Balinese; *Boehmeria nivea Gand*). The pattern is arranged in narrow strips, and shows the old arrow head or snakeskin motif.

The fascinating thing about this fabric is its design, which is produced by the material as much as the patterning, and which changes according to the light – like the constantly changing colors in the sheen of a snakeskin. A further example of the preservation of earlier motifs is a ceremonial shawl (*pha biang*) of the Tai Phuan in Laos. Made of silk and cotton and decorated with pattern weft, this shawl features S-shaped motifs, lozenges, and triangles, which are found in very similar form in a ceremonial mat from Kuala Kapuas in South Kalimantan on Borneo, a further proof of early connections between mainland and island Southeast Asia.

Similarities not only of motifs but also of technique and function are found in ceremonial textiles from Lampung in southern Sumatra and from northern Thailand, Laos, and southern China. Ceremonial cloths (*tampan*) from Lampung are relatively small rectangular fabrics with a width of 30 to 100 centimeters (12 to 40 inches). The cotton fabric is decorated in a pattern-weft technique with cotton or, more rarely, silk thread. A loom with a comb and not a continuous warp was used for this, whereby several such cloths were woven on one piece and then cut apart. Fabrics of a structurally similar nature were produced in northern Thailand and south China, likewise decorated with cotton with pattern weft. They

Opposite, far left

Ceremonial shawl (pha biang)

Early 20th century, acquired 1986, silk, cotton, natural dyes, ikat-patterned weft, L 260 cm, B 42 cm, Tai Phuan, Xieng Khouang, Laos, Australian National Gallery, inv. no. 1986.1922

Opposite, right

Mat for ceremonial occasions

Acquired 1963, natural dyes and black-dyed rattan strips, L 188 cm, B 96 cm, Kuala Kapuas, south Kalimantan, Borneo, Staatliches Museum für Völkerkunde, Munich, inv. no. 63-3-1

Above

Ceremonial banner (tung)

1st half of 20th century?, acquired 1985, also man's shoulder wrap (pha chet luang), cotton, ikat-patterned weft, L 280 cm, B 26 cm, Tai Lue, northern Thailand, possibly produced in Sip Song Pan Na (Xishuangbanna) in South China, Staatliches Museum für Völkerkunde, inv. no. 85-305 775

Right

Ceremonial cloth (tampan)

1st half of 20th century, acquired 1993, cotton, ikat-patterned weft, L 73 cm, B 68 cm, Kalianda area, Southeast Lampung, south Sumatra, Staatliches Museum für Völkerkunde, inv. no. 93-317 420

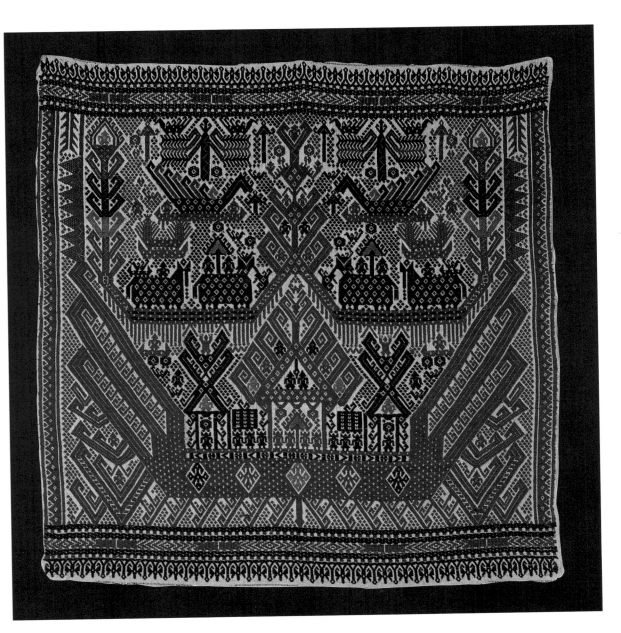

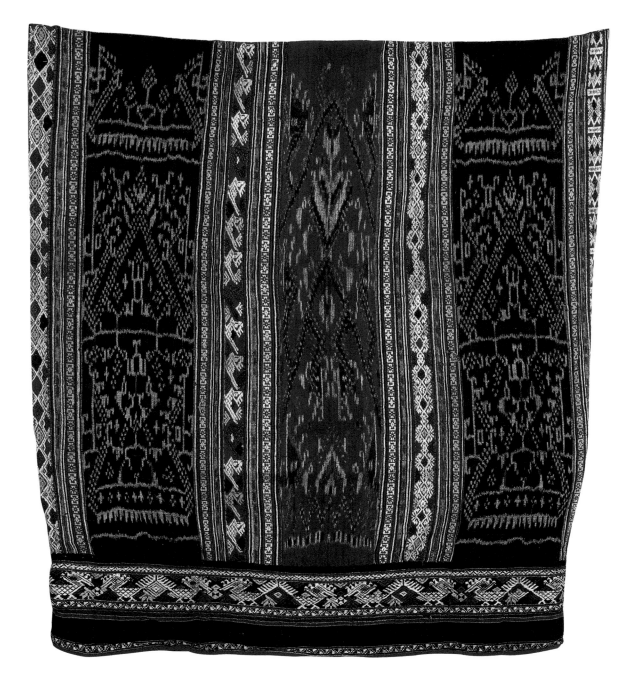

serve as the ceremonial banners (*tung*) and as the ceremonial shoulder wraps (*pha chet luang*) of the Tai Lue. The motifs on both types of textile display astonishing similarities, such as stylized depictions of ships with raised prows and sterns, elephants, and birds (most probably peacocks); even the geometric motifs and borders resemble each other. New research has traced these and other motifs back to (now lost) prototypes of Indian export textiles that must have had enormous influence on the iconography of the whole Southeast Asian region. Although certain decorative features crop up again and again – prestigious animals such as elephants, peacocks, tigers, and horses appear on *patola* – the diverse local variations indicate a long history of development, the beginnings of which are nowadays traced back to some time between the beginning of the first and second millennia A.D. They are thought to be partly connected with Buddhist influences at the time of the Srivijaya empire (7th–11th centuries A.D.), which was centered in the vicinity of Palembang in southern Sumatra and had cultural

connections with Thailand. The use of ceremonial cloths as gifts at major rituals in the life cycle, for covering dishes, and, in Thailand, for wrapping gifts to Buddhist temples suggests a common cultural basis. A further example of the different ways materials and motifs were taken over is a ceremonial skirt of the Tai Nuea in northern Thailand, who were originally indigenous to Laos (see above). The skirt displays red and indigo weft *ikat* strips, which alternate with bands of pattern weft worked in silk. The red weft *ikat* strips are in silk, whereas the indigo strips are worked in cotton – the indigo dye takes better to cotton, while silk is better with the red dye made from the scale insect. The red strip in the middle displays a stylized snake motif (*nak*), and the indigo side strips show depictions of temples (*prasat*). On the upper edge of the indigo lengths a motif occurs that is strongly reminiscent of the stylized ship pictures on the ceremonial cloths from Lampung and northern Thailand. The pattern weft strips, on the other hand, display not only geometric motifs but also depictions of peacocks.

Ceremonial skirt (*pha sin*)

(Overall view, above; and detail, opposite page), around 1900?, acquired 1990, silk, cotton, weft ikat, pattern weft, with snake, temple, and peacock depictions, L 76 cm, B 68 cm (double), Tai Nuea, northern Thailand, Staatliches Museum für Völkerkunde, Munich, inv. no. 90-312 795

Similarities not only of motifs but also of techniques and function are found in ceremonial textiles from Lampung in southern Sumatra, northern Thailand, Laos, and southern China. Adorned with cotton or silk pattern weft, they show astonishing similarities in the use of motifs, for example ships with raised prows and sterns, elephants, and peacocks (compare the illustration on page 147). This may possibly be traced back to Buddhist influences during the Shrivijaya empire on Sumatra.

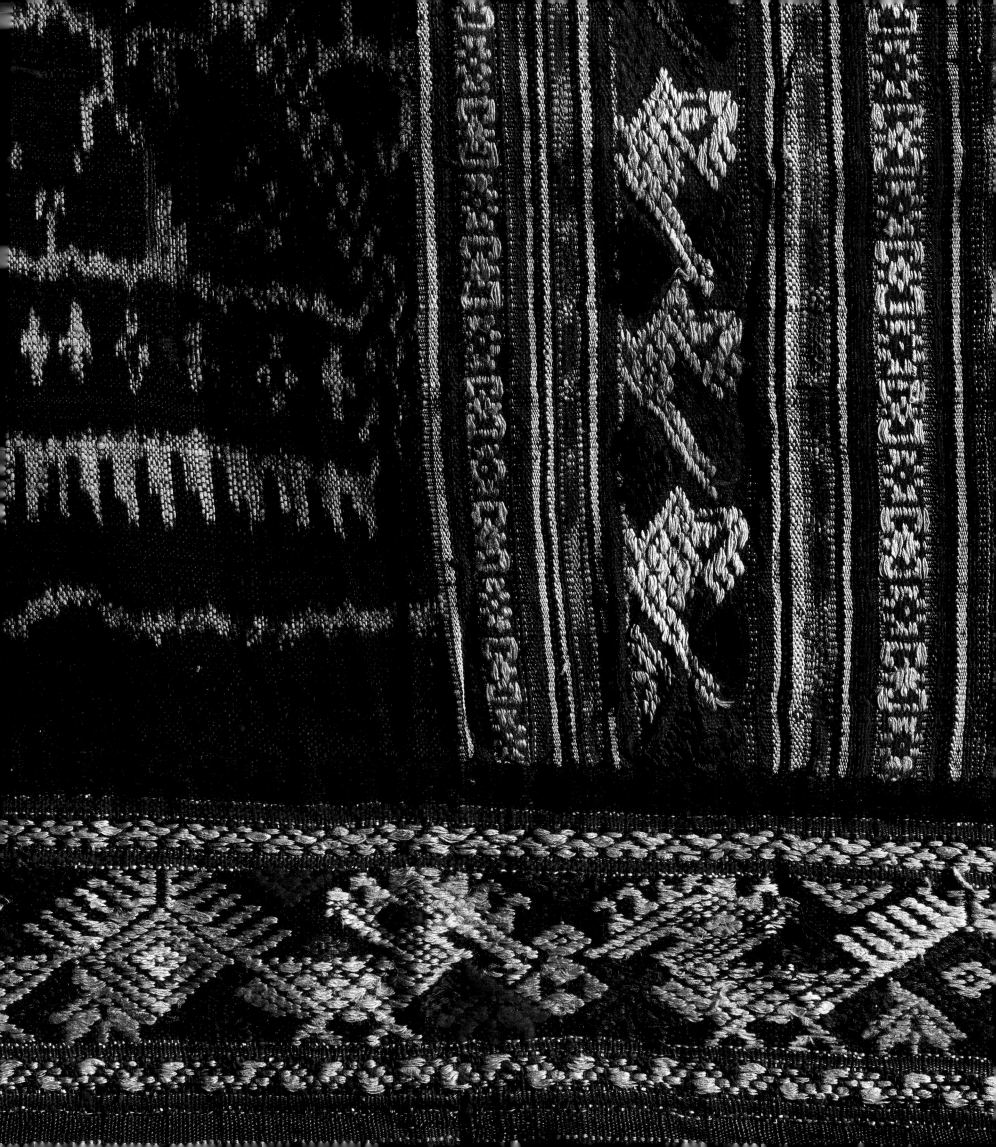

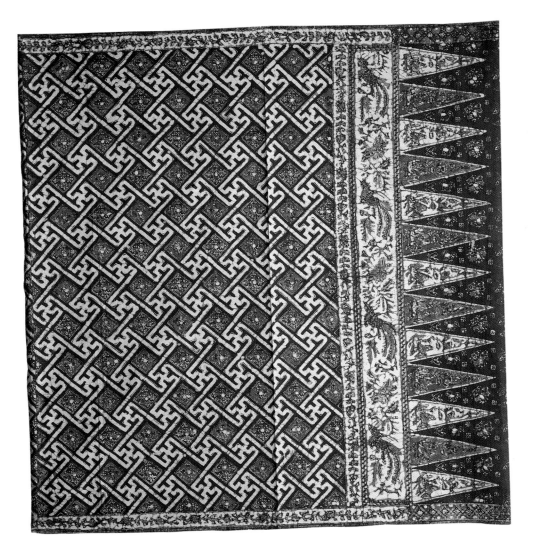

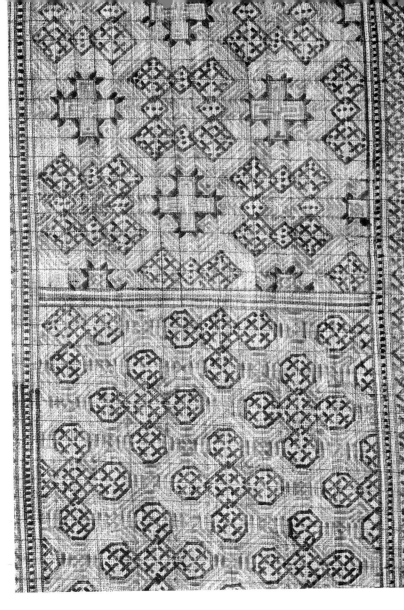

Chinese influence

Opposite
Batik pattern cloth

Pre-1890, L 107 cm, B 57 cm, central Java, Staatliches Museum für Völkerkunde, Munich, inv. no. B. 3967

Above
Sarong

Pre-1889, with banji and tumpal motifs, L 103.5 cm, B 97.5 cm (double), central Java, Staatliches Museum für Völkerkunde, Munich, inv. no. 89.467

Top right
Batik strip

Acquired 1985, hemp, beeswax, L 85 cm, B 28 cm, Blue Hmong (Mong Njua), northern Thailand, Staatliches Museum für Völkerkunde, Munich, inv. no. 85-305 776

As well as geometric motifs, the batik pattern cloth displays swastika or *banji* motifs in the bottom left corner, which features in complete form on the sarong (above); the geometrical motifs of the batik strip from northern Thailand are the same as those of the sarong from central Java.

Whereas Indian influences on the art and textiles of Southeast Asia are generally acknowledged, the effects of Chinese culture on the artistic activities of the region are often underestimated or even ignored. This may in part be because Chinese influence did not lead to impressive architectural survivals comparable to Borobudur or Angkor, where the spread of Indian culture can be clearly seen. Another factor is the presence of complex social, economic, and political tensions aroused by the settlement of Chinese immigrant communities in the region, especially in the last 150 years. In recent decades, these tensions have turned into open conflict, which has led to an unfavorable climate for examining the Chinese contribution to the shaping of Southeast Asian art and culture. Nonetheless, the historical presence of the Chinese cannot be overlooked, and even less so the common cultural roots that lie in border areas between southern China and Southeast Asia.

Many of the ethnic groups in mainland Southeast Asia – such as the Hmong in northern Thailand, the Tai Nuea in Laos, and the Shan in northern Burma – share common ancestors and cultural features with neighboring ethnic groups in southern China, especially the minority groups in the provinces of Yunnan, Guizhou, and Guangxi. Whereas historical circumstances and political borders now separate peoples with very similar material cultures, extensive migrations of these groups into Southeast Asia continued until very recently.

Many of the early motifs that we find on textiles throughout the region should therefore not be seen as indicating Chinese influence, but as suggesting a shared cultural substratum underlying the textiles of Southeast Asia and the arts of China. Some of the elementary Southeast Asian textile techniques, and the decorative elements resulting from them, already existed in prehistoric times, before the migration from south China, as these peoples took with them not only their knowledge of agriculture and domesticating animals, but also the art of weaving continuous loops on back-slung looms. This shared legacy may also have included techniques such as batik and pattern weft, both of which have a long tradition among the mountain tribes of mainland Southeast Asia such as the Yao,

Tai, Shan, and Hmong. Although batik, a wax-resist technique, is nowadays identified explicitly with Indian-influenced textiles from Java, the origins of the technique could lie in south China, northern Thailand, or northern Burma, where it is still used by the Hmong.

The complicated batiks of central Java, hand-drawn with an implement known as a *canting*, seem to be a relatively late development, possibly of the 17th or 18th century. Nonetheless, the batik cloth from central Java shown here (see page 150) contains simple geometric motifs and swastikas (called *banji* in Java) alongside more playful motifs such as flowers. The Javanese term is said to derive from Chinese *ban* (ten) and *ji* (thousand), and therefore means "ten-thousand motifs." According to Warming and Gaworski, the Chinese believe that this motif comes direct from heaven. Although it was possibly imported from India, it is considered a very ancient motif.

One complete Javanese sarong combines the *banji* motif with rows of triangles called *tumpal* (see page 151). The true origin of the *tumpal* motif has been lost. These days it is interpreted variously as a spearhead, bamboo shoot, or human figure. It is certainly a very ancient motif in Southeast Asia. Many authors are of the view that it spread from Southeast Asia to India, whence it was re-exported to Southeast Asia, for example on the edge strips of *patola* fabrics. Nowadays we find it not only on Javanese sarongs but on textiles throughout Indonesia (see pages 133 and 144).

The geometric motif on the batik pattern cloth from Java recurs in similar fashion on a batik strip from the Blue Hmong (*Mong Njua*) in northern Thailand, which again underlines the common cultural roots and the great antiquity of this motif (see page 151, right). Unlike the pattern cloth from Java, however, the batik strip of the Blue Hmong does not serve as a demonstration of various batik patterns, but as an example of a batik insert for a woman's skirt. The women of the Blue Hmong wear knee-length pleated skirts made of hand-woven hemp or cotton cloth, though hemp is preferred because it retains the fine pleats better than cotton. The central, horizontal batik strip is 25–30 centimeters (10–12 inches) wide. Using a special instrument made by a smith consisting of a wooden handle and a three-bladed brass attachment, the women apply the desired pattern on to the material with a beeswax resist. Subsequently they dip the material in cold indigo dye. The wax is then boiled off and skimmed for reuse. The batik insert is finished at the top with a 15-centimeter (6-inch) wide strip of single-color material, but the hem is given a braid trimming in bright cross-stitch embroidery and appliqué work in red or other bright colors. The width of the braid varies with the age of the wearer, young girls generally preferring the wider braid. A white stripe is sewn on to the lower hem as a border. The whole skirt, which can measure over six meters (almost 20 feet) for an adult, is pleated like a concertina and sewn up with herringbone stitches. The first time they wear the skirt, the women draw a thread through the pleats so that they keep their shape. Fabrics decorated with cross-stitching, appliqué work, and batik, which form the characteristic features of the ceremonial wear among the Blue Hmong, are called *pa ndau* or "flowered material." It is said that these *pa ndau* motifs distinguish the living from the spirits of the dead.

A combination of geometric motifs with the swastika or *banji* motif occurs also on the side parts of a ceremonial cushion embroidered with silk and gold thread from the region of Palembang and Lampung in southern Sumatra (see left). On the coasts of Sumatra, it was the custom at important ceremonies, such as marriages, to set up a ritual bed for the display of certain textiles and cushions; the number of cushions, textiles, and mats was determined by the family's rank. Although such cushion decoration was not normal in China itself, lavish embroidery of this sort in the Chinese style was produced in Malay ports in Sumatra and Malaysia for ceremonial occasions. This is another example of the different ways certain motifs were used in various parts of Southeast Asia.

It is unclear how the batik technique came to spread throughout Southeast Asia. In southern China, where it is called *laran*, it has a long tradition. Archaeological finds of batik in China date back to the Han dynasty (206 B.C.–A.D. 220), and sophisticated batik work produced by a wax-resist method had spread from China to Japan by the 8th century A.D. The Kulaman-Manobo on Mindanao in the Philippines also use a wax-resist technique (called *be bed* there) in which men's shirts and trousers made of banana fiber (*abaka* in the Philippines; *Musa textilis*) are embroidered with

Piece of silk (*bantal peluk*) for a ceremonial cushion

Acquired 1985, silk, commercial cotton fabric, natural colors, gold thread, embroidery, L 21.5 cm, B 14.5 cm, Palembang and Lampung region, Sumatra, Australian National Gallery, inv. no. 1985.385

Although cushion decoration of this kind was not common in China itself, this example from Sumatra combines swastika and geometric motifs with embroidery in the Chinese style – a further example of the many different ways motifs and materials were used in Southeast Asia.

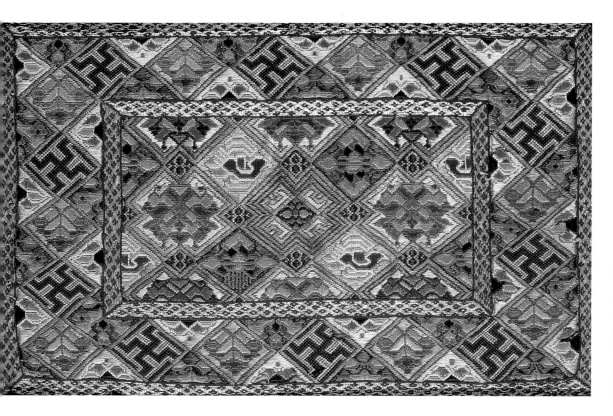

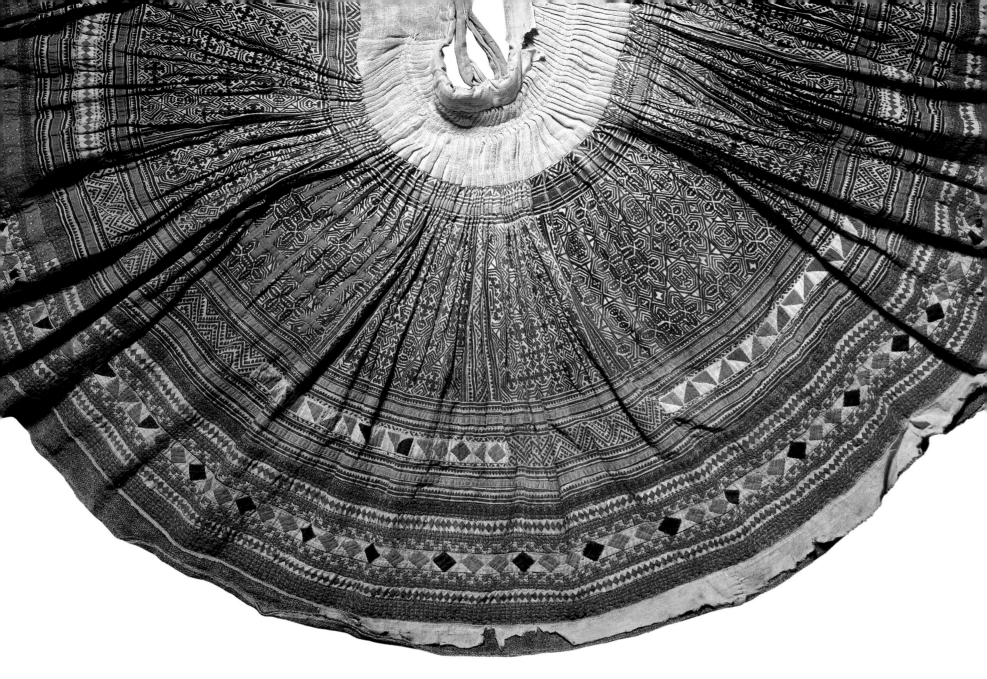

Woman's skirt (*tia mooing njua*)

Acquired 1985, cotton, batik, cross-stitch embroidery, appliqué work, skirt L 55 cm, Blue Hmong (Mong Njua), northern Thailand, Staatliches Museum für Völkerkunde, Munich, inv. no. 85-305 777

Wax-resist techniques, nowadays generally called "batik," are best known in Java, but batik is produced even today in northern Thailand, southern China, and the Philippines. The inserted batik stripes display ancient geometric motifs.

thread impregnated with wax so that when the fabric is steeped in dye, the red color does not dye these areas. After dyeing, the threads are removed and a geometric pattern in natural color is produced. According to Maxwell, such clothing is reserved for warriors who have killed more than five enemies, the color red (as elsewhere in Southeast Asia) representing strength and bravery. In the detail picture of the trousers, remains of wax-impregnated threads still in place can be seen (see page 155). Simple wax-resist techniques were possibly more widespread in Southeast Asia, later giving way to other decorative techniques such as weaving or embroidery. Therefore the shirts and trousers of the Kulaman-Namobo are today decorated only in part with variegated cross-stitch embroidery, while those of the neighboring Bagobo and Bilaan are exclusively decorated with it.

In China and some areas of Southeast Asia, embroidery seems to have replaced weaving techniques such as pattern weft in order to obtain more ambitious patterns. The single-color cross-stitch

embroidery produced in the mountainous parts of south China goes back a long way, and Yao legend tells of a first embroidering ancestress who created the landscape with her needle and thread. Yao women in northern Thailand wear broad trousers embroidered with dense geometric patterns – on the back of the material, astonishingly, so that the pattern is to be seen only when they turn the material inside out. The weave stitch, so-called because of its resemblance to a woven pattern, was in earlier times the only known type of stitch. A horizontal-vertical type of stitching, following the warp and weft threads of the material to create a lace effect, was introduced later.

About 40–50 years ago, the diagonal cross-stitch was introduced. Only a few old women have never learnt this technique. The trousers shown here display triangle, lozenge, cross, hook, and T-shape motifs, plus the already mentioned swastika on the upper edge (see page 154, left). Like the men's trousers of the Kulaman-Manobo on Mindanao, they have a Chinese cut. Despite the

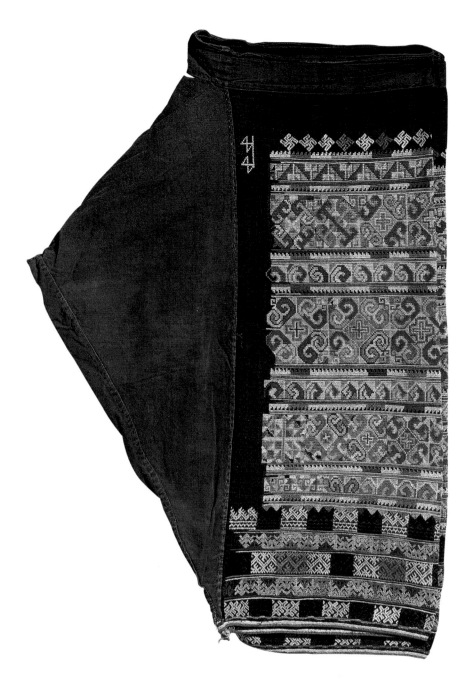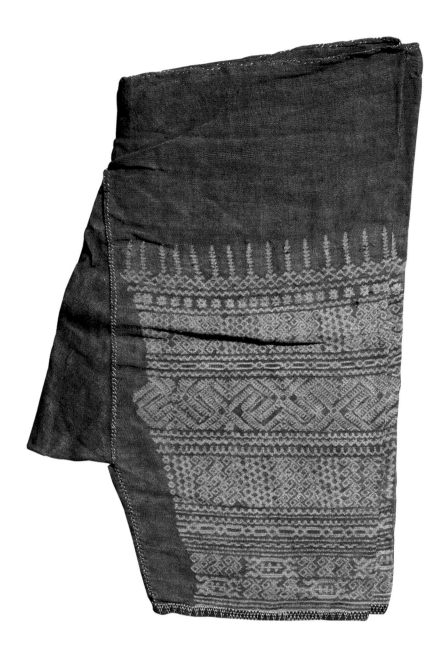

introduction of embroidery, weaving techniques with pattern weft have survived in some areas, and are easily mistaken for embroidery; examples include those made by the Iban on Borneo, on Timor, and among the Manggarai on western Flores (see page 157). The Manggarai produce quite different textiles from all other ethnic groups on Flores, a circumstance most probably to do with influences from Sumbawa and southern Sulawesi, and borne out linguistically. These sarongs for men and women are called *lipa songké jok* on Flores. *Lipa* is also the term for skirt on Selayar and southern Sulawesi; *songké* is obviously derived from *songket* or *sungkit*, meaning fabric with a pattern weft. Fabrics from western Flores are decorated with geometric motifs in a pattern-weft technique, and the most valuable of them have knitted edges with triangular motifs (*jok*) reminiscent of *tumpal*. Both techniques occur in fabrics from Sumbawa.

Finally, we should mention the clothing of the Lisu women from northern Thailand. The Lisu give the upper reaches of the Salween River as their homeland, in mountainous southern China, and the Lisu that live today in northern Burma are quite different from other Lisu tribespeople that have migrated into Thailand. This is due in part to their isolation from the rest of the Lisu population over many generations, and in part to the fact that they have contracted mixed marriages with the Yunnanese. Thus, Lisu women in northern Burma and southern China weave their clothes from hemp even today and use simpler decoration, while Lisu women of northern Thailand have learnt to appreciate the advantages of commercial cotton, and decorate their clothes lavishly (see page 156). A blue or green tunic slit to the waist is knee-length in front and calf-length at the back. It is crossed over the chest, fastened with a silver button at the neck, and closed under the right arm.

Above left
Woman's trousers

Acquired 1983, cotton, embroidery with geometric patterns, including swastika motif, L 74 cm, Yao, northern Thailand, Staatliches Museum für Völkerkunde, Munich, inv. no. 83-302 732

Above right, and opposite
Warrior's trousers

(Overall view, above right; and detail, opposite), pre-1928, banana fiber fabric (abaka in Philippinese; Musa textilis), decorated with a wax-resist technique, L 55 cm, B 66 cm, Kulaman-Manobo, Mindanao, Philippines, Staatliches Museum für Völkerkunde, Munich, inv. no. 29-5-1

The detail picture of these trousers from the Philippines reveals the remains of wax-impregnated threads.

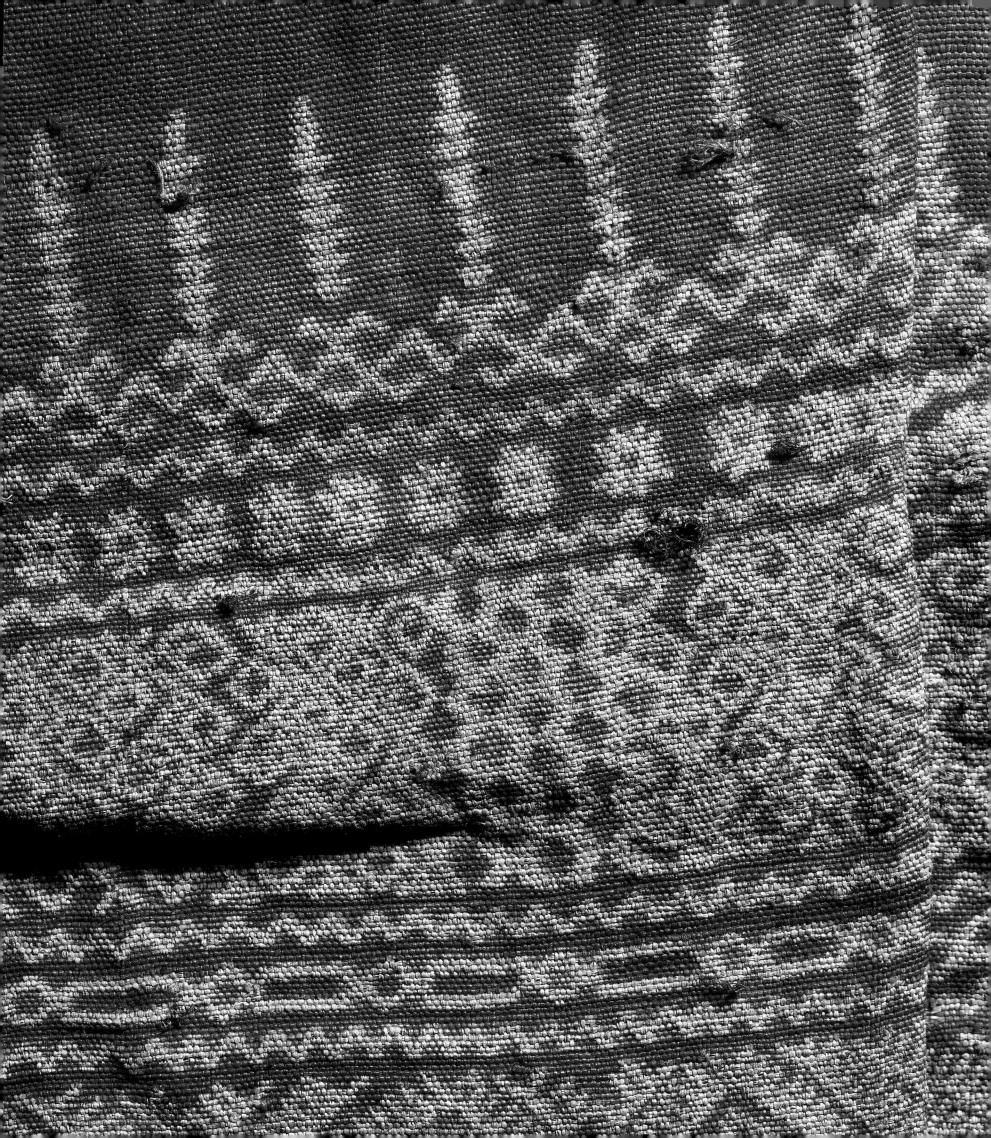

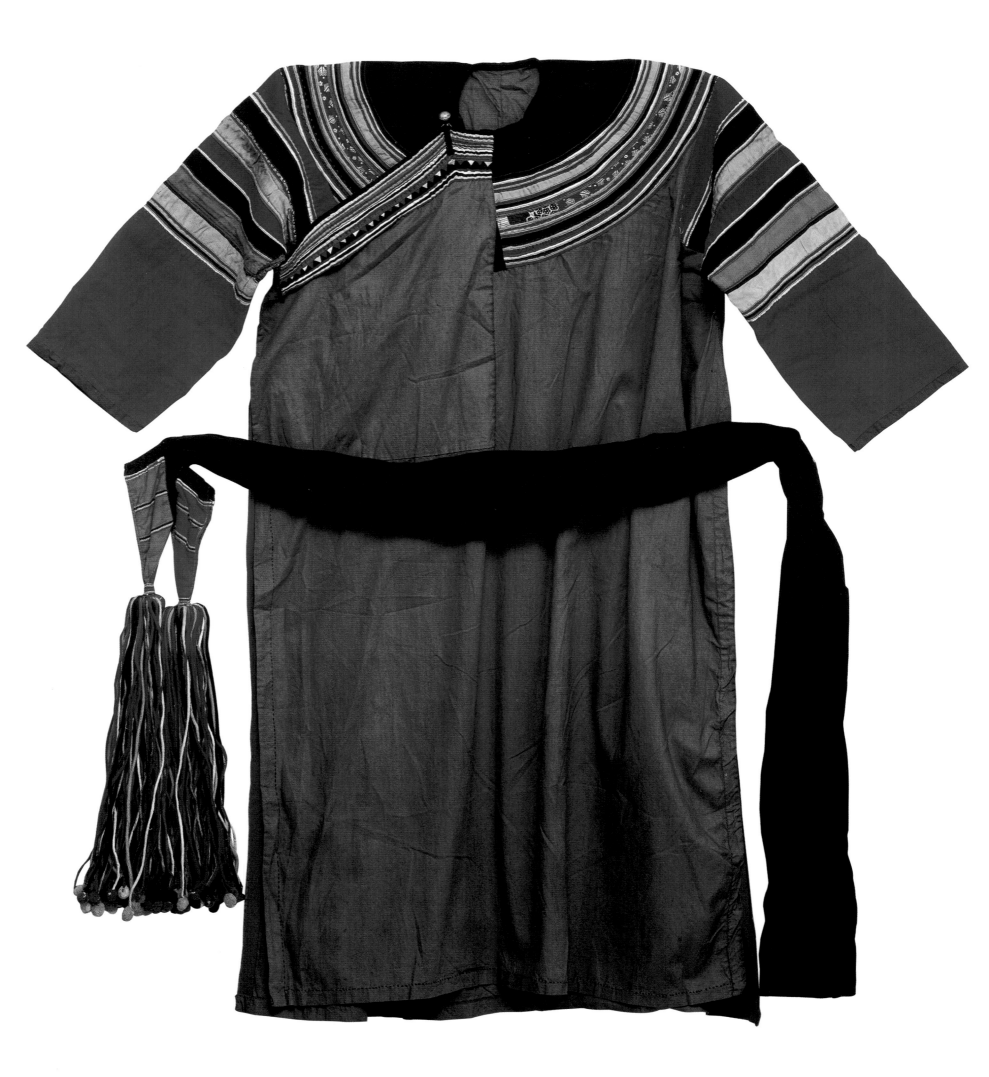

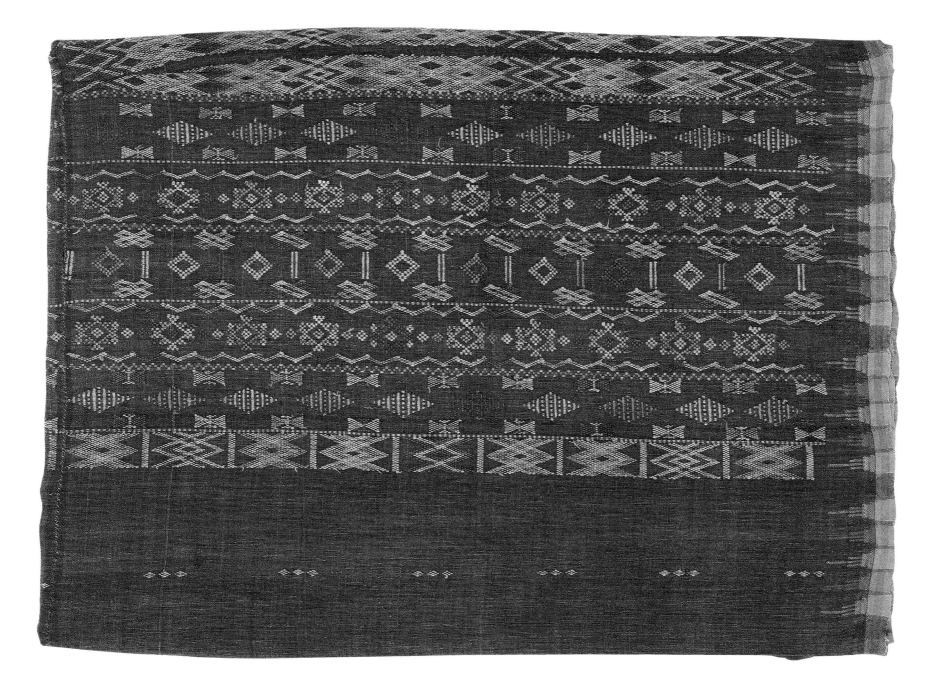

Numerous bands of material are sewn on to the round black yoke of the neck in a range of bright colors. This stripe pattern is repeated on the upper sections of the sleeves, though the lower parts of the sleeves are always kept red.

The young women of the Lisu vied with each other to see who could sew the narrowest strips on to the yoke, while the older women (like the Lisu in northern Burma) preferred fewer, wider strips. The women wear knee-length trousers in the Chinese style and red puttees decorated with gaily embroidered pieces of blue material. A wide sash about four to six meters (13 to 20 feet) long is tied tightly over the tunic round the waist; it is wound together at the back, its end forming an imposing pair of tassels about two feet long. These tassels consist of closely rolled, brightly colored strips of material sewn together with numerous delicate stitches in contrasting colors. At the ends of these strips of material are small pompoms made of different

colored yarns. On festive occasions, young girls and women wear black turbans decorated with gay woolen threads, tassels, and luster pearls, whereas older women prefer loosely wound unadorned black turbans. The garment closed diagonally over the chest worn by the Lisu and the jackets of many other mountain peoples in northern Thailand, northern Burma, and southern China call to mind the simple designs of the artistically embroidered coats of Chinese officials.

It is obviously impossible to give a comprehensive account of all textile traditions of Indonesia and mainland Southeast Asia, but this selection will highlight certain aspects of textile production.

The peoples of Southeast Asia have conserved to the present-day materials, techniques, and motifs dating to prehistoric times. On the other hand, new influences, for example from India and China, and later from the Islamic world or Europe, were never excluded; in fact such external influences were

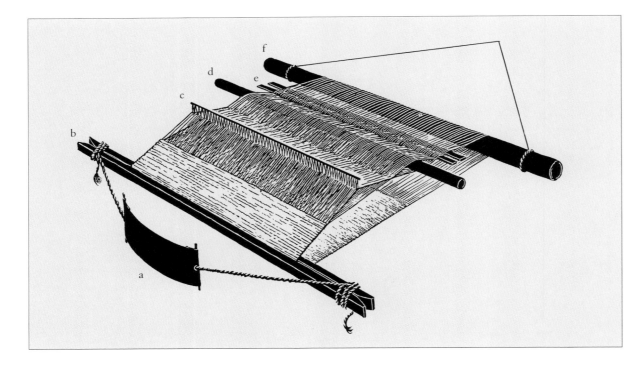

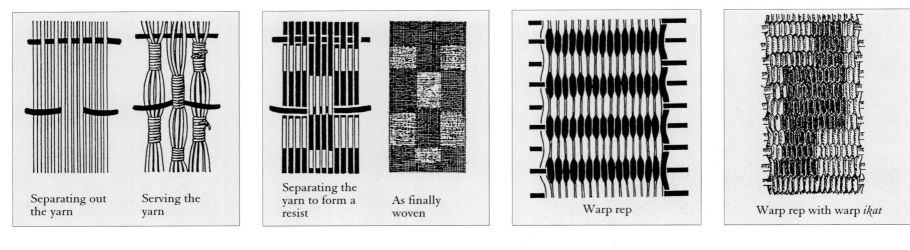

| Separating out the yarn | Serving the yarn | Separating the yarn to form a resist | As finally woven | Warp rep | Warp rep with warp *ikat* |

adapted in a great variety of ways and imaginatively incorporated into native traditions.

Traditional Looms

Even today, a large proportion of textiles in Indonesia and mainland Southeast Asia are produced on two simple types of loom, the back-slung (back-strap) loom, and the back-bar loom with comb. They are used almost identically. When weaving, the weaver sits with her legs outstretched on the ground or on a low stool. The loom is in front of her, with the warp stretched out in front of her more or less horizontally.

In a loom of Type A (see above), a continuous length of warp runs round two wooden bars. The rear one, called the warp beam (f) is attached to a post of the house or a frame. The front bar (b, the breast beam), which can also consist of two parts joined together, is tied with cords to a back strap or back bar (a). The weaver can control the tension of the warp by bending forwards or backwards. Within

the warp is the separator (d), a bar over which all odd warp threads run. Odd and even threads are thus separated, and a gap appears (called the "shed") through which the shuttle with the weft threads can be passed. In front of the separator is the heddle beam or harness (c). Every loop of the heddle has a warp running through it, so that when it is lifted a second shed can be created. The sheds are enlarged by the insertion of a "sword" (d). The sword also ensures that the weft is firmly pressed down so that the fabric does not become loose. Behind the separator there are also usually two narrow cross lathes (e) in the warp, over which the even and odd warps run; among other things, these help to avoid the warps getting tangled at the back.

In fabrics thus produced in linen weave, the warps lie so close together that they cover the weft threads, and this is known as warp rep. Looms of Type A are probably the oldest and most wide-spread type of loom in Southeast Asia. They were used to weave cotton and other plant fibers, including in the warp *ikat* technique. The latter is

In warp *ikat*, the warp threads are served (to form a resist), dyed, and only then woven. In warp *ikat* with warp rep, a special type of linen weave, only the warp thread is visible.

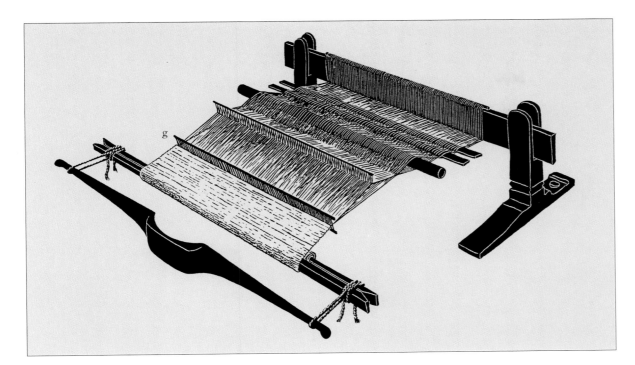

Left
Horizontal back-bar loom with comb (Type B)

The introduction of the back-bar loom with comb made it possible to combine a looser linen weave for fabrics with weft *ikat* and pattern weft.

Linen weave with pattern weft

Linen weave with pattern weft

Linen weave

Linen weave with weft *ikat*

a process by which the warps are served in bast to constitute a resist before weaving in accordance with a pattern (in other words no dye penetrates at these points when dyeing takes place).

With looms of Type B (see above), one end of the individual warp threads is fastened at the front on the breast beam and wound at the other end on the warp beam. The warp thus extends only on one level and not in two, as with a continuous warp. This means that, after getting to a certain point, the weaver winds round the breast beam the fabric she has woven so far, and unwinds further warp thread from the warp beam.

Looms of Type B display a comb (g) in front of the harness, between the closely set teeth of which one or more warp threads run. This determines the distance between the warps. The comb can also be used to press down the weft. In other respects, this type of loom corresponds closely to Type A. Sheds are created in the same way. Looms of Type B are found in coastal landscapes and areas under the direct influences of princely

courts, and they are used to weave both silk and cotton. The introduction of the comb made it possible for warp threads to be kept further apart, allowing the weft to show through. Weft *ikat*, double *ikat*, pattern weft (in which additional weft threads of silk or metal can be woven in) and other techniques have been developed since then and are found principally in the above-mentioned areas. In the case of weft *ikat*, it is the weft threads that are served and dyed, rather than the warp threads.

Unlike with warp *ikat* with warp rep finish, where only the warps are visible on the finished fabric, on weft *ikat* with linen weave both warp and weft are visible. Likewise in the case of double *ikat*, in which both warp and weft are served (see above).

In the pattern weft technique, patterning threads of silk or metal additional to the basic weft are woven in, either running across the entire width of the fabric or remaining limited to just the patterned part and not extending over the whole width of the weave.

Above
Weft *ikat* and pattern weft

In plain linen weave, both warp and weft threads are visible, so that weft *ikat* is possible. In pattern weft, additional weft threads are woven in, which either run across the whole width of the weave (far left) or are limited to the patterned parts.

JAPAN

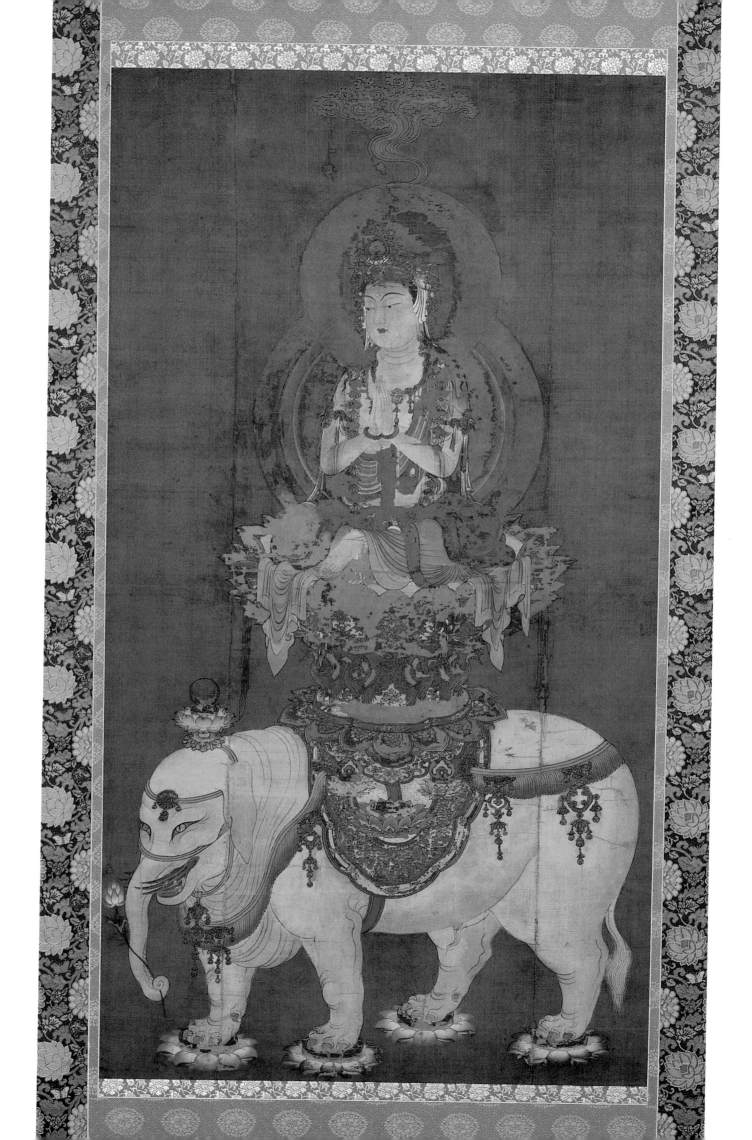

Painting and Graphic Art

At first sight, the world of Japanese painting seems to extend between two very opposite poles: from the deep spirituality and calm captured in the few ink brush strokes of a small, Muromachi hanging scroll on one hand, to the almost outrageous flamboyance, the huge scale and daring design of a set of gold doors in a Momoyama castle on the other. The first has the effect of quietening the passions, and of coaxing the soul to enter a magical territory where the path to the deepest mysteries can only be followed by contemplation and intuition. The second has the effect for which it was intended — to impress the viewer with a splendor that demonstrates the power and wealth of the owner. One is subdued and tranquil, the other is loud, muscular, and energetic, and between these two there lies an extraordinary wealth and diversity of painting.

It would be difficult to think of similar extremes in Western painting: perhaps a small watercolor landscape by Turner and one of Rubens's larger tableaux might be as close as one can get, but even these genres are part of a schema of man's relationship to God and nature for which it would be difficult to find an equivalent in Japan.

Bodhisattva Fugen

Heian Period, 12th century, ink, colors, and gold on silk, 155.6 cm x 83.1 cm, Collection of the Freer Gallery of Art, USA

One of the largest known Heian paintings of Fugen shows the sumptuously jeweled bodisattva seated cross-legged on an elaborate lotus throne mounted on an elephant. Each one of the animal's feet is planted in a lotus flower.

Introduction

The art of Japanese painting has a long history, during which there have been four main waves of influence from overseas. The first of these was during the 6th and 7th centuries A.D., when Buddhist and mythological subjects from China and Korea were imported, along with the know-how of making paper and ink. Inspired by the new faith and art works from the mainland, religious painting and sculpture flourished and reached a triumphant peak during the Heian and Kamakura periods. This period marked the peak for Japanese religious art, and although it has continued to be produced until the present day, it gradually became derivative and slid into a decline from which it never really recovered.

The second wave appeared during the 13th and 14th centuries, when Zen priests from China, and Japanese priests who had studied at monasteries on the mainland, brought with them the ideals of ink painting that had reached fruition during the Chinese Song dynasty. These were to set the standard for ink painting during the Muromachi period and later provided the seeds for the germination of the great Kanō school of artists.

The third wave arrived at the end of the 17th century and was again introduced by priests and artists from China, some of whom came to live in Japan in order to escape the upheavals occasioned by the collapse of the Ming dynasty. With them they brought the styles of Ming-dynasty painting that at home had been practiced almost exclusively by scholar-bureaucrats, but which in Japan were adopted by a much more varied group of artists who had classical cultural aspirations and ideals. Many of these were refreshingly eccentric, and were known as *bunjin*, the "literati."

The last cycle of overseas influence – and one that has been on a scale unprecedented since the 6th century – has occurred over the past 130 years or so; and, in a departure from the historic pattern, has come not from China, but from Western countries. After the country's long isolation, its much wider contact with America and Europe since the Meiji restoration has led to a dramatic change in almost all areas of life, including painting and the other arts. Not only have themes of painting been expanded widely to include subjects that previously had had no aesthetic recognition (the still life or the nude, for example), but also the choice of artist's materials has been increased, and now canvas, oils, and acrylic pigments have to a large extent replaced the traditional ink, paper, and silk.

Despite occasional times of hermit-like isolation, Japan has basically been a cultural sponge that has long been open to absorb almost anything that comes to its island shores. It is a land that has never really been known as a wellspring of ideas; it has never germinated any political or religious "ism" to spread and convert others, and it would be hard to recollect the name of a single native philosopher or ground-breaking scientist. But this is not by any means to imply that there is any lack

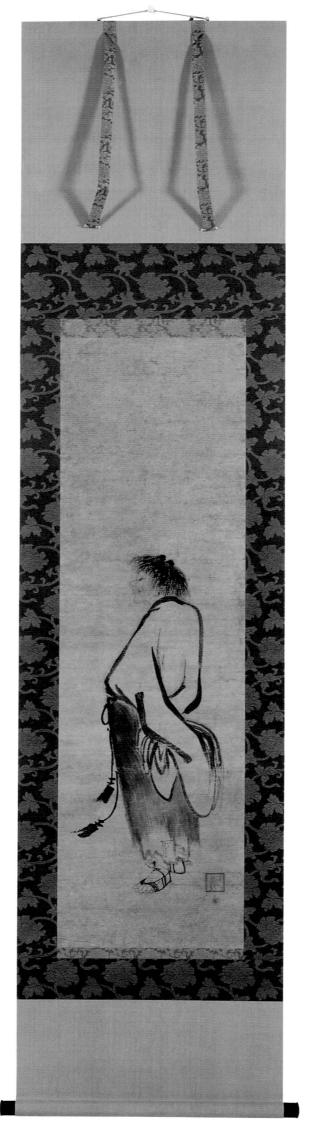

Kanzan

Kao (?–1345)

*Ink on paper, 102.5 cm x 30.9 cm,
Collection of the Freer Gallery of Art, USA*

Kao was one of the first Zen priests, who after spending more than a decade in China returned to Japan and became one of the founders of the Muromachi suiboku school of painting. In this portrait of Kanzan, who was one of the more eccentric figures of Zen mythology, Kao has captured the alert expression of the subject in a few finely controlled brush strokes.

of imagination or talent; while Japan has been content to leave it to those of other nations to suffer the birth-pangs of invention, it has at the same time shown a singular genius in the selection and synthesis – one might say the "Japanese-ification" – of intellectual and cultural imports in order for them to become acceptably absorbed in the native culture. This has been true of the above-mentioned waves of foreign influence on Japanese painting, and in each case the new vision has been first adopted and then adapted, until a few decades later what was at first novel and exotic seems to be completely at home and Japanese.

It might be stretching a point, but it could be said that among the many Japanese painters through the course of history, one can find some of the first Impressionists, the first Expressionists – and even the first Abstractionists. "Impressionist" is surely the appropriate word to describe those early "broken ink" landscapes where a few pointillist dots can make a rock look more ancient, more lichen-encrusted, more *rock-like* than it would with more painstaking draftsmanship. And what could be more expressive than the daring, wild strokes of some of the later Edo eccentrics such as Soga Shōhaku, or more abstract than the *ensō* circles drawn by Zen monks to succinctly represent one of their more profound philosophical concepts? Japanese painting is rich in its complexity and full of surprises for a Westerner because, more than anything else, it reveals a way of looking that is completely different – and, therefore, profoundly fascinating.

Until the modern period, paintings in Japan were usually seen in the formats of hanging scrolls, folding screens, long hand scrolls (almost always for narrative purpose and with images that convey a story from right to left), fans, picture books, and sliding doors, which were once standard in Japanese buildings – all this in marked contrast to the framed canvas or wall fresco seen in Western countries. Whereas Western paintings are hung on the wall more-or-less permanently, Japanese screen and scroll paintings are traditionally stored in a fire-proof go-down (store) and brought into the house for a brief time to reflect some special event or some aspect of the season; only the sliding doors, an architectural feature of the house, remain inside.

A hanging scroll is the focus of the *tokonoma*, a recessed alcove in a traditional Japanese room, where it can be seen by itself, without the cluttered competition of other paintings, and where it is often respectfully complemented only by a vase with a couple of fresh wild flowers, or a small incense burner. The painting is mounted with borders of brocade and plain silk on a backing of paper and has two narrow strips of matching brocade known as *futai*, which hang from the top. These are relics of the bindings on ancient Chinese scrolls and still remain as a design feature with no practical purpose. They do, however, provide an aesthetic function of seeming to give the effect of a slightly three-dimensional approach, and of leading the viewer's eye to the painted surface (see page 164).

Landscape

Attributed to Sesshū Tōyō (1420–1506)

Six-panel screen, ink on paper, 156.2 cm x 357.8 cm, Collection of the Freer Gallery of Art, USA

This screen is one of a pair reputed to have been in the collection of the Tokugawa family, who ruled Japan throughout the Edo period. The artist has used a wide repertoire of brush strokes to build up an idealized, complex landscape that shows much inspiration from mainland China.

Autumn Grasses

Ki-No-Masunobu (Mid-Edo, 18th century)

A pair of six-panel screens, colors, and gold-leaf on paper, private collection

The Ki family have been connected with court circles in Kyoto since ancient times. No biography of Masunobu has been located but these screens indicate that he was an accomplished painter working in the Rimpa tradition and using only the finest quality materials. The design shows an almost musical composition of fall grasses, bell-flowers, bush-clover, and wild orchids and evokes the poetic feeling of fading summer.

Scroll paintings can be easily rolled up and are stored in boxes made of paulownia wood, a material that does not burn easily and has the added quality of absorbing humidity. Particularly valuable paintings are stored in a paulownia box that is housed in yet another box, usually finished with lacquer.

Screen paintings are essentially moveable, folding walls, and were used to delineate space and create a special atmosphere for some household activity. For example, a pair of screens with paintings on a seasonal theme might be brought out to create a more intimate area in a large room, and to provide a dramatic background for entertaining and impressing visitors. They were made of paper pasted on a lattice-like wooden frame, with the painted front usually bordered with brocade, and the whole arrangement framed with a thin wooden strip that was finished with red or black lacquer. Usually screens were constructed with two or six panels (although occasional examples are seen with four or eight), which are hinged so that the screen can stand in a zigzag shape and also be folded flat for storage. Six-panel screens are almost always made in pairs with some contiguity in the design or painting. A pair of screens with paintings of landscapes for example, will usually depict different seasons, but in viewing from right to left the composition moves from foreground to distance on one screen, and back from distance to foreground on the other (see page 218).

Paper made from mulberry fibers is the material usually used for paintings, although finely woven silk was sometimes selected for those needing a more meticulous execution as it is less absorbent and can carry a finer line. Ink that was made from the soot of burning oil was the classic medium for painting, and its use had to be mastered thoroughly by every artist. When painting with ink there is no room for mistakes, no chance to rectify, and so each brush stroke has to be absolutely correct. In historic times, many samurai warriors also practiced the gentlemanly art of ink painting, and it is not surprising that the rigorous training that was required to be able to use a sword-blade with accurate and deadly skill also developed the fine control needed for wielding a brush and ink. Colored pigments made from vegetable or mineral sources were also used, and gold leaf was often applied for decorative effect – especially in screen paintings, where it was valued for the remarkable quality it has of picking up light from the weakest of sources, and of gleaming magically in the deep shadows of rooms lit by candle or lamp.

As in other countries, the life of an artist without independent means was highly risky and some sort of patronage was necessary in order to keep starvation at bay. Until the 12th century, almost all art was basically religious in content and so no artists were really independent as they were all in the employ of the temples that enjoyed lavish

official support. Many later artists also happened to be priests (particularly those who lived during the Muromachi period) and even though their paintings may appear more secular, there is in their works a strong religious flavor of Zen, the Buddhist sect which was then permeating all aspects of life.

Artists were later also patronized by the imperial family, the nobility, and the military shogunate, all of whom commissioned them to decorate their palaces and castles. A system of ranking that had originally been used for priests provided security, in the form of title and a stipend of rice, for those outstanding painters who were in good favor with officialdom; with this artists could provide for themselves, their family, and a number of studio staff and servants.

The borderline between artist and craftsman was never clear and many wonderful works have survived whose creators are unknown and uncelebrated. The idea of associating a painting with a painter seems to have appeared only in the Muromachi period, when artists first started the practice of putting their written signatures and personal seals onto their paintings. Later artists were fond of using not only their given names, but also *go*, in other words *noms de pinceaux*, which in addition to stamped seals, were often numerous and frequently changed as their career progressed. The study and classification of these is a continu-

ing effort today, and misattributions abound to present endless but interesting hurdles for the scholar or art collector.

Early works and the rise of Buddhist painting

The oldest paintings found so far date from the end of the Tumulus period in the 7th century A.D., and consist of images that were executed in colored pigment on the walls of burial chambers. The Takehara tomb in Fukuoka Prefecture on the Island of Kyushu has a wall painting showing two standing fans, two strange horse-like beasts, a human figure, a boat, and stylized waves: they probably depict a spirit's journey after death. Other tombs in the Nara area reveal paintings that are almost identical to those of the same period in China and Korea. The famous Takamatsuzaka burial chamber contains images of groups of men and court ladies clad in mainland attire together with the Sun, Moon, stars, and mythological beasts, which were originally painted in colored pigments, together with gold and silver leaf, on plaster that had been applied to the stone walls. Better preserved paintings were recently found (in 1998) in the Kitora mound near Nara and have been photographed with a miniature high-resolution camera. These too depict the heavenly bodies on the ceiling and fabulous mainland

Haya-Raigō: The Descent of the Amida Buddha and Heavenly Host

Early 13th century, gold-leaf, colors, and ink on silk, H 144.7 cm, Collection of Chion-in temple, Kyoto

In one of the most extraordinary religious paintings of Pure Land Buddhism, the Amida Buddha is shown accompanied by bodhisattvas and a heavenly orchestra, speeding to earth on clouds in order to rescue the soul of a devout believer waiting below. Even though the cherry blossoms indicate spring, the landscape is dark as if night has fallen, adding to the miraculous atmosphere of the scene. It was said that the Buddha would descend to earth "in the blink of an eye" and the aerodynamically shaped clouds seem to emphasize the sense of speed. Glowing in the far distance in the top right-hand corner, the Western Paradise can be seen, waiting to welcome the new soul.

beasts around the tomb; the Azure Dragon on the east wall, the White Tiger on the west, and a *gembu* (an extraordinary hybrid of snake and tortoise) on the north wall.

Buddhism had been introduced to Japan by Korean emissaries in A.D. 552, and by being associated with mainland culture (which was highly admired at the time), spread rapidly through the country to live alongside the native Shinto beliefs. Shinto was and still is a religion without a central god, but it has similarities to other animist beliefs seen in agrarian societies, where there is a reverence and respect for that which is not understood – the mysteries of seasons and the harvest, fertility, and the power of nature. In Japan, spirits (*kami*) are believed to be the forces behind these phenomena, and their benevolence can be invoked through proper respect and correct ritual. Shinto is above all about life and living, and with few exceptions is not concerned with death. Buddhism, on the other hand, is preoccupied with the afterlife and how to prepare for it with meritorious conduct. Strangely, the two religions cohabit not only in the same land but also in the same mind, and almost all Japanese get married in a Shinto ceremony (often with a Christian one thrown in for good measure, together with a change of costume), while the rituals of death are Buddhist.

Through the pious efforts of Prince Shōtoku Taishi (572–621), Buddhism was established in Japan as the state religion, and artists, sculptors, and architects were invited from the mainland to help with the building and decoration of a large number of temples. From the middle of the 6th century A.D. until the end of the 8th century, the culture of Japan reflected that of the glorious T'ang dynasty in China, and much of this splendor and religious art has survived to the present day (especially in the area around Nara), whereas it has long ago vanished on the mainland. But with the passing of time, both religious painting and sculpture gradually changed in appearance, and the process of "Japanese-ification" mentioned earlier led to an evolution from the mainland stereotypes to the appearance of a new imagery that was truly native, an imagery with its own energy and inspiration.

The faith that inspired this art had many branches, and that which was most in favor until the end of the 10th century A.D. was Esoteric Buddhism, a mysterious sect with secret rituals and a cast of thousands in its pantheon of deities and subdeities. All were supposed to be manifestations of the Enlightened One, but on closer examination the attributes of earlier Hindu figures from pre-Buddhist times can be discerned, just as European images of the Christian Holy Family and accompanying saints can reveal some unmistakable characteristics of Greek and Roman pagan gods. The paintings that survive from the Heian period show scenes from the life of the Buddha and myriad deities with their terrible attributes, strange gestures, and ritual paraphernalia, together with mandalas of a detailed complexity

where every element is linked together to make a symbolic picture of a particular doctrine. They were carefully painted using mineral colors on silk, and embellished with decorative details sometimes made with *kirikane*, gold leaf cut to shape or in thin strips, which was used to emphasize the lines of a robe or the veins of a lotus leaf.

One should not forget that these early paintings were created as the embodiment of an intense faith and with a very distinct purpose – to instruct and warn, not to delight. As such, and despite their spirituality, they can appear to be strangely unspirited, with their carefully drawn lines of equal thickness, and forms painted with body paint or flat gold: a sort of early "painting-by-numbers" where nothing of the artist's personality is revealed. Seen in the dark recesses of a temple and shimmering through a haze of incense smoke, they make a hypnotic focus for believers, reinforcing all they have been taught, and inspiring them to follow the tricky path of accumulating merit. But for others they have a slightly unsettling quality, curious and exotic, but also cold, distant, and somewhat unfriendly. To be sure, there is a strong intellectual interest, depicting as they do one of the most profound and enduring of man's efforts to reconcile himself to his part in the universe; but maybe the perfect truth is too frightening to face, and one looks away to seek something warmer and imperfect – something with human failings that is easier to recognize and with which to feel more at ease (see page 164).

It seems that in time the Japanese felt the same way and by the 11th century Esoteric Buddhism was seen to be gradually losing favor to a more basic and widely spread belief in the merciful Amida Buddha in his Western Paradise (see page 169). The message was straightforward and far easier to grasp: the deserving faithful would be reincarnated in the Garden of the West with its cool streams and jeweled trees, and there they would stand a better chance of attaining Nirvana (the ultimate liberation from the cycle of birth and death); the unfaithful would face a hell of torment, and eventual rebirth somewhere down the ladder of life forms.

Throughout the following two tumultuous centuries of the Kamakura period, Buddhist art blossomed to its fullest glory, and even though we see images as complex as those of the previous Heian period, the faces now seem to have gained a little more expression, the limbs are fuller and rounded, the gestures more natural; one can easily imagine that living people had been studied or used as models. Imbued with some recognizable human qualities, the benevolent deities begin to radiate mercy and compassion, while on the other side – in paintings of the underworld – the kings of hell make their judgements with cool authority, while their demons carry out ferocious and horrifying punishments on the damned. Of course only a human could possibly imagine such refinements of relentless cruelty; and in fact the painter probably did not have to use his imagination at all

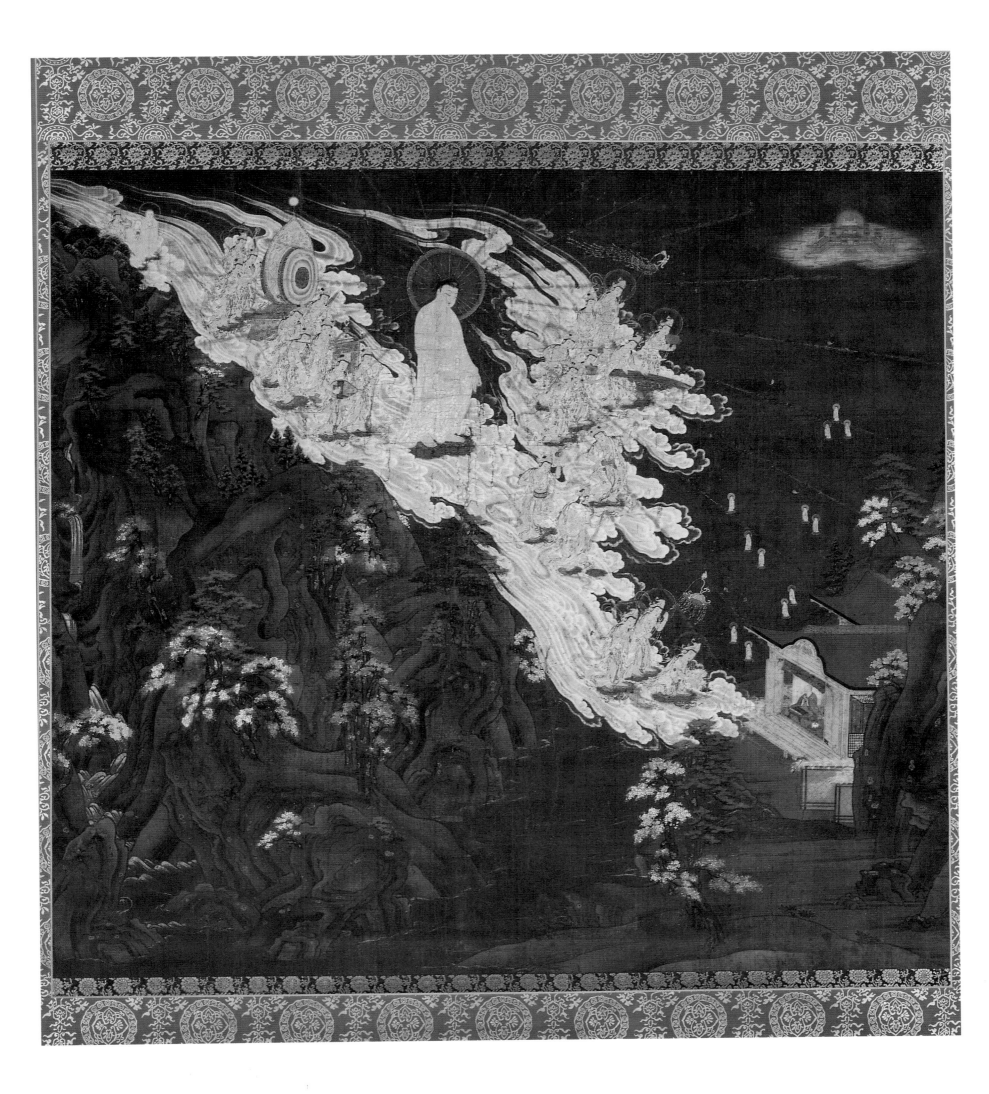

as such atrocities were to be seen all around in the country, which at the time was being torn apart by competing clans in a vicious civil war.

For most people, a faith in the afterlife provided the only relief from the relentless fear and danger, and this is seen in one of the most extraordinary paintings of the late Kamakura period in the temple of Chion-in in Kyoto, which depicts a *haya-raigo*, the rapid descent of the Amida Buddha to claim a soul for rebirth in Paradise (see page 169). It reveals the strongly held belief and fervent wish that everyone held in those troubled times: to be whisked away from the misery and chaos of earthly life to a place of peace and ease.

The Amida Buddha is shown accompanied by a host of deities and an orchestra playing heavenly music, descending on clouds over a landscape with cherry trees in full bloom. It was said that the Amida would come down from Heaven and pick up a soul "in the blink of an eye," and one is startled to see how this is indicated by the energy, speed, and movement in the Chion-in painting. The clouds form a diagonal from the top left to the bottom right of the picture, and are aerodynamically rounded in front, with shock waves like those seen in wind-tunnel tests; at the back they taper away into wispy tendrils. Amida and all of the other cloud-riders have been painted in gold, as have 12 miniature manifestations of the Buddha, which float in the air above the figure of the fortunate whose soul is being claimed. The earthly landscape is painted in dark colors as if to emphasize that the day is ending – as is a life on Earth. Even the cherry blossoms are rather somber, making the heavenly descent of the gold figures on their white clouds all the more miraculous and brilliant. One automatically envisages the following moment when the kneeling deity Kannon, at the front of the cloud, will reach for the new soul and transport it back to Amida's palace in the Western Paradise, which can be seen in the distance in the top right corner. And then, a split second later, the miracle would be over – in the blink of an eye.

Early Zen painting and Muromachi Suibokuga

Towards the end of the 12th century, another sect of Buddhism was introduced to Japan by priests who had visited China and studied there; it was a sect that was widely embraced and which would eventually have a profound influence on all aspects of Japanese cultural life that has lasted to the present day.

This new force was Zen Buddhism, known as Chan in China, where it had appeared some six centuries before, and it espoused the practice of meditation in order to directly achieve the enlightened awareness of truth, the method the Buddha himself had employed in his search for enlightenment. Two branches of the sect became well established in Japan: Rinzai and Sōtō. Rinzai Zen, which caught the attention of the military and artistic circles, taught that enlightenment could

come suddenly as the consequence of some Archimedean "trigger" that would in an instant remove mental blocks and open up the mind to enlightenment. Rinzai monasteries maintained tough discipline and demanded that their adherents practice a rigorous life of hard work, meditation, and study – all qualities that were readily recognizable for the samurai warriors, who were used to such austerities and who became avid followers of the sect. The other form, Sōtō Zen, was more popular among rural people and, while hardly more gentle than Rinzai, it promoted the idea that enlightenment would come slowly like the piecing together of a jigsaw puzzle, as a result of diligent meditation and hard work.

The effect of Zen on art was far-reaching and can immediately be recognized in many of the paintings, ceramics, and even costumes and folk crafts that are illustrated in this book. Just exactly what that effect was can be discussed endlessly, but – like Zen itself – it is very difficult to define.

The most concise explanation was put forward some decades ago by the writer Shin'ichi Hisamatsu, who suggested that there are seven characteristics which determine the nature of Zen aesthetics, and that these should be recognizable in any work by an artist or artisan who had either trained in Zen, or was imbued with its spirit. Leaving the philosophical background aside for the sake of simplicity, the recognition of these

Above
Ryōkai Mandala

(Detail), 12th century, gold on purple-dyed silk, 74.3 cm x 64.5 cm, Collection of the Freer Gallery of Art, USA

This detail of a mandala shows different deities in the format of a lotus flower, and was made by applying finely cut gold leaf to silk.

Opposite
Mandala of Divine Bodhisattvas

12th century, gold on purple-dyed silk, 74 cm x 64 cm, Collection of the Freer Gallery of Art, USA

Mandalas such as this, which depict the complex nature of the myriad deities of Esoteric Buddhism in a diagrammatic form, were displayed in Shingon temples near the central image of the Buddha.

characteristics can help in the understanding of Zen art. They can be briefly described as follows:

1. Asymmetry

As I come out
To this fishing village,
Late in the autumn day,
No flowers in bloom,
Nor any tinted maple leaves.

Fujiwara Sadaiye (1162–1241)

A sharp contrast can be seen between the Heian mandalas and Buddhist compositions, which are all composed to form a perfectly symmetrical arrangement, and works by any of the Zen painters, whose works all show an asymmetrical composition. The Heian idea was to picture perfection; but Zen teaches that such a concept is in itself a barrier to higher truth and has to be broken through. This idea carries through not only in art but in daily practice. For example, a container of flowers will be placed slightly to one side of a *tokonoma*, and the flowers too will be simply arranged, leaning out to one side – just as they might appear naturally at the side of a path in the countryside. Likewise the elements in a Zen painting will be arranged in an interesting, asymmetrical way, with mountains grouped on one side, or a figure facing out of the frame of the picture.

2. Simplicity

The pine tree lives for a thousand years,
The morning-glory but for a single day;
Yet both have fulfilled their destiny.

The Zen mind tries to keep uncluttered, as anything that is not necessary or in its rightful place is considered to be an impediment. This discipline can be seen in a tea room, which has no furniture and is kept scrupulously clean and free of any clutter. The only adornment might be an ink painting and a wild flower or two in the *tokonoma*; and because there is no other visual distraction, these items can be seen and appreciated better in their own pure state. Ink on paper is chosen for painting because, unless the artist was extremely skilled, colored pigments would be an encumbrance that would get in the way of the image. A Zen-trained painter could reveal the "colors of ink" in his work, and could make ice look colder, a lake deeper, the fall leaves more russet than would be seen on a more superficial level by using colors.

3. Astringency or Dryness

Autumn is come!
Though not visible
So clearly to the eyes,
One knows it by the sound
Of the wind as it blows.

Left
Boy on a Buffalo

Attributed to Sekkyakushi (late 14th–early 15th century)

Ink on paper, 97.2 cm x 35.6 cm, Collection of the Freer Gallery of Art, USA

With masterly brushwork and the use of varying intensities of ink, this bucolic scene conveys a powerful message of Zen teaching. Controlling the mind during meditation requires "not thinking:" to concentrate on nothing, to empty the mind. But this is easier said than done and is likened to taming a buffalo. While naturally having a rather peaceful temperament, the buffalo is large and heavy and is used to having its own way. Here the small boy is shown sitting triumphantly on the beast, which has its head turned to show the pleasing shape of its horns and ears, illustrating that the mind has been conquered.

Opposite
Daruma

Artist unknown
16th century, ink on paper, 63 cm x 29 cm, private collection

Daruma (also known as Bodhi-darma) was the Indian Buddhist monk who in the 6th century A.D. introduced into China the idea of individual meditation as a practice for achieving enlightenment. In Zen paintings he is typically shown unshaven, bald-headed, and with wide eyes – according to legend he cut off his eyelids to prevent himself from falling asleep during meditation.

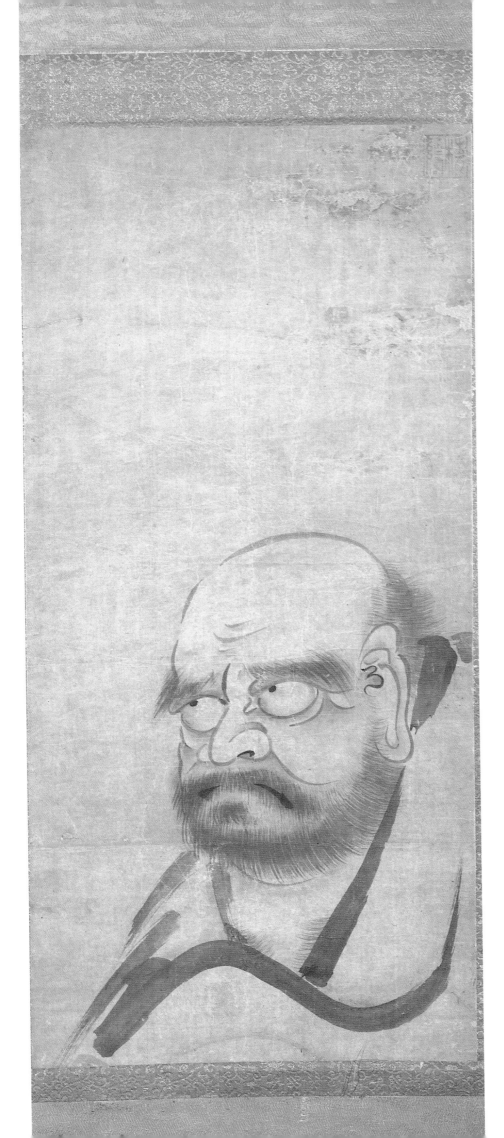

Astringency, or dryness, implies the qualities associated with age; of being wintry, worn, and weathered – the opposite of the springtime of full-fleshed youth and luscious sensuality. In Zen-inspired art, human figures are bony and sinewy, lined and wizened with much experience of life. All that is unnecessary has been left out and what remains is reduced to the basic, concentrated essence, like that of a dried persimmon, or the thick resin of an ancient pine tree. There is a strong feeling of this reduced essence in the concept of "beauty born of use" that is seen in some crafts; the patina of worn furniture, the cracks and chips on an old stoneware dish. And it is also sensed in the accompaniment to the Nō drama, where we hear none of the vocal acrobatics and passionate emotions of an Italian aria, only the deep, half-swallowed words that seem to be emanating from something that was once human, but that now seems much closer to the world of spirits.

4. Naturalness

There comes a wood-gatherer
Walking down the meandering mountain path:
"Tell me, O my friend,
Those on the peak: are they cherry blossoms
or clouds?"

Minamoto no Yorimasa (1104–1180)

In Zen art, naturalness does not imply mere naïve innocence, and in fact it can only be attained after gaining so much experience that the act of creating something can be done spontaneously, with "no mind." This is illustrated in the story of an old painter who, when asked how long it had taken him to paint a bamboo, replied: "Fifty years and five minutes: fifty years studying the bamboo, and five minutes to paint it."

Naturalness implies honesty and it is important to understand clearly what this means: for example, a pot that *turns out* to be asymmetrical will have a beauty that will not be seen if the pot has been *made* to look asymmetrical – just as the real patina of an old piece of furniture is vastly different to that which has been contrived with stains and trickery. Above all, naturalness is honesty.

5. Profundity, or reserve

The snow-covered mountain path
Winding through the rocks
Has come to its end;
Here stands a hut,
The master is all alone;
No visitors he has,
Nor are any expected.

Sen no Rikyū (1521–1591)

This refers to the withholding quality of Zen art: not everything is revealed at once, and the viewer

has to make an effort in order to fully appreciate the object. It is seen most profoundly in early ink paintings which, even though small in format, have such depth that they are like a portal to another world. This profundity certainly cannot be faked and it takes the hand of an artist steeped in Zen to achieve this special atmosphere: a darkness achieved with ink that is calm and free of danger, as opposed to the darkness seen in many of the earlier Buddhist paintings, which is uneasy and threatening. The greatest of the early Zen masterpieces have many layers of meaning and their full qualities can only be appreciated by contemplation and by opening the mind. They are best seen with the eye of intuition, as they do not lend themselves easily to the usual analytical dissection of the art historian.

6. Non-attachment

*Though not consciously trying to
guard the rice fields from intruders,
the scarecrow is not after all standing
to no purpose.*

Bukkoku Kokushi (1241–1316)

Even though highly disciplined, the true Zen adept will have a free spirit that can often appear to be very odd, and many of the more celebrated figures of the sect have also been quite eccentric and unconventional. Adherence to any fixed way of thinking, any "ism" whether religious or political, is a constraint of the spirit and the mind. In Zen painting, the artist has to discard any regulations or rules so that his mind can apply itself directly and freely without any mental fetters. This freedom can extend to everyday practice and a true Zen artist would never worry that if his brush was broken he would be unable to paint; he would be able to free himself from this convention and paint with his fingers – or a handful of straw.

7. Tranquility

*The court is left covered
With the fallen leaves
Of the pine tree;
No dust is stirred
And calm is my mind!*

Sen no Rikyū (1521–1591)

The last of these characteristics refers to the soul of the artist, which has to be quiet and undisturbed and in a meditative state of calm before he puts brush to paper. Any agitated state or stress will be unmistakably revealed in the painting, and so an artist or calligrapher will always sit quietly for a moment or two before working: not to *think* about the painting or what he is going to write, but to empty his mind – to think about nothing – and in this state, and after years of training, his hand can act directly from his spirit.

This is a very superficial outline of these seven characteristics, but it is necessary to understand also that not one of them alone would be a qualification of Zen art: they all have to manifest themselves together in some way. Even so, they will not reveal themselves easily to a checklist approach to be ticked off one by one, and are best felt intuitively rather than analyzed intellectually. The aim of the Zen painter was always to try and capture the essence of the subject rather than depict it photographically and this ideal includes the concepts of *aware*, which is beauty of an emotional, slightly sad, bittersweet quality; and *yūgen*, an even deeper, more mysterious "resonance" that transcends form. This spirit of Zen can be seen in almost all aspects of cultural life through the Muromachi period: in paintings, architecture, ceramics, poetry, the Nō dramas, and in utensils for tea ceremonies. The practice of tea or *cha-no-yū* is essentially the experience of Zen for the layman, and this, more than anything, was the vehicle by which the teaching was disseminated to the laity outside the precincts of the monasteries.

Suibokuga means "water-and-ink pictures" and refers to the majority of paintings that were made by Zen artists throughout the Muromachi period. Although one or two artists, such as Sesshū (1420–1506), Kantei (last half of the 15th century), and Minchō (1352–1431), used delicate colors in their paintings, they were only complementing what had already been finished in ink.

Outside their native land, these paintings appear beautiful and somewhat exotic, but it is only after seeing the wet, misty mountains of Japan that one can appreciate how monochrome ink can be so much more suitable than color for capturing atmosphere and depth. Distance in landscape painting is indicated by dividing a more strongly defined foreground from rather more faintly painted distant mountains, with a "negative space" of mist in between; the Japanese learned of the concept of the vanishing point in perspective only after seeing European paintings imported by the Dutch a couple of centuries later. The Zen painters gave the same emphasis to light and space as they did to mass and form, and this is a concept is also a major aesthetic rule in Japanese garden design and flower arrangements (see page 165).

During the Muromachi period, the country was very unsettled, with almost continual warfare and hopelessly bad government, as the imperial courtiers and the followers of the military shogun competed for control. The social divide became more extreme, with desperate poverty afflicting the ordinary people while the upper classes, ignoring these realities, chose to spend their time in the pursuit of art and religion. The greatest influence was that of the culture of Song dynasty China and this is reflected in painting throughout the almost two centuries of the Muromachi period. Classical Chinese subjects were those most portrayed: Daruma, the first Zen patriarch, Taoist immortals, famous priests, birds and flowers, and haunting misty landscapes that were idealized views of West

Opposite
Landscape

Gakuō Zōkyū (active about 1500)

Ink and slight color on paper, 80.7 cm x 35 cm, Collection of the Freer Gallery of Art, USA

This landscape illustrates the suiboku technique of indicating distance in landscape by means of a dividing area of mist, or "negative space." The artist's treatment of the mountains, which look like crumpled paper, adds interest, as does the slight color used in the buildings. Such landscapes were modeled after Chinese Song dynasty examples, and sought to create an Arcadian idyll in which to escape from the horrors of the Muromachi civil wars.

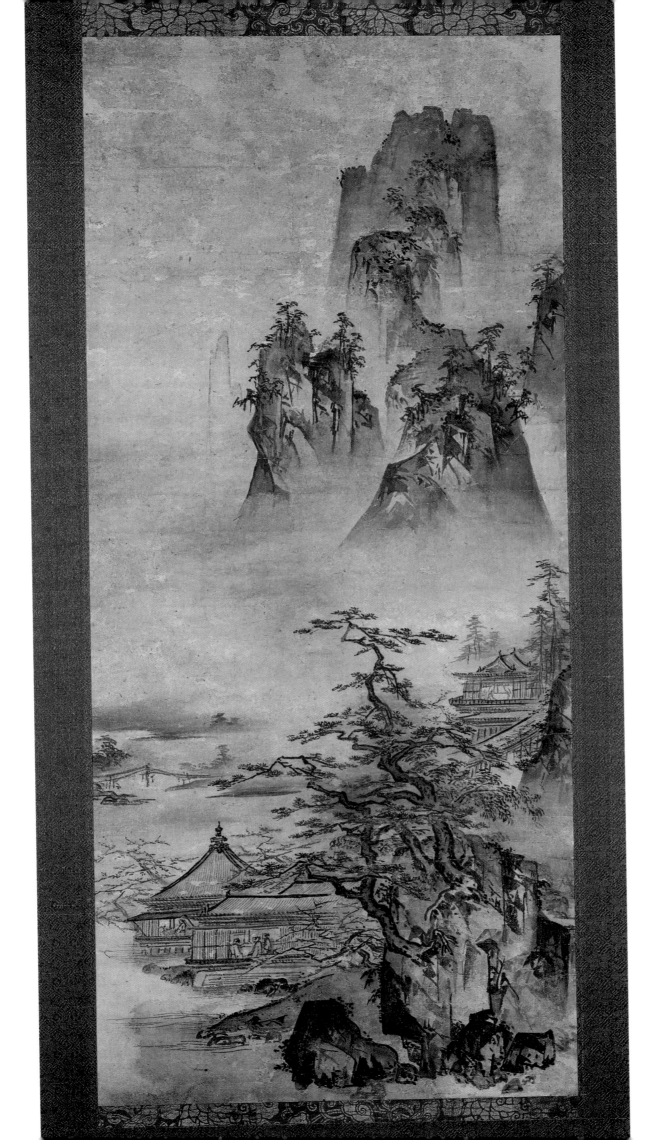

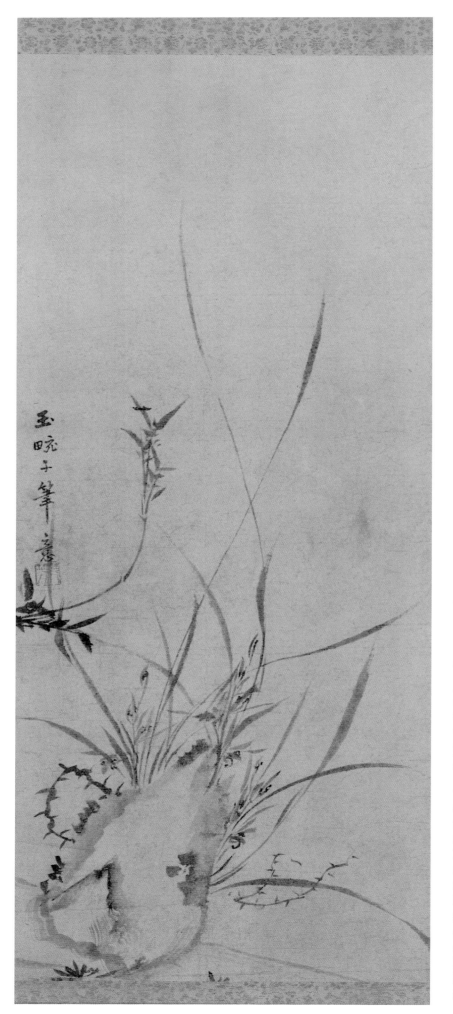

Lake and the Hsiao Hsiang rivers. In all of them can be felt a quiet but earnest yearning to escape from the daily miseries of the times and the mortal coil on Earth. In many cases, Zen artists painted only the bottom part of the scroll, so that in the empty spaces above admirers or associates could write poems or inscriptions that emphasize the philosophical content of the work.

In the Muromachi period a particularly abstract kind of landscape painting appeared known as *haboku* ("broken or flung ink"), inspired by the works of Chinese painters such as Yü-chien (early 13th century). Seemingly easy to paint, a *haboku* landscape is perhaps the most difficult of all subjects: because the picture is without structure, the artist has to capture the distance and mass of a landscape with just a few rough brush marks. It is the negative space (the part not painted) that forms the misty atmosphere out of which the elements of the scenery are suggested in ink – the impressionism of atmosphere rather than light (see opposite).

From this tradition of *suiboku* painting, the founders of the Kanō school emerged in Kyoto during the latter half of the Muromachi period, and instituted the idea of an hereditary line of painters passing the artistic skills from father to son. Reason would conclude that this system was far from perfect, and occasionally talented outsiders had to be adopted into the family when there were no suitable heirs in the bloodline. However, while enjoying official patronage the Kanō school continued to survive both as studio and academy until the late-19th century.

While initially associated with Zen and ink painting, the early Kanō school painters were more catholic in their choice of subjects and materials and borrowed freely from the courtly Yamato or Tosa schools. Yamato was an ancient name for Japan and *yamato-e* are paintings that essentially depict purely Japanese subjects, as opposed to *kara-e*, which show Chinese subjects. The earliest *yamato-e* appeared during the Heian period, at a time when almost all painting was religious, and differed from the usual religious iconography of the time in that they showed didactic images illustrating how Buddhism was introduced to Japan, but with recognizable Japanese details and background scenery.

This period also saw the development of *e-maki*, which are long narrow paper scrolls backed with silk and painted with narrative images that illustrate a story or legend in *yamato-e* style. Such hand scrolls were designed after imported Chinese Buddhist scriptures, and were unrolled from right to left to reveal scenes that progressed in a narrative form. Perhaps the most well known is a late Heian period hand scroll that illustrates the famous *Tale of Genji*, a complex and lengthy story about the love affairs of an imperial prince which culminates in his passionate relationship with Lady Murasaki. The story relates that despite the lady's peerless beauty, she was unfortunately not of noble birth and so could never formally marry

Above
Landscape

Artist unknown

16th century, ink on paper, private collection

This atmospheric landscape uses seemingly haphazard splashes of light and dark ink, a technique known as *haboku*.

Opposite
Wild Orchids

Gyokuen Bompō (1344–about 1420)

Ink on paper, 84.4 cm x 35.5 cm, Collection of the Freer Gallery of Art, USA

Bompō was a Zen monk much influenced by the works of Chinese painters.

Prince Genji. The prince died at the early age of 52, and the novel then continues in epic style with accounts of the Byzantine affairs and feuds of his successors. Fragments of the scroll that still remain show Genji scenes painted with exquisite colors and embellished with gold and silver leaf, scenes that evocatively capture the romance and intrigue of Heian court life.

In many of these scrolls we see one of the unusual but distinctive features of Heian *yamato-e* painting, an artistic device known as *fukinuki yatai* ("the blown-away roof"). In these scenes, the roof of a palace is eliminated showing the interior and its romantic episodes from a bird's-eye view, allowing the viewer to have a voyeur's partici-

pation. In addition there is an architectural arrangement (perhaps a disturbing pattern of posts and beams, or some feature of the season, to which the Japanese were always acutely sensitive) that underscores the emotion of the scene depicted. Apart from noble romances, *yamato-e* picture-scrolls also depict the stories of famous battles, legends, and classical poets. This style set the standard for the courtly paintings of the Tosa School in following centuries.

Although still much imbued with the flavor and discipline of Zen, the new Kanō school artists took elements from both *suibokuga* and *yamato-e* to give rise to a style of painting that was more secular and distinctly Japanese. Kanō Masanobu (1434–1530)

was the founder of the school, which from its inception was fortunate in enjoying the generous patronage of the military shogunate. He and his son, Kanō Motonobu (1476–1559), worked on paintings of a grander scale, such as sliding doors and folding screens, more suitable for the decoration of palaces, in addition to the typical Muromachi hanging scrolls made for the more intimate tea rooms. To some extent influenced by the Che school of academic painting in Ming China, Kanō painters chose natural subjects such as landscapes, birds, and flowers, which they depicted with powerful brush strokes to make a clear and direct image – far removed from the small, misty dreamlike views of the Zen painters. This trend towards the monumental continued and reached a flowering in the Momoyama period, when the land was more-or-less at peace under a military shogunate and an economic boom had been generated by the rebuilding of a war-torn country.

Momoyama painting:
Kanō, Rimpa, Tosa, and genre painting

The Momoyama period lasted just over four decades: from 1573, when the Ashikaga shogunate was finally overthrown by the Toyotomi clan after years of civil war, until 1615, when, in turn, the Tokugawa clan burned down their opponents' castles and seized power. They were to rule the country until 1867, at which time the shogunate collapsed and imperial power was once more restored. The Momoyama period was an era that marked a splendid renaissance in all artistic fields – a glittering bridge between the mediaeval Muromachi, and the following, very different, 250 years of Tokugawa administration and control.

With the new regime, social classes were juggled to some extent, and while some of the old guard lost their status and wealth, others who had been on the winning side found themselves well rewarded. The victorious ruling war lords built themselves magnificent castles with huge reception and audience rooms, and hired the leading artists to decorate them with wall paintings and screens. The purpose was certainly to impress, perhaps also to intimidate, and it can be seen that the powerful monumental designs with their elaborate gold-leaf decoration were calculated to underscore power, prestige, and fabulous wealth.

Kanō Eitoku (1543–1590) was the fourth generation of the Kanō school who developed a style of brush painting that was not only on a monumental scale, but also showed a new kind of composition and framing of the image. He was commissioned to paint a large number of works to decorate the new Azuchi castle of Oda Nobunaga (1534–1582), and later the castle of his ruling successor Toyotomi Hideyoshi (1536/7–1598) at Osaka. These castles were destroyed in military struggles and so some imagination has to be added to remaining evidence in order to reconstruct a picture of these legendary edifices. What remains

of Eitoku's work shows screens or doors painted with massive designs. The famous *Cypress Tree* eight-panel screen in the Tokyo National Museum shows an extraordinary picture of just the middle section of an aged tree, painted with bold brush strokes on a background of gold-leaf clouds. The composition is startling, especially for one used to seeing European paintings with the tree depicted properly in context: the earth below and the sky above. But Eitoku's genius has created an effect which is extraordinarily powerful, and by cutting off the top and bottom sections of the tree, the image of weight and age is all the more vivid. Overwhelming though this picture we see today is, what would one not give for a glimpse of one recorded commission he made, of a single tree painted on sliding doors that stretched for nearly 30 meters (over 98 feet)?

Another example of this expressive style is seen in a screen in the Honolulu Academy of Arts that has been attributed to Eitoku or his studio. The six-panel screen shows the mid-section of an old pine tree with branches and clumps of green needles floating like clouds over dead twigs (see pages 180–181). Huge rocks painted with strong brush strokes balance the composition on the right-hand side, and a flowering cherry tree and red azalea add points of color. Small grasses and dwarf *sasa* bamboo complete the picture. The trunk itself is spread over two panels and its age is enhanced with white patches of lichens that echo the delicate petals of the cherry blossoms. The background is of pure gold leaf and it is not difficult to imagine the effect that such a painting would have had in the dark rooms of a Momoyama castle when seen by candlelight at night, or in daylight softened and diffused through paper *shoji* screens.

But the decorating of castles was only one of the facets of Momoyama art, and with the boom in construction and the rapid generation of wealth, skilled artists were in much demand and the best were able to establish their own schools and studios. The Momoyama period was noted for its artistic variety and innovation and many new styles appeared and matured in the lively artistic milieu, especially around the capital city of Kyoto. It would be difficult to think of any other place on earth where exquisite taste has evolved to such a degree. What was the reason for this?

Apart from the social and political reasons cited, one might look at the natural environment for an answer: Kyoto is surrounded on three sides by thickly forested mountains, and has a wide plain on the southern side which leads down to Osaka and the sea. The clear waters of the Kamo River flow in a southerly direction through the center of the city. The climate has four seasons (one might say five if the five-week rainy season is taken into account) and while there may be snowfalls in winter, it rarely freezes. For the rest of the year it is warm and the summer is quite tropical, creating the ideal growing conditions for a rich variety of flora. These dramatic seasonal changes bring continual delights to which every Japanese was

acutely sensitive – from catching fireflies on hot summer nights, to viewing the scarlet maple trees in the fall. One only has to see this lush nature in order to recognize the source of inspiration for the legacy of poetry and nonreligious art throughout Japan's history (see pages 166–167).

Kyoto came to prominence during the Heian period when it was built according to the same layout as the great Chinese city of Xian at the eastern end of the fabled Silk Road. Great care was expended in its design and planning, taking into account the *feng shui* principles regarding sunlight, the flow of vital energies, air, and water – and the traffic of nature's dragons. Until the early 1970s it was a magnificent ancient repository of art, and a serene center of palaces, temples, and gardens that blended perfectly with the lush surrounding nature. Tragically, the forces of darkness have seduced the city fathers and over the past three decades or so much of Kyoto's serene and nostalgic beauty has been lost with a disheartening lack of citizens' resistance, as concrete has speedily replaced tile and wood. This desecration has recently culminated in the construction of an

Old Pine and Cherry Tree

Attributed to Kanō Eitoku (1543–1590)

Ink and colors on gold leaf, 152 cm x 331 cm, Collection of the Honolulu Academy of Art, USA, Gift of Mrs L Drew Betz, 1982

Eitoku is famous for his bold, monumental designs on gold screens, which were favored by the Momoyama military elite for the decoration of their castles. This screen shows just a part of the trunk of an ancient pine in a composition that is graphically startling, and that emphasizes the massive girth of the tree.

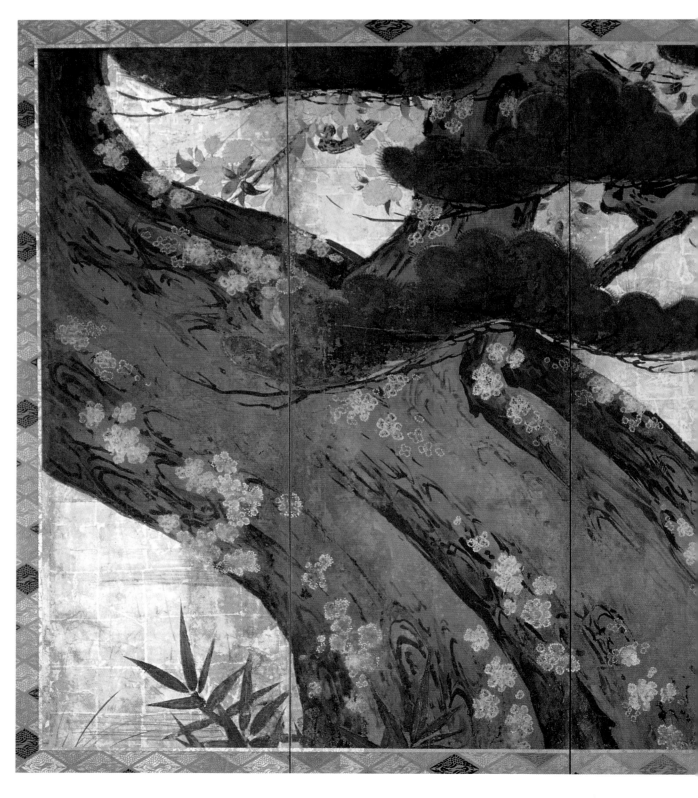

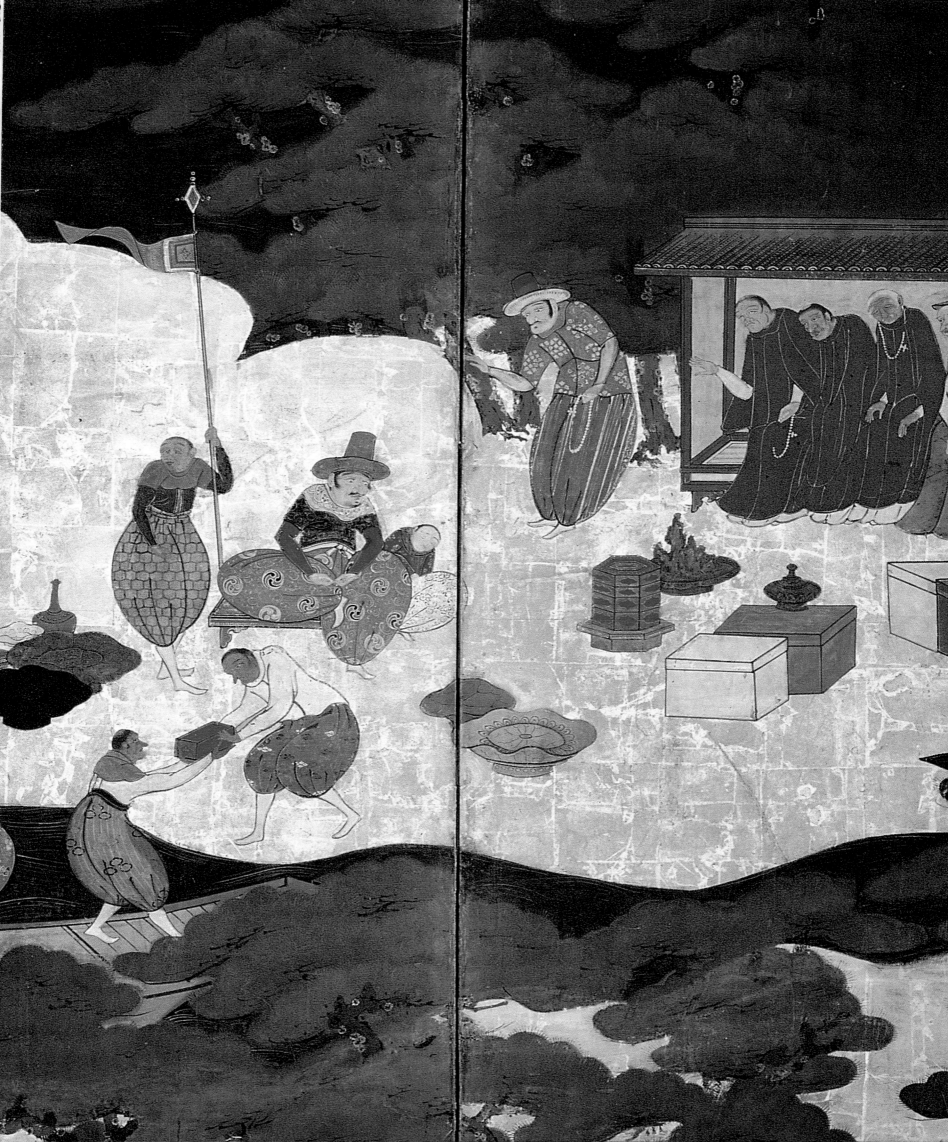

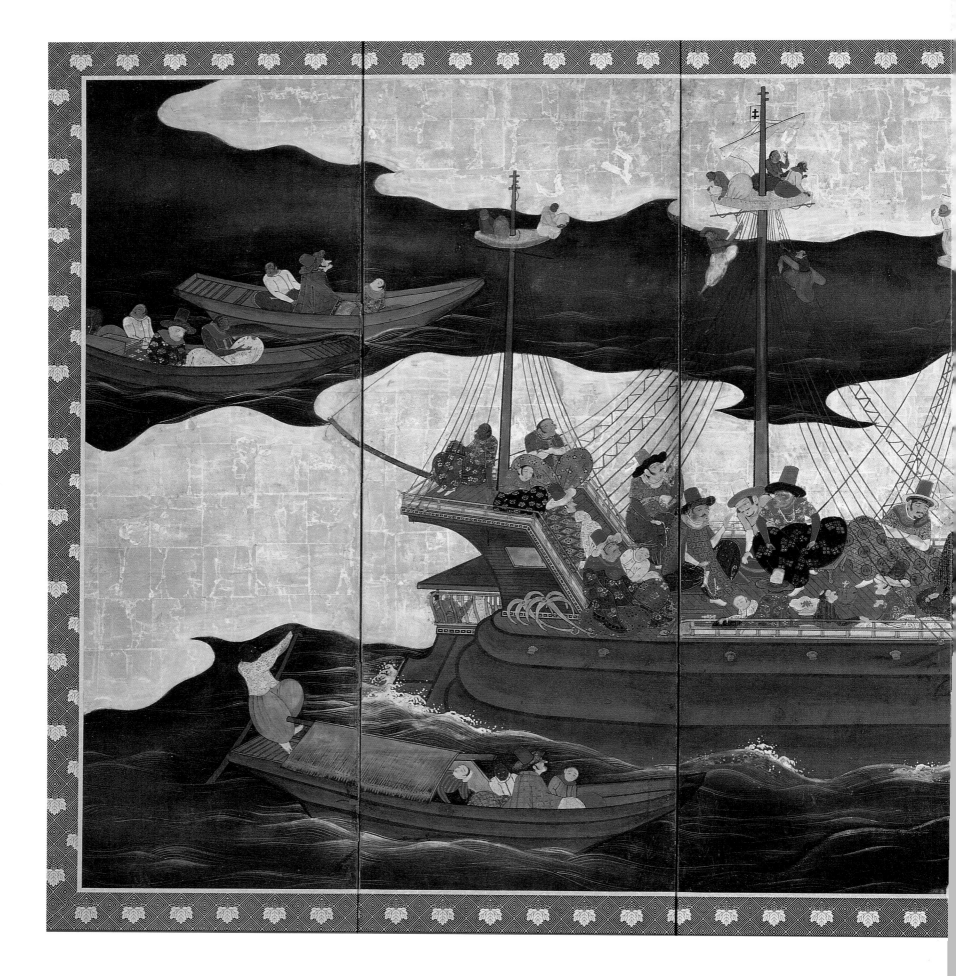

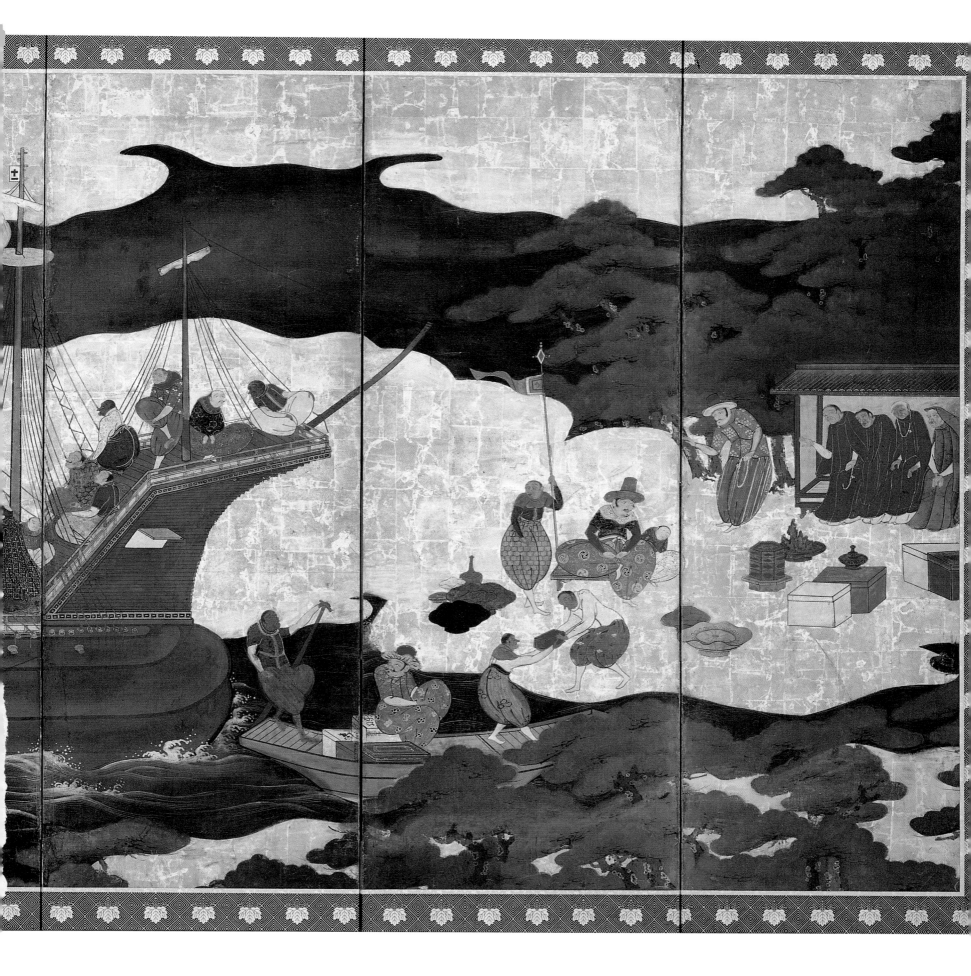

enormous Kyoto Station Building, a monstrous monolith that, in defiance of ancient wisdom, serves no vital purpose, is incompatible with the surrounding scenery, and blocks both light and breeze. The dragons most certainly are not pleased…

Until these dark days, and since the mediaeval wars, nature and its celebration has been the main inspiration for generations of artists in Kyoto, and the Momoyama period saw the appearance of many who had a new way of looking. Tawaraya Sōtatsu (?–1643) came from an obscure back-ground, but he seems to have moved freely in the city's artistic circles. He often collaborated with Hon'ami Kōetsu (1558–1637), a master calligra-pher who was born into a well-to-do family of sword specialists (and to whom he may have been related through marriage), and together they made works combining poetry and painting in the purest Japanese taste. Sōtatsu is considered to be the founder of the Rimpa school, enough was named after Ōgata Kōrin (1658–1716), an artist who was active a couple of generations later, and who in his time was more celebrated.

Following pages
A namban screen

Momoyama period, late 16th century, pair of six-panel screens, each 152 cm x 331 cm, ink, colors, and gold leaf on paper, Collection of the Freer Gallery of Art, USA

The first Europeans who started visiting Japan were Portuguese explorers looking for goods to trade and souls to convert to Christianity. With their oceangoing ships, strange dress, African slaves, and terrifying firepower, they were subjects of exotic fascination for the Japanese, and were often depicted in screen paintings such as these, known as *namban* paintings.

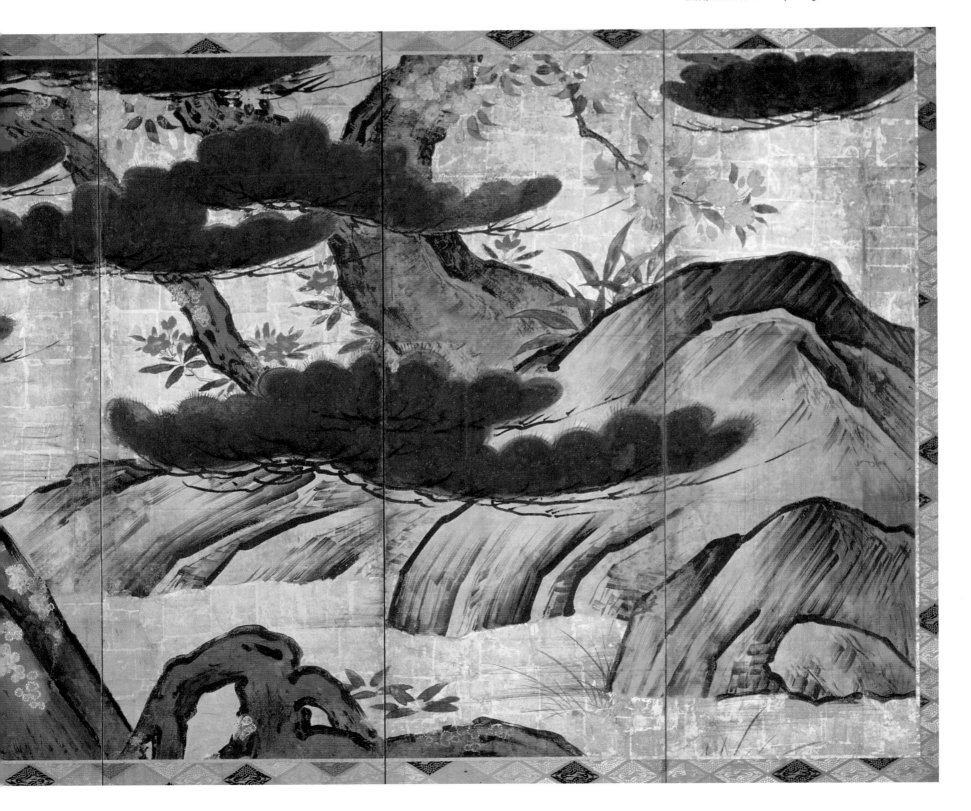

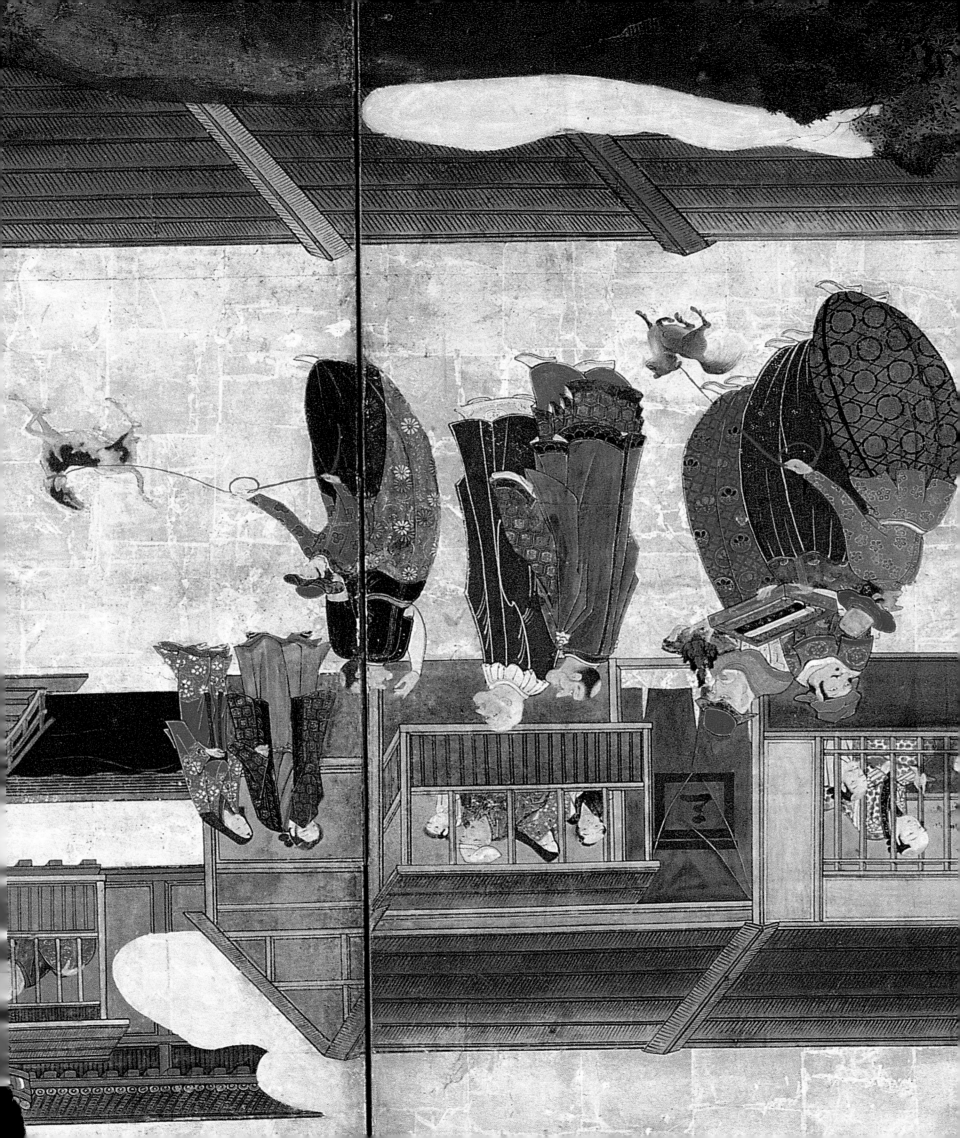

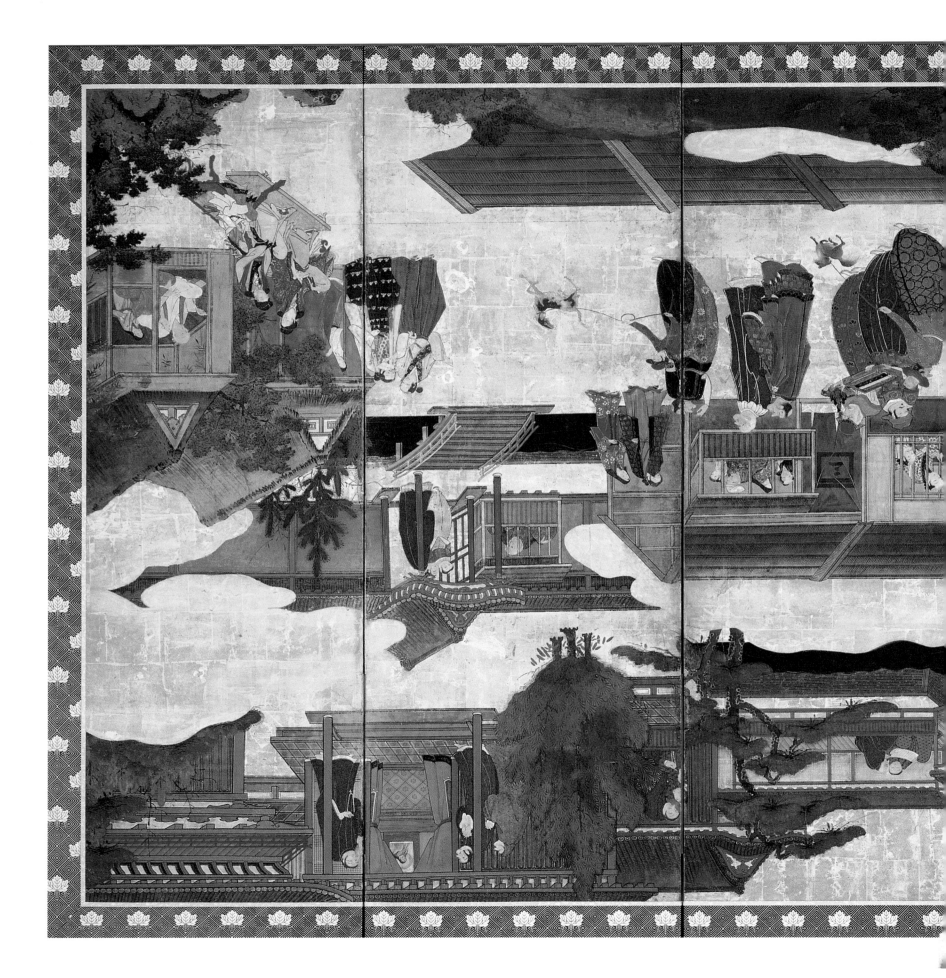

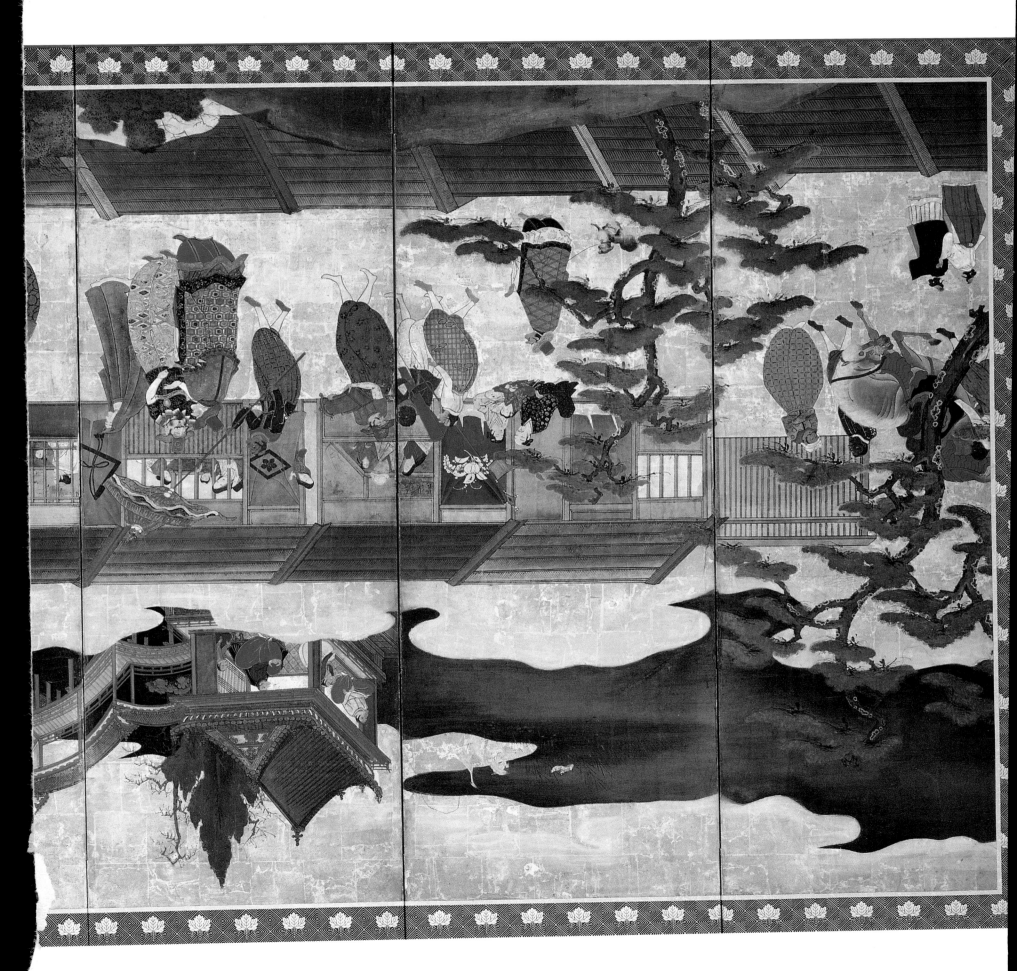

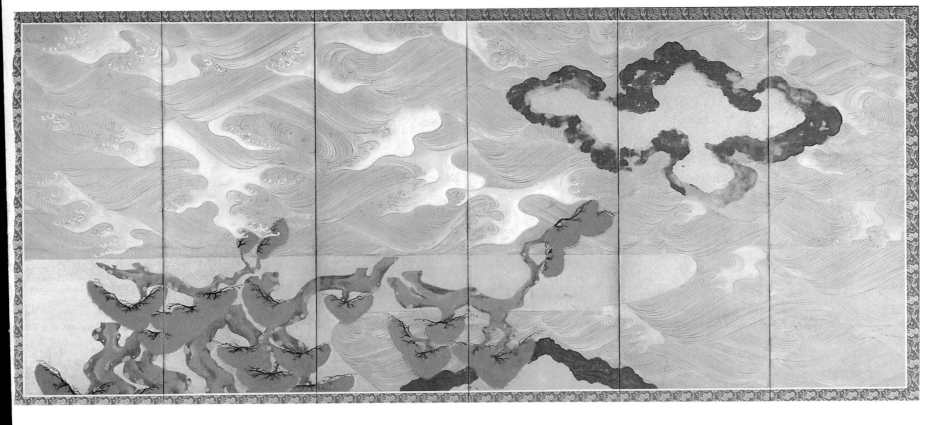

Waves at Matsushima
Tawaraya Sōtatsu (?–1643)

*Pair of six-panel screens, each
152 cm x 355.7 cm, ink, colors, and
gold leaf on paper, Collection of the Freer
Gallery of Art, USA*

In true Rimpa style, Sōtatsu has taken the natural elements of Matsushima – a famous scenic bay of islands near Sendai City – and organized them into an extraordinary decorative arrangement that is full of interest and movement.

If Sōtatsu had any artistic precedents to which his work could be likened, it would no doubt be the tradition of *yamato-e* described above, and also perhaps some of the ink paintings of the Chinese Southern Song dynasty that were in the treasures of the major Kyoto temples. It is known that he had worked with fans and hand scrolls and so was familiar with the standard art styles of the time, and he also used many *yamato-e* themes in his works. Yet his way of using ink and color was completely fresh and individual, and adroitly effective at capturing a particularly subtle moment in some scene of the surrounding nature (see opposite, top).

This illustration shows a water bird under the decaying leaves and seed pod of a lotus. Various elements here contribute to conveying a very poignant, perhaps slightly sad feeling of fleeting fall and the prospect of winter. The bird's focus and direction is to the left of the picture, and this is reinforced by the lotus leaves, which are leaning in the cool breeze. Two of the leaves have decayed to such extent that they hang from their stems, adding to the bittersweet quality of the image, and to the sense of seasonal change. Sōtatsu has used a special technique in this painting, that of applying ink to wet paper so that it spreads to make an interesting tonal gradation as it dries; the process, known as *tarashikomi*, also emphasizes the gray atmosphere of the scene. The same technique became a distinguishing trademark of generations of later Rimpa artists and in addition to ink was also used with color pigments.

In Japan, as in China, painting and calligraphy were never greatly distanced from each other, and even in Heian times poets were writing on hand-made papers that were often exquisitely decorated with paintings, and the application of gold and silver leaf. In the same manner, Sōtatsu painted hand scrolls with designs to illustrate the lyrical content of poems that were written on them by Kōetsu in his elegant and graceful calligraphy. Apart from his peerless writing hand, Kōetsu also excelled in lacquer design, landscape gardening, poetry, and Raku-style pottery – all arts that revolved around the world of the tea aesthetes. Despite his disclaimer of having no talent, he must have tried his hand at painting, one of the gentlemanly arts, though the only known example of such work is a marvelous fan-painting of the moon and a rabbit in fall, together with his own superb calligraphy, that is now mounted as a hanging scroll in the Hatakeyama collection in Tokyo (see page 190).

This famous painting exemplifies the taste and extraordinary artistic sense of the early Rimpa circles. Most startling is the "telephoto lens" depiction of just the *edge* of the moon in gold leaf across the top right of the fan, in a composition that would have been unimaginable in any other country at the time. The white rabbit, too, is shown among flowering *hagi* (bush clover) in an unusual pose with its head turned towards the sky – looking as if it has just heard something and is on guard. The flat gold expanse of the moon is used in the picture as a backdrop for a romantic poem originally composed by Fujiwara no Hideyoshi (died 1240), which Kōetsu has inscribed in flowing, jet-black characters. The words of the poem echo the evocative painted

scene, and describe how the tears shed by a lady for her loved one soak into the sleeves of her kimono and softly reflect the full moon of fall.

A completely different Momoyama style can be seen in genre painting, here using the word in a broad sense to mean those subjects chosen by artists from the everyday life around them instead of those from idealized Chinese or *yamato-e* pictures. The idea of recording the passing scene was not new and examples can be seen from as far back as the Heian period. One such piece, dating from the 12th century and in the possession of the Shitenno-ji temple in Osaka, is in the format of a fan and has a Buddhist sutra text written over the prosaic but colorful underpainting of a fisherman's shop. The concept gained momentum during the artistic explorations of the Momoyama, and continued through the Edo period to leave a fascinating, and historically very valuable record of everyday contemporary daily life. This trend eventually focused more on the depiction of the more *déclassé* world of the Kabuki theater and pleasure-quarters as can be seen in the *ukiyo-e* pictures that later held so much fascination for so many foreigners when Japan opened its ports in the mid-19th century.

But before the Tokugawa shogunate practically closed the country to outsiders in the early-17th century, Japan had already had its first contact with Europeans, mainly traders and Jesuit priests, a century before. They arrived in galleons from recently established trading posts in the Indian Ocean, accompanied by dark-skinned slaves, and with two motives in mind: to convert, and to do business. For a while they succeeded, and by

Lotus and Waterfowl

Tawaraya Sōtatsu (?–1643)

Ink on paper, 117 cm x 46 cm, Hatakeyama Collection, Tokyo

By using a *tarashikomi* technique of applying ink to wet paper, Sōtatsu has captured the withered quality of lotus leaves in the fall. The more intense black that was used for defining the head of the waterfowl, makes the composition more lively.

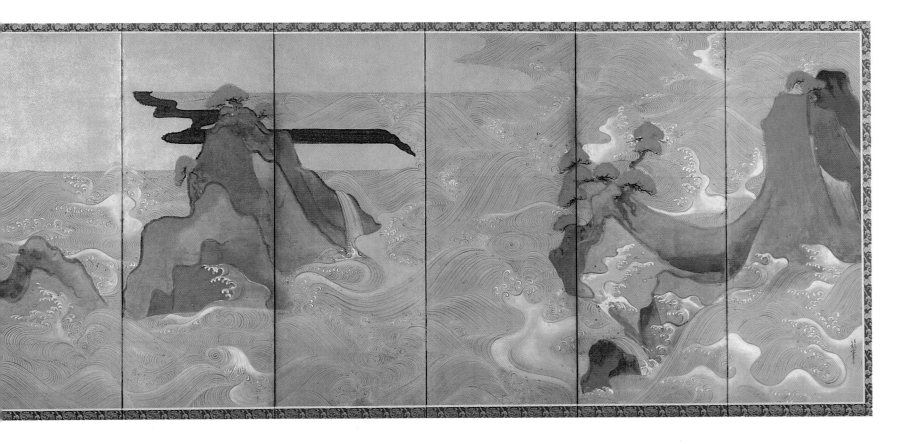

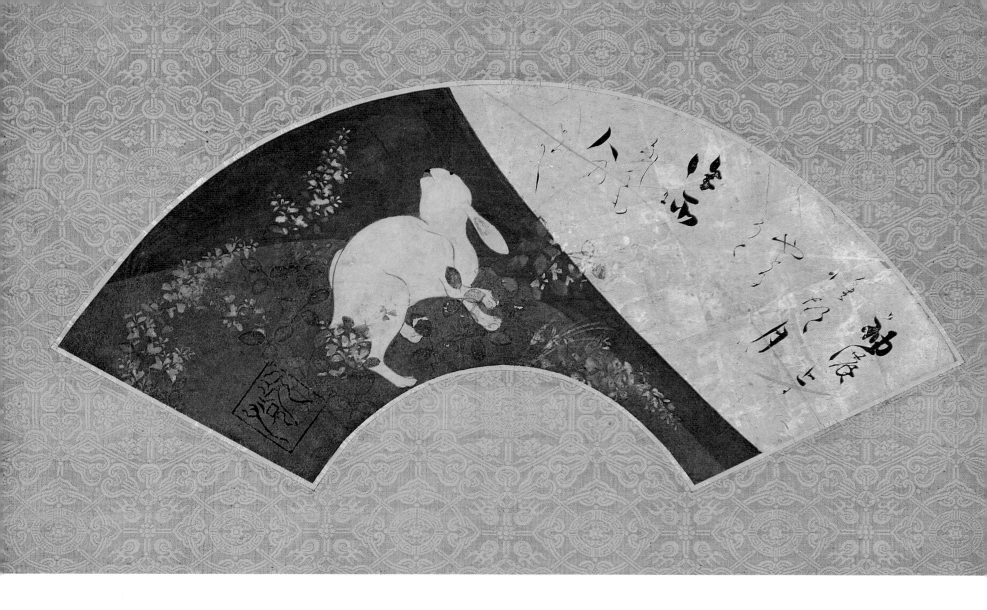

Rabbit and Moon

Hon'ami Kōetsu (1558–1637)

Fan painting, ink, colors, and gold on paper, 18 cm x 54.4 cm, Hatakeyama Collection, Tokyo

Showing the refined taste of the Momoyama Rimpa painters, Kōetsu has inscribed a romantic poem, written in his celebrated calligraphy, on this segment of Moon that takes up the right-hand side of the painting.

taking advantage of the instability of the late Muromachi period they managed to convert large numbers of the natives of northern Kyushu to their Catholic faith, even to the extent of numbering an influential *daimyo* feudal lord among their converts. However, their presence was not to last for long, and after hearing that other countries visited by Europeans had found to their bitter cost that conversion seemed to be followed by conquest, the Tokugawa shogunate outlawed Christianity, severely restricted any contact with foreigners, and enforced these edicts with the most Draconian punishments.

These European visitors were derogatorily called *namban* ("southern barbarians") on account of the direction from which the boats arrived to the island of Kyushu. The clash of two totally alien cultures can be imagined: the unwashed, meat-eating, fervently evangelistic Europeans with their formidable firearms and oceangoing vessels, meeting the non-proselytizing Buddhist, well-bathed Japanese who lived on a largely vegetarian diet. This exotic sight was the stuff of legends, and large screen paintings depicting the visitors and their galleons reveal the fascination that the new arrivals held for the Japanese (see pages 182–187).

Despite what would seem to have been insur-

mountable language difficulties, the visitors were exhaustively quizzed on all aspects of the lands from which they came. The Japanese impressions of these outlandish faraway places are to be seen in a few rarer screen paintings that show imaginary scenes of bucolic foreign landscapes together with cities, kings, and battles, in addition to some fairly accurate maps of the world. Using the large-scale screen painting conventions of the Momoyama period, *namban* screens were lavishly executed in rich colors and gold leaf. In some of the screens and scrolls that show European subjects the influence and imitation of western oil paintings that must have been carried on the Portuguese ships can be seen in chiaroscuro shading (see page 191). It is known that early Jesuit missionaries established schools in Japan, where converts were taught European techniques of oil painting and engraving to depict religious subjects. The students learned quickly, and looking at some of the votive pictures still extant it is difficult to tell clearly whether they are by the hand of a foreign or Japanese artist.

Perhaps the most informative of the genre screen paintings are those known as *rakuchū-rakugai* ("scenes in and around the capital"), which show famous areas of Kyoto from a bird's-eye view peering through clouds of gold leaf. These were painted in fine detail by artists of the

court-favored Kanō and Tosa schools and present an accurate and detailed representation of the splendors of the city, much of which had been reconstructed after the widespread damage caused by the wars of the 15th century. The *machishu* (leading merchants of the city), who had made quick fortunes out of moneylending, were behind the financing of this phoenix-like resurrection, and *rakuchū-rakugai* screens reflect the new civic pride and mood of celebration. Palaces, famous temples, beauty spots, and amusement areas were finely painted in colors, and clouds of gold leaf were used as a clever artistic device to fill in areas that were of less visual interest. This style of displaying the city's glories became very popular and continued in a more-or-less derivative form well into the 19th century.

After the grim stoicism of the years at war, the more hedonistic Momoyama and early Edo periods saw the appearance (or reappearance) of many festivals that celebrated seasonal or historic events (see page 193). In some of the *rakuchū-rakugai* screens, the street scenes are livened by the depiction of the famous *Gion* festival and its magnificent processional floats, which was revived in 1500 and has continued each summer to the present day. Horses were also a favorite subject and are seen on screens showing stables, the famous Kamo shrine races, and dog-chasing games, while paintings of perched falcons with intricately knotted jesses reveal another aristocratic pursuit.

Perhaps the most fascinating of the early genre paintings are those that show outdoor seasonal excursions and picnics (especially those of the cherry-blossom viewing in early April), and the world of the pleasure-quarters and the early theater. Many are very detailed and provide an intriguing insight into the fashions and social mores of the times. This trend to picture popular subjects grew as the 17th century progressed, and the newly rich merchant class devoted more and more of its time and energies into a relentless pursuit of pleasure – a colorful milieu that was a source of inspiration for the great *ukiyo-e* artists of the Edo period.

The Edo period:
Ukiyo-e, pictures of the "floating world"

For the duration of the Edo period, Japan was closed to the outside world except for a small outpost of the Dutch East India Company, which was isolated on the island of Deshima in the bay of Nagasaki, and the occasional contact with China and Korea. Being cut off from the events that were shaping the rest of the civilized world during these two-and-a-half centuries, the Japanese had to rely on their own resources for all artistic endeavors. They excelled themselves in this hothouse environment and produced such a rich and colorful legacy of painting, crafts, theater, music, and fashion – it is tempting to wonder how interesting it would be for whole societies to be isolated in this way for the enrichment of their own cultures!

For Westerners, the Edo period is perhaps most noted for the *ukiyo-e* pictures, which reached Europe in the mid-19th century, showing an exotic and beautiful land waiting to be "discovered." The word *ukiyo* ("the evanescent floating world") first appeared in writings that date from the mediaeval period, at which time it had a religious connotation and was used in referring to the transience of life on earth – illusive, often painful, and all too brief. Later, during the Edo period, the meaning of the word changed somewhat and took on rather a sardonic tone to denote the new world of hedonism, fashion, and style; the world of the Kabuki theater, and the pursuit of delectation in the pleasure-quarters, particularly those of the Yoshiwara in north Tokyo.

A 17th-century Japanese novelist astutely catches the nuances of the word: "... Living only for the moment, turning our full attention to the pleasures of the Moon, the snow, the cherry blossoms and the maple leaves; singing songs, drinking wine, diverting ourselves in just floating; caring not a whit for the pauperism staring us in the face, refusing to be disheartened, like a gourd

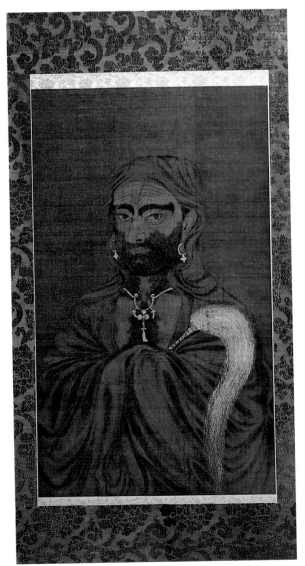

Daruma

Unknown Artist, Nagasaki school

18th century, ink, colors, and gold on silk, private collection

This extremely unusual painting shows Daruma (the first Zen patriarch) executed in Western style and with Portuguese facial details. Many questions are raised by the mystifying detail seen in the gold earrings, which have the shape of a cross, as Christianity was severely persecuted throughout the Edo period.

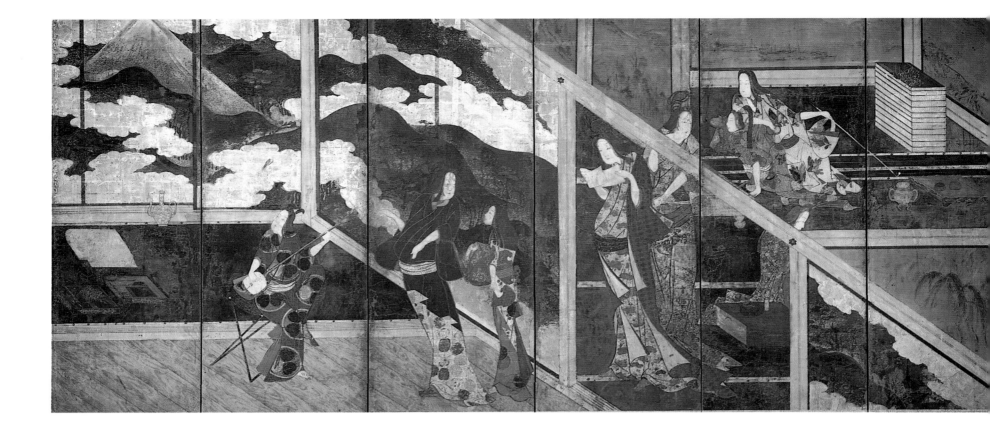

Courtesan screen

Momoyama period, late-16th–early 17th-century, 150 cm x 350 cm, ink, colors, and gold leaf on paper, Collection of the Freer Gallery of Art, USA

One of the earliest examples of *ukiyo-e* picturing the "floating world" of courtesans and actors, this screen shows the interior of a splendid "house of pleasure" with flamboyant gold paintings around the walls. The reclining lady on the right is holding a long tobacco pipe and it looks as if the women are idling their time, waiting for the first customers of the evening.

floating along with the river current: this is what we call the floating world…" The word caught on in popular usage: *ukiyo* talk was highly colored, racy, and suggestive, the language of dalliance and flirtation; and *ukiyo* madness referred to an addiction to the exquisite delights of the pleasure-quarters, which was becoming epidemic. *Ukiyo-e* were the paintings and prints that depicted this floating world. This new and colorful stratum became a vital part of Edo society and especially its art, and to see how it evolved it is worth looking briefly at the historical background.

The early-17th century saw the whole of Japan, after more than a couple of centuries of intermittent civil wars, at peace and unified under the rigid government of the Tokugawa shogunate. The city of Edo (Tokyo) had become the new administrative capital, where the *daimyo* (the regional feudal lords) were required by law to spend part of each year. The purpose of this requirement was twofold: firstly the *daimyo*'s family had to stay in Edo while the lord was visiting his country fiefdom, and were in fact hostages; and secondly, the level of splendor in which he was obliged to live in the city usually kept him painfully short of money and therefore unlikely to be able to marshal the funds and forces for any antigovernment mischief. This demonstrated considerable shrewdness and caution on the part of the shogunate, and the system worked rather well for the greatest part of the two and a half centuries that the regime was in power.

Social stratification in the country was clearly delineated, with the shogun, imperial family, noble courtiers, and regional *daimyo* lords forming the apex of the pyramid, followed by the samurai (the arms-bearing warrior class), and bureaucratic administrators. About 80 percent of the population were rice farmers and formed the middle-ranking layer, while the bottom layer of society was made up of craftsmen and merchants. Known as *chonin*, they counted as the bulk of the residents of Edo and the other main cities.

In the early years of the Edo period, the ruling *daimyo* had been economically independent and lived luxuriously off a taxed percentage of the rice harvest produced on their country landholdings. Rice had always been the basis of all wealth and was bartered for other goods. However, the economy quickly changed in the first part of the 17th century from one that was simple and agrarian, to a more complicated one that was based on money: cash that was issued by the shogunate and used as the currency for commercial transactions. As this new system established itself, many of the resident *daimyo* found that their fortunes were changing – and not necessarily to their advantage. As they were restricted in wealth to what could be generated by their local peasantry, and prohibited by the social code from engaging in trade or money-making activities, they frequently had to borrow from the *chonin* and usurers, pledging their next year's rice harvest as collateral for the loan. Living in Edo entailed lavish expenditure on the maintenance of palaces and numerous retainers, a fiscal hemorrhage that steadily worsened in the struggle to keep up appearances with the other regional lords. This transplanted aristocracy formed an insatiable market for luxury goods, and was catered to by

an increasing number of eager artisans and tradesmen. While only a small fishing village in the 16th century, the city of Edo grew enormously: from around 150,000 residents in 1623, to 500,000 by 1700, and reaching 1,000,000 a century later. The majority of these were of the low, *chonin* class, the tradesmen, craftsmen, and merchants who became the *nouveau riches* of the booming city. By the end of the 17th century an economic disparity had arisen, with many of the *chonin* having more wealth at their disposal than many of their better-born superiors.

The *chonin*, however, had no rank in the social hierarchy, and were restricted in their manner of living by all kinds of petty regulations governing such matters as the size and decoration of houses, and personal dress. With no chance of buying a country estate, or even a palace in the city, there was little to do with excess riches once the essentials had been taken care of than to spend it on the pursuit of pleasure. It was to satisfy this relentless urge that the floating world evolved.

In Edo, the center of this world was the Yoshiwara, the vast courtesan quarter situated close to the Sensō-ji temple in Asakusa in the northeast of the city. (Evil supposedly came from this direction and the temple was sited to protect the Edo castle and the resident shogun.) The area was established in 1657 and immediately became a highly successful enterprise. With all of the visiting *daimyo* and their numerous attendants, together with increasing numbers of traders seeking their fortunes, Edo at the time was a city of bachelors on the loose.

The city administrators showed common sense and perspicacity in realizing that the pleasure-quarters would not only serve as an escape valve for energies that could be dangerous if channeled in other directions, but would also provide a rich source of taxable revenue. It was virtually a self-contained city within a city, and although much altered by fire and earthquake, it diligently catered to the men of Edo for over 300 years. The end came in 1958, when the Japanese government outlawed prostitution and so drove this ancient profession underground into the hands of criminals. Now little remains but one or two Turkish baths, and a few geisha houses, which represent a sad, fading echo of the former glory.

The Yoshiwara was approached along a narrow road on a built-up embankment between the rice fields, just a few minutes walk from the Asakusa temple. This also showed an astute choice of location by the city fathers, for the temple attracted huge crowds throughout the year, and, after all, what could be better after a token prayer than a visit to the nearby pleasure-quarters? Entrance to the Yoshiwara was through a large gate, the *O-mon*, and at this point the visitor's behavior was governed by regulations that were very different from those outside. Long swords were prohibited, so were palanquins, and retinues of servants — though it was always good for one's image to arrive at the entrance gate as ostentatiously as possible.

At the *O-mon*, however, the retainers had to be dismissed and the customer entered on foot into a broad street, the *Nakadori*, which was crossed by numerous side streets, all lined with tea houses and brothels.

The area came to life at dusk as the lanterns were lit and the first customers appeared through the gate. In each house the courtesans sat at street level, carefully made up and dressed in their finery with their *obi* sash tied at the front in the manner unique to their profession. In some of the buildings, they were typically separated from the street by wooden slats through which they could conduct negotiations with a customer before he was allowed into the house.

The greater the prestige of a courtesan (which was determined by her beauty and her skills in entertaining), the more adept a new customer had to be to secure her attentions. Of course, it goes without saying that lots of money was necessary; but it was also necessary to show a level of wit and to demonstrate a debonair manner, style, and interesting taste in costume and accessories. The word *iki* was coined to denote good dress-sense: a clever combination of colors, an unusual weave of

Summer Festival

Unknown artist

(Detail), six-panel screen, 17th century, private collection

The 17th century saw artists beginning to show an interest in the colorful sights around them. This detail from a six-panel screen of Kyoto festivals shows a group performing a summer dance around a trio of musicians in the street.

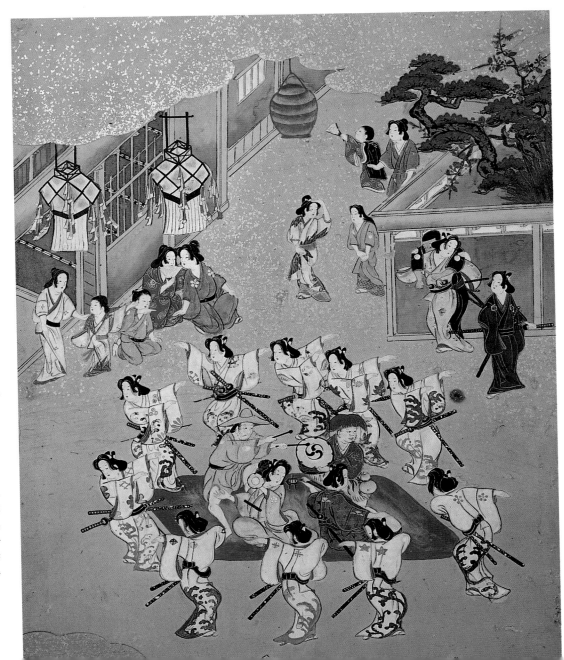

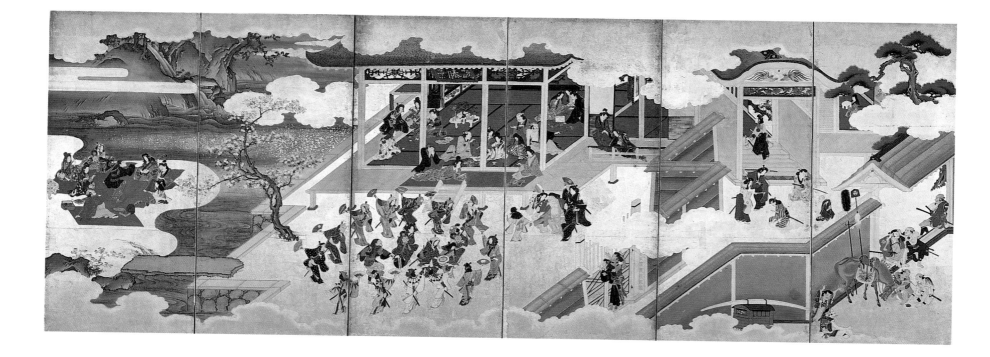

cloth, a daring but successful pattern… Lack of this sense was *yabo*, out of date, boring, and tasteless, and any customer so afflicted would have to seek his pleasure in the side streets where some of the ladies might be less choosy.

Once inside one of the better houses, the customer was wined and dined lavishly, and amused with song and dance before spending the night with his chosen courtesan. Next morning he would awake to the usual bustle of Japanese hostelries: the rolling up of bedding, the opening of *shoji* screens, the morning tea. No customer was allowed to remain in the Yoshiwara for more than 24 hours, and in any case the day's business – and the chance to earn enough for some further excesses – was waiting in the city. The early morning saw a procession of rakes and gallants, physically and financially spent, making their way back to Edo proper; the wealthy carried in palanquins, and the lower orders went on foot.

Courtesans were ranked according to their beauty and abilities, and of course their price followed suit. Highest of all were the *oiran*, the most beautiful of all, peerless in wit, and, above all, skilled in the handling of men. At the most there were 18 in the Yoshiwara, who were treated like princesses, and could take their pick of lovers from the highest ranks of nobles, courtiers, and samurai. Most of the better-class courtesans had two young girl assistants or *kamuro*, who followed their mistresses everywhere in attendance. They are often depicted in *ukiyo-e*, side-by-side and walking a couple of paces behind their mistress, holding flowers or carrying little gifts for some favored customer (see page 196). If, by the age of 14, the young *kamuro* showed promising signs of becoming a good courtesan herself, she was trained by her mistress and inducted into the business with appropriate ceremony.

Through the changing seasons there was always some festival or other in the Yoshiwara, some excuses to wear special clothes, or to have a picnic in the nearby countryside. In early spring, the *Nakadori* was planted with flowering cherry trees lit with flickering lanterns, and the most celebrated courtesans paraded down one side, and back along the other, admiring and being admired. Each would have been dressed in layer upon layer of the most expensive silk kimono, her hair would be exquisitely arranged and decorated with lacquer combs and tortoiseshell pins, and under the weight of their costumes, she would have walked in a curious "figure of eight" fashion, balancing on *geta* footwear 20 centimeters (8 inches) high – spring goddesses to the adoring crowd.

However romantic this scene must have been, it served as a cruel metaphor for the transience of the courtesan's glory. As the cherry blossoms soon fell and were swept away, so the courtesan's professional life was over by the time she reached her late twenties. The lucky ones would find administrative work in the Yoshiwara, but most would be rejected with the fading of youthful freshness and forced to live as common streetwalkers, carrying their bedrolls with them, luring customers into the dark shadows; a hopeless and usually brief life of insecurity, misery, and disease…

*Unknown and unadmired, even I live on in
this world;
Why do these cherries then pass away
So heartlessly from the sight of the admiring
crowds?*

Monk Saigyō (1118–1190)

The floating world attracted the attention of a whole school of artists who have left a remarkable

Above, and opposite (detail)
*Entertainments at a House
of Pleasure*

Unknown artist, 17th century
*Six-panel screen, 115 cm x 310 cm,
private collection*

This especially informative painting shows in great detail the lavish entertainments at one of the grander houses established for the entertainment of men. On the far right a young customer is having his eyebrows plucked – a last-minute adjustment before entering. In the third panel from the right (see detail opposite) four young women seem to be encouraging a tipsy man to dance, while in the pavilion men and women smoke and play games. On the far left of the screen another party, sitting around a dancer, are celebrating the flowering cherry tree nearby.

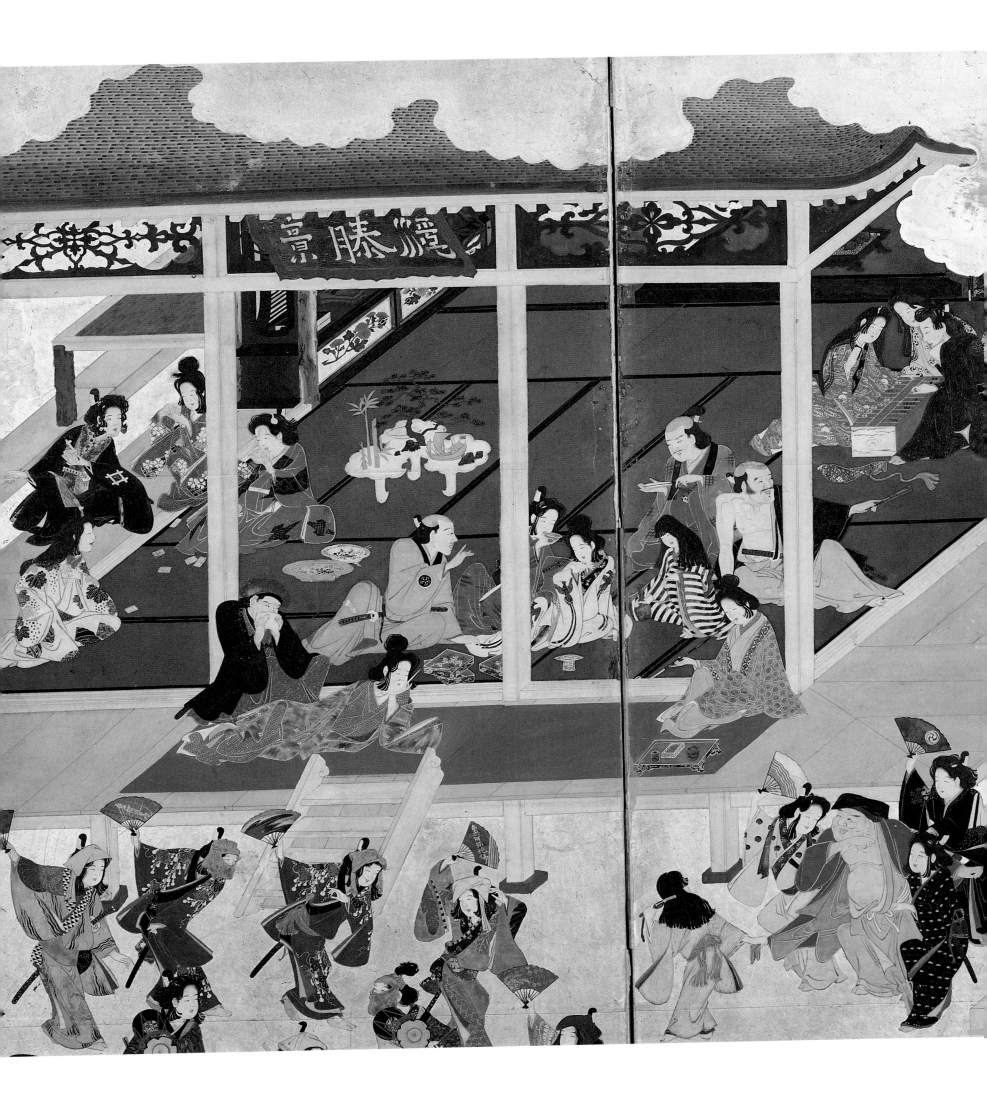

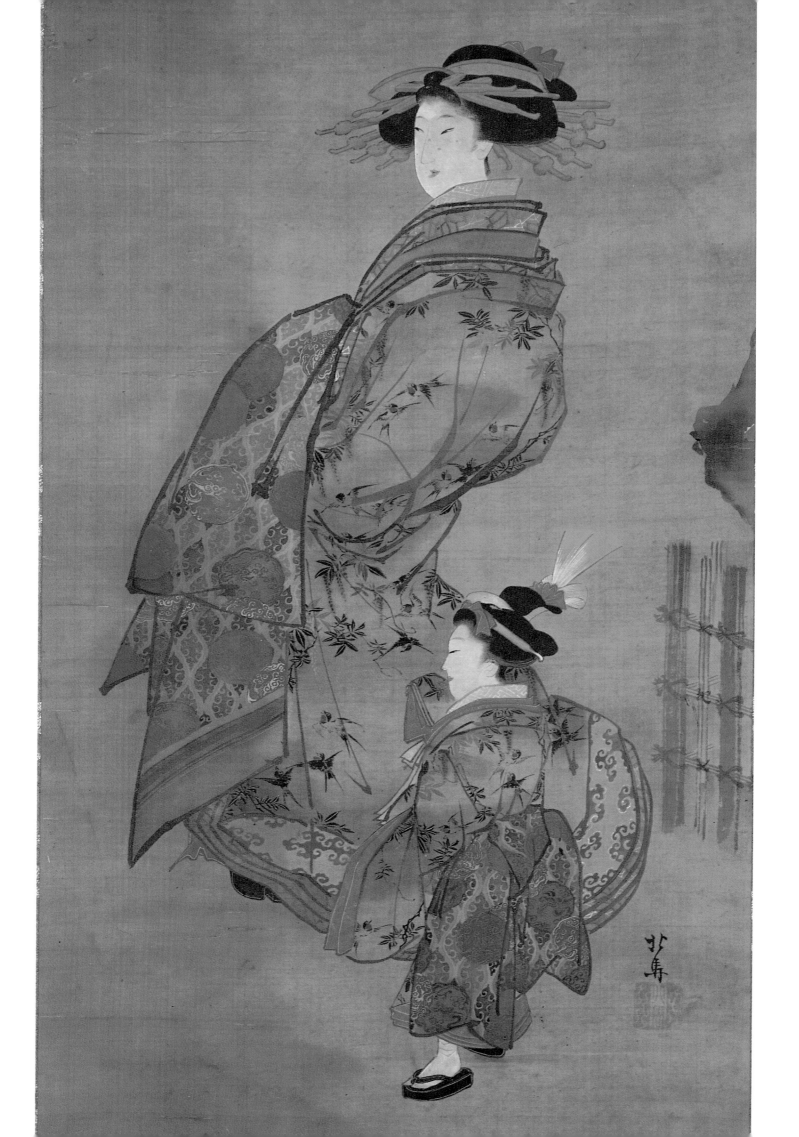

record of the colorful daily sights, and also its bittersweet quality. A large percentage of their *oeuvre* is startlingly erotic and explicit. (And has shocked many a Western widow on going through the desk of her deceased "old Japan hand" in more conservative times.) Instructive hand scrolls showing 12 sexual positions (one for each month of the year), were commonly given to young brides to give them some idea of what awaited them in married life; and later, whole books were published on all kinds of racy subjects, amply illustrated with woodblock prints (see pages 198 and 203). Mildly suggestive pictures were known as *abuna-e* (*risqué*), and those that show no compromise in their explicit graphics are appropriately labeled *shunga* ("spring pictures").

Ukiyo-e followed the typical pattern of all schools of artistic endeavor and evolved from an initial period of development and experimentation to a peak of maturity, and finally a decline into decadence and repetition. The first signs of *ukiyo-e* are seen in the genre screen paintings of the early-17th-century Tosa and Kanō school artists mentioned above, which show in minute detail the colorful, proletarian life in the streets and temples of Kyoto, and the festivals and popular amusements in the countryside (see pages 194 and 195).

In a short time, these artists departed from the epic, wide-scale views seen on screens, and turned their attention to focus on more intimate detail: figures shown singly or in a group for example, this trend reaching an apotheosis in the *kubi-e* ("head-and-shoulder") prints of famous courtesans and actors by such artists as Utamaro (see page 199). For sheer color and interest (and also no doubt for fun), the *ukiyo-e* artists spent more time portraying the fascinating goings-on in the Kabuki theater, and later in the Yoshiwara.

Kabuki had evolved from origins in Shinto shrine performances to become a popular amusement where, under the guise of theater, courtesans cavorted and displayed their charms to potential customers in the audience. Frequently this led to lawless bedlam and rowdy disturbances among competing swains, so that around 1629 the government was inspired to issue an edict banning all women from the Kabuki stage.

However, one vice was replaced with another, and goodlooking boys acting in female roles soon found themselves the objects of attention for gentlemen with different tastes. In no time at all, the Kabuki theater became a center of commercial pederasty and once again prompted government intervention. In 1652 regulations were enforced that permitted only grown men to act on stage, and they were required to shave off their forelocks (considered by aficionados to be one of the most endearing features of a youth), the effect of which was to remove any doubt about the gender of the performers, and also make them less attractive. The Kabuki continued to be a male preserve and still is today, but throughout the Edo period it remained a rather *déclassé*, plebeian, but wildly popular entertainment, like pantomime or vaudeville in the West, and one that provided a rich supply of subjects for the *ukiyo-e* artists.

In addition to picturing subjects such as Kabuki and the Yoshiwara, the *ukiyo-e* artists frequently adapted classical scenes from famous poems or stories, as allegorical subjects for depiction in the new style, rather like European painters of the Renaissance who portrayed Biblical characters in 15th-century costumes. *Ukiyo-e* prints (particularly triptychs) are often seen showing a group of courtesans and their lovers in some pastiche of a scene from ancient legend (see page 201).

Most of the *ukiyo-e* from the mid-17th to the mid-19th century are *kakemono* (hanging scroll) paintings, or woodblock prints, along with some screen paintings, printed books, and *e-maki* (hand scrolls). In the West, the word *ukiyo-e* is often mistakenly used to mean just woodblock prints, no doubt because Europeans were the first to rediscover the beauty of these prints when they were used as wrapping paper by the Japanese for goods exported to Europe during the late-19th century. It was at this time that some of the finest collections of *ukiyo-e* were made in the West, when they were still considered rather vulgar objects of some disdain in the land of their origin. The influence of *ukiyo-e* on such artists as Whistler, Monet, and Van Gogh is well known and much studied, and Impressionism is the one area of Western art with which the Japanese most identify today.

It is because these *ukiyo-e* were created for a popular market – that of the *chonin* classes who frequented the Kabuki theater and the Yoshiwara – that so many have survived. Considering the number of works that must have been destroyed by fire, earthquake, and neglect, it is easy to see that the original volume must have been vast indeed. What remains can only provide a few tantalizing clues to help the imagination recreate the complete picture of the world they portrayed. As a mirror of popular culture, *ukiyo-e* eventually looked to subjects other than the Yoshiwara beauties and Kabuki actors: to the sumo wrestling ring and, with an increased interest in travel, to famous scenic spots located on the routes that radiated from Edo.

The first figure to appear out of the tradition of 17th-century genre painting who can be considered to be a *ukiyo-e* artist is unidentified by name, so has been known simply as the Kambun Master, after the period (1660–1674) to which his works can be dated. There may in fact have been more than one artist responsible for these paintings and early woodblock prints, which depict courtesans and their lovers outlined in flowing black lines, sometimes highlighted with rather rough, handapplied coloring (see page 202, left). Many of his prints are erotic and were originally issued in sets of 12 to be mounted in the format of hand scrolls or albums.

Woodblock printing was invented in China and was imported into Japan around the 5th century

A.D. The process is basically simple. The artist first makes a drawing that is copied onto thin paper and pasted on the flat surface of a plank of wood (usually cherry by choice, because of its fine grain). Artists rarely carve the blocks themselves; this job is given to a skilled engraver who carves through the pasted drawing leaving the lines of the design in relief. The block is inked and a sheet of paper is pressed onto this so that the design is stamped. The same block could then be recarved to duplicate the design, or it could be discarded. In the case of religious prints, the content was of more importance than artistic quality and so the blocks were often used for a long time.

During the Edo period, the better *ukiyo-e* artists would draw the design on paper and a professional printing house would arrange for the engraving of the block, and also the production and sale of the prints. With the development of multicolored prints in the 18th century, a set of blocks would be made, each block printing a single color. Refinements that can be seen particularly on *suri-mono* (limited-edition prints for special occasions) include *gauffrage* (embossing to give a textured

surface to the paper), and the application of special materials, such as powdered mica, to give a shiny appearance. Blocks were usually used to make about 200 prints before being recut for the next edition. The slight variations seen from one edition to the next provide ample material for connoisseurs to argue over which was the first and which the last.

The first *ukiyo-e* artist who can be identified by name was Hishikawa Moronobu (about 1618–1694), who was possibly a pupil of the Kambun Master, and whose style he imitated early in his career when he was illustrating printed picture books. His early works were also largely erotic or suggestive depictions of the floating world, simply printed in black ink on paper. But as his popularity grew, commissions came in from wealthier clients and he turned his hand to painting *ukiyo-e* subjects in colors on hanging scrolls, hand scrolls, and screens in his own very distinctive style. Typically, his women were full-fleshed and plump-cheeked, with narrow eyes and raised eyebrows, which give them a questioning look, as if they were calculating what a client might pay.

Frontispiece from *The Poem of the Pillow*

Kitagawa Utamaro (1753–1806)

Woodblock print, private collection

Ranking surely as one of the most romantic and erotic pictures of all time, this famous print was originally the frontispiece of a far more explicit series. While not immediately discernible, Utamaro's genius can be seen in the amazing composition of the focused eye of the gentleman and the line of his lady's hair.

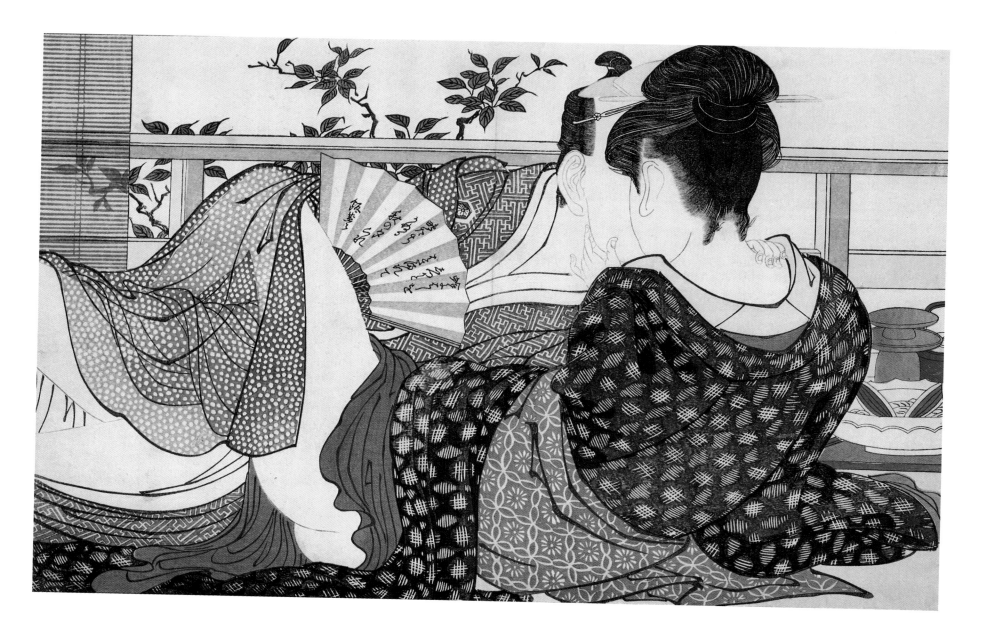

From Moronobu's time, the world of *ukiyo-e* took off and scores of new artists appeared to set up their own studios. Many of them are household names as popular in the West as they are in their native Japan: Kaigetsudō Ando, Koryūsai Isoda, Torii Kiyonaga, Suzuki Harunobu, and of course the peerless masters Utagawa Utamaro, Katsushika Hokusai, Utagawa Hiroshige, and the mysterious Sharaku.

Suzuki Harunobu was the undisputed master of the deluxe *nishiki-e* ("brocade print"), which he made using the finest materials and pigments and a large number of blocks to print his sumptuous spectrum of colors (see page 202, right). No effort was spared to make prints of the highest quality with perfect lines, careful composition, controlled coloring, and the discreet use of *gauffrage* to add a textural interest to a background or some part of a kimono. Typically, he portrays those who are in the springtime of their lives, fresh youth caught at some poignant moment, hesitating at the passions that maybe were not quite understood (see page 203). The school, or movement, of *ukiyo-e* reached its peak with Harunobu, and although later artists may have been more brilliant in skill and imagination, they had no hesitation in crossing the invisible line of good taste for the sake of effect, and in doing so began the slide into decadence.

Although there have been many attempts to identify Tōshūsai Sharaku with a number of artists, both inside and outside the world of *ukiyo-e*, to date there is nothing at all known about his birth, training, or demise. What remain are some of the most unusual and expressive prints, all of which were issued by his publisher, Tsutaya Jūzaburō during some ten months in the years 1794 and 1795... after which he disappeared just as suddenly and mysteriously as he had arrived. The most famous ones are *kubi-e* (head-and-shoulder pictures) of the leading Kabuki actors of the time, many of which are now so well known that they have almost become international icons. His major prints are finely made using colors contrasting with black, which he used in a strong graphic manner to make the "bones" of the composition. His *kubi-e* masterpieces published during the first few months of his debut are embellished with a finish of powdered mica that enhances the figures and furnishes them with a shiny purplish-gray background.

Today his works are most sought-after, and achieve the highest prices in the international art auction houses, but it is said that he was unpopular during his brief working career and a lack of customers may well have been the reason for his disappearance. Perhaps the reason for this is because he satirized rather than idolized the heroes of the Kabuki theater, and so may have upset the dreams of their adoring fans. Sharaku delighted in exaggerating the features and gestures of his subjects in almost a cartoon-like manner: a nose a little longer, eyes more crossed, a grimace more forced. The result is far more interesting than that of the decorative poses of actor prints by

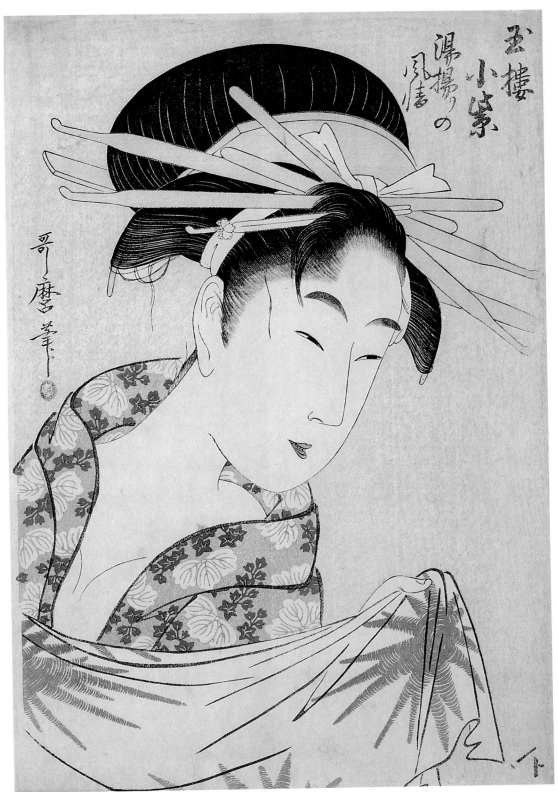

previous artists and one wonders why another century was needed for his genius to be fully recognized (see page 204).

Kitagawa Utamaro (1753–1806) excelled among the *ukiyo-e* artists for his pictures of the women who lived and worked in the pleasure industry of Edo. Apart from the excellent draftsmanship and quality of his prints, Utamaro also shows an uncanny knack of revealing the moods and temperaments of his subjects, and even

Courtesan

Kitagawa Utamaro (1753–1806)

Woodblock print, 38 cm x 25 cm, private collection

An example of a *kubi-e* (head-and-shoulders) print depicting an *oiran*, one of the high-ranking courtesans of the pleasure-quarters.

produced a series of prints just to depict types of women (see page 205). It is obvious that he spent his life studying them with great care; to understand the very nature of their femininity, their way with fashions, their skilled enticements and expressions… and he knew just how to capture them at just such moments when they were irresistible to men. His output was voluminous and it is not surprising that it includes many well-known series of *shunga* prints as well as some fine paintings. His style is unmistakable, with his elongated figures defined in flowing lines, and some of his best pieces are the frontispieces to *shunga* editions, such as the famous album plate in *Utamakura* (*The Poem of the Pillow*), which was published in 1788 (see page 198). This undisputed masterpiece of *ukiyo-e* shows two lovers embracing on a balcony in what must be one of the most romantic and erotic pictures ever created. The woman is facing away; her left hand caressing the face of her lover, and it is presumed that they are kissing. He has his hand on her right shoulder and his other hand is holding a fan. Their kimonos are coming adrift and hint deliciously at what will follow. It is in this print that Utamaro demonstrates his wonderful sense of line; close inspection reveals that the lover's right eye seems to connect with his lady's hair in extraordinarily successful, compositional bravado. Just look at that eye!

Granting that the culmination of *ukiyo-e* prints was marked by Utamaro's efforts, pictures of the *demi-monde* made by his later followers tend, with the odd exception, to become more decadent and in many cases sink into unmitigated vulgarity, with coarse and inexpert coloring and poor composition. But two artists stand out not just for portraying beauties or actors in the *ukiyo-e* mode, but also for turning their attentions to other colorful everyday sights that abounded all around during the late Edo period.

Having had two marriages, a dysfunctional family, over 50 *noms d'artiste*, some 90 changes of residence, and leaving behind a prodigious number of prints, paintings, and drawings, Katsushika Hokusai (1760–1849) could hardly be considered an ordinary figure, and is in fact to be included in the ranks of the world's leading artists for his superb draftsmanship and unmistakably unique style. Above all he was an artist's artist, absolutely dedicated to his work, always looking and experimenting, capturing new poses and expressions, and bursting with ideas for new works. He lived longer than most of his contemporaries, but by his own admission nearly nine decades was not enough and he always hoped that he could defy the Grim Reaper for a few more years in order to perfect his hand – a wish that unfortunately was not to be granted, as he died soon afterwards at the age of 89.

His drawings are both brilliant and instructive, and show the clever use of a line of varying thickness, for example to capture a profile; but above all they reveal that he really *looked* at his subjects and studied them from every angle in order to select

Left
Courtesan with Flower
Arrangement

Kambun Master

*Ink, colors, and powdered mica on paper,
20 cm x 18 cm, private collection*

This early example of a *ukiyo-e* painting
was painted in the 1660s. The atmosphere
has been enhanced by preparing the paper
with powdered mica, which gives a silvery
sheen to the background.

Right
Courtesans on a Veranda

Suzuki Harunobu (1724–1770)

*Woodblock print, 28.3 cm x 21.7 cm,
private collection*

The torrid heat of a summer evening is
indicated by the sparkler fireworks floating
on a small raft in the water, and the fan
held by the girl on the left. Some fruit are
cooling in the flowing stream. The lantern
on the post is inscribed with "Kawase-Ya,"
which is probably the name of the house
where they worked.

the most interesting features to put to paper. His
paintings range from simple brush-and-ink
sketches to fastidiously detailed paintings that
usually make one look twice – either because of
the subject, which is often bizarre or shocking, or
because of the composition, which will be unlike
anything seen before. He loved to explore the zany
side of life, and also its horrors – the bloodshed
and torture that was still very much a reality in
Edo times, as well as ghosts and demons from the
world of dreams (see page 206, left). Portrayed by
the hands of amateurs, many of these subjects
would be considered to be in questionable taste,
but Hokusai's works always stand above this judg-
ment; saved not only by his remarkable draftsman-
ship and inventive composition, but also by his
rather sardonic, tongue-in-cheek sense of drollery
with which he viewed the passing scene, and
captured in his work.

He also turned his attention to scenic subjects
that were becoming popular as Japanese were
allowed to travel around their own country with
more freedom than before (see page 206). His
Thirty-six Views of Mount Fuji are well-known

everywhere, particularly his famous *Beneath the
Wave off Kanagawa* (see page 207) reproduced
these days on enough calendars, Christmas cards,
and table mats to make the master turn in his
grave. In these images he emphasizes the diminu-
tion of human subjects to contrast with the magni-
tude and power of nature. In the famous *Wave*
print, for example, the foreground consists of the
swelling ocean with a towering wave about to
crash, its white-capped spume forming claws that
menace the boats beneath. The long shape of the
boats follow the lines of the billowing waves and
the huddled boatmen aboard seem so insignificant
that they are not immediately noticed. And in the
distance, framed by the water, is the snow-covered
peak of Mount Fuji (the subject of the print
edition), now seen in a way never depicted before.

While not having been born with quite the
same potency of artistic genius that may have been
both the blessing and curse of Hokusai, Utagawa
Hiroshige (1797–1858) chose to limit his *oeuvre* to
depicting the idyllic scenery of pre-concrete Japan,
and by so concentrating his talents excelled in this
field more than any other of the *ukiyo-e* print

Lovers with a Shamisen

Suzuki Harunobu (1724–1770)

Woodblock print, 20 cm x 28 cm, private collection

A variety of amusements is indicated in this scene – the go tables, the koto stringed instrument, the remains of a sumptuous feast, and the accoutrements of tobacco smoking on the right, and the young woman, who seems to be abandoning her musical performance for more amorous pursuits. Harunobu has used his own signature as that of the artist of the screen behind the lovers.

artists. The atmospheric images that he made of his native land became highly popular in the West when they were first seen in the mid-19th century, and had considerable influence on European artists – particularly those of the Nabis group such as Paul Gauguin and Émile Bernard.

Hiroshige started his artistic studies at the age of 15 under the direction of several teachers, but had to continue his inherited duties as a fireman until the age of 27, at which time he was able to hand over his post to his son and pursue his creative career full-time. He soon departed from the usual *ukiyo-e* subjects of the floating world, and after a journey along the Tokaido route between Edo and the ancient capital of Kyoto he published the famous print series *Fifty-three Stages of the Tokaido*, showing scenic spots along the way with all of the rest-stops, lodging-houses, and res-

taurants for the numerous travelers who passed by. While not quite as inventive as Hokusai (whose work he tried to emulate) Hiroshige showed great ingenuity at capturing the seasonal romance of the countryside in both his prints and paintings – a mood that today can be experienced only by hiking far away from the roads and railways of modern Japan (see page 209).

Apart from having to endure one or two domestic tragedies, it is easy to imagine that long episodes of Hiroshige's life were quite idyllic, with the master setting out on journeys through what was once some of the most splendid and interesting countryside in the world, or even wandering around Edo, which at that time was a city of palaces, gardens, and temples, with diverse spots for excursions or picnics (see page 209). One can only lament the change – and yet be thankful that

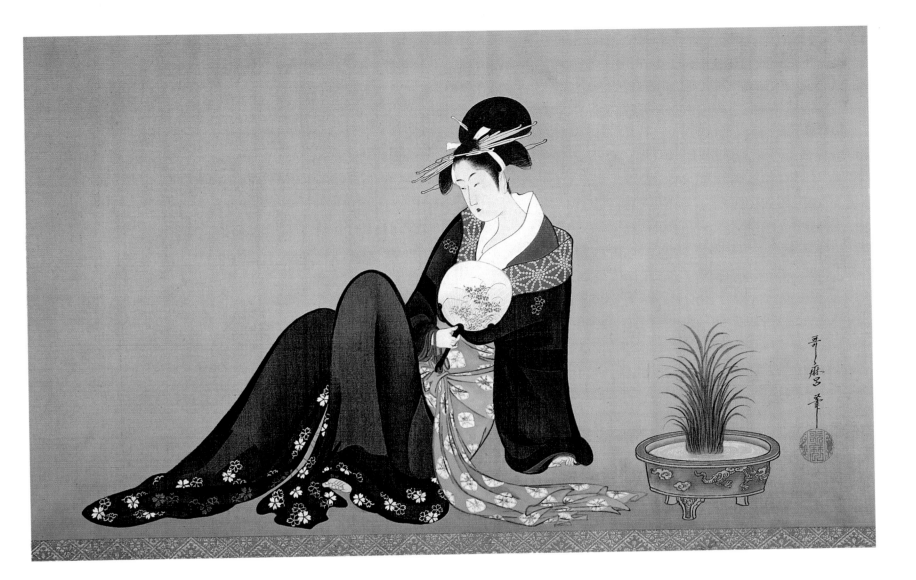

Above
Beauty Enjoying the Cool
Kitagawa Utamaro (1753–1806)

*Ink and colors on silk, 39.5 cm x 65.6 cm,
Collection of the Chiba City Museum of
Art, Japan*

Utamaro's genius at observing and
capturing the different moods of the
women of the period can be seen in this
delightful study of a young beauty almost
overwhelmed by the summer heat. A basin
of water with some green plant, and the
languidly held fan are the only hints at
any relief.

Opposite
*The actor Mitsugorō II in the role
of Genzō*
Tōshūsai Sharaku (active 1794–1795)

*Woodblock print with mica ground,
25 cm x 38 cm, private collection*

Sharaku is famous for his actor prints such
as this this, in which he shows stars of the
Kabuki theatre in one of their exaggerated,
and much celebrated poses.

these images remain of a land where industrial progress has been far from kind and very little remains of that which was so keenly observed by Hiroshige. He died of cholera in his prime at age 62 during an epidemic that was raging throughout the country in that year. On his deathbed he wrote his last words:

*Leaving my brush on the Azuma Road,
I go to see the famous sights
Of the Western Paradise…*

Traditional schools of the Edo period: Unkoku, Rimpa, and Kanō

While the genre and *ukiyo-e* artists were portraying the heroes and heroines of the theater, and the pleasure-quarters in the cities, other artistic movements were evolving in quieter areas: in the studios connected with the court and regional *daimyo*, and in tranquil temples and monasteries. The Unkoku school was established by Unkoku Tōgan (1547–1618) during the Momoyama period in order to continue the style of landscape painting that Sesshū had introduced over a century before. Sesshū had painted in two main styles: the impressionist, almost abstract

haboku "broken ink" manner, in which no outlines are used to delineate the forms; and a "crackling" style, in which each brush stroke is like a bolt of lightning – strong, confident, unwavering. Tōgan and his followers lived and worked mainly in the western part of Japan where Sesshū himself had settled, and continued to paint idealized landscapes inspired by the West Lake and the Hsiao-Hsiang rivers in China, together with birds and flowers and classical figures from legend, in the pictorial "crackling" manner of Sesshū, but with a softer, less forceful touch than that of the master (see page 210).

The earlier work is the most interesting, and even though Unkoku school artists were working throughout most of the Edo period, their landscape painting gradually became more and more derivative and one feels that the artists were imprisoned by their limited choice of Chinese subjects and academic brushwork. Their tradition was a noble one no doubt, but the Edo period was one of change, and as new artistic innovation claimed the interest of customers, the Unkoku artists were gradually left behind. Except for the first three generations or so of Unkoku painters, the school has remained still largely unresearched. Occasionally paintings surface, dating from the

Right
Boy and Mount Fuji
Katsushika Hokusai (1760–1849)

*Ink and colors on silk, 36.2 cm x 51 cm,
Collection of the Freer Gallery of Art, USA*

This scroll, painted when Hokusai was
fully 80 years old, demonstrates his
extraordinary sense of design and
composition. Like the artists of the
Rimpa school, he sometimes used the
tarashikomi technique of applying ink or
pigment to a wet surface to achieve a
special effect of blended tones. In this
Arcadian scene, a boy is seated on a
willow tree in springtime, playing his
flute to the great sight of Mount Fuji
that is emerging from the mists.

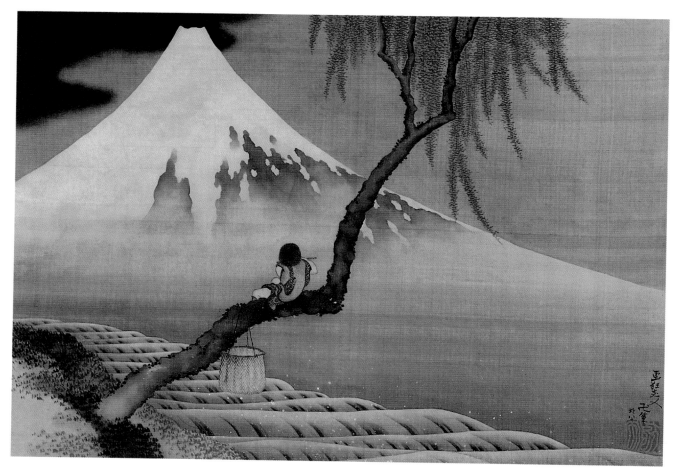

Above
Severed Head of a Female Criminal
Katsushika Hokusai (1760–1849)

*Ink and colors on silk, 27.3 cm x 47.7 cm,
private collection*

Hokusai was a keen observer of everything
around him and never hesitated to portray
unpleasant subjects, whether real or
imaginary. The ghostly effect of the
gruesome image is enhanced by the light
"halo" of the tie-dyed fabric on the
surrounding scroll mount.

Sekiya Village
Katsushika Hokusai (1760–1849)

*Woodblock print, from the series
Thirty-six Views of Mount Fuji,
about 1830, 25 cm x 38 cm,
private collection*

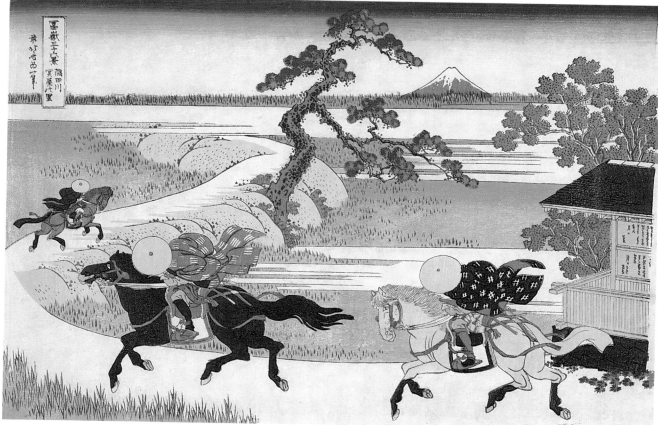

late-17th and early-18th centuries, that indicate some attempted to break out of the rather stuffy academic mold and tried to recapture some of the splendor of Momoyama decorative work by using colors and gold (see pages 212–213).

The Rimpa style of aristocratic painting that had appeared with Sōtatsu and Koetsu during the early-17th century saw two more waves of illustrious artists who continued this very Japanese decorative style of work during the Edo period. Ogata Kōrin (1658–1716) was much influenced by his forebears of the earlier part of the 17th century, but for some reason managed to achieve an even more exulted status in the history of Edo painting. The story of his life is the familiar one of a man born into a wealthy merchant family who misspent his youth and inheritance in the pursuit of pleasure. His urbane and stylish manners allowed him to mix freely with the grander families of Kyoto, and there he was fortunate enough to make connections that were certainly to prove useful when his money later ran out.

In between adventures in the houses that catered to men with money, and the parties and amusements of Kyoto's social whirl, Kōrin learned to paint and developed two distinct styles for which he is famous. In one style he painted freely in ink and light color with rapid, gestural brush strokes that at first sight look simple, but on scrutiny show the highly developed taste to be expected of one who moved among the Kyoto tea aesthetes. These are usually in the small format of hanging scrolls suitable for the *tokonoma* of a tea room, for fans, and for wrappers for incense, but are also seen on ceramic wares that he worked on in collaboration with his brother, Ogata Kenzan. His second style is that most influenced by Sōtatsu and the other Rimpa artists of the early-17th century, and is seen in exquisitely decorative painting that display a lavish use of color and gold leaf (see pages 214 and 215). His subjects are classic subjects of the Rimpa school: birds and flowers (which in many cases have a literary connotation), classical poets, and figures from Chinese legends.

Beneath the Wave off Kanagawa
Katsushika Hokusai (1760–1849)

Woodblock print, from the series Thirty-six Views of Mount Fuji, about 1830, 25 cm x 38 cm, private collection

One of Japan's most celebrated images, which has become an icon recognized worldwide, this print shows how Hokusai's extraordinary sense of composition and design marks him as one of the world's great artistic visionaries.

clumps of flowers forming an almost musical composition. The screens are always displayed as they would have been on the *tatami*-covered floor of a 17th-century palace, standing in a zigzag with a 90-degree angle between the panels. The musical analogy can be carried further when one looks at the screens from either side; it is always a surprise to notice that the composition is still just as coherent and interesting when, viewed from this angle, only three panels can be seen from each screen.

This style of painting directly in color, without first drawing an outline of the composition, was a typical Rimpa technique known as *mokkotsu* that was used by Kōrin and other members of the school. Combined with the *tarashikomi* method of applying paint or ink to wet paper so that it pools into an interesting form, the effect is impression-istic and to some extent resembles the designs that were used for making fine textiles.

For a few decades following the time of Kōrin, the Rimpa style of painting lost its position as other artistic innovations caught the eyes of patrons, only to resurface again during the early-19th century, the last years of the Tokugawa adminis-tration. Sakai Hôitsu (1761–1828) was born into the aristocratic family of the Himeji castle, between present-day Osaka and Okayama on the coast of the Inland Sea. He studied painting, in particular the works of earlier Rimpa masters such as Kōrin, and in middle age entered the priest-hood, possibly in search of a quieter life away from responsibilities that were automatically inherited with such a grand background. His work is elegant and finely executed in the manner of his earlier Rimpa predecessors, with a delicate, finely con-trolled touch and superb coloring. Having no money problems, he was always able to buy the very best materials and so one finds that most of his paintings are on silk. The effect of the contem-porary Maruyama-Shijo school can be seen in a more natural touch in his paintings, although it has to be said that a good many of them, even though quite delightful, are just a little too deriva-tive of earlier Rimpa works to be really interesting.

Though not quite as technically skilled, one of his followers, Suzuki Kiitsu (1796–1858), and another contemporary, Nakamura Hōchū (flour-ished late-18th and early-19th centuries) showed a little more imagination in their treatment of Rimpa themes. Kiitsu worked as an assistant to the illustrious Sakai Hoitsu and therefore his works tend to be considered as being somewhat in the shadow of those of his master; but even though his work shows less finesse, his compositions are much more dramatic.

In his two-panel screen of *susuki* grass – one of the "seven plants of fall" that has many poetic connotations for the Japanese – Kiitsu has made a strong but elegant graphic pattern out of the plants on a background of silver leaf, which has tarnished attractively over the years to a soft gray (see page 216). A different but equally imaginative sense of design, and one on a grand scale, can be

Mount Fuji from Satta Point

Utagawa Hiroshige (1797–1858)

Woodblock print, from the series Thirty-six Views of Mount Fuji, 1859, 38 cm x 25 cm, private collection

Hiroshige was much inspired by his predecessor Hokusai, and produced his own series of views of Mount Fuji. Here, with the curling wave and "fingers" of spume, there is more than a hint of Hokusai's famous *Beneath the Wave off Kanagawa* (see page 207).

Perhaps his most famous work is the pair of six-panel screens that are displayed every May to June at the Nezu Museum in Tokyo, showing clumps of irises on a background of gold leaf. Kōrin used no outline to define the shapes of the plants and just painted the color directly on the paper: a flat green for the leaves and two shades of blue to give a certain three-dimensional effect for the flowers. At first sight, and especially in low lighting, the effect is one of seeing a silhouette of the forms against the glowing gold background, with the

Above

Moonlit Night at Miyanokoshi

Utagawa Hiroshige (1797–1858)

Woodblock print, from the series Sixty-nine Stations of the Kiso Highway, late 1830s, 25 cm x 38 cm, private collection

By removing outline and detail in the background and reducing it to simple shapes, Hiroshige shows the effect that was later to have so much influence in Europe, particularly those of the Nabis school in France during the later part of the 19th century.

Below

Night Rain at Karasaki

Utagawa Hiroshige (1797–1858)

Woodblock print, from the series Eight Views of Lake Biwa, 1834, 25 cm x 38 cm, private collection

No people can be seen in this picture, and the heavy rain falls quite vertically as if the skies were emptying. In most Western countries this would be a gloomy scene but in Japan it is one that is typical of the summer monsoon, warm and romantic.

seen in the superb pair of six-panel screens of morning glories painted on gold leaf, now in the Metropolitan Museum of New York. In these we can see that by leaving out anything unnecessary (such as whatever it was that the plants were climbing on), Kiitsu has made an exciting arrangement with a bold use of color, and has painted the creepers so that they enclose gold space in a manner that is almost calligraphic.

Nakamura Hōchū was a master of the Rimpa decorative technique of *tarashikomi* and used this to great effect, especially in his small-scale works such as fans and hanging scrolls. But in addition he had a very individual way of looking at his subject matter, particularly flowers, and of painting them in a way that was quite out of the ordinary (see page 217, left). In his famous *White Plum Tree* scroll painting in the Chiba City Museum, Hōchū has ignored the usual petal arrangement of the blossoms and reduced them to round shapes of different sizes, leaving the contained area unpainted except for the stamens which have been softly highlighted with a slight gold touch. By contrast, the background of the painting has been painted in a very pale ink wash perhaps to indicate the moonlight by which plum-blossoms have traditionally been considered to look their best. The branches are painted using an unusual *tarashikomi* ink treatment with a slight highlighting in gold, and the whole arrangement seems to be strangely disembodied and unattached. The result is extraordinarily effective and is an excellent example of what can be done by using imagination with traditional Rimpa painting techniques.

After Eitoku and the other great masters of the Momoyama period, the Kanō school flourished as the appointed academic painters to the Tokugawa

shogunate's court, and continued to paint screens, scrolls, and *fusuma* doors either in ink or with colors and gold leaf, and using classical Chinese subjects. The standards were high and some very notable work was produced, particularly during the earlier part of the Edo period by such artists as Tan'yū (1602–1674; see page 217, far right); Tsunenobu (1636–1713); Tōun (1625–1694; see pages 218–219, bottom); and Chikanobu (1660–1728; see pages 220–221).

Because of their prestige, the studios of the Kanō school became the prime targets during the Edo period for young budding artists who wished to learn the techniques of painting before branching off independently to develop their own styles. The paintings of successive Kanō family artists unfortunately start to show the stultifying effect of Tokugawa conformity and the weight of rigid, institutionalized Confucianism; although their work was professionally executed, it tended gradually to lack interest for it had no new themes, the same old subjects being rehashed time after time. There were some who, perhaps luckily, lived away from the studios near the Edo castle and who felt sufficiently liberated to experiment a little and try a more personal style of brush stroke than that which they had learned.

Edo painting: Nanga

But the latter half of the Edo period saw the appearance of new schools of painters who had not only fresh ideas but also the freedom to express themselves without having to conform to outdated ideas. Among these were the Nanga, or Bunjinga, painters who followed the Chinese ideals of the scholar-gentleman, that member of the cultured intelligentsia who was skilled in poetry, callig-

Peonies and Bamboo Fence

Unkoku school

Eight-panel screen, ink, colors, and gold leaf on paper, late-17th century, 126.6 cm x 371 cm, private collection

While most of the painters of the Unkoku school painted ink landscapes after the manner of Sesshū, some tried to recreate the rich splendor of Momoyama decorative gold screens such as those made by the Kanō school, particularly around the turn of the 17th–18th centuries. At first sight, this screen looks like the work of a Kanō painter, but the treatment of the rocks and the waterfowl reveal the hand of an Unkoku school painter.

raphy, and painting. Their painting styles showed considerable variety as the artists themselves came from different backgrounds, but all were influenced by paintings from Ming dynasty China. Manuals and printed books such as the well-known *Mustard-seed Garden*, which detailed the brush stroke techniques of Chinese painting, had turned up in Japan, where they were reprinted and widely used by the Nanga artists. Other sources of information on mainland matters were the Chinese merchants and priests with cultural leanings who occasionally appeared in the trading port of Nagasaki, which at the time was the only window to the outside world.

The style blossomed in the warm artistic climate of Japan, and whereas in China the literati were all members of an elite bureaucracy with all of its *idées fixés* and restrictions, the Nanga painters had much more freedom to break a few painting rules for the cause of their own artistic expression. At odds with most painters of other schools, but in

keeping with gentleman-literati ideals, many Nanga artists were also highly proficient in some other art such as poetry or pottery. They tended to choose subjects for painting that were favored by the mainland literati: idealized landscapes and the "four gentlemen" (plum, chrysanthemum, orchid, and bamboo), together with rocks and venerable Chinese classical figures. All of these artists were competent calligraphers as well, and frequently combined their writing with painting. Some became so besotted by a single subject that they devoted their careers to painting almost nothing else. Yoshida Zōtaku (1772–1802) was a samurai warrior from Matsuyama who, while having no serious duties to perform during the peaceful Edo times, devoted himself to painting bamboo, often with a highly unusual composition (see page 225, left). The long-lived Tenryū Dōjin (1718–1810) came from Nagasaki, where he must have had some exposure to visitors from China, and along with becoming a priest, poet, and engraver of seals,

achieved fame for his dedication to the worthy cause of painting vines and grapes (see page 225, right). Another, Katori Nahiko (1723–1782), a classicist and noted haiku poet from near Edo, experimented for a short time with the usual Nanga subjects before devoting his career to painting plum blossoms (or prunus blossoms, to be more accurate [see page 226, left]).

Two of the main figures of the many Nanga artists were Yosa Buson (1716–1783) and Ike-no-Taiga (1723–1776), both of whom became accomplished in the painting principles and brushwork of the Chinese masters. Buson came from a farming family that was apparently prosperous enough for him to be released to follow his cultural pursuits. He experimented with many styles of painting to accumulate experience before his own style matured. He also became famous as one of the great haiku poets of Japan.

(Haiku are short verses with 17 syllables in three lines of five-seven-five. They often have a Zen flavor in their manner of encapsulating a certain moment or scene in a few brief, pithy characters. While many have been translated, and there is a fashion now for writing them in English, like most poetry they are best appreciated in their native language.)

At an early age Buson lived for a while in Edo to study poetry, and then spent a rather peripatetic life roaming around the country before finally settling in Kyoto. His works are mainly landscapes that if studied at close quarters reveal some literary content – some vignette or illustration from Chinese classics (see page 227, right), or *haiga*, quick, impromptu sketches to accompany his own haiku poems.

Ike-no-Taiga was an extremely prolific artist whose work shows a wide repertoire of styles and techniques, often very lively and humorous, with some painted in an almost cartoon-like manner. While having mastered the standard literati brush styles, Taiga was not averse to borrowing painting

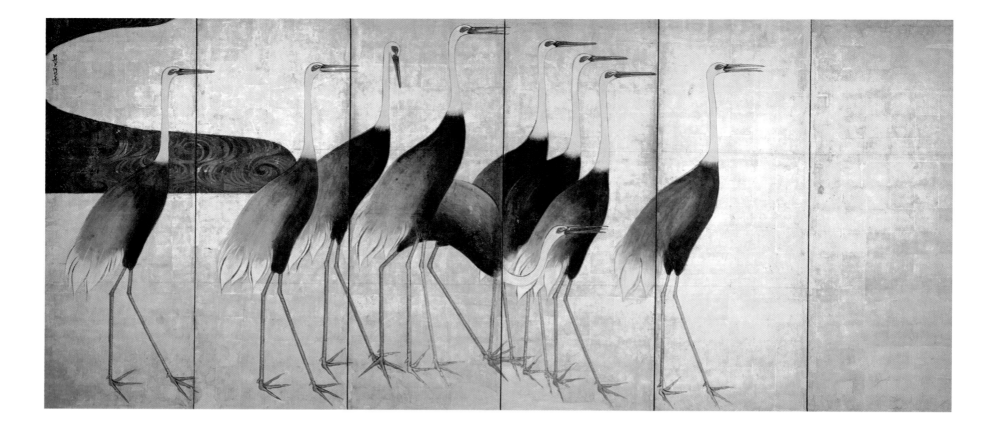

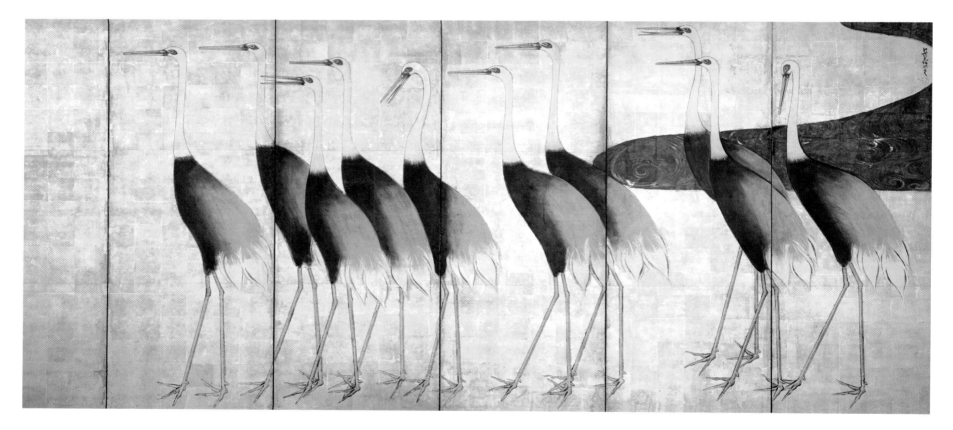

Cranes

Ogata Kōrin (1658–1716)

*Pair of six-panel screens, each
166 cm x 371 cm, ink and colors on gold
leaf, Collection of the Freer Gallery of Art,
USA*

Born into a prosperous Kyoto family, Kōrin
misspent his inheritance and was reduced
to poverty towards the end of his life. He
ranks with the leading Rimpa painters of
the Edo period in making works that shows
a keen observation of the subtle nuances
of nature combined with a daring and
exciting graphic sense.

In this large-scale pair of screens, Kōrin
has contained the water to an enclosed
pattern on each side, and has lined up the
cranes to make a bold composition.

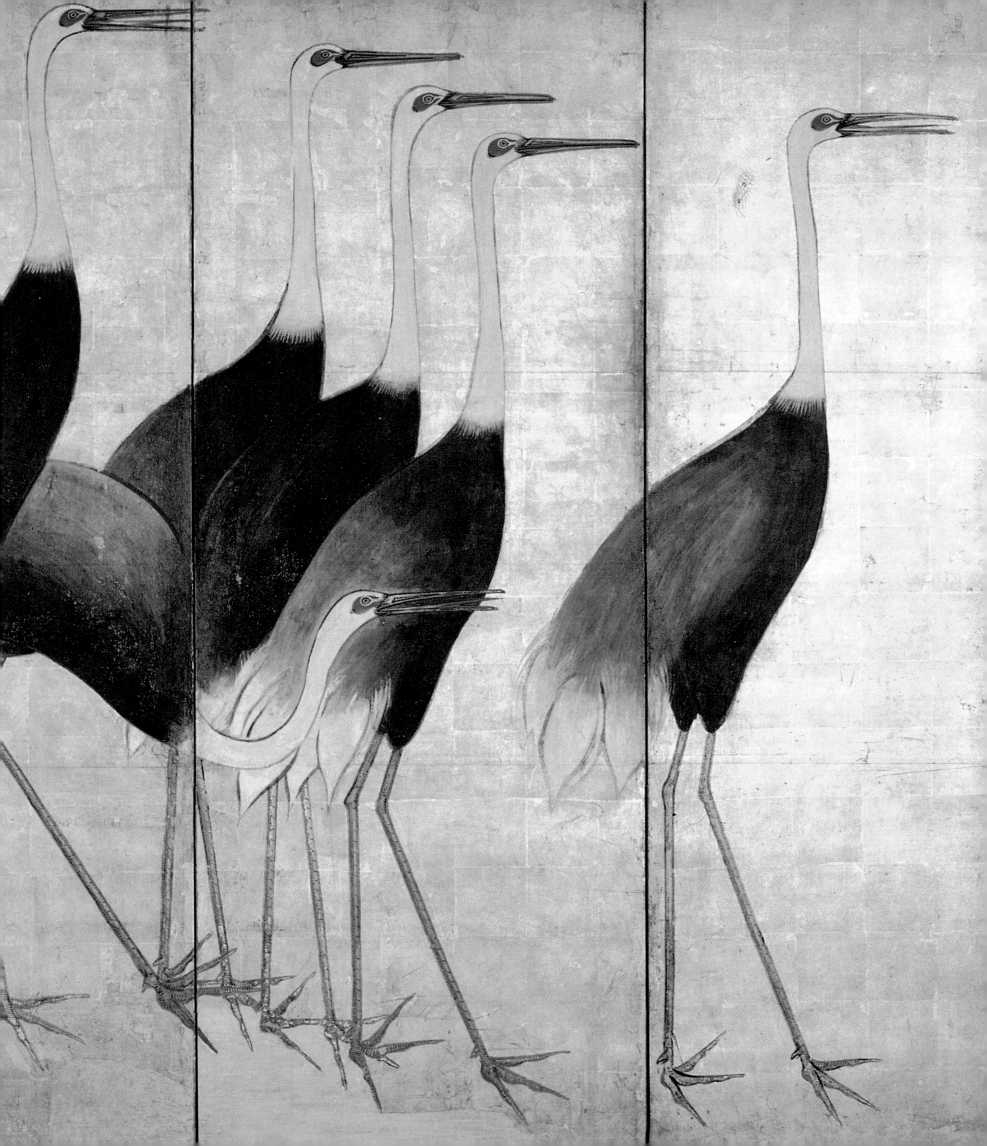

Field of *Susuki* Grass

Suzuki Kiitsu (1796–1858)

*Two-panel screen, ink, and silver on silver
leaf, 144.2 cm x 165.6 cm, Collection of the
Chiba City Museum, Japan*

One of the "seven flowers of fall," *susuki*
grass shimmering silver in the October
sunshine is one of the unforgettable
images for anyone who has lived in Japan.
In this screen, Kiitsu has emphasized this
image by using a background of silver leaf,
and has used the shapes of the feathery
seed-heads of the grass to make a painting
that is more pattern than picture.

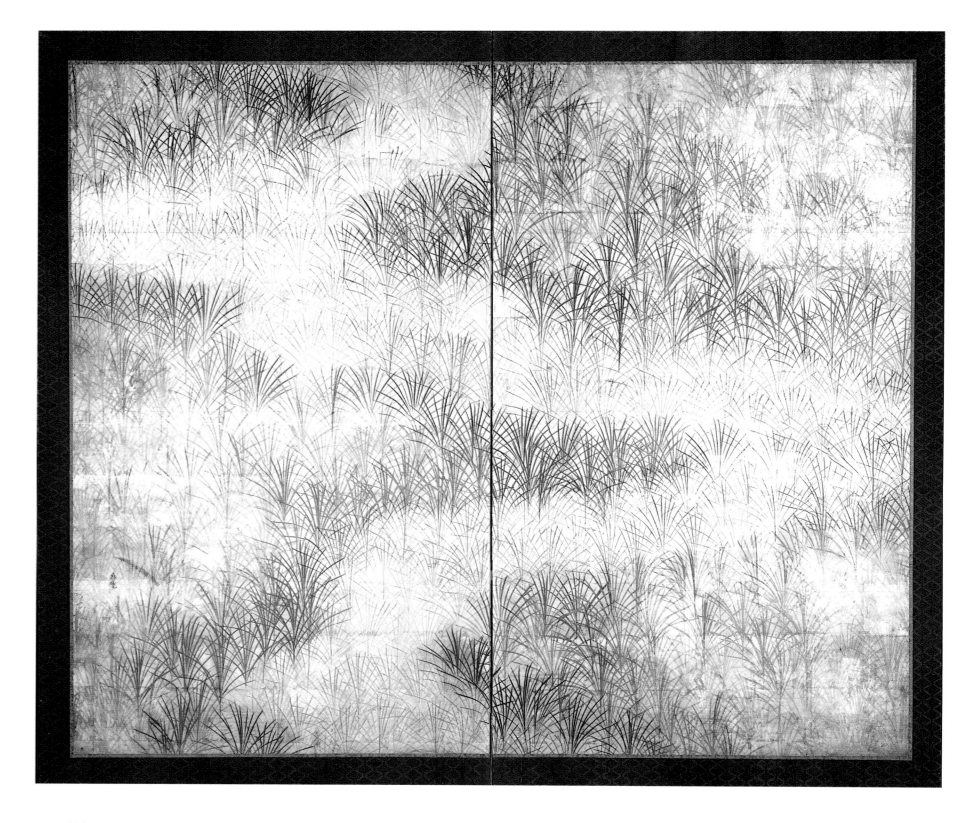

techniques from other schools and it is sometimes surprising to see in his work the *tarashikomi* treatment of pooling ink or colors into wet paper, a technique usually associated with the Rimpa painters, but used with orthodox Nanga brush strokes. He also practiced Zen and was associated with some of the other more eccentric painters of Kyoto, such as Soga Shōhaku, and these influences can be seen in some of his brilliant and very edited brushwork (see page 227).

Yamamoto Baiitsu (1783–1856) departed to some extent from using the delicate colors and sharp, clear forms of the landscapes of most Nanga painters, and excelled in brush-work to create the kind of bird-and-flower paintings that in China were associated with professional painters rather than cultured literati (see page 228, left). This interest was probably learned as a result of having been the pupil of a noted rich collector of Chinese paintings who lived in Nagoya and who inspired him to study a wide range of styles. Baiitsu perfected an interesting technique of painting the leaves of plants with a wash of color which he would then outline in ink of different intensities before the paint had dried, to give an effect that was natural as well as decorative, and also in some way a departure from the geologically outlandish landscapes that were the usual province of Nanga artists.

Fujimoto Tesseki (1817–1863) represents the later group of Nanga painters, who were active during the turbulent years that marked the end of the Edo period. He is remembered not only for his landscapes, which he painted with a rather animated brush, but also for his accomplishments as a calligrapher and a swordsman. As a samurai warrior from the Bizen area of Okayama (which is famous for its pottery), Tesseki fought for the restoration of the imperial system and the overthrow of the Tokugawa shogunate. Unfortunately his timing fell short by a couple of years, and he was killed while fighting for his cause near the city of Nara.

Edo painting: foreign influences and the Maruyama-Shijo School

One of the pitfalls in trying to make sense of the complexity of a country's art history is that of defining each school as if it were insulated and aloof from the others, its practitioners having no interest in what anyone else was doing. In fact there was much cross-pollination of ideas, and generally an open interest in what the other artists were up to; though, for many, creative experimentation was curbed by the ponderous bureaucracy of the patronage that paid for their daily rice.

Until the latter half of the 18th century, there seemed to have been no interest in the *realistic* portrayal of subjects in painting: everything seems to have been used as a motif for a design with a religious, philosophical, or decorative purpose. Maybe the closest that art came to realism was not in the field of painting but in that of sculpture, as

Left
Flowering Prunus Tree

Nakamura Hōchū (early 19th century)

Ink and gold on paper, 134.5 cm x 66.5 cm, Collection of the Chiba City Museum of Art, Japan

The decorative style of Rimpa painting is well illustrated in this highly unrealistic picture of the winter-flowering prunus, a tree much celebrated in Japan for its fragrant and long-lasting blossoms. Hōchū has reduced the trunk to a sinewy shape and has edited the ground out altogether. Likewise the blossoms have been reduced to roundels, ignoring the arrangement of petals seen in real life. With the skillful use of *tarashikomi* and the spare use of gold, a daring design has been made from a commonly seen subject.

Right
Red-robed Daruma

Kanō Tan'yu (1602–1674)

Ink and colors on paper, Collection of J. E. V. M. Kingadō, USA

Priest, poets, and painters interacted frequently, and in this painting Tan'yu has painted a Zen subject which has an inscription added by Obaku Ingen, one of the leading Zen figures of his time. Even though Tan'yu was a professional artist, his devotion to Zen is strongly felt in this painting, which falls between decorative painting and Zen spontaneity.

Top
Chinese Sages

Kanō Eichō (1821–mid-Meiji period)

Pair of six-panel screens, ink on paper, each 171.5 cm x 376 cm, private collection

Kanō Eichō started his career working in the imperial palace in Kyoto, but then entered the service of the lord of Okayama, where he developed his own distinctive brush-style. These screens show a favorite Kanō subject of Chinese sages enjoying three of the "four gentlemanly accomplishments:" (from right) music, calligraphy, and painting. The group on the left would normally be shown playing Chinese checkers but here it seems that they are diverted to observe the others. Eichō escaped from the rather stultifying Kanō academic style in Kyoto, and developed his "knobbly" manner of ink painting while working near the Inland Sea.

Winter and Summer Landscapes

Kanō Tōun (1625–1694)

Pair of six-panel screens, ink and slight color on paper, each 170 cm x 373 cm, private collection

A leading Kanō painter in the service of the shogun, Tōun has painted a winter scene in "reverse" – where the herons and the snow are the color of the paper and everything else is defined in ink. The right-hand scene illustrates the typical Kanō treatment of the pine and rocks.

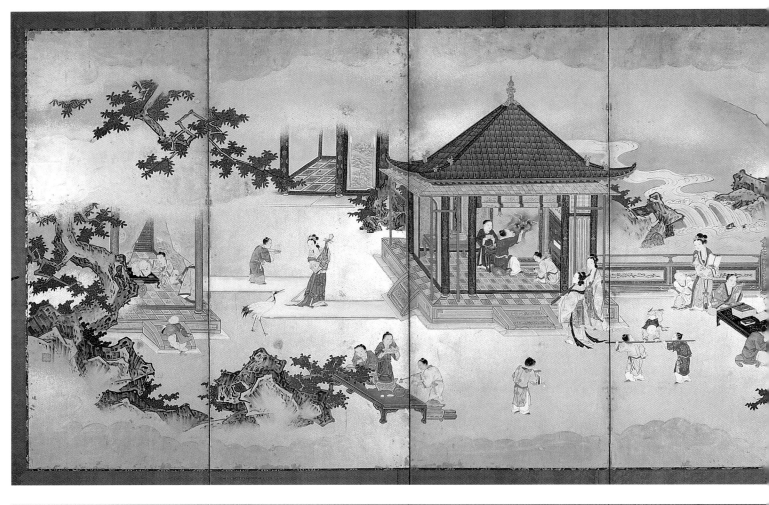

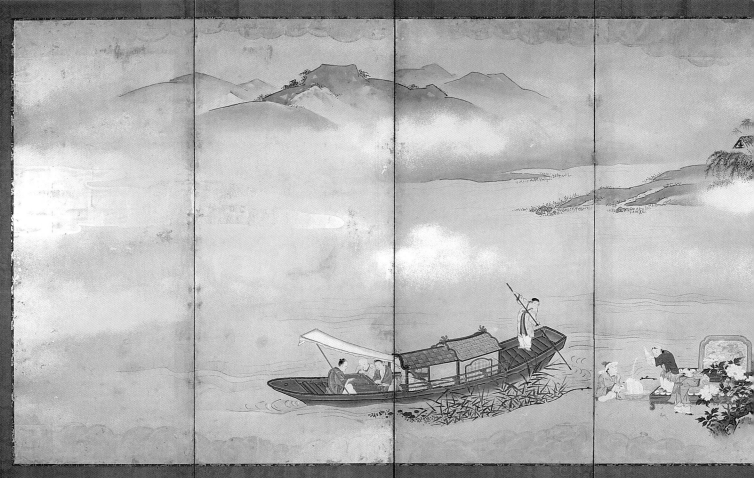

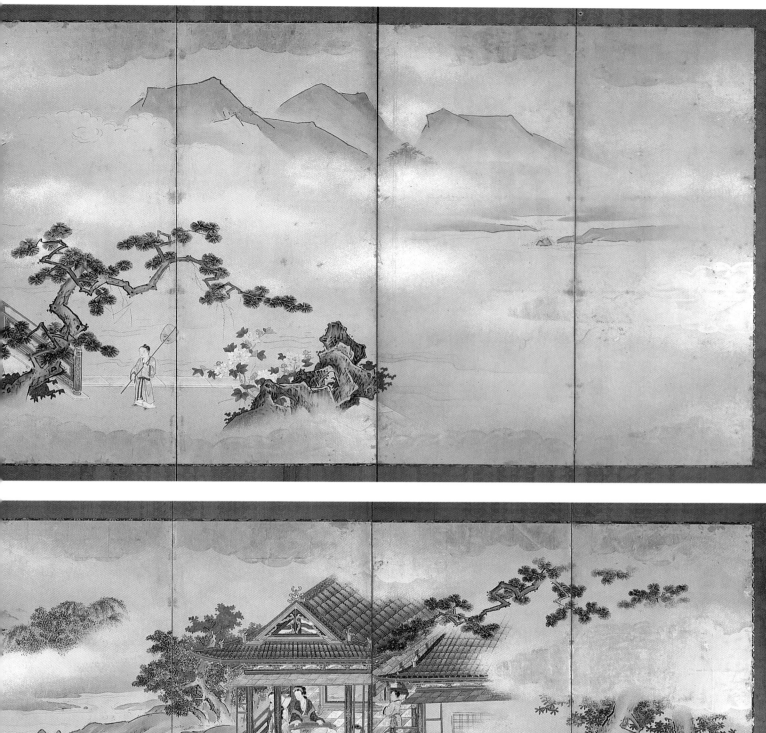
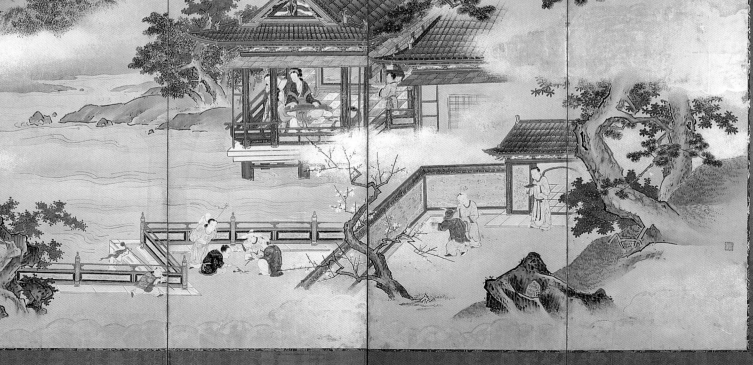

Left
Bamboo and Calligraphy (diptych)
Doi Gōga (1817–1880)

Ink on paper, Collection of J. E. V. M. Kingadō, USA

This diptych demonstrates how closely painting and calligraphy are associated in the Eastern art, where one can become the other. Doi Gōga was the son of a doctor who lived in Ise, the site of the Imperial Shrine. He diligently studied Confucian classics (the importance of which he valued more highly than poetry or literature) and was much attracted to the bamboo paintings of the monk Obaku Taihō (1691–1774).

Previous pages
Classical Court Scenes
Kanō Chikanobu (1660–1728)

Pair of eight-panel screens, each 122.3cm x 419.2 cm, ink, colors, and gold leaf on paper, private collection

Chikanobu was also employed in the service of the shogun and had his studio in the Edo Castle. These screens show Chinese children pursuing scholarly accomplishments – one of the classical subjects used by Japanese artists – just as images from ancient Greece and Rome provided inspiration for Western painters. Gold leaf has been used for the clouds, and gold powder and gold flecks have been applied elsewhere in the background to give a rich effect that would have been all the more impressive by candlelight.

Nanga Landscape with Boats

Uragami Shunkin (1779–1846)

Ink on paper, 161 cm x 71.7 cm, Collection of J. E. V. M. Kingadō, USA

Uragami Shunkin was born in Bizen (an area famous for swords and ceramic wares) and pursued his painting career in Kyoto. In his paintings such as this landscape he uses a repertoire of brush strokes inspired by Chinese Ming dynasty works, but also shows a certain naturalism more typical of the Maruyama-Shijō painters who were working in Kyoto at the same time.

Right
Landscape

Tani Buncho (1763–1840)

Ink and slight color on paper,
167 cm x 90.3 cm, Collection of
J. E. V. M. Kingadō, USA

Although born to the discipline of a
samurai family in the service of one of the
members of the Tokugawa shogunate
family, Tani Buncho became a wildly
eclectic painter in his later life. He is
primarily known as a Nanga artist, but he
studied the styles of all schools, and these
elements are often seen in his paintings.

Oppposite, left
Bamboo

Yoshida Zōtaku (1772–1802)

Ink on paper, 133.5 cm x 58 cm,
Collection of J. E. V. M. Kingadō, USA

Zōtaku was one of the many samurai who,
finding little to do during the peaceful
Tokugawa period, turned to painting as a
pastime. Primarily a Nanga artist, painting
in a style influenced by Chinese literati
painters, he developed a fascination
for bamboo.

Opposite, right
Grape Vine

Tenryū Dōjin (1718–1810)
Ink on paper, 128.8. cm x 55 cm,
Collection of J. E. V. M. Kingadō, USA

Tenryū Dōjin was born in the port of
Nagasaki and spent the first part of his life
attempting to rally support for the
imperial family. He failed in this calling
and retired to Lake Suwa in Nagano
prefecture, entering the priesthood and
passing his time painting, writing poetry,
and engraving seals. Just as Zōtaku had
become fixated by bamboo, so Dōjin was
attracted to grape vines.

seen for example in the wonderful life-like images of famous priests that were made during the Kamakura period, and which appear to embody their serenity and spirituality.

It is not clear what exactly sparked an interest in realism (for want of a better word, for dragons were later to be painted this way), but it is likely that the idea came from abroad. During the late Muromachi and early Momoyama period, the young students of Jesuit missionaries had been painting portraits of the Holy Family in European Renaissance style, but all of this had vanished or fled when the Tokugawa closed off the country… and it was certainly far from healthy to show any interest in Christianity or its artifacts while the shoguns remained in power.

But there was one portal to the outside, and that was the town of Nagasaki on the west coast of Kyushu. This was the only place in Japan where foreigners were allowed to be based for trading purposes, though on the strict understanding that they neither proselytized Christianity nor broke any Japanese laws. The local staff of the Dutch East India Company had no difficulty complying with these conditions as their main interest was in the pursuit of business. Although they were mainly trading in goods where there was a chance of profit, they occasionally brought books and paintings with them that fascinated the few Japanese who were fortunate enough to have access to them. The other main foreign presence was that of the Chinese traders and it was through them that Ming dynasty paintings found their way to Japan, where they also attracted great interest from the curious natives.

A few Japanese artists gravitated to Nagasaki just for the chance of being able to be exposed to the exotic foreigners. Shiba Kōkan (1738–1818)

painted Japanese subjects and imaginary foreign scenes in a Western style, using chiaroscuro, shading, and perspective, in an attempt to imitate the realism that he had seen in imported paintings (see page 229). Another, Hiraga Gennai (1726–1779), was ordered to Nagasaki to study the Dutch language and any other foreign learning by the lord of his home region on the island of Shikoku. While there he also became moderately competent in European-style oil painting, which he later taught to pupils in other parts of the country.

However, the revolutionary artist who synthesized this new realism while still using ink and the traditional formats of paper screens and scrolls, was Maruyama Okyo (1733–1795). He had the ability to understand the technical matters of realistic depiction such as the rules of perspective and shading, but wisely realized that the mere imitation of foreign painting would be no more than an outlandish curiosity, and that some adaptation would be necessary for his career to be successful. He accomplished this my mastering the medium of ink painting in addition to the newly imported techniques, but by using his keen observation and sensitivity his work remained in keeping with the refined Japanese tastes of Kyoto (see pages 230–231, top).

He was fortunate in having his talent recognized at an early age, and with some important commissions from high-ranking patrons he was able to establish his own studio and found a school of painting later to be known as Maruyama-Shijo (Shijo being an area in Kyoto near the river where artists congregated). Students flocked to study under Okyo's direction, many of whom in turn became highly renowned painters who set up their own studios. His most successful followers

Opposite, left
Birds and Prunus Blossom

Yamamoto Baiitsu (1783–1856)

Ink and slight color on silk, Collection of J. E. V. M. Kingadō, USA

Baiitsu was born in Nagoya and studied Chinese painting under the guidance of a wealthy collector. His paintings are naturalistic and finely executed, with controlled lines and skillful coloring.

Opposite, right
Landscape

Fujimoto Tesseki (1817–1863)

Ink on paper, 142 cm x 63 cm, Collection of J. E. V. M. Kingadō, USA

Tesseki's studies of Chinese painting are evident in the variety of brush stroke shapes that make up this landscape.

Right
Fishermen

Shiba Kōkan (1747–1818)

Ink and colors on silk, 24.8 cm x 22.4 cm, Collection of the Chiba City Museum, Japan

Although appearing rather amateurish to Western eyes, the work of Shiba Kōkan was quite revolutionary in Edo period Japan, as he emulated the Western chiaroscuro and perspective seen in the few paintings that had been imported by the Dutch traders in Nagasaki.

Following pages, top
Landscapes

Maruyama Okyo (1733–1795)

Pair of six-panel screens, each 154.6 cm x 348.2 cm, ink and gold leaf on paper, Collection of the Chiba City Museum of Art

In a complete departure from the academic style of the official Kanō painters, Okyo developed a new style of naturalism in ink painting. In this pair of landscapes, he has painted the winter scene on the left in "reverse:" the snow is unpainted paper, and every other element is painted in shades of ink.

Following pages, bottom
Waves and Rocks

Yoshimura Kōkei (1769–1836)

Pair of six-panel screens, each 380 cm x 170 cm, ink on paper, private collection

Kōkei continued the naturalistic style that became the hallmark of the Shijō school. In these large screens, the artist has succeeded in conveying the violence of the sea with a few simple brush strokes.

(Genki, Rosetsu, Nangaku, Tetsuzan, Nantei, Soken, Kōkei, Bummei, Gessen, and Kakurei, known as the "Ten Great Pupils of Okyo") developed their own individual styles using the techniques of their master (see pages 230–231, bottom); and then they in turn trained their own pupils to continue the tradition throughout the 19th century (see pages 232–233).

Edo eccentrics and Zen monks

Along with the Maruyama-Shijo break-away from the long-established Kanō, Tosa, and Rimpa schools of painting, the Edo period saw the refreshing appearance of some eccentric individualists who "did their own thing" in defiance of all established conventions. Nagasawa Rosetsu (1754–1799), despite having been born into the stoic discipline of a samurai family, became a pupil of Maruyama Okyo, but was apparently expelled for departing too far from the master's controlled and mannered painting. He was famous for his bold compositions and the broad sweeps of his brush in his paintings of subjects borrowed from all sources – Zen landscapes, animals, human figures – in a versatile but quite unique style.

Even more extreme was the slightly earlier Soga Shōhaku (1730–1781), a self-proclaimed artist of the Soga school (after a distant painter of the Muromachi period), whose work was unlike anything ever seen before or since. Shōhaku, who came from a merchant family, was well known in the art circles of Kyoto, and to some extent was admired for the wild, gestural brush strokes in his paintings (see pages 234–235). His figures are always fantastic with mad expressions and crazy gestures, his landscapes exaggerated, bizarre, and with topographical features that to any mind would seem to be geologically impossible – even more so than those seen in works of the Nanga artists. It is a delight to know that his behavior found disapproval among the stuffy bourgeoisie of Kyoto, and one can only have wished that his life had been longer so that there would be more of his works to amaze us today (see page 236, bottom left).

The Edo period also saw the appearance of a number of monk-artists who were followers of Zen and who used painting and calligraphy to illustrate points of doctrine. A resurgence of interest in Zen can be associated with the arrival of Chinese monks escaping from the chaos at the end of the Ming dynasty in the 17th century, and the fascina-

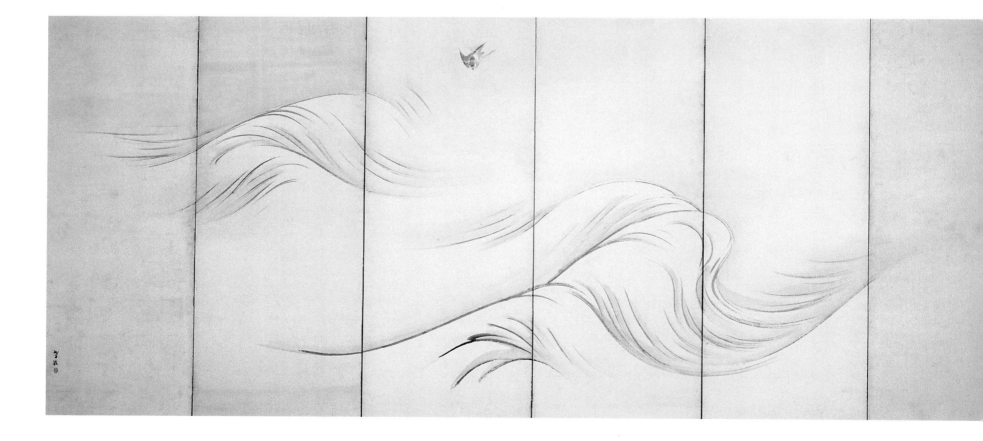

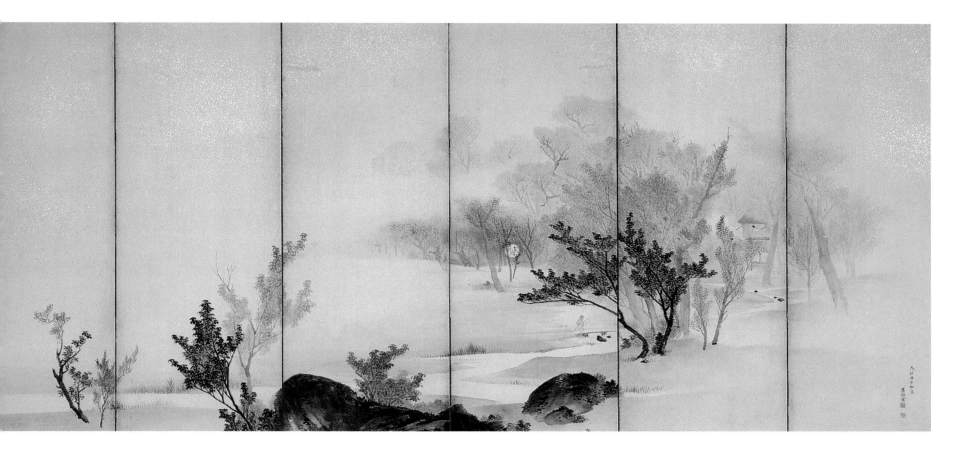

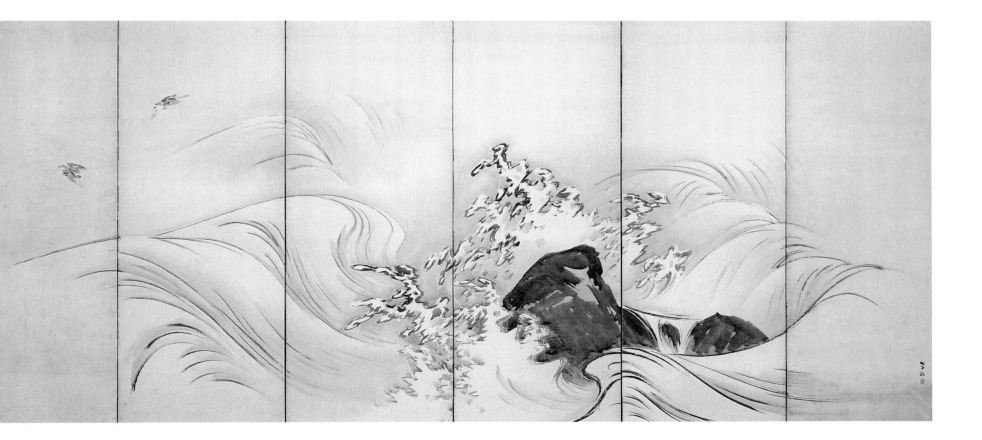

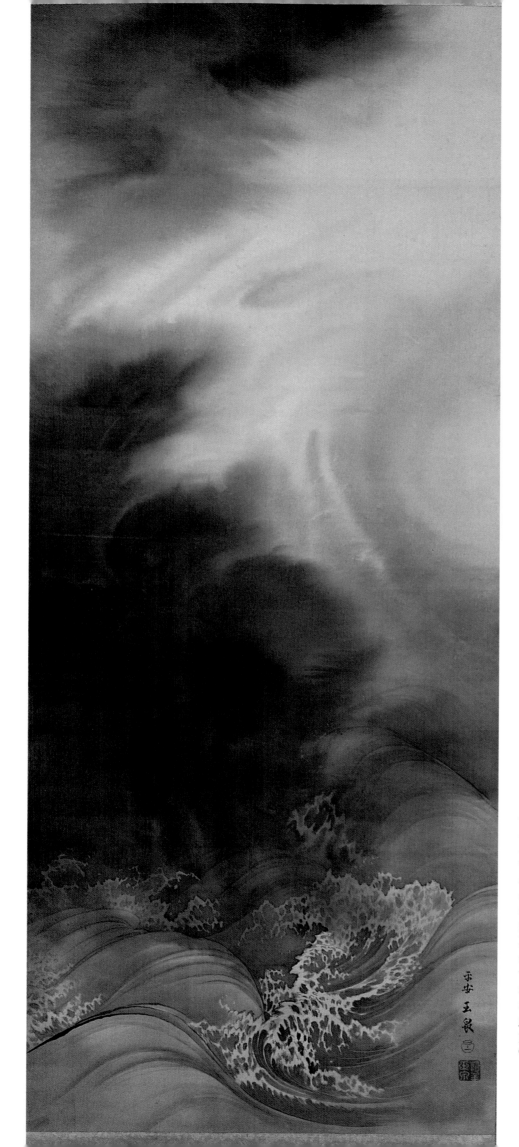

tion that the Japanese had with these new visitors, along with anything else that came from beyond the shores of enclosed Japan. After arriving in Nagasaki, they founded a new sect known as Obaku that so impressed members of both the imperial and shogunal courts that they were invited to build the temple of Mampukuji near Kyoto. The sect gradually spread and at one time there were several hundred Obaku Zen temples throughout the country.

Monks of this sect as well as those practicing Rinzai and Sōto Zen made simple paintings, usually accompanied by a *san*, an aphorism to provide a clue to the meaning of what was pictured. It is important to remember that every Zen painting has a meaning and a message, and was never created just for the purpose of decoration. Almost without exception they are painted in ink on paper in the small hanging scroll format that would be suitable for hanging in the *tokonoma* of a tea room (see page 236, top). Many at first sight look like amateur doodles, but there is always a forcefulness in the brush strokes that cannot be faked and close examination of some of these paintings under a microscope has revealed that the particles of ink in a genuine Zen painting (in other words by an experienced monk), are much denser and more closely clustered than in other works. In calligraphy particularly, the Zen energy is an important part of the creation, and it is said of one master that he would never accept the work of any pupil who did not get drenched with sweat through the spiritual exertion of writing.

Some subjects that Zen painters used are recognizable, such as Daruma, the first Zen patriarch, who introduced the practice to China (see page 239), or figures who have migrated from sanctity to folklore, such as Hotei with his stick and bag (see pages 237–238). But many Zen paintings are completely mystifying, and not only to Westerners but also to most Japanese today, depicting as they do subjects that have no meaning without an understanding of Zen and the vital *san* accompaniment.

The *ensō* is a simple ink circle that was drawn by Zen monks with one brush stroke. Some are thickly rendered, some violently so that the ink splashes on the paper, while others are at first sight more fragile affairs until the meaning is perceived – at which moment their character changes and they can appear as tough as wire. Most are accompanied by a *san* that is usually little more than a hint at the wealth of meaning that should be seen with intuition and practice. So what does this circle mean? There is no simple answer; it could mean "nothing," which is what the mind should be focused on while meditating; or it may mean the Buddha; or it could be the gateway to enlightenment. In other words, the image should lead the viewer to *intuitively* deduce the most appropriate meaning relative to his stage of spiritual development. It is interesting to note that the form has not gone unnoticed by contemporary artists in the postwar period: Yoshihara Jirō painted a large *Red Circle on Black* in acrylic on canvas in 1965; and a

Opposite
Dragon's Cloud

Mochizuki Gyokusen (1834–1913)

Ink on silk, private collection

In both Chinese and Japanese mythology, the dragon is associated with water and power. Even though the beast was a common subject for artists, in this painting Gyokusen has chosen instead to show the powerful energy of swirling cloud and waves with just the barest hint of gold scales and something writhing in the middle. By leaving the dragon barely on the edge of perception, the sense of sheer nascent animation is emphasized even more in the almost Turner-like atmosphere.

Above
Boating Party

Tanaka Nikka (?–1845)

Pair of six-panel screens, ink and slight color on paper, each 170 cm x 370 cm, private collection

Nikka studied under the direction of Toyohiko, one of the "Ten Great Pupils of Okyo," and his work tends to differ from the usual Shijō school of painting. These screens were inspired by the classical Chinese prose poems by Su Tung-p'o in which he describes visits to Red Cliff – a subject often used by Japanese painters. Here they are seen in an unusual composition that emphasizes the magnitude of the great cliffs.

曾我次郎曉〇雄画

Tiger and Karashishi Lion

Soga Shōhaku (1730–1781)

Pair of two-panel screens, ink on paper, each 154.3 cm x 156.6 cm, Collection of the Chiba City Museum of Art, Japan

The late 18th century saw the appearance of some highly eccentric painters in Kyoto, who provided a refreshing change to the refined, but rather stuffy artistic milieu of the imperial capital. Soga Shōhaku was considered to be one of the most eccentric. He did, however, have complete control of his brush and produced paintings that are refreshingly expressive.

couple of years later Yagi Kazuo made a doughnut-shaped form out of ceramic called *Circle*, which is now in the Museum of Modern Art in Tokyo. In this decade, Yanagi Yukinori uses the shape in his neon-light installations. It seems that the *ensō* of the Edo period exercises a continuing fascination over the Japanese mind.

The most important, and certainly the most celebrated of the Edo Zen artists, was Hakuin Ekaku (1685–1768), who in a modest way revived the vitality of Zen, which to some extent had slid in appeal after the end of the Muromachi period. He revived Zen temples and traditional teachings and practices, bringing the teaching of the sect not only to monks and the intelligentsia, but also to the peasant farmers and ordinary folk who flocked to listen to him. In the course of his life he made large numbers of simple Zen paintings, which he gave away if he thought that someone could gain benefit from them. Many of them are lighthearted and humorous on first sight, but a closer scrutiny always reveals some deeper message that is serious. In a way they have the role of parables, and by cloaking a profound truth in a subject which is earthy and recognizable, the message could be more easily dispersed to common folk.

Many followers continued making Zen paint-
ings, and it is curious to note that most of them
produced their best work late in life, after decades
of experience and meditation. Zen paintings are
still made even today for religious purposes by
monks in temples all over the country, but the last
major figure was Nantembō Tōjū (1839–1925),
who saw Japan through the turmoil of its change
from an enclosed feudalism to a modern industrial
state. He was named after a stick (bō) that he cut
from a nandina tree and used to discipline monks
who dozed off during meditation practice – and
also employed as the subject for paintings executed

in a single violent stroke of ink. Nantembō came to
realize that there were three methods of teaching:
by silent meditation, by studying the written words
of past masters, and by paintings (see page 241,
right). He saw that for the average person with a
mind clogged with trivia, paintings were perhaps
the most effective conveyers of the truth.

Art after the Meiji restoration

The year 1868 marked the beginning of a process of
radical change in Japan, and on a scale the like of
which had not been seen since the wholesale

import of mainland culture and religion during the 6th century A.D. There were two decisive factors: the first was the fall of the Tokugawa shogunate and its replacement with the Meiji Emperor; the second was the opening up of the country to foreigners. In a race to catch up with the technological superiority of Western countries, large numbers of foreign experts in all areas were invited to Japan to reform and teach, and for the first time in centuries a few Japanese journeyed to Europe and America to study the scientific wonders first-hand. Centers of higher learning were established by the government and teachers such as Ernest Fenollosa (1853–1908) from America, and the engraver Edoardo Chiossone (1832–1898) from Italy, were invited to train Japanese students in Western theory and techniques. The result was an intellectual revolution polarized by the avant-garde protagonists of everything Western on one hand, and die-hard traditionalists on the other. The resulting froth provided a rich nutrient for the growth of a lively art scene and the evolution of two new modes of painting: *nihonga* and *yōga*.

The literal meaning of *nihonga* is "Japanese painting," but in the late-19th century it came to refer to a new type of painting that used Japanese colors and materials to paint Japanese subjects. The *nihonga* painters were liberated from all of the restrictions of established traditional schools, Kanō, Rimpa, Nanga, and so on, and borrowed new ideas freely from the Western paintings to which they now had access. Even the last noted Kanō painter Kanō Hōgai (1828–1888), while continuing to paint hanging scrolls in traditional ink on paper, used compositions which seem more evocative of 19th-century German Romanticism than those of the classic Chinese-style for which the school was famed.

Many still painted traditional-style screens and scrolls, but there was also a move to the idea of the Western frame in a rectangular format. At its best, *nihonga* painting includes some of the most wonderful works in the whole of Japan's art history, and it should be remembered that the country had not yet been ruined, and still abounded with delightful images that served as a rich source of inspiration. The better *nihonga* artists such as Yokoyama Taikan (1868–1958) and Kawai Gyokudō (1873–1957) have left a large corpus of beautifully lyrical pictures of Japan that reveal not only its heart-aching beauty but also the haunting quality of a fragile soul that has now nearly perished with the advent of television. At its worst (and usually seen more in the work of recent artists), the images can become hackneyed and boring; carp rising to the pond surface, blushing geisha, and yet again Mount Fuji in carmine red – images that hang on the walls of executive offices in the concrete cities as a sad warning of what can happen when art loses its direction and becomes repetitious.

The other painting style that appeared after the Meiji restoration was known as *yōga*, which means "Western painting," by which it was inspired. *Yōga* painters used oils and canvas, and the largely rectangular format of works that they had seen from Western countries, but used them to portray subjects both Eastern and Western. Even though many *yōga* artists would not have known the terms, it was the works of the Post-Impressionists – Cézanne, Gauguin, and Van Gogh, and particularly the Fauve artists, such as Matisse – that had a profound effect on their ideas. The Japanese artists showed no lack of perception or sensitivity to the Western treatment of color and atmosphere (remember the *haboku* landscapes from four centuries before) and they quickly mastered the medium.

Kishida Ryūsei (1891–1929) was active with various avant-garde art groups in Tokyo and, experimenting in various directions during his

Hotei

Fūgai Ekun (1568–1654)

Ink on paper, 24.4 cm x 57.4 cm,
Collection of J. E. V. M. Kingadō, USA

Ekun was one of the great masters of Zen painting, his expressive works showing a masterly control over brush and ink. He was particularly adept at using diluted ink to make gray volume, then adding details like punctuation, with delicate touches in jet black. Hotei was one of the great sages of Zen lore. An eccentric, he roamed the land carrying a stick and bag. With children, his image is like that of Santa Claus in the West, but his rather buffoonish and unkempt appearance hid a man who had a profound understanding of Zen.

Above
Daruma
Daishin Gitō (1656–1730)

Ink on paper, 53 cm x 30.5 cm,
Collection of J. E. V. M. Kingadō, USA

Daishin Gitō was a Zen monk at the Daitoku-ji temple in Kyoto and became the abbot in 1706. His paintings on Zen subjects such as Daruma (the first Zen patriarch) are simple but beautifully painted.

short life, he painted Japanese scenes in a manner very similar to that of André Derain in France. Nakagawa Kazumasa (1893–1991), while largely a self-taught artist, was associated with Kishida from time-to-time and painted landscapes that, especially in their treatment of light, appear to share much with those works of the Fauvist Henri Manguin (1874–1949) from when he lived in the south of France. Others continued in the same vein to produce the kind of pictures that one would like to take home and hang on the wall. But they are after all "in the style of…" and apart from the subject depicted, there is little to impress those who are used to the real thing.

Apart from about two decades between the 1930s and 1950s, when Japan's political environment hardly provided a fertile soil for artistic growth, painting has flourished in the 20th century, with art schools being established and amateur groups thriving throughout the country. Since 1945 (or rather since the end of the occupation in the early 1950s), lively avant-garde artists and groups have been active in the exploration of all areas of expression, with one or two interesting, if sometimes bizarre, results. The educational system, however, has its faults, and while maintaining excellent standards in the teaching of basic

techniques (such as good draftsmanship and the principles of color and composition), the Japanese reverence for authority has unfortunately not been helpful. Artists have to sell in order to eat (although these days many earn a living in the advertising and graphic-design world), and the climb up the ladder of exhibitions and public recognition can only come by working under the safety-umbrella of an established artist-mentor. Just as the Kanō school gradually stifled under the doctrinaire teaching of past masters, where there was an established "right" way to paint a bamboo, a rock, a pine tree, so many of today's artists have been stifled by the system. Some artists have fled to the more congenial artistic climate of New York or London, where they can take their chances on survival, but at least they can paint freely without some teacher "correcting" their work.

A visitor to any of Japan's main cities can see endless painting exhibitions at department stores and galleries, in addition to major shows of works from overseas. There is certainly no lack of reference material or inspiration, but in contemporary Japanese art there does seem to be a certain poverty of ideas, and with such a splendid historical heritage for artists to draw upon one wonders what has gone wrong. One (foreign) art critic who recently

left after spending several years in Japan, commented that there were no serious critics; an astute observation that is quite correct. Almost all writers for the press will either write something favorable or nothing at all, with the result that painters can churn out the most appalling kitsch and yet still, so long as they cultivate the right people, need fear nothing as daunting as the intellectual honesty that would be par for the course in the art milieu of any other country.

There are two other points that perhaps have a bearing on the present state of affairs. The first is economic: as a result of the most admirable qualities, hard work and discipline, Japan has very quickly risen to become the second most powerful economy in the world. With this new wealth, art has been treated as a commodity on which to speculate – with catastrophic results, as events in the 1990s have shown. The second is that Japan is still culturally confused as a result of two historic events with which the fragile culture of Japan has been unable to cope: the opening of the country with the Meiji restoration, and the trauma of being vanquished in World War II. Most artists of Japan get their stimuli from television and magazines, and when looking at their efforts in the Ginza galleries one always seems to have a feeling of *déjà vu*: a hint of Stella here, a whiff of Picasso over there... one looks in vain for something truly Japanese. Yamaguchi Takeo (born 1928) comes close with his simple powerful forms that are evocative of the strong graphics on Momoyama military banners, as does the previously mentioned Yoshihara Jirō and his *ensō* circles, and Shiraga Kazuo (born 1924) and his "action painting" that is reminiscent of violent, earlier Zen brush work.

Perhaps this process of adjustment is still continuing. As the Japanese have a national trait of watching, absorbing, and "Japanese-ifying" any ideas from abroad, one of the reasons why the present painting scene is so impoverished is because there is not that much overseas that lends itself to being imitated. This would appear to be rather a strange phenomenon as in other artistic areas – fashion, architecture, advertising design – some exciting and innovative work is being produced and is attracting international attention. But it is a mistake to underestimate the Japanese ability to amaze, and perhaps the confusion of the present will prove to be a fertile soil for the appearance yet again of some exciting painting in the future.

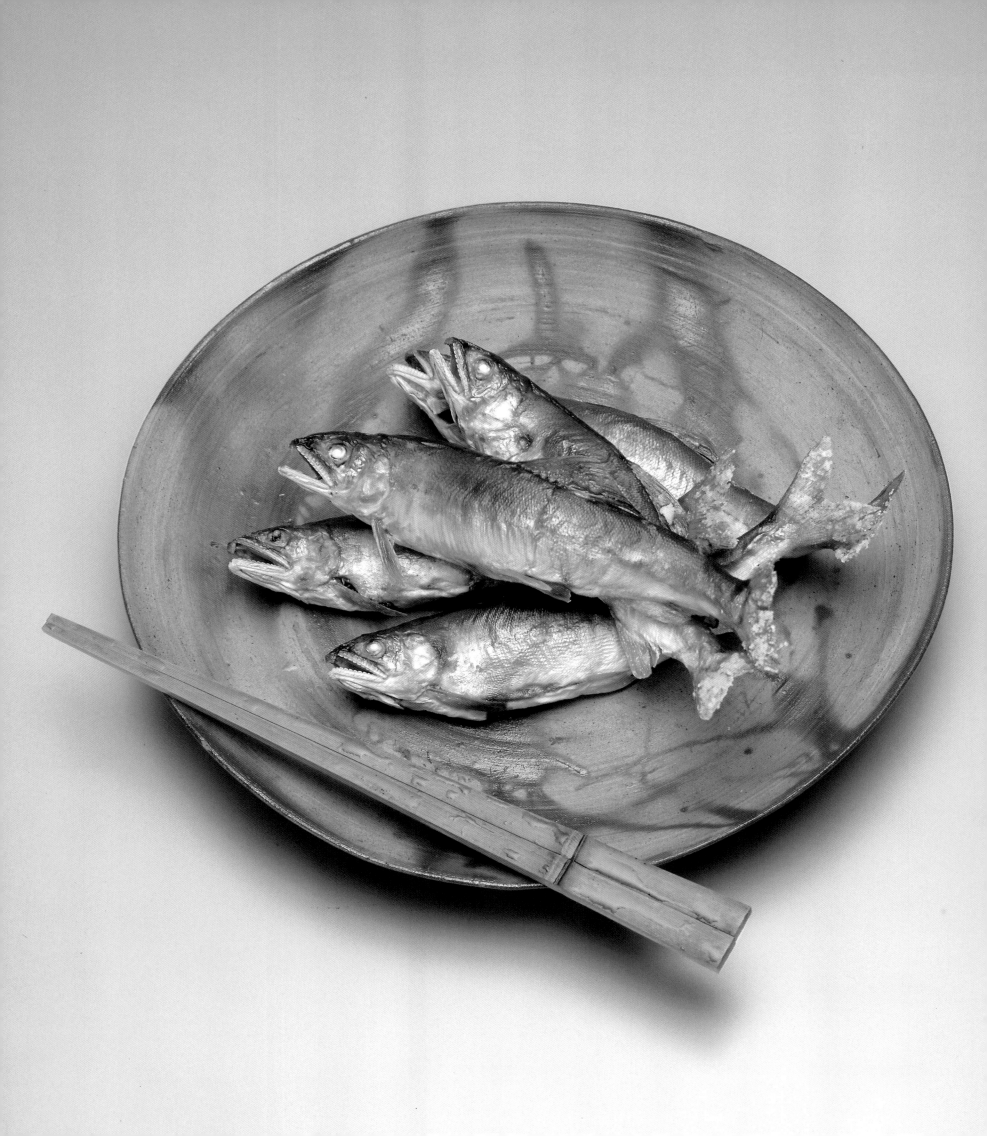

Japanese Ceramics

One of the surprises waiting in store for a Western visitor sitting down for the first time to a traditional Japanese meal is that all of the dishes on which the food is served are different. Everything blends but nothing matches; and that is the whole point. The variety of wares is meant to complement the food, to make it look not only interesting but also more appetizing. In Western countries the serried sets of crystal, china, and silver may certainly be elegant, but their appeal seems rather limited when compared to that of the more artistic presentation in Japan. Every serious cook in Japan has the sure intuitive skill of being able to select just the right piece with that certain glaze, texture, or pattern that will make the food appear as attractive and delicious as possible: a plate of Bizen ware with red fire-marks to show off two or three ayu fish (a summer delicacy) grilled with salt (see opposite); or perhaps a white slip-brushed Hakeme bowl to provide a neutral background to some pickles of bright yellow radish and green cucumber. After all, what looks good should taste good, and the better restaurants and private residences take pride in their collections of tableware, which will have been carefully chosen to present food as works of art, as "feasts for the eyes," that are — and this is most important in Japan — totally in keeping with the subtle moods of the passing seasons.

Bizen hidasuki dish

*Momoyama period, late-16th century,
diameter 25 cm, Hatakeyama Collection,
Tokyo*

These distinctive markings on Bizen wares
were caused by wrapping rice straw around
the clay body before firing, and by careful
placement in the kiln, where it would have
been protected from the fallout of ash.
Here the dish is seen as it should be used,
for the presentation of food, in this case
five ayu river fish that have been grilled
with salt.

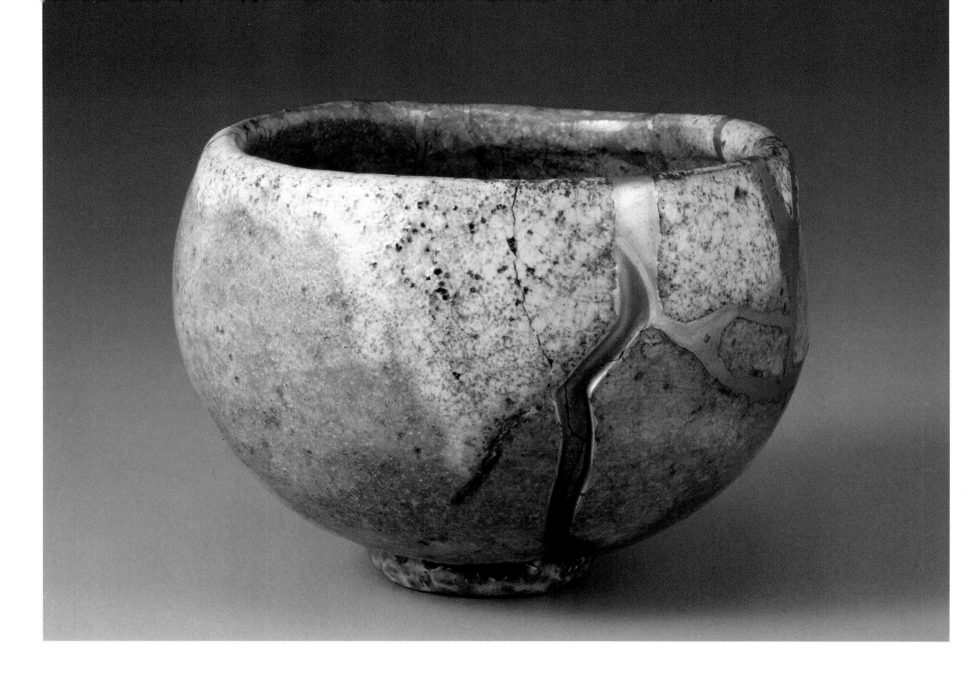

The Living Tradition

Raku ware red tea bowl known as "Seppō"

Hon'ami Kōetsu (1558–1637)

Momoyama period, beginning of the 17th century, H 9.5 cm, dia of mouth 11–11.5 cm, Hatakeyama Collection, Tokyo

Kōetsu was one of the great artists of the early-17th century, excelling at calligraphy, the practice of tea, landscape gardening, poetry, lacquer design, and pottery. This famous tea bowl was once broken and repaired with gold lacquer. Because of its illustrious pedigree and the image conjured by the light glaze against the red, it was given the name "Seppō," "Snowy Peak."

Of course in Japan food is presented on a variety of other materials as well; glass is sometimes used to suggest a cool feeling during Japan's tropical summer months, sushi is traditionally presented on plain wood or aspidistra leaves, and soup is almost always served in a lacquer bowl. Most widely used, however, are ceramic wares that are produced in a tremendous variety at pottery centers, many of ancient lineage, that can be found throughout the main island of Honshu and the western island of Kyushu (see the map on the opposite page). Until the recent infestation of convenience foods and the blight of plastic, all Japanese were familiar with the pottery utensils they used every day, and for which they had an inherited "feel." Ceramic works, however important and valuable they may be these days as objects of art, are basically utilitarian, and like so many good things are made to be handled and used in order for their beauty to be revealed. For the connoisseur of pottery, the overall appearance is naturally very important, but in judging a piece he or she will also appreciate the weight, shape, surface texture, and feeling to the touch; and, on another level, will sense the "spirit" of the potter who has been able to work the magical metamorphosis of turning a lump of clay into an object of beauty. To some extent it is a tragic fact that many pieces are now so valuable that they are kept in museums, and for obvious reasons cannot be handled except by specialists. One feels that there, imprisoned in a glass showcase and under the glare of electric light, they gradually die. This is especially true of tea ceremony items where, however beautiful they are to look at, one itches, even at the risk of damaging them, to release them; to use them again, to bring them back to life.

Fortunately, most ceramic wares are found in more prosaic surroundings, and even in these bleak days when most things are factory produced, they are still being crafted, used, and appreciated. Because almost all native Japanese still enjoy using such handmade pieces, the production even today is enormous: it is estimated that there are about

32,000 potters in Japan who make their living from this single activity. And this figure does not include the large numbers who work for commercial corporations, some of them world famous, that make mass-produced tableware in the Western style for both domestic and export markets. In addition to tablewares, there is an enormous repertoire of other ceramic items ranging from large storage jars, containers for plants and flower arrangements, to more mundane but essential items such as roof-tiles, bathroom furniture, and drainpipes. In recent years, technological innovations have led to the appearance of even more unusual ceramic products such as kitchen knives that miraculously never seem to need sharpening, and even specialized parts for car engines.

Whereas much Japanese culture has been heavily influenced by, or even copied from, that of the mainland, ceramics have largely developed independently in a way unique to Japan – especially those that have been made for the use of ordinary people outside the aristocratic circles. Occasionally, there have been times when the strong influence of China or Korea can be seen in Japanese ceramics, particularly those used by nobles or clerics; but it has not taken long before a certain "Japanese-ification" can be recognized that most surely distinguishes them from wares seen on the nearby continent.

Japanese ceramics can be divided into two main types: finely made porcelains inspired by imported wares from China; and simple, native stoneware pots with natural ash glazes. Surprisingly, the two complement and enhance each other, especially when carefully selected for the presentation of food. With everyday pottery there is above all, an artless beauty, born of the honest use of clay and natural glazes; shapes that are practical and quietly pleasing, and colors that harmonize with those of nature. Imperfections of shape or glaze are seen as adding interest, and even broken pieces that would be discarded in most other countries are often repaired with lacquer mixed with gold dust (see opposite). Visitors from the West may at first be shocked by the asymmetry and uneven glazes of Japanese pottery, as these challenge their inherited aesthetic rules; but it should not take long before their eyes will open to a beauty that above all reveals its humanity. It is a beauty that needs no philosophy or intellect for explanation; a beauty that speaks for itself silently but directly.

Young potters usually learn their skills the old-fashioned way, by apprenticeship to an established craftsman, and in Japan this involves repetitious doing and imitating rather than instruction by the master. At first, the duties would be hard, difficult, and basic: gathering wood, stoking the kiln, and kneading the clay to remove air bubbles, and these mundane chores would have to be carried out perfectly before the novice would be allowed to make his first pot. Even then, years may be spent making endless repetitions of the same object – a small rice bowl or a saké cup for example – so that the action of making the object becomes unthinking: artless and automatic. Only when this stage has been reached, when the potter can mold clay to his will, can he be considered mature enough to experiment with designs of his own inspiration. Amateurs sometimes try the shortcut of learning basic pottery in arts-and-crafts courses in the cities, but these rarely lead to any serious commitment, and almost all wares of any merit are made in country potteries. It should be added that so as to be near convenient supplies of clay and wood, pottery centers tend to be located in Japan's more scenic areas, and many of the craftsmen who work there have inherited their trade in families that may have been making ceramic wares in the

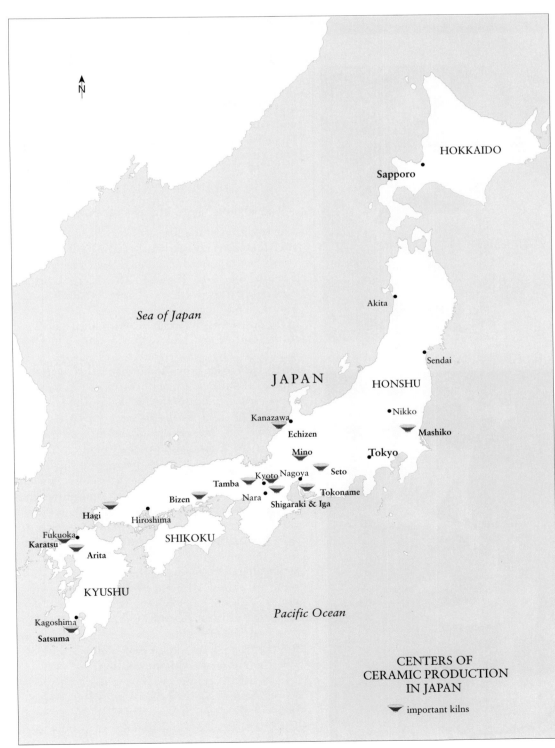

CENTERS OF
CERAMIC PRODUCTION
IN JAPAN

▼ important kilns

same place for hundreds of years. It would seem that a close affinity with pottery runs in their bloodlines, and that their lives, though far from easy, must be enviably satisfying.

Nowadays, those potters who show special talent will reach the stage of holding exhibitions, and so, with sponsorship and increased fame, they will be able to raise their prices. The top artisans often achieve a hallowed status and become famous not only in Japan but also in those foreign countries where there are aficionados of contemporary crafts. New exhibitions of their latest efforts are eagerly awaited by devoted collectors, and of course their works can become quite expensive. At any one time there are numerous exhibitions of ceramics in craft galleries and department stores throughout Japan, so there is always plenty to see, and as in the world of painting and other arts, buyers are always looking for new, interesting potters whose works have yet to be "discovered." In addition, there is a wealth of books and magazines devoted to ceramic arts, both ancient and modern, and compared to the sad state of many traditional crafts that are gradually dying off, the world of Japanese pottery is flourishing with a vigor that will certainly ensure its future.

Early Japanese Pottery

The Jōmon, Yayoi, and Tumulus periods

The tradition of making ceramics in Japan is very ancient, and may perhaps be the oldest in the world: pottery shards excavated from a cave in the western island of Kyushu have been dated by Carbon-14 tests to what is known as the Incipient Jōmon period, over 12,000 years ago. The origins of the ten-millennia long Jōmon culture date back to the end of the Ice Age, at a time when the islands of Japan were connected to Siberia in the north, and Korea in the southwest. A warming climate and the receding of the ice led to a rise in the sea level, and caused what is now the Japanese archipelago to gradually become separated from the mainland. The people inhabiting these islands lived in small nomadic groups or tribes, and, to judge by the stone weapons, bones, and shells they left behind, they lived like their neolithic cousins in the rest of the world, by fishing, hunting, and gathering edible plants. Remains of villages indicate that these groups were settled from time to time, but as there are no written records there is little known about their social organization. Archaeological remains of the Jōmon culture are found in almost all areas of Japan and reveal a pottery culture of low-fired earthenware that shows not only an extraordinarily fertile imagination and creativity, but also an artistic evolution that seems to have progressed along a separate path from those of mainland cultures.

Evidence of ceramic production in the Incipient Jōmon period consists of excavated fragments, from which it can be guessed that the original pieces were small pots for cooking, or storing food or water. They had round or pointed bases (a prac-

tical shape for standing in earth or sand; see page 249) and were made by hand-molding slabs of clay or by rolling it into a "rope" for coiling into the shape of a vessel, a technique that is still used today. This was then smoothed out by the potter, using either his wet hands or a flat piece of wood to paddle the surface, before the vessel was fired in an open bonfire.

Throughout the 10,000 years of the Jōmon period, almost all pots were decorated, usually by impressing the soft clay to make a textured surface. The name Jōmon in fact means "cord pattern," the term being coined because so many of this culture's pots were embellished with a tweed-like surface achieved by rolling a rope or cord onto the clay. Other decorative effects were made by applying a flat braid twisted into a spiral or a cord wrapped around a stick; by rolling a short, squarish piece of wood in the clay to give the effect of a straw mat; or by impressing with shells, fingernails, or the ends of split bamboo. Considerable variation is seen in shapes and designs depending on geographical location, and it should be remembered that although there was human presence all over the country, regional hostilities and primitive communication routes caused areas to be isolated long enough for regional pottery types to evolve.

Innovations appeared slowly during those long eons, as sheer survival must have had priority over anything else. However, by the Middle Jōmon a further warming of the climate led to a subculture emerging in the mountains of the central area of the island of Honshu (around present-day Tokyo) that has become known for its splendid large and richly decorated pots (see opposite). As can be expected, some degree of settlement provided suitable conditions for the germination of this creativity, and remains of villages of pit-dwellings have been found widely throughout the area. Not only are some of these pots too large to be easily portable, but in many cases the decoration is so elaborate and top-heavy that they would have been impractical for everyday use. There is evidence that some sort of spiritual beliefs had appeared at this time and it can be presumed that many of these ornate vessels were made for ritual purposes, or perhaps even purely to demonstrate artistic virtuosity.

The decoration of these Middle Jōmon pots extends beyond the characteristic impressed marks seen on the earlier pieces, and includes elaborate sculptural flourishes that reveal an advanced artistic sense and imagination. A wide variety of pot shapes appear that could have been used as lamps, charcoal holders, or drinking cups, as well as the everyday utilitarian vessels used in cooking. The sculptural decoration was achieved by modeling the clay into forms that were then used to construct the pot. Many of these are abstract (or possibly symbolic), but some are recognizable as animals, reptiles, birds, insects, or human faces – all imaginative but bizarrely unrealistic. There is no doubt that the Middle Jōmon potter loved to play with clay, and the results of his fertile imagination are often spectacular.

Opposite, top
Working the clay for Hagi pottery

Japanese potters still always use the *nejimomi* technique, in which the clay is worked 50 to 100 times in a spiral, so that air bubbles are removed and the material becomes as smooth as possible.

Opposite, middle
Shaping a Hagi tea bowl

Here the surplus clay is being scraped off with a blade.

Opposite, bottom
Potter's wheel

This form of wheel, which is operated by foot, was introduced into Japan by Korean immigrants. In direct contrast to the conventional Japanese potter's wheels, it moves in an anticlockwise direction.

Right
Decorating blue and white pottery

The large brush with which the decoration is applied is known as *dami fude*. *Fude* means simply "paintbrush," while *dami* refers to painting with a color, which here is a blue made from cobalt oxide.

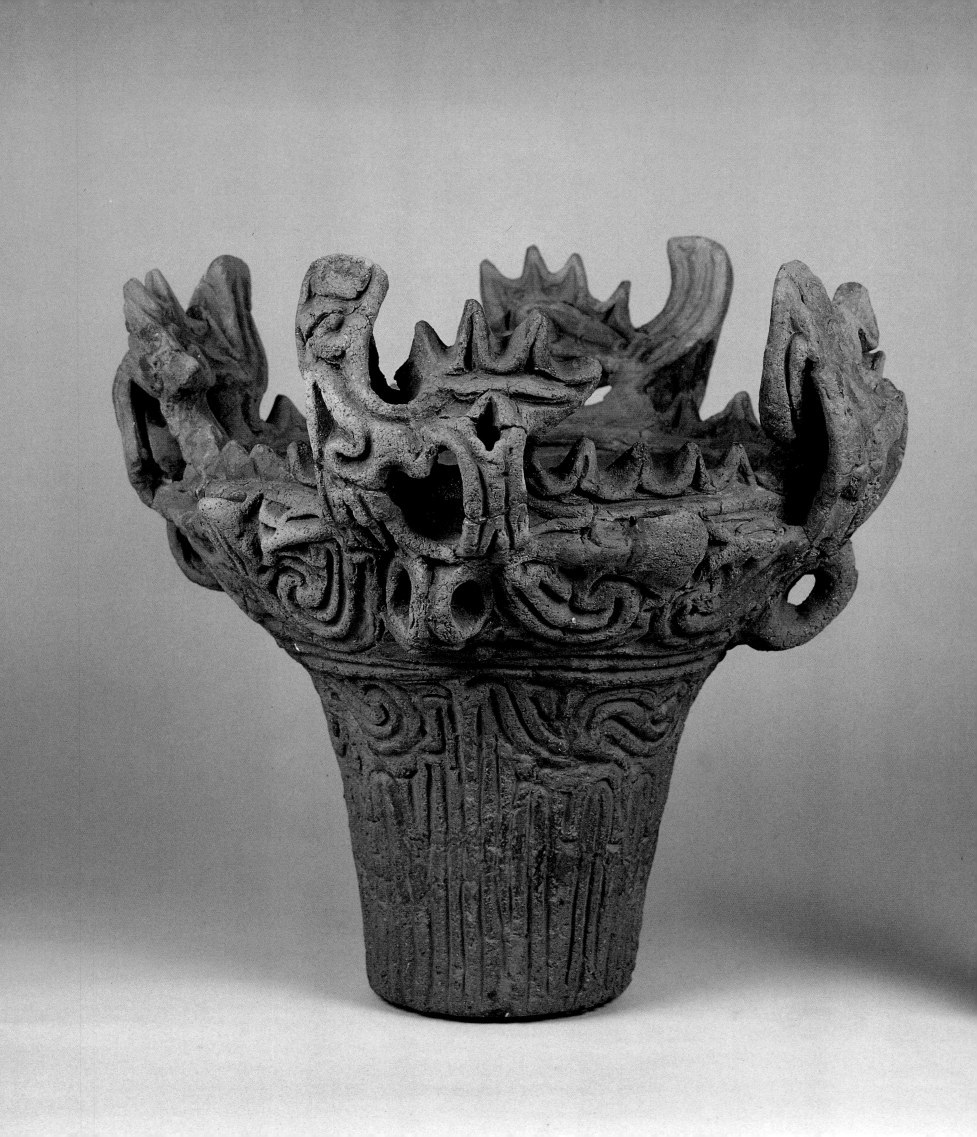

About 1500 B.C., in an echo of the earlier Ice Age, the climate cooled again, leading to a migration from the mountains; more and more of the people of the Late Jōmon period chose to live in the warmer lowlands along the Pacific coast. Bountiful food from the sea formed the basis of their diet, as can be seen from the large mounds of shells that remain, and there is also evidence of early rice growing and agriculture towards the end of the period. They were able to travel around on foot or by boat more readily than their ancestors had been able to in the thickly forested mountains, and as pots of the Late Jōmon show fewer regional differences than those of earlier times, it would appear that a nationwide culture was gradually beginning to emerge.

Late Jōmon pots tend to be less exuberantly "baroque" than those of the earlier period, and show a variety of new forms such as spouted "teapots," bowls on pedestals, probably used in ritual, and some very elegant vessels with wavy rims. Clay reproductions of objects from nature (such as shells) are also found that date from this period. The clay tends to be finer than that used earlier, and the Late Jōmon pots are often molded with thinner walls, and have the surface smoothed and polished on the outside. Some examples are found that have been lacquered (perhaps to make them waterproof, as all Jōmon pots were fired at a low temperature and are therefore porous), or painted with mineral pigments such as iron oxide.

While there is still some adornment in the Middle Jōmon style to be seen, most of the Late Jōmon pots show a surface decoration made by impressed cord-marks or carving, though now with the added refinement of the textured surface being restricted to defined areas, as part of the overall design. This was achieved by first drawing a pattern on the pot, impressing with cords or other materials to make a textured surface, then rubbing and smoothing out this texture except for that within the lines of the original pattern.

The following Yayoi period (300 B.C.–A.D. 300) was an era during which many social and technological changes appeared. In part this came about through the influence of Chinese and Korean culture, with which there were increasingly more and more contacts, and which spread gradually from the island of Kyushu throughout the rest of the country. Two factors of wide-reaching significance that came about at this time were the development of metal working, which was quickly learned by Japanese craftsmen after seeing iron and bronze objects that had been imported from the mainland; and the development of techniques of irrigating paddy fields that made successful rice growing more predictable.

The Yayoi ceramic wares were of low-fired earthenware, still made by the old method of coiling clay ropes, but often finished on a wheel, and they tend to be more thinly potted than earlier, Jōmon pieces. Apart from pots made for use with food, some with pedestals were probably used in rituals, and much larger ones were used as coffins or as cinerary urns for storing the bones of the dead. They were still baked at a comparatively low temperature in an open fire, although this was done with more skill and care than in earlier times. However, the most noticeable features of Yayoi wares are their elegant, simple forms, and their more tasteful decoration; some even have no decoration, which makes them noticeably different from the flamboyant products of the earlier Jōmon. Some pots are painted with ochre pigments or red cinnabar; but on many the most attractive toning, and one that has a strikingly modern look, is a burn-mark of black on the reddish clay caused by the cooking fire.

The Tumulus (Kofun) period (A.D. 300–710) is named after the huge burial mounds that were made for the tombs of members of ruling families. These were built round or in a "keyhole" shape, and the largest were meant for the imperial family, which had gained control over the economy and the military, and could afford the enormous resources that were needed for such grandiose projects. Within the tumuli were tombs built of stone and filled with treasures to accompany the departed into the life beyond. Many of these burial objects — which include gold crowns, jewels, weapons, and the accoutrements of horse riding —

Pointed earthenware pot

Early Jōmon period, H 42 cm, Keio University, Tokyo

This pot was excavated in Aomori Prefecture in the north of the main island of Japan, and has a pointed base which would have been practical for standing in soft sand or mud. Even in such ancient times, the decorative possibilities of impressing the wet clay were already being explored.

Opposite
Pot with elaborate decoration

Middle Jōmon period (about 2500–1500 B.C.), H 32 cm, Collection of the Nagaoka Municipal Natural Science Museum, Japan

This remarkable pot is a fine example of the expressive sculptural embellishment seen on pots dating from the Middle Jōmon period. Clearly such a vessel would be extremely impractical for everyday use, and so it is presumed that they had some function in ritual.

are similar if not identical to those found in nearby Korea, showing that there were very close contacts between the two countries at that time, and quite possibly even military occupation of Japan.

A rather simple earthenware pottery made for everyday use, called Haji, appeared during the Tumulus period, and resembled some of the earlier Yayoi wares. While not so impressive from an artistic point of view, Haji wares were able to withstand the heat of the fire without cracking and were made in more or less the same fashion for several hundred years until the 12th or even 13th centuries, when metal cooking vessels came into use. However, the era is noted more than anything else for the wonderful *haniwa*, the terracotta images of human figures, animals, houses, and objects that were originally half-buried over the surface of the burial mounds, the first two of these (it is thought) supplanting what originally had been sacrificial victims. Along with other ceramic images from the earlier Jōmon and Yayoi period, the *haniwa* are best looked at in the context of sculpture and are therefore to be discussed in another chapter.

Sueki and Heian glazed pottery, and Sanage wares

Around the 5th century A.D., the whole culture of Japan changed dramatically through wholesale imports from the mainland that included Buddhism, the written language, architecture, city layout, central government, and bureaucracy. Along with these, a new type of ceramic ware called Sueki (Sué) ware appeared (see page 251), which initially was indistinguishable from the Silla stonewares of Korea. It was undoubtedly first made by immigrant Korean potters: the chronicle *Nihon-Shoki* (*History of Japan*) mentions that potters were invited to Japan along with other technical experts around A.D. 463 from the Korean kingdom of Paekche. Sueki differs from all of the earlier earthenwares in having been highly fired at over 1,100 degrees centigrade (2,000 degrees fahrenheit), at which temperature the clay particles melt together and form a stoneware that was, for the first time, waterproof.

The production of stoneware was achieved by using a new firing technology brought from Korea and using a tunnel-like kiln, up to 10 meters (30 feet) in length, that was built on the slope of a hill. These new kilns, called *anagama*, were able to generate a far higher temperature than that created by an open fire due to the powerful updraft; moreover, the firing atmosphere could be controlled to some extent by blocking or opening apertures into the kiln. This type of kiln spread throughout Japan and in a more or less similar form is still being used by many potters today because of the special effects that it can generate. By intuition and experience, observing the color of the fire, and even listening to the sound made by a kiln when it is being fired, the potter can learn to exact the best results. However, whereas the temperature and atmosphere of modern electric and oil-fired kilns can be controlled with some degree of accuracy, the *anagama* kiln has a passion of its own which may be favorable or disastrous – but never quite predictable.

Then and now, the firing of an *anagama* kiln is a ritual that usually takes some days. Firstly, the pots are stacked inside the kiln and then a fire of soft-woods (pine by choice) is lit in the bottom chamber. This has to be monitored carefully as the first fire should ideally dry the kiln, and too rapid a rise in temperature can cause the pots to crack. The fire is stoked throughout the firing until the temperature rises over 1,100 degrees centigrade (2,000 degrees fahrenheit), at which level the particles in the clay melt and fuse to form a hard, nonporous stoneware. When the critical point has been reached, the firing is stopped and the kiln allowed to cool for two or three days until it is possible to enter and unload the pots.

During the firing, ash and burning debris will surge on the updraft throughout the kiln – landing on some of the pots – and at the optimum temperature will melt to make a natural ash glaze which can quite often be very attractive. In later centuries, potters learned how to help things along by placing bits of wood or ash on the pots before firing. Accidents happen. If the clay has not been kneaded carefully, a bubble of air can cause an explosion which at best can leave interesting bits stuck to the other pots, and at worst can cause such havoc that many of the pots have to be discarded. Being acutely aware of this capricious nature, all potters have respect for the kiln and through experience learn how to minimize the more unfortunate disasters. The opening of the kiln after firing is always a moment awaited with both anticipation and trepidation; with good fortune, the crucible of fire and earth will have worked its magic, and the long hours of effort will be rewarded with some fine pots.

Sueki pots were finely made by the traditional coiled-rope method and finished on a potter's wheel. They are thin-walled and of a characteristic gray that was a result of loading more fuel in the kiln at the end of the firing to produce a dense smoke which penetrated the clay. They are unglazed except for the spots and dribbles caused by wood-ash that has landed by chance and melted during the firing. Rather more advanced skills than those needed to make earthenware were necessary to make Sueki, and it is certain that there were guilds of professional craftsmen who had learned the tricks of the trade, such as finding the right kind of clay that could be thinly-potted without collapsing, and controlling the heat of the kiln so that the contents would not crack.

The earliest Sueki wares of the 5th and 6th centuries were used for religious or ceremonial purposes much the same as the almost identical Silla wares of Korea, after which they were modeled. The name of the ware probably derives from *sueru*, the Japanese verb meaning "to offer," which implies ritual use. Many examples have been excavated from burial mounds and are found in the forms of smooth, covered dishes, some with

Sueki ware pot

Tempyō period, 8th century, H 20 cm, Collection of the Freer Gallery of Art, USA

Sueki wares were made in Japan after Japanese potters had learned new techniques from the Koreans, such as the use of the potter's wheel, and the construction of kilns that were capable of reaching a high temperature suitable for firing hard stoneware. The green droplets of glaze on the shoulder of this pot were caused by particles of wood-ash melting in the high temperature.

pedestals, cups with handles, flasks, bottles, and large-necked pots (see page 251). Some of the more exotic shapes include pots on three legs, which are reminiscent of Chinese bronze cooking vessels; clusters of several pots or dishes on one pedestal (see page 252); and molded animal or human figures. Decoration is limited mainly to simple but elegant combed or scratched markings, and also holes, cut in the pedestals in a variety of shapes, that would also have served to lessen the risk of cracking while being fired in the kiln (see page 253).

From the end of the 7th century, Sueki wares tended to be made for everyday, rather than ceremonial use. Being waterproof, they were particularly useful for storing and serving food, while the previously mentioned Haji earthenware continued to be used for cooking. The later pots tend to be mass-produced, of less elaborate form, and with little or no decoration. The production of Sueki wares was widespread throughout the country, and there were several large pottery-making centers, particularly in north Kyushu, the Inland Sea area, and near present-day Osaka. Except in a few remote

rural areas (such as the Noto Peninsular, where a gray stoneware variant known as Suzu continued to be made through the mediaeval period), the output of Sueki kilns dropped rapidly by the 10th century as new types of stonewares appeared.

During the 8th century, in the area around the ancient capital of Nara, the first Japanese pottery with applied glazes was made, in imitation of the polychrome wares of T'ang dynasty China. Known as *saiyuki*, these pots were made of a grayish earthenware that was first fired to harden the clay, and then refired after the application of one or more glazes made of metallic oxides. Three colors could be made: green, a transparent gold-brown, and a light yellow, which were applied either singly or in combination. Those pots with three colors are known as Sansai wares. The firing was accomplished in a simple kiln designed with a base area for the fire, and a round, short chimney on top which would generate an updraft of flame capable of raising the temperature to about 800–900 degrees centigrade (1,450–1,650 degrees fahrenheit). This was nowhere near the temperature needed for

making Sueki-type stoneware, but it was sufficient to cook the clay into an earthenware of a significantly better quality than the earlier Jōmon and Yayoi pieces, and was also hot enough to melt the glazes.

These glazed earthenwares appear to have been used for ceremonial purposes, and examples have been excavated in various parts of the country especially in the Kansai area around present-day Osaka, Kyoto, and Nara. Being low-fired, the glazes of excavated pieces have usually been degraded through burial; the best examples are those seen in the Shōsō-in treasury in Nara, which have been kept since they were first made, together with an ancient document which records in detail the chemistry of the glazes used at that time. By a century later, this technology was being used to make green-glazed wares, which were by now preferred to the earlier Sansai polychromes, and which were similar to the proto-celadons of China. However, as with the previous Sueki wares, the production of this kind of low-fired glazed pottery seems to have declined around the mid-12th century in favor of practical stonewares, which by this time were being made in many areas of Japan.

One development of Sueki-type ceramics appeared during the 9th century in the area of Mount Sanage in Aichi Prefecture, not far from the present-day city of Nagoya. Eponymously known as Sanage wares, they were fired in a kiln fueled by cleaner-burning, less smoky wood, and so the clay body is of a lighter color than the more typically dark-gray Sueki pieces. They differ in their variety of shapes, and have a pleasant, nearly transparent green glaze – this was inspired by observing the haphazard natural effects caused by molten fragments of ash in the kiln, and then achieved deliberately by applying wood-ash mixed with water to the pots before firing. The Sanage potters also discovered that by building a dividing pillar in the middle of the kiln tunnel, the heat would be deflected on each side more effectively. As a result, the firing chamber could now be made larger to contain more pots, and so production could be considerably increased.

Sanage-type wares have been excavated in various parts of Japan, showing that the techniques of mass-producing stoneware had gradually spread to regional kilns. It is this Sanage tradition that gave birth to a profusion of centers making stoneware, the differences of which were mainly dictated by local variations in clay and geography. The two vanguard kilns that developed new wares using Sanage techniques were those of Atsumi and Tokoname in the Nagoya area of central Japan near the Pacific coast; these in turn provided inspiration for the evolution of Japan's great mediaeval kilns.

The Six Ancient Kilns

Seto, Tokoname, Echizen, Shigaraki, Tamba, and Bizen

It would be misleading to conclude that the famous Six Ancient Kilns were the only ones to

have been spawned from the Sueki-Sanage stoneware tradition. In fact, more than 30 have been identified that were active through the warring Kamakura and Muromachi periods, until the golden Momoyama era, when the country was united in peace under the powerful shogunate. At their beginning, they were all making unglazed pots mainly for everyday purposes such as storing foodstuffs, and the differences between them were mainly due to regional variations in the clay. The exception was the Seto pottery center, which catered to the higher ranks of society and produced glazed wares that were inspired by examples imported from Song-dynasty China.

However, the six centers cited above rose to a special prominence not only because they were located near to plentiful supplies of raw materials, but also because their craftsmen knew how to

Sueki pot

About 6th century A.D., H 55 cm, Collection of the Tokyo National Museum

This elaborate pot is embellished with four small mouths on the shoulder, and small models of animals. The "windows" in the tall stand are for decoration and to prevent cracking while being fired.

Opposite
Pedestal supporting seven bowls

6th century A.D., H 28 cm, Collection of the Tokyo National Museum

Made of unglazed stoneware, this object was most likely used for ritual offerings, and shows a strong resemblance to the Silla ceramics of neighboring Korea. The shaped holes in the pedestal provide greater strength during firing.

whitish-glazed *ch'ing-pai*, the greenish Lung Ch'üan celadons, and the dark *temmoku* ceramics that had been imported into Japan from Song-dynasty China. Being rare and expensive, these imports were used only by the high-ranking nobility who could afford them, and the Seto potters sought to make similar products in order to develop and cater to a larger market. Lacking the necessary technical know-how, they never quite succeeded in their quest, except perhaps for the *temmoku* iron-glazed tea bowls, which are often difficult to distinguish from the Chinese originals. However, through experimentation with the lighter-colored glazes, they luckily succeeded in achieving a satisfying compromise and began producing distinctive wares that later become known as Ko-Seto, "Old Seto."

These take the form of rather widemouthed jars, some with lids, bottles, flower vases, spouted pouring vessels, tea cups and caddies, incense burners, and so on, and some wares for use in Buddhist ritual and burial (especially during the Kamakura period when the Seto kilns were still evolving). The distinguishing feature of Seto wares is the characteristic, transparent "withered leaf" glaze which ranges in hue from a pale, straw-color, to pale green, brown, and black (see left and opposite). Under-glaze decoration is another feature seen on the earlier, Kamakura-period examples and shows a direct influence of the similarly decorated imports from China: impressed or incised flowers such as peonies and lotus, scrolling leaves, fish, waves, and abstractions such as comma shapes and roundels. Some have moldings that were applied before glazing to make a three-dimensional embellishment.

But it was the celebrated colors of the Seto glazes that most appealed to the restrained Japanese taste of the time, and both underglaze and applied decorations tended to disappear during the following period. This reflected not only the bleak austerity of those long years during which the country was engaged in civil war, but also the more astringent taste dictated by the tea ceremony, which was beginning to emerge and grew to a cult-like preoccupation. Towards the end of 16th century, the Seto kilns, together with the nearby Mino kilns that had come under their influence, were largely occupied with producing utensils for the upper levels of society who were practicing the tea ceremony.

Tokoname

The complex of Tokoname kilns is located on the Chita peninsula in Aichi Prefecture to the southeast of Nagoya City, and was by far the largest producer of pots during the Kamakura and Muromachi periods. Being close to a seaport, they were able to use coastal shipping traffic to distribute their wares all over the country, and until recent times it was still possible to find large, almost indestructible 15th and 16th century stoneware pots lying around country farmhouses,

Seto ware pot

Kamakura period, 14th century,
H 27.1 cm, Tokyo National Museum

This typical Seto jar is decorated with a design of peony flowers incised in the clay (see detail, opposite page) before being covered with a straw-colored glaze. Both the decoration and the glaze of such Seto wares were inspired by Chinese Song dynasty celadon wares.

conduct business – even after many changes of fortune throughout their history, all of them are still producing pottery today. In their heyday, two of these centers were truly enormous, with the Seto area having some 600 kilns, and Tokoname working well over 1,000. Both of these areas supplied a nationwide market with pottery, while the remaining four (Echizen, Shigaraki, Tamba, and Bizen) catered largely to the demands of their more immediate local regions. All of these pottery centers have long histories that have continued to the present day, but for all of them it could be said that their golden age was reached during the mediaeval period between the 13th and the beginning of the 17th centuries.

Seto

The large complex of kilns at Seto originated in one of the old Sué sites, and by the 12th century was making Sanage-type ash-glazed wares for everyday use. Since that time, the area has grown to be the largest pottery-producing center in Japan, and for a long time the place and the products have been so much associated with each other in the popular mind that the word *setomono* (wares of Seto) has come to mean "ceramics" generally.

However, the first appearance of wares that are considered to be typical of Seto appeared in the 13th century and were attempts to imitate the

**Preparation of the clay
at Shigaraki**

In this simple method of clay extraction,
still used in some provinces in Japan, the
potter digs a hole that is then lined with
wooden boards. A mixture of water and
clay is poured into it, sieved through
a bamboo mesh and comes out at a
lower level.

particularly on the southwest side of Japan, facing
the Pacific Ocean.

The Tokoname kilns evolved in the late Heian
period from the nearby Sanage tradition of making
high-fired stoneware with a wood-ash glaze. The
earliest Tokoname pieces date from the 12th cen-
tury and are found in a variety of shapes, the most
splendid of which are large jars with a wide mouth
and inverted lip. Many are quite impressive in size
(occasionally over one meter (three feet) tall), and
though they were never artificially glazed, many
have an interesting "scenery" made up of bits of
adhering debris and also globs and dribbles caused
by the melting of natural ash in the kiln. They
were made of rather rough clay, found in a variety
of colors depending on where it was dug up, and
have mostly been finished on a potter's wheel.
Characteristically they have high, broad shoulders
and a tapering body (see opposite, left).

Some of these large jars have been found in
burial sites, and containing bones, or Buddhist
sutras; but others (often with a narrower neck)
were made to store foodstuffs: water, honey, miso,
beans, pickled vegetables, and the all-important
rice – part of each harvest needed to be saved for
planting in the following spring. The inverted lip
was designed to make it easy to tie a cover over the
mouth, and so protect the contents from maraud-
ing rats and insects.

Other common Tokoname pottery shapes are
mortars of various sizes with a beaked lip for pour-
ing, and long-necked bottles with a bulbous body
and a flared mouth for containing saké. All are
made of rather coarse stoneware that has burned to
either a reddish-brown, or a gray that ranges from
almost black to a light fawn color. The natural ash
glaze is found more abundantly on the side of the
pot facing the updraft coming from the bottom of
the firing chamber in the kiln, and depending on
the complex chemistry occurring at those high
temperatures, can appear in a variety of colors
from an attractive green, through brown, to even a
bluish-gray.

Tokoname pots are largely undecorated; they
were after all made as rather utilitarian products.
However, some occasionally have a simple pattern
stamped into the clay, or a grooved line or two
around the circumference of the body. Many show
a "potter's mark:" simple, incised marks (not used
solely at Tokoname) that allowed the potter to
identify his own work, as kiln firings were tradi-
tionally communal affairs that were shared by a
group of craftsmen.

The shapes of the Tokoname wares subtly
changed through the medieval times (and even
into the Edo period), with the bodies becoming
more rounded and less dramatic. But pots contin-
ued to be produced in large quantities for the prac-
tical, everyday use by rural folk; and Tokoname,
unlike other kilns, chose to (or were chosen to)
remain firmly in the proletariat sector, at a distance
from the refined tea tastes that had been captivat-
ing society from the middle of the 16th century.

Echizen

On the opposite side of the island from Tokoname,
the kilns of Echizen are located close to the Japan
Sea coast in Fukui Prefecture facing the Asian
mainland. The climate here is more extreme than
that of the more densely settled Pacific coast, espe-
cially during the long winter, when the whole
prefecture is often buried for months under deep
snow. And for much of the historic period the area

was isolated from the main centers of influence. However, the practice of making ceramics in this area dates back to very ancient times, as can be seen from the Jōmon, Tumulus *haniwa*, and Sueki pieces that have been excavated from archaeological sites all over the prefecture.

The kilns that we now know as Echizen were established sometime in the late Heian era, and throughout the mediaeval period produced large, utilitarian container jars, together with mortars and bottles that show a strong influence of the stonewares of Tokoname, and with which they are frequently confused. (Having been more-or-less isolated, the Echizen kilns have always been far less celebrated than the other great kilns, particularly those of Tokoname. In this writer's experience, the classification "Tokoname" is often used as a convenient graveyard for otherwise-unidentified pots.) The Echizen pots are mostly undecorated (although many show potters' marks) and are of a brownish stoneware, due to the iron content of the clay. As with Tokoname, there are often dramatic splashes and dribbles of natural, wood-ash glaze that melted from fallen debris in the kiln, particularly those that were placed closest to the firing chamber.

The area is blessed with abundant supplies of good-quality clay and firewood, and has always been the most important pottery-producing center on the side of Japan facing the Japan Sea. The kilns are conveniently located near to the port of Shigaura, and with the availability of coastal shipping the Echizen potters were for centuries the main suppliers, catering to markets of agrarian communities along the coast; it is in these areas that surviving pieces can still be found.

Shigaraki

Not far from the old capital of Kyoto, to the east of Lake Biwa in Shiga Prefecture, are kilns that produce the stoneware known as Shigaraki. This site emerged as a pottery-producing center around the middle of the 13th century, in the Kamakura period, and like the other mediaeval kilns produced large jars and mortar-shaped dishes for everyday use. As with the other wares of that time they have little or no decoration, although a simple, hatched "bamboo fence" design is sometimes found around the shoulder of narrow-mouthed jars (see page 259). The clay used by the Shigaraki potters is characteristically laden with granules of feldspar, which tend not to fuse with the other component particles during firing, but migrate to the surface, where they appear as white, sugary *hoshi* ("stars"). If the temperature in the kiln passed 1,300 degrees centigrade (2,300 degrees fahrenheit), some of the feldspathic grains would melt and disappear to create a typical effect of little craters in the surface known as *ishihaze* ("fire bursts").

The Shigaraki clay usually has a lower iron content than that used by the other mediaeval kilns and so tends to show an attractive palette of

Shigaraki ware pot

Muromachi period, 16th century, H 48 cm, Jeffrey Montgomery Collection, Lugano, Switzerland

This storage jar shows the typical white "stars" of feldspar that have come to the surface of the body, as well as little craters where some of these "stars" have evaporated during the intense heat of firing. Here, unusually, the splash of natural ash glaze is found on the lower part of the pot, which suggests that it was located in a higher position in the kiln and caught the updraft of ash from underneath. The lipped mouth is rather narrow so that it could be easily covered to protect the contents of the jar.

reds and salmon pink after firing. This, together with the feldspathic phenomena described above, and the glassy splashes of natural wood-ash glaze, can produce effects that are majestic and startlingly beautiful. These pots are judged by connoisseurs for the interesting "scenery" that has been created by the fire, and the unique combination of elements found in the Shiga clay (see above). The best and rarest are highly prized.

But it should be remembered that these wares were not made intentionally as works of art, but as ordinary utensils for farmers to use for everyday purposes such as storing rice. Most of the large mediaeval Shigaraki pots were made rather crudely by coiling a "rope" of clay to make several sections that were then stuck together to make the complete vessel. Sometimes one side sagged or bulged in the kiln, and it is no wonder that many turned out to be of less than perfect shape – though in this writer's opinion it is precisely these imperfections that give these pots a distinctive presence, and that make them so appealing to our contemporary eyes.

The recognition of these qualities is not new and as long ago as the late-15th century an aesthete, Murata Shuko, chose certain Shigaraki wares to rank along with imported pieces for use in the tea ceremony. At first, such pieces were selected from among the general production turned out by the kilns, but it did not take long for the potters to catch on to this new craze during the 16th century, and to start making small, rustic pieces with the tea market in mind.

Tamba

In the mountains of Hyogo Prefecture, to the west of Kyoto, the Tamba kilns have been making pottery since sometime in the Kamakura period until the present day. Old Sueki sites have been found in the area and, as with the other mediaeval kilns, the first Tamba pots were produced with the inherited techniques of making stoneware in an *anagama* tunnel kiln. The most typical pots that remain from the mediaeval period are storage jars about 35–45 centimeters (14–18 inches) high with a flared lip, and a distinctive natural ash glaze which has often fired to a bright grass-green and contrasts dramatically to the red stoneware of the body (see page 260). The earlier pots were carefully smoothed, but later ones have comb-marks which indicate a rush to get them finished on time, most likely to store rice seeds through the winter in this agricultural area. The rather light-colored Tamba clay was used in a way similar to that used in the other mediaeval kilns: by coiling ropes into segments, which when firm enough, were stuck together to form the pot. Decoration was rare, with just one or two of the early pieces having the simple embellishment of a leaf or flower that has been incised into the clay on the shoulder.

Opposite
Shigaraki ware pot

15th century, H 43 cm, Tokyo National Museum

This splendidly formed pot shows the simple decoration of a band of cross-hatching incised into the clay before firing. The dribbles of ash glaze formed naturally from debris in the kiln that melted in the high temperature.

Tamba ware pot

Late Muromachi period, 16th century,
H 43 cm, private collection

This sturdily potted storage jar shows the typical green glaze of molten natural ash, which was sufficiently liquid during the firing that it ran in four rivulets that contrast with the red body. The narrow-lipped mouth was designed to be easily sealed to protect the contents from insects and rodents.

There was little change in the Tamba wares throughout the mediaeval period: perhaps a tendency to make the mouth of the pot straighter rather than flared, more rounded shoulders and less tapering of the body – being so isolated, there was little opportunity to either see what was happening in other areas or to fall under their influence. This quiet stagnation ended in the Momoyama period when a new type of kiln (introduced by Korean potters) led to experimentation with glazes and forms, and a proliferation of new products. With the easing of communication to other parts of the country, and the flourishing of artistic interests, particularly among the emerging merchant classes, the Tamba kilns began to flourish and sell their wares to a wider market than that in their own remote valleys.

Bizen

Unlike those of the other major mediaeval kiln centers, the wares of Bizen did not achieve much fame until the late-16th century, when they came to be patronized by practitioners of the tea ceremony, who found that the dark, subdued tones of these pots fitted with their artistic ideals. The area, near Okayama on the Inland Sea, has an ancient tradition of ceramic making dating back to the Tumulus period but the wares that are considered to be characteristic Bizen only started to appear in the 12th century.

Bizen wares are rather different to those of the other ancient kilns and are made easily recognizable by the dark-red color of the stoneware body. Wares of the mediaeval period are mainly large wide-mouthed jars (used *en vogue* in some modern houses for keeping umbrellas near the front door), as well as smaller containers of various shapes that

are sometimes seen with a few wavy lines around the shoulder in discreet decoration. The local clay is rich in iron, thick and sticky, and is less than ideal for making pots if it is fired in the same way as other stonewares. However, the Bizen potters found that by firing at a lower temperature for a long period of time (one recorded firing was for 60 days followed by another 60 days to cool) they could make a dense, heavy stoneware with a smooth surface that at times is shiny or almost metallic.

Most of the Bizen mediaeval pots are rather uninteresting when compared to those of the other ancient kilns with odd exceptions as they have few of the characteristic dramatic splashes and dribbles of contrasting-colored wood-ash glaze. The surface effects on Bizen are a little more subtle as a result of the longer, but less fierce firing, and during the 16th century it was learned how to control or enhance some of these to please the tastes of the tea market. One feature which was highly prized, *gomayu* ("sesame seed glaze"), was caused by small particles of ash melting to form flecks or patches of a yellowish-brown glaze that contrast with the dark-red body of the pot. Another desired effect was created deliberately by wrapping the wares in straw before stacking in the kiln: this would then burn off leaving marks of a darker red, called *hidasuki* ("fire stripes"), that contrast with the lighter body.

During the Momoyama period, the Bizen potters achieved considerable virtuosity in manipulating the complex goings-on in the kiln, and so succeeded in producing a wide range of goods that appealed to the wealthy "tea taste" market. One refinement that pleased such clients was created by placing small cups on the surface of a pot (particu-larly a flat dish or container) before firing. This had the effect of protecting the area sheltered by the cups from the fallout of ash, and also of creating slightly different atmospheric conditions in the sheltered part, so that the area fired to a color different from that of the surrounding areas. The result can be very impressive with the unglazed roundels like persimmons against the flecks of fudge-colored ash glaze (see below).

Tea Ceremony Wares

The influence of the tastes of the masters of the tea ceremony on ceramic design from the 16th century cannot be overestimated and craftsmen working in almost all media were strongly affected by this fashionable new aesthetic. Of the mediaeval kilns, Seto, Bizen, Tamba, and Shigaraki adapted to cater to the tea market, in addition to which new kilns appeared that offered an increased variety of shapes and glazes. The tea ceremony had been practiced in some form since the 12th century, but at first the taste in utensils was largely dictated by the prestigious imports from China in upper-class collections. During the late Muromachi period, the tea practitioners began to notice that many native Japanese wares showed the restrained qualities demanded by the philosophy of "beauty from poverty," and gave suggestions to the potters on how to design for their special tastes. (Then, as now, the tea hierarchy had no compunction whatsoever in reconciling lofty aestheticism with business, and many of its leading figures prospered as advisors or dealers.) During the Momoyama period, when the economy was booming and the

country enjoyed a period of peace under a military administration, an artistic renaissance saw the creation of some of the finest ceramics in Japan's history. Many of those that are most treasured, that have a particularly illustrious pedigree dating back to the great tea masters, are so famous and celebrated that they have been given individual names and are accorded almost animate personalities.

Seto and Mino

Towards the end of the Muromachi period, the Seto potters moved a few kilometers to the north, into the province of Mino (present-day Aichi Prefecture), in order to escape from the disturbances caused by the civil war. Here, under military protection, they established new kilns to continue the tradition of making glazed stonewares; and with the coming of peace, they developed new glazed wares, notably Shino and Oribe, in addition to Seto ceramics.

The new kilns concentrated on making the utensils needed for specific use in the tea ceremony: tea bowls, flower containers, dishes of various shapes for the *kaiseki* meal (which is served first in the formal tea ceremony), water jars, tea caddies, incense burners, saké bottles, and saké cups. From the old Seto tradition of glazed stoneware, new types appeared in the late-16th century that differed from their predecessors in having a

body of whitish clay, and more interesting glazes. *Aburage* ("fried tofu"), was the name given to wares having a distinctive, light-yellow glaze with a matte, slightly grainy, non-shiny surface; *seto kuro* was a variety with a black glaze that was achieved by withdrawing the pot from the kiln at a certain stage and allowing it to cool in the open air. The *aburage* yellow-glazed wares were often decorated with designs incised in the clay before glazing, and highlights of brown and green which were made by applying iron or copper compounds before firing (see above).

Shino wares appeared in the late-16th century and were the first Japanese wares to be decorated by painting with iron oxide on the body of the vessel before glazing and firing. According to popular legend, they were named after Shino Sōshin, a noted expert on incense (from the Heian period onwards there were social gatherings to guess the identity of different kinds of incense, a pastime of the upperclass) who was also active in the tea circles of the shogun's court. The earliest Shino pieces, however, were undecorated, having only a white glaze with an attractive crackle of fine lines, and were known as Shino *temmoku*, after the shape of the Chinese Song dynasty *temmoku* bowls. Only two or three examples have survived but it was these early white wares that inspired the development of the later, more typical Shino glazes.

Ko-Seto ware dishes

Momoyama period, late-16th century, dia 15 cm, Hatakeyama Collection, Tokyo

These two dishes were possibly part of a set of five with the same shape but with interesting differences in the designs. Simple floral motifs were incised into the clay body and then roughly highlighted with splashes of iron oxide. The rather matte yellowish glaze was known as *aburage* because of its resemblance to fried tofu.

White clay was plentiful in the area of the Mino kilns, and by experimenting with local ingredients the typical Shino glaze was developed; primarily white, of uneven thickness, and with a soft surface, like icing sugar about to melt – an effect that found much favor among the tea aficionados. A smooth flat surface was not at all desirable, and the uneven variations caused by the thick application of glaze were valued for their interest and "scenery." Particularly prized were the tiny holes seen in the glaze making a texture called *yuzuhada* ("citrus skin"). During the early Momoyama period, the Mino potters demonstrated their artistic license by making tea ceremony wares with a large variety of shapes, designs, and patterns. One of the extraordinary features of Mino wares is that no two pieces are the same, and even sets of five dishes or cups will show interesting variations. (Food dishes in Japan are usually made singly or in sets of five, this number of men dining together being considered to be the ideal for balanced conversation.)

Horimishima wares were decorated by applying a slip to a dried pot, then scratching a design through this slip to the underlying clay, before glazing and firing to make a pattern of contrasting colors. Depending on the thickness and composition of the glaze, and the conditions of firing, Shino wares can be white, gray or red, or show a combination of these colors. The under-glaze painting on the body was inspired by forms seen in the abundant surrounding nature or by pattern motifs in local, handwoven textiles, and is frequently abbreviated to a few simple brushstrokes reduced almost to abstraction.

The wares known as Oribe were produced in the early-17th century in a new kind of multichambered kiln introduced into the Mino area from Karatsu in the north of the island of Kyushu (another major ceramic center established by potters from Korea). This kiln was much more efficient and easier to control than the old *anagama* tunnel kilns, and its use led to a sharp demise of Shino-type wares. The wares are named after Furuta Oribe (1544–1615), a high-ranking tea master, advisor to the shogun Hideyoshi, and pupil of Sen-no-Rikyū, who was the leading arbiter of tea aesthetics at the time. Rikyū's taste in ceramics was for quiet, understated, rather rustic wares, whereas Oribe delighted in the energetic and expressive designs, and asymmetrical forms that are seen in the ceramics named after him. He may have acted as an advisor to the kilns on the shapes and designs that were required by the tea market, although the exact connection has not yet been clarified.

Oribe wares are made of the light-colored Mino clay and are seen in a large variety of forms, many of which seem quite eccentric when compared to the works of previous kilns, and extend to tobacco pipes, candlesticks and ink-stones, in addition to the usual tea utensils. There was also a tremendous variety of painted designs, usually inspired by the local flora and fauna as seen in the Shino wares, but also many were influenced by, or copied from the sumptuously rich Momoyama textiles, especially the *tsujigahana* tie-died fabrics that had become fashionable among the military elite.

There are several main types of ware that are typical of the Oribe family: Shino Oribe is white in appearance and with similar under-glaze iron decoration; but having been fired in the new, multichambered kiln, the glaze is thin and less interesting than that of the soft, warm Shino wares that were fired in the old *anagama* kilns a generation earlier.

Black Oribe has a black slip usually applied in patches or trails that contrast with areas having painted designs, and all covered with a transparent glaze and fired. The effect is most often seen on tea bowls which have been potted into a free-form shape that can appear remarkably modern to Western eyes today (see page 264). Sometimes, as with the old Shino wares, a slip has been applied to the body before firing, and a design scratched through to the clay beneath.

Green Oribe is what normally comes to mind as being the most representative of these kilns, and the wares have patches of a lustrous, semi-transparent green glaze, darkening where it runs thickest, and again contrasting with areas that are painted with black, iron oxide designs on the pale body. More rarely, the whole pot was just glazed green with perhaps a design incised into the clay and visible through the transparent coating (see page 265, bottom).

A Shino ware *mizusashi*

Momoyama period, late-16th century, H 17.2 cm, dia 19.2 cm, Hatakeyama Collection, Tokyo

A *mizusashi* is used in the tea ceremony for holding fresh water, and is often fitted with a black lacquer lid. This jar is decorated with an effective and almost abstract design of reeds or grasses (painted in iron oxide) that contrast effectively with the white Shino glaze.

Oribe ware tea bowl

Momoyama period, early-17th century,
H 10 cm, dia of mouth 10.5 cm,
Hatakeyama Collection, Tokyo

This tea bowl is of the type known as *kuro-oribe*, "black Oribe," and is distinguished by its imaginative shape and iron-oxide painting. The mouth is irregularly shaped and has molded rings or corrugations for interest. The simple design painted on the remaining white part of the body that might have been inspired by curtains used to demarcate an outdoor party.

Opposite, top left
Karatsu ware bottle

Momoyama period, early-17th century,
H 13 cm, Hatakeyama Collection, Tokyo

This small bottle was most likely used for serving saké, but would also be suitable for holding a simple wild flower or two in the *tokonoma* of a tea room. The combination of dark iron glaze with a light glaze made from rice-straw ash is typical of the wares known as *Chosen-karatsu*, "Korean Karatsu." An attractive toffee-colored effect has appeared where these two glazes meet.

Opposite, top right
Karatsu ware dish with spout

Jinenbo Nakagawa (born 1953)

Modern period, 1990s, L 31.5 cm,
W 27.8 cm, H 14.7 cm, private collection

Nakagawa was born in Saga Prefecture on the island of Kyushu and makes wares using traditional Karatsu clays and glazes. This pouring dish shows an ancient Korean type of decoration known as *Chosen-karatsu*, "Korean Karatsu," using black iron slip and light feldspathic slip to create an attractive contrast with the dark clay.

Photograph by Narimi Hatano

Opposite, bottom
Green Oribe ware dish with handle

Momoyama period, early-17th century,
L 22 cm, Hatakeyama Collection, Tokyo

A handled dish such as this would have been used for serving *kaiseki* food at the beginning of a formal tea ceremony. The shape has been imaginatively molded from thin slabs of clay. A patterned design has been painted in black iron glaze before the handle and two corners of the dish were dipped in the typical Oribe green glaze.

Narumi Oribe is the name given to pieces where an iron-rich clay has been used to make the body, which has fired to a light reddish color instead of the usual white. However, as green glaze would appear rather muddy on this color body, two clays were used to make the vessel: the iron-rich clay for the part that would not carry the green glaze, and ordinary clay for that part that would. This was quite a difficult job that demonstrated advanced technical skills, and was accomplished by using a mold so that the different clays could be pressed together to form the pot before glazing the respective area. Developing this procedure must have involved much trial-and-error experimentation as the two kinds of clay had to have a compatible reaction to firing, otherwise the pot would have fallen apart in the kiln.

Iga

The Iga kilns were located slightly south of the mediaeval Shigaraki center in present-day Mie Prefecture. Their early history is not clear, but they were probably making utilitarian wares more or less the same as those from Shigaraki. They certainly used a similar clay (dug out from the shallow bed of Lake Biwa), and the pots show the same phenomena of "stars" and "fire bursts" caused by the granules of feldspar migrating to the surface during firing. But it was during the

Momoyama period that the Iga kilns rose to glory, when, under the advice and guidance of leading tea masters (Furuta Oribe and later Kobori Enshū), they made wares both for the local feudal lord and also the tea world of Kyoto.

The Iga kilns are famed for their water containers (*mizusashi*) and flower vases. The clay body and wood-ash glaze is almost identical to that of Shigaraki, but the shapes are markedly different, revealing the hand of the tea aesthetes who advised on their making. All of them are irregularly shaped, with some of the later pieces having stamped patterns, or carved lines in the clay, and others have "ears" or handles that serve no real purpose except that of being part of the overall appearance (see page 266).

On seeing these pots, there is little at first that can be recognized by the Westerner who is used to the perfection of Wedgwood or Meissen porcelain. By comparison, they look rough and mis-shapen, and for many not worth a second glance. But the Iga vases reveal a taste of an extremely high order, and their beauty is best seen when they are used for their original purpose. They are certainly impressive when seen in a museum (all of them are priceless treasures), but it is when they are displayed with a couple of wild flowers still wet with morning dew in the *tokonoma* alcove of a tea room, and with soft, diffused light filtering through the paper *shoji*, that they quietly assert their noble presence like an ancient weathered rock in a mountain

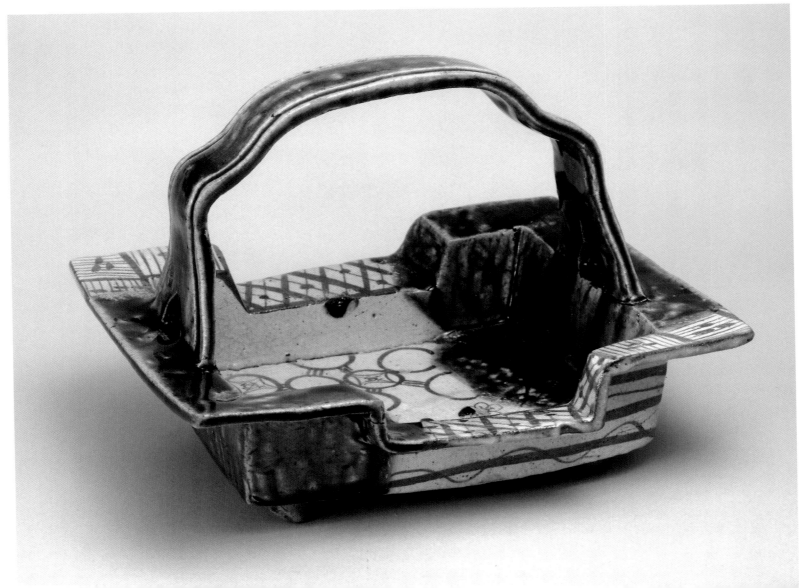

Iga ware *karatachi*

Momoyama period, late-16th century,
H 28.4 cm, Hatakeyama Collection, Tokyo

The shape of this famous vase has been
free-formed, and vertical and horizontal
lines have been incised in the red clay
body. Two "ears" add balance to the
overall design, and the natural ash glaze
has fired to a dark color around the lower
part of the pot to contrast with a lighter
color at the top. Kiln debris has stuck to
the piece during firing to make an
interesting surface. Iga vases reveal their
true qualities best when they are wet, and
used to display one or two wild flowers.

ravine – and provide a glimpse into the refined world of the great tea masters.

Raku

The Raku kiln in Kyoto differs from those above in that it had no prior history and was established around 1580 by a potter named Chōjirō (who had previously been employed in making roof tiles) under the direction and guidance of the tea master Sen-no-Rikyū. Raku wares consist mainly of tea bowls, and occasionally other utensils made specifically for the tea ceremony. They are of a type of earthenware that has been quickly fired so that the clay body remains porous and light, with a softly lustrous glaze that is usually black or red (see below). The black Raku bowls were particularly favored because they enhance the attractive color of the green tea, and have insulation properties that serve both to keep the tea hot and to protect the hands. The kiln and the Raku family were patronized by later tea masters, and is still continuing the pottery tradition in Kyoto today.

Karatsu

Karatsu is the name given to a complex of kilns located around the northern coast of the island of Kyushu in west Japan, near to the castle town of Karatsu. They were established sometime in the early 1500s, but were first launched into prominence by Korean potters who had immigrated into Japan after an unsuccessful attempt to invade Korea by the Shogun Hideyoshi at the end of that century (not necessarily of their own volition as they were most likely to have been captives or hostages). These potters brought new skills with them such as the kick-wheel and the multichambered firing kiln, which had a revolutionary effect on the making of ceramics in western Japan.

The Karatsu kilns were conveniently located close to a seaport, allowing for easy distribution to markets in the western part of the country, and the majority of them were devoted to making utilitarian wares for daily use. Most of the Karatsu products tended to be rather small and were made in a variety of styles that show a strong influence of the wares of Yi-dynasty Korea. During the Momoyama period, the kilns caught the attention of the tea masters and under their advice and direction a few of the kilns specialized in making utensils exclusively for this elite market.

Karatsu clay is typically dark brown in color and fires to a stoneware that is surprisingly light in weight. The most popular Karatsu ware was called *e-karatsu* ("painted Karatsu"), and shows underglaze iron oxide painting of simple designs

Black Raku ware tea bowl

Ichinyu Kichizaemon (1640–1696)

Edo period, 17th century, H 8.5 cm, dia of mouth 12.5 cm, Hatakeyama Collection, Tokyo

Ichinyu was the fourth generation of the Raku family and became a Buddhist monk shortly before his death. While continuing with the Raku tradition of making tea bowls, he invented some new glaze effects such as the brown flecks that can be seen in the soft black glaze of this tea bowl.

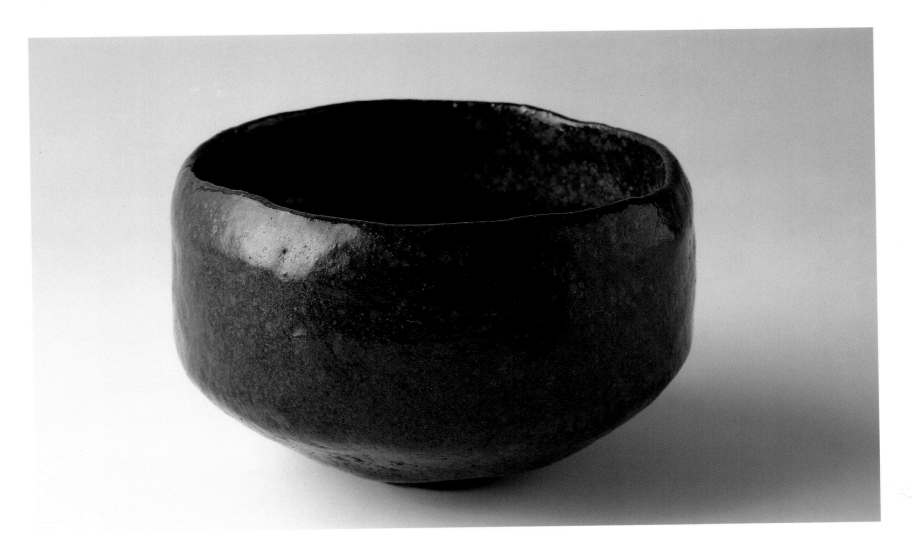

selected from the abundant, lush nature of north Kyushu, such as pine trees, grasses, vines, willows, and birds, that are executed with rapidly drawn brush strokes (see page 270). Glazes are seen in various colors from straw to gray, depending on the kiln, and one variety, known as *Chōsen-karatsu* ("Korean Karatsu"), is decorated with abstract splashes of two glazes; one amber-colored, the other thick and milky.

Apart from Karatsu, other kilns such as Hagi and Takatori also came to prominence under the Korean influence, and distinguished themselves by quickly learning how to make wares with "tea taste" in addition to items needed for daily use. Karatsu-type wares however went into a sharp decline together with most of the other tea ware kilns in the early-17th century as a completely new development appeared in north Kyushu that was to radically change the world of Japanese ceramics – the invention of porcelain.

The Rise of Porcelain

Arita, Kutani, Kakiemon, and Nabeshima wares

According to popular legend, a Korean immigrant named Li Sampei came across deposits of kaolin (the fine white clay suitable for making porcelain) in the area of Mount Izumi in north Kyushu in Japan around 1615. However, excavated shards reveal that wares were being made in the early

years of the 17th century that imitated the celadons and blue-and-white pieces of China and Korea, and indicate that porcelain-making kilns must have been established sometime prior to this date. Porcelain differs from stoneware in that it is fired to a higher temperature (over 1,200 degrees centigrade/2,200 degrees fahrenheit), at which level the fine particles of the kaolin clay melt together into a hard, dense, glass-like china that will ring clearly like a bell when lightly struck.

The earliest examples, however, were not so fine, and it took a decade or two for the kilns to develop suitable technical proficiency in order to produce the thin-walled, finely shaped pieces for which they became world-famous. The center of the porcelain industry was the area of Arita in Hizen province, now known as Saga Prefecture. Nearby was the port of Imari, and with the growth of an export trade this small town became the starting-off point for ships laden with Arita ceramics that were destined for markets overseas. The terms "Imari ware" and "Arita ware" refer to the porcelains made in north Kyushu, while "Hizen ware" refers to any ceramics made in north Kyushu area, but especially those of Karatsu.

The oldest pieces, dating from the first few years of the 17th century, tend to be rather course and thickly potted, but they have an innocent, rural charm that appeals to many connoisseurs of ceramics. Being less refined, the clay often has a slight orange tinge and the glaze has small pittings

Left, and opposite
Plate

Momoyama period, about 1620–1630, known as Shoki-Imari, dia 20.2 cm, Hetjens Museum, Deutsches Keramik-Museum, Düsseldorf, Inv. Nr 1974-48

The flat round plate has an almost horizontal rim 1.3 cm (half an inch) wide. The reddish brown fired pieces of pottery are covered with a thick matte, porous grayish-white glaze. The center painting in blue underglaze shows a moon and a steep mountain in a roughly sketched landscape (see detail, opposite).

Right
Plate

Momoyama/Early-Edo period, 1st quarter 17th century, known as Shoki-Imari, porcelain, diameter 18.9 cm, Hetjens Museum, Deutsches Keramik-Museum, Düsseldorf

In the center of the plate with its gentle rounded edge is a landscape with two boats on a mountain lake, motifs familiar in the ink painting of the literati painters. Sketchy clouds decorate the rim. The painting is done in underglazed cobalt blue which, on account of the different thicknesses, produces a greater variety in the tone.

E-karatsu dish

Momoyama period, early-17th century, dia 36.5 cm, Tokyo National Museum

This large dish has been decorated with a design in iron oxide inspired by the flora of north Kyushu, before being covered with a transparent, straw-colored glaze.

and imperfections caused by flying debris in the kiln. The foot too is rather small as the techniques of making it wider without the dish sagging in the middle had not yet been developed. And for the first time in Japan, pots were decorated with underglaze painting using a blue pigment made from mineral cobalt (see page 272) in the manner of Chinese Ming porcelains.

Towards the middle of the 17th century, an Arita potter named Sakaida Kizaemon learned techniques of decoration with overglaze colored enamels, reputedly from a Chinese potter who was living in Nagasaki. Great efforts were made to guard these secrets in order to keep a monopoly on polychrome wares for the Kakiemon kilns, which had been founded by Sakaida. However, the formulae were somehow leaked to other potters and colored wares were soon being made at most of the other Arita kilns.

The new ware necessitated two or more firings: the first to make the porcelain ware, which when it had cooled was painted with designs using various pigments and then fired again. Different colored

enamels reacted at different temperatures and another one or two firings were necessary to melt these glass-like colors and fuse them on to the first, clear glaze. Refinements involved using gold dust mixed with the enamels, and painting on wares that had already been decorated with underglaze blue to give an effect of depth – that of one design floating on top of the other.

The perfection of these skills could not have been better timed: mainland China, which previously had practically monopolized the international porcelain trade with its wares from the Ching-te-chen kilns, was going through a period of chaotic instability after the collapse of the Ming dynasty, and in consequence was leaving a wide-open market to be exploited. The mighty Dutch East India Company had a trading post on Deshima Island in Nagasaki Bay (the only place in Tokugawa Japan where foreigners were officially allowed to live), and was poised to develop a thriving business selling Arita wares to the export markets of Southeast Asia and faraway Europe. The porcelain business grew enormously and for a

Opposite
Decorating a Karatsu tea bowl

Unlike other ceramics, which are almost exclusively painted with the aid of a brush, Karatsu ceramic can also be decorated by finger-painting using iron-oxide pigments.

couple of decades the Arita potters had no competition until China, at peace again, restored its own kilns and again entered the export business, and with competitively lower prices. As a result, Japan's export trade gradually dwindled to almost nothing by the mid-18th century and the Arita kilns were once again left to cater to the domestic demand. However, during the boom years in the latter half of the 17th century, the Arita kilns produced a tremendous variety of porcelain wares, not only for the domestic market but also those that had been specially made to order for foreign tastes. In Europe, Japanese porcelain was fashionable not only for use as tableware but also

for ornament, and there can hardly be any palace or grand house in England or on the Continent that does not have one or two pieces of Arita ware from this period.

There are three types of wares produced in the Arita kilns that stand out for their unique characteristics: Kutani, Kakiemon, and Nabeshima. It had long been presumed that Kutani wares had been made in the Ishikawa area on the Japan Sea coast, where they had been associated with the local ruling Maeda family; however, recent research indicates that they were more likely to have been made at Arita. Kutani wares are noted for the colors of the overglaze enamels used in

An Arita *tokkuri*

Edo Period, 17th century, H 31 cm, Jeffrey Montgomery Collection, Lugano, Switzerland

A *tokkuri* was used for storing or serving saké, a wine made from rice. This early piece shows an underglaze design of a branch of prunus blossom in a rather grayish cobalt. The single line around the lower part of the bottle has the effect of balancing the decoration and making it appropriate to the rounded shape.

Left

Ai-kutani ware dish

17th century, dia 20 cm, Hasebeya Collection, Tokyo

The wares known as *ai-kutani* show the same characteristic palette of glazes in green, black, yellow, and aubergine-purple, which in this dish have been used to make a design of camellia flowers and leaves against a background of clumps of pine-needles.

Below

Kutani ware plate

Edo period, mid-17th century, dia 19.5 cm, Hatakeyama Collection, Tokyo

This plate is painted in the typical ko-kutani palette of glazes: mustard-yellow, aubergine-purple, red, and green. The central design is rather Chinese-looking, with tree-peonies, a strange-shaped rock, and what could be the edge of a viewing platform, and has been drawn with black lines before being filled in with color.

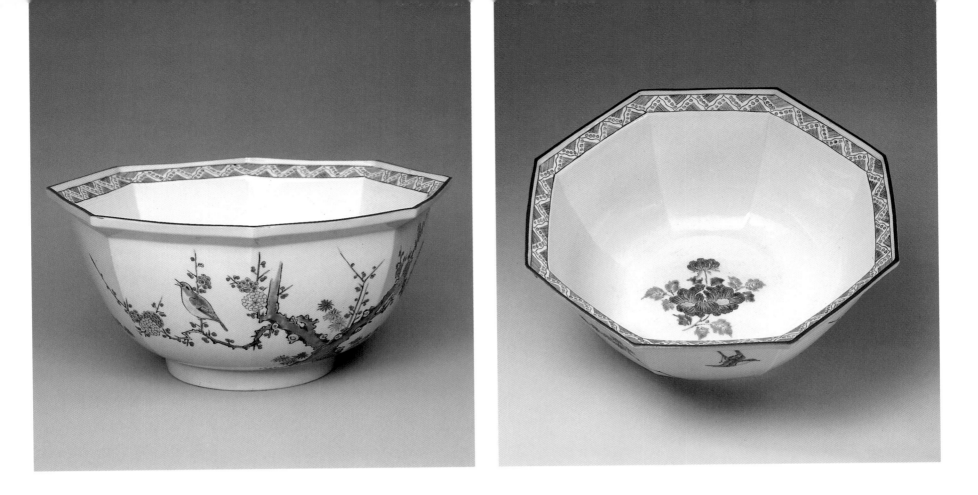

Kakiemon ware bowl

Edo period, late-17th–early-18th century, dia 23.5 cm, Hatakeyama Collection, Tokyo

This eight-sided bowl shows the flawless, milky-white glaze on the white clay body that is characteristic of Kakiemon wares. The rim of the piece and the pattern around the edge is colored in red, and at the bottom there is a small spray of peony flowers in green, yellow, red, blue, and black. The outside is meticulously painted with a delicate design of a bird on a branch of stylized prunus blossom.

decoration, particularly those seen in the variety known as *ai-kutani* ("green Kutani"). A rich, intense green is used in combination with yellow, black, blue, and a purple color like that of eggplants. The famous *ai-kutani* pieces date from the latter half of the 17th century and are typically large, impressive dishes which are completely covered with a decoration in two or more of these colors to make a striking pattern (see page 274, top). Smaller pieces are usually more sparingly decorated and the typical Kutani colors are used to paint a design that contrasts with the white porcelain body (see page 274, bottom).

For reasons not yet clear, the early Kutani kilns seemed to have gone out of business around the end of the 17th century; however, kilns making Kutani wares were revived again in the early-19th century in the Ishikawa region, and these have continued in production to the present day. There they have been making porcelains with colored enamels that resemble 17th century old Kutani, in addition to a range of more modern shapes and designs.

Kakiemon wares are famed for their characteristic milky white porcelain body and very carefully applied decoration in underglaze blue and (or) overglaze enamels. They were developed in the first half of the 17th century by an Arita potter named Sakaida Kizaemon, who refined colored enamels, especially one with a rich, orange-red color that looks like that of ripe persimmons, the fruit known as *kaki* in Japanese, hence the name Kakiemon. The wares produced that used these new enamels became so celebrated that Sakaida Kizaemon took the name Kakiemon,

by which his family descendants have been known until the present day.

Kakiemon wares differ from the usual Arita porcelains in having a highly refined decoration that is usually asymmetrical with the painted area artistically balancing the unpainted area. This effect is seen in the polychrome enameled wares and also in those with designs only painted in underglaze blue. Sometimes in the colored enameled wares, a thin, black outline is seen that has the effect of highlighting the designs against the milky white background (see page 275). During the last half of the 17th century, many fine quality Kakiemon wares were exported to Europe, where they were not only highly prized but also much imitated by the potters at Delft and Meissen.

The finest of all the Arita wares was made by the Nabeshima workshops and kilns under the administration of the local feudal lord with the same name, and for the exclusive use of his clan, the shogun, and the highest-ranking nobility. At first the kilns were established close to the sources of kaolin clay, but eventually moved to a remote compound in the mountains where the craftsmen could pursue excellence in their work without distraction. They were carefully chosen for their talents and had to put up with tight restrictions and security so that their trade secrets could be guarded from outside competitors. In return they were comparatively well paid and the most loyal and outstanding of them were given an honorary samurai rank and were allowed to carry arms. The kilns always produced porcelains of the highest quality until their demise after the end of clan rule in the Meiji period; from the point of view of

innovative design, their golden age was during the first 30 or 40 years of the 18th century.

Nabeshima wares are typically round dishes that were usually made in sets of five, ten, or twenty, in addition to other dining wares, small cups and pourers for saké, and incense burners. Most of the plates and dishes have a characteristically high foot. They were decorated with underglaze blue or overglaze painting in colored enamels, and occasionally green celadon was used as a single glaze, or in combination with others. The decorative designs are sophisticated and imaginative and to a large extent were inspired by those used in textiles of the same period (see pages 276–277).

The perfection of Nabeshima patterns was achieved by first drawing the design on paper with a specially concocted ink, which was then placed reverse side up on the unglazed plate, the drawing being transferred to the clay surface by a little gentle rubbing. The same paper drawing could be used to transfer the design numerous times and so a uniform pattern could be made on sets of plates. The transferred lines were then carefully drawn over again with cobalt blue before the glazing and firing. Having been used only by the top echelons of the social order, Nabeshima wares are rather rare and unlike other Arita wares, which were exported to Europe, would have appeared outside their designated market only if given as gifts.

Ceramics of the Edo Period

During the 17th century, the discovery of polychrome ceramic decoration had a profound effect on many potteries throughout Japan, and to a large extent the Momoyama "tea taste" for quiet, subdued wares was replaced with an interest in the new decorative effects that could be achieved by using brightly colored enamels.

In Kyoto, a variety of kilns started to make stonewares known as Kyōyaki (a contraction of *Kyoto yakimono*, "pottery of Kyoto"), with a characteristic, transparent ash glaze of a light, yellowish-brown that shows a fine network of cracks when fired. The typical palette of enamels used in these wares consisted of blue, green, and gold and the designs were mostly pictorial, usually featuring flowers or plants. In addition to making the standard pottery shapes, the Kyōyaki craftsmen were often inspired to copy shapes in clay that were normally associated with other materials – fans or water buckets, for example. Looking at some of the Kyōyaki pieces, one gets the feeling that apart from making wares that are meant to be used, the potter used clay as a "canvas" for his own artistic expression. For the first time, famous potters in Kyoto were associated with their pots just as painters were associated with their paintings, often by signing them or impressing with a stamp, whereas previously all potters had worked anonymously – the many unsung heroes of a long heritage.

Nonomura Ninsei (about 1574–1660/6) was one of the earliest to develop the Kyōyaki wares,

Nabeshima ware dish

Edo period, early-18th century, L 18.5 cm, Hatakeyama Collection, Tokyo

This free-form small dish shows the highly sophisticated artistic sense of design and pattern to be expected of Nabeshima wares, which were made for exclusive use by the nobility. The pale blue–purple body glaze forms a background for an extraordinary band of chrysanthemum flowers and leaves in yellow, black, and green, in which the white body has been left unpainted to form the mass of each bloom.

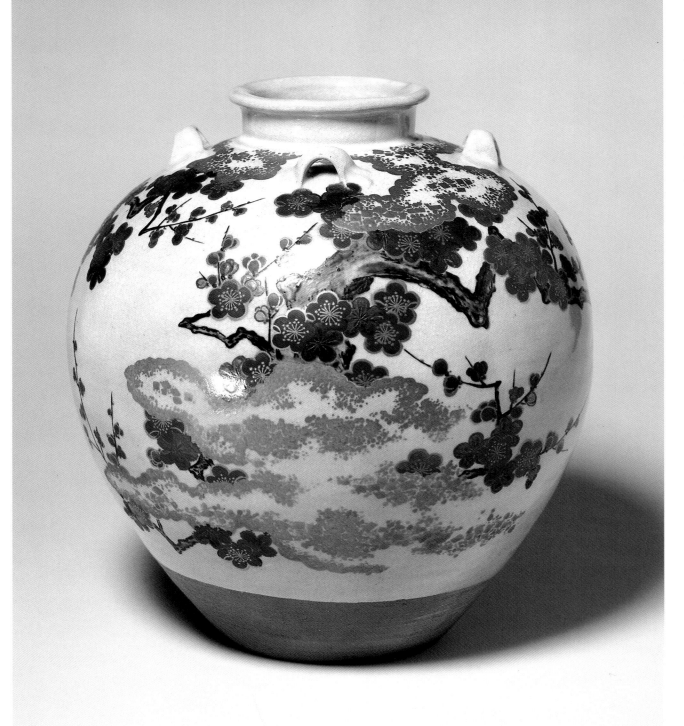

first making utensils for the tea ceremony, and then, with great technical aplomb, concentrating on making pots that were exquisitely painted with fine colored enamels used together with gold and silver. He borrowed subjects freely from the Kanō and Rimpa schools of decorative painting, which were thriving at the time, using exuberant colors and expressive designs that in his hands were carefully controlled with taste and skill (see above). However, the easy availability of too many decorative materials, combined with the new, more controllable firing technology, inspired many Kyōyaki potters (and Arita potters as well) to go "over the top" with decoration and produce pieces that at times can seem to be in somewhat doubtful taste. This decline continued in some kilns until reaching a nadir in the Meiji period with the

Satsuma export wares where, perhaps to cater to the Victorian taste of markets in the West, form and purpose was completely sacrificed for the sake of elaborate over-decoration.

A generation later, Ogata Kenzan (1663–1743) often worked in collaboration with his elder brother, Ogata Kôrin, who was perhaps the most illustrious of the Rimpa school of painters. Often Kenzan would make the ceramics (generally for tea ceremony use) and Korin would execute the painting, though many works were made and painted by Kenzan himself. As painting goes, his works are rather unpretentious, but he succeeds in treading the rather dangerous path of balancing the use of bright enamel colors with good taste in order to capture the mood of a season. At first sight they may seem artless but in fact his wares reveal a

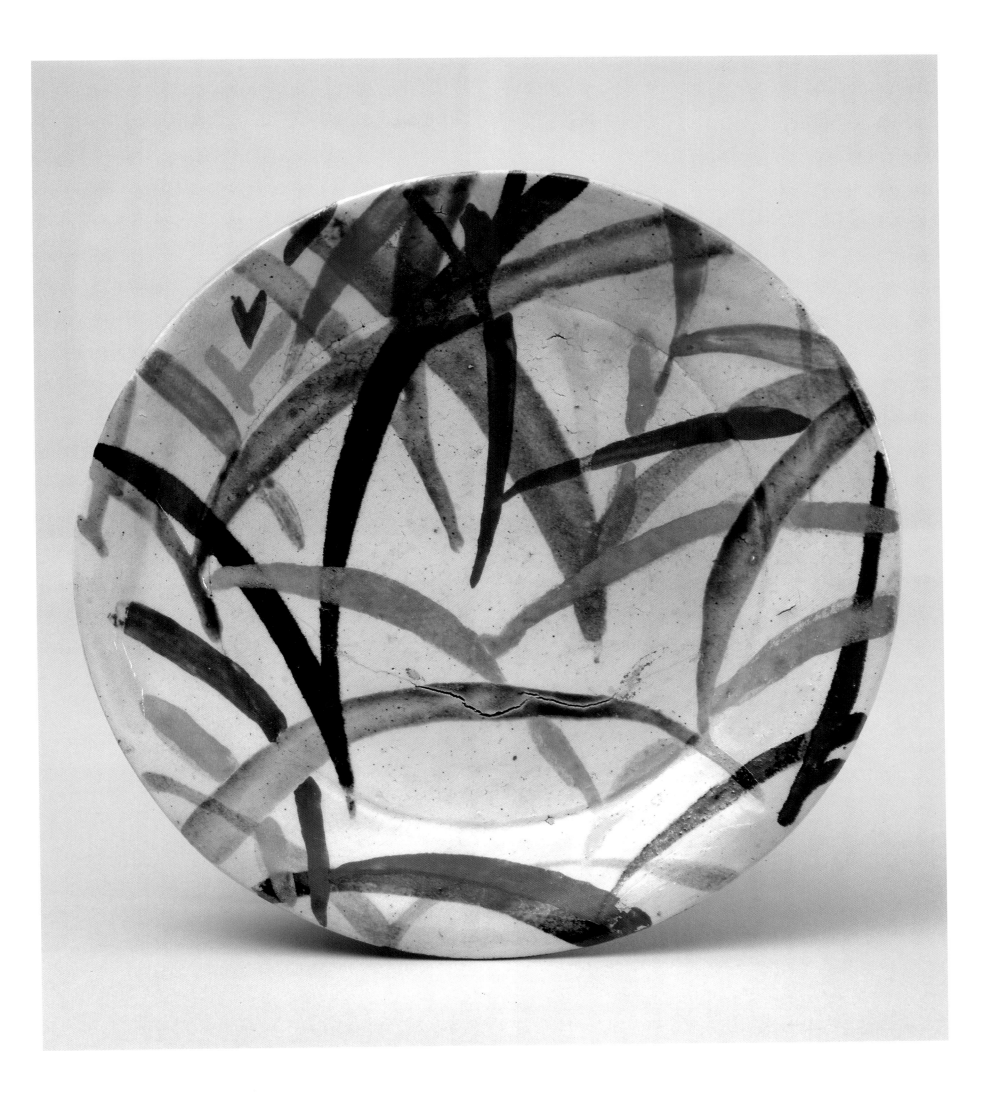

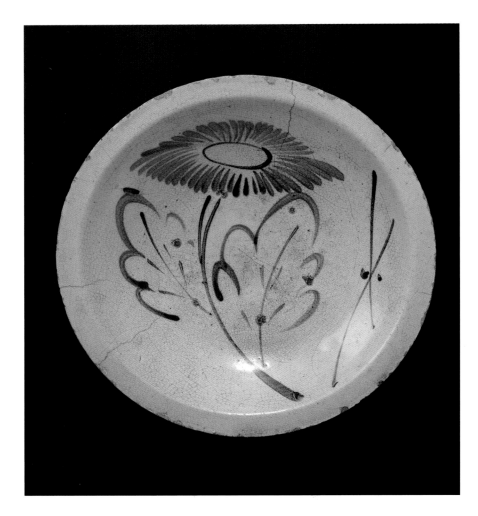

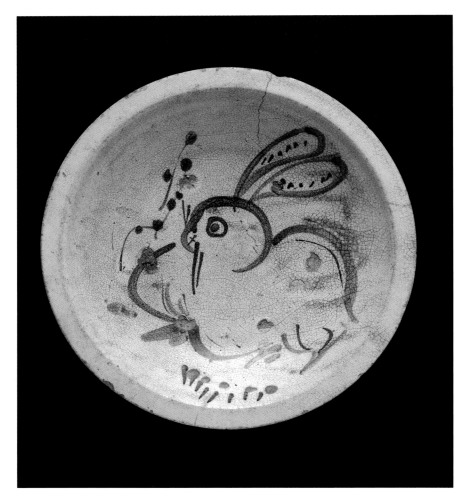

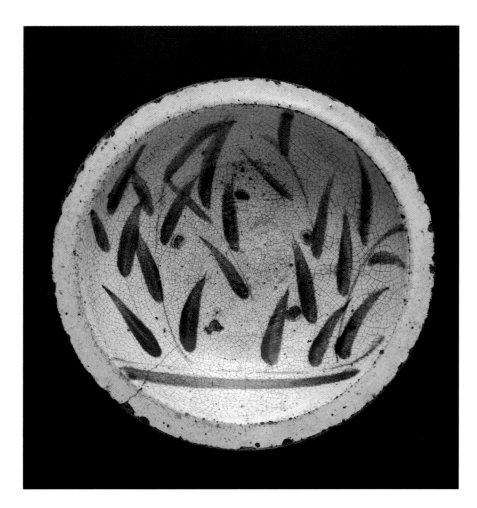

E-zara

Late Edo period, early-19th century, Seto ceramic, dia 27 cm, Jeffrey Montgomery Collection, Lugano

A chrysanthemum stem in bloom in light blue and rust-brown with a suggestion of a trellis. The whole piece is coated with a light, cream-colored, finely crackled glaze. Traces remain of the five "spurs" that separated the stacked plates while being fired in the kiln.

E-zara

Late Edo period, early-19th century, Seto ceramic, dia 27 cm, Jeffrey Montgomery Collection, Lugano

A crouching hare is portrayed alongside a roughly sketched flower in light blue and rust-brown colors. The whole piece is coated with a light, cream-colored crackled glaze. Here too traces of a five-part firing stand can be recognized.

Andon-zara

Late Edo period, early-19th century, Seto ceramic, dia 23 cm, Jeffrey Montgomery Collection, Lugano

The plain silhouette of a snow-covered Mount Fuji-Yama with an aubergine lying in front of it was produced by using a template. This combination symbolizes a dream bringing happiness. On the fruit are the arms of the Asano family, consisting of two crossed falcon feathers. The plate is covered with a slightly porous, cream-colored glaze; the decoration consists of a rust-colored glaze dabbed on with a sponge.

E-zara

Late Edo period, early-19th century, Seto ceramic, dia 27 cm, Jeffrey Montgomery Collection, Lugano

E-zara means "picture plate." The traditional Seto kilns produced these ceramics with a wide variety of painted motifs; they were primarily used for serving food. This piece presents a very lively picture. The brown stems and blue leaves may represent a willow, dwarf bamboo, or a type of reed. The whole piece is coated with a transparent, straw-colored crackled glaze. Five indentations indicate the brackets that prevented the stacked-up plates from sticking together during firing. The chips and cracks caused by years of use enhance the character of this beautiful piece.

Andon-zara

Late Edo period, early-19th century, Seto ceramic, dia 22.5 cm, Jeffrey Montgomery Collection, Lugano

Andon-zara means "lamp plate." The flat pieces are occasionally also called *abura-zara* ("oil plates"), because they caught the dripping wax from candles or oil from lamps. In the Late Edo period the Seto kilns produced these pieces in great number. This plate shows the unusual motif of overlapping pieces of charcoal (painted in underglaze with iron pigment coloring) that reveals the considerable inventiveness of an artist who was inspired by such everyday material. The plate has the typical clear Seto glaze with a fine mesh of crackles; it was partly dipped into a dark green glaze of the Oribe type which seems to lend an earthly quality to the "heavenly body" of the pieces of charcoal hovering above.

Bowl

Edo period, 17th century, Karatsu mishima ceramics, dia 30 cm, Jeffrey Montgomery Collection, Lugano

One of the ceramics produced by the traditional kilns of Karatsu was known by the name mishima. The production technique reached Kyushu through Korean immigrants. All mishima ceramics have a white slip, which in this case was applied to the engraved pattern on the clay and later rubbed off. The white slip settled in the depressions of the pattern and formed a sharp contrast with the dark clay. The bowl was glazed before firing.

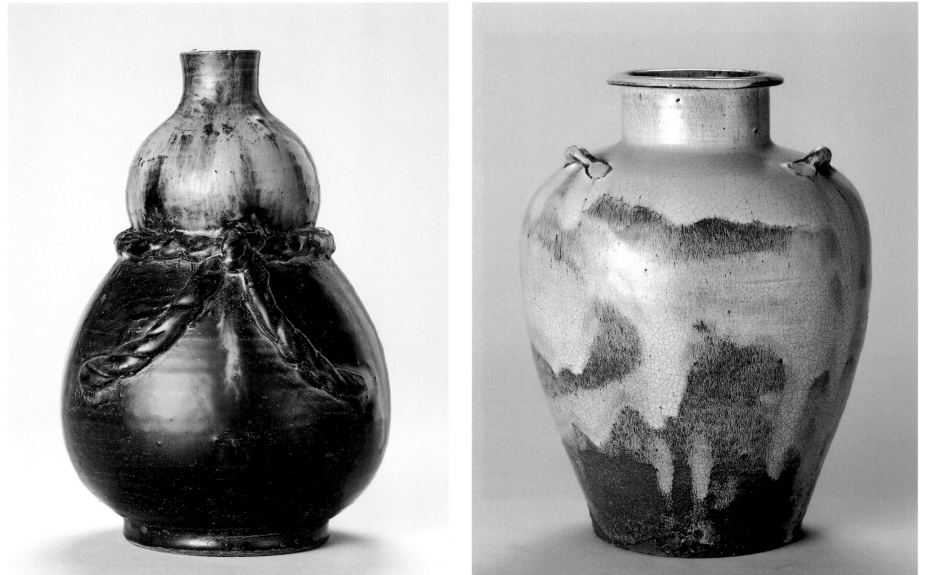

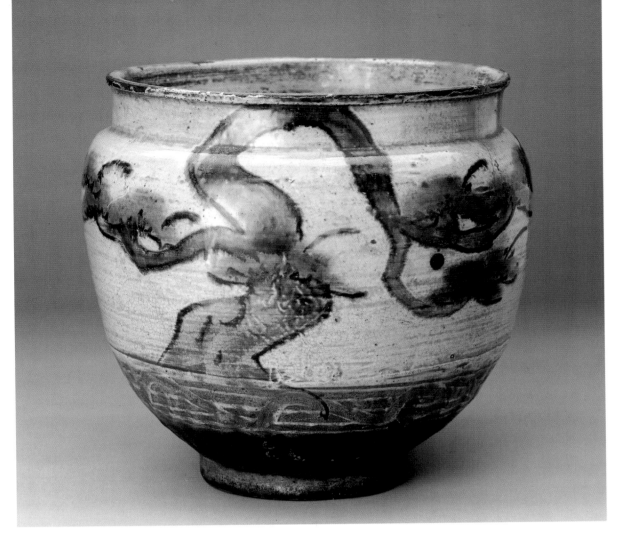

sure eye and a sense for adapting a painted design
to a three-dimensional object. His works can be
roughly divided into two groups of low-fired
pottery, most of which are embellished with his
own signatures: plain, transparent-glazed wares
with dark underglaze paintings that have often
been inspired by his training in Zen; and bold,
brightly colored enameled pieces (see page 279).

At the same time that the polychrome revolu-
tion was going on in Arita and Kyoto, many
country kilns established themselves and made
unsophisticated everyday wares for the use of local
markets. They flourished throughout the Edo
period but then many faded away after the Meiji
restoration, being unable to compete with the
larger centers of ceramic production. The Six
Ancient Kilns also began to cater less and less to
the tea aesthetes, who were becoming enamored
with the new colored wares, and returned to
making a variety of sturdy pots that, while artlessly
and unpretentiously created and decorated, can
still have a strong aesthetic appeal.

The Seto kilns were known in the later Edo
period for their *e-zara* (painted plates), which
appear in the form of shallow dishes for serving
food (see page 280, top), and small flat plates
known as *andon-zara* (lantern plates), which were
used to catch any falling wax or oil (see page 280,
bottom). They were typically decorated with
delightful, hastily drawn designs in underglaze
blue or iron oxide and have the characteristic,

crackled transparent straw-colored glaze of the
Seto kilns. Occasionally, they are seen with the
rich, green, glassy overglaze embellishment
normally associated with the Mino Oribe wares.
Without any artistic training, the potters who
made these common wares took their inspiration
from what they saw around themselves: trees and
plants, a rabbit or horse, sometimes with simple
inscriptions, and always executed with a fresh,
lighthearted touch that makes one like to imagine
(perhaps not necessarily correctly) that they lived
in a carefree Arcadia.

In Kyushu, a bewildering number of folk kilns
were established throughout the north and west of
the island, partly under the influence of the large
number of Korean potters that had arrived after
Hideyoshi's military incursions. The Shōdai kilns
in Kumamoto Prefecture were established by two
potters who had moved from Agano in the early-
17th century, and there started to make domestic
wares using Korean techniques but adapting them
to Japanese tastes. The bodies are usually of a dark
clay and have beautiful glazes that range in color
from white to amber and a pale, blue-purple,
which were applied in a very liquid form so that
they form a semitranslucent veil draping the pot
(see opposite, bottom right).

The Kyushu folk kilns usually made "dark
wares," in other words with a body of dark-colored
clay, in contrast to the "white wares" produced by
the kilns that used fine kaolin such as Arita, where

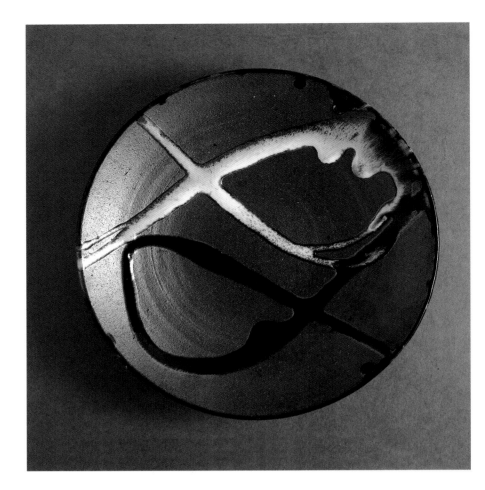

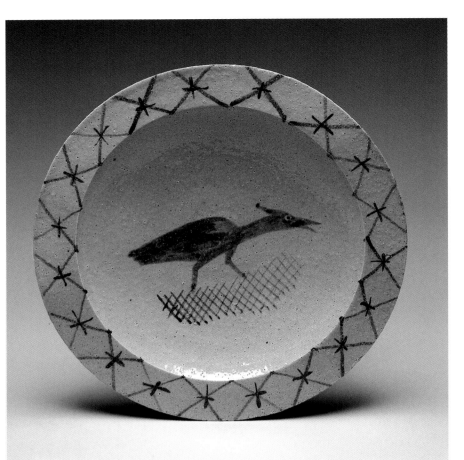

they catered to a more affluent market. As the folk wares were largely destined for use in gloomy farmhouse kitchens, the potters resourcefully used a variety of decorative techniques with simple materials at hand in order to make them more attractive. Patterns were sometimes carved into the clay body before glazing, or impressed with a stamp design which would then be wiped with a white slip which remained in the recessed parts and stood out against the dark background. Some of the Satsuma kilns in the southeast of the island were known for employing clay moldings that were used to make a three-dimensional decoration on the pot before glazing (see page 282, bottom left). And at the Yumino kilns, which were located among those of Karatsu in north Kyushu, the pine trees of the nearby coastline were used as a decorative subject (almost a trademark) and were painted in brown and green flourishes on a white slip before the whole pot was covered with a clear glaze and fired.

The Modern Period

All of these folk wares were taken for granted by the country farmers and ordinary people who used them, and an awareness of the quiet beauty and artistic quality of these everyday objects only appeared during the present century. Yanagi Soetsu (1889–1961) was the pioneer in writing about the beauty of craft, and it was he who coined the word *mingei* (from the Japanese words

meaning "folk" and "craft") to refer to the "artless" art of craft. He started a *mingei* movement, which gathered numerous followers, including the English potter Bernard Leach and various native Japanese potters, who agreed with his philosophy and who devoted themselves to creating crafts as objects of beauty. Shōji Hamada (1894–1977) was one of this group who worked with Leach in England for four years before returning to Japan and establishing his kiln in the pottery village of Mashiko, to the north of Tokyo. Along with his associate, Kawai Kanjiro, he became widely known in the West as well as in his own country for his sturdy ceramics and decorative designs that, while being perfectly straightforward, reveal a highly trained eye and a deep understanding of pottery techniques (see above, left).

One of the more colorful potters of the early to mid-20th century was Kitaōji Rosanjin (1883–1959), who started his career in calligraphy and seal carving but entered the field of ceramics in his early thirties. His main interest was food and its presentation, and this was always in his mind when making pots – or rather having them made, for he maintained a studio of workers who made the basic wares under his direction, he himself attending to the final shaping details and any painted decoration. From the point of view of inventing new forms or glazes, his works rarely broke new ground, but he excelled in having the uncanny genius of being able to extract the essence of classical pottery – he made Shigaraki wares that

Left
Large stoneware plate

Shōji Hamada (1894–1977)

Made about 1953, dia 24 cm, Jeffrey Montgomery Collection, Lugano, Switzerland

In this piece Hamada has applied, then removed, a black glaze to leave a non-reflective background against which is contrasted two abstract "fish" achieved by pouring thick, shiny black and white slips.

Right; and opposite, bottom
Two Seto ware dishes

Kitaōji Rosanjin (1883–1959)

Mukyō Gallery, Tokyo

Left: A dish with a design of a heron on cross-hatching (dia 28 cm).

Opposite: A small dish with an abstract design in iron oxide (dia 32 cm)

Rosanjin had a perceptive genius for recognizing artistic features of traditional wares and enhancing them in his own works.

Opposite, top
Shigaraki "Object"

Makoto Hashimoto

Modern period, 1990s, L 77 cm, W 38 cm, private collection

This monumental piece is constructed of interlocking blocks of clay. It would be suitable for displaying food, or with skill, for modern-style flower arrangements.

Photograph by Narimi Hatano

were more Shigaraki-like than the originals, and Shino wares that were more Shino-like than their originals, though always with a keen awareness of how they would appear associated with food (see page 284, right, and page 285, bottom).

The past 30 years have seen a wealth of exciting works by potters who have progressed from making wares that are purely utilitarian (however fine) to using clay and glazes as a medium for sculptural expression. Some of the more interesting pieces are still essentially usable, but challenge the viewer to work out just *how* they may be used – such as the "flower vase" by Makoto Hashimoto that comes to life and reveals a monumental beauty when it is wet and combined in some way with foliage or flowers (see page 285, top). Born in 1946, Masamichi Yoshikawa, who lives and works in the ancient pottery area of Tokoname, has mastered the skill of making porcelain with the fine bluish-white glazes that resemble those of Chinese Song dynasty Ch'ing-Pai wares, but with forms that could be described

as architectural (see above). A similar Ch'ing-Pai glaze is seen on the fine flower vases made by Kenichi Iwase, who works with a variety of clays that he buys from different parts of the country to make stonewares as well as porcelain (see opposite).

Ichiro Harada draws on his upbringing in the Bizen area for inspiration in his works, which are often made in organic shapes that can be used for flowers or food, or that can stand in their own right as sculptures (see page 288). Slightly more orthodox in their choice of forms and glazes, but still making wares that have a very modern appeal, are Jinenbo Nakagawa from the Saga area, who uses traditional Karatsu clays and glazes; and Kuroemon Kumano, who lives and works in Echizen, and again uses traditional clays and techniques to make pieces that are sturdy and powerfully shaped. Kumano has refined a procedure where the temperature in the kiln is pushed up to 1,500 degrees centigrade (2,700 degrees fahrenheit) at the end of firing which gives the glazes a

Bizen leaf-shaped dish

Ichiro Harada

*Modern period, 1990s, L 64 cm,
private collection*

Harada has used the characteristic, sticky
red clay of Bizen to make this leaf-shaped
dish, which is very different from the
traditional designs normally seen in wares
of these kilns. While being appropriate for
serving food – especially during the fall
months – this piece also stands by itself
as a sculptural object.

Photograph by Narimi Hatano

"dried out" rather than a glassy surface (see page 289, top).

One of the veterans of modern ceramics is Takako Araki, who was born in Hyogo Prefecture (near Kobe) in 1921, and had the opportunity to study painting and sculpture in New York. Perhaps better designated as a ceramist rather than as a potter, she has chosen the rather extraordinary theme of the Bible, which she depicts as rotting, burned, or otherwise distressed, in her rather disquieting and mysterious works (see opposite, bottom).

The few potters and their works mentioned here are but a narrow selection from the exciting world of Japanese ceramics today, and it would be a full-time occupation keeping up to date with the rising stars. Many fall under the influence of Western artistic fashions and one frequently detects an echo of the artists Frank Stella or Brancusi in some of the sculptural pieces. Others are inspired by works from the historic ceramic legacy of Japan, though with varying degrees of success: it is not easy to make something better than the great works of each genre, be it Shigaraki, Shino, or Seto, and many attempts are boring and derivative. But just as a pencil and a sheet of paper is sufficient for infinite expression in the right hands, so too is earth and fire, and it is certain that potters of Japan will have more surprises for us in the future.

Echizen ware dish with handle

Kuroemon Kumano

Modern period, 1990s, L 42 cm, W 36 cm, H 19 cm, private collection

Kumano works in the Echizen area and uses traditional techniques for making strongly formed stoneware pieces with a natural ash glaze. He occasionally pushes the kiln temperature to a much higher level at the end of firing in order to achieve the attractive "dry" surface that can be seen on this pot.

Photograph by Narimi Hatano

Ceramic Bible

Takako Araki (born 1921)
W 27 cm, D 23 cm, H 16 cm, private collection

Taking the utilitarian field of pottery into a hitherto unexplored direction, Araki has specialized in making mysterious, rotting Bibles out of brittle ceramic that look as if they have been rescued from the wreckage of a burned-down building. The fragile effect of impermanence is even more strongly underlined as these objects are almost impossible to handle without damage, and pieces of the pages break off at the slightest touch.

Photograph by Narimi Hatano

Japanese Sculpture

*The art of sculpture in Japan is a tradition that has continued in some form
or another for nearly 5,000 years, and has been expressed in a variety of materials:
ceramic, wood, dry lacquer, metal, stone — all materials to be found in Japan — as well as
ivory and other exotic materials that have been imported from overseas.*

Nō mask *Ko-omote*

*17th century, H about 21 cm, Hatakeyama
Collection, Tokyo*

This mask represents a beautiful young
woman and was used in Nō plays such as
Kocho or *Funa-Benkei*. Even though the
mask is completely frozen in expression, a
skilled actor is able to convey a number of
moods and emotions by turning or tilting
his head slightly to change the way the
light falls across the mask.

Earliest Masterpieces

The earliest Japanese attempts to make objects in the round were an offshoot of the ceramic-making culture of the long-lasting Jōmon period, approximately 12,000–250 B.C. As there are no written records, the history of the country at that time is not clear, but even though from time to time there must have been considerable cultural cross-pollination with the Asian mainland, Japan was independently developing its own distinct culture. The Jōmon people survived by hunting and gathering the rich gifts of the seas, forests, and rivers; by the time that they had organized themselves into settled communities, they were also making earthenware vessels for the storage and preparation of food.

During such a long period of cultural evolution it was to be expected that human creativity would naturally find expression in the handling of wet clay, and the Jōmon period is noted for its legacy of extraordinary earthenware objects that are quite unlike any others anywhere in the world. Pots were made with elaborate decorations, and in a variety of shapes that reveal a fertile imagination and an astute sense of how to use the material.

By the Middle Jōmon period the modeling of these pieces had become so ornate that it is difficult to see how they could have had any practical use (see above). Some of the modeled forms on these pots are actually recognizable as reptiles or grotesque animals, rather than decoration, and so

this development can be seen to mark the beginning of sculpture in Japan.

During the Late Jōmon period, a separation can be seen of pottery for use (which became much simpler and less "baroque" than that of the middle period), and clay sculptures that demonstrate a very different artistic urge. Some of these are in the shape of animals or shells that would have been familiar to people who by necessity were living close to nature. Others, however, are of human forms and there are also masks that are truly extraordinary: one famous figure that was excavated in Miyagi Prefecture has strange bulbous limbs (which brings to mind the 20th-century Columbian artist Fernando Botero), with hands and feet that are diminished almost to points, and a body that is covered with a decoration indicating an elaborate sense of costume design (see above, right). What is most extraordinary is the head, which has huge round eyes with slits, and looks a little like that of a praying mantis or some other predatory insect. Also, the mouth and nose look more like the proboscis of an insect than anything human. Just what exactly was the purpose of these objects is a question often asked but so far there has been no answer. More imaginative interpreters have suggested that they were images of alien visitors; but along with most strange figures made by prehistoric or so-called "primitive" societies, they

were most likely connected with religious belief and ritual (see opposite left). More than anything else, they may have been inspired by dreams. What is interesting about these images is that those depicting a shell or a wild boar, for example, are naturalistic and recognizable, whereas the human-oid figurines bear almost no resemblance to reality.

Other objects were carved from stone, and because of the difficulty of working this medium, the shapes tended to be of an almost abstract simplicity. One such figurine, found in Akita Prefecture, has a tapering body with no feet, and arms ending in points across the breast. So far from nature are these objects that one can only presume that they too were used for magic or ritual. Other materials such as bone or horn were also carved to make objects that seem more likely to have been used more for bodily adornment than for any other purpose.

Sculptural activity seemed to have been diminished throughout the following Yayoi period (about 250 B.C.–A.D. 250), but it reappeared in force during the era of the great burial mounds – the Tumulus period (A.D. 250–552) – with the appearance of the spectacular earthenware *haniwa* figures. Although Japan was under considerable influence from the mainland at this time (and even the idea of huge burial mounds with accoutrements to accompany the departed had come from China), the *haniwa* figures are uniquely Japanese in form and concept. The word itself means "clay circle:" *haniwa* objects were placed, or rather half-buried, around the mound of the tomb to represent what was needed to go with the soul to the world beyond.

All sorts of baked-clay images are seen that provide a fascinating insight into life at the time: houses (see page 306), human figures, and animals – especially horses, which had been introduced from the mainland (see right, bottom). The placing of *haniwa* varies according to the subject depicted: the *haniwa* in the shape of houses were placed at the top of the mound, while animal and human forms were placed in a roughly circular pattern around the mound. One legend suggests that the human and animal figures replaced earlier live sacrifice – which certainly had been practiced in China during the much earlier Shang dynasty – but there is little evidence that this was true in Japan. Terracotta images, however, have a much grander precedent on the mainland, and one has only to look at the enormous clay army of warriors and horses buried with the Qin Emperor near Xi'an to find a possible source of inspiration.

Haniwa were hollow and made in one piece standing on a cylinder – the part that was buried in the ground – so that the image was visible above. Many of these human figures show a highly advanced sensitivity and sculptural flair, with the eyes and mouths cut through to the dark hollow within to create a powerfully haunting impression, as though we could peer through them to the souls of their makers. Some are stern-faced warriors with carefully sculpted armor and headgear (see

Haniwa statuette

Tumulus period, 5th–6th century A.D., H 39 cm, Collection of the Arthur M Sackler Gallery, USA

Clay figures like these lay half-buried on huge grave mounds dating from the pre-Buddhist period. They were obviously intended as grave offerings, and may have replaced earlier human sacrificial victims. The eyes and mouth cut through to the darkness within create a haunting expression.

Clay vessel in the form of a shell

Late Jōmon period, L 16.6 cm, National Museum, Tokyo

During the Late Jōmon period, clay objects were made with great artistic skill, and so were not just regarded as utilitarian items. The vessel pictured here is in the carefully observed form of a whelk, a shellfish that is abundant in Japanese waters.

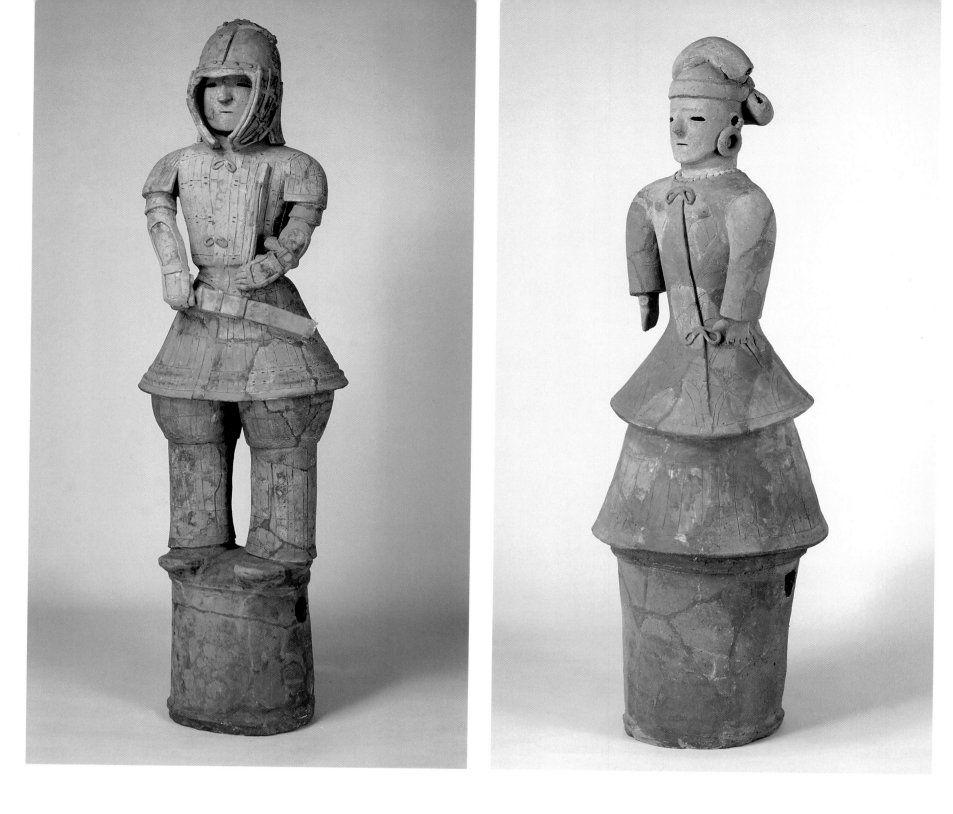

Left
Haniwa soldier

Tumulus period, 6th–7th century A.D., terracotta, H 130.5 cm, National Museum, Tokyo

A soldier is wearing riding breeches, helmet, and armor.

Right
Haniwa woman

Tumulus period, 7th century, H 127 cm, National Museum, Tokyo

This figure of a woman wears a long dress neatly fastened at the front with ribbons, and a soft cloth hat. Her earrings are particularly noticeable.

above, left), while others are smiling elf-like creatures employed to liven up the final voyage. These human figures are occasionally painted with a red pigment that could signify the marks of tattooing, or even early makeup. The horses are shown caparisoned with all of the equipage needed for riding, and reveal a wealth of information on how the animals must have been used for military purposes (see page 293, bottom).

The Tumulus period marked the end of prehistoric Japan and during the subsequent Asuka (A.D. 552–645) and Nara (A.D. 645–794) periods, the old culture was overwhelmed by the wholesale importation of mainland ideas on an unprecedented scale. Buddhism and the adoption of

Chinese writing had a profound effect on the course of thinking and culture in Japan; similarly, city planning, architecture, bureaucracy, clothing, and lifestyle, were all imported, copied, and then, in that inimitable Japanese way, distilled and refined.

Religious sculpture

The 7th to the 14th centuries mark the great age of Japanese sculpture, most of it Buddhist, and to a much lesser extent, Shintō, which was the native Japanese religion. Many examples from these early times are still preserved, with the greatest number to be found in the temples of Nara, Kyoto, and

Kamakura. The earliest are cast in bronze, which was sometimes gilded, and they are almost indistinguishable from the Buddhist images imported from the mainland, from which they were copied. But as wood was a familiar and abundantly available material in the heavily forested mountains of Japan, it was soon the chosen material for making the colossal number of images that were needed to furnish temples as Buddhism spread across the country. The native Japanese skill in working with wood combined with an intense faith led to a creation of some of the finest religious sculpture in the world, a tradition that was to flourish and continue for well over 700 years.

Located just a few kilometers southwest of Nara city lies the temple complex of Horyu-ji. It is spaciously laid out in an asymmetrical plan with a five-storied pagoda, a great hall, lotus pond, and various subsidiary buildings, all in a serene setting with wooded hills behind and old pine trees planted in the grounds to soften the architectural lines. From time to time, fires have necessitated various restorations, but the original buildings that still stand date from the 7th century and were constructed to mainland designs with the help of Korean craftsmen. They are the oldest wooden buildings in the world, and within them are some of the earliest treasures of Buddhist art in Japan. Of almost identical design as that of images seen in the late Wei dynasty in China a century before, but on a much larger scale, the famous gilt-bronze Shaka Triad, which was cast in A.D. 623, shows the seated Buddha with a standing bodhisattva on each side, and a huge mandorla (a halo around the body) behind in the shape of a lotus petal. The whole arrangement is almost completely symmetrical, but for the subtle arrangement of the "waterfall" of drapery in front, and the different gestures of the right and left hands of the figures, which save the work from appearing too static.

One of the earliest wooden images is to be seen in an 8th-century, octagonally shaped building in the compound known as Yumedono (the Hall of Dreams). The statue is of the Bodhisattva Kannon (Chinese: *Kuan Yin*), perhaps the most loved of the Buddhist pantheon, who, around the 12th century or so, took on female characteristics and came to be considered as the Goddess of Mercy. The single statue was made in the 7th century before the construction of the building in which it is housed, and shows the beautifully proportioned deity standing on a lotus pedestal with a mandorla behind the head. The head is fitted with a high crown of gilt-bronze decorated with jade, and the graceful hands hold a sacred jewel (the Sanskrit *cintāmani*, which can make wishes come true). The robe falls away on each side of the figure in splayed tiers that look like the profile of a Christmas tree – exactly the same as seen on Chinese Buddhist images of the Six Dynasties.

To the side of Horyu-ji is a little nunnery called Chugu-ji, which contains one of the most moving images of this early period: the Miroku, the Buddha of the future who has postponed gradu-

ating to the highest level in order to remain as a bodhisattva and help to save mankind. The wooden statue is almost identical to images of the Miroku that can be seen in Korea, and shows the bodhisattva seated with his left leg pendant, the thigh serving as a rest for his crossed right foot, in the meditative pose known as *hanka-shi-i*. The head is carved with two stylized top-knots which emphasize the youthfulness of the deity, and behind there is a mandorla with a design of flames encircling a lotus. The whole statue is almost black as a result of centuries of incense smoke, but if anything this soft dark sheen even enhances the effect of the statue, and it seems to radiate the serenity and compassion that Miroku represents. But the most unforgettable aspect of this statue is the gesture of the raised right hand with the middle finger almost touching the chin – a pose that is so mysteriously calming, so human, that one can almost sense the image quietly breathing.

The following few centuries saw a bewildering proliferation of religious imagery in various materials, forms, and styles as Buddhism spread throughout the country and established its place in a gentle cohabitation with the native Shintō customs. Wood was preferred above other materials, although bronze and iron were occasionally used, as were, to a lesser degree, dry lacquer, clay, and stone. Craftsmen soon refined special techniques for making large images out of blocks of wood, with the inside hollowed out so that the sculpture would not split as the wood dried and shrank. The statues were sometimes painted or coated with a kind of plaster made of lacquer mixed with powdered stone to make a ground for adding fine details; from around the middle of the 12th century, eyes were constructed from a rounded piece of crystal covering a piece of paper that had been painted with a black pupil to create an effect that can be uncannily lifelike.

As there are numerous Buddhist deities and Heavenly Beings that appear in many different manifestations and attributes, a great variety of statuary has been created to depict them. A rather simple but convenient classification would include the following:

1. Five types of Buddha (Shaka, Dainichi Nyorai, Miroku (see page 295), Amida, and Yakushi), each of whom wears the simple robes of a priest, with one arm and part of the torso uncovered.

2. A number of bodhisattvas (Japanese: *bosatsu*), who, even after having accumulated enough merit to become Buddhas and achieve eternal bliss, choose to stay and help the souls of unfortunates on earth (see page 300).

3. Groups of Myō-ō divinities with ferocious expressions whose duty was to thwart evil (see page 301). This includes various heavenly beings (Japanese: *tenbu*), divinities mainly recruited from Hinduism, who serve as guardians. Separate from this pantheon, but still important in the religious sculptural tradition, are images of Shintō deities and noted earthly priests.

Seated Maitreya
(Detail), Old Silla, Korea, 7th century A.D., gilt bronze, H 93.5 cm, Courtesy of the Cultural Service, Korean Embassy, Tokyo

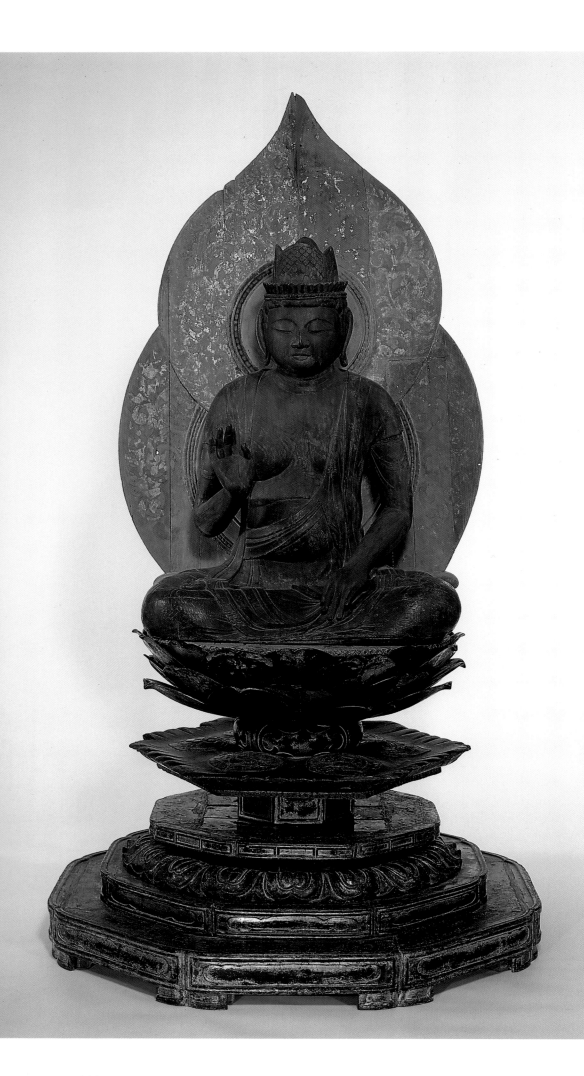

Shintō deities are usually simple figures shown wearing the dress of the imperial court of Japan rather than the Indian or Chinese priestly costume seen on Buddhist images. Except for the few in museum collections, they are rarely seen as they were hidden away in the dark inner recesses of shrines, in contrast to Buddhist figures, which were always on view, and in fact the main focus of temple rituals. Shintō means "the way of the gods" and its origins go back into prehistoric times, long before the arrival of Buddhism. The Shintō gods and spirits can be associated with natural objects that inspire a certain reverence, such as an unusually ancient tree or a strange-shaped rock; or with human figures connected to the imperial family, who are descendants on Earth of the sun goddess. (Whereas in the West, the word "emperor" refers to the monarch of an empire, the Japanese word *tennō* has a connotation with heaven. The position of the emperor in Japan has much more of a spiritual aspect than that of a worldly ruler, and this is indicated further when one notices the name of the bureaucracy that governs the imperial household, *kunaicho*, also refers to the "administration within the shrine".)

Shintō sculptures are almost all carved from a single block of wood, and have pure, simple lines, and expressionless faces. Not having all of the complex manifestations that are seen in images of the Buddhist pantheon, these figures all resemble court figures and as deities are difficult to identify. One Shintō figure that is more recognizable is that of Hachiman, the deified figure of the emperor Ojin (A.D. 201–312) who is usually shown bareheaded and looking a little like the Bodhisattva Jizō, but wearing courtly costume instead of priestly robes (see pages 298–299).

The entrance to a Shintō shrine is marked by a *torii*, a gateway made of a rafter supported by two columns, and on each side of the path one usually notices two beasts with bushy tails and faces that look a little like Pekingese dogs. These are the *karashishi* (loosely translated as "lion dogs") and

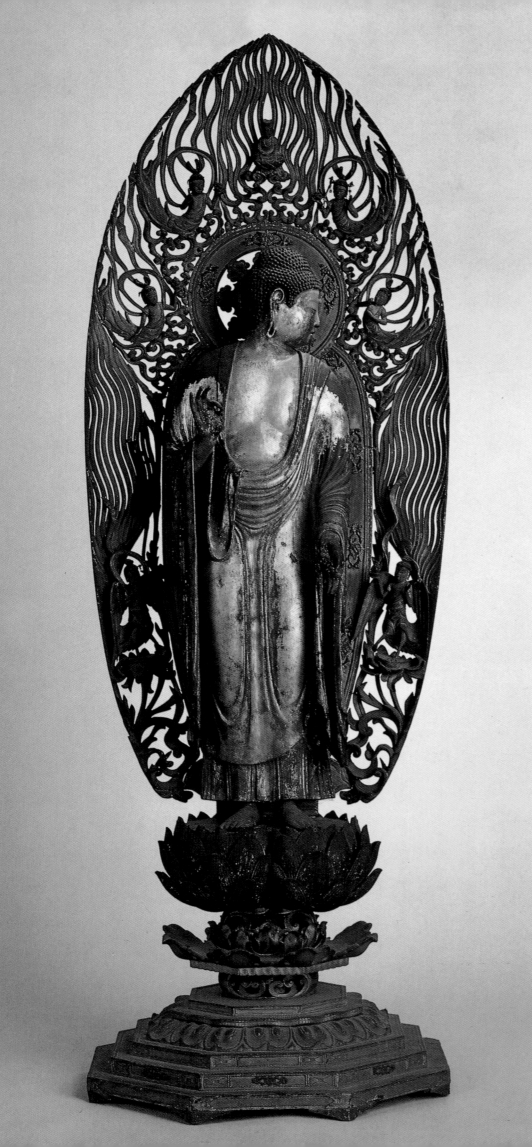

Left and below

Mikaeri-no-Amida

Kamakura period, the Buddha Amida looking back over his shoulder, wood, H 77 cm, Zenrin-ji, Kyoto

This statue is from the Zenrin-ji, Kyoto, the main temple of the Jōdo shu (Buddhism of the Pure Land). The temple was founded by the priest Shinshō in AD 855 and today is generally called Eikandō in honor of the seventh abbot, Eikan (1032–1111), still popular today for his humanity and virtue. The legend recounts how on 15 February 1082 the Buddha Amida descended from the altar in order to precede Eikan as he walked around the altar praying and chanting. Eikan was so amazed that he stopped and then noticed how the Buddha looked back at him over his left shoulder and reproved him with the words: "Eikan, you're dawdling." Eikan later had a sculptor make a statue of Amida in just this position.

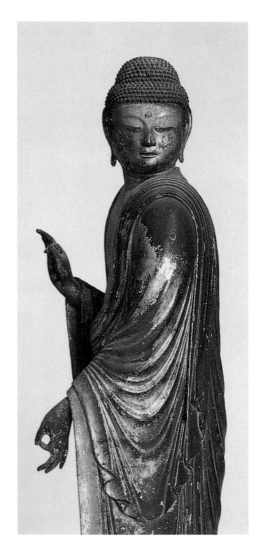

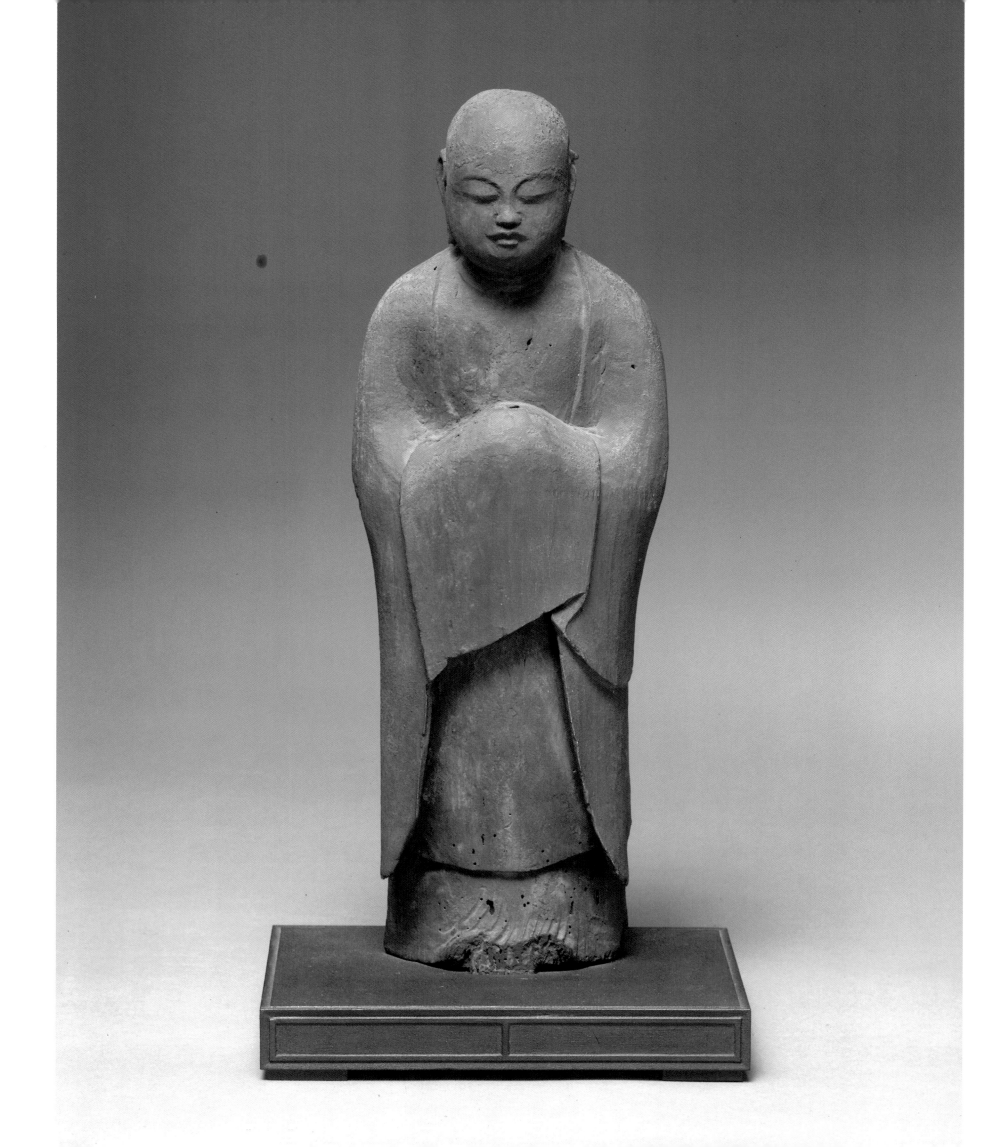

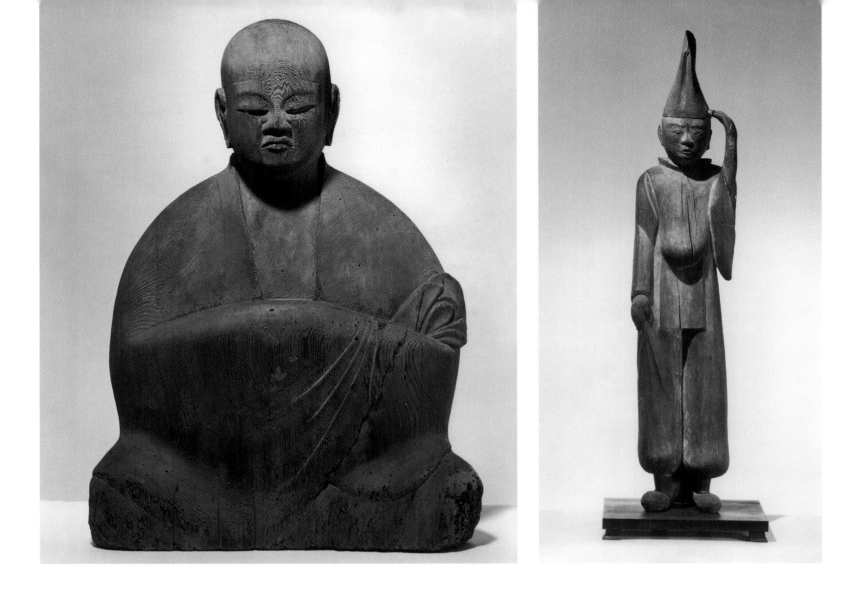

have mythical origins in China, where they are often shown with peony flowers or playing with an intricately pierced ball; at a Shintō shrine, by contrast, they serve as fierce guardians – one with its mouth open, the other with its mouth closed. They are carved from either stone or wood, and as they were usually installed outside, many have been beautifully weathered by the sun, wind, and rain.

The Buddhist statuary of the early Heian period appears with rather exaggerated features (thick limbs, rounded faces, and bulging bellies) and to some extent still resembles the images found in China and Korea. Contact with the mainland diminished for a while after the middle of the 9th century and from this point on Japanese carvers developed their own sculptural styles independently from any mainland influence. Late-Heian statuary seems to be more serene and calm, reflecting the belief in the Pure Land sect and the Amida Buddha, a form of Buddhism that offered more hope to the ordinary person than had the previous rather aloof and secretive Esoteric form. To satisfy the demand for furnishing new temples with the appropriate images, sculptors cooperated in workshops and some became celebrated for their accomplishments.

The 11th-century sculptor Jōchō was one of the first of a line of noted sculptors who specialized in temple images. No doubt his greatest masterpiece is to be seen in the Byōdō-in temple in Kyoto (the one shown on Japan's 10-yen coin), now a designated National Treasure. The Byōdō-in was built on the orders of Fujiwara Yorimichi (992–1074), of a powerful military clan, for the purpose of depicting on Earth the paradise that could be entered by the proper practice of Pure Land Buddhism. It consists of a three-meter (nine-feet) high Amida Buddha seated in meditation on a multi-petaled lotus with an intricately carved mandorla behind, the entire image covered with gold leaf. The face of the Buddha is rounded, clearly defined, and so calm and beautiful that it became the ideal model for religious sculptors until the following Kamakura period. Hanging on the walls around the Buddha are 52 small bodhisattvas in the form of angelic musicians, each floating on a cloud, and assembled to make a sculptured image of the Amida *raigo* – the descent of the Amida Buddha to Earth to take the soul of a believer back to heaven. Each bodhisattva is exquisitely carved with flowing drapery; some are dancing, and some are seated or kneeling while playing the instruments of heaven. The effect is one of ecstatic grace and lightness, and, apart from demonstrating the inspired sculptural genius of Jōchō, they also reflect the deep faith that for many

provided the only possible hope of alleviating the misery of their life on Earth.

Jōchō's style was imitated for several generations until a variety of new influences led to the appearance during the Kamakura period of a more vitally realistic sculpture (see opposite) that radically contrasts with the serene and contemplative images of the late Heian. Kōkei and his followers Unkei and Kaikei became the main figures of the Kei school of sculptors who were vigorously active from the late-12th, through the early-13th centuries, and who refined the techniques of woodblock construction, and decoration with cut-out strips of gold leaf. Other artists were heavily influenced by the Kei school and the Kamakura period saw religious sculpture reach an apotheosis beyond which any further progress or artistic development was difficult to imagine.

An example of Kamakura sculptural genius is seen in the statue of a far less joyous character than the bodhisattvas of the Byōdō-in: the *Ankoku Dōji* in the Hōshaku-ji temple in Kyoto. Depicting one of the attendants of the King of Hell, this figure is carved from joined wooden blocks with remaining traces of a polychrome finish. He is shown dressed in a simple, peasant shirt kind of garment over trousers that are tucked into his boots, and he is seated on a stool covered by an animal skin. On his head is a strange hat with propeller-like "wings" sticking out from each side. His face is frowning in the knowing but impartial manner of a judge, and his eyes, which are made of inlaid crystal, reveal with cold expression the nature of his terrible duty. In his hands he holds a wooden board and a brush poised to record the judgements handed out to the sinners brought before him. The feeling invoked is one of dread and terror, and testifies to the sculptor's imagination and expressive genius; this image is just as inspired as the Byōdō-in bodhisattvas, but with a totally different and terrifying effect.

The Kamakura period is also noted for portrait sculpture depicting the more earthly figures of nobles, military leaders, and worthy priests and monks, particularly those of the Zen sect that had

Below left
Bodhisattva

*Suiko period, AD 552–645, H 81.2 cm,
Collection of the Freer Gallery of Art, USA*

This very early Japanese Buddhist figure is carved from one single block of wood, which has been lacquered and at one time covered with gold leaf.

Below right
Jizō Bosatsu

*Kamakura period, late-13th century, wood with gold-leaf decoration, H 35.5 cm,
Collection of the Freer Gallery of Art, USA*

This bodhisattva was especially popular in Japan as the saviour of those souls condemned to Purgatory or Hell, and as a patron saint of women and children. He carries a jewel in his left hand to light the way when venturing into the Regions of Darkness. These small images are seen at roadsides where children have died in road accidents.

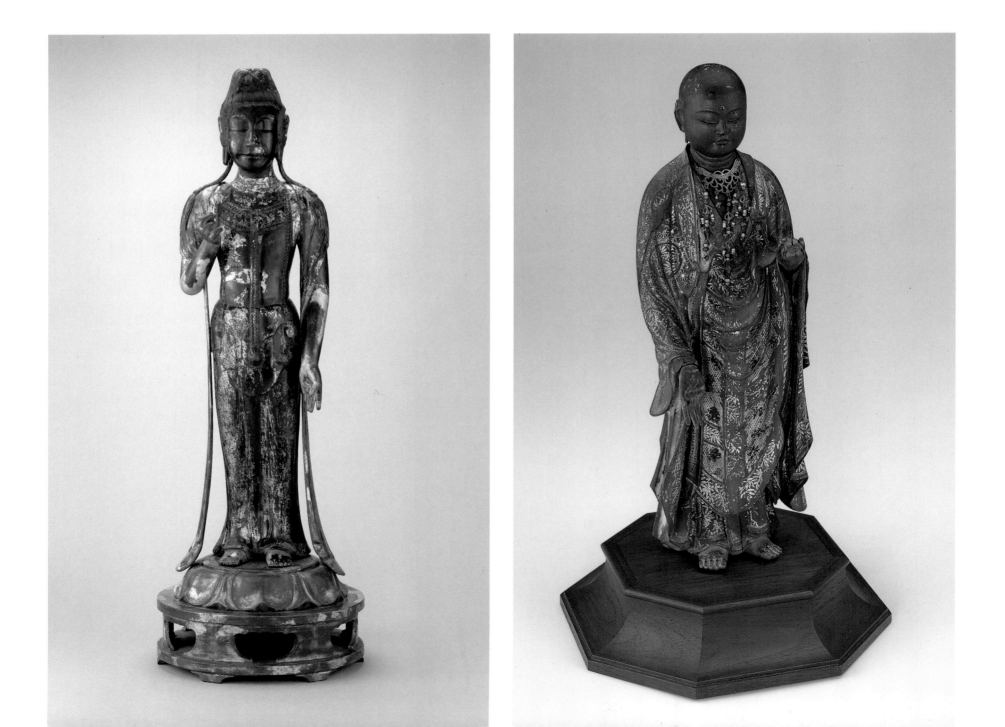

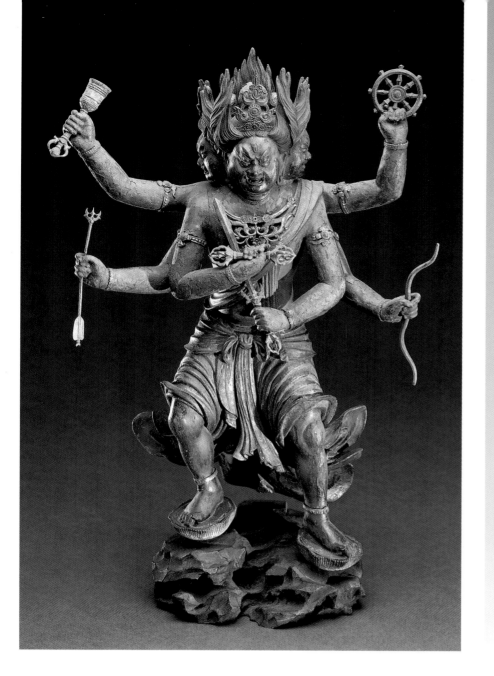

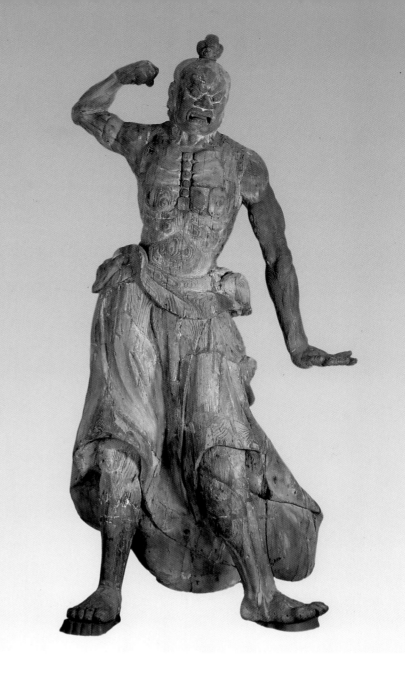

been introduced after contacts had been renewed with Song-dynasty China. Many of these are masterpieces that, in addition to being works of great technical skill, also reveal much about the character of the subject. The 13th-century statue of Shunjōbō Chōgen in the Shunjōdō of the Tōdaiji temple in Nara, a life-size image of the seated priest telling his rosary beads, is startling in its realism. The advanced years of the priest are indicated by the aged skin stretched over his skull, the sinews standing out on his neck, his stooped posture, and the tired, hooded eyes that gaze out at a world he knows only too well. Another example in the Rokuharamitsu-ji temple in Kyoto shows an unidentified priest seated cross-legged and reading a sutra text from a torn scroll. The statue seems to be frozen in movement for a split-second, with the eyes looking hesitatingly upwards as if to memorize the words that he is murmuring silently to himself. The image is uncannily lifelike, relaxed, quiet, and perhaps a little untidy... it wryly captures what would have been an everyday sight in any monastery in Japan at any time during

the past 700 years or so. The statue was made of hollow wooden blocks that were carefully carved to shape and then covered with layers of lacquer to provide a suitable surface for painting the final realistic details.

Of all of these treasures, the outstanding pinnacle of Kamakura sculpture – on a level with Michelangelo or Bernini in Italy – is perhaps seen in the two deities Misshaku-kongō and Naraen-kengo, which belong to the Rengeō-in, a subtemple under the Myōhō-in in Kyoto. The origin of the figures depicted here goes back to ancient Hindu mythology, before a time when they were adopted into the Buddhist pantheon as heavenly guardians. Representative examples of the same deities are usually seen on each side of the entrance gate to a temple, standing in characteristic poses, one with an open mouth, and one with mouth closed. (A parallel can be seen with the Shintō *karashishi* beasts mentioned above.) The Rengeō-in pair are each about 160 centimeters (60 inches) tall and stand in a threatening pose with flamboyant hand gestures. They are each

Left
Kongō Yasha

Kamakura period, wood, gesso and colors, H 42.9 cm, Collection of the Freer Gallery of Art, USA

One of the Godai Myōō or Five Radiant Kings, Kongō Yasha is shown with three heads with a hair style like wild flames, and six arms holding various ritual objects.

Right
Guardian figure

Kamakura period, 13th century, wood, H 233.5 cm, Collection of the Freer Gallery of Art, USA

This oversized figure was made as one of a pair that would have been installed at the entrance of a Buddhist temple. They were adopted into the Buddhist pantheon from ancient Hindu deities for the purpose of intimidating visitors to behave with proper decorum when entering a temple. This piece was originally covered with painted gesso, which has worn away to reveal the skilled carving beneath.

Statue of Minamoto No Yoritomo

Kamakura period, wood, paint and inlay work, H 90.3 cm, National Museum, Tokyo

Portrait sculptures were very popular during the Kamakura period. In this portrait of Minamoto No Yoritomo, Japan's first shogun, one can see clearly how the contours of the costume served as a sculptural effect.

dressed in a folding skirt that is richly patterned with gold designs, and they also have flying scarves that emphasize the sense of movement and energy, and also act as a frame to the naked upper torso. Both are superbly modeled in almost a super realistic manner, with bulging highly defined muscles, tendons, and blood vessels, and finely carved nails, lips, and ears. Their heads appear shaved except for a punk-like top-knot tied with a flying ribbon, and their ferocious expressions are accentuated with frighteningly lifelike eyes of inlaid crystal.

The decline and decadence of religious culture soon followed for a variety of reasons apart from the fact that the sculptural peak had been scaled; the most important was the spread of Zen and its teaching that images were unnecessary obstacles to spiritual enlightenment. Religious figures were still made to furnish temples, and have been to the present day, but with no real inspiration they became derivative and mediocre. The days of glory were over and we have to look in completely different areas during the following centuries in

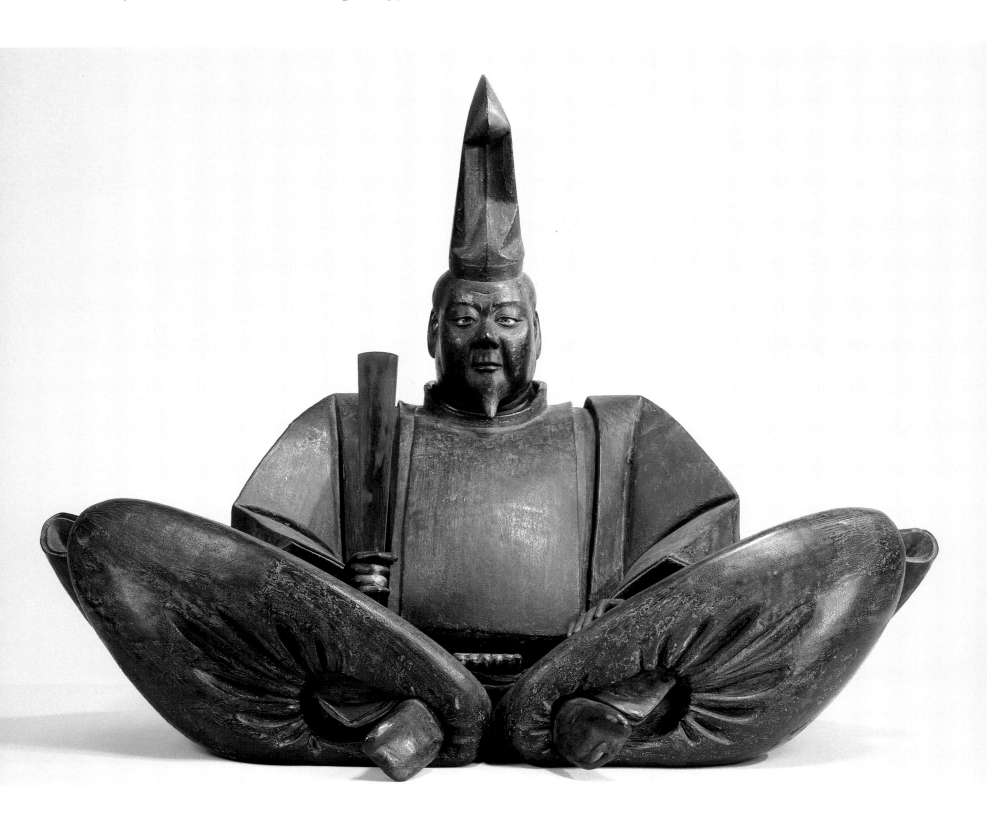

order to find any outstanding sculptural expression. One of these is in the world of performance and takes the form of masks. The other is in personal adornment during the Edo period, when dress was prescribed by social class, and consists of netsuke and other carved items.

There are two main groups of masks in Japan: those which were used in religious ceremonies and dances, and those worn in the Nō drama, which evolved as an aristocratic entertainment during the Muromachi period. Since the Heian period, *gyōdō* masks have been worn in Buddhist processions, while masks used in Shintō shrine dances were perhaps used even earlier. The refined Bugaku performance had already been developed in the courts of China and Korea, and the strange masks used in these dramas and dances represent humans and mythological beasts such as the dragon and the phoenix. The features on some of the human face masks hint at origins as distant as India and similarities can be seen with masks used in dances in Bali.

These masks are still treasured and used in Japan, even though little trace remains of them in either China or Korea. The splendour of those ancient courts can be sensed at the *On-matsuri* festival which has been held every 17 December since the year 1136 in the Deer Park grounds near the Imperial Kasuga Shrine in Nara for the purpose of entertaining and placating a rather unruly young god for 24 hours, and to invoke his favor for the rest of the year. The god is brought to a clearing in the forest and lodged in a simple shrine for the duration of the entertainment, the climax of which is an evening of Bugaku dances performed by priests of the Kasuga Shrine.

The Nō performance evolved from an ancient tradition of religious dances and humorous plays that were performed at temples. These gradually separated into the serious Nō drama and the comic Kyōgen farce, which is always included in the same program for balance. They appeared in their present form between 1350 and 1450 as a result of the work of Kan-ami and his son Zeami, who wrote down the dramas and refined their costumes and masks. The number of subjects for masks was limited by the number of different roles in the Nō dramas, and so the mask carvers soon reached the extent of their expression.

The earliest masks that date from the Muromachi and Momoyama periods are the most expressive and can be quite magical if used by a skilled performer. A mask is not a face; it represents another completely different being, and the Nō performer will always pause for a while to look at a mask and take on its persona before wearing it. The actor does not try to imitate the character of his role: Nō is on a much deeper level than Kabuki, for example, where the *onagata* (a male actor playing the role of a woman) tries to be as "womanly" a woman as possible – whether a virginal maid, a knowing courtesan, or a virago mother-in-law. In the Nō performance there is nothing unusual when a heavy, elderly gentleman

with a deep voice takes the part of a beautiful princess in the world of spirits. The mask is itself sufficient allusion to the material world (see right).

The second major area of sculptural expression is seen in the *sagemono* ("hanging things") – which consists of *netsuke* (small toggles), *inro* (medicine containers), and *kiseru-zutsu* (pipe cases) – worn by men through the later Edo period. Perhaps they should be considered as craft works, because they were actually used; but many are masterpieces of sculpture and are limited to a personal appreciation only by their small size. They were favored by the newly rich merchants who, because of their low-ranking status, were prohibited by Tokugawa regulations from wearing any sumptuous dress. The only outlet for spending on personal adornment was on the *sagemono* that were suspended from the *obi* sash worn around the hips to secure the kimono. Purely because there was so much money available for the purchase of fine pieces, *netsuke* carvers excelled in making exquisitely detailed and inspired sculptures in miniature (see page 327, left).

Sculpture since the Meiji Restoration

Since the country opened up to Western contacts in the mid-19th century, Japan became exposed to the cultural efforts of the West, particularly those of France and the United States. At first, the Japanese were taken aback by the concept of making art for its own sake, as previously all art had been made for a religious or decorative purpose. However, it did not take long to learn the new Western techniques which, when blended with the already formidable native skills, culminated in the appearance of a new kind of sculpture that was more accessible to international tastes.

With over 1,300 years experience to draw upon, the sculptors of the Meiji period excelled in working with both wood and metal, but in a Western way and with a Western sense of realism. Takamura Kōun (1852–1934) worked more with the familiar materials of wood and ivory to depict native subjects. His famous masterpiece is a life-size image of an old monkey (the local Japanese ape, which is quite a large creature), carved out of a single, solid block of wood. This lifelike work is now in the Tokyo National Museum and shows a monkey with a face expressing frustration and bewilderment at his declining powers, his hand clutching the few feathers of a bird that he had failed to catch (see page 304).

As with painting, the postwar years have seen Japanese sculptors experimenting in every direction, with the most successful being those that have looked with confidence at their own cultural heritage for inspiration instead of imitating the *dernier cri* from America or Europe.

Masayuki Nagare (1923–), after a rather bohemian youth has become an internationally famous abstract sculptor working in stone and bronze, and has specialized in large-scale projects for public spaces. Some notable works produced are the

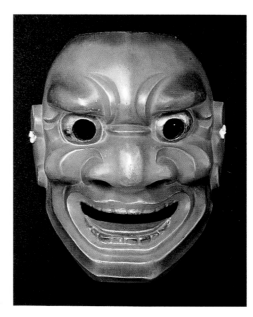

Top
Nō mask, *Jo*

Old Man, 14th–15th century, H 21 cm, W 15.2 cm, D 7.8 cm, Tokyo Fujii Art Museum, Tokyo

Below
Nō mask, *Otobide*

Demon with diabolical grin, 14th–15th century, L 23.2 cm, W 18.1 cm, D 9.5 cm, Tokyo Fujii Art Museum, Tokyo

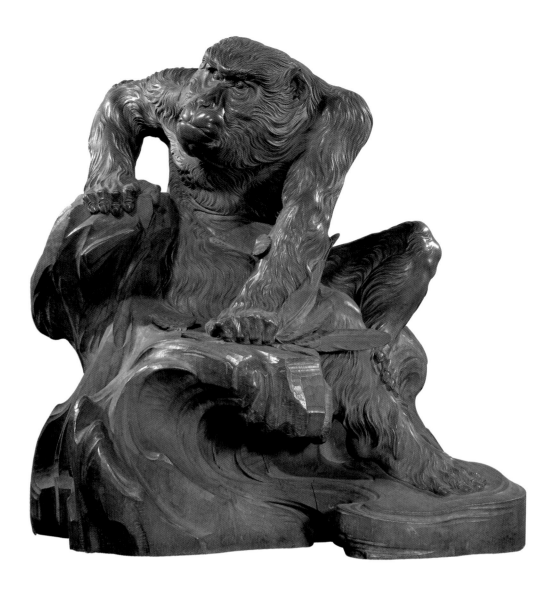

Opposite
Nō mask

17th–18th century, H 21 cm, Hatakeyama Collection, Tokyo

This mask represents Hannya (the unsettled spirit of a woman who has turned into a demon) and is used in Nō plays such as *Kurozuka* and *Dojoji*. Such ghosts appear for vengeance, and if worn by a trained actor, such a mask can convey the powerful emotions of the most frightening of all supernatural beings.

Cloud Fortress (*Kumo no toride*), in front of the World Trade Center Building in New York, a black granite, angular monolith looking very much like some sinister mountain; and the *Nagare bachi*, also .in black granite, in the Takamatsu City Museum of Art, which takes the graceful form of a *samisen* plectrum.

Satoshi Yabuuchi (1953–), worked on the repair and restoration of ancient Buddhist statues while teaching at the Tokyo Imperial University of Fine Arts, and so understands the techniques of sculpting with wood and lacquer, as well as being familiar with the figures of religion and Japanese folklore. He now specializes in the figurative depiction of animals and legendary subjects, carved from wood with a highly refined lacquer finish, often with wry humor and expression.

Kenji Misawa (1945–) has become famous for using unlikely materials together in a startling combination; metal imbedded in stone, and white marble looking like cream poured over wood. At first sight they look like some strange geological specimen, but then, as the impossibility becomes clear, one is left with a sense of awe that is almost religious – like seeing an ancient *ginan* tree standing next to a forest shrine.

Just as this country adopted and refined culture from the mainland in the 6th century AD, so today, we are witnessing the transformation of Western culture, style, and technology in a way that is truly Japanese – and quite fascinating. Looking at the genius of the Heian and Kamakura sculptors, and the innovation of the postwar artists, we can be confident in looking forward to the creation of exciting sculpture in Japan.

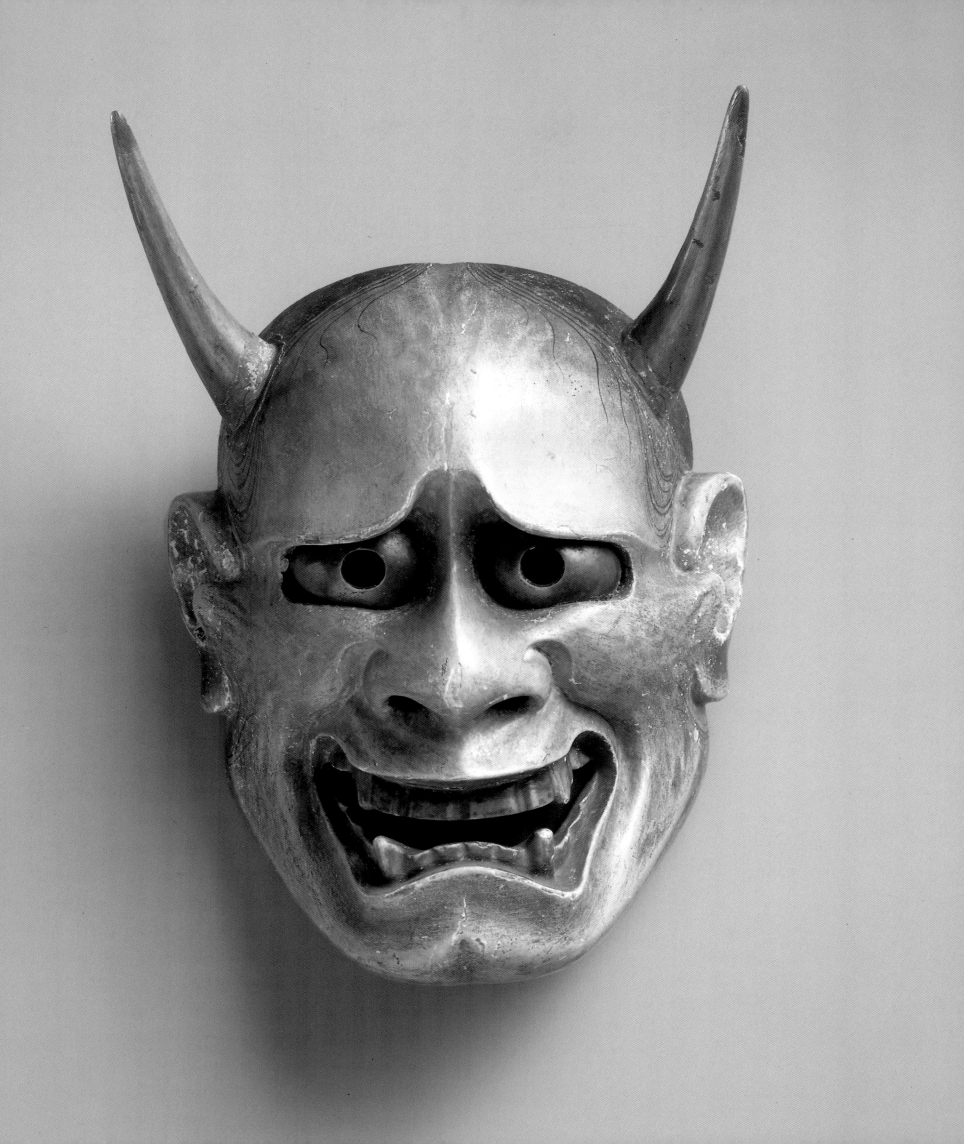

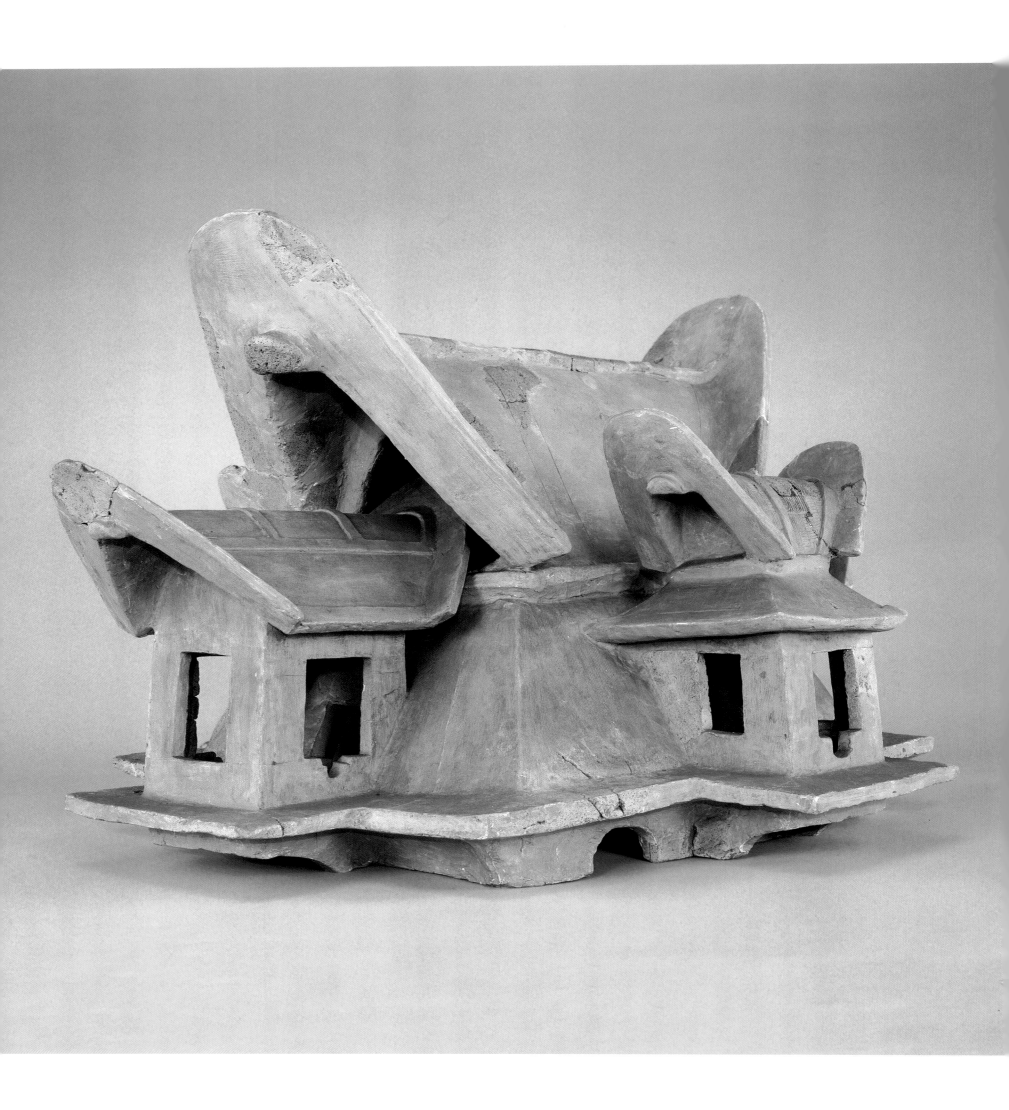

Japanese Architecture and Gardens

It is interesting to note that in the Japanese language the word for a home is katei, which is written with the combined characters for a house (ka) and garden (tei) — a telling indication of how inseparable the two used to be in the Japanese mind. Housing is obviously born out of our coping with our environment, both topographical and climatic, and in the areas of Japan where most people live the land is hilly or mountainous, and the weather, except for the tropical summer, is usually temperate. Until the postwar years, the Japanese built with this warmer weather in mind, the general philosophy being that one can put up with anything during the short winter, but a house that is not built to provide relief from the summer heat would be simply unbearable.

Haniwa model house

Late Tumulus period, 5th–6th century A.D., terracotta, H 52.2 cm, National Museum, Tokyo

The house depicted in this model, a house from the 5th–6th century A.D., has four wings, a surrounding veranda, and a gabled roof. The model displays influences from South Pacific cultures, especially those of Indonesia.

The Japanese House

Until the past few decades, most people in Japan lived in houses made of wood-paper and straw that were built to take maximum advantage of a private garden – however small – and also any view beyond. The Japanese use the word *shakkei* ("borrowed scenery") to refer to the natural advantages of a site, and the trees and hills that can be seen beyond, even though they are not part of one's property. Architects and gardeners have learned to design walls and hedges very skillfully with the purpose both of obscuring less attractive sights, and also of including the more pleasing ones such as neighboring treetops, in order to enhance the view from the house. Even dwellings in the cramped cities usually had an enclosed courtyard garden so that the inhabitants were always aware of the presence of nature and the passing of the seasons. Being of organic materials, these houses came from nature and would eventually return to nature, and so it stood to reason that they should be complementary with nature throughout their useful life.

Houses were raised above the ground to avoid dampness and to allow for the circulation of air. They were built on an ingenious modular system, with sliding doors that could be opened up (or even removed) to make space flexible for family and social functions, and to take advantage of the cooling summer breezes and views of the greenery outside. As a result, every Japanese lived close to – and was acutely sensitive to – all of the subtle signs and moods of nature: the sounds of birds and fall insects, the breeze whispering in the pine-needles, and the smells of the earth after a summer rain shower. In Japan there were no dangerous predators to guard against, and apart from a few mosquitoes, which could be screened out, nature is soft, welcoming, and seductively beautiful.

These modules of a traditional Japanese house are based on *tatami* mats, which are made of tightly woven reeds over a padding of rice straw, and are bordered with a strip of fabric, usually indigo-colored brocade. They measure slightly under one meter by two (three by six feet), but this size can vary according to different regions of the country, and also according to the type of building. The size of a room is indicated by the number of mats (for example six-mat, eight-mat, and so on), and as these terms are used by real-estate agents to describe a property, particularly in the western part of Japan, the customer can immediately envisage what space is being offered. The dimensions of the *tatami* mat also dictated the proportions of the rest of the room; the height of the ceiling, the ledge of the *tokonoma* (an alcove for hanging scrolls and other *objets d'art*), the placing of entrances and windows. These linear and spatial relationships were carefully thought out in ancient times, before the Heian period, with an eye to both practicality and aesthetics, but were then refined under the influence of the tea masters during the 16th century.

No feature is allowed to stand out, the whole point being the creation of a harmonious space where people and objects – the hanging scroll, a simple arrangement of wild flowers – can be brought into a space for a specific time and purpose, and then removed to leave the space bare and empty for the next time. Seen this way, the traditional Japanese room seems a little like a stage that the occupants, and the occasional objects brought in, use for one act at a time as they go through their lives.

It goes without saying that such architecture demands a certain standard of dress and behavior on the part of the inhabitants, and Japan is noted for the refinements of punctilio and discipline that have evolved to govern such matters. A *tatami* mat should be sat upon cross-legged in proper fashion within the brocade borders (and the appropriate kimono worn), so that it seems as if the occupants become a part of the total design. As a result, if one is not used to them, Japanese houses can be excruciatingly uncomfortable after any length of time; the beauty of living in them can be appreciated only if one has been raised to sit formally, to wear a kimono properly, and to suffer the bitter cold for several months of the year. This philosophy is totally at odds to that behind architecture in most other countries, where the design of buildings has evolved to solve or ameliorate the challenges presented by heat, cold, security – and comfort. But like so many finer things, a sacrifice is necessary: here the occupant has to meet the requirements of the house in order for them to live together. Until this last generation, almost everyone was raised in a traditional way and so the adjustment was part of growing up. Elderly people still seem to be more at home living on *tatami*, and feel more secure with the familiar wood and straw than they do with contemporary building materials. However, this traditional way of living is vanishing rapidly and these days most people live in concrete buildings with air-conditioning and central heating – there is certainly very little harmony with nature.

The Japanese Garden

In earlier days the Japanese garden too was made to look as natural as possible: well established and old. Certain plants and trees were chosen to represent the attractions of the seasons: pine, camellias, and scented prunus blossom in the chill of winter; cherry blossom, azaleas, and iris in spring; hydrangeas, water-plants, and lilies in summer; and grasses, bell-flowers, and chrysanthemums in the fall. Water was an essential component, which may have been present just in a stone water-basin, or if space and funds permitted, in a pond made in an irregular, natural shape, the edges softened with water-plants and reeds. Water was always teamed with rocks: rocks chosen for their shape and weathered quality, then placed with great care and encouraged to grow moss and ferns (see pages

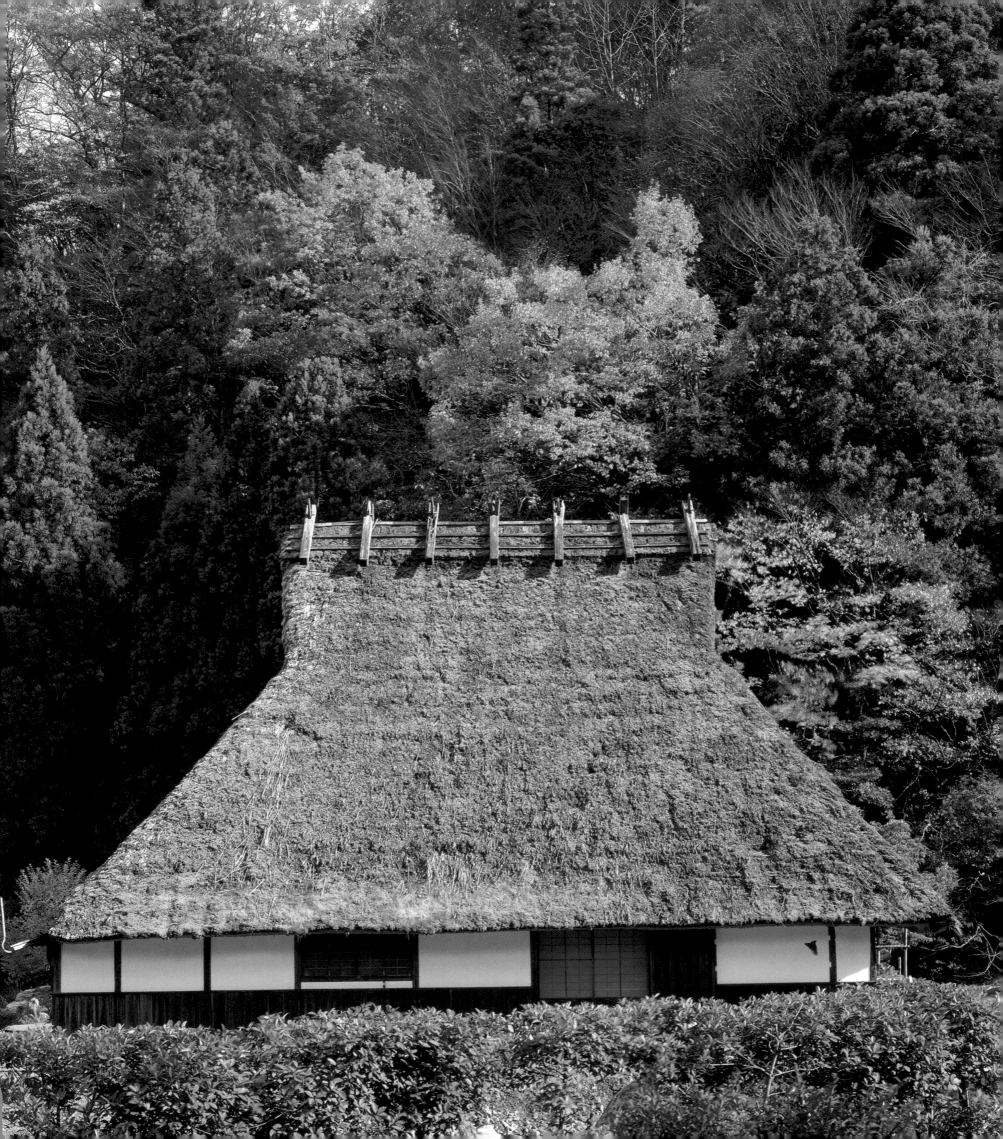

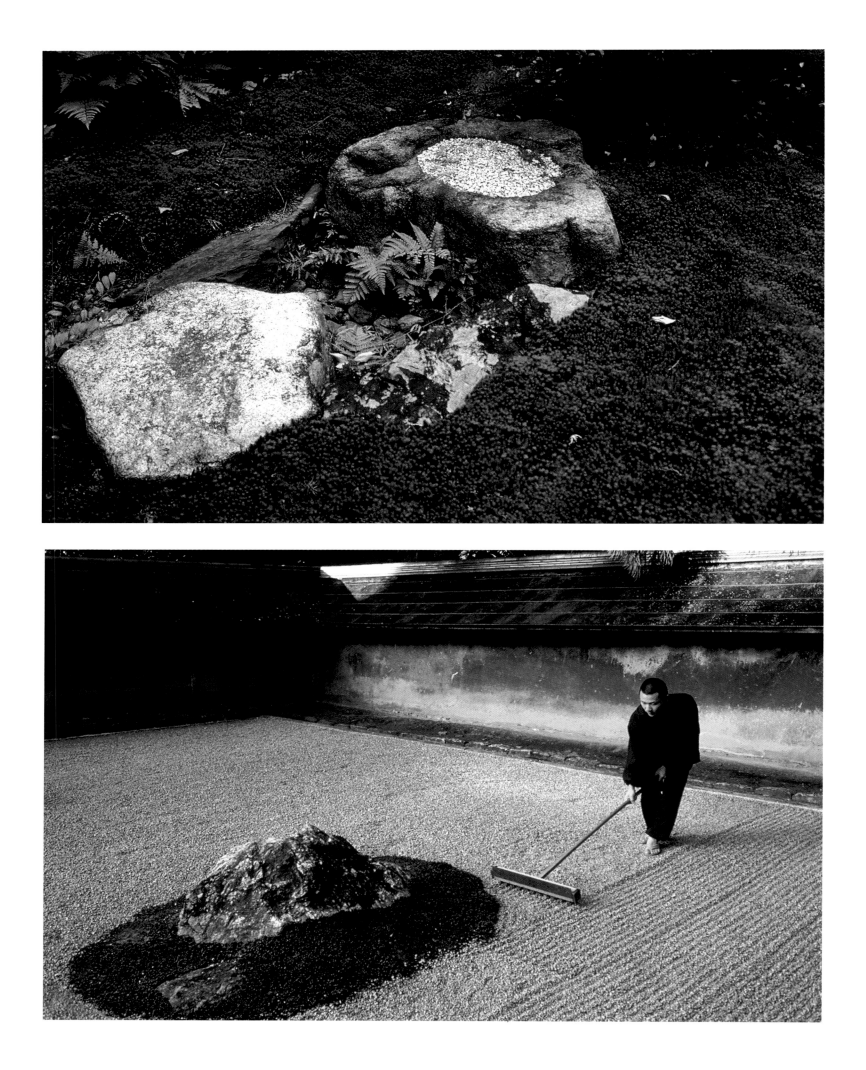

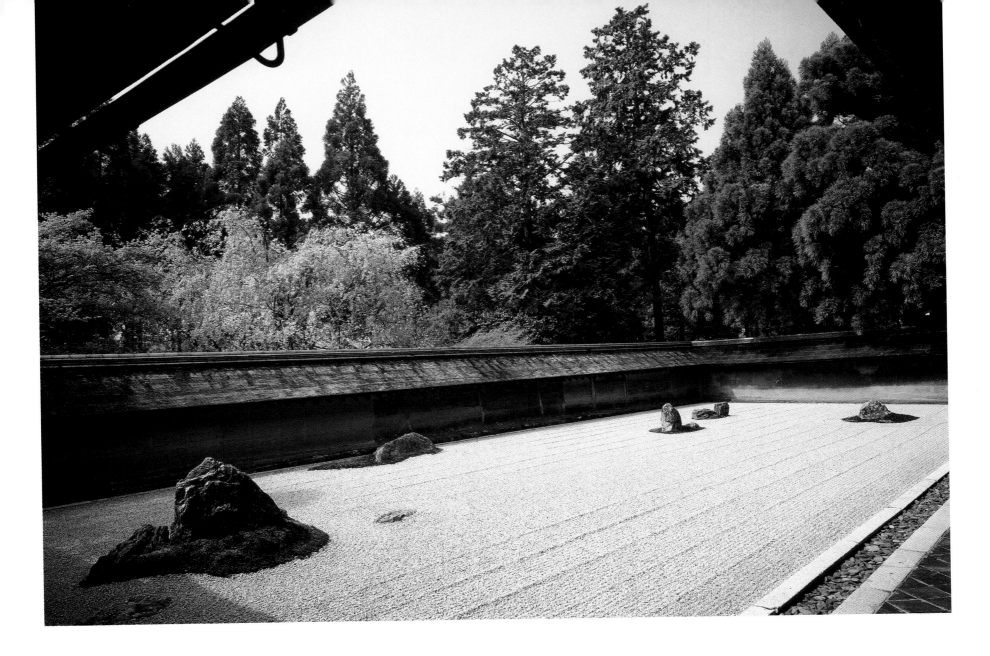

Opposite, above

Stone washbasin in Katsura Rikyu, Kyoto

In Japanese gardens like this, the *chōzu-bachi*, a stone washbasin used for washing the hands, is meant to have a natural, unintrusive form.

Opposite, below; and this page

Zen garden of Ryōan-ji temple

Founded in 1473, Kyoto

How the rock garden is looked at is a matter of interpretation and feeling. One may see in it a boundless lake, or mountain peaks rising through the clouds. The famous artist Soami created it as a reflection of his subjective Zen inspiration.

312–313). To give the impression of permanence – as if they were naturally breaking through the ground just as they would in the mountains – the greater part of their bulk had to be under the surface of the earth. Man-made objects were kept to an absolute minimum; perhaps a rarely used stone lantern, or a water basin that was kept filled from a dripping bamboo spout – preferably so aged and weathered that they looked as if they had been there forever. Lamps needed for the actual purpose of lighting would be relatively simple affairs made of paper and bamboo that could be put out to light the pathway for guests, and then afterwards removed.

In a Japanese garden the effect is that of nature tamed, controlled – and hidden. There were no open flower beds or front gardens open to the view of passersby, nor – that curse of Sunday mornings in Western suburbia – lawn mowers. Japanese gardens are enclosed, which is only natural as they are considered to be an integral part of the house and are therefore just as private. If the necessary acclimatization has been achieved (and it is worth the effort), it is a most civilized and harmonious way to live.

An exception to the lush green gardens of the kind just described can be seen in one or two Zen temples, where, as an inspiration for meditation or spiritual concentration, plants have been almost edited out completely to leave only an arrangement of rocks. These gardens differ from most of the other gardens that are complementary to a house or villa in that they are made for viewing, not for strolling around. The best known must be that of the Ryōan-ji temple in Kyoto, which to the uninitiated eye must seem as far as possible from what would normally be considered a garden (see opposite, below, this page, and page 314). There are no trees to be seen except those beyond an old wall made of pounded earth that demarcates two sides of the garden, and which has weathered to a subtle and interesting blend of natural tones. The other two sides, which are next to the temple building, are lined with a border of straight-cut stones and a band of pebbles. One looks out over five groups of rocks in a bed of gravel carefully raked into furrows that are circular around the "rock islands," but straight everywhere else. It is a prime example of *kū-tei* (an "empty garden"), absolutely static and calm, and with no plants

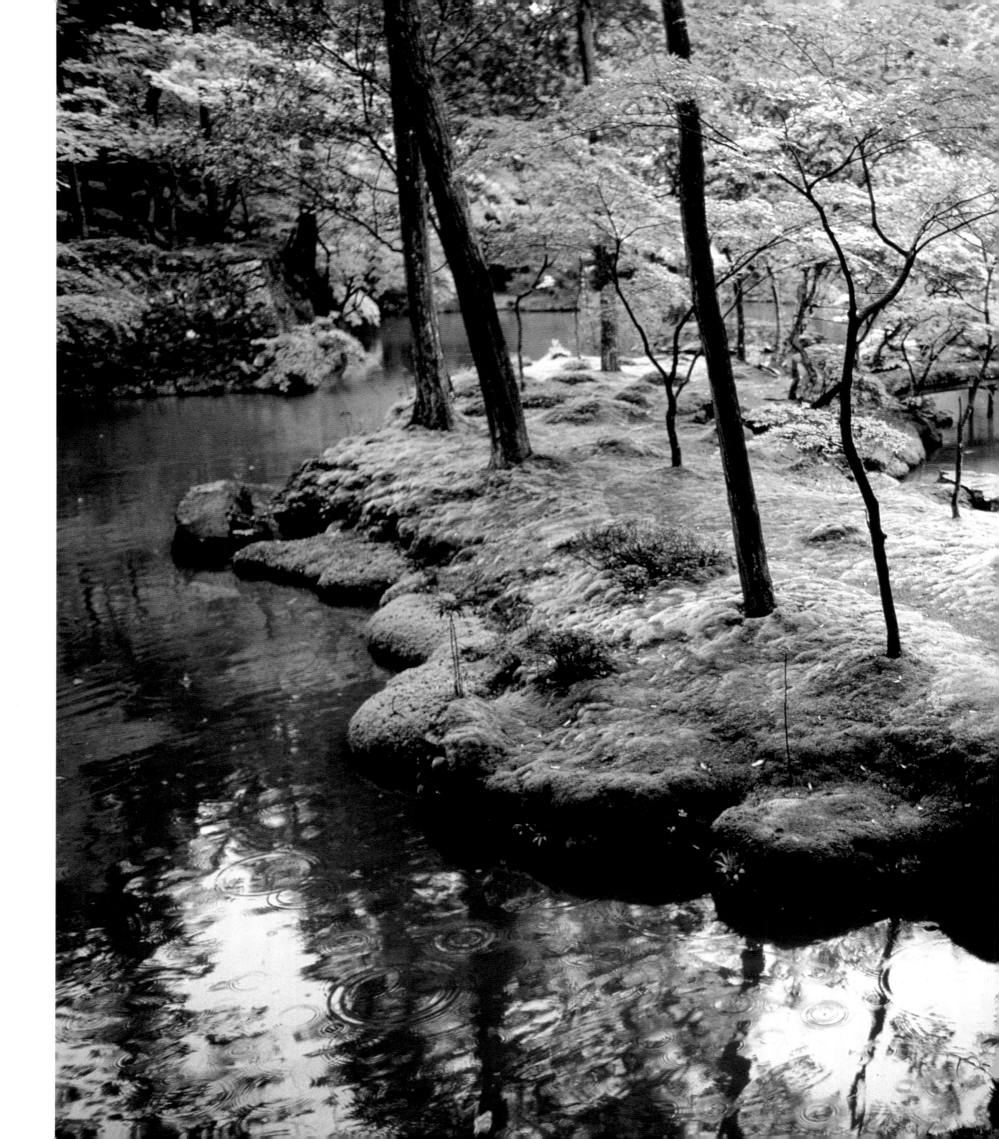

Saihō-ji, also known as Kokeder
16th–17th century moss temple-garden,
Kyoto

except for green moss that acts to soften the border between the rocks and gravel. It is a challenge to understand the purpose of this extraordinary creation, which dates from the 16th century, and a lot of words could be wasted in trying to provide any kind of sensible explanation. There are two clues that might be considered. One is that quality of stillness that the garden has, and that it brings to the viewer; a stillness that if punctuated by the sound of a bird-cry or the temple bell, seems afterwards to be even more still, even more silent – which is where the mind should be in the practice of Zen. The other clue is provided by its abstract quality (also seen in the painting and calligraphy of Zen monks) where a meaning can be more profoundly expressed by not expressing it directly. The Ryōan-ji garden expresses nothing at all directly, and the tourist's guidebook suggestions that the rock arrangements represent the "peaks of mountains above the clouds" or a "tigress with her cubs" are missing the point. The garden does not ask to be understood, nor does it symbolize anything: that would defeat its true purpose, which is that of helping the mind reach the state of "no-mind" or "no-thought," the gateway to an intuitive grasp of higher truth.

But these are special gardens for a special purpose and for the less pious, with human failings, the sight of water and greenery and the feel of the earth underfoot provide a softer route to the appreciation of Zen. Most people these days do not even have this, as in modern Japanese cities a garden of any kind is a luxury; if there is space at all, it is devoted to potted plants that can be brought into the house from time to time to give just a hint of the nature that is now so distant.

Traditional Domestic Architecture

Traditional architecture in Japan can be divided into the main groups of domestic housing, temples, shrines, palaces, and castles. To a certain extent, all of these were developed from styles that had originally been imported from nearby countries. Throughout most of the Jōmon period, buildings consisted of simple circular pit-dwellings with a roof of straw, not dissimilar to those excavated in other parts of the world; but by Yayoi times, the appearance of metal tools led to a more sophisticated use of natural materials, and buildings (particularly granaries for storing rice) began to be constructed on wooden pillars above the ground level.

The first evidence of what early housing actually looked like is seen in the *haniwa* terracotta models from the Tumulus period, which were found on burial mounds (see page 306); and also

Zen garden of Ryōan-ji temple
Founded 1473, Kyoto

Opposite
Traditional Japanese farmhouses, *minka*

in designs cast on the reverse side of excavated bronze mirrors. Some of these depict houses with raised floors and verandas, wings that branch off from the main building, and tall roofs with overhanging gables that strongly resemble those in countries to the south, particularly north Sumatra and the Sulawesi Islands of Indonesia. Even though all Japanese buildings until recent years were miserably cold in the winter, it can be seen that even at that time, they were being constructed more with the tropical conditions of summer in mind than the snows of winter.

Country houses were usually more spacious than those in the city, and apart from having to house a large extended family might also, in some parts of the country, be used for raising silkworms. Traditionally, roofs were thatched (see right), but as this kind of roofing has to be replaced every few years, increased wealth in the countryside has seen thatch replaced with tiles, which are longer lasting and less of a fire risk. Farmhouses were built mainly of wood with a system of interlocking posts and beams that is strong and flexible enough to withstand the force of frequent earthquakes and the fall typhoons. Despite the discomforts of poor heating and a smoky atmosphere, Japanese *minka* (farmhouses) have a captivating and homely character that is welcoming and honest; they provide the sense of satisfaction that can only be achieved by living close to natural materials, namely wood, straw, and paper. They have served their owners well through the centuries and it is regrettable to see that so many are now being destroyed, only to be replaced with mass-produced modern houses made of synthetic materials that have no redeeming architectural features whatsoever.

Shinto Shrines

Evolving from these raised granaries of the Yayoi period (and so emphasizing the importance of the rice harvest in Shinto beliefs) are the great imperial shrines of Ise and Izumo. Both are set in hills covered with thick forest, and demonstrate how, with skill and sure taste, the designers of the shrines have used the available materials around to achieve an effect of simplicity and purity conducive to invoking the spirits of nature.

The main hall of the Ise shrine is built of plain, unfinished cedar wood with a raised surrounding veranda, an X-shaped arrangement of end beams, and a very slightly curved roof made of layers of cypress bark. It stands in an enclosure of pebbles of light-colored granite, unpainted and unadorned by any carving. Like nature itself, it is renewed: every 20 years since the late-7th century (except at odd times when prevented by civil war), the Ise shrine has been demolished and rebuilt anew in exactly the same way, reflecting in building the cycle of life, death, and rebirth in the natural environment surrounding it.

The Grand Shrine at Izumo is dedicated to the deity Okunishi-no-Mikoto (who according to

popular legend was responsible for introducing the secrets of making silk and other mainland know-how), and, unlike the Ise shrine, it is rebuilt only when absolutely necessary. The present buildings date from the middle of the 18th century. The main hall at Izumo is more square-shaped than that of Ise but the basic design is very similar, having a raised encircling veranda and the X-shaped rafters. The roof, however, differs from that seen on the Main Hall at Ise in that the slope is slightly concave rather than convex. After some two hundred and fifty years of exposure to the ravages of the elements, the whole building has an air of mystery that makes it seem even more appropriate a place for housing the ancient gods. And as these Shinto shrines have hardly changed in design since ancient times, they are probably the best surviving examples of what buildings must have looked like in the last centuries before that revolutionary importation of mainland culture and religion that so changed Japan during the 6th century AD.

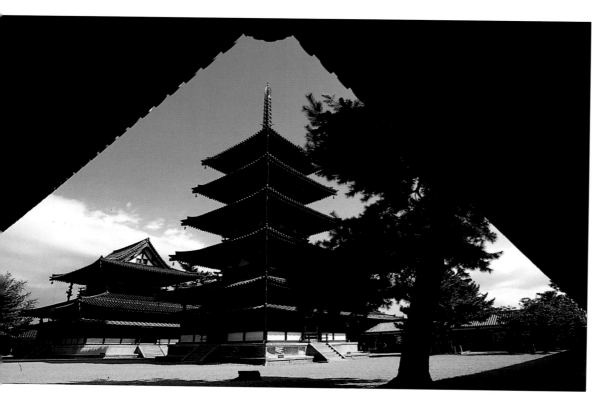

Hōryū-ji temple precinct

607, Goju-noto (five-story pagoda) and kondo (golden hall), Nara, Japan

Hōryū-ji is the oldest surviving temple in East Asia, and its buildings are at the same time the oldest preserved wooden structures in the world. Seventeen structures in the precinct form part of Japan's national treasure.

Structural diagram of a Japanese temple

The diagram shows the complex system of dovetailing that guarantees both strength and flexibility. It is earthquake and typhoon-proof.

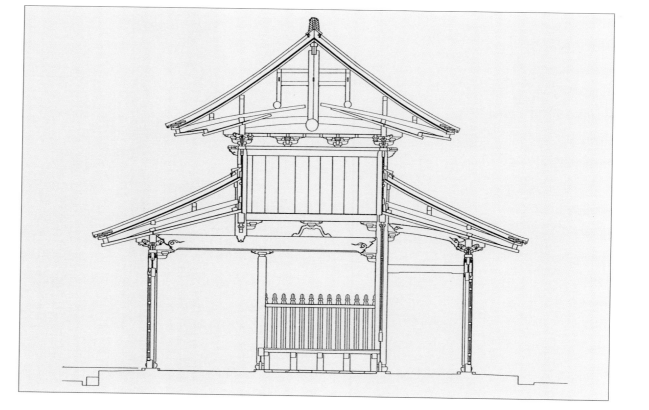

Mainland Influences and the Great Temples

Not least among the new cultural arrivals from Korea and Japan were advanced methods for the designing of cities and the building of temples and palaces. As Buddhism gradually became accepted and (after a nod of approval from the sun goddess, Amaterasu, who was consulted on the matter) assimilated into native beliefs, there was a flurry of temple building that started in the Nara area and then eventually spread throughout the country. At that time the Japanese were already highly accomplished at working with wood and also well understood the principles of pillar-and-beam construction, as can be seen at the Ise shrine. This early style of temple architecture remained almost static in China and Korea and more or less the same kind of buildings were constructed to the same pattern through the ages up until the present day. In Japan, which at the time was somewhat in awe of the superior mainland culture, the mainland buildings were admired, but then copied with the help of imported experts, and finally modified to suit local conditions and materials. Before a

couple of centuries had passed, numerous architectural refinements had been developed that were distinctly Japanese, and just as painting and sculpture had taken their own evolutionary paths, so the styles of building evolved further and further away from mainland prototypes.

The most noticeable mainland features to be seen in the new temple complexes are the layout of the temple compound, the tiled roof, and the pagoda, which can be seen as close in style to the original at the Hōryū-ji Temple near Nara City. The compound is bordered by a cloister wall with a tiled roof supported by wooden pillars, which provides security and a route where the priests and monks can walk under cover if necessary. The entrance gates are double-storied and have tiled roofs. Within the compound is the main temple building, the *kondō*, which houses the famous Shaka triad (see the chapter on Japanese sculpture) together with other Buddhist images, and which is used for various ceremonies and services (see opposite page, top). The pagoda, that unfor-

Shūgakuin imperial villa

From 1629, view of the surrounding garden landscape, Kyoto

The Shūgakuin villa is set in delightful natural surroundings in a location opening to extensive views over the distant mountain range. Somewhat below it, a long dam was constructed at great expense and effort to create an island-studded lake fed from a diverted stream. The topographical and natural characteristics of the surroundings are included in the total appearance of the cunningly and carefully devised park in a most skillful way. The tree-lined slopes behind the buildings serve as a backdrop that makes the garden appear much bigger than it really is.

weight of the roof, the changes of weather, and even earthquakes (see page 316, bottom). But wood is perishable if left exposed to the elements for too long and that is the reason why the tiled roof was seen as such a revolutionary innovation: it allowed buildings to survive far longer than they could with thatch or shingle. In addition to being highly practical, the graceful shapes and slightly curved lines of the temple roof has the attractive quality of being able to complement and enhance the forms of nature – the pine trees, the distant hills, the sky. How well the ancients understood these important matters...

Residences of the Nobility

Any information about the style of early palaces and mansions is limited to scraps of information in literature, and gleanings from ancient scroll paintings depicting aristocratic romances. In Nara and Kamakura, foundations have been excavated that indicate the layout of rather grand houses and gardens, and it can be presumed that they were just as elaborately constructed as the great temples. The surviving evidence indicates that they were built with a large number of rooms, which would be expected for the housing of a noble family, their retainers, and all the necessary accoutrements of court life. They were incorporated with surrounding gardens for strolling and enjoying the seasonal delights. However, by far the finest and most complete examples of noble architecture that are to be seen date from the much later 17th century: the Shugakuin palace located on the slopes of Mount Hie to the northeast of the city;

gettable image of the Buddhist world in the Far East, serves both as a reliquary for sacred treasures and as a symbol for the path of truth and the direction of heaven, similar perhaps from a spiritual point of view, to the spires of Gothic churches in Europe. The *kōdo* is the other larger building that is used for religious instruction within the compound, while all other living quarters and subsidiary buildings are located outside the walls.

The construction of all of these buildings is a marvel of carpentry and joinery, and, without the use of any nails, has taken into account all of the stresses and strains that can be caused by the

and the Katsura palace, which is on flat land next to a river in the southwest. Although many of the refinements in these buildings came about as a result of tea aesthetics, they probably resemble the kind of noble residence that had also been enjoyed in earlier centuries.

"Palace" is not perhaps the most appropriate word to use, conjuring up as it does European images of heavy stone, glazed windows, and expansive parklands. These two Japanese buildings would be better described as villas or princely country retreats. Both are famous for their simple and elegant architectural lines and superb gardens; the most refined merging of nature and building that at first appears to be totally artless, but which could only have been achieved by the most painstaking attention to detail and absolutely sure taste. Both types were built for the use of imperial family members and courtiers: a place where they could escape from the tedium of everyday rituals and relax in a rustic setting, to practice the tea ceremony, compose poetry, and enjoy the beauty of nature as it progressed through its seasonal changes.

The Shugakuin was built on a site that was chosen for its natural beauty and the extensive views it offered of the city and distant mountains. On the lower slope, a long embankment was constructed, at great effort and expense, to contain a large pond with one or two islands, a pond that was kept supplied with water from a diverted stream. Although the garden has been organized with great care and skill, the topographical features and surrounding scenery have been ingeniously utilized as part of the total design. The forested hillside behind the buildings act as backdrop to the garden, giving the impression that it is much larger than it in fact is – an excellent example of the previously mentioned *shakkei* ("borrowed scenery"), where available natural features and scenery have been incorporated for maximum effect in the planning of the villa.

The buildings are in the style known as *sukiya*, in which construction is kept simple and the natural textures of wood and plaster are left bare so that their own beauty will complement that of that of the natural world all around. Decoration is minimal and restricted mainly to paintings on the sliding doors. One door in Shugakuin is of plain, honey-colored cedar wood and has the design of two painted carp swimming behind a torn net (a gold tracery that covers the whole surface); the eye of the larger fish peers out through the mesh to complete a composition that is quite startling modern in its conception. Another pair of doors have paintings of two wheeled floats that were used in the annual *Gion* festival – filled with flowers, exquisitely costumed dolls, and decorations – and again the lavish design is toned down but made more elegant by the plain cedar wood

Himeji-jo

About 1580, extended in the 17th century, fortified palace in Himeji

The site bears the name "Castle of the White Heron" because of the thick layers of blindingly white plasterwork that cover the wooden building as a protection against fire. Himeji-jo is an outstanding example of a Japanese defensive complex, with ramparts, outworks, towers, and secret doors.

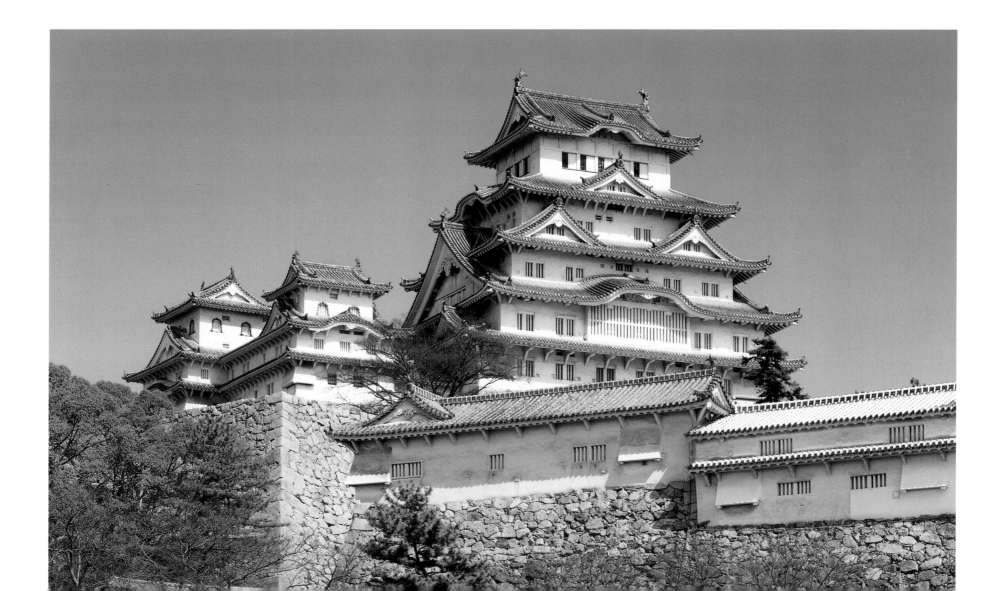

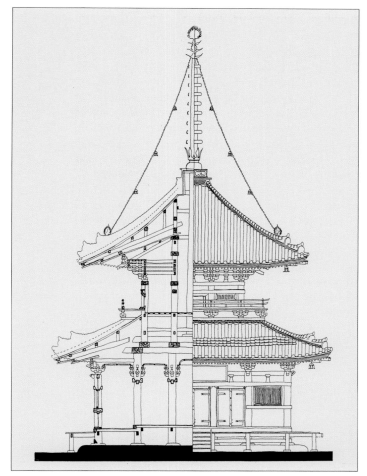

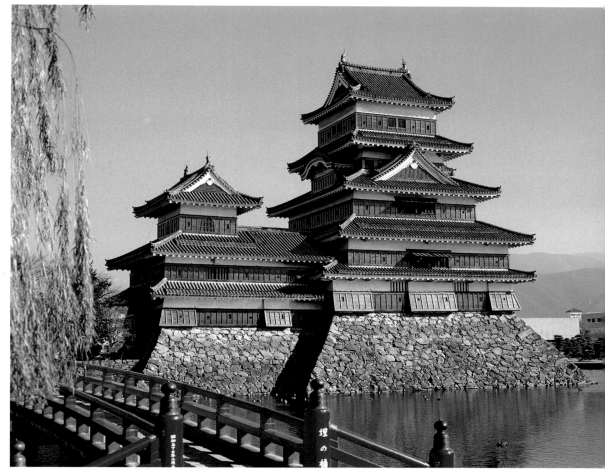

background. The only other adornments in the villa consist of discreetly patterned paper in the shelved *tokonoma*, and the intricately worked details on metal fittings such as nail-head covers and door-pulls.

The Katsura villa, by way of contrast, was built on a site that was not blessed with any "borrowed scenery," and all of the details of the garden were instead planned around a pond that had remained from an old estate of the Fujiwara family that dated from the Heian period (see page 318). The pond was expanded and redesigned with the addition of islands that were connected to the shore, and provided walkways and viewing points around the garden. The building is irregularly shaped: it grew by stages, the earliest part having been completed in the first two decades of the 17th century by Prince Toshihito. As the area is damp and at risk of flooding from the nearby river, the whole structure is raised off the ground on wooden pillars. Seen from the eastern garden side, the structure appears light and almost floating; a brilliant rectangular arrangement of dark posts and white-papered sliding doors, topped by interlocking cedar-bark and tile roofs of subtly different curves and lines – all weathered to a soft gray that contrasts perfectly with the green foliage around (see page 319). It is one of the world's great masterpieces of architecture, and it never ceases to amaze and delight those who make the pilgrimage to it. It is perhaps the most refined example of how a

building can exist harmoniously with nature. And if the beautifully proportioned rectangles and contrasts of white and dark gray look modern to our 20th-century eyes, it is because this is the building that provided the inspiration and model for the Bauhaus and a whole generation of designers and artists in the west from Charles Rennie Mackintosh to Piet Mondrian – and particularly Frank Lloyd Wright, who understood more than anyone else that the site as well as the building are equally important components in architecture.

Japanese castles

A completely different kind of architecture is to be seen in the great castles that were constructed in the late-16th century to emphasize the glory of the warlords who had control of military, economic, and political power. The most famous ones were destroyed by war and few have survived in their original condition. Perhaps the finest are those of Himeji between Kobe and Okayama (see page 320); Hikone on Lake Biwa; and the rather remote Matsumoto in Nagano Prefecture (see page 321, right), which still stand in proud feudal defiance of the surrounding concrete.

Even by world standards at the time, these military edifices were masterly feats of construction, having heavy stone walls, sloping at such an angle that "could not be climbed by man nor rat," and

Left
Cross section and exterior of a pagoda

Right
Matsumoto-jo

About 1590, fortified palace in Matsumoto

In terms of contemporary world standards, these fortifications, with their massive stone walls that fall away at an angle which "neither man nor rat could scale," were daring masterpieces of construction. They were built with several tapering stories to form a earthquake-proof pyramidal structure, and each story was provided with a superb tiled roof.

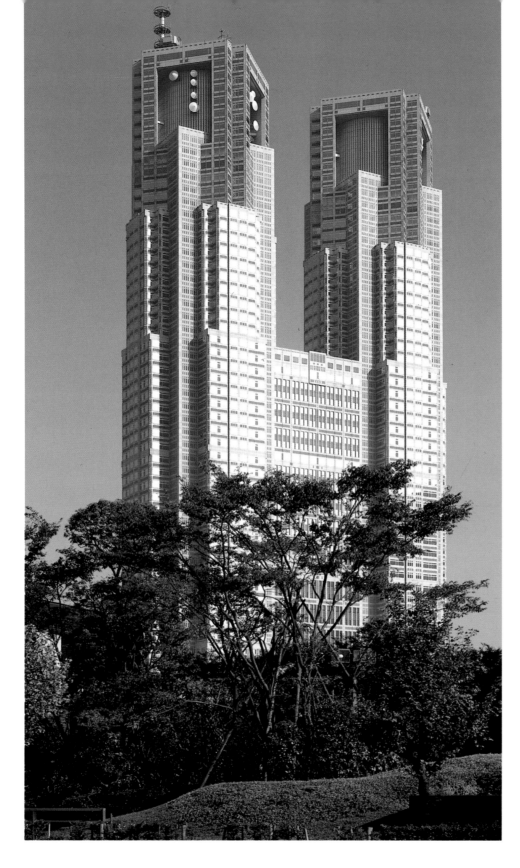

Tokyo City Hall

Kenzo Tange (born 1913)

1990/95, Shinjuku, Tokyo

Tange's most celebrated building is the national sports hall built for the Olympic Games in Tokyo in 1964. The buildings of the city administration in Shinjuku are an example of the integration of Western architecture into the aesthetic principles of the Japanese tradition. In size and formal feel, the towers resemble a Gothic cathedral, whereas the skeletal structure, with its fragile wall cladding, is reminiscent of American curtain walls made of aluminum.

surmounted by several floors of diminishing area to make an earthquake-proof pyramid-like structure – all with tiers of those wonderful tiled roofs. The approach and entrance-way was often made in a complicated fashion, with abrupt turns and slopes so that anyone who approached would be at a strategic disadvantage and exposed to hostile fire from the castle guards. Around this structure there was a moat, and the grander castles had large surrounding compounds with housing for the lord's relatives, retainers, and horses as well as space for gardens and warehouses, which in turn were encircled by fortifications. These great castles would seem to have been indestructible, but in fact they were vulnerable to that ever-present hazard of all Japanese buildings until the modern period – fire, which could consume any wooden building in a matter of minutes and was eventually to be the cause of destruction for the majority of the castles in Japan.

Architecture Today

With the influx of foreigners during the latter half of the 19th century, the larger cities, and in particular Tokyo, Yokohama, and Kobe, saw the appearance of many Western-style buildings for domestic and, particularly, commercial use. However, most Japanese continued to live in traditional Japanese-style buildings until very recently, with the greatest, almost revolutionary changes occurring over the past 25 years. For a variety of reasons – the urgent necessity to rebuild after the destruction of the war and the absence of anything like zoning regulations – the cities of Japan present an architectural jumble which is often surprising to foreign visitors who expect to see something out of a Hiroshige print. The cities seem to be in a state of continual experimentation, with relentless demolition and reconstruction, but there has also been the appearance of some highly unusual and distinctive buildings. And despite all of the crowding and aesthetic shocks, urban Japan has evolved on a very human scale that may have much to teach the sterile suburbs of the West. Not only have the Japanese solved the problems of transportation of large numbers of commuters with the finest and safest subway system in the world, but every residence has the essentials of living within a few minutes walking distance: foodstore, drugstore, bookstore, optician, dentist… Even the metropolis of Tokyo, with a population of around 25 million people, resembles to some extent an accumulation of villages that are self-contained and independent of the greater sprawl around them.

There is nothing more constant in modern Japan than change, a change that seems super-accelerated compared to that in most other countries, with the exception perhaps of China.

The view of the country is forward into the 21st century, and one construction company has recently announced plans to build enormous pyramid-like structures, hundreds of meters high,

with a framework of some indestructible alloy, and with "nodules" at the joints that will provide commercial and domestic housing for large numbers of people. Such a structure would be earthquake-proof and could be built on almost any kind of land – or even the sea. But it would also be hermetically sealed and in order to have any contact with the natural elements, trees and plants, the inhabitants would have to make an extensive journey to the ground via walkways and elevators. The image is no doubt an exciting one; but one cannot help wondering whether architects could, if they drew their inspiration from the Katsura villa or a country farmhouse, get back to designing buildings that satisfy all our needs, both conscious and subconscious.

Villa Kidosaki
Tadao Ando (born 1941)
1982/86, Setagaya, Tokyo

Traditional architecture – primarily the typical Japanese view of nature and the skillful handling of materials – plays an important part in Tadao Ando's style. The Kidosaki villa is contained entirely in a concrete cube that opens up spatial areas exposed to sun and wind and allows views of the colorful landscape of gardens and terraces.

Traditional Arts and Crafts

Before the advent of industrialization in Japan, every item needed was made by hand — and so had a quality that cannot be achieved with the machine-made goods we have today. Even though these objects were not consciously made as art, they nevertheless stir the artistic senses, particularly in these modern times when, bored as we are with the abundance of objects that look exactly the same, anything handmade appears novel and interesting.

Industrialization came late to Japan and until recent times the country had a rich history of specialized arts and crafts made with the ingenious use of local, readily available raw materials. In Japan, the border between the fine arts and the crafts is rather blurred and difficult to define, especially in spheres such as the tea ceremony, where a humble stoneware bowl can have the status — and value — of the most prestigious work of art. In each of the main categories of lacquer, textile, metal, and wood, it is noticeable that almost all objects have an appeal that makes them satisfying to look at and to use, and many of them are works of art in their own right.

Lacquered box

Attributed to Hon'ami Kōetsu (1558–1637)

Lacquer, mother-of-pearl, lead, H 23.2 cm, W 29.2 cm, D 23.8 cm, Collection of the Freer Gallery of Art, USA

One of the leading artists of the early Rimpa school, Kōetsu was famed for his pottery, lacquer work, and calligraphy. This box shows a bold use of inlay using mother-of-pearl and lead, to make an unusual design that wraps right round the box.

Lacquer Work

Made from the sap of a tree that grows in Far Eastern countries, lacquer dries to a hard but slightly flexible and waterproof surface that can be used to protect and decorate a variety of other materials. In Japan there is evidence that it was used even back in the Jōmon period to embellish pottery, but it was not until the Heian period that lacquer working began to blossom as a decorative art, most likely under the inspiration of pieces imported from the mainland. The most common decorative feature is that known as *maki-e* ("sprinkled design"), which is achieved by using finely flaked or powdered gold or silver to define the pattern on a base of wet lacquer. This is allowed to dry and then smoothed down with charcoal before applying another layer of lacquer. Many layers of lacquer, and many sprinklings of gold or silver, can create an attractive, three-dimensional effect, with the gleaming designs seeming to float like tiny jewels suspended in the clear surface (see below).

The raw lacquer sap is toxic, like poison ivy, and the lengthy *rite de passage* that every lacquer worker has to suffer is to develop gradually an immunity or tolerance to the material. This toxicity vanishes completely when the lacquer is dry and so it can be safely used to make table ware.

Working with the material is time-consuming as it is extremely sticky and has to dry very slowly (strangely enough in an atmosphere of high humidity, so lacquer production has traditionally been an activity restricted to the rainy months from May to October). Lacquer has to be applied like paint to a base material, and this is usually wood. In its pure state lacquer is normally clear and transparent, but it is commonly tinted with red or black pigments to provide a better background for decoration.

The art of lacquer working has become far more finely developed in Japan than anywhere else, and appears in an extensive variety of different styles. It has commonly been used for tableware (particularly soup bowls); boxes for various purposes, such as holding the brushes and ink sticks for writing; and those widely collected *sagemono* ("hanging things"), such as small *inro*, segmented containers for medicines and so on, which were secured from the *obi* sash of a man's kimono by a netsuke toggle (see opposite). Studios of craftsmen specialized in making lacquer objects, which from the 17th century onwards were sold at speciality shops in the cities (see above).

Because of its simplicity, one of the most appealing varieties of lacquer is known as *negoro*,

Lacquer cabinet

Momoyama period, late-16th century, H 28 cm, W 33.4 cm, D 21.3 cm, Collection of the Freer Gallery of Art, USA

This small chest shows a variety of lacquer-working techniques with inlay of mother-of-pearl, and *nashiji*, which involves applying flecks of gold with different coats of lacquer so that the gold particles seem suspended. Other areas show *hiramakie*, where the decoration is painted on the surface to make a design in low relief.

Kirin netsuke

Mid Edo period, 18th century, ivory,
H 9 cm, by kind permission of Klefisch
GmbH Art Dealers, Cologne

This small netsuke is of a seated kirin (a
mythical animal similar to the European
unicorn), its head turned backwards, its
curly tail held high against its body. A fine
detail in the carving is the kirin's tongue
curling up in its mouth.

Inro

Shibata Zeshin (1807–1891)

Late Edo/Meiji period, H 7.6 cm, lacquer,
signed: Zeshin; by kind permission of
Klefisch GmbH Art Dealers, Cologne

This *inro* (medicine box) consists of five
compartments. The lacquer technique used
is known as *ginji*, in which lacquer is
combined with silver powder – here so
abundantly that the surface appears to be
of solid silver. Fine intaglio engraving,
partly filled with black and red, depicts a
gathering of foxes in a forest; in the
background are red gates leading to a
Shinto shrine. The depiction continues on
the back.

Inro

Shibata Zeshin (1807–1891)

Late Edo/Meiji period, H 9 cm, lacquer,
signed: Zeshin and Koma; by kind
permission of Klefisch GmbH Art Dealers,
Cologne

Made of shiny scarlet lacquer, this six-
compartment *inro* is decorated in light
relief with a lobster picked out in two-
tone gold (*takamakie* technique), red,
brown, and black. On the reverse side is
a sprig of chestnut with two spiky
chestnuts.

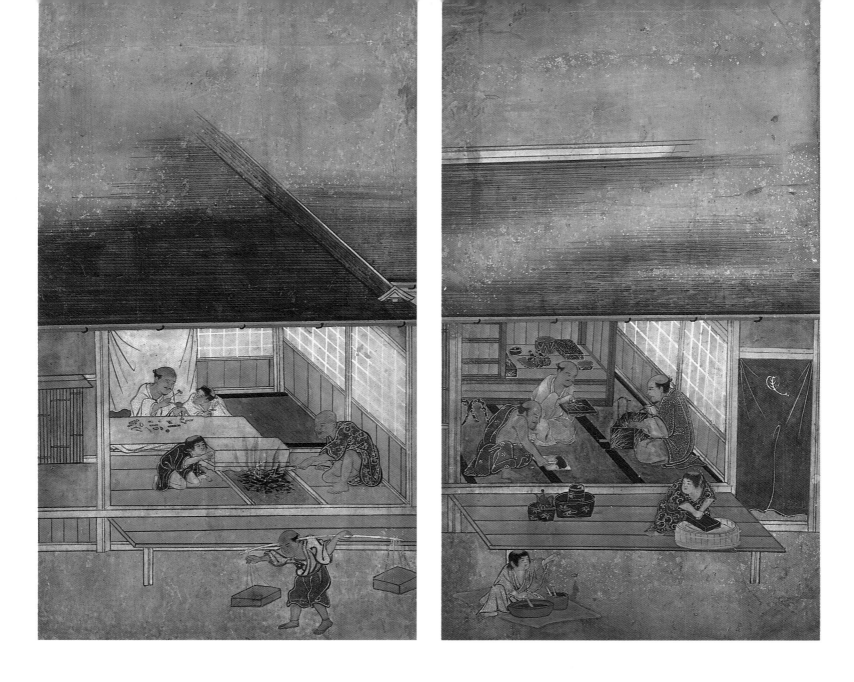

which was first made by monks at the Negoro temple in Wakayama Prefecture, not far from Osaka. *Negoro* wares are seen in a variety of utilitarian shapes – such as serving trays or bowls, as well as objects for Buddhist ritual – which were carved from wood and then coated with layers first of black and then red lacquer. The beauty of *negoro* is unpredictable, appearing only with time: after parts of the red lacquer become worn through after repeated use to reveal the black undercoating. The resulting patterns are completely abstract and unplanned, and exemplify the words of a later connoisseur who commented that "the beauty of craft is the beauty born of use."

The technique of making carved lacquer originally came from Song-dynasty China, and because of the cost of effort and material required items made were usually rather small, such as incense boxes. On a thinly carved wooden box, which would provide the base, up to 300 layers of lacquer were applied, with each coat being allowed to dry before being painted with the next. The thick layers of lacquer were then carved to leave a three-dimensional design through (see

opposite, top left). Black and red were the colors most usually chosen for carving, but a more elaborate effect could be achieved by using lacquer in different colors that reveal themselves like geological strata as the layers are cut through.

Lacquer lends itself to being used together with other materials in order to create special effects. From early times, gold and silver particles have been used to make the *maki-e* decoration mentioned above, but pewter, mother-of-pearl, abalone shell, and even ceramic have also been widely used. The use of the rather dull-colored pewter was introduced by Rimpa artists such as Ogata Kōrin and Hon'ami Kōetsu, who designed and supervised the making of lacquer objects even if they did not handle the raw material themselves (see page 324). The native abalone shell was often chosen for decorative inlay because it shows a blue and green spectrum of iridescent colors, and could be cut into a variety of decorative shapes such as flower petals to make up a design in a lacquer base (see page 329, bottom).

During the Edo period two artists stand out for their innovative skill in using lacquer to

Traders' shops selling lacquer goods and metal fittings

17th century, details of a six-panel screen, ink, colors and gold leaf on paper, complete screen 355 cm x 109.5 cm, private collection

Lacquer was made at workshops that were normally distanced from inhabited areas because of the irritation caused by the raw sap. Finished articles were taken into town, where they were sold at shops similar to the one shown above (right). The illustration on the left shows the preparation of small metal goods.

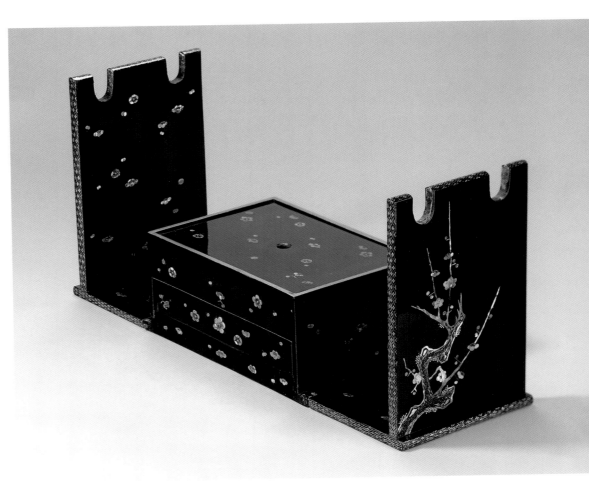

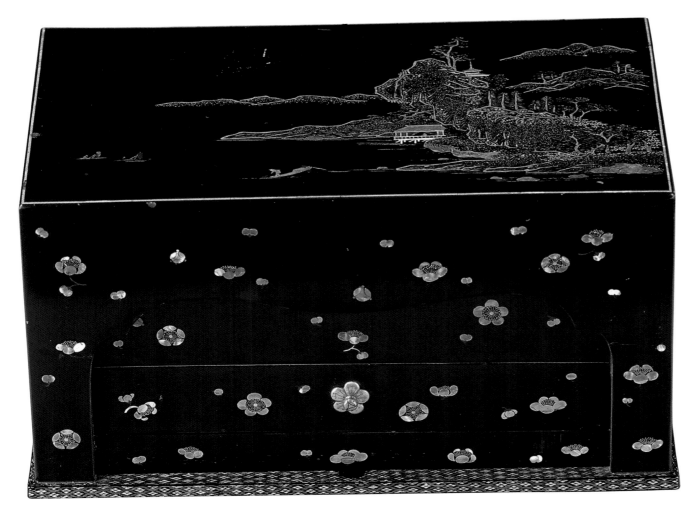

Top left
Incense box

Kamakura period, carved lacquer,
H 8.3 cm, dia 25 cm, Collection of the
Freer Gallery of Art, USA

This technique of carving through many
layers of applied lacquer was a speciality
of the old capital of Kamakura and
imitated similar works that had been made
in China. The beauty of this piece is
enhanced by the centuries of wear, which
has revealed parts of the black layer of
lacquer underneath.

Left, and above right
Portable sword stand

18th century, lacquer with mother-of-pearl
inlay, Collection of Jeffrey Montgomery,
Lugano, Switzerland

This stand has been made in collapsible
form. When open (above) it has two
notched ends for supporting the swords.
These fold in and a top is added to form a
convenient box. It was made in Okinawa
and is decorated with fine inlay of mother-
of-pearl.

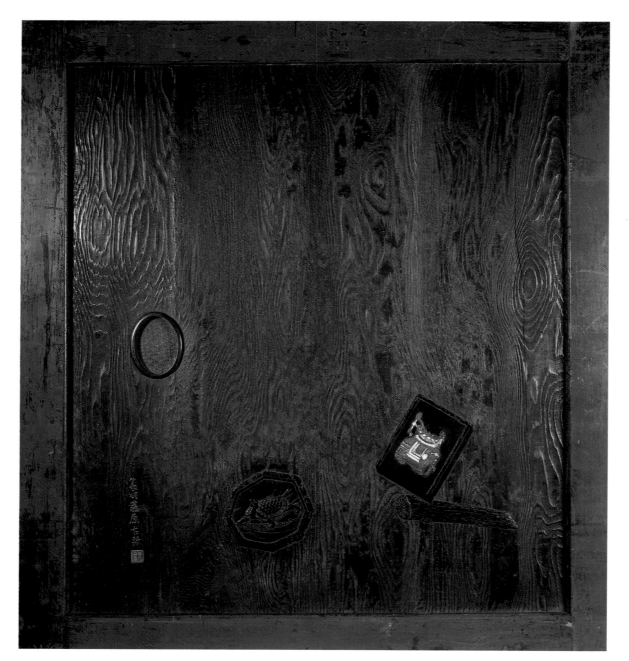

Pair of doors with lacquer decoration

Ogawa Haritsu (also known as Ritsuo, 1663–1747)

58 cm x 51 cm, Collection of the Linden-Museum für Völkerkunde, Stuttgart

Ogawa Haritsu was famed for his innovative technique of using lacquer to imitate other materials. In these doors he has made a bas-relief design in lacquer imitating decorated sticks of ink.

deceptively imitate other materials. Ogawa Haritsu (1663–1747) came from a samurai family, from which it is reputed that he was expelled for bad behavior. He moved to Edo and there, after starting his career as a poet, later changed to painting and to making lacquer items; remarkably, he produced his best works during his mature years, at an age when most lacquer workers were thinking of retirement. He invented a process to make lacquer look exactly like other materials, such as bronze, or ink sticks. In the illustrations above and on the opposite page, we can be seen how Haritsu decorated a pair of plain wooden sliding doors with a design of Chinese ink sticks, showing the surface texture complete with chips and cracks of age that are convincingly realistic. Two of the sticks have further decorative features made from glazed ceramic imbedded in the lacquer, which adds a touch of discreet color to the elegant composition.

A century later, the prolific Shibata Zeshin (1807–1891) followed in Haritsu's footsteps by also using lacquer to cleverly imitate other materials. In addition, Zeshin was an accomplished painter who used not only the traditional ink and pigments, but managed to process lacquer in such a way that it could be used for painting yet remain flexible enough for the repeated rolling and unrolling of a hanging scroll. He had an extraordinary eye for nature's subtleties, which he was able to capture in his lacquer work with astonishing realism, often taking great pains to depict a fall leaf, a spiky chestnut, or a column of tiny ants, particularly in the small netsuke and *inro*, for which he is famous.

Textiles and Costume

Japan has had a long history of spinning and weaving native silk and other fibers, and has produced some of the most elaborate costumes to be seen in the world. Obviously, few remnants are left of the earliest textiles, but Heian period picture scrolls, such as those that illustrate the famous 11th-century novel *The Tale of Genji*, show the nobility wearing sumptuous silk robes, and an 8th-century fragment of silk in the Shōsō-in treasure house in Nara shows that by that time the sense of pattern and color was also very highly developed. Most costumes that remain intact, however, date from the past 400 years or so, since the Late-Muromachi period.

The standard costume for all levels of society in Japan until the period of Westernization started was the kimono, which is basically an unstructured T-shaped robe made from one rectangular length of cloth that is cut up as shown in the diagram below.

Over-jackets and under-kimonos were worn as extra layers during the colder months and were made as variants of this same practical shape. Bolts of cloth were made in a standard length and width, and as larger men and smaller children could be clothed merely by increasing or reducing the proportions of the same pattern, there was hardly any material wasted.

The kimono was secured by an *obi*, a sash that was tied around the hips. Small items of necessity could be carried in the pockets of the hanging sleeves and samuri warriors wore their sheathed swords by tucking them through the *obi*. For the style of living during that period of time, nothing could have been more elegant – or, indeed, more practical.

There was no "tailoring" or padding, and yet this simple garment was used as a base for some of the most beautiful costumes ever seen. Who wore what was governed by social rank, occupation, and official regulations, but these conventions were continually breached, especially by successful courtesans and the lower-class, but newly rich, merchants. Naturally, silk was favored by the higher ranks, while the farmers wore fabric made from regional vegetable fibers, as well as cotton (since the 16th century or so). During the stifling summer, all classes wore some kind of linen, which was made from flax, hemp, or (in the sub-tropical southern parts of the country and the Ryukyu Islands) banana tree fiber. The farming people who lived in remote areas wove rather coarse material from the long-lasting fibers of native wisteria, and trees such as the mulberry, which also provided the raw material used for making paper.

The Japanese excelled in weaving and in producing the most intricate embroidery patterns, and were also very dextrous in the use of both gold and silver thread. These skills are best demonstrated in the most splendid *kosode* kimono, which were worn by the highest of the social classes and are still seen today in a modified form worn by the actors of the Nō drama (see opposite, and page 334). Designs gradually changed through the Edo period, but the earlier, mid-17th century examples seem to be bolder and graphically more flamboyant, only later becoming tighter in design and more complicated. Almost all dyes were made from vegetation sources yielding a wide palette of beautiful colors that even at their brightest are nevertheless restful on the eyes, unlike the hot

Opposite

Nō costume

(Detail), 17th century, costume L 130 cm, Hatakeyama Collection. Tokyo

The detail here shows not only the refined embroidery, but also a technique, used mainly with Nō costumes, called *nuihaku*, where gold leaf is beaten onto the woven silk to make a shimmering background for the design.

Right

Kimono

This diagram clearly shows that the traditional Japanese kimono is not only an elegant garment, but also one that is very practical and economical. On the left is a piece of cloth divided into the various parts of the kimono; there is not a single piece wasted.

Collar

Neckband

Collar

Body piece

Neckband

Sleeve

Body piece

Body piece

Sleeve

Sleeve

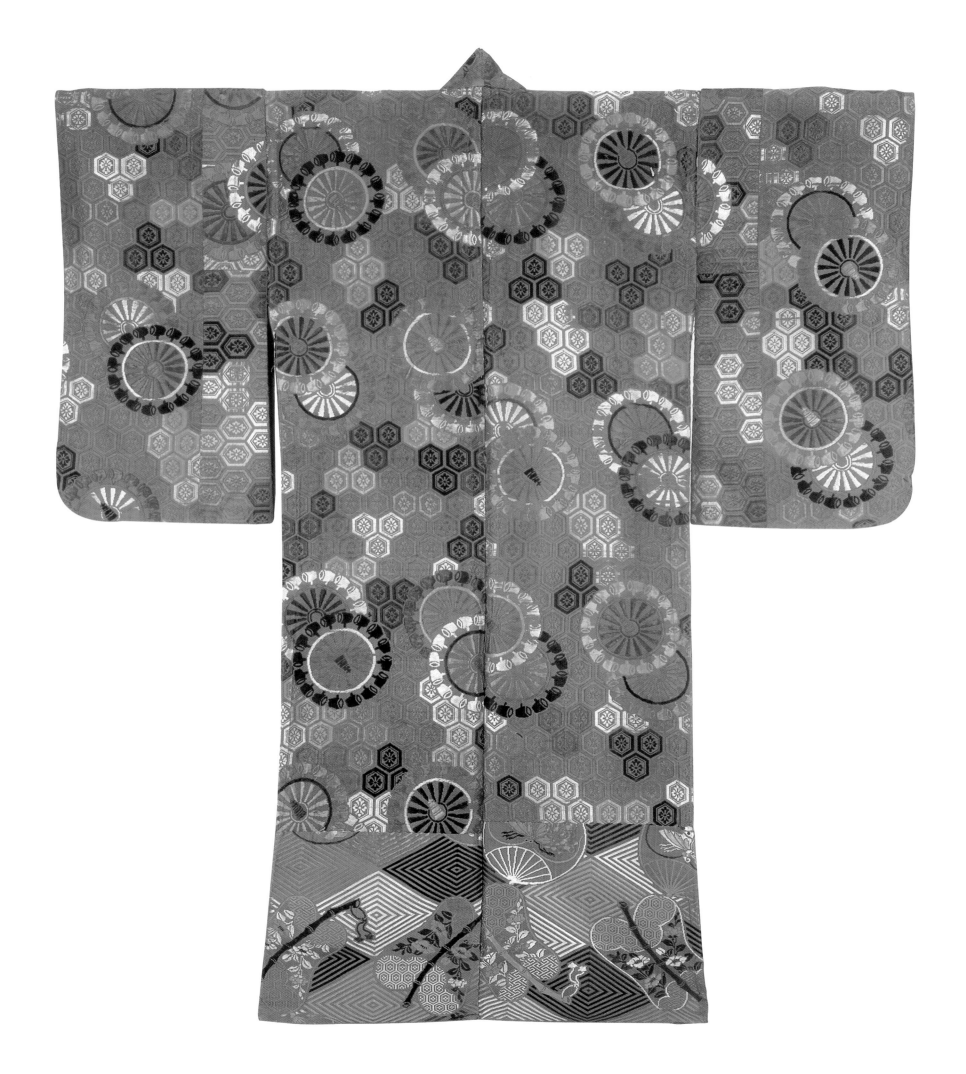

chemical tones that we are sadly so used to these days. It is important to remember that light has a tremendous effect on the way that colors are perceived, and one can only imagine the wonderful appearance of these costumes as they were worn in the very plain surroundings of a traditional Japanese house, the shimmering silks catching the soft light of burning candles and oil lamps.

The rise of the merchant classes and the influence of the pleasure quarters had a profound effect on the fashion-consciousness of city dwellers during the Edo period, and much can be learned about the current styles from the many *ukiyo-e* pictures that depict the celebrated beauties of the time and their dashing paramours. Any occasion was an excuse to dress-up, and much prestige was attached to high style, and to having the sure taste to choose attire that was properly in keeping with the season, but also interesting, and perhaps just a little outrageous.

A totally different sartorial scene was to be found in the countryside, where the farming communities were prohibited from wearing silk (even though they manufactured it) until the modern period. Despite this restriction, they created textiles that were practical for their occupation, and also beautiful in a direct and natural way, by using the materials that were available to them: clothes made with economy and a large degree of skill. And even though country life was not always the Arcadian idyll that we might like to imagine, there was from time to time some festival or celebration for which it was appropriate to dress up. The dye that was mostly used for its practicality and availability was indigo, and it is this blue, which seems to soften and improve with age, that is associated with country textiles more than any other color. Numerous shades could be made depending on the time that the fabric was left soaking in the dyeing vat, and cloth could always be redyed if required. Indigo also provided the ideal background to complementary colors (browns, reds, ink grays, and yellows) that were available from other vegetable sources found abundantly in the countryside.

Country fabrics were used not only for clothing but also for *futon* (Japanese bedding) covers, wrapping-cloths, banners, cushion covers and so on, and these were often decorated in a way that enhanced the material and how it was used. *Sashiko* is basically a stitching process using a thread of a contrasting color, which was frequently used to strengthen or repair work clothes, or patch together remnants of old fabrics to give them a second life. The resulting patterns could be simple and graphic, or complex to create an almost three-dimensional, textured appearance (see page 336).

Two techniques of dyeing were frequently used to make colored decoration. One of these used stencils, made of waterproof handmade paper, which were placed on the fabric and covered with rice paste. The stencil was removed to leave the design in paste, which was allowed to dry before

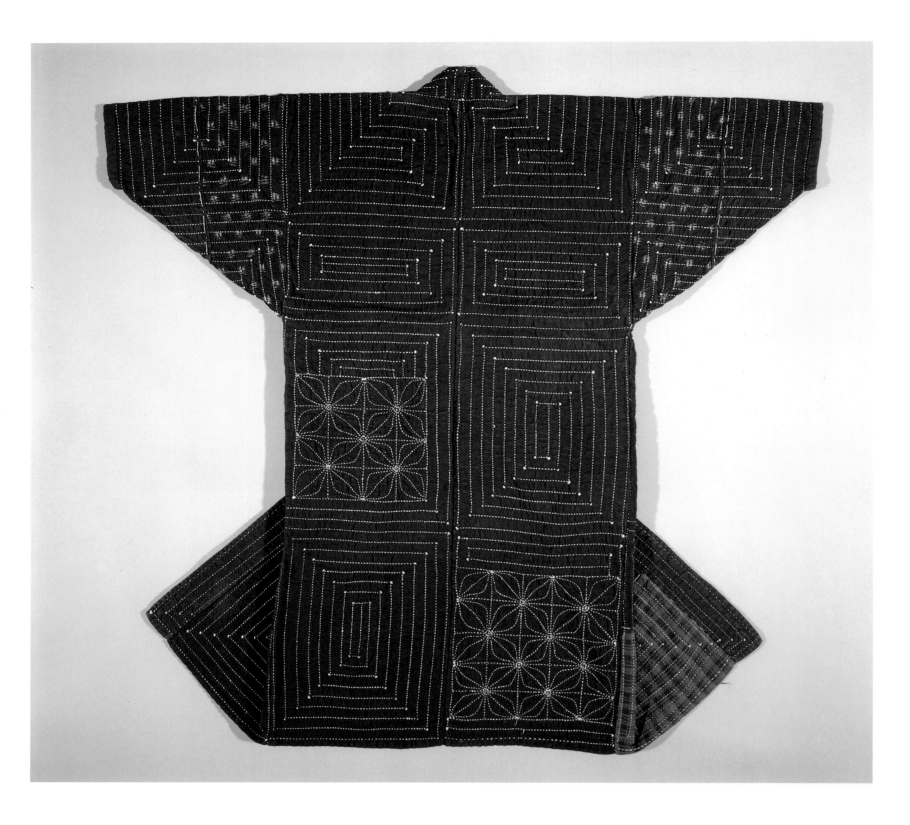

Farmer's smock

19th to early-20th century, cotton, sashiko stitching, L 115 cm, Collection of Jeffrey Montgomery, Lugano, Switzerland

dipping in the indigo dye. The paste was then washed off to leave the stencil pattern in the un-dyed areas, which could then be left in its natural color or decorated with other colors.

The other technique, known as *tsutsugaki*, involved the direct painting of a design on the fabric with paste squeezed from a paper cone, and then dyeing as above. *Tsutsugaki* designs are much freer and spontaneous than those that have been stenciled, and by definition are always one of a kind (see opposite).

In the northern island of Hokkaidō, the indigenous Ainu people made distinctive costumes with patterns of stitching that are completely different to those seen in the rest of Japan, and echo such diverse motifs as those seen on Jōmon pottery, Chinese bronzes of the Shang dynasty, and even the carvings of the indigenous tribes of western Canada. The Ainu had no tradition of growing cotton and they used the under-bark fibers of native trees, or the local nettle plant, to make rather coarse but very practical fabrics. Decoration was achieved by stitching and also the appliqué of pieces of indigo-dyed cloth that had been bought or bartered from traders who visited from the main island of Japan. Surviving Ainu costumes are very

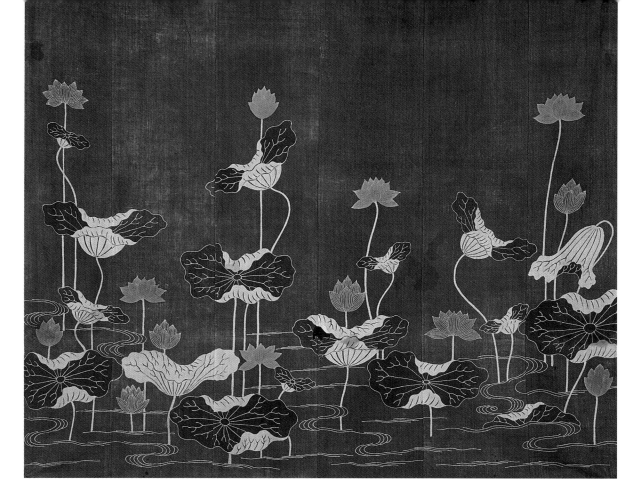

Sheet with lotus designs

19th century, cotton, tsutsugaki *technique, 187 cm x 187 cm, Collection of Jeffrey Montgomery, Lugano, Switzerland*

When used as a design motif in the Far East, lotuses have a strong connotation with Buddhism, and it is likely that this sheet was used as a wall hanging or altar cover in a country temple.

Below left
Futon cover

Late-19th–early-20th century, cotton, tsutsugaki *and* katazome *techniques, 160 cm x 125 cm, Collection of Jeffrey Montgomery, Lugano, Switzerland*

Below right
Futon cover

Late-19th–early-20th century, cotton, tsutsugaki *technique, 220 cm x 160 cm, Collection of Jeffrey Montgomery, Lugano, Switzerland*

This futon cover has a mixture of auspicious elements: the pine, bamboo, and plum blossom, which are the "three friends of winter," together with eggplants, Mount Fuji, and a falcon, which are connected with fertility and masculinity.

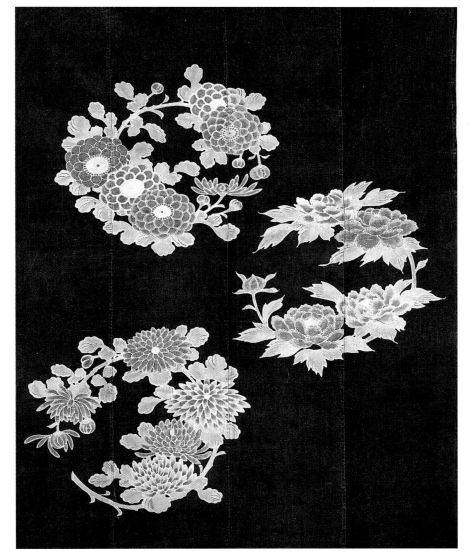

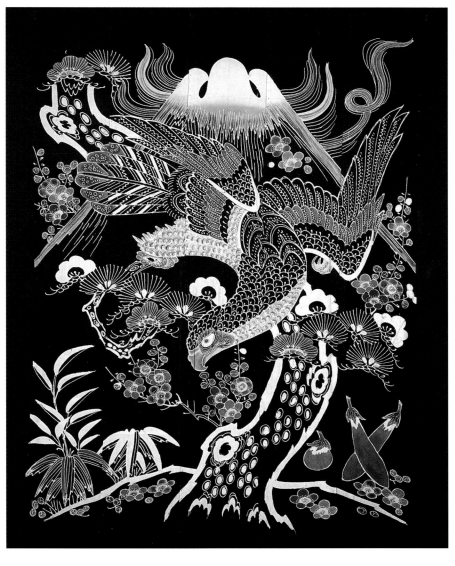

rare, and those that do remain show graphic lines and shapes that reveal the artistic mind of the more solitary northern hunters – close to the spirits of the bear and the deer – rather than that of the more socially organized rice growers living in the warmer southern islands (see opposite).

Mention should be made of the costumes worn by ordinary people in the cities, who while also being prohibited to wear silk under the Tokugawa regulations, wore clothes that related to their work. Some of the most graphically striking were the *happi* or *haori* coats – short kimono that were worn by carpenters and fire fighters – particularly those that were reserved for ceremonial use and festivals. Edo period fire fighters were the heroes of the cities, much celebrated for their bravado, swagger, and snappy attire, a reputation that was most deserved, as in the cities fires were a constant hazard. They had their own guilds and groups, which were identified by the *mon*, badges

emblazoned on their jackets. Thick cotton was worn for everyday use as it could be soaked in water to offer resistance to flames, but some were also made out of lined deerskin that, combined with a head cover, offered an even better protection while on duty (see above).

Fireman's jacket

Deerskin, L 131 cm, Collection of Jeffrey Montgomery, Lugano, Switzerland

Although this jacket would serve its purpose well, especially if soaked with water, it is more likely that it was worn only for festivals. This kind of strong, attractive design exemplifies the Edo sense of *iki* – in sure taste, but also daring and flamboyant.

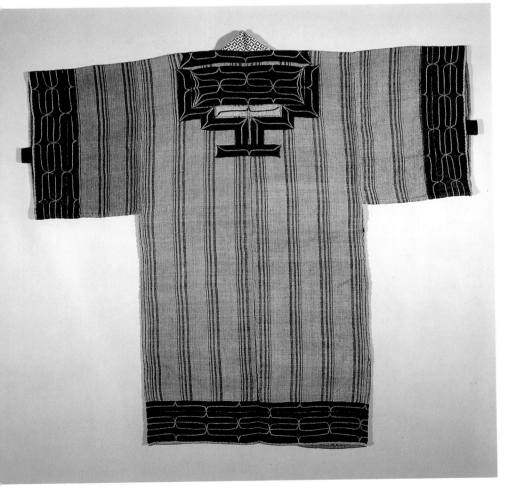

Above left

Ainu costume

Late-19th–early-20th century, cotton with yellow thread stitching, L 128 cm, Collection of Jeffrey Montgomery, Lugano, Switzerland

Left

Ainu costume

About 1900, vegetable fiber with blue cotton appliqué, L 128 cm, Collection of Jeffrey Montgomery, Lugano, Switzerland

The Ainu people of Hokaido made costumes out of vegetable fibers, which they decorated with cotton pieces bought from traders and stitched with their own unique designs. In this piece the vertical stripes are also of fiber and must have been dyed separately.

Above

Farmer's smock

19th century, cotton, sashiko technique, L 130 cm, Collection of Jeffrey Montgomery, Lugano, Switzerland

This robe is from Kagawa Prefecture on Shikoku Island and has a tight *sashiko* stitching of white thread on an indigo background, which gives a thick, textured appearance.

Arms, Armor, and Metalwork

Perhaps there is nothing that more symbolizes traditional Japanese culture than the sword, the weapon that has attained an almost mystical status not only in its home country, but also among aficionados in the West. In the minds of many Japanese, the sword is considered to be art in its highest and purest form, the apotheosis of man's creativity, and made for the purest of purposes: that of violent death. So what is the reason for this mystique? One answer can perhaps be found when we look at the extraordinary work that went into their making.

Below
Samurai sword in scabbard

Edo period, lacquered wood, inlay, Tokyo Fuji Art Museum, Tokyo

Middle
Blade of a samurai sword

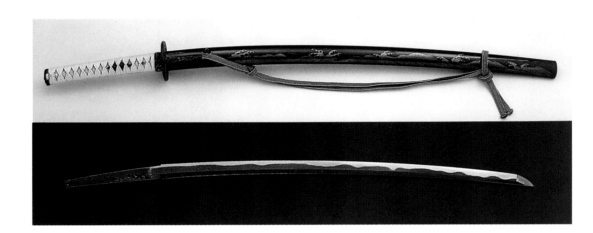

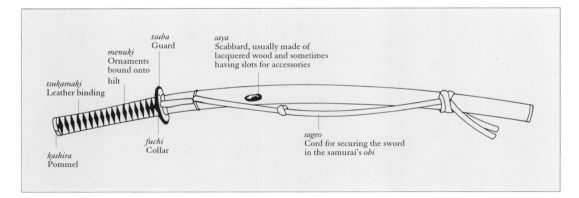

tsukamaki
Leather binding

menuki
Ornaments bound onto hilt

tsuba
Guard

saya
Scabbard, usually made of lacquered wood and sometimes having slots for accessories

fuchi
Collar

kashira
Pommel

sageo
Cord for securing the sword in the samurai's *obi*

While earlier swords developed from prototypes that had arrived from China and Korea, they suffered the disadvantage of breaking easily under the stresses of fighting, and as deadly weapons they were generally not very efficient. It was during the warring Kamakura period and the establishment of the shogun military rulers, that a new type of weapon was perfected, after much trial and error, and which in retrospect must have been a miracle of metal working.

The extraordinary difference between the Japanese sword and those that were used in other countries is that while the edge is razor-sharp, the blade is also extremely tough and sturdy for fighting. According to legend, the technology was originally revealed to a smith named Amakuni

sometime during the early-8th century A.D., after he had prayed for seven days and nights to the Shinto gods. (It is significant that the sword is one of the three sacred treasures of Japan, preserved in the Imperial Shrines along with the Mirror and the Jewel.)

Earlier swords had been designed for the task of trying fatally to stab the enemy, but armor had been developed so that it could effectively thwart the thrust, and cause the weapon to snap. An additional disadvantage of the stabbing method was that in making a lunge the attacker was momentarily made very vulnerable.

By way of contrast, the new sword killed by cutting – the razor edge with the force of toughened metal behind it being one of the deadliest forces imaginable – and was capable of slicing through a human body with one stroke. There was almost no chance at all of surviving an attack with a sword in competent hands and even if death was not caused immediately by the first stroke, it would almost certainly follow quickly as a consequence of the massive bleeding. It goes without saying that it was vitally important to land the first stroke.

The process of manufacturing a sword was commenced only after appropriate ritual austerities and purification. Firstly, the smith would prepare to make a sword by selecting and refining the finest sand ore, which was then forged to make the base metal. Then followed a complicated and often secret process of heating, folding, and beating the metal into the rough shape of a sword, and it is this procedure of layering the metal that created the legendary toughness of the finished weapon. When it had reached its final form, the sword was covered with a paste of clay, charcoal, and other ingredients, then heated again and tempered in cold water. The smith would cut his signature on the *tang* (the part of the sword encased in a handle) before handing it over to a polisher for honing the edge and smoothing the blade to a mirror-like luster.

Other craftsmen would make the sword's fittings (see left). This includes a *tsuba*, the guard that encircles the sword between the blade and the tang; and the handle itself, which is made of wood covered with the skin of a ray fish, and bound with flat cords or leather. Other metal fittings are the *fuchi*, the collar between the *tsuba* and the handle; the *kashira* at the end of the handle, and *menuki* ornaments secured in the binding. The sword is housed in a *saya* scabbard made of wood and usually lacquered, which sometimes has slots for samurai accessories, such as metal chopsticks or a *kozuka* knife used for less lethal, utilitarian purposes. Many of these items are masterpieces of metal art and use silver, gold, and colored alloys to make miniature sculptural designs that are impossible to imitate today.

For battle, the samurai would be fitted out in a suit of armor. This differed from the protective gear seen in Europe in that, being made in a

Left
Helmet

14th/16th century, iron and copper, lacquer and urushi *technique, Tokyo Fuji Art Museum, Tokyo*

Ainu quiver

18th–19th century, wood and metal, L 51 cm, Collection of Jeffrey Montgomery, Lugano, Switzerland

This extremely rare object shows a use of materials and sense of pattern that is completely different from that seen in the rest of Japan, and shows similarities to the designs of the Northwest American Indian tribes.

complex grouping of leather, metalwork, silk, and lacquer, it was a good deal lighter in weight, and so any warrior unfortunate enough to fall at least had a chance of being able to stand upright again. This splendid panoply was topped off with a ferocious *somen* mask made of iron lined with lacquer, and a helmet – a sculpture in itself (see above) – which, in the words of the modern sculptor Isamu Noguchi, "has more use than to protect the head. More mask than hat, it is a disguise to transform the wearer into a personage of otherworldly ferocity. Intended primarily to frighten the enemy, it may also have had an even more subtle function, that of transforming the wearer. Thus garbed, his true status confirmed, he is the samurai dedicated to death and governed by a code beyond the pale

and beyond reproach. The mask of terror becomes the man himself." How well put; and can a comparison be seen here with the gruff performer in a Nō play who, for a few minutes before going out on stage to commence the performance, contemplates the mask of a beautiful princess in order to take on her spirit and persona?

Mingei: Folkcrafts

Until the latter half of the 19th century, almost everything in Japan that was man-made could be considered as craft for the simple reason that, as the country had arrived late to the industrial revolution, machine-made goods were extremely rare. The land was rich in raw materials, and objects of ceramic, wood, straw, metals, stone, lacquer, and textile had been made since ancient times with a sense of design and beauty that make them unique in the world.

Houses were made of wood – with a flooring of *tatami* mats, a roof of thatch, and walls of mud – by skilled craftsmen using techniques that had been handed down from generation to generation. And while these dwellings were not too warm during the winter, the *shoji* screens could be opened up for most of the rest of the year, and so people lived with a sense of being part of nature and the flow of the seasons. Almost everything was made from natural materials and so their beauty became more apparent with the passing of time. "Beauty born of use" was the phrase that Yanagi Soetsu used in his famous book, *The Unknown Craftsman*, to describe the patina of well-handled wood, the fading of silk and cotton, the rustic bowls stained by tea, the glow of worn lacquer…

The appeal of such objects had not escaped the Japanese, and as far back as the Muromachi period the cult of the tea ceremony, which was much inspired by Zen Buddhism, had focused on the beauty of simple objects produced by humble craftsmen. It was this particular sense that led to the highly evolved concepts of *wabi* and *sabi* that at first shocked and confused the Westerners who later came to Japan, but then seduced them as their eyes were opened to the appreciation of some of the most beautiful objects made by man. For the most important characteristic of the beauty of craft is its humanity; no intellect is required: just feeling. The art of craft is artless.

Wabi and *sabi* refer to aesthetic ideals that are particularly associated with Zen and with the tea ceremony. Both terms are difficult to translate directly, but *wabi* evokes rather poignant nuances of sparseness and quiet understatement, even poverty, while *sabi* has a connotation of age, patina, and loneliness.

Closely associated is the word *shibui*, which is often encountered in reference to Japanese art and implies an astringency, a hidden quality, that requires the viewer to seek out concealed beauty. It is associated, too, with poverty and an absence of any trace of ostentation; with simple shapes and dark monotones, the nicks and scars of life, the wear of age…

> *Last year's poverty was not yet true poverty.*
> *This year's poverty is at last true poverty.*
> *Last year there was nowhere to place the gimlet.*
> *This year the gimlet itself is gone.*
>
> Zen monk Hsiang-yen

Perhaps if we could step back in time a hundred years or so, we would be most surprised to find that everything was unique; for, being made by hand, no two objects were the same. For example, ceramics were mostly created on a wheel and had the subtle imperfections of shape, design, and decoration that made them, above all, interesting. In addition, there was much variation from village to village, from province to province, which made even a short journey a delight of discovery. Nowadays, uniformity has reached such a nadir that when sitting in a room of any of the world's major hotels, one would be hard pressed to even guess what country one was in.

Of course, it did not take too long for Japan to catch up industrially after opening its ports to the West, to the extent that it now has the second largest economy in the world and, despite the odd setback, is still growing. Today in Japan, in contrast to a century ago, most things are made by machine and hardly anything gets more beautiful with use, even if there had been some attractiveness when new. With odd exceptions, modern buildings begin to look depressingly ugly only a year or two after they are built, and in addition are plagued with a wide variety of unhealthy phenomena: poisonous fumes from paint and synthetic materials, electromagnetism and radiation, unnatural lighting… all of which contribute to the malaise, common in Japan, known as "new building sickness." Almost anything made of synthetic materials feels unpleasant and looks distinctly sad after only a very short while, and hardly anything lasts for very long anyway, having been made with "built-in obsolescence," from *prêt-à-porter* to *prêt-à-jeter*…

The economic reasons for this industrialization are well known and there is certainly a sound argument for the improvements in social conditions and general well-being over recent decades. And fortunately, there has also been a renewed and encouraging interest in crafts, as if in rebellion against the onslaught of plastic, and there are always plenty of exhibitions of new works to be seen in department stores and galleries around Japan. In particular, there is a healthy following for the crafts of ceramics and textiles, and Japan is probably one of the few countries in the world where an individual potter or weaver can make a good living.

Perhaps more than anyone, the man most responsible for the interest in the craft movement in Japan was Yanagi Soetsu (1889–1961). Born to a prosperous family, he was educated at the elite Peers' School (*Gakushuin*), and later read philosophy at the Tokyo Imperial University. In his celebrated *The Unknown Craftsman* he elaborates on the "artlessness" of craft and how craft workers develop their skills by doing (*jiriki*), not by thinking – to the point when creation becomes second nature. Yanagi uses the word *tariki*, which can be interpreted as: "it is not I who am doing

Yokogi in the form of a rolled scroll

18th–19th century, wood, L 30 cm, Collection of Jeffrey Montgomery, Lugano, Switzerland

Yokogi were usually made of wood and are seen in a variety of forms, usually with some auspicious meaning. This piece is very unusual in having been carved in the shape of a tied-up scroll.

Opposite

Statuette of Gengon

Muromachi period, 15th–16th century, wood with traces of gesso, H 47 cm, Collection of Jeffrey Montgomery, Lugano, Switzerland

this." The evidence of this skill can be seen intuitively in the beauty of the finished object. An object that has been "thought about" will not "work" however much care has been taken to make it, and this lack is noticed most of all in the works of beginners.

Having already studied the works of William Morris, who had established the Arts and Crafts movement in Britain, Yanagi's ideas were further influenced by his association with Bernard Leach (another Englishman, who came to Japan to study pottery under Ōgata Kenzan VI), and the Japanese potters Hamada Shōji and Kawai Kanjiro. Kawai lived in Kyoto where his splendid house is now open to the public, and Hamada and Leach worked at Yanagi's estate at Abiko, near Tokyo, in a "commune of crafts" that was calculated to pave the way to a post-industrial society, "where beauty would reign."

Unfortunately, this ideal still remains a dream; however, a start had been made. Yanagi coined the word *mingei* from the Japanese words meaning "folk" and "art" to refer to this artless art of craft, and founded the *Nihon Mingei Kyokai* (Japanese Society for the Study of Folk Art) in 1926 to foster the movement. This association established the Japan Folk Art Museum, which has branches all around the country, and also published the magazine *Mingei*, which is still published today.

The movement has had its ups and downs, but it is basically strong today, with more and more people coming to recognize the need for craft, and the beauty of natural handmade objects. Unfortunately, one of the less desirable sides of the movement has been the encroaching cultism of *mingei* and its commercialization, to the extent that its products are often sold as if they were objects of fine art. Surely, by definition, folk art should be affordable to most people; but if a single plate can cost several hundred thousand yen (several thousand dollars), then it is much too precious to use and can no longer be honestly considered as *mingei*. In most cases, the problem has been caused by retailers who have promoted certain craftsmen just as they would a painter or sculptor, so that their objects are often priced in the same realm as are fine arts.

For foreigners visiting Japan, craft works are probably most appreciated because, while exotically different, the skill involved in making the object can easily be seen and understood. In the West, and particularly in Britain, there has been a long craft tradition, and so visitors are quite capable of displaying considerable connoisseurship. It is true that just as *ukiyo-e* prints were first collected by Westerners in the 19th century, so today some of the best examples of *mingei* can be found in America and Europe. The appeal lies to some extent in the choice of materials not often used in the West, such as bamboo, lacquer, *keyaki* wood (Japanese elm), and *kiri* wood (Japanese paulownia). But the appeal also lies in the objects themselves, which are often made for some uniquely Oriental purpose: *wadansu* (storage chests), *hibachi* (braziers for charcoal), *andon* (lamps), *kago* (baskets), *yokogi* (a device for altering the length of a potholder), saké containers, *tetsubin* (iron kettles), and kimonos are just a few examples of craft objects that hold a great deal of fascination because they are, to the Westerner's eye, so refreshingly unfamiliar.

It is not only the object and its purpose that makes Japanese craft so attractive, but also the extraordinary motifs chosen for decoration. Naturally, these are largely inspired by nature, but that is not uniquely Japanese; nature has provided the main source of decorative ideas almost everywhere on Earth until modern times. What is unique is the flair for using motifs taken from the natural world, or even from household objects, in a way that is very different from the way that they would have been treated in the West. An example is the *yokogi*, a perforated gadget for altering the height of the potholder suspended over the charcoal fire in country houses. These are carved from wood and can be seen in a variety of shapes, the most usual being a fish (see left), particularly the auspicious Pacific snapper or the carp (a symbol of bravery and perseverance for boys).

But the *yokogi* can also appear in the form of a rolled hanging scroll of the kind used for displaying paintings or calligraphy (see page 343); in the example illustrated, the cords for tying up the scroll have been realistically carved, and even a label is shown carved on the side (which in reality would have a note written to identify the artist or the contents). The result is highly effective, and yet it is still intriguing to imagine why the craftsman chose such a subject; after all it is normally the art or calligraphy which is contained inside the scroll that is considered to be the object of beauty, and yet here the "wrapping" has been chosen instead. This alternative way of looking at objects can also be seen in some Nō costumes, when objects such as books are made part of the sumptuous pattern, together with small birds and fall berries, on a background of gold in brilliant and surprising designs.

Being amateurs, the craftsmen who made *mingei* lacked the refined skills that were the province of those whose training enabled them to work for the nobility or the great temples, but this was no impediment to their capturing of the soul of a subject in a way that makes these objects so much more accessible. On page 342 we see a statuette of Gengon, one of the Japanese deities with ancient Hindu antecedents, who is usually employed as a guardian figure in Buddhist sculpture. It is quite apparent that the carver had not trained with a leading master – the proportions are a little odd, the shoulder unnatural, the face rather coarse – but by trying to capture the ferocity of this formidable being within the limits of his modest skills, he has succeeded in diffusing the menace and bringing the deity down to earth. The same diminution can be seen in the carvings of other gods and supernatural beings, which show how the

country carver has quietly stripped them of any authority or terror, and has in fact domesticated them to a level where they would be acceptable in the rural community (see page 346). The wooden rabbit or hare shown above is also somewhat unnaturally proportioned, but seems to have far more character than one which may have been more realistically carved – a character, moreover, that has been improved by the gentle effects of time and weathering. But this beauty does not appear automatically and has nothing to do with being trained or not trained, as can easily be discovered if any dilettantes try craft-making for themselves. It appears as a result of recognizing the limitations of one's skill, and of having humility and respect for the material being worked; of trying to make a good object, not a work of art. That, and luck.

Respect and feeling for the material and its possibilities mark the work of the Japanese craftsman. This is apparent even in ordinary everyday items, and it is easy to imagine what a visually exciting and stimulating place Japan must have been in historic times. The two fan-shaped objects illustrated at the top of page 347 show the characters *dai* ("large") and *sho* ("small"), which are made of metal and inset into the wood. They are in fact *kamban*, the shop signs for a money-lender – graphic, unobtrusive, and discreet – which could be taken in at night or when the business was closed. They are excellent examples of how good taste and design sense could be used successfully for the most prosaic purpose. Even with objects made of metal, the Japanese craft workers seemed to have an intuitive way of coaxing out the best qualities of the material. The bronze saké pourer (page 347, bottom), apart from its sculptural interest and attitude, is extraordinary in that it has a surface that looks exactly as if it has been made of iron (by what exact process this was achieved is still very much a mystery today), but it remains an eminently practical object and a delight to use. And even the ordinary door lock, created by the hands of a craftsman, can turn into a sculpture that, even when not in use, can be enjoyed purely for its satisfying shape (see page 346).

These are artifacts of a way of life that has almost completely vanished, and in many cases the secrets of the craftsmen have gone sadly with them to the grave. Even though the component metals of the alloys used on sword fittings can be analyzed accurately, no one today can exactly duplicate the wonderful colors that could be conjured up in centuries past. Likewise, there is no one today who can sustain the strength, concentration, and

Rabbit

18th–19th century, wood with traces of color, L 29 cm, Collection of Jeffrey Montgomery, Lugano, Switzerland

Statuette of Daikoku

*Iron, H 17.1 cm, Collection of Jeffrey
Montgomery, Lugano, Switzerland*

Daikoku is one of the "seven gods of
fortune" and is here shown standing on
bales of rice, carrying a sack over his
shoulder and holding a magic mallet in his
right hand. Small statuettes such as this
were commonly found in farmhouses to
invoke prosperity and abundant harvests.

Above

Iron locks

*18th–19th century, L 17 cm, Collection of
Jeffrey Montgomery, Lugano, Switzerland*

rhythm to beat out the *nanako* (textured surface)
on an iron *tsuba* sword guard. And the story goes
that all of the carvers of pipe cases who could make
the oval-shaped cylindrical parts fit one inside the
other – and part with a soft "pop" so well they
matched – all lived in the same street in north

Tokyo that was destroyed by the 1923 earthquake.
A great deal of time and ingenuity are needed
for such invention to evolve… and yet it can all
vanish in a brief instant. One can only hope that
the future can offer something worthwhile to take
its place.

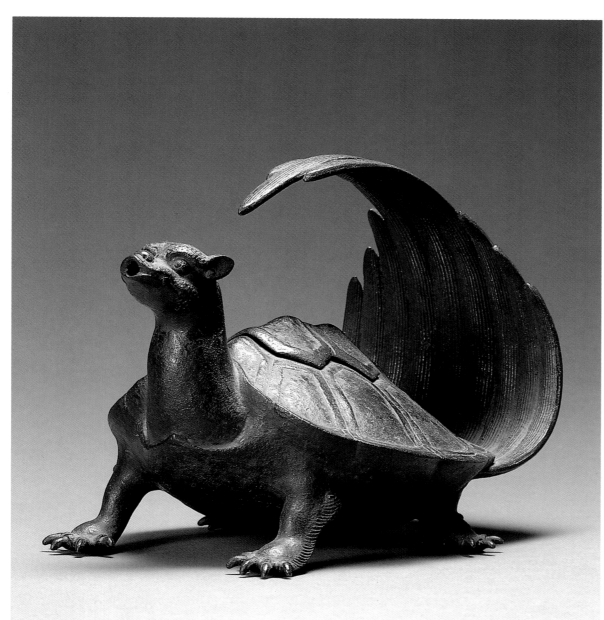

Above
Money-lender's shop signs

Early-19th century, wood with inserts of metal, L 50 cm, Collection of Jeffrey Montgomery, Lugano, Switzerland

The signs show the characters meaning "large" and "small."

Left
Saké pourer

18th–19th century, bronze, L 17.5 cm, private collection

The shape is of the *minogame*, an auspicious turtle with a long growth of seaweed flowing from its shell in the form of a tail. The metal is bronze (with a patina that makes it look exactly like iron) and the mouth is so well crafted that it will pour cleanly without ever spilling.

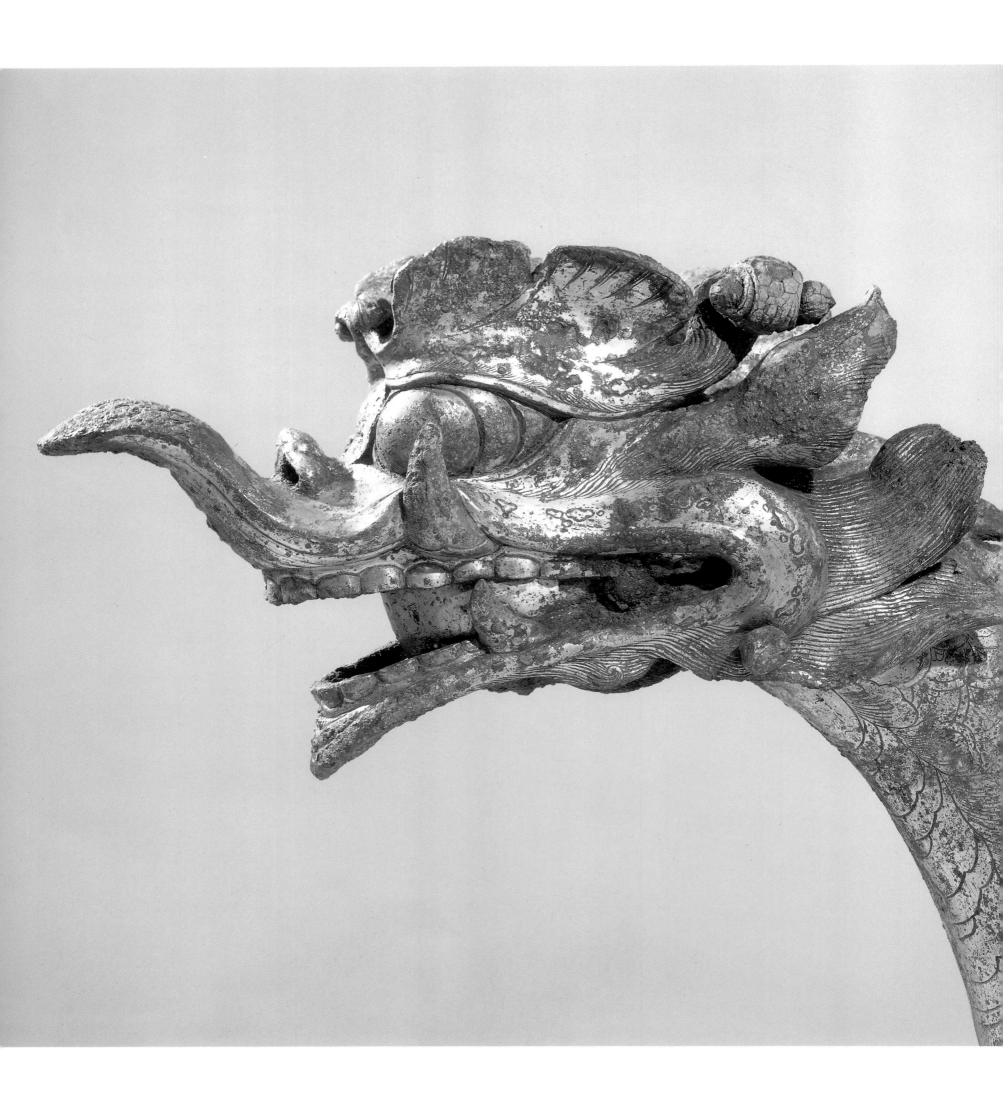

Korea

The situation of the Korean peninsula, occupying a position midway between China and Japan, is reflected in Korea's intellectual and artistic role as an intermediary. Korean artists, adopting many Chinese forms and techniques, provided inspiration for Japan and raised Korean art itself to a high level of achievement. Among the finest examples are Korean celadon ware and the porcelain of the late Yi dynasty, which was manufactured in large quantities for everyday use. The potters who made these ceramics did not claim to be producing masterpieces, yet masterpieces they indeed created, in the opinion of Yanagi Soetsu of Japan, who wrote in the 20th century that the best art is natural and comes from the heart. These unique works were created "by chance," for want of a better term, and so they were never made twice.

Finial of a temple banner pole

Unified Silla, 8th–9th century AD, gilt-bronze, H 65 cm, by courtesy of the Cultural Service, Korean Embassy, Tokyo

This splendid dragon head with the sacred pearl in its mouth, once decorated a banner pole and was used in temple ceremonies.

Cultural Background

The art of Korea, compared with that of the closest neighbors, Japan and China, has been much less exposed or celebrated, and until recent times it was almost unknown in the West. There are several reasons for this. Firstly, while long known poetically as "the Land of the Morning Calm," over recent centuries Korea has also been called "the Hermit Kingdom" on account of its isolation; during the course of history it seemed to have taken a place somewhat to one side of the international stage. For the past 500 years or so until the 1950s, the country was conservative – static both economically and intellectually – and shared with the Chinese the belief that the climax of civilization had already been reached and therefore further change was unnecessary; a policy that left them unaware of the Enlightenment in Europe, and resulted in the inevitable decadence and vulnerability. This is not to say that Korea has enjoyed continuous peace: there were frequent hostilities within the country, numerous wars with the Chinese and the Mongols to the north, and two devastating invasions by the Japanese at the end of the 16th century. In addition, for some

35 years of this century (1910–1945), Korea suffered under a less-than-benign occupation by the Japanese, who did much to quash the native language and culture. And, finally, this was followed by a vicious and tragic civil war in the 1950s that has left the country still divided and politically polarized between north and south. During this unfortunate period, and before the turnaround that occurred with the help of armed assistance from Western countries, the northern forces had almost reached the southern coast, leaving a trail of carnage and damage both in advance and retreat.

In Korea, as in many other countries, most of what is now considered to be "art" was made in its time as utensil or furnishing, and all too often shows the damage and wear and tear associated with boisterous daily living. The sad fact is that there is not much left of the former glory, so extensive has been the destruction, and in many cases what remains is hidden away and inaccessible. Fortunately, postwar archaeology has unearthed some spectacular metalwork and ceramics in fine condition, and so there are at least some excellent museum exhibits to be seen in Seoul and the provincial cities. Collections of Korean art in the West are less common, as the early visitors to the Far East focused their attention on China and Japan, where there were more encouraging commercial prizes to be won, and cultural relics were far more easily come by. Strangely, and despite a traditionally rather prickly relationship between the two countries, many of the finest examples of Korean art are today to be found in Japanese collections and museums.

For the Japanese, the attraction of Korean art has been mainly concentrated on the ceramics of the Yi dynasty, and in particular the rustic, unpretentious nature of Mishima and Ido wares, which caught the eyes of the Kyoto tea aesthetes during the 16th century. But in much earlier times Japan owed an even greater cultural debt to its nearest neighbor. From the Yayoi period, and through the Tumulus and Asuka periods, the imports of Buddhism, horse riding, writing, architecture, and almost everything else of any cultural merit arrived in Japan via Korea; it was only much later that Japan established its own connections directly with China. For hundreds of years, Korea, which adjoined China to the north and faced Japan to the south, was the bridge between the two countries. As Korea naturally synthesized and adapted all that it absorbed from China, it is no surprise to see that early Japanese culture has a strong Korean flavor, as can be seen in the excavated Tumulus-period trappings of horse riding, Sueki-style pottery, and the architecture, sculptures, and paintings of the great temple of Hōryū-ji, near Nara in Japan.

Despite being in the cultural shadow of China – and from time to time having had to survive invasions by Mongols and Japanese – Korea has,

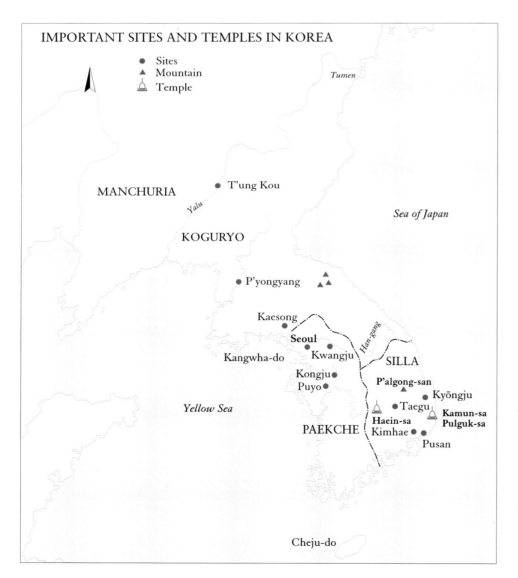

IMPORTANT SITES AND TEMPLES IN KOREA

- ● Sites
- ▲ Mountain
- ⛩ Temple

MANCHURIA

Tumen

T'ung Kou

Yalu

Sea of Japan

KOGURYO

● P'yongyang

Kaesong

Seoul

Kangwha-do

Kwangju

Han-gang

SILLA

Kongju

Puyo

P'algong-san

● Kyŏngju

Yellow Sea

Taegu

Kamun-sa

Haein-sa

Pulguk-sa

PAEKCHE

Kimhae

Pusan

Cheju-do

Tea bowl known as "Matsudaira"

15th century, Punch'Ùng ware, Korea,
dia 15 cm, Hatakeyama Collection, Tokyo

Of a style known as "powder Mishima"
(*Kohiki*), this kind of ware with the
simplest of all decoration (a dip in white
slip) seems to have been made only at one
or two kilns. The few that remain are
mainly in Japan, where they have been
treasured by the tea aesthetes for their
quiet, unassuming beauty. This famous
tea bowl is more striking because, in
letting the white slip flow around the
clay, the potter left a wedge of the body
uncovered, and in doing so created a
dramatic contrast.

surprisingly, preserved a national identity that is unique in language, style, and artistic expression. What remains extant after such a stormy history shows evidence of an advanced and inspired artistic tradition in sculpture, metalworking, ceramics, and painting, together with a popular and lively culture of folk art.

Despite its proximity and size, China was not the only civilization to have a cultural influence on Korea, and there are many relics discovered that share similarities with those to be seen as far away as Europe – such as the prehistoric stone cairns and dolmens that would normally be more associated with the ancient Celtic world on the Atlantic coast than a country in the Far East. There is evidence supplied by legend and anthropology that the first inhabitants of the Korean peninsula (or rather some of them, as they consisted of groups of tribes) were more Caucasoid than Mongol, and physically resembled the heavily bearded and wavy-haired Ainu who still remain in parts of Hokaido in north Japan. Many questions concerning the long prehistoric period are still unanswered and will remain so unless archaeological research can ever be carried out again in the northern part of the country, where new revelations may possibly be waiting to be unearthed. However, there is no doubt that Korean culture emerged as a synthesis that was the result of being under the sway of an agrarian and settled China. But something else also played an important role – something of equally ancient roots,

evoking the vast steppes of Asia, nomadic tribes of hunters, horse-riding Scythians, Siberian shamans, and still mysterious but far-reaching prehistoric trade routes.

The powerful effect of China was rapidly accelerated and concentrated during the Han dynasty, when over 60,000 Chinese families lived in a colony in the ancient capital of Lo-lang (close to present-day P'yongyang in North Korea). Their purpose was to trade with the myriad tribes of Korea, and the community survived, albeit with one or two ups and downs, for over 400 years until its fall in A.D. 313. During its long stay, the colony acted as a catalyst for the "Sinofication" of Korean life, bringing in superior goods and tastes, architecture, lacquer, and gold work, together with written language, all of which were to have an effect on the local culture that would last for hundreds of years.

The many diverse tribes of the peninsula also noticed the merits of Chinese central organization and power, and in time they too consolidated themselves into three kingdoms: Koguryo in the north, Paekche in the west, and Silla in the southeast. (Another independent territory known as the Kaya States was located on the south coast facing Japan, but from a cultural point of view this is considered as an extension of Silla.) Being closest to the border of the great empire, and having the Lo-lang colony at their center, the Koguryo were the first beneficiaries of all that China had to offer. But the resident Chinese skillfully used their

rather exalted position to look further afield, and with the shrewd granting of useless but nonetheless very flattering titles, and a patronizing bestowal of decorations, ceremonial hats, and other symbols of rank, they managed to manipulate and control the chiefs of even the more distant tribes to their own advantage. As a result, the country gradually started to follow the same cultural pursuits, and in the fullness of time something like a national homogeneity of style and language began to appear.

Of the three constituent kingdoms, the northern Koguryo kingdom is noted for the large number of grand tombs (step pyramids and large tumuli) that were constructed for the housing and glorification of the departed. They were all ransacked during later wars, and being located in the northern sector are now extremely difficult to visit. However, surviving photographs that were taken inside the tombs before partition show wonderful murals of dancers, animated hunting scenes, and strange, lively supernatural creatures painted with wisps of cloud; similar to those seen on Han dynasty lacquer objects, they convey an extraordinary feeling of energy and movement. The Koguryo were highly advanced in construction techniques (and, it goes without saying, in the administration of slave labor), as can be seen in the remains of huge walled castles located at strategic positions overlooking the northern plains, and the great step-pyramid tombs. Some of these measure some 60 meters (180 feet) square, and are built on foundations constructed of massive rocks that measure as much as three or four meters (nine or twelve feet) along each side.

Separated from north China by Koguryo, the rich and fertile Paekche kingdom chose instead to establish closer relations with south China and with neighboring Japan, which was gradually unifying under an imperial administration. Sea traffic had apparently become well developed, with trading routes and a steady exchange of scholars and monks having been established between the three countries. Buddhism was adopted by the Paekche ruling family in A.D. 384 after being introduced by Marananda (an Indian monk sent by the king of the Eastern Chin dynasty), and in turn the new religion was transmitted to Japan by the Koreans. Huge temple and monastery complexes were built that were self-contained and self-supporting, almost like small cities; but despite the large degree of wealth and high culture that Paekche enjoyed during its golden age, there is unfortunately little that still remains in Korea, and the best examples of its arts, particularly architecture and sculpture, are to be seen in Japan (especially in the Nara area), where they have fortunately been preserved to the present day.

The finest example of what Paekche culture must have been like can be seen in the Hōryū-ji temple, with its sculptural treasures; it is located near Nara City in the Kansai area of Japan. At the time, the relationship between the two countries

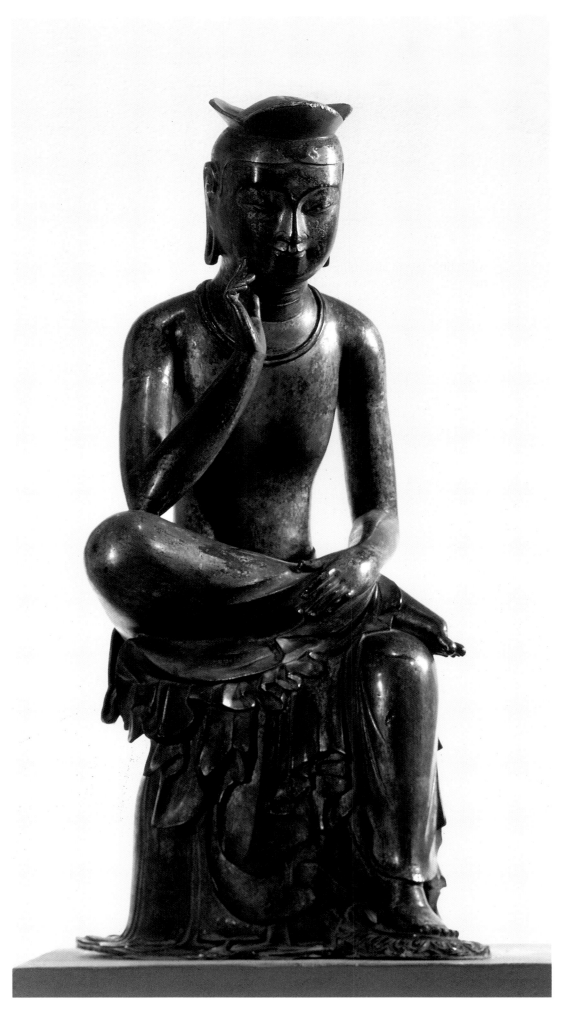

was very close, and along with the many monks needed to explain the minutiae of the new faith, went architects, scholars, scribes, painters, and sculptors to teach the skills needed for establishing and furnishing the new temples. Later they were to be followed by a further emigration of perhaps 100,000 or so refugees who fled Paekche to start a new life in Japan after their own kingdom fell in the late-7th century A.D. Representing the superior culture of the mainland, they were welcomed for the skills that they had to teach, and they easily assimilated with the noble classes in the western part of Japan.

Being located on the eastern side of the peninsula, and separated by distance and mountains from the border with China, the Silla kingdom was a little late in absorbing the cultural influences that took root in Koguryo and Paekche. Buddhism was first introduced in A.D. 424, but did not really begin to bloom until it had been accepted by the local court a century later. However, after the acceptance of the new religion, relations became well established with cosmopolitan T'ang-dynasty China and the kingdom grew and prospered both culturally and militarily. Eventually it became the dominant power on the peninsula towards the end of the 7th century and unified the three kingdoms under United Silla, with one hereditary king.

For 250 years a united Korea enjoyed peace and a tremendous cultural advancement as it absorbed more and more of the achievements and learning of the T'ang Chinese. Buddhism was the great catalyst that allowed for close links between students and scholars, and it was Buddhism that provided monastery schools where the knowledge could be transmitted. State administrators were recruited from the *Hwarangdo* (a monastic, military establishment) where, during a severe, 10-year-long course, students were taught swordsmanship, gentlemanly behavior, Buddhist philosophy, and Confucian ideals of scholarship and the pursuit of excellence.

At first sight it would seem that the course echoed the bureaucratic examinations of China, but in fact it had a pronounced Korean flavor, and the emphasis on chivalry and martial arts ensured that its graduates were strong and resilient enough to handle the complexities of local administration.

The unification of the country and the spread of Buddhism led to a building boom of temples and palaces across the peninsula, with all the attendant workshops, kilns, and smithies needed to provide the necessary furnishings, religious images, and luxury goods. From China, different sects of the new faith arrived, together with the political and social ideas of Confucianism, creating a climate of keen intellectual inquiry and the emergence of the first literature. The written Chinese script was adapted to the very different Korean spoken language by the invention of syllables that were used to link the imported ideographs into some grammatical sense. This had the effect of greatly facilitating the growth of

scholarship and the recording and conveying of ideas and knowledge.

But the circle turned for the worse towards the end of the 9th century as Chinese support was withdrawn after the collapse of the T'ang dynasty, and in this time of political weakness the administrative power was seized by a new leader Wang Kŏn, who established the Koryŏ dynasty in Korea. (Rather sportingly, considering the standards of the time, he also looked after the vanquished last king, providing him with a palace and all the trappings that were necessary for him to enjoy a peaceful retirement.)

The new dynasty lasted for nearly 500 years, roughly the same as the Song and Yuan dynasties of China, with which it shared similar cultural endeavors during this time. Together with China, Korea was also fated to suffer all too frequent

Sage Cooling Off

Yi dynasty, ink on silk, by courtesy of the Cultural Service, Korean Embassy, Tokyo

This delightful picture is very much influenced by the work of Chinese ink painters and shows a simple, abbreviated style of brush work with a strong flavor of Zen. The droll gesture of the feet however, shows a human touch that marks this painting as being uniquely Korean.

Opposite

Seated Maitreya

Old Silla, 7th century A.D., Korea, gilt bronze, H 93.5 cm, by courtesy of the Cultural Service, Korean Embassy, Tokyo

This is one of the most serene Buddhist images to be seen in the Far East, and is almost identical to some found in Japan and dating from the same period.

predatory invasions by the nomadic Mongols from the north, and for some decades was under their direct control.

Artistically, the Koryō period shows a departure from the earlier, heavy Chinese influences, as with changing political allegiances the Koreans were often left to their own devices. As a result, there was a flowering of native Korean culture that far excelled anything previously seen. This was particularly true in ceramics, where the remarkable Koryō wares still stand as the highest achievement of the art; despite many efforts, they have never been successfully duplicated since that time. One of the other outstanding achievements of the dynasty was the invention of moveable metal type (some 200 years before Gutenberg in Europe), which allowed for a far more efficient dissemina-

tion of Buddhist and Confucian teaching. The meditative sect of Ch'an Buddhism also became widely popular during the 12th century and had some influence on artistic trends of the time, though not to the extent that Zen had in Japan. The much more mysterious Lamaist variety of Buddhism also took root as a result of Mongol invasions, but perhaps it was the alien nature of this sect – its strange rituals and complex imagery – that sparked a nationalist resistance to foreign religion. Corruption gradually replaced the original spiritual rigor that had made the religion so popular in the first place, and Buddhism gradually lost favor to Confucianism (especially ancestor worship), as well as the native shamanistic beliefs, which were never too far below the surface in this rice-growing nation.

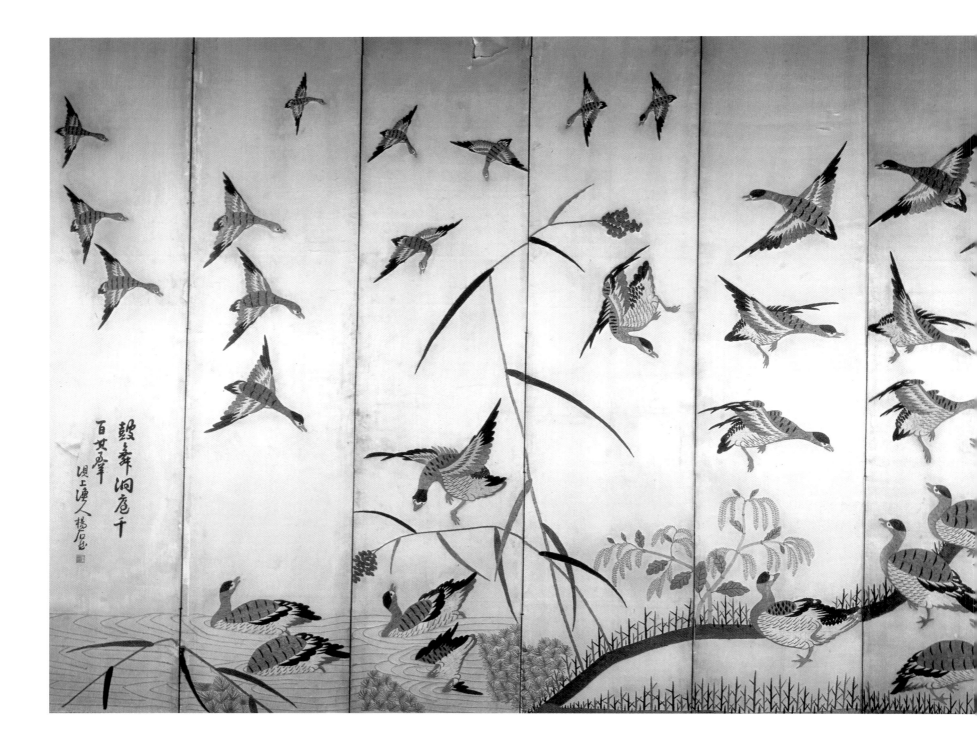

Towards the end of the Koryō dynasty, Korea was not only under the domination of Yuan (Mongol) China, but was also suffering attacks around its coastline by raiding pirates from the islands of Japan. Internal power struggles and bad government almost saw Korea absorbed into China as a province, but timely salvation came through the efforts of a military strongman, Yi Sōng-Kye, who reorganized the country under the new Yi dynasty, named after his own household. By building on what was left of Koryō's administration and bureaucracy, Yi Sōng-Kye demonstrated political astuteness in addition to formidable military control. He established the city of Seoul as the new capital (it is still the main center of the country), and for a while stable and wise government led to another renaissance in some areas of intellectual and cultural pursuits. Adding to the earlier achievement of the invention of moveable metal type, the practical use of the written language was revolutionized by the development of a phonetic alphabet (*chongun*) that directly represents the sounds of the spoken language. The great advantage of this was that, because it had only a limited number of signs or letters, it could be quickly learned and easily put to use. For the first time, literacy became more accessible to the common people. Chinese characters were, and still are, used for literature and poetry, but the liberating effect of not having to spend long years just learning endless ideographs – before actually being able to read anything worthwhile – is easy to imagine. (By way of contrast, Japan is still burdened with having to use Chinese ideographs

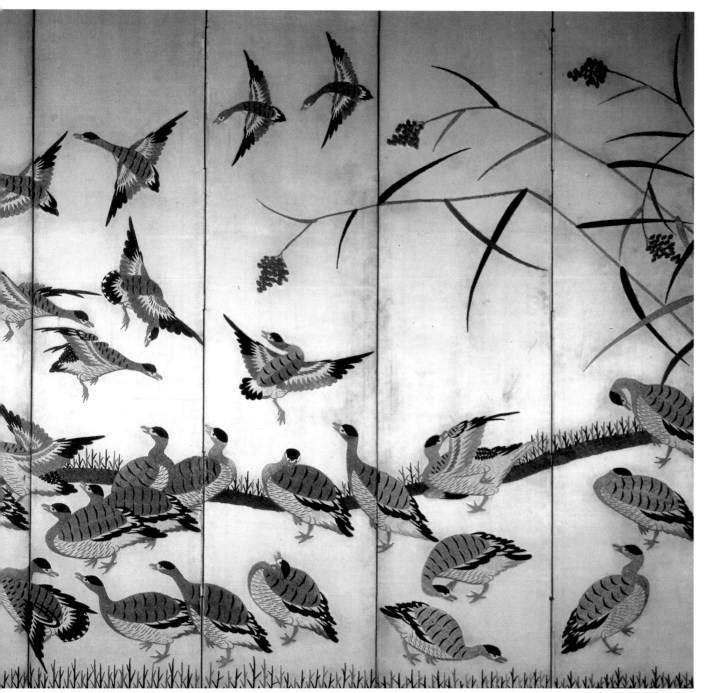

Wild Geese and Reeds

Yi Dynasty, about 18th–19th century, 10-panel screen painting, ink and slight color on paper, by courtesy of the Cultural Service, Korean Embassy, Tokyo

Although an amateur, the artist has made a very interesting design out of what would have been an everyday sight in the countryside. The elements of the water and shoreline with its little plants, has almost been made into an abstract pattern, while the arrangement of the reeds and the birds shows a strong graphic sense.

together with two phonetic scripts, and nowadays the Roman alphabet as well, in what must surely be the most cumbersome writing system on Earth.)

The Yi dynasty lasted until the beginning of this century, but its golden age was seen during the first peaceful couple of hundred years following its establishment. At the end of the 16th century, Korea suffered devastating invasions by the Japanese under the military leader shogun Hideyoshi – a fiasco which resulted in tremendous damage and the abduction of large numbers of artisans to Japan, but no real victors. A couple of decades later the country saw two further invasions by the Manchus from the north. Again the damage was widespread, not only to property and the economy, but also to the will of the people, and the country seemed to retreat into a state of shock and withdrawal. Time eventually brought a state of peace, or rather inertia, under the benign umbrella of Qing China, that lasted until the beginning of the 20th century and its tragic events. The 18th century saw another artistic revival, particularly that of painting, a skill that was widely cultivated along with calligraphy and

Scratching Dog

Kim Du-Ryang (1696–1763)

Album leaf, ink on paper, by courtesy of the Cultural Service, Korean Embassy, Tokyo

In a small leaf of an album, and with a masterly control of ink tones, the artist has brilliantly captured the rather prosaic scene of a dog scratching itself. The details of the animal are shrewdly observed and carefully painted, while the branches of the tree and the surrounding grasses are simply but effectively sketched.

the writing of poetry by the *yangban*, the aristocratic officials.

Despite Korea's tumultuous history – but maybe because of its stimulus – there has been a rich legacy of creative activity from the very earliest times. The influence of neighboring cultures is plain to see, but this has often been transcended to create an art that over the past 500 hundred years or so has shown an aesthetic sensitivity similar to that seen in Japan – but one that is unassuming, honest, and less precious. (It is interesting to note that these characteristics are mostly seen in Japanese pottery, which owes so much to Korean craftsmen.) It is an art without artifice or intimidation; an art that is easy to warm to simply because it is so recognizably human. One notices it in the folk paintings of tigers (animals which were endemic in Korea and a serious terror until very recently) being irritated by magpies. The image serves to diminish the frightful beast, to bring it down to size (see right). But we can also see in them a subtle metaphor, the little magpie representing the peasantry, the tiger the oppressive rulers. Nothing is too obvious here – the painters were unlikely to have been jailed for sedition – and the "tigers" would probably have missed the nuance in any case. But by putting a wry smile on the face of humility, these rural painters showed their strength and powers of survival and durability under daily conditions that were arduous, oppressive, and insecure.

Sculpture and Metalwork

While the exact origins of bronze working are unknown, it is thought that the technique first appeared in Korea around the 5th century B.C., most probably having been introduced from China. Metalworking replaced the neolithic culture and was used to make artifacts that were more likely used for ritual purposes than anything practical. The techniques of smelting and forging iron appeared a couple of centuries later, leading to a rapid increase in the production of metal goods for everyday use, and above all for the manufacture of weapons and the equipage of horses.

Artistically, Korea's finest examples of metalwork date from the period of the Three Kingdoms and are to be seen in gold and silver jewelry, artifacts of personal ornament, and Buddhist imagery, much of which has come to light through the archaeological excavation of tombs over the past few decades. The best-preserved are the objects made of gold, which, being an inert element, does not decay like other metals (see pages 358–359). The most splendid of all is the gold headgear, which is unlike anything to be seen in neighboring countries (with the exception of Japan, which at the time was very much under the cultural influence of Korea in any case). When seen in its complete form, the assemblage consists of an inner peaked cap of thin gold that is perforated (both for decorative effect and to lessen the overall weight)

Tiger and Magpie

Yi Dynasty, 18th century, ink and colors on paper, by courtesy of the Cultural Service, Korean Embassy, Tokyo

A common subject in Korean folk painting is the tiger being irritated by a squawking magpie, and in this painting, the ferocious beast is so demoralized that his terrible paws are seen impotently resting one on the other. A political metaphor can be read in such pictures, with the rather idiotic-looking tiger representing the ruling authorities, and the plucky little magpie signifying the down-trodden country folk of Yi-dynasty Korea.

with a design encircled by a crown of thin gold sheet with tall vertical bars and branches (see above, left). The inner cap of a famous crown excavated from Kyŏngju has two backward-pointing wings on each side, and the whole piece is covered with spangles of gold and comma-shaped beads of jadeite suspended from twists of gold thread. The upright bars of the outer crown are possible abstractions of deer antlers and trees, and resemble headgear that has been excavated from tumuli in southern Russia – far beyond the cultural orbit of the Far East, but again hinting at the ancient connections with nomadic tribes that were scattered across the great steppes.

Further artifacts to adorn the monarch include belts or girdles of thin gold, perforated with a decorative pattern and having a lower band of loops. From these loops are suspended bands of gold ending in pendants of different shapes that may have had auspicious meaning – the whole thing is rather like an oversized charm bracelet. Gold earrings, bracelets, rings, and necklaces completed the outfit and were sometimes encrusted with colored stones or glass. The workmanship to be seen in Korean gold jewelry of the Three Kingdoms is superb and includes delicate refinements such as a filigree work in which gold grains are attached to the surface to make an interesting play of light – again, this is a technique that is more associated with Central Asia and the Middle East than more neighboring countries. With the

round foils attached by twists of gold wire, and the suspended beads of jadeite, the effect must have been one of shimmering movement, like the rustle of leaves in a breeze; it is easy to imagine what a truly dazzling spectacle this must have presented when seen by the flickering candle or lamp lights of an ancient palace.

Even though Buddhism was first introduced in the late-4th century A.D., the earliest Buddhist sculptures seem to have been made over 200 years later. The majority of them are small gilded cast-bronze figures similar in form to those of the Northern Wei dynasty in China, and from the point of view of sculptural proportion many of them seem rather crude with oversized hands and heads. (A failing, in our modern eyes, that continued through the Koryō period, though it should be remembered that these images were originally made not as art objects but as a focus for veneration.) These characteristics lingered in the smaller images that were made for more intimate devotions; but in the larger images of the early part of the 7th century we can see some of the masterpieces of Korea's sculptural history, especially in the statues of the Maitreya Bodhisattva (Miroku Bōsatsu in Japan).

These wonderful images show the crowned figure seated on a stool covered with drapery that is hanging in folds (see page 352). The left leg is hanging with the foot resting on a lotus stand, the left thigh providing support for the right foot. The

left hand rests on this foot and the right hand is raised with a finger just about to touch the face, which has that serene smile so characteristic of many Korean images. It is a pose that has ancient origins and can be seen in earlier Indian and Gandharan sculptures. Maitreya statues also remain in Japan (in the Hōryū-ji temple, for example), but these are so close to those of the Silla kingdom that it is evident they were either imported from Korea or made by immigrant Korean craftsmen.

Buddhist images were also cast in iron during the later years of the 9th century through the early years of the 10th century of the Unified Silla kingdom. They are usually in a larger format (life-size or more) and show finely modeled details and expressions. Because of the nature of the metal and the mold, iron images show a slightly rougher surface than those that are made of gilt-bronze, and originally they would have been covered with plaster that was gilded or painted with life-like details. (It is interesting to recall that the marble statues of ancient Greece were also painted when new; they also provide a telling example of how real beauty may be better revealed with the kind touch of wear and age.)

Granite and marble are both widely available in Korea and so it is not surprising to find that there has been a long tradition of using these materials for making Buddhist images. (By way of contrast, most stone in Japan is either volcanic or crystalline and does not lend itself easily to fine sculpture; easily available wood has always been the material of choice.) Carved statues and bas-relief images of Buddhist subjects are to be found in many areas of the Korean peninsula, but the finest example of all can be seen in the famous group at Sōkkuram just outside Kyōngju in the southeast of the country (see page 360).

There, the pilgrim makes his way up a winding path to the crest of Mount T'ohan, which looks over the sea towards the Japanese islands. A little further along the ridge, and up a long flight of stone steps, an opening leads into one of the finest Buddhist shrines in the Far East. The structure is an 8th-century cave-temple that is approached through an antechamber and short vestibule that lead to an extraordinary circular room; the entrance is supported by massive stone pillars and the room has a high-domed ceiling of carefully measured and cut granite blocks. In the room is a statue of the Shaka Buddha on a lotus pedestal, some three and a half meters (11.5 feet) tall and carved from granite, with the right hand bent down in a gesture known as "calling the earth to witness," and the left hand resting in the lap to indicate a state of meditation. Unusually, it is placed slightly to the rear of the center, so that a devotee is able to walk all the way around the image. The carving is simple in detail but finely executed, and the expression on the face is more godlike than human: one of dignity, but also of all-encompassing awareness. The image impresses not only by its massive size, but also by its setting in

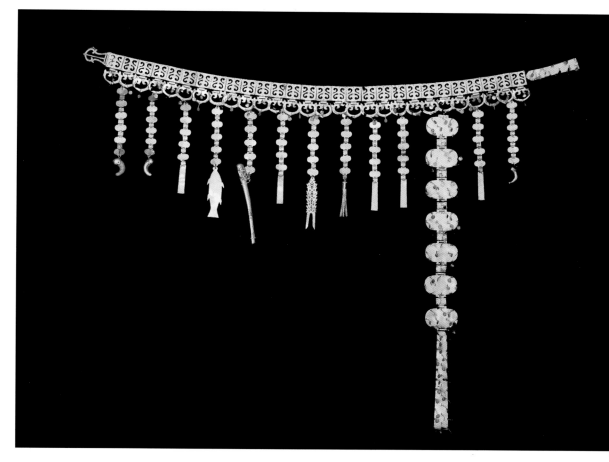

Above
Gold girdle

Old Silla, 5th–6th century, L 120 cm, by courtesy of the Cultural Service, Korean Embassy, Tokyo

This belt is decorated with dangling objects that may possibly have had an auspicious meaning. A fish, which has connotations of male children, can be seen, together with three comma-shaped beads made of jadeite.

Gold earrings

Old Silla, 5th–6th century, L 8.7 cm, by courtesy of the Cultural Service, Korean Embassy, Tokyo

The decoration of these earrings has been made by adhering minute "beads" of gold onto the surface, a technique more associated with jewelry made by the Scythians, thousands of kilometers to the west.

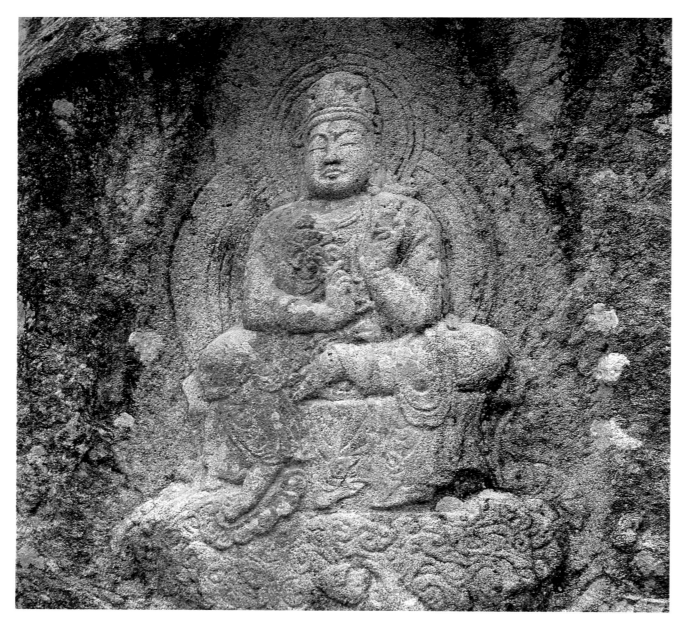

this high-domed room, which gives a feeling of
light and space to what must be an extremely
heavy figure. Again, there is evidence of a
borrowing from distant cultures, and here, at the
farthest end of the Asian land mass, we can see the
most easterly example of a cave-temple that has an
architectural style with much earlier roots in India,
thousands of kilometers away on the other side of
the Chinese empire.

Around this circular room are niches containing
eight smaller statues of seated Buddhas, below
which are bas-relief carvings, larger than life size,
of the Ten Disciples of the Buddha. The walls of
the entrance and vestibule are embellished with
similar carvings of guardian deities, figures of
ancient Hindu lineage who were eventually
absorbed into the Buddhist pantheon. The
Sŏkkuram group of sculptures perhaps represent
the high point of religious carving in Korea. After
this there was no further innovation – unlike the
brilliant, later flowering of religious sculpture in
Kamakura-period Japan – and the styles of

Buddhist images, while perfectly professional and
competently made, appear to be derivative of
whatever forms were current at the time in neigh-
boring China. As in Japan, the 14th century more
or less marked the end of any further artistic devel-
opment in this area, and later images, with few
exceptions, are mere repetitions of what had been
done before.

Korean Painting

The earliest examples of painting on the peninsula
date from the Three Kingdoms period and consist
of wall paintings in Koguryo tombs in the north of
the country, as mentioned earlier. While it is very
difficult to study these tombs with the present polit-
ical partition, a couple of tombs that have been
discovered in recent years in the Asuka area of
Japan (near Nara) show paintings that, if not actu-
ally executed by Koguryo craftsmen, were certainly
made under a direct influence from the Korean
mainland. Decorating the stone walls and ceiling,

they depict a tiger and dragon together with heavenly bodies, all painted in a pure Korean style. Scarcely any paintings remain of the Paekche or Silla kingdoms apart from a few fragments, but from these – and the lines of designs on metal artifacts such as temple bells – it can be seen that all the trial and error of draftsmanship and composition had been surmounted, and art had by this time already reached a highly developed and self-assured level.

It is known that an official "Bureau of Painting" had been established by the time of the Koryō period to train and supervise artists in the illustration of books and the decorating of palaces and temples. As in Japan, most paintings dating from at least the early part of this period are religious, and illustrate Buddhist figures in a way that is modeled after those painted in China, but that is already showing a very individual style of brush work. Also, the usual formats for paintings (more or less as in Japan but with slight variations of mounting) were hanging scrolls, narrative hand scrolls, folding screens, albums, and fans.

The rare early Buddhist paintings that survive from the Koryō period show a richness of material and detail that reflects the status of the religion at the time. A large painting of the Buddha with the attendant bodhisattvas, Manjushri and Samantabhadra, would have been hung in a temple on the wall, over the altar and therefore over the main Buddhist image. As in Japan, centuries of incense smoke has darkened the paintings of this period, but even through this murky layer one can see images with exquisitely delineated details, fine coloration, and an enhancement of outlines and patterns in gold which gives an otherworldly effect. This triad has a symmetry that is normally associated with Buddhist images of earlier eras (T'ang China, or Heian Japan) but also shows the influence of Song-dynasty painting of a few decades previously, particularly in the stance of the bodhisattvas and the fine fluid lines of the costumes.

A hanging scroll dating from the 14th century – a time when Korea, like China, was very much under the rule of Mongols from the north – shows the deity Avalokiteshvara (Japanese: *Kannon Bōsatsu*). The artist is unknown, but judging by the skill of the painting and the use of gold for decoration it is certain that he was of some standing and was most likely connected with the official academy. This painting is completely asymmetrical, in contrast to the one described above, and the bodhisattva is shown seated on a rocky throne within two circular auras of holiness, one around the head and shoulders, and an outer one encompassing most of the body (see page 362). He is richly clothed and adorned with elaborate jewelry, and while still retaining a modest mustache and beard, is already revealing a certain languor, together with a plump-featured voluptuousness, that foretell his shift of gender in later centuries. (In Japan the *Kannon Bōsatsu* is known in common lore as the *Goddess* of Mercy.) His right

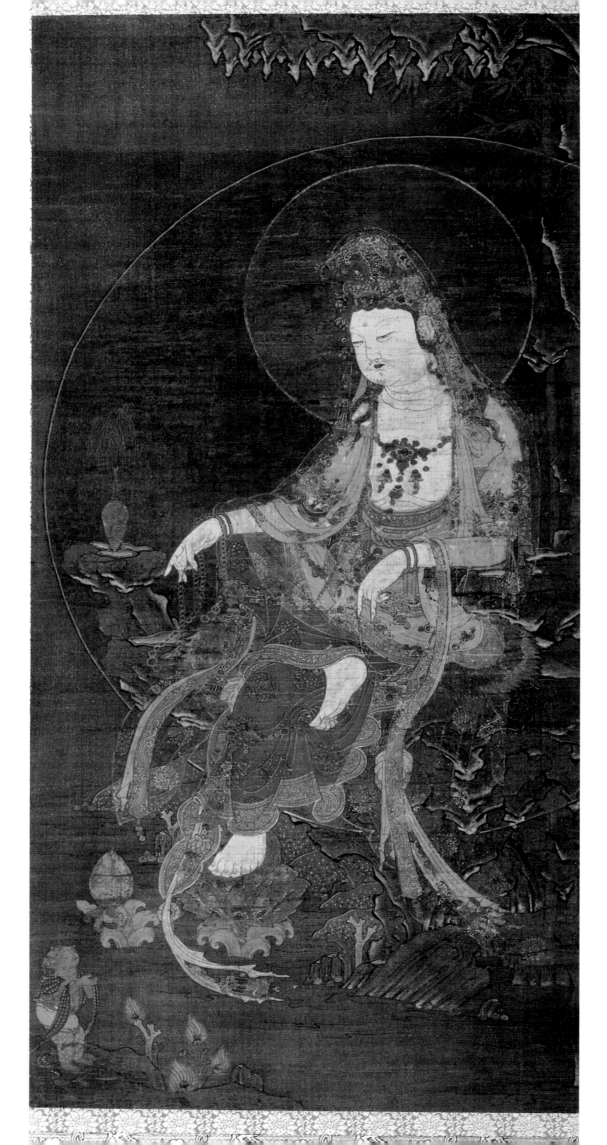

Avalokiteshvara with Willow Branch
Koryō period, 14th century, ink, colors and gold on silk, 98.4 cm x 47.8 cm, Korea, Collection of the Freer Gallery of Art, USA

foot is resting on his left thigh, and with the other foot supported by a lotus stool (see right) we see similarities with the Maitreya statues of the Three Kingdoms. However, the body has a different posture, and whereas the Maitreya statues lean slightly forward, attentively, the Avalokiteshvara in this painting shows an ease that seems more appropriate to a that of Koryō courtier. A rocky outcrop next to the right hand provides a stand for a narrow-mouthed bottle that contains a branch of willow, one of the traditional attributes of the deity, as are the elaborate headdress and the rich jewels. Overhead, like the roof of a cave, the pointed stalactites of rock, highlighted in white, together with the more distant bamboo leaves outside, form an interesting pattern at the top of the picture.

With the new interest in Ch'an Buddhism and its emphasis on meditation came a taste for monochrome ink paintings that were inspired by those of the Song dynasty in China (see page 361). Towards the end of the Koryō period, there was a fashion for painting subjects that were traditionally favored by scholar-gentlemen, such as bamboo, prunus blossoms, and wild orchids. Quite a few paintings are still extant that date from the following Yi dynasty, but as they have not been studied and researched to the same extent as those of China and Japan, their classification until recently has been rather vague. It would appear, however, that there were two main groups of painters: the members of the official Bureau of Painting, who were in the employ of the ruling family and the government administration; and amateur, scholar-painters, who emulated the cultivated style of living enjoyed by their associates in China. When one realizes that the high point of the career of any member of the first group was a commission to immortalize members of the royal family and high-ranking dignitaries, and that in addition they had to work under the command of bureaucrats, it is not surprising to find that their work, while technically accomplished, can be a little dull. Their main job was to record their subjects as realistically as possible, and as they were selected by careful examination there is no doubt that their work was highly competent; but it is a competence achieved by sacrificing any spark of individual expression.

In contrast, the work of the scholar-painters is much more lively and interesting, for it reveals both the freedom of their amateur status and also the joy of painting purely for the pleasure it provides. They modeled themselves on those idealized scholar-officials of China, and devoted themselves to the artistic, gentlemanly pastimes of calligraphy, poetry, and painting (see page 365). The system of bureaucratic examination was established early in the Yi dynasty (again modeled after the Chinese prototype); for the lucky *yangban* (the winners) it promised the opportunities and privileges of financial security, and a life in and around the court. The paintings of the *yangban* elite are very much in the literati tradition seen in

China, with the usual subjects rendered in monochrome ink that is occasionally highlighted with soft colors (see page 366, left). But there is something apparent in Korean Yi-dyasty painting that marks it as being just as distant as that of Japan from the artistic movements of China, and for two main reasons. The first is the artless, unselfconscious freedom and innocence that almost characterizes Korean art (see page 356); and the second is the splendid natural environment of the country, which provides endless inspiration for the painter or poet. Just as the scenic spots of West Lake and the Hsiao-Hsiang Rivers have been the paragon inspiration for landscape painters in Japan and China, Korean artists realized that there was just as much grandeur and mystery at home, especially in the range of needle-shaped peaks known as the Diamond Mountains, which are located on the eastern side of the peninsula, and these days are in the northern sector (see page 367).

Avalokiteshvara with Willow Branch
Detail of painting opposite

The foot of Avalokiteshvara resting on a lotus.

Orchids

Kim Chŏng (1786–1857)

Ink on paper, 53 cm x 30.6 cm, by courtesy of the Cultural Service, Korean Embassy, Tokyo

With apparently haphazard but highly controlled brush work, this wild orchid is depicted in an almost calligraphic arrangement, an effect heightened by the jet-black detail in the flower and the surrounding calligraphy.

Opposite

"Bookshelf" screen

Yi dynasty, 18th century, ink and colors on paper, ca. 81 cm x 45 cm, by courtesy of the Cultural Service, Korean Embassy, Tokyo

Reflecting the Confucian emphasis on learning, these screens were commonly used in a man's study in a Korean house. They show the items for the scholar's desk: books, an ink-stone, a tray of carved seals, a suspended jade object, a rolled scroll, and small pots and vases for flowers.

Left
Bamboo

Yi dynasty, ink on paper, by courtesy of the
Cultural Service, Korean Embassy, Tokyo

The painting of bamboo was considered to be one of the highest challenges to the skill of an artist. Here the artist reveals a Zen sensitivity in that he has ignored the slender, graceful quality of the plant and has chosen instead to depict these cut-down stubs. Even though the subject would appear to be far less attractive, the artist has met the challenge and made this spare, rather dry painting.

Despite Buddhism's falling out of favor, many Yi-dynasty paintings have a strong flavor of Ch'an (Zen) in their ink monotones and gestural brush strokes. (Despite having quite polarized philosophies, it is interesting to note that a certain no-nonsense stoicism is shared by both Ch'an and Confucian followers.) One of the famous paintings in the Seoul National Museum by Kang Hūi-an (1419–1464) shows a contented sage contemplating the water below the rock on which he is comfortably perched. Like the paintings of Japanese Muromachi-period Zen monks, the rocks and hanging foliage are quickly rendered in ink with rapid brush strokes, capturing the mood perfectly. It is perhaps even more appealing than the Chinese or Japanese paintings in the same genre because of the completely informal pose of the sage, who is not sitting in formal meditation as one would expect, but instead has molded himself to the shape of the rocks, and, with his hands tucked into the sleeves of his robe, smiles dreamily at the landscape. It would be easy and natural to

take his place and while away some time looking at the cool water below – a pleasant reverie that must surely go through the mind of everyone who looks at the painting.

There is no doubt that rocks and mountains stir something deep in the soul of the Korean artists, and the myriad ways in which they have been painted and interpreted show strong signs of ancient magic and shamanism. This artistic muse seems to have been particularly stirred since ancient times by the Diamond Mountains, as can be seen in the bas-relief pattern on a 17th-century Paekche clay tile in the Seoul National Museum, which shows the range depicted like fish scales (see page 368). Since that time, the interpretation of the forms suggested by the fantastic formations has ranged the whole gamut from realistic to Cubist.

Chōng Sōn (1676–1759), an outstanding Yi-dynasty painter, was born into the family of an impoverished scholar and won his way into the Bureau of Painting in order to earn a living. As his

career progressed he found himself turning more and more to the scenery of his native land for artistic inspiration, in a welcome departure from the Chinese stereotypes so often copied from the painting manuals. After wandering around the country for some time, he settled on the Diamond Mountains as his favorite location, finding ample artistic inspiration in the 12,000 or so peaks that make up the range. Chŏng Sŏn followed the tradition of Far Eastern landscape painters by placing more importance on capturing the essence or mystical properties of the subject rather than on portraying it realistically. In depicting the fantastic formations of the Diamond Mountains, he experimented with composition and brush strokes in a completely original way that owed little to his academic training or to anything that could be seen in China or Japan, and made paintings that look surprisingly modern (see page 370). He reduced the mountains to almost crystal-like faceted shapes by painting with knife-edge vertical brush strokes, emphasizing the pointed, jagged home of so many mountain spirits.

This crystalline quality is seen in a painting (formerly in the Tŏksu Palace Museum) that shows how Chŏng Sŏn, at the age of 80, handled the dilemma of how to depict all of the 12,000 peaks of the great Diamond Mountain range as he was nearing the end of his life. With short brush strokes and a masterly composition, he reduced the scale of the mighty mountain range into the tiny format of a fan, so that the great mountains appear condensed and intensified, like a handful of diamonds.

The interpretations of the Diamond Mountains are seen in an even more surrealistic manner in works by unschooled and forgotten folk painters — country farmers who painted for the best reason of all, their joy and the pleasure in seeing these images, hidden away from the world, in their rural houses. It is because these paintings were secluded in the men's quarters (traditionally the sexes were segregated for most of the day in a Korean household), and seen only by the occasional guest, that some have survived to the present day.

Tile with design of Diamond Mountains

Paekche, Three Kingdoms period, 7th century, 29 cm x 29 cm, by courtesy of the Cultural Service, Korean Embassy, Tokyo

Ceramics

This country style, which has many variations, is known as *muni kurim*, which basically means the "interpretation of a subject into pattern." This is not a new idea at all: the bas-relief design on the Paekche tile mentioned earlier shows the Diamond Mountains reduced to make a pleasing and interesting pattern of rounded, fish-scale shapes punctuated with more jagged forms and pine trees. But some of the folk painters went beyond that, and in many cases we see examples of how one of the rock formations has inspired more animate images. This is not new, either, as surely everybody has at some time had the experience of seeing a rock or tree that in a certain light, when the shadows work their magic, will reveal a face, or the shape of an animal in brilliant clarity for a moment or two, until, with another shift in the light, the image disappears. The Diamond Mountains had this effect on the amateur artist and inspired some of the strangest images to be painted: a mountain looking like a sleeping pig with bristles of pine trees; peaks that turn into statues of the seated Buddha; pure Cubist interpretations that reduce the mountains to a heap of building bricks; and one marvelous animist screen painting where every peak is depicted as a ghostly figure – the mountain spirits transmuted into hooded, stony sentinels in the swirling mists.

The one area of artistic achievement where Korea has truly excelled is that of ceramics, and it is the opinion of many connoisseurs that even the masterpieces of China and Japan take second place to Korean wares produced during the Koryŏ and Yi dynasties. In addressing the subject of excellence, the Chinese author Taiping Lao-Ren wrote:

The books of the Academy,
The wines of the Palace,
The inkstones of Duanxi,
The peonies of Luoyang,
The tea of Fujian,
The brocades of Sichuan,
The porcelains of Dingxhou,
The celadons of Korea…
all are first under Heaven.

"First under Heaven" – this, from a Chinese, shows how very highly these wares were regarded. There is evidence from archaeological excavations in China revealing that Koryŏ celadons had achieved such fame and status that they were imported into the empire in large quantities, and were traded in exchange for silks and tea.

But the history of ceramic production on the peninsula goes back to much earlier times and shards have been excavated that reveal a neolithic

Mount Inwang after Rain

Chŏng Sŏn (1676–1759)

Ink and color on paper, 78.8 cm x 138 cm, by courtesy of the Cultural Service, Korean Embassy, Tokyo

Borrowing from Chinese painting the idea of using an unpainted area to indicate mist and distance, in this painting Chŏng Sŏn has used the same technique to convey the wet atmosphere after a rainfall. Small waterfalls carrying runoff from the mountain add to this effect.

tradition of reddish or yellowish-colored earthenware bowls, lightly decorated with impressed or appliqué designs. (It is interesting to note that even though Japan has been dependent upon Korea for so much cultural input throughout its history, archaeological evidence there points to a far more ancient ceramic culture in Japan. However, as some future evidence may be uncovered to rewrite what is known at present, it is perhaps best to withhold any judgments about who did what first.)

The first major advance came during the Three Kingdoms period when immigrants from Han China introduce the potter's wheel, and also the climbing chamber kiln which, when properly made and used, was able to generate the high temperatures needed to make stoneware. Throughout the Three Kingdoms and Unified Silla periods, Korean potters made a gray stoneware in a wide variety of shapes – shapes that determined whether they had a utilitarian function, usually for use with food, or had a more esoteric use in shamanist ritual. In shape, color, and design many of these vessels show such a strong similarity to the early Sueki wares of Japan that they are easily confused, and so provide strong evidence of the ties existing between the two regions at that time.

The earliest pieces, which date from the 3rd century A.D., when the Koreans were still learning to master the new techniques, are not so highly fired as the later stonewares, and are often seen, rather surprisingly, in the shape of a duck, a creature with a status at that time as a symbol of abundance (see below). As these strange objects would have taken some effort to mold in clay, and as they have openings in the top and tail, it can be presumed that they were used for pouring a liquid of some kind at religious ceremonies. A century later, firing methods had been successfully mastered and large, elegant, round-bottomed jars were being made with thin walls, and impressed designs that were created by paddling a rope onto the soft surface of the clay. Most of these wares are unglazed except for the natural specks caused by ash debris that melted in the kiln (see page 372); but during the United Silla we see the appearance of a few pieces that have been covered with a shiny green or yellowish glaze in an imitation of those of T'ang China. These early pieces marked the beginning of a glazed stoneware production which was to evolve quickly and, during the following dynasty, produce some of the world's finest ceramic masterpieces.

After a history that had lasted hundreds of years, the manufacture of Silla-type stonewares gradually came to an end during the Koryŏ dynasty with the development of the wonderful celadons for which the era is so famous. Again, the incentive came from China, with the Korean potters attempting to imitate the green-glazed wares that were being made across the Yellow Sea at the Yue kilns in Zhejiang province, and the rare Ru celadon that was made in Henan. It took only a short time to overcome the technical problems of glaze chemistry and the control of kiln atmosphere and temperature, and by the early-12th century the Korean potters were making celadon wares that mark the peak of ceramic art.

The Korean peninsula was fortunately blessed with the necessary ingredients for the creation of fine ceramics: fine clay and plenty of wood for fuel.

Duck-shaped vessels
Kaya, 5th–6th century, stoneware, H (right) 16.5 cm, (left) 15.5 cm, by courtesy of the Cultural Service, Korean Embassy, Tokyo

But the potters also developed a knowledge of the magical way in which the raw materials are fused in the kiln, and so invented a glaze of such a serene, blue-green color that it has been likened to "the blue of the sky after rain." It is an extraordinary color, and one that has never been exactly imitated even with the arsenal of glaze and kiln know-how that modern science has provided. For nearly 200 years, the standard was kept at a high level and saw the production of celadon wares of all shapes and forms, even roof tiles. In one demonstration of truly admirable extravagance, the 12th-century King Uijong, a monarch not remembered by history for stinting on luxury, had his palace roof completely covered with green-glazed tiles. Each curved tile, together with the round ends of the ridges, was designed with a pattern of flowers and leaves molded into the clay and visible through the magical, transparent blue-green glaze. This roof must have made a splendid sight, changing in tone as the intensity and direction of the light gradually changed throughout the course of the day.

Underglaze molding, carving, and impressing were techniques used with great skill by the Koryō potters. Vessels were made in a wide assortment of imaginative shapes, such as dragons, tortoises, and bamboo shoots (the Koryō potters had inherited the genius at making sculptural forms from the earlier Silla potters), all of them transformed by that inimitable green celadon glaze.

Other decorative effects were achieved by painting or inlaying designs on the clay body. Pictorial designs were made by painting a solution of iron oxide on the clay with a brush, the pot then being dipped in the celadon glaze and fired. Inlay was achieved by incising or impressing the chosen design into the clay body and filling this with a white, reddish-brown, or occasionally black, slip. The piece was then fired at a low temperature to "fix" the design before being covered with a celadon glaze and fired again at a higher temperature to make a hard stoneware. This decorative technique may possibly have been inspired by the inlay of mother-of-pearl that was used as a common embellishment in lacquer wares and marked the beginning of a trend in ceramic decoration. This was to continue through the following Yi dynasty, and later in Japan would be seen in the wares of the folk kilns of Kyushu, made under the direction and influence of Korean potters.

Towards the end of the Koryō dynasty, the peninsula was subjected both to the control of Mongol invaders from the north, and also to raids by Japanese pirates around the coast. Cultural standards which had reached such an illustrious peak began to deteriorate, reflecting the encroaching decay and corruption of the country's political structure. Ceramic wares from the last century or so of the dynasty show a sad drop in standards, with thick bodies inelegantly formed of gray clay, crudely executed decoration, and a thin,

Left

Pouring vessel

Old Silla, 5th–6th century, stoneware, L 13.8 cm, by courtesy of the Cultural Service, Korean Embassy, Tokyo

This stoneware vessel is so small that it is difficult to imagine what sort of liquid would have been poured from it. It is molded into the shape of a fantastic dragon, with dangling pendants of the same shape as those seen on gold crowns, and could have had some ritual purpose.

Right

Stoneware cart

Old Silla, 5th–6th century, H 13.8 cm, by courtesy of the Cultural Service, Korean Embassy, Tokyo

Silla potters were very accomplished at making high-fired stoneware, which they often designed with more than merely utilitarian purposes in mind. The shape of this piece is similar to carts across Asia, and the Roman chariot in Europe.

Opposite

Wine ewer in the shape of a bamboo shoot

Koryō dynasty, 12th century, H 23.5 cm, green celadon-glazed stoneware, by courtesy of the Cultural Service, Korean Embassy, Tokyo

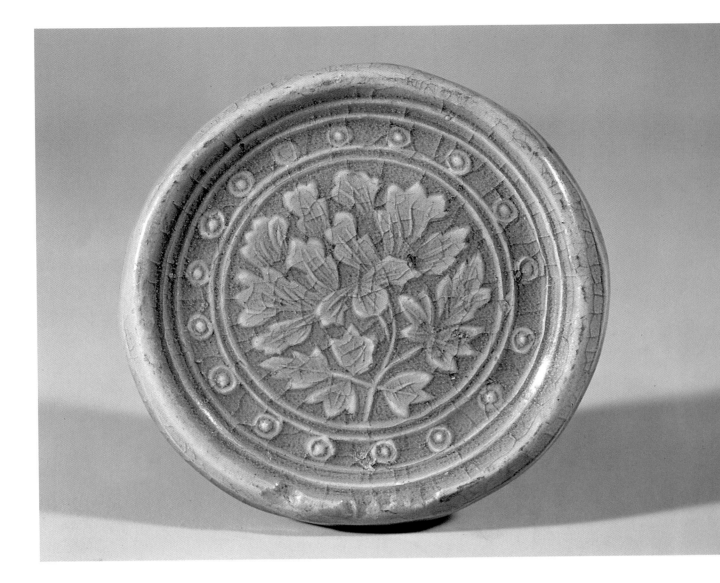

End of a roof tile

Koryō dynasty, mid-12th century, celadon-glazed stoneware, dia 8.2 cm, by courtesy of the Cultural Service, Korean Embassy, Tokyo

Opposite
Wine ewer in the shape of a gourd

Koryō dynasty, 12th century, H 23.5 cm, inlaid celadon-glazed stoneware, by courtesy of the Cultural Service, Korean Embassy, Tokyo

The bucolic scene of ducks and a willow tree has been inlaid by cutting or scratching out the design in the clay and filling with black and white slip before covering with a celadon glaze and firing.

miserable glaze that had lost the magical "blue of the sky after rain" color that had been previously so highly prized. But with the healing hand of time, this gradual change from sophisticated, courtly wares to rougher and more rustic pieces gave birth to a new aesthetic – a new way of looking that saw beauty in the unassuming and the imperfect, and that was to flower with the pottery of the following Yi dynasty.

Punch'ōng (Japanese: *mishima*) is the name given to the characteristic wares of the early Yi dynasty that have a similar clay body to that of the Koryō celadons, albeit with a thinner glaze and a finish or decoration that is characterized by the use of a white slip. Within the use of this rather simple process, the peaceful early part of the Yi dynasty saw a new wave of creativity and artistic expression in ceramics that was above all defined by its spontaneity and directness. But this artistic expression was not especially cultivated and that is what makes the *punch'ōng* wares so very special. In order to understand this, however, it is necessary to look briefly at the social and political environment that prevailed and in which the Yi potters had to work.

One of the most radical changes brought about by the reforms after the demise of the Koryō dynasty was the adoption of Confucianism as a state religion, and the rejection, even suppression, of Buddhism that was so extreme that its practice survived only in remote, isolated temples. It is difficult to imagine such a mental shift being enforced, for Buddhism offered a metaphysical system, with some clear ideas on man's nature and reason for being born on earth, whereas Confucianism offered basically a code of ethics that only made sense if one believed in an established and unchanging social order. As a philosophy, Confucianism was particularly vague on any notion of the afterlife, and yet its simple and restrained ceremonies were mainly for the purpose of worshipping worthy ancestors and invoking the benevolence of their spirits. Whatever its original merits, it was a philosophy that could obviously be used to consolidate power in the hands of a few, for better or worse, most often the latter, and had little flexibility in answering to the complexities of human nature. "Tremble – and obey!" was the policy of the government (like the legendary orders from the Chinese throne), a policy accompanied by endless nit-picking rules and regulations that even to the present day are a major curse in those countries that at some

time in their history have chosen to adopt the Confucian code.

But apart from its social intrusions, Confucianism, in contrast to Buddhism, was aloof from art and even tended to disapprove of beauty for its own sake. Craftsmen were relegated to the lower echelons of the social order, and apart from having to suffer miserable conditions and stipend were also admonished to either avoid decoration in their work, or at least to keep it to a minimum. The Yi potter had already inherited the skills of working with a plain whitish or gray clay from his Koryŏ predecessors, but the artistry required to make the glorious celadons had been long forgotten, and in any case such luxury would not have found favor with the new regime. In addition, and even though forever under the direct influence of their northern neighbor, China, the Koreans had always chosen the more subdued wares to emulate in contrast to the more usual Chinese taste for bright colors and bold patterns. So it can be seen that making the simple rustic wares that were to be so highly prized by the tea aesthetes of Japan came naturally to the Yi potter. While always to some extent under the influence of things Chinese, the Yi potters chose not to imitate the patterns and colors of the later

Ming porcelains, but reduced them to simple decorations that were painted in underglaze blue, iron brown, or red. At first sight, the results are not so impressive or spectacular, but being restrained and subdued in color and design they have a beauty which for the true connoisseur is far more satisfying.

The *punch'ŏng* ceramics made throughout the first couple of centuries of the Yi dynasty have the same grayish body of the earlier Koryŏ celadons, coupled with a decoration of white slip that was applied in different ways. The simplest of these involved simply dipping the pot into the slip, or wiping it on with a rag before firing (Japanese: *hakeme*). Humble though they are in execution and purpose (possibly used as the rice bowl of a farm worker), some of these are sublimely beautiful when seen in the light of the Zen aesthetic. The tea bowl shown on page 351 is one of those wares imported into Japan from Korea that has achieved such fame among the tea connoisseurs that it has been bestowed with its own name. It is an example of the simplest decoration achieved by dipping the bowl into the white slip (Japanese: *kohiki*), which fires to a powdery, non-shiny finish. In this case, the potter missed completely covering

Lacquered chest

(General view, below; and detail, opposite page), late-19th century, Korea, wood, brown lacquer, fleck of gold, mother-of-pearl, brass fittings, shark skin H 60 cm, W 86 cm, D 38.3 cm, Museum für Lackkunst, Münster, Inv. No. AS-K-a-1

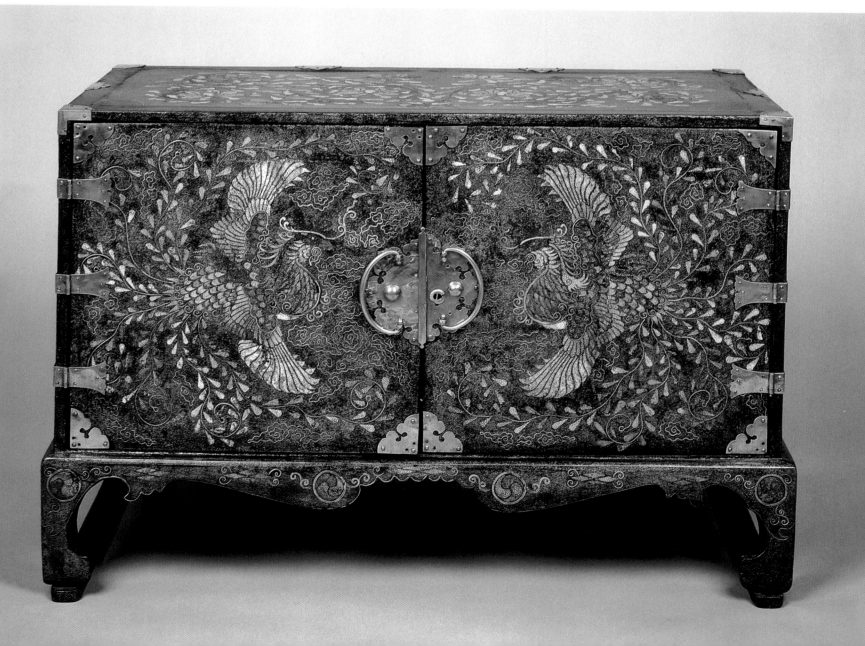

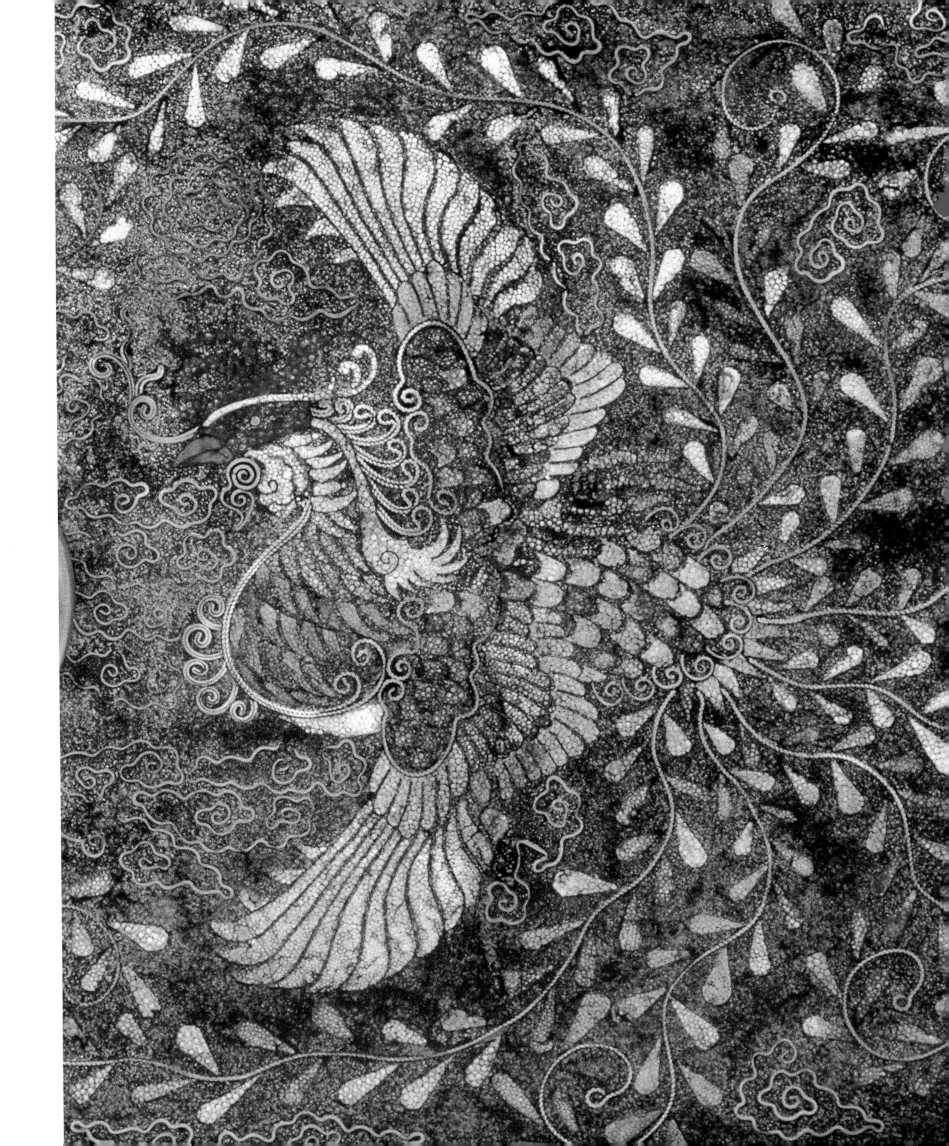

the piece and a wedge of the brownish unglazed body shows through in sharp contrast. It is difficult to imagine how this would occur if the bowl had simply been submerged in the liquid; so we can presume that the potter dipped the bowl into the slip and then turned it to allow the slip to flow all around – or almost. Two thickened white dribbles at the top and middle of the exposed wedge would add weight to this interpretation. The effect is earthily simple and unassuming – and yet quite unforgettable. In addition to the graphic effect of this "slipped slip," time has also been kind and has revealed the "beauty born of use:" small pieces of the slip glaze have flaked off where it was too thin and friable around the rim of the bowl (a desired effect known in Japanese as *mushi-kui*, "insect-nibbled"), and has left a pleasing line of contrasting brown patches.

Other variations of *punch'ŏng* decoration are hangovers from the Koryŏ ceramic tradition and are seen where designs were stamped or carved into the clay body and filled with white slip before glazing and firing. This can result in a "tweed-like" effect that was much admired and imitated by Japanese folk potters in later centuries.

Another pleasing two-color effect was created by a *sgraffito* technique, in which, before glazing and firing, the pot is covered with white slip and then a design is scraped through this to reveal the gray color of the clay beneath. A rarer variation of this is sometimes seen where all or part of the scraped-out design is filled with a contrasting inlay of iron-black slip. But even though this decorative repertoire has its roots in the ceramic work of the earlier dynasty, the Yi designs show a very marked difference from the mannered and carefully controlled execution of the Koryŏ celadons in that they are completely free, spontaneous, and "artless."

Undecorated ceramics were also made throughout the long dynasty, particularly plain stonewares and porcelains that appeared in shades of white and gray depending on the quality and color of the clay. Others appear in dark hues that range from black to rust to amber, depending on the concentration of the iron oxide glaze, and show an influence of the *temmoku* wares of Song-dynasty China. A couple of rare, specialized early Yi ceramics known in Japan as Ido- and Totoya-type wares, are highly prized items that were used in the tea ceremony and, as they are not found in Korea, it can only be assumed that they were made on order for export.

The ill-fated Japanese invasions of 1592 and 1597 eventually led to the widespread destruction or abandonment of practically all the pottery kilns in Korea, and marked the end of the production of white-slip *punch'ŏng* wares. Large numbers of potters were taken as captives to Kyushu, where they became largely responsible for the development and diversity of ceramic making in the Momoyama and early Edo periods. For many of them life in fact improved, and whereas they had suffered an almost serf-like existence in their homeland, the more accomplished of them were granted an honorary samurai rank, which conferred prestige and security. They all remained in Japan, where their talents were recognized, and eventually took Japanese nationality; their descendants are still making ceramics in the folk kilns of Kyushu.

After peace had been restored on the peninsula, the kilns were rebuilt and the pottery industry was reactivated. Under government direction an emphasis was placed on the production of more highly fired white wares, again under the influence of Chinese porcelains. However, one area of kilns near the city of Pusan on the south coast functioned from 1639 to 1717, catering to the Japanese market and making tea bowls for the Kyoto tea masters and the shogun military ruler. During this time there was a steady traffic of both Japanese and Korean potters between these kilns and Japan in order to learn the refinements of tea taste in pottery.

The finest tea bowls were kept for the Tokugawa shogun, who gave them away as prestigious gifts to regional *daimyo* (feudal lords)

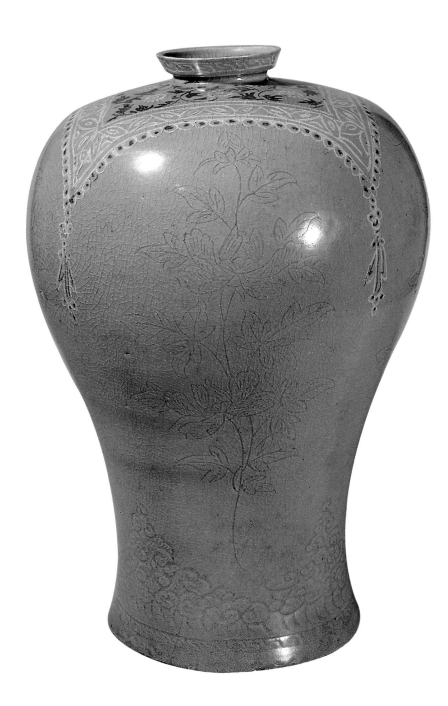

Inlaid celadon vase

Koryŏ dynasty, 12th century, inlaid celadon-glazed stoneware, H 35.4 cm, by courtesy of the Cultural Service, Korean Embassy, Tokyo

This type of broad-shouldered vase is known as a *maebyŏng*, a shape that is typical of Koryŏ and early Yi dynasty wares. This vase has peonies delicately incised into the clay; there is also black and white inlaid decoration over the shoulders in the shape of a cloth cover, with tassels at each corner.

Left
Inlaid celadon bottle

Koryŏ dynasty, 12th century, celadon-glazed inlaid stoneware, H ca. 27 cm, by courtesy of the Cultural Service, Korean Embassy, Tokyo

The potter has built up the decoration of this bottle by inlaying with white and black clay to create designs with auspicious motifs.

Right
Bottle

Yi dynasty, 15th century, Punch'ŏng inlaid stoneware, H ca. 26 cm, by courtesy of the Cultural Service, Korean Embassy, Tokyo

The floral design on this wine bottle was made by covering the body with white slip and then carving through to show the clay beneath. The exposed clay looks as if it may have been painted with an iron solution to make it darker and so contrast more effectively with the areas covered with slip. The whole piece was covered with an almost transparent glaze before firing.

to buy allegiance and support. These wares were carefully recorded and copying was strictly forbidden. Such an extraordinary value was attached to these simple tea bowls – firstly because they were Korean, and secondly because they had been presented by the shogun – that it would be difficult to imagine any equivalent phenomena in the West (the tulip craze in 17th-century Holland might be the closest). There are stories of whole fiefdoms being exchanged for one tea bowl, and even in recent times prices have been paid for famous pieces that would be unbelievable anywhere other than in Japan. The political significance of such values is the stuff of novels and is certainly that of one or two Kabuki plays that are based on the dilemma and shame of some *daimyo* having misplaced a shogun-bestowed tea bowl.

Of the porcelains and high-fired stonewares that were made in China, Japan, and Korea, it could be argued that those made by the later Yi potters include some of the very finest. This is not because the materials were superior – a Korean potter would never bother to filter and refilter clay to get only the finest, most microscopic particles, as would his Chinese equivalent working in the Imperial workshops. In fact it may be because materials such as cobalt (for underglaze blue painting) were scarce or expensive that they were used with great economy, though to better effect.

As a result, we see lightly drawn decorations that reveal both the artists' ability to make full use of the shape of the pot, and also their appealing sense of whimsy. In addition, the glaze of these later Yi pots is pleasantly soft and milky (and perhaps blemished here and there with bits of grit from the kiln) and with an unctuous surface like candle wax that is warm and immediately familiar (see page 380).

At times iron or copper pigments would be used to create designs in black or red, sometimes in combination with cobalt blue. A large high-necked vase in the National Museum of Korea is painted with a folk design of a deer and a flying crane in a landscape with a pine tree, distant mountains, and a sun that would have been highly successful even if it had all been painted in blue. But this piece is made outstanding by the use of copper under the glaze to paint the sun, pine tree, and the spots on the hide of the deer, so that they stand out in a bright, contrasting red (see page 381).

Throughout most of the latter part of the dynasty, the Yi potters quietly turned out large quantities of ceramic wares that were needed for everyday use. None of these craftsmen ever had the intention of making a masterpiece, and the concept would in fact have been totally alien to them. But masterpieces were created, and we come back to the words of Yanagi Soetsu of Japan in the 20th century, who pointed out that the best art is

Opposite
Vase

*Yi dynasty, 19th century, white porcelain
with underglaze design in blue and red,
H 39.9 cm, by courtesy of the Cultural
Service, Korean Embassy, Tokyo*

Brush stand

*Yi dynasty, 18th century, white porcelain
with underglaze blue design, H 16 cm, by
courtesy of the Cultural Service, Korean
Embassy, Tokyo*

This simple straight-sided jar was used on
a scholar's desk for holding brushes. The
underglaze blue design shows wild orchids
which were a favored subject of the literati
gentleman-scholars.

artless and comes from the heart. The extraordinary fact is that whenever a masterpiece was made it appeared, for want of better words, by "accident" and therefore was never repeated. And because the potter's efforts were automatic and unthinking, he would not be able to repeat himself in any case.

Knowing that they endured such low status and even poverty, and received no encouragement or praise, one wonders what they would have produced – considering their formidable technical skills and their natural feeling for what could be coaxed from a lump of inert clay – if only they had been able to enjoy some encouragement. The proponents of Confucian ethics must have had much to answer for when they met their Maker. But when we see one of those wonderful, idiotic-looking tigers or dragons decorating one of these pots, it is comforting to imagine that the Yi potters had their moments of wry satisfaction, and moreover were able to convey their feelings to us.

Notes

Acknowledgments

My deepest debt of gratitude is due in the first place to the authors of the present publication, who have managed an extraordinary achievement in a spirit of tremendous cooperation.

Our ambitious project would have been scarcely conceivable without the support of numerous institutions, museums, libraries, archives, and photographers at home and abroad. My profound thanks are due to all of them, but especially to the Staatliches Museum für Völkerkunde in Munich. My thanks also go to the editors and translators, whose work required maximum commitment in view of the great breadth of the subject matter.

The present publication is dedicated to the memory of Mr Kazuie Furuto.

Gabriele Fahr-Becker

The Kingdom of the Khmer

1 Sui shu, chapter 82, quoted from: Donatella Mazzeo/Chiara Silvi Antonini: Foreword by Han Suyin: *Angkor, Monumente großer Kulturen.* Wiesbaden 1974, pp. 33.
2 Op. cit., pp. 5–8.
3 Norman Lewis: *A Dragon Apparent. Travels in Cambodia, Laos and Vietnam.* London 1951, pp. 231, 234.

Thailand

1 Quoted from: Carol Stratton/Miriam M. Scott: *The art of Sukhotay: Thailand's golden age.* Kuala Lumpur 1981, p. 108 f.
2 Quoted from: Jushua Eliot/Jane Bickersteth/ Georgina Matthews: *Thailand & Burma Handbook.* Bath 1995, p. 213.
3 Loc. cit., p. 213 f.
4 Cees Nooteboom: *Im Frühling der Tau – Östliche Reisen. (Ayutthaya, der zerstörte Diamant, Juni 1980).* Frankfurt am Main 1995, p. 308 f.
5 Quoted from: Jushua Eliot/Jane Bickersteth/ Georgina Matthews: *Thailand & Burma Handbook.* Bath 1995, p. 92.

Laos

1 Norman Lewis: *A Dragon Apparent. Travels in Cambodia, Laos and Vietnam.* London 1951, pp. 283–285.
2 Quoted from: Jushua Eliot/Jane Bickersteth/ John Colet: *Vietnam, Laos & Cambodia Handbook.* Bath 1995, p. 349.

Burma

1 Cees Nooteboom: *Im Frühling der Tau – Östliche Reisen. (In Birma, In der Stadt der Könige, April 1986).* Frankfurt am Main 1995, p. 139.
2 Shway Yoe (Sir James Scott): *The Burman: His Life and Notions.* London 1882.

3 Adolf Bastian: *Reisen in Birma in den Jahren 1861–1862.* Leipzig 1866, pp. 73, 77.
4 Cees Nooteboom: *Im Frühling der Tau – Östliche Reisen. (In Birma, In der Stadt der Könige, April 1986).* Frankfurt am Main 1995, p. 142.
5 Shway Yoe (Sir James Scott): *The Burman: His Life and Notions.* London 1882.
6 Quoted from: Jushua Eliot/Jane Bickersteth/ Georgina Matthews: *Thailand & Burma Handbook.* Bath 1995, p. 711.
7 Gerd Höpfner: *Marionetten aus Birma.* Exhibition sheet 174–11, Staatliche Museen Preußischer Kulturbesitz Berlin, Museum für Völkerkunde, South-East Asia Department. Berlin 1987.
8 Adolf Bastian: *Reisen in Birma in den Jahren 1861–1862.* Leipzig 1866, p. 506 f.
9 Crown Prince Rupprecht of Bavaria: *Reiseerinnerungen aus Indien.* Munich 1923, p. 291.
10 Op. cit., p. 278 f.
11 Adolf Bastian: *Reisen in Birma in den Jahren 1861–1862.* Leipzig 1866, p. 265.
12 Quoted from: Jushua Eliot/Jane Bickersteth/ Georgina Matthews: *Thailand & Burma Handbook.* Bath 1995, p. 656.
13 Loc. cit.
14 Cees Nooteboom: *Im Frühling der Tau – Östliche Reisen, (In Birma, Am Fuße der Shwe-Dagon-Pagode, Februar1986).* Frankfurt am Main, 1995, pp. 106, 108.

Vietnam

1 Bernard-Philippe Groslier: *Indochine, Carrefour des Arts. Collection L' art dans le monde.* Paris 1961, p. 227.
2 Stanley Karnow: *Vietnam: A History.* New York 1983, p. 186.
3 Op. cit., p. 198.
4 Norman Lewis: *A Dragon Apparent. Travels in Cambodia, Laos and Vietnam.* London 1951, p. 31.

Textiles

Acknowledgments

My special thanks are due to the photographers at the Staatliches Museum für Völkerkunde in Munich, Mrs Swantje Autrum-Mulzer and Mrs Marietta Weidner-El Salamouny, for their splendid photos of the textiles; my thanks go also to those in Australia and the USA who loaned photos, namely the Australian National Gallery in Canberra, Traude Gavin, Roy W. Hamilton and Robert J. Holmgren. A special debt of gratitude is owed to Dr. Gabriele Fahr-Becker and Dr. Sri Kuhnt-Saptodewo for their exceptional cooperation.

Michaela Appel

1 Cf. Gerald L.Tichelman: *Het snel-motief op Toradja-foejas.* In: Cultureel Indie 2, 1940, p. 114.

2 "Wori kapa dena dara goö dadi tegor". Käthe Tietze: *Sitten und Gebräuche beim Säen, Ernten, Spinnen, Ikatten, Färben und Weben der Baumwolle im Sikka-Gebiet (östliches Mittel-Flores).* In: Exotisches Kunstgewerbe. Leipzig 1941, p. 21.
3 "Tutu kapa, dena dadi luk mole mior" (beat the cotton flat, so that it becomes thin and beautiful), op. cit., p. 23.
4 Käthe Tietze: *Sitten und Gebräuche beim Säen, Ernten, Spinnen, Ikatten, Färben und Weben der Baumwolle im Sikka-Gebiet (östliches Mittel-Flores).* In: Exotisches Kunstgewerbe. Leipzig 1941, p. 36 f.
5 Op. cit., p. 48 ff.; i.e. "the soul of the ikat pattern".
6 Op. cit., p. 49.
7 Op. cit., p. 50.
8 Op. cit., p. 61 f.
9 Traude Gavin: *The Warpath of Women. (A ngar ritual at Entawau, Baleh in October 1988).* In: Sarawak Museum Journal XLII (63), 1991, p. 5.
10 Cornelia Vogelsanger: *A Sight for the Gods: Notes on the Social and Religious Meaning of Iban Ritual Fabrics.* In: Mattiebelle Gittinger (ed.): *Indonesian Textiles.* Washington 1980, p. 121, quoting from Derek Freeman's field notes (1949–1951), undated.
11 Op.cit., p. 118, quoting from Derek Freeman's field notes, 23. Nov. 1950.
12 Laura W. Benedict: *A Study of Bagobo Ceremonial Magic and Myth.* New York 1916, p. 209.
13 James D. Legge: *Indonesia.* New Jersey 1980, p. 30.

Japan and Korea

Acknowledgments

My contribution to this book would have turned out much less substantial without the friendly assistance and cooperation of museums, collectors, scholars and friends throughout the world. My special thanks go to the photographer Narimi Hatano, who despite frequent changes in my requests worked untiringly and professionally, also to all the collectors who do not wish to be mentioned by name but still continually preferred their advice and help, corrected my mistakes and allowed me access to photographs of precious objects hitherto unpublished. I am indebted to colleagues in museums abroad and here in Japan who provided unstinted help in initiating me into the secrets of Japanese databases in order to find photos relevant to the text, and also allowed me to use them in this publication. I should have been completely lost without the generous help of colleagues at the Korean embassy in Tokyo, who came up with and lent me photographs that would otherwise have been impossible to trace. I should like to express my particular thanks to the editor, Dr. Gabriele Fahr-Becker, who helped me to complete my task with the carrot and stick approach of encouraging words and "Teutonic" deadlines, based on the apparently straightforward brief to be "to the point and interesting".

Michael Dunn

Japan	
Jōmon era	c. 12000–250 B.C.
Incipient Jōmon era	c. 12000–5000 B.C.
Early Jōmon era	c. 5000–2500 B.C.
Middle Jōmon era	c. 2500–1500 B.C.
Waning Jōmon era	c. 1500–300 B.C.
Yayoi era	c. 250 B.C.–A.D. 250
Kofun (Tumulus) era	A.D. 250–552
Asuka era	A.D. 552–645
Nara era	A.D. 645–794
Heian era	A.D. 794–1185
Fujiwara era	A.D. 897–1185
Kamakura era	A.D. 1185–1333
Nambokucho era	A.D. 1333–1392
Muromachi era	A.D. 1392–1573
Momoyama era	A.D. 1573–1615
Edo (Tokugawa) era	A.D. 1615–1868
Meiji era	A.D. 1868–1912
Taisho era	A.D. 1912–1926
Showa era	A.D. 1926–1989
Heisei era	A.D. 1989–

Selective bibliography

The Kingdom of the Khmer

Boisselier, Jean: *Le Cambodge, manuel d'archéologie d'extrême-Orient.* Paris 1996

Coedès, George: *Angkor: Pour Mieux Comprendre Angkor.* Paris 1947

Eliot, Jushua/Jane Bickersteth/John Colet: *Vietnam, Laos & Cambodia Handbook.* Bath 1995

Felten, Wolfgang/Martin Lerner: *Das Erbe Asiens, Skulpturen der Khmer und Thai vom 6. zum 14. Jahrhundert.* Stuttgart 1988

Freeman, Michael/Roger Warner: *Angkor: The Hidden Glories.* Boston 1990

Geoffroy-Schneiter, Bérénice/Claude Jacques/ Thierry Zéphir: *L'ABCdaire d'Angkor et l'art khmer.* Paris 1997

Girard-Geslan, Maud et al.: *Südostasien. Kunst und Kultur.* Freiburg – Basle – Vienna 1995

Groslier, Bernard-Philippe: *Angkor, hommes et pierres.* Paris 1966

Jacques, Claude: *Angkor.* Paris 1990

Jacques, Claude/René Dumont/Federico Mayor: *Angkor.* Paris 1990

Jessup Helen, Ibbitson/Thierry Zéphir (ed.): *Sculpture of Angkor and Ancient Cambodia, Millenium of Glory.* Washington 1997

Lewis, Norman: *A Dragon Apparent, Travels in Cambodia, Laos and Vietnam.* London 1951

Loti, Pierre: *Un pèlerin d'Angkor.* Paris 1912

Malraux, André: *La Voie Royale.* Paris 1954

Mannika, Eleanor: *Angkor Wat: Time, Space and Kingship.* Honolulu 1996

Mazzeo, Donatella/Chiara Silvi Antonini/Foreword by Han Suyin: *Angkor, Monumente großer Kulturen.* Wiesbaden 1974

Mouhot, Henri: *Travels in Siam, Cambodia and Laos. 1858–1860,* reprinted Oxford 1991

O Murray, Stephen: *Angkor Life.* Bua Luang 1996

Pal, Pratapaditya/Stephen Little: *A Collecting Odyssey, Indian, Himlayan, and Southeast Asian Art from the James and Marilynn Alsdorf Collection.* Chicago 1997

Rawson, Philip S.: *The Art of Southeast Asia: Cambodia Vietnam Thailand Laos Burma Java Bali (World of Art).* London 1990

Smitthi, Siribhadra/Elizabeth Moore: *Palaces of the Gods: Khmer Art and Architecture in Thailand.* Bangkok 1991

Thailand

Dittmar, Johanna: *Thailand und Burma, Kunst-Reiseführer, Tempelanlagen und Königsstädte zwischen Mekong und Indischem Ozean.* Cologne 1991

Eliot, Jushua/Jane Bickersteth/Georgina Matthews: *Thailand & Burma Handbook.* Bath 1995

Fickle, Dorothy H.: *A Glossary of Terms Used in the Arts of Thailand.* Bangkok 1978

Girard-Geslan, Maud et al.: *Südostasien. Kunst und Kultur.* Freiburg – Basle – Vienna 1995

La Loubère, Simon de: *Du royaume de Siam.* London 1963

Korea

Era of the Three Kingdoms	37 B.C.–A.D. 935
Kingdom of Koguryo	37 B.C.–A.D. 68
Kingdom of Paekche	18 B.C.–A.D. 660
Kingdom of Silla	57 B.C.–A.D. 935
United Silla	A.D. 668–918
Koryo	A.D. 918–1392
Choson (Yi)	A.D. 1392–1910

Mouhot, Henri: *Travels in Siam, Cambodia and Laos. 1858–1860,* reprinted Oxford 1991

Nooteboom, Cees: *Im Frühling der Tau – Östliche Reisen.* Frankfurt am Main, 1995

Ringis, Rita: *Thai Temples and Temple Murals.* Kuala Lumpur – Oxford – Singapore – New York 1990

Pal, Pratapaditya/Stephen Little: *A Collecting Odyssey, Indian, Himlayan, and Southeast Asian Art from the James and Marilynn Alsdorf Collection.* Chicago 1997

Rawson, Philip S.: *The Art of Southeast Asia: Cambodia Vietnam Thailand Laos Burma Java Bali (World of Art).* London 1990

Stratton, Carol/Miriam M. Scott: *The Art of Sukhotay: Thailand's Golden Age.* Kuala Lumpur 1981

Wenk, Klaus: *Mural Painting in Thailand.* 1 vol. of text, 2 vols. of illus., Zürich 1976

Wyatt, David K.: *Thailand: a short history.* New Haven 1982

Laos

Bassene, Marthe: *In Laos and Siam.* London – Bangkok, undated

Berval, René de: *Kingdom of Laos.* Paris 1959

Eliot, Jushua/Jane Bickersteth/John Colet: *Vietnam, Laos & Cambodia Handbook.* Bath 1995

Girard-Geslan, Maud et al.: *Südostasien. Kunst und Kultur.* Freiburg – Basle – Vienna 1995

Gosling, Betty: *Old Luang Prabang, Images of Asia.* Oxford – New York – Singapore 1996

Lewis, Norman: *A Dragon Apparent. Travels in Cambodia, Laos and Vietnam.* London 1951

Mansfield, Stephen: *Laos, Culture of the World: Group 15.* Cavendish 1998

Mouhot, Henri: *Travels in Siam, Cambodia and Laos. 1858–1860,* reprinted Oxford 1991

Rawson, Philip S.: *The Art of Southeast Asia: Cambodia Vietnam Thailand Laos Burma Java Bali (World of Art).* London 1990

Zickgraf, Ralph: *Laos, Places and Peoples of the World.* London 1990

Zimmer, Heinrich: *The Art of Indian Asia: Its Mythology and Transformations.* 2 vols., Princeton 1955

Burma

Aung, Taik Aung: *Visions of Shwedagon.* London und Bangkok 1989

Bastian, Adolf: *Reisen in Birma in den Jahren 1861–1862.* Leipzig 1866

Dittmar, Johanna: *Thailand und Burma, Kunst-Reiseführer, Tempelanlagen und Königsstädte zwischen Mekong und Indischem Ozean.* Cologne 1991

Eliot, Jushua/Jane Bickersteth/Georgina Matthews: *Thailand & Burma Handbook.* Bath 1995

Fraser-Lu, Sylvia: *Burmese Lacquerware.* Bangkok 1985

Fraser-Lu, Sylvia: *Burmese Crafts: Past and Present.* Singapore 1994

Foucar, E. C. V.: *Mandalay the Golden.* London 1963

Girard-Geslan, Maud et al.: *Südostasien. Kunst und Kultur.* Freiburg – Basle – Vienna 1995

Höllmann, Thomas O./Achim Bunz: *Burma.* Munich 1996

Höpfner, Gerd: *Marionetten aus Birma.* Exhibition sheet 174–11, Staatliche Museen Preußischer Kulturbesitz Berlin, Museum für Völkerkunde, South-East Asia Department. Berlin 1987

Lewis, Norman: *Golden Earth, Travels in Burma.* London 1951

Lowry, John: *Burmese Art.* Victoria & Albert Museum London. London 1974

Nooteboom, Cees: *Im Frühling der Tau – Östliche Reisen.* Frankfurt am Main 1995

Ono, Toru: Pagan: *Mural Paintings of Buddhist Temples in Burma.* Tokyo 1978

Pal, Pratapaditya/Stephen Little: *A Collecting Odyssey: Indian, Himlayan, and Southeast Asian Art from the James and Marilynn Alsdorf Collection.* Chicago 1997

Pichard, Pierre: *Inventory of Monuments at Pagan.* Volume 2, Whiting Bay 1995

Rawson, Philip S.: *The Art of Southeast Asia: Cambodia Vietnam Thailand Laos Burma Java Bali (World of Art).* London 1990

Rupprecht, Crown Prince of Bavaria: *Reiseerinnerungen aus Indien.* Munich 1923

Scherman, Lucian/Christine Scherman: *Im Stromgebiet des Irrawaddy: Birma und seine Frauenwelt.* Munich-Neubiberg 1922

Scott O'Connor, V. C.: *The Silken East, A Record of Life and Travel in Burma,* no place of publication, 1904, reprinted by Paul Strachan, Kiscadale 1993

Shway, Yoe (Sir James Scott): *The Burman: His Life and Notions.* London 1882

Singer, Noel F.: *Old Rangoon: City of Shwedagon.* Kiscadale 1996

Steinbacher, Johannes Maria: *Burma Myanmar, Traumreise auf dem Irrawaddy.* Weishaupt 1995

Strachan, Paul: *Imperial Pagan: Art and Architecture of Old Burma.* Honolulu 1990

Thaw, Aung: *Historical Sites in Burma, Government of Burma.* Rangoon 1972

Thomann, Thomas H.: Pagan: *Ein Jahrtausend buddhistischer Tempelkunst.* Stuttgart 1923

Vietnam

Crawford, Ann: *Caddell Customs and Culture of Vietnam.* Vermont 1980

Eliot, Jushua/Jane Bickersteth/John Colet: *Vietnam, Laos & Cambodia Handbook.* Bath 1995

Girard-Geslan, Maud et al.: *Südostasien. Kunst und Kultur.* Freiburg – Basle – Vienna 1995

Groslier, Bernard-Philippe: *Indochine, Carrefour des Arts. Collection L'art dans le monde.* Paris 1961

Hejzlar, Jean: *L'art du Viêtnam.* Paris 1973

Karnow, Stanley: *Vietnam: A History.* New York 1983

Lafond, Philippe: *Hue, the Forbidden City: His Majesty Emperor Bao Dai.* Paris 1996

Le, Lu/Kevin Bowen/Luu Le/David Hunt: *A Time Far Past.* Massachusetts 1997

Lewis, Norman: *A Dragon Apparent, Travels in Cambodia, Laos and Vietnam.* London 1951

Pal, Pratapaditya/Stephen Little: *A Collecting Odyssey: Indian, Himlayan, and Southeast Asian Art from the James and Marilynn Alsdorf Collection.* Chicago 1997

Rawson, Philip S.: *The Art of Southeast Asia: Cambodia Vietnam Thailand Laos Burma Java Bali (World of Art).* London 1990

Unger, Ann Helen/Walter Unger: *Hue, die Kaiserstadt von Vietnam.* Munich 1995

Textiles in Southeast Asia

Adams, Marie Jeanne: *System and Meaning in East Sumba Textile Design: A Study in Traditional Indonesian Art.* Southeast Asia Studies Cultural Report Series 16. New Haven 1969

Appel, Michaela: *Pua sungkit: Ein Zeremonialtuch der Iban auf Borneo im Staatlichen Museum für Völkerkunde München.* In: Münchner Beiträge zur Völkerkunde 3, 1990, pp. 51–72

Appel, Michaela: *Textilien und Elfenbein: Indische*

Elefanten in Ostindonesien. In: Münchner Beiträge zur Völkerkunde 4, 1994, pp. 203–218

Barbier, Jean Paul/Douglas Newton (ed.): *Islands and Ancestors: Indigenous Styles of Southeast Asia.* New York 1988

Bellwood, Peter: *Prehistory of the Indo-Malaysian Archipelago.* Sydney 1985

Benedict, Laura W.: *A Study of Bagobo Ceremonial Magic and Myth.* New York 1916

Bühler, Alfred: *Turkey Red Dyeing in South and South East Asia.* In: Ciba Review 39, 1941

Bühler, Alfred: *Patola Influences in Southeast Asia.* In: Journal of Indian Textile History 4, 1959, pp. 1–43

Bühler, Alfred/Urs Ramseyer/Nicole Ramseyer-Gygi: *Patola and Geringsing: Zeremonialtücher aus Indien und Indonesien.* Basle 1975

Bühler, Alfred/Eberhard Fischer: *The Patola of Gujarat.* 2 vols. Basle 1979

Cheesman, Patricia: *Lao Textiles: Ancient Symbols – Living Art.* Bangkok 1988

Cole, Fay-Cooper: *The Wild Tribes of Davao District.* Field Museum of Natural History, Chicago 1922

Diran, Richard K.: *The Vanishing Tribes of Burma.* London 1997

Drake, Richard Allen: *Ibanic Textile Weaving: Its Enchantment in Social and Religious Practices.* In: Expedition 30 (1), 1988, pp. 29–36

Fischer, Hendrik Willem: *Katalog des Ethnographischen Reichsmuseums Vol. IV: Die Inseln rings um Sumatra.* Leiden 1909

Fox, James J.: *Roti, Ndao, and Savu.* In: Mary Hunt Kahlenberg (ed.): *Textile Traditions of Indonesia.* Los Angeles 1977, pp. 97–104

Gavin, Traude: *Kayau Indu: The Warpath of Women. (A ngar ritual at Entawau, Baleh in October 1988).* In: Sarawak Museum Journal XLII (63), 1991, pp. 1–41

Gavin, Traude: *The Women's Warpath: Iban Ritual Fabrics from Borneo.* UCLA Fowler Museum of Cultural History. Los Angeles 1996

Gittinger, Mattiebelle: *Splendid Symbols: Textiles and Tradition in Indonesia.* The Textile Museum. Washington 1979

Gittinger, Mattiebelle (ed.): *Indonesian Textiles: Irene Emery Roundtable on Museums Textiles 1979 Proceedings.* The Textile Museum. Washington 1980

Gittinger, Mattiebelle: *Sier en symbool: De kostuums van de etnische minderheden in Zuid- en Zuidwest-China.* In: Loan Oei (ed.): *Indigo: leven in een kleur.* Weesp 1985

Gittinger, Mattiebelle (ed.): *To Speak with Cloth: Studies in Indonesian Textiles.* Museum of Cultural History. Los Angeles 1989

Gittinger, Mattiebelle: *A Reassessment of the Tampan of South Sumatra.* In: Mattiebelle Gittinger (ed.): *To Speak with Cloth: Studies in Indonesian Textiles.* Museum of Cultural History. Los Angeles 1989, pp. 224–239

Gittinger, Mattiebelle/H. Leedom Lefferts Jr.: *Textiles and the Tai Experience in Southeast Asia.* The Textile Museum. Washington 1992

Hamilton, Roy W.: *Gift of the Cotton Maiden: Textiles of Flores and the Solor Islands.* Fowler Museum of Cultural History. Los Angeles 1994

Hauser-Schäublin, Brigitta/Marie-Louise Nabholz-Kartaschoff/Urs Ramseyer: *Textilien in Bali.* Museum für Völkerkunde. Basle 1991

Holmgren, Robert J./Anita E. Spertus: *Early Indonesian Textiles from three Island Cultures: Sumba, Toraja, Lampung.* The Metropolitan Museum of Art. New York 1989

Holmgren, Robert J./Anita E. Spertus: Is Geringsing Really Balinese? In: Gisela Völger/Karin von Welck (ed.): *Indonesian Textiles Symposium 1985.* Cologne 1991, pp. 59–79

Holmgren, Robert J./Anita E. Spertus: Newly Discovered Patolu Motif Types: Extensions to Alfred Bühler and Eberhard Fischer (1979), The Patola of Gujarat. In: Gisela Völger/Karin von Welck (ed.): *Indonesian Textiles Symposium 1985.* Cologne 1991, pp. 81–86

Jasper, J. E./Mas Pirngadie: *De Inlandsche Kunstnijverheid in Nederlandsch Indie II: De Weefkunst.* The Hague 1912

Kahlenberg, Mary Hunt (ed.): *Textile Traditions of Indonesia.* Los Angeles County Museum of Art. Los Angeles 1977

Kajitani, Nobuko: Traditional Dyes in Indonesia. In: Mattiebelle Gittinger (ed.): *Indonesian Textiles.* Washington 1980, pp. 305–325

Kartiwa, Suwati: *Tenun ikat - Indonesian Ikats.* Jakarta 1987

Kaudern, Walter: *I Celebes Obygder.* Stockholm 1921

Khan Majlis, Brigitte: *Indonesische Textilien: Wege zu Göttern und Ahnen.* Ethnologica, N. F., Vol.. 10, Cologne 1984

Kooijman, Simon: *Ornamented Bark-Cloth in Indonesia.* Leiden 1963

Kron-Steinhardt, Christiane: Textile Influences between Mindanao (Southern Philippines) and some Indonesian Islands. In: Gisela Völger/Karin von Welck (ed.): *Indonesian Textiles Symposium 1985.* Cologne 1991, pp. 92–103

Kruyt, Albert C.: *De West-Toradja's op Midden Celebes.* Amsterdam 1938

Legge, James D.: *Indonesia.* New Jersey 1980

Lewis, Paul/Elaine Lewis: *Völker im Goldenen Dreieck: Sechs Bergstämme in Thailand.* Stuttgart 1984

Ling Roth, Henry: *Studies in Primitive Looms.* Halifax 1917

Marshall, Harry Ignatius: *The Karen People of Burma: A Study in Anthropology and Ethnology.* (1922) Reprint. Bangkok 1997

Maxwell, Robyn: De rituele weefsels van Oost-Indonesie. In: Loan Oei (ed.): *Indigo: leven in een kleur.* Weesp 1985

Maxwell, Robyn: *Textiles of Southeast Asia: Tradition, Trade and Transformation.* Australian National Gallery, O.U.P. Melbourne et al. 1990

Monier-Williams, Sir Monier: *A Sanskrit-English Dictionary.* Oxford 1976

Nabholz-Kartaschoff, Marie-Louise: De bijzondere plaats van een gewone kleur: Blauw in de traditionele kleding van de bergstammen van Birma, Thailand, Laos en Vietnam. In: Loan Oei (ed.): *Indigo: leven in een kleur.* Weesp 1985

O'Connor, Deryn: *Miao Costumes from Guizhou Province, South West China.* Farnham 1994

Oei, Loan (ed.): *Indigo: leven in een kleur.* Weesp 1985

Pastor-Roces, Marian: *Sinaunang Habi: Philippine Ancestral Weave.* Manila 1991

Prangwatthanakun, Songsak/Patricia Naenna: *Lan Na Textiles: Yuan Lue Lao.* (1987) Bangkok 19903

Rosenberg, Carl B. Hermann von: *Der Malayische Archipel.* Leipzig 1878

Tichelman, Gerard L.: *Het snel-motief op Toradja-foejas.* In: Cultureel Indie 2, 1940, pp. 113–118

Tietze, Käthe: Sitten und Gebräuche beim Säen, Ernten, Spinnen, Ikatten, Färben und Weben der Baumwolle im Sikka-Gebiet (östliches Mittel-Flores). In: *Exotisches Kunstgewerbe.* Leipzig 1941, pp. 1–64

Völger, Gisela/Karin von Welck (ed.): *Indonesian Textiles Symposium 1985.* Ethnologica, N. F., Vol. 14, Cologne 1991

Vogelsanger, Cornelia: A Sight for the Gods: Notes on the Social and Religious Meaning of Iban Ritual Fabrics. In: Mattiebelle Gittinger (ed.): *Indonesian Textiles.* Washington 1980, pp. 115–126.

Warming, Wanda/Michael Gaworski: *The World of Indonesian Textiles.* London 1981

Japan

Berndt, Jürgen (ed.): *Japanische Kunst,* 2 vols., Leipzig 1974

Egami, Namio: *The Beginnings of Japanese Art.* Heibonsha, Tokyo 1969

Eight Hundred Years of Japanese Print Making. Museum of Art, Carnegie Institute. Pittsburgh 1976–1977

Exquisite Visions: Rimpa Paintings from Japan. Honolulu Academy of Arts in assocation with Japan House Gallery. Honolulu 1980

Fahr-Becker, Gabriele (ed.): *Japanische Farbholzschnitte.* Cologne 1993

Fujioka, Ryouichi: *Shino and Oribe Ceramics.* Tokyo – New York – San Francisco 1977

Fujioka, Ryouichi: *Tea Ceremony Utensils.* Tokyo 1973

Genre Screens from the Suntory Museum of Art. Japan House Gallery. New York 1978

Hauge, Victor/Takako Hauge: *Folk Traditions in Japanese Art.* Tokyo 1978

Hayashiya, Seizou: *Iga Ware.* Nippon Toji Zenshu, Vol. 13, Chuo Kouronsha. Tokyo 1977

Hufnagel, Florian (ed.): *Japan: Hülle und Gefäß, Tradition - Moderne.* Die Neue Sammlung, Staatliches Museum für angewandte Kunst München. Munich 1992

Illing, Richard: *The Art of Japanese Prints.* London 1980

International Symposium of Japanese Ceramics. Seattle Art Museum. Seattle 1973

Kanazawa, Hiroshi: *Japanese Ink Painting: Early Zen Masterpieces.* Tokyo 1979

Kennedy, Alan: *Japan – Costume. History and Tradition.* Paris 1990

Keramos. Zeitschrift der Gesellschaft der Keramikfreunde e. V.. Düsseldorf 1979

Kidder, J. Edward: *Japan before Buddhism.* London 1959

Kidder, J. Edward: *Jōmon Pottery.* Tokyo – Palo Alto 1968

Koyama, Fujio: *The Heritage of Japanese Ceramics.* New York – Tokyo – Kyoto

Lane, Richard: *Images from the Floating World.* Oxford 1978

Lee, Sherman: *A History of Far Eastern Art.* London 1964

Lee, Sherman: *Japanese Decorative Style.* New York 1972

Mason, Penelope: *History of Japanese Art.* New York 1993

Mingei-Arbeiten anonymer Kunsthandwerker in japanischer Tradition. Mingei-Museum. Tokyo 1992

Mitsuoka, Tadanori/Naoshige Okuda: *Sekai Toki Zenshu.* Vol. 4: *Momoyama Period I Bizen, Tamba, Shigaraki & Iga Wares.* Tokyo 1977

Mizuo, Hiroshi: *Edo Painting: Sotatsu & Korin.* Tokyo 1965

Miyajima, Shin'chi/Yasuhiro Satoh: *Japanese Ink Painting.* Los Angeles County Museum. Los Angeles 1986

Nakanishi, Touru: *Tamba no Ko-Toki.* Tamba Pottery Museum, Sasayama

Narasakai, Shoichi: *Sekai Toki Zenshu.* Vol. 3: *Japanese Medieval Period.* Tokyo 1977

Narasaki, Shoichi: *Tamba Ware.* Nippon Toji Zenshu Vol. 11, Tokyo 1977

Nihon Bijitsu Kaiga Zenshu. Vol. 4, Sesshu, Tokyo 1980

Nihon Byobu-e Shusei. Tokyo 1982

Nihon no Toki. Tokyo National Museum. Tokyo 1985

Okakura, Kakuzo: *The Book of Tea.* Tokyo – New York – London 1989

Okazaki, Johji: *Pure Land Buddhist Painting.* Tokyo 1977

Rhodes, Daniel: *Tamba Pottery. The Timeless Art of a Japanese Village.* Tokyo – New York – San Francisco 1970

Rosenfield, John (ed.): *Song of the Brush. Japanese Paintings from the Sano Collection.* Seattle Art Museum. Seattle 1979

The Shibata Collection. Vol. 2 (1991), Vol. 3 (1993), Vol. 4 (1995), Vol. 5 (1997), The Kyushu Ceramic Museum, Saga Prefecture. Japan Arita

Shimazaki, Susumu: *Kutani.* Nihon Toji Zenshu, Vol. 26, Tokyo 1976

Spectacular Helmets of Japan. 16th–19th century. Japan House Gallery, Japan Society. New York 1985

Suzuki, Daisetz: *Zen and Japanese Culture.* Princeton University Press. Princeton 1979

Smith, Lawrence/Victor Harris/Timothy Clark: *Japanese Art. Masterpieces in the British Museum.* London 1990

Tanaka, Migaku/Shouzou Tanabe: *Sue Ware.* Nippon Toji Zehnshu, Vol. 4., Tokyo 1977

Trubner, Henry/Mikami Tsugio: *Treasures of Asian Art from the Idemitsu Collection.* Seattle Art Museum. Seattle 1981

Unkoku School. The Successors of Sesshu's Style. The Yamaguchi Prefectural Museum of Art. Yamaguchi 1981

Wilson, Richard L.: *Inside Japanese Ceramics.* New York – Tokyo 1995

Wood, Donald/Tanaka Terushi/Frank Chance: *Echizen: Eight Hundred Years of Japanese Stoneware.* Birmingham Museum of Art (USA). Birmingham 1994

Yumoto, John, M.: *The Samurai Sword.* Tokyo 1958

Korea

Akaboshi, Goro/Heichiro Nakamaru: *Five Centuries of Korean Ceramics.* Tokyo 1975

Folk Art of Korea. The National Museum of Korea. Seoul 1975

Kim, Chewon/Lena Kim Lee: *Arts of Korea.* Tokyo – New York 1974

McCune, Evelyn: *The Arts of Korea. An Illustrated History.* Tokyo 1962

Ri-chō Minga – Folk Painting of the Yi Dynasty of Korea. Odakyu – Tokyo 1979

Selected Treasures of National Museums of Korea. National Museum of Korea, Seoul 1985

Tōyō Tōki-Ten. Ataka Collection. Nagoya City Museum. Nagoya 1979

Wickmann, Michael: *Korean Chests. Treasures of the Yi Dynasty.* Seoul 1978

Zozayong: *Diamond Mountain 1.* Emille Museum. Seoul 1975

Zozayong: *Diamond Mountain 2.* Emille Museum. Seoul 1975

Zozayong: *The Life of the Buddha in Korean Paintings.* Emille Museum. Seoul 1975

Zozayong: *Spirit of the Korean Tiger.* Emille Museum. Seoul 1972

5000 Years of Korean Arts. Tokyo National Museum. Tokyo 1976

Glossary

Abaka banana fiber (*Musa textilis*), used to make fabrics.

Abalone shellfish (*Haliotidae*) whose inner shell provides mother-of-pearl.

Abhayamudra the symbolic attitude of the Buddha which means "one who protects and preserves from suffering." The Buddha figure is either standing or seated, his right hand (sometimes both hands) raised with the palm turned outwards.

Abuna-e "daring image:" Japanese erotic pictures of pairs of lovers.

Abura-zara "oil dish:" in Japan, a dish for lanterns, to catch the drips of wax or oil.

Ainu original population of Japan, having round eyes and curly hair, today resident in the most northerly part of Hokkaido.

Alang in Toraja, Sulawesi (Celebes), a building for storing rice.

Amaterasu Japanese sun goddess and ancestral mother of the Japanese imperial house.

Amida-Yakushi a depiction of the Buddha in the simple robes of a priest with one arm and part of the upper body uncovered.

Amitabha the Buddha of the western paradise. He is mainly venerated by the Pure Land Sect.

Anagama tunnel kiln with ventilation slits; *anagama* kilns introduced a great deal more control over the firing process.

Ananda the most important disciple of the historical Buddha. According to legend, it was Ananda who first wrote down the Buddhist sacred texts, the Sutras. Together with another disciple, Kasyapa, he is often depicted as a companion of Buddha dressed in a monk's costume.

Andon Japanese lamps.

Andon-zara underplates for Japanese lamps.

Angenan Balinese sacrificial gifts offered during the ceremony for the dead.

Anjuang in Sumatra, a side room in a Minangkabau house.

Apple blossom in China, a symbol of the season of spring, and of female beauty. In China the wild apple (haitang) is a symbol of Yang Guifei, the celebrated concubine of a Tang emperor.

Appliqué textile decoration in which pieces of cloth, beads, or other materials are sewn onto a fabric.

Apsaras "those who glide over the water:" in Cambodian mythology, dancing celestial nymphs.

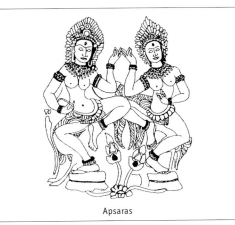

Apsaras

Arhat see **Luohan**

Arita porcelain from the early 17th century, Japanese porcelain made from kaolin clay and noted for its glass-like appearance. Most frequently decorated in underglaze blue and colorful overglaze enamels, often mixed with gold dust. Characteristic colors are intense green combined with yellow, black, blue, and aubergine. Also from Arita is Kakiemon porcelain, milky-white in color, decorated in underglaze blue and/or overglaze enamels, often in the orange-red color of the *kaki* fruit, whence the name Kakiemon. The choicest Arita porcelain, called Nabeshima, was reserved for the highest levels of society. The design is first drawn on paper with a special ink and then transferred to the vessel by means of light rubbing; the transferred lines are then painted in cobalt blue.

Artemisia (leaf) originally a medicinal herb, then regarded as a symbol of good fortune.

Arts and Crafts a movement of artists and craftsmen in Great Britain from the mid-19th century who advocated a return to the craft traditions that were being lost through industrialization. This involved both a return to the practice of these crafts and also an attempt to introduce high standards of design into industrial manufacturing processes.

Arupadhatu in Buddhism, the sphere of "formlessness," a stage in the soul's journey to spiritual enlightenment.

Asura in Hinuism and Buddhism, a demon.

Aware in Japanese art, a type of beauty that has a slightly melancholic, or bittersweet quality.

Ayu freshwater fish, a delicacy in Japan, caught by fishing with cormorants.

Bagu fibers made from the bark of white China-grass (*Boehmeria nivea Gand*); the material made from *bagu* is linen-like, tough and smooth.

Baimiao "outline style:" Chinese painting technique in which only the outline is drawn on the paper, uncolored, without any change of tone.

Bamboo one of the most important motifs in Chinese and Japanese painting, bamboo is a symbol of both resistance and endurance, derived from the plant's characteristic ability to bend in the wind but not break, and stand upright again after a storm. Also very commonly found as a motif in craftwork.

Banten on Bali, a sacrifice to the gods.

Function	Cooking food				Storing/serving food					Wine		
Vessel type → / **Stage of development** ↓	ding	fang-ding	li	xian or yan	gui	yu	dou	fu	dui	jue	jia	he
Ceramic Prototype												
Early Shang period												
Late Shang period												
Early Zhou period												
Late Zhou period												

Bark fiber fabric a fabric produced from the fine fiber that grows between the trunk and bark of certain trees, such as types of fig tree (*Ficus*), breadfruit trees (*Artocarpus*), and the paper-mulberry (*Broussonetia papyrifera*).

Basir on Borneo, a priest.

Bat in China, a symbol of good fortune. This meaning is derived from the identical sound of the Chinese characters for *fu* (happiness) and *fu* (bat).

Batik a process of patterning and dyeing fabric in which the design is covered (reserved) with wax. After dyeing and the removal of the wax, the design appears in the basic color of the fabric. To obtain a design of several colors, the complete process is repeated several times.

Bell one of the eight symbols of Buddhism, the symbol of respect; the sound of a bell is thought to dispel evil spirits.

Betang among the Ngaju Dayaks of Borneo, a longhouse.

Betel mildly intoxicating substance, used widely in Southeast Asia, consisting of a chewing tobacco made from the betel nut (*Areca catechu*) or betel leaves (*Piper betle*) chewed with chalk powder.

Bhūmisparscamudra a symbolic attitude of the Buddha meaning "calling upon the earth goddess as a witness to his enlightenment and his victory over Mara, the king of the demons." The Buddha's right hand rests on his right knee with the fingertips pointing downwards, and the left hand rests on his lap, open and palm upwards.

Bi disc in neolithic China, thin jade disc (probably symbolizing the sun) with a large central hole; commonly used as grave goods.

Biliak in Sumatra, a bedroom in a Minangkabau house.

Bilik among the Iban of Borneo, separate closed rooms in a longhouse.

Bizen ware Japanese pottery made from the 12th century onward. Made from a sticky clay with a high iron content, it is dark red in color, often with a smooth, sometimes transparent and almost metallic surface. Decorative effects include wavy lines running around the shoulder of large containers, and contrasting spots or dribbles produced by woodash glazes.

Bodhi tree (*Ficus religiosa*) sacred fig tree. It was under this tree that the Buddha achieved enlightenment (*bodhi*).

Bodhisattva "one who is enlightened:" a being who, though capable of moving on to the final stage of enlightenment, has chosen to remain at a lower level of spiritual reality in order to help others in their journey.

Bodhisattva Maitreya in Korean art, an attitude or pose of the Buddha. The left foot rests on a lotus, while the right foot rests on the left thigh. The left hand is raised and one finger is about to touch the bodhisattva's face, across which is spread a radiant smile typical of many Korean images. This pose, which has a very ancient origin, is also known from early works from India and Gandhara. There are several famous Maitreya statues in Japan.

Bonsai tree Japanese dwarf tree.

Bōsatsu Japanese term for a bodhisattva.

Bot chief shrine and ordination hall in a Thai temple complex.

Brahma in Hinduism, the creator of the universe, one of the gods of the Hindu trinity.

Bronze vessel forms in East Asian art bronzes, which frequently had a ritual use, into those for cooking, storing, and serving food; and those for storing, holding, serving, or drinking wine or water. The table of bronze forms (see above) shows their purpose (horizontally) and their historical development (vertically), using examples of the most commonly found vessels.

Bronze casting the casting technique for early Chinese bronzes was basically as follows. A clay model, which included all the essential decorative details, was prepared and fired in a kiln. Clay panels about 15 mm (half an inch) thick were then pressed onto the model (the "positive") in order to obtain the "negative" mold. Large and complex bronzes were made in several parts. A clay core for the vessel was newly made or created from the positive by removing a layer the thickness of the wall of the intended vessel. The negative and positive molds were then carefully assembled, small metal bridges keeping the two apart. Molten bronze was now poured into the form, narrow channels allowing the air to escape. Once the bronze has cooled, the molds were taken apart, or broken, leaving the cast vessel.
 A special type of bronze casting is the lost-wax method (*cire-perdue*). Archaeological evidence of this process is found from the 6th century B.C., and from the Han period it became a standard method for casting sculptures. With this technique, a wax model of the vessel to be cast was made. When the molten bronze was poured

gu	zhi	zun	animal-zun	lei	hu	you (Type I)	you (Type II)	fang yi	gong	pan	yi	jian

into the mold the wax melted and ran out of the mold, its exact form being taken by the bronze. After the metal had cooled, the clay mold was broken open to reveal the bronze vessel.

Buddha the central figure in Buddhism. The historical Buddha was Siddhartha Gautama (about 560–480 B.C.), also known as Shakyamuni, the son of the raja of the state of Kapilavastu, near Nepal. At an early age he rejected his wealth and privilege and lived as a hermit, taking instruction from Hindu teachers. Spiritual enlightenment finally came as he sat under a *bodhi* tree. The disciples who gathered around him regarded him as the Buddha, the "enlightened one." As a spiritual being, the Buddha gradually acquired a complex nature, sometimes being ascribed the characteristics of being and deities from other religious traditions.

Buddha Amida the merciful, gracious Buddha.

Buddha images in China, various types of seated figures developed out of the art of Gandhara. At first they were closely related to their Indian models, but during the Sui and Tang dynasties an independent Chinese style developed.

Buddhist canon the central texts of Buddhism.

Bunjinga in Japan, painting by scholars (bunjin).

Calabash a gourd used as a container; in China, a symbol of medicine, magic, and the black arts, attribute of the immortal Li Tieguai. See **Eight Immortals**

Calendar the traditional Chinese calendar is based on the combination of two cycles: the heavenly cycle of 10 years, and the earthly cycle of 12 years (so that each unique pairing of the

signs attributed to the years occurs every 60 years). From as early as the Tang era each of the 12 earthly years has had an animal attributed to it. There are many accounts of the origin of this tradition. According to one of the best known, the Buddha summoned the animals to him when naming the years, and the sequence was determined by the order of their arrival. The rat arrived first, then came the ox, tiger, hare, dragon, snake, horse, sheep/goat, monkey, rooster, dog, and finally the pig ambled along at a leisurely pace.

Candi in Indonesia, a temple.

Canopy one of the eight symbols of Buddhism, the symbol of kingliness, dignity, and authority.

Cao-Daism "highest palace:" Southeast Asian religion founded in 1926 as a synthesis of all world religions and world views.

Caoshu in Chinese calligraphy, an abbreviated shorthand script, characterized by long, arching, interlinking strokes. Also known as "draft script." The translation "grass writing" is also found, but this is based on an early error in translation.

Cardamom Asiatic spice derived from the ginger plant (*Elettariasp*).

Celadon since the Chinese Song era, a ceramic ware with a clear green glaze in various shades. Celadon with a greenish-blue glaze, "the blue of the sky after rain," reached its full flowering in the Koryo period of Korea. Decoration is of wide-ranging types: modeled, scratched, or pressed-in underglaze decoration, painting, or inlay work. Pictorial motifs were painted on with the brush and a solution of iron oxide. With inlay work, the desired motifs were cut or pressed into the clay body, and the depressions were filled with white, reddish-brown, or sometimes black slip. The term is derived from European literature of the Baroque period: the French writer Honoré d'Urfé gave the name Céladon to the hero of a pastoral play, who usually wore a greenish-blue garment.

Chan Chinese Buddhist sect, closely related to the Zen sect in Japan.

Cha-no-yū the Japanese tea ceremony.

Chao fa "princes of the sky:" the upswept roofs typical of temples in Laos.

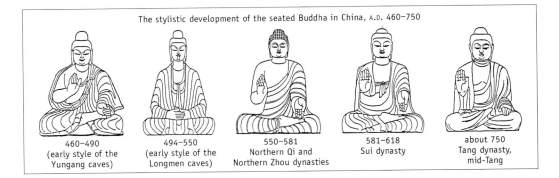

The stylistic development of the seated Buddha in China, A.D. 460–750

460–490 (early style of the Yungang caves) | 494–550 (early style of the Longmen caves) | 550–581 Northern Qi and Northern Zhou dynasties | 581–618 Sui dynasty | about 750 Tang dynasty, mid-Tang

Chedi in Thailand, a memorial site, a building containing a religious relic; a stupa.

Chiang Mai style an art style that marked the emergence of a distinctively Thai culture. It appeared in Chiang Mai (later Chiang Saen) in 11th century A.D., notably in sculpture.

Chonin in ancient Japan, the class of manual workers, dealers, and merchants.

Chrysanthemum in China, the flower of the 10th lunar month. A frequent motif in Chinese painting (and known as the "eastern fence motif"), it is a symbol of the retired life of the official, this theme being closely linked to a poem by the scholar Tao Yuanming.

Chua Buddhist temple.

Cicada in China, a symbol of immortality, often depicted on bronzes as a relief motif.

Cili on Bali, sacrificial gift, or an image of the deity for whom the sacrifice is prepared.

Clouds in China, a symbol of rain and fertility.

Cobalt a metal which in compounds forms an important pigment in art, particularly in the decoration of porcelain.

Cochineal a red pigment obtained from the secretion of the female scale insect or shield louse (*Lakshadia chinensis*), which discharges it onto certain trees.

Confucius Latinized form of the name of the Chinese philosopher Kong Zi, Master Kong (traditional dates 551–479 B.C.). Founder of the philosophy of Confucianism. Confucius traveled from one small state to another, offering his advice to the nobles of his time, many of whom were engaged in a bitter struggle for supremacy. His thoughts were written down and later brought together by his disciples. His ideas, which relate in particular to social and political life, had a profound effect on Chinese thought and culture.

Cong in the Chinese neolithic era, a rectangular block, usually hollow, that symbolized the earth. Exclusively found in tombs of boys and men.

Coral in China, a symbol of long life or a successful career.

Crane in China, a symbol of good fortune and long life. They are often the attributes of immortals or holy figures, and in folk religion and in Taoism they are closely linked to legends of immortality.

Daimyo a regional lord during the Shogun rule in Japan.

Dainchi image of the Buddha wearing the simple robe of a priest, with one arm and part of his upper body uncovered.

Dalang wayang in Indonesia, a puppeteer.

Daun doyo fibers of a marsh grass (*Curculigo latifolia*) used in making fabrics.

Devatas female deities.

Dharma in Hinduism and Buddhism, the eternal law; an individual's rights and duties; in Buddhism, the universal truth proclaimed by the Buddha.

Dok sofa "bouquet of flowers:" on the roof gable of a Laotian temple, a fan-shaped decoration usually consisting of floral motifs.

Dong Son archaeological site in North Vietnam that gave its name to a Bronze Age culture (7th–1st century B.C.).

Double ikat largely in Indonesia, a very complicated decorative process in weaving. Both warp and weft threads are separated out and dyed and then woven together. Found in India only in Gujarat, and in Indonesia only on Bali. See **Ikat**

Dougong in Chinese architecture, a system of interlocking wooden U-shapes that bears the load of the roof and allows eaves to extend well beyond the outline of the building. See box.

Dragon in China, a symbol of masculinity and power, allocated to the creative yang aspect of the yin-yang dualism; from the time of the Han dynasty, a symbol of the emperor. Chinese mythology distinguishes between dragons of heaven, of earth, and of water, and dragons which protect treasure; they are all governed by a dragon king. In art, there are two major forms: the Yu dragon, which has a fish's tail, and the Pan dragon, which appears greatly distorted.

Duck in China, a symbol of fidelity (on account of its reputation for monogamy).

Dvaravati kingdom in central Thailand and lower Burma with a predominantly Mon population, probably 3rd to 13th century A.D.

Earthenware unglazed pottery.

Echizen ware Japanese pottery first made in the late 12th century. Made from clay with a high iron content, it has a brownish color and is mostly undecorated, though with a lively surface texture of spots and dribbles created by a natural woodash glaze.

Edo former name of Tokyo, the eastern capital. Seat of the Tokugawa Shoguns from 1603 to 1867.

Eight Immortals in China, the eight most famous Taoist saints: three of them are historic characters, five are mythical. Symbolizing good fortune and long life, they have the following in common: all possess superhuman powers, all mingle among mortals from time to time in order to do good, and all have numerous legends and folk tales associated with them. They are characterized by well-known attributes. Apart from their general character as bringers of good fortune, some of the eight have become patron saints of certain groups. Zhongli Quan, a stout man with a naked belly and a fan, is the leader of the eight saints; Zhang Guolao, the magician, carries a musical instrument as his attribute, or, less frequently, is seen riding on his magical mule; Li Tieguai carries a bottle-gourd (calabash) and a crutch; Lü Dongbin has a fly-swatter; Han Xiangzi carries a flute; He Xiangu, the only female immortal among the eight, usually holds a lotus stem; Cao Guojiu wears an

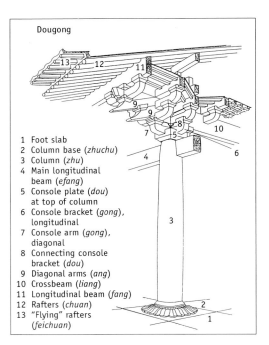

Dougong

1 Foot slab
2 Column base (*zhuchu*)
3 Column (*zhu*)
4 Main longitudinal beam (*efang*)
5 Console plate (*dou*) at top of column
6 Console bracket (*gong*), longitudinal
7 Console arm (*gong*), diagonal
8 Connecting console bracket (*dou*)
9 Diagonal arms (*ang*)
10 Crossbeam (*liang*)
11 Longitudinal beam (*fang*)
12 Rafters (*chuan*)
13 "Flying" rafters (*feichuan*)

official's cap and a rattle (*paiban*); the last, the hermaphrodite Lan Caihe, has one shoe, is often dressed in blue, and carries a basket of flowers.

Eight symbols of Buddhism symbols of various aspects of Buddhist teaching: wheel of teaching, lotus, umbrella, canopy, vase, two fish, endless knot, sea-snail. Sometimes a bell is seen instead of a wheel. These symbols are often seen in paintings and sculpture, and as decorative motifs on a wide range of objects.

Eight treasures (Chinese: *ba bao*) in Chinese thought, the eight most important virtues or attainments. They are (with their symbols): purity and female beauty (a pearl); symbol of wealth and material prosperity (a coin); order in the state (a rhombus); the culture of the scholar (painting); music (a jade "sounding stone"); scholarship (books); good fortune (a pair of rhinoceros-horn cups, which can detect poison in a drink); and finally happiness (an artemisia leaf).

E-maki in Japanese art, picture scrolls.

Engobe slip a slip that gives a piece of ceramic ware a different color from that of its body. It is sometimes used to allow a glaze to adhere more effectively, and also to provide a suitable surface for *sgraffito* decoration (in which a design is scratched through the slip to reveal the surface below).

Ensō circles simple circles drawn by Zen monks with a single stroke of the brush.

E-zara in Japanese art, a painted dish; tableware with a multiplicity of painted motifs.

Feibai in Chinese painting and calligraphy, a brush technique which allows the paper to show through a brushstroke. It is achieved by pressing down so hard on the brush that the bristles separate.

Fish in China, a symbol of abundance and wealth. The symbolic meaning derives from the identical sound of the characters for *yu* (fish) and *yu* (surplus).

Fish (pair) one of the eight symbols of Buddhism, the symbol of marriage; as an amulet, a pair of fish was protection against evil.

Fish kite in China, a symbol for endurance, and especially success in examinations (derived from the carp, which swims upstream and even surmounts waterfalls).

Five Gods of Happiness (Chinese: *wu fu*) the gods of long life, wealth, well-being, virtue, and health. They are represented by men in red clothes, or by five bats.

Flowers of the Four Seasons in China, the flowers traditionally associated with the months of the year. They include: plum blossom (Chinese: *meihua*) for the 1st month of the Chinese lunar year; peach blossom for the 2nd month; the peony (*Paeonia mudan*) for the 3rd month; cherry blossom (*yinghua*) for the 4th month; magnolia (*mulan*) for the 5th month; pomegranate (*shiliu*) for the 6th month; lotus blossom (*lianhua*) representing the 7th month; pear (*lihua*) the 8th month; mallow (*guihua*) the 9th month; chrysanthemum (*juhua*) the 10th month; gardenia (*baichan*) the 11th month; and poppy (*afurong*) the 12th month.

Forbidden City the imperial palace in Peking.

Four Noble Ones the four classic motifs of Chinese and later Japanese painting: the lotus, plum blossom, chrysanthemum, and bamboo.

Four Painter Monks the Chinese painters Hongren, Bada Shangren, Shitao, and Kuncan.

Four Treasures in China and later Japan, the four treasures of scholars: brush, ink, paper, and ink block.

Frangipani tree a tree often associated with temples.

Fuchi on a Japanese sword, the metal mount at the lower end of the hilt, separating the guard from the hilt.

Fukinuki yatai "the blown-away roof:" in Japanese painting, the device of not painting a roof so that the interior of a building can be seen.

Fusuma in a Japanese house, a sliding door.

Futai brocade ribbons.

Futon Japanese quilt-like mattress which is rolled up and kept in a cupboard during the day.

Gamelan in Southeast Asia, particularly Java and Bali, a musical ensemble consisting of tuned metal or wood chimes and other percussive instruments; one of these instruments.

Ganbi "dry brush:" a painting technique in which color is applied sparingly. The Chinese painter Ni Zan in particular was famous for this.

Gandhara province of ancient India, in present-day western Pakistan and eastern Afghanistan.

Ganesha in Hinduism, the elephant-headed god, son of Shiva and Parvati.

Garuda in Cambodian mythology, a mythical bird, traditional enemy of the *nāga*.

Gautama See **Buddha**

Geisha in Japan, a woman trained as a singer and dancer, responsible for the entertainment of men, not necessarily offering sexual favors. Until about the early 16th century there were also male geishas.

Gembu mythological creature, combination of a serpent and turtle.

Geta traditional Japanese wooden sandal.

Gion festival In Japan, the Shinto summer festival in Kyoto.

Go "brush name:" an artist's professional name, used in addition to his actual name or seal.

God of long life (Chinese: *shoulao*) in the Chinese pantheon, the god of long life is always represented as an old man with a bald head, often accompanied by a stag, and sometimes carrying a small child in his arms or a peach in his hand.

Guanyin Chinese name of the bodhisattva with the Sanskrit name of Avalokiteshvara. His virtue is compassion. Originally a male figure, in the course of the Song dynasty Guanyin began to be portrayed as a female. This bringer of salvation is regularly invoked as the god(ess) of mercy; in one of his female forms the deity carries a child as an attribute, and some representations, under the influence of Western art, began to resemble the Madonna and Child. Fertility prayers are directed to this figure.

Guru religious teacher in Hinduism, seen as the personification of a divine being.

Gyosho Japanese cursive or "italic" script.

Haboku "drop of ink:" style of landscape painting.

Hachiman deified form of the Chinese Emperor Ojin (A.D. 201–312), usually portrayed bareheaded.

Haiga in Japanese art, a quick sketch.

Haiku short Japanese poem of 17 syllables.

Haji simple Japanese clay vessels from the Tumulus period (A.D. 250–552).

Hakeme Japanese pottery decorated with designs painted in slip.

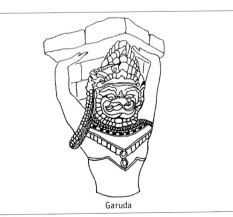
Garuda

Hambaruan among the Ngaju Dayaks of Borneo, the part of a person known as the "dream-giving soul."

Han Fei Zi Master Han Fei, Chinese philosopher of noble birth. The year of his birth is not known precisely but is taken to be about 280 B.C.; he died in 234 B.C. See **Legalism**

Hangul Korean phonetic alphabet which reproduces the sounds of spoken language.

Haniwa Japanese clay tomb figures dating from of the Tumulus period (A.D. 250–552).

Hanka-shi-i a meditative attitude of the Buddha.

Hanuman the monkey general in the Indian epic the *Ramayana*.

Happi, haori uniforms of Japanese carpenters and firefighters; short kimonos.

Harta pencaharian among the Minangkabau in Sumatra, possessions acquired during marriage.

Harta pusako among the Minangkabau in Sumatra, the possessions owned in common by a family.

Haya-raigo the rapid descent to earth of Buddha Amida, in order to take from the world a soul to be reborn in Paradise.

Hibachi in Japan, a portable charcoal-burning brazier, usually used for cooking.

Hinduism religion originating in India. Unlike many of the other major world religions, it had no founding figure and no central body of dogma, embracing as it does abstract philosophy, mysticism, animism, and a wide range of magical and cultic practices. Its central deities are Vishnu, Shiva, and Brahma, known as the Trimurti.

Hiragama Japanese syllabic script.

Hiramakie lacquer technique in which the decoration is cut into many layers of lacquer so as to produce a low relief.

Hor trai library of a Laotian or Thai Wat, or a Burmese temple complex.

Hor way roofed sacrificial temple in a Thai or Laotian Wat.

Hti delicate umbrella form that crowns stupas in Burma, frequently decorated with jewels.

Hua yan esoteric form of Buddhism that developed in China. Leading figures were the monks Tushun (A.D. 557–640) and Fazang (A.D. 643–712), who derived their doctrines from the Avatamsaka Sutra.

Hundred Antiquities in China, a list of objects having particular significance (in part these overlap with the Eight Treasures). The most prominent objects are: flower vase (Chinese *huaping*); wine dispenser (*jue*); incense burner; bronze wine vessel; rare vase (*baoping*); flower bowl; coral; tripod; bronze mirror; teapot; scepter; silver shoe; feathers; rhinoceros cup; ink block; brush holder; paintbrush; chessboard; picture scrolls; books; paintings.

Hundred Children (Chinese *wawa*) in China, a symbol of good fortune. They are usually shown as a great crowd of children playing happily.

Hwarangdo monastery-like military academy in Korea.

Ideogram a written character which is a picture or symbol of a thing or concept. (In a syllabic system, by contrast, written characters represent sounds.)

Ido ware Japanese term for Korean pottery popular at the distinguished tea parties in Kyoto in the 16th century.

Ikat particularly in Indonesia, a process by which a warp of unwoven yarn is "reserved" (has thin strips of fiber tied around the threads) so that when dyed a pattern is created by the undyed areas. This warp *ikat* is the most familiar form. In weft *ikat*, by contrast, weft threads are reserved. In double *ikat*, both warp and weft are reserved. With a few exceptions, warp *ikat* is used for cotton fabrics and fabrics from other plant fibres, and prepared on a so-called backstrap weaving apparatus with the warp running around.

Ikebana the Japanese art of flower arranging.

Iki in Japan, good taste in the selection of clothes; to be up to date or stylish.

India ink a dense black ink which, according to legend, was invented in China by Zi Lu, a pupil of Confucius. Other sources refer to the inventor as being a calligrapher of the Han era, Wei Dan. There is archaeological evidence for India ink even earlier than the Han era. The India ink of the Han era was a mixture of lamp-black (soot) and glue, pounded in a mortar and then dried. To use it for writing, the substance was crushed and mixed with water.

Indigo blue dye obtained from a kind of shrub (*Indigofera tinctoria*); oldest organic dyestuff.

Indra Vedic god of the heavens, of the thunderstorm, and of war.

Inro in Japan, small container for medications; often beautifully crafted, they are tied to the *obi*, a sash worn around a kimono.

Iron and copper pigments very durable and weather-resistant natural pigments such as red chalk, ochre, sienna, or inorganic pigments containing chemically linked iron, such as red or yellow iron oxide.

Iron oxide glaze a ceramic glaze refined by the addition of iron oxides as coloring agents.

Jadeite a hard, compact mineral, granular or fibrous, of a whitish-green color, that can be carved into decorative objects.

Jatakas narratives of the early life of Buddha, often illustrated in the early wall paintings of the cave temples in China. Generally there are 547 legends. In Burma three more were added, in order to achieve symmetry in the wall paintings and sculptures. The last ten stories were considered the most important.

Jing Hao Chinese painter of the late Tang period, who lived from about 870/80 to 925/35. A famous tract on painting is attributed to him: *Bifaji* (Notes on the Techniques of Drawing).

Jiriki in Japanese aesthetics, the supreme skill of an artist or craftsman who can create "without thought," as if by second nature.

Job's tears seeds of a grass (*Coix lacryma Jobi*), which are used as decoration on clothes.

Jōmon ware pottery from about 10,000 B.C., ie from the earliest period of early Japanese history. A mass of clay was either modeled by hand, or rolled into a "cord" that was then coiled spirally into the shape of a vessel (a technique still in use today). The surface was made smooth by being worked with wet hands or by being beaten with a flat piece of wood. The pot was fired over an open fire. The surface decoration was created by rolling cords over the clay, or by rolling a short square piece of wood over the clay in such a way as to produce a decoration resembling the surface of a straw mat. Often relief decoration was scratched in with mussel-shells, the fingernails, or the point of a bamboo splint.

Kabuki in Japan, a popular form of theater that developed toward the end of the 17th century. All the roles are played by men. As the emphasis is on the vividness of the portrayal of stock characters, the actors' make up is highly stylized.

Kago baskets.

Kailasa in Hindu mythology, a legendary peak in the Himalayas, home of the god Shiva. Also known as Meru.

Kaiseki elegant Japanese cuisine; the food and its presentation, as well as the dishes on which it is served, are all governed by strict rules.

Kaisho in Japanese calligraphy, "normal script."

Kaishu in Chinese calligraphy, official or "normal script."

Kaja in Bali, "towards the mountains," in other words the direction of purity and godliness. Compare *kelod*.

Kakemono a Japanese hanging scroll, generally hung in a recess called a *tokonoma*.

Kaki Chinese date palm, common in China and Japan. It produces a yellowish to white blossom and a yellowish-orange fruit similar to the tomato.

Kalakang garu feathers of the rhinoceros-bird, regarded in the ceremonies of the Ngaju in Borneo as the "landing place" for the spirits of the "world above" when they descend to religious rites.

Kalas "those the color of night:" in Hinduism, mythical monsters which eat time. In Javanese mythology they are believed to be the sons of Shiva.

Kamadhatu in Buddhism, the "sphere of desires" and in the soul's journey to enlightenment.

Kamban in Japan, a business or shop sign.

Kami in Japanese Shintoism, spirits or deities closely associated with nature, particularly the seasons and fertility.

Kamuro female pupil and servant of a Japanese courtesan.

Kana the two Japanese syllable scripts, *katakana* and *hiragana*.

Kanjan a ritual dance of the Ngaju-Dayak in Borneo.

Kanji Japanese term for Chinese characters used in Japanese writing.

Kannon a personification of the compassionate Buddha.

Kaolin soft, easily worked clay used to make fine ceramics; also called China clay.

Kara-e in Japanese art, paintings done in the Chinese style.

Karashishi in Japan, the mythical "lion dog" whose carved figures, set on the steps, guard a shrine.

Karatsu ware form of Japanese pottery produced from early 15th century. Though produced from a dark-brown clay, the pottery is light in color. *E-karatsu* ware ("painted Karatsu") has iron oxide underglaze motifs depicting the fertile landscape of north Kyushu, drawn with a few brushstrokes. The glazes range from straw-yellow to gray.

Karma in Buddhism, the actions on earth which determine the form in which one will be reincarnated; more precisely, one's present destiny, determined by earlier actions.

Kashira metal plate at the upper end of the sword-hilt, a pommel.

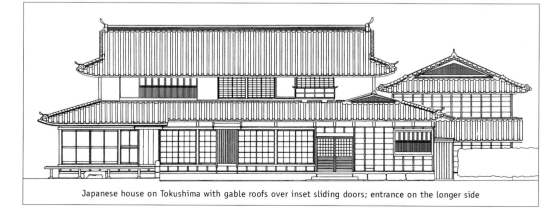
Japanese house on Tokushima with gable roofs over inset sliding doors; entrance on the longer side

Katakana Japanese syllable script with angular characters, used foreign names and words.

Katei Japanese word for "home:" a combination of the Japanese characters for "house" and "garden."

Kaunan among the Toraja in Sulawesi (Celebes), a slave.

Kelod in Bali, "towards the ocean," hence the direction of impurity and the demonic. Compare *kaja*.

Keris in the Malaysian region, a distinctive form of long dagger with a wavy blade. They often have great social and religious significance.

Ketoprak in Indonesia, a form of folk theater performed in dance, song, and dialog.

Ketupat in Indonesia, sacrificial offerings; cooked rice in palm leaves.

Keyaki the Japanese elm.

Kimono Japanese article of clothing worn by both men and women, consisting of a long coat-like garment tied with an *obi* at the waist (for women) or hips (for men). The traditional Japanese kimono is cut from a rectangular piece of fabric.

Kiri Japanese Paulownia tree.

Kirikane in Japanese art, gold leaf cut into patterns or narrow strips and applied to a painting.

Kiseru-zutsu in Japan, a pipe case worn, like *inro*, on a man's *obi* (kimono sash).

Konagamana one of the four last Buddhas.

Ko-seto Japanese ceramic ware from Old Seto.

Kosode kimono kimono for members of the highest social levels.

Kozuka in Japan, a knife for everyday use.

Kraton in Indonesia, a palace.

Kromo the language of upper Java.

Ksatriya in Indonesian theater and literature, a warrior-hero, nobleman.

Kubi-e in Japanese art, a head-and-shoulder portrait, usually woodcuts of famous courtesans and actors.

Kuku pancanaka in Indian mythology, a long, curved fingernail with supernatural power.

Kumbakarna a brother of Rahwana, a character in the Indian epic the *Ramayana*.

Kunaicho the administration of a shrine; hence the administration of the Japanese imperial household.

Kura-e in Japanese art, painting with Chinese motifs.

Kū-tei in Japan, an "empty garden," a garden consisting simply of raked pebbles and large stones.

Kyōgen a farcical interlude in the performance of a Japanese Nō play.

Kyōyaki pottery wares from Kyoto in Japan.

Lacquer lacquer is the juice of a tree native to south and middle China (*Toxicodendron verniciflua*). After being tapped, a tree has to be left to regenerate for five to seven years. The juice of the bark dries in damp, warm air. The raw lacquer is purified by boiling and straining. This is then applied to a base layer by layer, each layer being allowed to dry completely, which can take up to 24 hours.

Lakon in Indonesia, a theater performance, a play.

Lakshmī the Hindu goddess of good fortune and beauty, wife of Vishnu.

Lamaism form of Buddhism that flourished in Tibet and Mongolia.

Lambrequin "cloud collar:" a border decoration found on Chinese vessels from the 14th century, which has the appearance of a pearl necklace hung in festoons.

Lao Zi Master Lao, the Old One, a Chinese philosopher who lived in the 6th century B.C. The book traditionally ascribed to him, *Dao de jing* (Book of the Way), an anthology of lyric poetry, philosophical speculation, and mysticism, is one of the most original contributions to Chinese philosophical and religious thought.

Laterite red, porous stone with a pockmarked appearance; when first exposed to the air it is soft enough to be easily cut, but soon hardens.

Legalism (Chinese *fajia*) Chinese social philosophy, based on the writings of Master Han Fei. Legalism presupposes that people are evil by nature and can only become functioning members of a society by submitting (being made to submit) to strict laws. The law was to apply to everyone regardless of rank, the sole exception being the ruler, who is seen as possessing inviolable, supreme, and unlimited authority. The first emperor of the Qin dynasty adopted legalism as his state doctrine.

Leiwen in Chinese art, the "thunder pattern" decorative motif consisting of spirals.

Lemba the fibers of a marsh grass (*Curculigo latifolia*) used in making fabric.

Leopard in China, a symbol of courage and warlike savagery. Chinese military officials of the 3rd grade wear square insignia on the chest with embroidered leopards, known as "mandarin squares."

Lewu tatau for the Ngaju Dayaks of Borneo, Paradise.

Linga Parvata the lingam belonging to the spouse of Shiva.

Lingam the erect phallus of Shiva, an important object of devotion in Hinduism and a central feature of many temples.

Lishu in Chinese calligraphy, "official script."

Lokapala in Buddhism, the four guardians of the world. They protect the four points of the compass, the world, and the Buddhist faith. Portrayed as warlike figures with weapons, their images are set up at the four sides of an altar, near a stupa, and in sacred precinct.

Lokeshvara in Buddhism, the lord of the world.

Lontar fibers leaf strips from the young leaves of the lontar palm (*Borassus flabelliformis*), which are used for plaiting, weaving and tying off in *ikat*.

Lopburi style a style in Thai art based on Khmer models (named after the city of Lopburi in central Thailand, which is presumed to have been the center of Khmer rule in Thailand).

Lotus in China, a symbol of purity and beauty, since the plant, though it grows out of muddy water, grows pure white blossoms. Also a symbol of fertility, since the multiple fruit contains a large number of small seeds. The lotus often appears in representations of the Buddha or bodhisattvas.

Ludruk a form of folk theater in Java.

Luk the curved on the blade of a keris. The number of luk on a blade had a symbolic meaning.

Luohan (Sanskrit: *arhat*): an enlightened human being, the highest grade of holy man in Hinayana Buddhism. In China, *luohan* are portrayed in groups of 16 or 18 (sometimes more, and always an even number). Also known as *arhat*.

Magpie in China, the magpie is seen as a harbinger of marital happiness.

Mahayana "great vehicle:" one of the major branches of Buddhism. In Mahayana Buddhism, also known as the "Great Way," even laypeople can attain redemption, with the help of the bodhisattvas, without having to pass through several lives. In other forms of Buddhism, only monks who have devoted their lives to meditation can attain redemption.

Makara in Cambodian mythology, a creature that is part fish part reptile, and has an elephant's trunk.

Maki-e "scatter pictures:" a decorative effect achieved by scattering very fine gold or silver grains on wet lacquer. After drying, the object is polished with charcoal, before the subsequent layers of lacquer are applied and the process is repeated. The result is a three-dimensional effect.

Mamak among the Minangkabau of Sumatra, a mother's brother, an uncle (among the Minangkabau a woman's brother assumes an important role in family life).

Mandala a diagram used to assist meditation. A mandala's design is derived from the Buddhist concept of the universe.

Mandarin a high official of the Chinese empire.

Mandau a sword or large knife used by the Dayak in Borneo.

Mandorla in depictions of holy beings, an almond-shaped radiance enveloping a figure.

Manjusri See **Wenshu**

Mara in Buddhism, the "evil one," the king of the demons.

Marananda Indian monk who, at the invitation of the emperor of the Chinese Eastern Jin dynasty, introduced Buddhism into Korea.

Menuki decorative fittings on the hilt of the traditional Japanese sword.

Merantau departure from home in order to gather experience of life.

Meru a mythical mountain as the center of the universe, home of the gods.

Metal wire with soul silk thread sheathed in fine gold or silver thread. After long use, when the fine metal wrapping has worn away, the "soul," that is, the silk thread, is released.

Mingei in Japan, folk art, in particular a 19th- and 20th-century return to the values of traditional crafts.

Minka Japanese farmhouse.

Miroku a depiction of the Buddha in the simple garment of a priest, with one arm and part of his upper body uncovered.

Mirror in China, an object that wards off evil and which unmasks demons and spirits; a symbol of marital fidelity or good fortune.

Mishima ware a popular form of Japanese pottery produced in Karatsu kilns, and decorated with stamped patterns and white engobe slip.

Mizusashi in Japan, water container.

Mogu "boneless:" in Chinese art, a painting technique that dispenses with a drawn outline, the forms being created by areas of color.

Mondop in a Thai temple, an open hall or pavilion; usually a cube-shaped building surmounted by a conical structure, that acts as an assembly hall for the faithful.

Mo Zi Master Mo, Chinese philosopher, active about 479–438 B.C. He was a wandering scholar who offered the use of his expertise to the rulers of the minor states. Up to the Han era, the teaching of Mo Zi, called Moism in the west, was the most important teaching after Confucianism. In contrast to Kong Zi (Confucius), Mo Zi believed that everyone had a destiny determined in Heaven, that mankind was essentially good, and that a life conducted according to moral principles justified because socially beneficial. The most important principle for a well-run state was altruism (*jian ai*).

Mother-of-pearl intarsia inlay work using the iridescent internal layer of molluscs.

Muang in Cambodia, a city state.

Mudra the attitudes of the hands and body in depictions of the Buddha. There are 40 of these symbolic gestures, of which two are particularly important: *dhyanamudra*, in which both hands lie flat on the Buddha's lap, one above the other, palm upwards (the meditation *mudra*); and *varadamudra*, in which the right arm points downwards, the palm turns outwards (the *mudra* of compassion).

Mukuta crown.

Muni kurim in Korean art, the highly stylized interpretation of a motif.

Muromachi a district of Kyoto in Japan.

Mushroom (Chinese: *lingzhi*) in China, a symbol of immortality and long life.

Myō-ō in Japan, deities with savage facial expressions, believed to ward off evil.

Nāga particularly in Cambodia, a kindly, mythical water snake, depicted as a many-headed cobra.

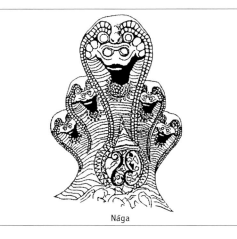

Nāga

Nāga-makara hybrid mythical creature, part *nāga*, part *makara*.

Namban a Japanese term for Europeans, "southern barbarians" (after the direction from which their ships arrived at the island of Kyushu).

Names Chinese names of emperors and artists. As early as the Zhou dynasty, rulers were recorded in history with several names, a personal name and a ruler's name; for example, Ping Wang, "the peaceful king" (ruled 770–720 B.C.), used his clan name, Ji. The first emperor (Qin) had himself exchanged his personal name for a ruler's name. The Chinese chronicler Sima Qian writes that, after intensive consultation with his advisers, the emperor called himself "Shi Huang Di." Because of taboos relating to names, once a ruler had ascended the throne, he could not use his former name again. Moreover, once a ruler had died, he was referred to by yet another, posthumous, name in historical chronicles (dynastic histories were always published toward the end of the dynasty concerned, or at the beginning of the subsequent dynasty).

One of the Han dynasty rulers was Wu Di, "the warlike emperor" (ruled 140–87 B.C.), whose real name was Liu Che. One of his predecessors, Wen Di, "the cultured emperor" (ruled 179–157 B.C.), was actually called Liu Xuan. Up to the Ming dynasty emperors are identified in literature by their posthumous names.

An emperor's reign can also be referred to by the motto or slogan the emperor chose to characterize his rule, a practice begun by the emperors of the Ming and Qing dynasties. Such designations are still used to refer to an emperor's reign, but it would be wrong to refer to the emperor himself by this name: the first Ming emperor, for example, was not Emperor Hongwu, for Hongwu was the name of his reign. This ruler, whose birth name, Zhu Yuanzhang, became taboo on his accession, ruled from 1368–1398 under the motto of Hongwu ("powerful and warlike"), and after his death acquired the name Taizu ("sublime ancestor"). But government mottoes are not an invention of the Ming rulers. As early as the Qin time the emperor placed an era of his rule under a government motto chosen by him, and as positive in tone as possible. Wu Di, mentioned above, proclaimed a new motto every six years. Another example is the Tang emperor Tai Zong (ruled 627–649 B.C.), whose real name was Li Shimin. His government motto was not changed during the 22 years of his rule. His successor, Gao Zong, however, diligently proclaimed a series of government mottoes; during the years of his rule, A.D. 650 through 683, he used 14 different slogans.

Gao Zong's real name was Li Zhi. Here the first name is the clan name or surname, the second his personal name. Generally the surname, given first, consists of only one character, but there are exceptions to this rule: Sima and Ouyang are two-syllable surnames. A personal name in childhood can be different from the one used in adulthood. Thus when names are stated there is often an addition of the manhood name, *zi*.

Artists, similarly, often used *hao*, professional names, during their career, and sometimes they acquired posthumous names.

Nanako on a Japanese sword, the surface texture of the iron sword-guard.

Nandi in Hinduism, a white bull, attribute and mount of the god Shiva.

Nat a Burmese spirit or god. The are 37 *nats*, made up of local spirits and deities borrowed from Hindu mythology, and they play an important role in Burmese mythology.

Negoro lacquer wares first produced by monks in the temple of Negoro in the prefecture of Wakayama (near Osaka) in Japan. Negoro wares are intended as everyday objects (trays or bowls, for example), but also as objects of Buddhist ritual. They are carved from wood and covered with a layer of black or red lacquer.

Neolithic pottery forms Neolithic pottery exhibit forms that have continued to be used up to the present day. The development of two major cultures far apart (the Yangshao and the Longshan) meant that a wide variety of forms emerged through variations on a few basic types.

Nephrite a translucent stone consisting of irregularly interwoven mineral strands varying in color from leek-green to gray-green.

Netsuke a Japanese toggle; small sculpture in wood or ivory worn on the *obi* (the sash of a kimono).

Ngoko colloquial Javanese.

Nihonga in Japanese art, painting in the Japanese style.

Nirvana "extinction:" in Buddhism, the final release from all earthly life and union with the absolute.

Nishiki-e in Japanese art, a color woodcut print.

Nō "ability, art:" classical Japanese drama with masks, dance, music, and singing, performed on a bare stage.

Nuihaku technique in Japanese fabrics, gold leaf spun on silk, which creates a shimmering effect.

Nyorai a depiction of the Buddha in the simple robe of a priest, with one arm and part of his upper body uncovered.

Obi sash worn to fasten the kimono. Women in general wear the *obi* artistically tied on the back; courtesans wear it in front. A woman wears the *obi* around the waist, a man around the hips.

Obsidian a very hard, glassy stone.

Oiran in Japan, the most beautiful courtesans (geishas) of all, whose manners were unrivalled and who above all understood the wishes of men. In the geisha district of Yoshiwara there were no more than 18 *oiran* at any one time.

Onnagata in Japanese theater, a male actor who plays female roles. Only men have appeared in the Kabuki theater from the mid-17th century to the present day.

Oracle bones in China, shoulder-bones of oxen used as a means of divination. The cracks which appeared when the bone was heated were the basis of the prediction.

Oribe ware Japanese pottery produced from the early 17th century from light-colored clay in kilns with several chambers. Oribe ware appears in a great variety of shapes and decoration. Shino Oribe ware is white and has light-colored iron oxide underglaze decoration. Black Oribe is covered with black engobe, applied in the form of spots or bands. Green Oribe has spots of a brilliant green glaze, semitransparent and becoming darker as it is applied more thickly. Narumi Oribe consists of clay with a high iron content, becoming reddish after firing.

Owl in China, a bird associated with the solstice. The earliest representations occur in rock paintings; they also appear as neolithic jade carvings (such as those in the tomb of Fu Hao). The owl is presumed to have been an emblem of the Shang dynasty. On the banner of the dead from Mawangdui, the owl is allocated to the underworld.

Pagoda (Burmese: *zaydi*; Pali: *cetiya*; Nepalese: *chaitya*; Thai: *cedi* or *chedi*; Singhalese: *dagoba*) reliquary shrine with stupa and series of ascending terraces. In Burma, the Western term "pagoda" describes the whole of the temple complex. In Vietnam: temple structure of Mahayana Buddhism, generally multistory, each story having its own canopy.

Pali sacred language of Theravada Buddhism.

Pamor a pattern on the blade of a keris. It is created by folding, turning, and finally engraving and filing the iron and steel compound that makes up the blade.

Panakawan a faithful servant of Pandawa in the Indian epic the *Mahabharata*.

Pangkalan in Sumatra, an anteroom in a Minangkabau house.

Paper The invention of paper in China is traditionally ascribed to Cai Lun, 2nd century A.D. The paper of the Han era was rag paper, a truly ecological product made from remnants of fabric such as hemp or silk rags, mulberry tree bark, or fishermen's nets.

Patola fabric Indian silk fabric from Gujarat, produced by the double *ikat* technique.

Pattern weft in textiles, a decorative technique in which an additional thread, of gold, silver, or silk, is worked into two basic wefts with the help of a needle during weaving. It creates a contour-like pattern.

Paulownia wood wood from the paulownia tree (named after the Russian princess Anna Pavlova), a fast-growing decorative tree of East Asia.

Peach in China, a symbol of long life; the peach blossom is the flower of the second month (see **Flowers of the Four Seasons**), and was thought to ward off evil.

Pearl in China, the ideal jewel, a symbol of purity, often used with a wreath of flames as the attribute of dragons.

Penghulu clan or family leader among the Minangkabau in Sumatra.

Penglai in Chinese mythology, one of the islands of the Immortals, set in the Eastern Ocean.

Pheasant in China, the pheasant has two conflicting symbolic meanings, being the bringer of either good or ill fortune. The golden pheasant is an emblem of a mandarin, a symbol of the arts and culture, and one of the four attributes of a scholar.

Phoenix (Chinese: *fenghuang*) in Chinese mythology, the king (ruler) of all flying creatures, the second of the four miraculous animals, possibly originally a wind god; also the symbol of the empress.

Phravet in Buddhism, one of the last reincarnations of Gautama Buddha.

Pig in China, the last of the animals of the annual cycle, symbol of masculine strength, and in ancient times a symbol of prosperity. Pigs also promise good fortune in examinations.

Pine in China, a symbol of endurance; one of the Three Friends of Winter.

Plum blossom in China, a symbol of renewal, as it is the first early blossoming plant of the indigenous Chinese flora. See **Three Friends of Winter**

Pomegranate in China, a symbol of fertility.

Porcelain a pure white ceramic material, transparent and giving a high, clear sound when tapped. The iron content is very low, if not non-existent, hence the white color. Porcelain is harder than other ceramic products, of a degree of hardness rated at 7, which is equivalent to that of rock crystal or amethyst. It is watertight even when fired without glaze. The basic materials of Chinese porcelain are kaolin (predominantly consisting of aluminum silicates, which are produced by the weathering of clay silicates), and a mixture of feldspar and quartz called petuntse, mixed in an approximate ratio of 1:1. Kaolin itself has an extremely high melting point and is therefore not suitable to be used on its own. Only by the addition of the petuntse to lower the melting-point can a firing be made at 13,000 degrees centigrade. In the firing process, the mixture of feldspar and quartz acts as a flux: it melts itself, and at the same time melts the kaolin crystal in the given form, and in this way supports the coalescence of the porous sinter. Further chemical reactions take place which produce water and gases, leading to the shrinking of the porcelain. The resulting porcelain vitrifies, that is, it becomes partly translucent and watertight. European porcelain also consists of the same raw materials, although in a different ratio. According to the combination of materials and the firing temperature, the terminology distinguishes between biscuit ware, bone china, and hard-paste (*pâte dure*) porcelain.

Porcelain decorative techniques:
Anhua decoration is a "hidden" scratched or cut decoration which, during the Ming period, was enhanced with underglaze blue. The technique of *anhua* decoration consisted in cutting relief-like patterns into the air-dried porcelain. After firing, a silhouette appears in low relief, the outline of a motif.

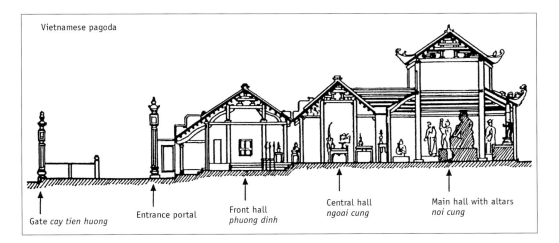

Vietnamese pagoda

Gate *cay tien huong* — Entrance portal — Front hall *phuong dinh* — Central hall *ngoai cung* — Main hall with altars *noi cung*

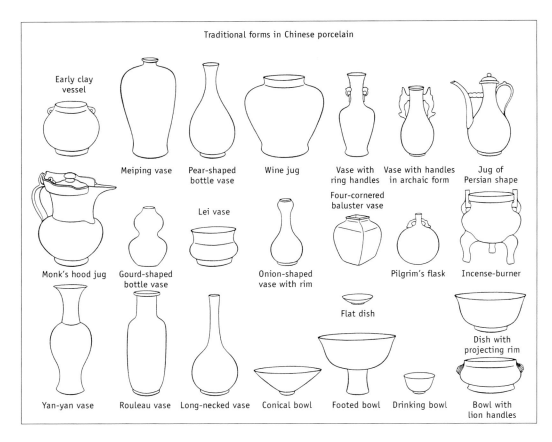

Traditional forms in Chinese porcelain

Early clay vessel
Meiping vase
Pear-shaped bottle vase
Wine jug
Vase with ring handles
Vase with handles in archaic form
Jug of Persian shape

Monk's hood jug
Gourd-shaped bottle vase
Lei vase
Onion-shaped vase with rim
Four-cornered baluster vase
Pilgrim's flask
Incense-burner

Yan-yan vase
Rouleau vase
Long-necked vase
Conical bowl
Flat dish
Footed bowl
Drinking bowl
Dish with projecting rim
Bowl with lion handles

Doucai decoration is technically comparable to *jiacai* decoration, but here the outline of the motifs which would later be filled in with color is first applied under the glaze with cobalt pigment. This category also includes the so-called five-color painting method, *wucai*, which uses red, green, yellow, black, and turquoise. With this technique, the outlines are applied to the glaze in black. The multiple firing processes made this ware an exclusive luxury item.

Enamel (*jiacai*) also known as vitrifiable pigment, consists of powdered glass with a high proportion of flux, which can be colored with metal oxides. They are applied by brush on the prefired glaze, and the porcelain object is then fired a second time at a lower temperature of 750–800 degrees centigrade in a muffle furnace, so that the pigments melt and adhere to the softened glaze. The color palette of this technique was originally (during the Jin dynasty) somewhat limited: tomato red (from iron oxide mixture), leaf-green (copper oxide), and yellow ochre (iron oxide).

Enamel and underglaze blue (sometimes known as *doucai*) a decorative technique documented since the mid-15th century, which requires a blue underglaze decoration for the first firing. For the second firing, the whole piece, omitting the areas with underglaze decoration, is painted with an enamel pigment. These pieces are often blue and yellow.

Fahua decoration is executed with lead silicate enamel colors, which are applied to the unglazed fired porcelain. The colors are separated by engraved lines or "bridges" (reminiscent of Tang *sancai* glazes). With this technique, the range of colors was restricted to blue, turquoise, green, yellow, violet, and a colorless, transparent variant.

Underglaze decoration in copper-red "red-white" (*youlihua*) Copper-red seems to have been used as a makeshift substitute when cobalt became rare toward the end of the Yuan period. Copper-red is very difficult to work, since it is unstable, reacts to fluctuations in the kiln, may disperse, and tends to change color to silver-gray tones. Moreover, a glossy effect is also more difficult to achieve with copper-red than with cobalt blue. Copper-red underglaze decoration is a sign of a very rare and technically ambitious piece.

Porcelain production marks and inscriptions
Many porcelain pieces of the Ming and Qing eras bear on their underside or rim a mark with the government motto, mostly composed of four or six characters, and giving the following information: "produced in the years of the era *xy*." This mark refers to production in imperial factories and allows the piece to be dated, but is not definitive, for from the 18th century onward marks of the Ming period were applied to contemporary pieces. These "forgeries" show that as early as the Qing dynasty there was great demand for porcelain in the Ming style. In addition, there were potters' marks (by name) and marks used by family businesses. During the Qing era, dealers' marks were also used.

Porcelain painting of blue-and-white pieces
After being shaped on the wheel, or with the help of a model, the pieces are first air-dried until they have reached the hardness of leather, and then painted with the cobalt pigment. This is *alla prima* painting, because nothing, once applied, can be removed; each brushstroke must be perfect. After painting, the whole piece is dipped in a bath of glaze; porcelain glaze is transparent. During firing, the glaze is fused with the porcelain, and the painted decoration is "locked in" under the glaze, so that, to use a modern term, it is dishwasher-proof.

Prang in Khmer-style architecture, a stupa in the form of a corncob.

Prasat a shrine in the form of a tower.

Punch'ong ware Chinese pottery of the early Yi dynasty, a coarse-grained stoneware with white engobe (slip) decoration, spontaneous and straightforward patterns, so-called Yi motifs. Often slip decoration is in the *sgraffito*.

Pura Dalem on Bali, a temple outside a village.

Pura Desa on Bali, a temple in the middle of a village.

Pusaka sacred heirlooms.

Puxian in China, a Buddhist bodhisattva whose Sanskrit name is Samanthabhadra: "the bringer of good fortune." His attributes are the elephant as a mount for riding, a small bottle, a lotus, and a solar disk.

Pyathat in Burma, a tower with either five or seven roofs; called "the center of the universe."

Qilin in China, a mythical animal, similar to a horse or lion, with scales, savage claws, and horns. The earliest mention is in the book of poems *Shijing*, the poems of which date from the 1st century B.C. In literature the *qilin* is generally regarded as a good omen; it is a symbol of prosperity and the production of children. Where the *qilin* appears, all is well.

Queen Mother of the West (Chinese: Xi wang mu) a royal figure common in Chinese myths. In her Western Paradise she guards the trees that bear the peaches of immortality, which bear fruit only every 3,000 years. A well-established motif since the Han era.

Raven in Chinese mythology, the raven nests in the Sun and is responsible for its heat; it is also a messenger for the Queen Mother of the Heavens.

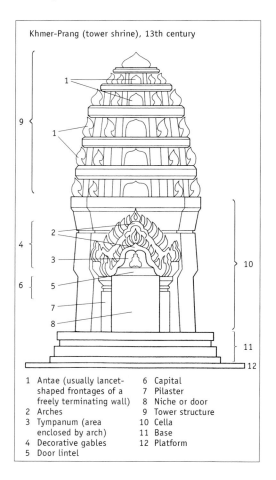

Khmer-Prang (tower shrine), 13th century

1 Antae (usually lancet-shaped frontages of a freely terminating wall)
2 Arches
3 Tympanum (area enclosed by arch)
4 Decorative gables
5 Door lintel
6 Capital
7 Pilaster
8 Niche or door
9 Tower structure
10 Cella
11 Base
12 Platform

Raigo in Buddhism, an appearance in the world of Amida Buddha from Paradise.

Raja in Southeast Asia generally, a king.

Raksasa demons.

Raku bowl in general terms, a Japanese a tea bowl. Raku is a type of Japanese pottery ware often used in the tea ceremony. Black Raku ware emphasizes the color of green tea and has insulating qualities, keeping the tea hot and at the same time protecting the hands from the heat. Raku bowls are almost a synonym for tea bowls.

Raku style artistic trend which is centered on the world of the "tea aesthetes" and of *cha-no-yū*, the tea ceremony.

Rakuchu-rakugai in Japanese art, painting on a folding screen that shows everyday scenes in and outside the imperial capital of Japan. Typically, the observer is allowed to gaze through gold-leaf clouds to see well-known districts of Kyoto from a bird's-eye perspective.

Rama the prince who is the hero of the Indian epic the *Ramayana*.

Ramakien the Thai version of the Indian epic the *Ramayana*.

Ramayana classical Indian epic telling the story of Prince Rama, who seeks his wife, who has been abducted by the demon Ravana.

Rasa in Indian dance and theater, the nine basic feelings or emotions a performer had to convey.

Rattan a climbing palm *Calamus rotang*; the thin, flexible stems of the rattan used for basket making etc.

Red pigments are obtained from the bark and roots of certain types of tree such as *Morinda citrifolia*, *Caesalpina sappan*, and *Pelthophorum ferrugineum*.

Reisho in Japanese calligraphy, the official or "legal script."

Rengnge in Toraja, Sulawesi (Celebes), a woman of noble birth.

Rhyta drinking horns.

Rinzai a form of Zen Buddhism that attracted supporters above all in military and artistic circles in Japan. It taught that one can attain enlightenment quite suddenly, as a consequence of a trigger reaction that allows the mind to burst through mental blocks and conscious controls.

Rock, stone in China, a symbol of endurance.

Roof forms in Chinese architecture, different roof forms have developed according to region and social level. The commonest forms for residential, palace and temple architecture are the saddleroof, the hipped roof, the Chinese gambrel roof, and the stepped or double gambrel roof. See box

Rooster in China, a bird that turns away evil; a symbol of the five virtues of Confucianism.

Ruai among the Iban of Borneo, a roofed gallery or anteroom in a longhouse.

Ruang tongah in Sumatra, the central room in a Minangkabau house.

Ru celadon celadons (ceramics with a clear blue glaze) from the Chinese province of Henan.

Rumah adat among the Batak in northern Sumatra, a traditional house.

Rumah gadang among the Minangkabau in Sumatra, a traditional house.

Rupadhatu in Buddhism, the "sphere of form" in the soul's journey to enlightenment.

Ruwat a ritual of exorcism on Java and Bali.

Ryotei geisha houses in Japan.

Sagemono "hanging objects:" in Japan, small objects such as *inro* (small containers for medicaments), which are fastened by means of a netsuke to the *obi* or sash of a man's kimono.

Saiyuki wares form of Japanese pottery first made in the 8th century A.D. It is an earthenware with a gray tinge, fired in a simple kiln. Saiyuki wares were the first Japanese ceramic ware with applied glazes consisting of metallic oxides.

Samanthabhadra see **Puxian**

Samurai the aristocratic warrior class in ancient Japan.

Roof forms in China
(the roof forms used by minor architects are not included)

Saddle roof without projections (*yingshan*)

Tent roof

Saddle roof with projections (*xuanshan*)

Conical roof

Roof with rounded ridge

Cross roof

Hipped roof

Stepped gambrel roof

Gambrel roof

San in Japanese art, a calligraphic inscription on a painting meant to provide a clue to the painting's meaning.

Sanage ware Japanese pottery made from the 9th century. It is of a lighter color than the dark gray Sueki ware, with an almost transparent green glaze. Fired in kilns with wood giving a clean flame, producing little smoke.

Sancai "three colors:" in ceramics, colored glazes developed during the Tang era in China. Four glazes in all were available (green, yellow ochre, blue, and brown) but usually only three were combined in one piece. In Japan *sansai* refers to the three-colored Saiyuki ware with one or more metallic oxide glazes. The three colors available, separately or in combination, were green, a transparent yellow ochre, and beige.

Sandung among the Ngaju Dayak of Borneo, a charnel house.

Sangiang among the Ngaju Dayak of Borneo, the inhabitants of the "upper world," deities.

Sanjaya dynasty Hindu dynasty on Java, about A.D. 732–929.

Sanskrit ancient Indian language.

Sapundu among the Ngaju Dayak of Borneo, sacrificial stakes erected in memory of the dead.

Sarong in and around Malaya, a garment, worn by men and women, consisting of a length of brightly colored cloth wrapped around the waist and hanging as a skirt.

Sashiko in Japan, a sewing technique using thread of contrasting colors.

Sawah paddy-field (wet) method of cultivating rice.

Saya a Japanese sword scabbard.

Scholar in Chinese art scholars are often shown with one of their four attributes: zither (*qin*), books, chessboard, or picture scroll.

Seals a text or design stamped onto a painting or document. In imperial China, and also as early as the Zhanguo period, they were used to authenticate a work. At the beginning of this development seals were used which were broken into two parts, and the bearer of the document retained one of the two complementary halves as proof of the document's authenticity.
　Cinnabar printing on paper is said to have become established around the Han era: in this inscriptions, cut into the stone, appear as white on a red ground (*yinwen*). From the 7th century A.D., seals are also found in which the characters are printed in red on a white ground (*yangwen*). Artistic seals were highly valued, and the first collection in book form of seal impressions was commissioned by the art-loving emperor Huizong of the Song dynasty.
　The content of the seals might be official names, personal names, or nicknames. From the Song dynasty, collectors' seals are found, that is, seals indicating ownership; these can be very useful in tracing a work's history. A seal is to be read from top right to bottom left, or clockwise, beginning from the top right.

Calligraphers would generally cut their own seals. Seals can only rarely be adduced as proof of the authenticity of a work of art, as they too were copied and forged.

Seal scripts in calligraphy, the official scripts of the first millennium B.C. in China. Two types of seal script are distinguished: the "great seal script" was used, for example, for bronze inscriptions of the time; "small seal script" denotes the characters inscribed on bamboo books. The great seal script is supposed to have been invented by the adviser to King Xuan (827–782 B.C.) of the Zhou dynasty, the small seal script by Li Si (3rd century B.C.), the chancellor of the first emperor of Qin. Artistic variations developed at an early stage from both script types. In later days, archaic script types were regularly used in art for painters' and collectors' seals.

Sea-snail one of the eight symbols of Buddhism, the symbol of the voice of the Buddha.

Sesajen sacrificial gift.

Setamono ceramic ware from Seto, Japan's greatest pottery center. Today, the term is frequently a general synonym for ceramic ware from Japan.

Seven Wise Men Chinese literary circle of the 3rd century A.D., which met in a bamboo grove to discuss the art of poetry and to drink together. The group were frequently depicted in art.

Sgraffito in pottery, a decorative technique in which a design is scratched through a light-colored layer of slip to a darker ground beneath.

Shailendra dynasty Buddhist dynasty on Java, about A.D. 752–929.

Shaka Depiction of Buddha in the simple robes of a priest with one arm and part of his upper body uncovered.

Shakkei principle "hidden landscape:" in Japanese design, the incorporation of the landscape and natural setting into the total image of a building; the view serves almost as a backdrop to the building and the designed garden, which can often be made to look considerably larger than it is.

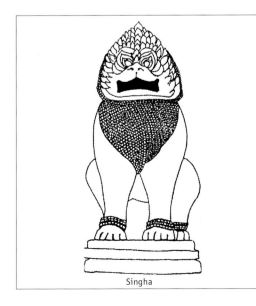
Singha

Shakyamuni one of the names of the historical Buddha. See **Buddha**

Shaman priest, someone who has access to the gods or spiritual forces.

Shamisen a Japanese three-stringed instrument typically played by courtesans and geishas, also used as accompaniment, for example in Kabuki theater.

Shendao a sacred way, an entrance and exit to a consecrated area, seen as a central axis.

Shibui in Japanese aesthetics, a subtle, hidden quality in a work of art that requires the viewer to search patiently for its meaning.

Shigaraki ware Japanese pottery first produced in the mid-13th century A.D. It is made from clay with low iron content, and often has rich colors, ranging from red to salmon pink, with glassy-green spots being created by a natural woodash glaze. As with most functional ceramic ware of that period, they have little or no decoration, though occasionally a crosshatched "bamboo fence" pattern.

Shino ware Japanese pottery first made in the late 16th century. It is white, gray, or red, and decorated, before glazing and firing, by being painted with iron oxide. The earliest Shino wares were largely undecorated, or merely had a white glaze with a few fine lines. Shino *temmoku* is the precursor of the typical Shino glaze, which is made from white clay and when fired has the appearance of confectioners' icing sugar.

Shinto "way of the gods:" an indigenous Japanese religion. Central features are a strong ancestor cult and the veneration of nature spirits and natural forces.

Shiva "the Benevolent One:" one of the gods of the Hindu trinity. Shiva is considered at once "the destroyer" and "the creator," and plays a central role in the eternal rise and fall of the cycles of universal history.

Shogun hereditary title of a military ruler in ancient imperial Japan.

Shoji in Japanese buildings, sliding doors whose wooden frames are filled with translucent paper.

Shrivijaya dynasty Buddhist dynasty in southern Sumatra, about A.D. 650 to the end of the 11th century (?).

Shunga "spring pictures:" in Japanese painting, erotic images.

Sikhara a beehive-like spire in Burmese temple complexes.

Sim the main shrine and ordination hall in a Laotian temple complex; the area reserved for the monks.

Singha the figure of a stylized lion, often used as a guardian figure.

Singhalese largest population group in Sri Lanka.

Slip painting painting in which engobes (slips)

are applied in layers on the raw or prefired ceramic piece.

Snake in China, one of the animals of the annual cycle, said to be crafty, evil, and deceptive, though many river gods were also depicted in the form of a snake.

Somen a terrifying mask work by Japanese warriors.

Sopo among the Toba Batak of North Sumatra, a rice store.

Sosho in Japanese calligraphy, "grass script," a kind of shorthand.

Sōtō in Japan, Sōtō was a form of Zen Buddhism that was particularly popular with the rural population, and the samurai. It demanded strict discipline from its adherents, its central claim that enlightenment was reached through long years of self-control, hard work, and meditation.

Stag in China, a symbol of prosperity (on account of its identical sound to the character meaning stag, *lu* and the character meaning the salary of an official); and also long life (because of the renewal every year of its antlers). Because of this renewal, the antlers have a reputation as an aphrodisiac.

Stele a free-standing panel or column with an inscription or relief.

Stoneware light-colored, watertight, nontranslucent ceramic ware.

Stupa originally a semi-spherical tomb mound in which relics of Buddha were preserved; later a building with a monumental as well as votive character. The method of construction, shape, and terminology vary from one country to another.

Sueki ware Japanese pottery first made in the 5th century A.D. It was a gray, watertight ware made by the traditional "cord wrapping" method and finished on the potter's wheel. The wares were unglazed apart from the spots and drops caused by the natural woodash glaze. Though essentially simple and unpretentious, they were sometimes elegantly decorated with combed or scratched patterns, and some were fashioned into complex forms.

Suibokuga in Japanese art, paintings in India ink and color; refers to the majority of paintings created by Zen artists in the course of the Muromachi period.

Sukiya style in Japan, a plain and unadorned building style. The textures of wood and plaster are undecorated so that their natural beauty complements that of the natural world. What little decoration there is chiefly restricted to the paintings on the sliding doors.

Suksmantaratman inmost nature of the king, the spiritual element that links a king with the gods.

Surau a Koranic school.

Surimono in Japan, commemorative prints given as gifts, announcements and so on.

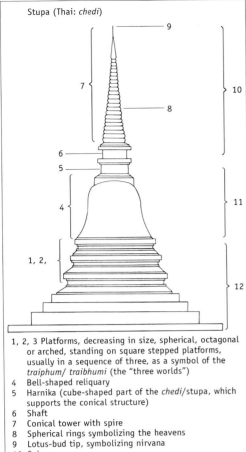

Stupa (Thai: *chedi*)

1, 2, 3 Platforms, decreasing in size, spherical, octagonal or arched, standing on square stepped platforms, usually in a sequence of three, as a symbol of the *traiphum/ traibhumi* (the "three worlds")
4 Bell-shaped reliquary
5 Harnika (cube-shaped part of the *chedi*/stupa, which supports the conical structure)
6 Shaft
7 Conical tower with spire
8 Spherical rings symbolizing the heavens
9 Lotus-bud tip, symbolizing nirvana
10 Spire
11 Body
12 Base

Sushi Japanese rice dish.

Sutras Buddhist doctrinal writings.

Taishi crown prince.

Tamba ware Japanese pottery first made during the late 12th century. A red ware, made from relatively light-colored clay, it is often fired with natural ash glaze in a light grass-green color. Sometimes worked as corded ware, but usually without decoration.

Tambun among the Ngaju Dayaks of Borneo, a water snake.

Taotie in China, a decorative motif consisting of a stylized animal mask; the most prominent motif on Shang bronzes. It is interpreted as a motif meant to ward off evil. The *taotie* has two prominent eyes, horns, a snout, and the body usually winds in an equally symmetrical way around both sides of the mask like a snake, though sometimes there are legs.

Tarashikomi in Japanese art, a painting technique that involves applying India ink to damp paper so that it runs, and on drying shows subtle gradations of tone. The same technique is also used with colors.

Tariki in Japanese aesthetics, the ability to create an object "without thought," as if naturally – combined with the ability to recognize intuitively the beauty of the completed object. An object that has been "thought about" cannot achieve an "effect," no matter how carefully the artist has worked on it.

Tatami mats made of rice straw in a uniform format, which are laid on the floors of Japanese houses. The size of rooms is often measured in terms of *tatami*.

Tazette the narcissus, in China a symbol of good fortune, and of the Nymph of the river Luo. It is a frequent motif in art.

Temmoku stoneware bowls from the China of the Song dynasty. Known in China as Jian ware.

Tenbu various supernatural figures, drawn from the Hindu pantheon, who function as guardian deities.

Tenno Japanese imperial title.

Terracotta fired, unglazed clay that becomes red or yellow on being fired.

Tet Offensive offensive of the Vietcong on New Year's Day (Tet festival), February 1, 1968, against 105 urban centers in Vietnam.

Tetsubi a Japanese iron pot.

Texture in Chinese art the tern *cun* refers to the texture created by brushstrokes. There were several metaphorical terms used to distinguish various textures, including raindrop texture (*yudian cun*); ax-stroke texture (*fupi cun*); hemp fiber texture (*pima cun*) – to name only three of the 27 concepts.
 The painter Shitao, in his study of painting written about 1700, names 13 textures: cloud curls (*juanyun*); ax stroke (*fupi*); hemp fiber (*pima*); disentangled cord (*jiesou*); devil's grimace (*guimian*); bony (*kulu*); brushwood (*luanzhai*); sesame seed (*zhima*); golden-green (*jinbi*); jade mist (*yuxie*); small spheres (*danwo*); alum heads (*fantou*); and boneless (*mogu*).

That a variation on the stupa found in Laos and areas of northern Thailand.

Theravada an early form of Buddhism in which the direct road to salvation is open only to monks. Laypeople must achieve salvation by living through several lives, each time moving a little higher up the spiritual ladder.

Thitsi tree the tree from which the basic substance of lacquer is obtained, by a process similar to tapping of latex in the production of rubber. See **Lacquer**

Thong mulberry tree, also called the Bo tree or Buddha tree.

Three Friends of Winter in China, the pine, bamboo, and plum, all symbols of endurance.

Three Islands of the Immortals Penglai, Fangzhang, and Yingzhou; according to Chinese theory these are located in the Eastern Ocean. Classically represented by three pointed mountains side by side, of which the middle one rises slightly above the others.

Tiger in China, a symbol of courage and strength, and the animal symbolizing the west. It was thought able to ward off demons and evil spirits.

Timber-frame architecture the traditional form of construction in Chinese architecture. Only the wooden columns and beams are load bearing; the walls are simple in-fill in one form or another. The half-timbered construction found in Europe was developed on similar principles.

Tiwah among the Ngaju Dayak of Borneo, a second funeral, when the soul of a dead person is finally able to leave this world and travel to Paradise.

Toad in China, a symbol of the moon, or of long life.

Tokoname in Japan, alcoves in which picture scrolls are hung or which are decorated with flower arrangements.

Tokugawa name of the shogun family which took over the government of Japan in 1603 and moved the seat of government to Edo. The period of government of the Tokugawa shoguns has given the name of the Tokugawa period or Edo period to the years from 1603 through 1867.

Tongkonan traditional Toraja house.

Torii at a Japanese Shinto shrine, the entrance gate.

Trimurti the "threefold form:" the Hindu trinity of Vishnu, Shiva, and Brahma.

Tripitaka the canon of Buddhist scriptures.

Tsuba the hand guard on a Japanese sword.

Tsutsugaki a technique for decorating fabrics by drawing a design in dye-resistant paste (squeezed from a paper bag); when the fabric is dyed the design is formed by the undyed areas.

Turtle in China, a symbol of long life and also the cosmos (because of its shell, which on top is round like the sky yet underneath is flat like the earth).

Twelve Insignia in China, the symbols of imperial power. They are: Sun, Moon, heavenly bodies, mountains, dragon, pheasant, axe, Fu-pattern, two sacrificial vessels, water plant, fire, and millet or rice.

Two children in China, two laughing children together usually represent the Genii Twins (Hehe and Erxin), the gods who protect merchants and potters. The god of long life is usually shown at their side.

Ukiyo-e "pictures of the floating world:" Japanese prints which depict scenes of everyday life in the Tokugawa era. They were produced by the combined efforts of artists, wood-engravers, and printers.

Umbrella one of the eight symbols of Buddhism, the symbol of authority and charitable acts.

Vairocana original or primeval Buddha.

Vajra "thunderbolt:" the weapon of the Hindi deity Indra.

Vase one of the eight symbols of Buddhism, the symbol for the highest insight; a reliquary. In China, the vase is also a symbol of peace (because the similar sound of the characters for "peace" and "vase.")

Vasuki in Hindu mythology, particularly in Cambodia, the snake who helped the deities to churn the Sea of Milk in order to create the elixir of eternal life.

Vihan an assembly hall for monks and devotees in a Buddhist monastery.

Wat (Sanskrit *vat*) a monastery complex, notably in Cambodia and Thailand.

Vibisana a brother of Rahvana in the Indian epic the *Ramayana*.

Vihara in Hindu mythology, a water monster.

Vishnu "protector:" one of the gods of the Indian trinity. In every age he appears in a new incarnation to bring salvation to the world.

Wabi, sabi in Japanese aesthetic, the ideals closely bound up with Zen Buddhism and the tea ceremony. *Wabi* suggests the subtle nuances of frugality, moderation, restraint, and even poverty; *sabi* has connotation of age, patina, and solitude.

Wadansu in Japan, a chest of drawers in which small objects can be kept.

Waves in Chinese mythology, the residence of dragons.

Wayang golek Indonesian form of theater using wooden puppets.

Wayang klitik Indonesian form of theater using flat wooden puppets with movable leather arms.

Wayang kulit Indonesian form of theater using leather puppets.

Wayang topeng Indonesian form of theater based on masked dance.

Weft ikat a form of *ikat* in which the weft threads are "served," used above all for silk fabrics and carried out on a loom with a comb. See **Ikat**

Wenshu the Buddhist bodhisattva of wisdom, called Manjusri in Sanskrit. He is often depicted riding on a tiger.

Wheel of teaching one of the eight symbols of Buddhism; the sacred wheel, or wheel of teaching, crushes superstition and, being a circle, symbolizes the person of Buddha.

Woodcuts standard sizes for Japanese *ukiyo-e* woodblock prints are:

Oban about 38 x 25 cm
Oban (large) about 58 x 32 cm
Chuban about 28.3 x 21.7 cm
Koban about 22.8 x 17.2 cm (with some variations)
Hashira-e about 73 x 12 cm
Hosoban about 33 x 14.5 cm

Smaller formats were used for offprints and for illustrating books.

Wutong tree a variety of Paulownia tree. In China, it is supposed to be the home of the phoenix.

Xieyi in Chinese art, a style of painting using very quick, sketch-like brushstrokes.

Xingshu in calligraphy, Chinese "cursive script."

Yabo in Japan, showing a lack of taste in the choice of clothes; anachronistic, boring, vulgar.

Yamato-e in Japanese art, paintings with purely Japanese themes; Japanese landscape painting. Yamato is an ancient name for Japan.

Yangban aristocratic official from the Korean upper class.

Yayoi ware Japanese earthenware made from around 300 B.C. It was made by the old method of preparing by coiling "cords of clay" in spiral form, often completed on the potter's wheel, and it was fired at low temperatures. The walls of the vessel are often thinner than those of vessels of the preceding Jōmon period. Yayoi wares are painted with ochre or cinnabar pigments. A striking characteristic is a black burn mark on the reddish clay, the result of its position during firing.

Yin, yang the two central and complementary concepts of Chinese thinking. *Yin* is associated with the dark, feminine, and receptive; *yang* with the bright, masculine, and active.

Yoga in Japanese art, "Western painting," a style of painting widespread in Japan after the Meiji restoration (from 1868). Yoga artists modeled themselves on Western artists, using Western techniques and materials.

Yokogi in Japan, a small device for altering the length of pot handles.

Yokthe-pwe Burmese puppet theater.

Yoshiwara the extensive courtesans' quarter near the Senso-ji temple in Asakusa to the northeast of Edo in Japan.

Zen "meditation:" Japanese Buddhist sect (derived from the Chan of China) which aims to achieve oneness with Buddha through meditation and self-mastery.

Zhuang Zi Master Zhuang, Chinese philosopher of the 4th century B.C. The *True Book of the Southern Land of Blossom* is attributed to him. His philosophy is also classed as Taoist, but is less worldly. He poses questions about the nature of being, which are answered in metaphysical terms.

Zodiac in China, the 12 animals of the yearly cycle, one animal for each year in a cycle with the following sequence: rat, ox, tiger, rabbit, dragon, snake, horse, goat, monkey, rooster, dog, pig. As in Western astrology, varying characteristics and positive properties are assigned to the animals.

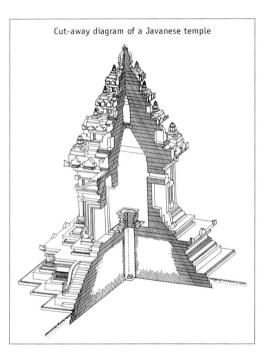

Cut-away diagram of a Javanese temple

Index

*The italics are references to
illustrations only.*

A

abaka see Banana fiber
Abaoji (1) 176, 178
abhayamudra (2) 63
aburage (2) 262
abura-zara (2) 280, *281*
Academy (1) 181
 Imperial (1) 153, 160
 (of the) Ming period (1) 193
Admonitions to the Court Ladies (1)
 116
afang (1) 78
Agama Hindu Dharma (1) 339
Agama Hindu Kaharingan (1) 343
ai-kutani ware (2) *274*, 275
Ainu (2) 341, 351
Ainu costume (2) 336, 338, *339*
Airlangga (1) 336
Akita (2) 293
alang (1) 321f.
Alaungsithu (2) *73*, 74, 79
Alun (2) 115
Amakuni (2) 340
Amarapura (2) 83, 88, *89*
Amaravati (1) 389
Amateur painter (1) 159
Amida (2) *169*, 171, 299
Amida *raigo* (2) 300
Amida *see* Buddha
Amitabha (1) 105, *107*
An Nam (2) 98
anagama (2) 250, 258, 263
Ananda (1) *108*, (2) 70, 76
Ananda Okkyaung (2) *73*
Anawrahta (2) *70*, 72, 74, 76, 77, 79
Ancestor worship (1) 45
Ancestor. depiction (2) 119
Ando, Tadao (2) *323*
andon (2) 344
andon-zara (2) 280f., 283
angenan (1) 358
Angkor (2) 12
Angkor Thom (2) 8, 17, *19f.*
Angkor Wat (2) 13–26, 33
Animal eating prey, motif (1) *65*
Animals of the four points of the
 compass (1) 85, 89
anjuang (1) 318f.
Ankoku Dōji (2) 300
Anou (2) *64*
Anourouth (2) 63
Anyang bronzes (1) 39
Appliqué work (2) 152
Appropriation, painting (1) 122
apsara (1) 105, 108, (2) *22–23*, 26,
 36
Arakanese (2) 88
Arapadhatu (1) 329f.
Arita Ware (2) 269–277, 283
Arjuna (1) 326, 367
Arrowhead motif (2) 135
Artificial mountains (*jia shan*) (1)
 90f., 130
Artists, orthodox (1) 228
Arts and Crafts movement (2) 344
Ash glaze (2) 254, 258, 261, 277
Ashikaga shogunate (2) 179
Asuka period (2) 294, 350
asuras (2) *22–23*
Atayal (2) *118f.*
Atsumi (2) 253

Autobiographical Text (Zi xu tie) (1)
 149
Autumn Colors in the Xiao and Hua
 Mountains (1) *180*, 182
Avalokiteshvara (1) *341*, (2) 361, *362*,
 363
Awakawayasuichi (2) *236*
aware (2) 174
Ax cut, brushstroke (1) 165
Ax, *Yue* (1) 40
Axis, central (1) 133
ayodhya (2) 42
Ayuthaya (2) 42, 45
Azuchi castle (2) 179

B

ba (1) 182
Babad Tanah Jawi (1) 382
Bada shanren *see* Zhu Da
Bagong (1) 384
Bai Juyi (1) 129, 131
Bai ta (1) 233, *235*
baici (1) 145
Bakong (2) 12, 25
Baksei Chamkrong (2) *10*, 12
Bali (1) 336–339, (2) *145*
balih-balihan (1) 384
Bamboo fence, design (2) 257
Bamboo, painting (1) 182
Banana fiber (2) 116, 135, 152, *154*
Banana leaves (1) 189
Bangkok (2) 45–52
Banh It (1) *396*
banji motif (2) 151f.
Banteay Kdei (2) 17
Banteay Samre (2) 24
Banteay Srei (2) *12*, 24, 26
banten (1) *355*
Baray (2) 12
Bark bast (2) 113–116
Basir (1) 347
Bathara Bayu (1) 367
Bathara Kala (1) 371
Batik (2) 116, 151f., *153*
Bauhandbuch Ying zao fa shi (1) 179
Bayon (2) 13–26
Beaker, prints (1) 17
bebali (1) 384
Bedhaya, dance (1) *381*, 382
Bells (1) 32, 52f., *55*
Benuaq (2) *136*
Bernard, Emile (2) 203
Besakih (1) 336
betang (1) 344
Betel (2) 119f., *122f.*
Bharatanatyam (1) 379
Bhineka tunggal ika (1) 340
bhumisparshamudra (2) 64
bi (1) 22
bi disks (1) 43, 94, *296*, *297*, 303, 306
bi yi (1) 122
Bi Yun Si (1) 104
bian (1) 54
bian hu (1) 96
Bian Shoumin (1) 232
biliak (1) 318
bilik (1) 316
Bima (1) 367
Bird
 motif (1) *48*, 49
 painting (1) 168
 script (1) 57
Bizen ceramic (2) 217, *242*, 253f.,
 260f., 287, *288*

blanc de Chine (1) 243, *244*
Blouse (2) *113*, 115
Blowpipe darts, containers (1) *345*
Blue and Green style (1) 146, 160
Blue Hmong (2) *151*, 152
bo (1) 54
Bo tree (2) 59–60
Bo Yuan tie (1) *126*
Bodhi tree (2) 76, 94
Bodhidharmas *see* Daruma
Bodhisattva (1) 102, *104*, 107f., 106,
 109, 110ff., *115*, 179, 331, (2)
 171, 295f., 300, 358, *360–361*
Bogu tulu (1) *171*
Borneo (2) 115f., 119f., 135, *136*, 147
Borobudur (1) 328–335, (2) *12*, 25
Bosatsu (2) 295, *296*, 358
boshan lu (1) 90
botamochi (2) 261
Bow
 bo type (1) *20*
 pen type (1) *19*
Bracketing system (*dou gong*) (1) 132
Brahma (1) 327, *341*, (2) 36
Brahmanism (2) 34, 72
Bread-fruit tree (2) 113
Brick fragment (1) *60*
Bridal gifts (2) 143
Bronze
 Age (1) 268
 art (1) 25f., *27*, 39, *42*, 47, *48*, 49
 burial objects (2) 249
 casting (1) 25, 47
 culture 64
 decoration (1) 28–55
 inscriptions (1) 49
 sculpture (1) 40–64
 vessels (1) *26*, 30, 32f., *45*, 47, 48,
 49, *271*, 309
Buddha (1) 108, 112, *114*, 340, (2) 19,
 41, 57, *62*, 63f., 76f., 95, 232, 295,
 360
Buddha palace temple of Fogong si
 (1) *178*
Buddhism (1) 100–115, 278ff., *309*,
 340 (2) 25, 34, 43, 57, 72, 77, *78*,
 168, *293*, 295, 299, 353f., 358,
 367, 375f.
Bugaku dances (2) 303
Buildings, underground (1) 47
Bummei (2) 229
Bunjinga (1) 279, 285, (2) 211
Bupaya stupa (2) 77
Byodo-in temple (2) 299f.

C

Calligraphy in China (1) 83f.,
 122–127, 145, 150f., 163, 181f.,
 200, 224, 262, (2) 212
 in Northern Wei style (1) *107*
Camellias (1) 130
candi (1) 327
Candi Mendut (1) 331, *333*
Candi Panataran (1) 335
Candi Pawon (1) 331
Candra Kasem palace (2) *43*
Canh Tien (1) *386*
cao sheng (1) 125
Cao Zhi (1) 117
Cao-Dai (2) 109
Cao-Dai temple (2) *109*
caoshu (1) 83, *120*, 123, 125, 150, 272
Carved lacquer technique (1) 174,
 215

Castiglione, Giuseppe (1) 237
Casting technique (1) 26, 28, 39, *48*,
 49
Castles, Japanese (2) 321f.
Casual/careless script *see caoshu*
Cave
 of Pindaya (2) *88*
 of the Thousand Buddhas (Qian fo
 dong) (1) 108
 monasteries (1) 102
Celadon wares (1) 127f., (2) 269, 372,
 375, *378f.*
Ceram (2) *110*, 115
Ceramic vessel types (1) 18–20, 23f.
 gong (1) 45
 guan (1) *18f.*, 31
 you (1) *33*
 zun (1) 30, 32f.
Ceramic vessels (1) 11, 19f., 23f., *62*,
 172
Ceremonial textiles (2) *118f.*,
 132–133, *146–147*, 152
cetiya (2) 94
Cezanne, Paul (2) 236
Ch'an (Chan) (1) 170, (2) 171, 354,
 363, 368
 Buddhism (1) 278f.
 painting (1) 123, 170, 228
 sect (1) 278
ch'ing-pai style (2) 287
Ch'ing-pai ware (2) 254, 288
Chōjirō (2) 267
Chōng Sōn (2) 368
chaitya (2) 94
Chakri dynasty (2) 45, 47
Chaliang (2) 41
Champassak (2) 34, *36*
Chang Lom (2) 41
Chang scepter (1) 299
Changchun yuan (1) 238
Cha-no-yū (2) 174
chao fa (2) 60
Chao Phraya river (2) 46
Chawa (2) 58
Che (2) 179
chedi (2) 34, *39*, 41, 43, 47, 49
Chen Qiquan (1) *264*
Chen Yuan (1) *186*
Chen-la (2) 11
Chi bui tu (1) 164, 165
Chiang Mai (2) 40, *48*, 64
Chiang Rai (2) 45
Chiarascuro, technique (2) 227
Chickens (1) *257*
Chikanobu (2) 211
Chikutai Osawa (1) 285
Chine de commande (1) 243
Chinese (1) *293ff.*, 297
Chion-in temple (2) 171
Chiossone, Edoardo (2) 236
chongun (2) 355
chonin (2) 192f., 197
Chosen-karatsu (2) 269
Chrao Phraya (2) 52
Chrysanthemum (1) 130, 170, 181,
 201, *202*, (2) 212
Chu (1) 52, 57
Chua Huong (2) *108*
Chuci (1) *198*
Chugu-ji (2) 295
Chunhua ge tie (1) 125
Chunqiu period (1) 44
Cicadas (1) 37
cili (1) *358*

Picture credits

(tp=top, bm=bottom, rt=right, lf=left, cn=center)

Arcaid, Kingston-on-Thames: Photo: Richard Bryant p. 323; Photo: William Tingey p. 322

© Art Institute of Chicago: p. 17; p. 26 rt; p. 27 lf; p. 27 rt; p. 46; Photo: Michael Tropea p. 78 rt

© Axiom, London: Photo: Jim Holmes p. 45 lf; p. 96; p. 98; p. 99 tp, rt; p. 100; p. 101 lf; p. 103 lf; p. 108 tp; p. 109 tp; Photo: James Morris p. 51; Photo: Mihiko Ohta p. 49

from: L. Bezacier "Relevés du monuments anciens du Nord-Viet-Nam", Paris 1959, École Française D'Extrême-Orient: p. 393

Bildarchiv Preußischer Kulturbesitz, Berlin: p. 340 tp

from: A. du Boulay "Chinesisches Porzellan", Frankfurt 1963, Ariel-Verlag: p. 394

© Achim Bunz, Munich: frontispiece, p. 30 tp; p. 30 bm; p. 31 tp; p. 31 bm; p. 32 tp; p. 32 bm; p. 41 tp; p. 41 bm; p. 42; p. 43 tp, lf; p. 43 bm; p. 48 tp; p. 50 tp, lf; p. 50 tp, lf; p. 50 tp, rt; p. 52; p. 70; p. 72; p. 73 tp; p. 73 bm; pp. 74–75; p. 76 lf; p. 77; p. 78 tp, lf; p. 79 rt; p. 79 lf; p. 80 bm; p. 81; p. 82 tp, lf; p. 82 bm; p. 83; p. 84 tp, lf; p. 84 bm; p. 86 tp; p. 87; p. 88; p. 89 tp; p. 89 bm; p. 90; p. 91 bm; p. 92 rt; p. 93; p. 94 bm; p. 95 tp; p. 103 tp, rt; p. 102 rt; p. 103 tp, rt

Chiba Museum of Art, Chiba: p. 205; p. 216; p. 217 lf; p. 229; pp. 230/231 tp; pp. 234/235

Edo Tokyo Museum, Tokyo: p. 200 tp; p. 200 cn; p. 200 bm; p. 201

from: J. Eliot/J. Bickersteth/J. Colet "Vietnam, Laos und Cambodia Handbook", Bath 1995, Footprint Handbooks: p. 14 tp; p. 20 tp, rt; p. 57 tp; p. 70; p. 101 rt; p. 385; p. 389; p. 392; p. 395; p. 396

from: J. Eliot/J. Bickersteth/G. Matthews "Thailand und Burma Handbook", Bath 1995, Footprint Handbooks: p. 44 tp; p. 50 tp, rt; p. 82 tp, rt

from: exhib. cat. "Art Treasures of Eikando Zenrin-ji", Japan 1996: p. 297 lf; p. 297 rt

from: exhib. cat. "Kunstschätze aus China", Zürich 1980, © 1998 by Kunsthaus Zürich: p. 386/387; p. 387 bm

from: exhib. cat. "Eternos Tesouros de Japão", São Paulo 1990: p. 303 tp; p. 303 bm; p. 340 tp; p. 340 bm; p. 341 lf

Astrid Fischer-Leitl, Munich: p. 11; p. 74; p. 245; p. 350

© Freer Gallery, Washington D.C.: p. 162; p. 164; p. 165; p. 169; p. 170; p. 171;

p. 172; p. 175; p. 176; p. 178; p. 179; pp. 182–187; pp. 188/189; p. 192; p. 206 tp; p. 214; p. 215; p. 251; p. 293 tp, lf; p. 296; p. 300 lf; p. 300 rt; p. 301 lf; p. 301 rt; p. 324; p. 326; p. 329; p. 361; p. 362; p. 363

© Traude Gavin, Los Angeles: p. 132

© Dr. G. Gerster/Agentur Anne Hamann, Munich: p. 33; p. 38; p. 40; p. 43 tp, rt; p. 44 bm; p. 76 rt; p. 94 tp; p. 108 bm

from: M. Gittinger "Splendid Symbols", Washington 1979, The Textile Museum: p. 158 tp; p. 159 tp

© Roy Hamilton, Los Angeles: p. 127

© Hasebe-ya Collection, Tokyo: p. 257 lf; p. 274 tp

© Hatakeyama Collection, Tokyo: p. 189 tp; p. 190; p. 242; p. 244; p. 261; p. 262; p. 263; p. 264; p. 265 tp, lf; p. 265 bm; p. 266; p. 267; p. 274 bm; p. 275 lf; p. 275 rt; pp. 276-277; p. 279; p. 290; p. 305; p. 332; p. 351

Hetjens-Museum, Düsseldorf: p. 268; p. 269 lf; p. 269 rt

© Collection of R. J. Holmgren & A. E. Spertus, New York: p. 141

Honolulu Academy of Art: pp. 180–181; p. 299 lf; p. 299 rt

from: C. Hornung "Traditional Japanese Stencil Design", London 1985, © by Dover Publications: endpapers

from: J. Hutt "Understanding Far Eastern Art", New York 1987, Roxby Art Publishing: p. 333

© Indonesian Archeological Service: p. 398;

from: S. Kartiwa "Indonesian Ikats", Jakarta 1987, Penerbit Djambatan: p. 158 cn, rt; p. 159 cn, rt

© J. E. V. M. Kingado Collection: pp. 4–5, p. 217 rt; p. 222 lf; p. 222 rt; p. 223; p. 224; p. 225 lf; p. 225 rt; p. 226 rt; p. 227; p. 228 lf; p. 228 rt; p. 236 tp; p. 237; p. 238; p. 239; p. 241 lf; p. 241 rt; p. 286

With the kind permission of the Cultural Service, Korean Embassy, Tokyo: p. 295; p. 348; p. 352; p. 353; pp. 354-355; p. 356; p. 357; p. 358 lf; p. 358 rt; p. 359 tp; p. 359 bm; p. 360; p. 364; p. 365; p. 366 lf; p. 366 rt; p. 367; p. 368; p. 369 lf; p. 369 rt; p. 370; p. 371; p. 372 lf; p. 372 rt; p. 373; p. 374; p. 375; p. 378; p. 379 lf; p. 379 rt; p. 380; p. 381

from: F. Koyama "The Heritage of Japanese Ceramics", New York, Tokyo, Kyoto 1973, Weatherhill/Tankosha: p. 246 tp; p. 246 cn; p. 246 bm; p. 247; p. 249; p. 250 tp; p. 250 bm; p. 256; p. 271; p. 272

Kunsthandel Klefisch GmbH, Cologne: p. 327 tp; p. 327 cn; p. 327 bm

Lindenmuseum, Stuttgart: p. 330; p. 331

Robert Lohbrunnert, Munich: p. 99 tp, lf; p. 102 lf; p. 104 tp, lf; p. 104 tp, rt; p. 105; p. 107 tp; p. 107 tp, lf; p. 107 tp, rt

from: D. Mazzeo/C. S. Antonini "Monumente großer Kulturen", Wiesbaden 1974: p. 12 lf; p. 13

© Mukyo Gallery, Tokyo: p. 284 rt; p. 285 bm

© Museum für Lackkunst, Münster: Photo: Kunsthandel Klefisch GmbH, Cologne: p. 376, p. 377

© National Gallery of Australia, Canberra: p. 146 lf; p. 152

National Geographic Society/Image Collection, Washington: Photo: Paul Chesley p. 45 rt; p. 48 bm; Photo: James L. Stanfield p. 86 cn; p. 86 bm; p. 95 bm

from: N. N. "Exotisches Kunstgewerbe. Arbeiten aus dem Rautenstrauch-Joest-Museum für Völkerkunde der Hansestadt Köln", Leipzig 1941: p. 124 lf; p. 124 rt; p. 125; p. 128; p. 129 lf, tp; p. 129 rt, tp; p. 129 lf, bm; p. 129 rt, bm

from: N. N. (Catalog of Architecture on Tokushima), Tokushima undated.: p. 316; p. 321 lf; p. 390

© Photobank Bangkok/Tettoni, Cassio and Associates PTE Ltd.: p. 19 tp

Jaroslav Poncart, Cologne: pp. 22–23

PPS Pacific Press Service,Tokyo: p. 309; pp. 312–313; p. 314; p. 315 tp; p. 315 bm; p. 316 tp; p. 317; Photo: Takeshi Mizukoshi p. 310 tp; p. 318 tp; p. 318 rt; p. 319 tp; p. 319 bm; Photo: Ben Simmons p. 310 bm; Photo: Steve Vidler p. 320; p. 321 rt; Photo: K. Yamamoto p. 311

© Private collection: Photo: Michael Dunn Archive p. 166/167; p. 177; p. 194; p. 195; p.198; p. 199; p. 201; p. 202 rt; p. 203; p. 204; p. 206 bm; p. 207; p. 208; p. 209 tp; p. 209 bm; pp. 210/211; pp. 230/231 bm; p. 236 bm; p. 328 lf; p. 328 rt; p. 335; p. 347 bm

© Private collection: Photo: A. C. Cooper p. 173; p. 260; p. 298

© Private collection: Photo: Hatano Narimi p. 193; p. 196; p. 202 lf; p. 206 lf; pp. 212/213; pp. 218/ 219 tp; pp. 218/219 bm; pp. 220/221 tp; pp. 220/221 bm; p. 226 lf; p. 232 lf; p. 233 tp; p. 233 bm; p.257 rt; p. 265 tp; p. 285 tp; p. 286 bm; p. 287; p. 288; p. 289 tp; p. 289 bm

© Private collection: Photo: Roberto Paltrinieri, Cadro p. 258; p. 273; p. 280 tp, lf; p. 280 tp, rt; p. 280 tp, lf; p. 280 tp, rt; p. 281 tp; p. 281 bm; p. 282 tp; p. 282 tp, lf; p. 282 tp, rt; p. 283; p. 284 lf; p. 329 tp, rt; p. 329 bm; p. 336; p. 337 tp; p. 337

tp, lf; p. 337 tp, rt; p. 338; p. 339 tp, lf; p. 339 tp, rt; p. 339 bm; p. 341 rt; p. 342; p. 343; p. 344 tp; p. 344 cn; p. 344 bm; p. 345; p. 346 tp, lf; p. 346 tp, lf; p. 346 rt; p. 347 tp, lf; p. 347 tp, rt

© RMN Agence Photographique, Paris: Photo: John Goldings p. 18; p. 26 lf; Photo: John Gollings p. 14 bm; p. 20 tp, lf

Franz Schertel, Passau: p. 8; p. 10 tp; p. 10 tp, rt; p. 10 tp, lf; p. 12 rt; pp. 14–15; p. 16 tp, rt; p. 16 tp, lf; p. 16 tp, rt; p. 16 tp, lf; p. 19 bm; p. 20 bm; p. 21tp; p. 21 bm; p. 21 cn; p. 24; p. 25; p. 28; p. 29; p. 34; p. 35; p. 36 tp; p. 36 tp, rt; p. 36 tp, lf; p. 37 tp; p. 37 bm; p. 47; p. 54, p. 56 tp; p. 56 bm; p. 57 bm; p. 58; p. 59, p. 60 rt; p. 60 lf; p. 61 tp; p. 61 bm; p. 62 tp; p. 62 tp, rt; p. 62 tp, lf; p. 63 rt; p. 63 lf; p. 64; p. 65 tp; p. 65 bm; p. 66 rt; p. 66 tp, lf; p. 66 tp, lf; p. 67 tp; p. 67 bm; p. 68; p. 69 tp; p. 69 bm; p. 99 tp; p. 104 bm; p. 106; p. 108 cn; p. 109 bm

from: V. C. Scott O'Connor "The Silken East. A Record of Life and Travel in Burma", 1904: p. 79 rt; p. 92 lf

from: A. Seiler-Baldiger "Systematik der textilen Techniken", Basle 1992

© Stiftung zur Förderung des Museums für Völkerkunde: p. 158 cn, lf; p. 158 cn, 2nd frm. lf; p. 158 cn, 3rd frm. lf; p. 159 cn, lf; p. 159 cn, 2nd frm. lf; p. 159 cn, 3rd frm. lf

Staatliches Museum für Völkerkunde München: p. 78; p. 80 tp; p. 91 tp; Photo: S. Autrum-Mulzer p. 53 tp, lf; p. 53 tp, rt; p. 80 tp; p. 84 tp, rt; p. 85 rt; p. 85 lf; p. 91 tp; p. 110; p. 112; p. 113; p. 114; p. 115; p. 116; p. 117; p. 118 lf; p. 118 rt; p. 119; p. 120 lf; p. 120 rt; p. 121; p. 122; p. 123; p. 126 lf; p. 126 rt; p. 131; p. 133 rt; p. 137 lf; p. 137 rt; p. 139; p. 142/143; p. 144; p. 145; p. 146 rt; p. 148; p. 149; p. 150; p. 151 lf; p. 151 rt; p. 153; p. 154 lf; p. 154 rt; p. 155; p. 156; Photo: M. Weidner-El Salamouny p. 133 lf; p. 135 tp; p. 135 bm; p. 136; p. 138; p. 140; p. 147 lf; p. 147 rt; p. 157

from: T. Thilo "Klassische chinesische Baukunst", © Köhler & Amelang, Vienna 1977: p. 388 lf; p. 388 rt

Tokyo Fuji Art Museum, Tokyo: p. 344 tp; p. 341 lf

© Tokyo National Museum, Tokyo: p. 248; p. 252; p. 253; p. 254; p. 259; p. 270; p. 278; p. 292 lf; p. 292 rt; p. 293 tp, rt; p. 293 bm; p. 294 lf; p. 294 rt; p. 302; p. 304; p. 306; p. 334

Acknowledgments

The publisher thanks everyone who helped to create these two volumes, especially adHOC Laureck & Beuster OHG, Dyrken Schulze-Ottmers, Uwe Kolsch, and Amir Sidharta.